Moche Art and Archaeology in Ancient Peru

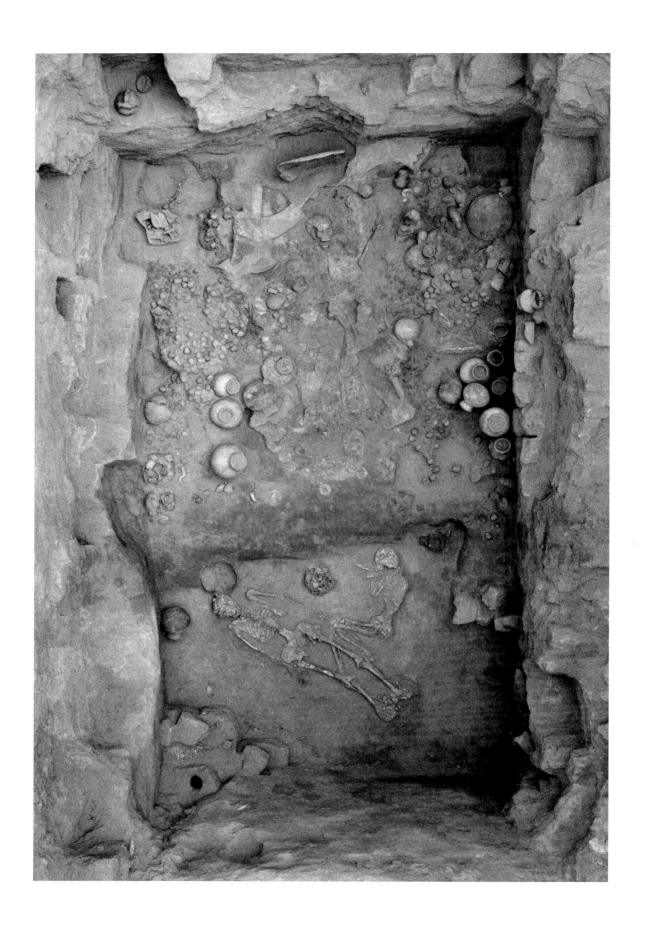

STUDIES IN THE HISTORY OF ART · 63 ·

Center for Advanced Study in the Visual Arts

Symposium Papers XL

Moche Art and Archaeology in Ancient Peru

Edited by Joanne Pillsbury

National Gallery of Art, Washington

Distributed by Yale University Press,
New Haven and London

This volume was produced by the Center for Advanced Study in the Visual Arts and the Publishing Office, National Gallery of Art, Washington. *www.nga.gov*

Editorial Board
JOHN OLIVER HAND, *chairman*
SUSAN M. ARENSBERG
SARAH FISHER
THERESE O'MALLEY

Editor in Chief
JUDY METRO

Managing Editor
CAROL LEHMAN ERON

Production Manager
CHRIS VOGEL

Copy-editing and design by
MICHAEL RAEBURN

The type is Trump Mediaeval, set by Cacklegoose Press Ltd., Hammersmith, England.

The text paper is Multiart Matt.

Printed by CS Graphics Pte. Ltd., Singapore

All Spanish translations by Mary E. Pye

Index by Jean-François Millaire

Distributed by Yale University Press, New Haven and London

Abstracted and indexed in BHA (Bibliography of the History of Art) and Art Index

Proceedings of the symposium "Moche: Art and Political Representation in Ancient Peru," sponsored by the Andrew W. Mellon Foundation. The symposium was held 5–6 February 1999 in Washington.

Library of Congress Cataloging-in-Publication Data

Moche art and archaeology in ancient Peru / edited by Joanne Pillsbury.
 p. cm. — (Studies in the history of art, ISSN 0091-7338 ; 63. Symposium papers ; 40)
 Proceedings of a symposium held in Washington, Feb. 5–6, 1999, sponsored by the Andrew W. Mellon Foundation.
 ISBN 0-300-11446-x (pbk.)
 1. Mochica art. 2. Mochica Indians. 3. Moche River Valley (Peru)—Antiquities. I. Pillsbury, Joanne II. National Gallery of Art (U.S.) III. Series: Studies in the history of art (Washington, D.C.) ; 63. IV. Series: Studies in the history of art (Washington, D.C.). Symposium papers ; 40.
 N386.U5S78 vol. 63
 [F3430.1.M6]
 709 s—dc22
 [704.03'98085] 2005022661

Frontispiece: Tomb of the Priestess (M-U41) found at San José de Moro in 1991 (shown head to top) Photograph by Christopher B. Donnan

Contents

Preface

In February 1999 the Center for Advanced Study in the Visual Arts sponsored a two-day symposium devoted to Moche art and archaeology. Entitled "Moche: Art and Political Representation in Ancient Peru," the gathering was convened to consider a series of issues arising from recent archaeological investigations of this culture that flourished on the north coast of Peru from the beginning of the common era through the eighth century A.D.

Sixteen papers were presented at the symposium, which was broadly concerned with the relationship between the visual arts and the archaeological record. Moche art, perhaps more so than any other ancient Andean tradition, has long been appreciated for the remarkable detail of narrative scenes and the visual power of ceramic representations commonly known as portrait vessels. Yet recent archaeological discoveries have made us question our previous assumptions about the use and significance of these objects. The new finds have illuminated a provocative yet problematic relationship between what is represented in the visual arts and what is represented in the archaeological record, and with special implications for the study of settlement patterns, urban planning, architecture, and visual arts of the Moche.

The Center for Advanced Study is grateful to the Andrew W. Mellon Foundation, which sponsored the symposium. In addition the Center wishes to thank those who assisted in the planning of this gathering, including Garth Bawden, Brian Billman, Elizabeth Boone, Luis Jaime Castillo, Anita Cook, Terence D'Altroy, Tom Dillehay, Christopher Donnan, Paul Goldstein, Ricardo Luna, Joanne Pillsbury, Jeffrey Quilter, and Santiago Uceda. Luis Jaime Castillo, Claude Chapdelaine, Joanne Pillsbury, and John Verano served as moderators of the symposium. Brian Billman presented a paper at the symposium but did not prepare one for publication.

The symposium series within Studies in the History of Art, of which this is the fortieth volume, is designed to document scholarly meetings sponsored under the auspices of the Center for Advanced Study. A summary of published and forthcoming titles may be found at the end of this volume. The Center for Advanced Study in the Visual Arts was founded in 1979, as part of the National Gallery of Art, to foster the study of the history, theory, and criticism of art, architecture, and urbanism through programs of meetings, research, publication, and fellowships.

ELIZABETH CROPPER
Dean, Center for Advanced Study in the Visual Arts

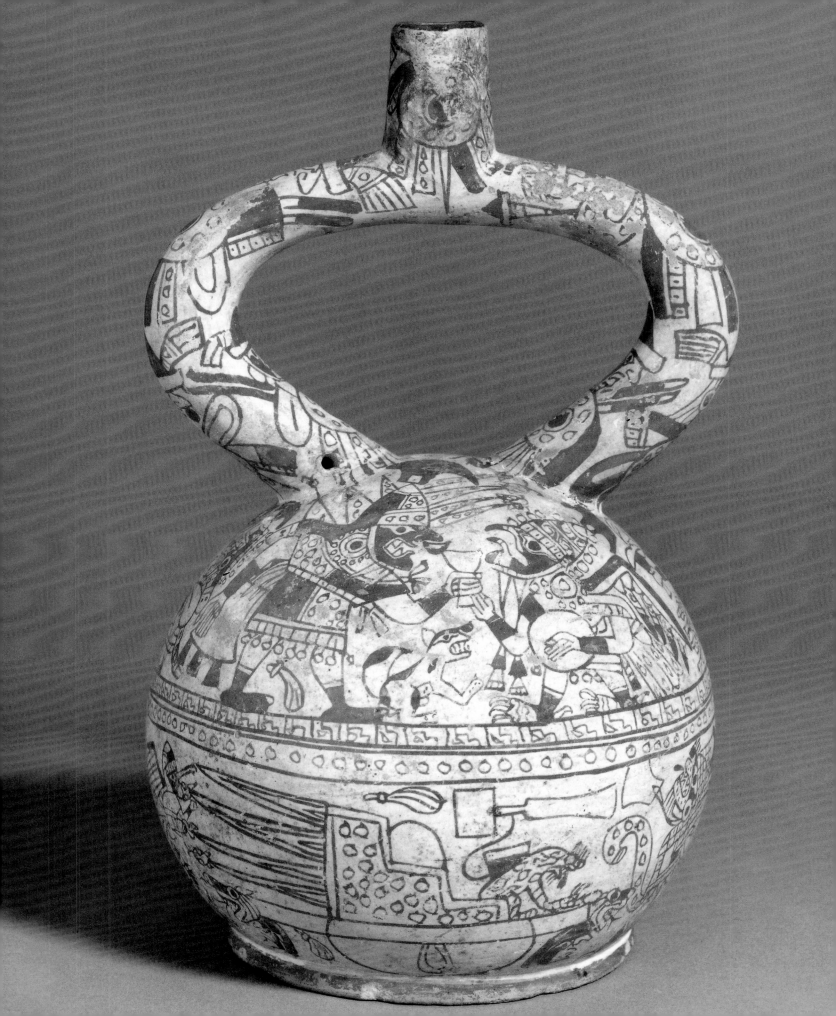

JOANNE PILLSBURY
University of East Anglia, Sainsbury Research Unit for the Arts of Africa, Oceania and the Americas

Introduction

Monumental architecture and objects of precious metal associated with a culture we now know of as the Moche have been written about since the arrival of the first Europeans on the north coast of Peru in the sixteenth century. Little was known of the people who created these works, however, as the Moche culture had ceased to flourish by c. A.D. 800, and the region was dominated by subsequent powers, including the Chimú and then ultimately the Inca. Systematic scholarly study of the archaeology of this region began only at the turn of the twentieth century, and continued for the most part on a relatively modest level until the late 1980s. The dramatic discoveries of the royal tombs at Sipán in the late 1980s and early 1990s heralded the beginning of a period of unprecedented attention to Moche art and archaeology. Large-scale and long-term projects in recent years have provided important new data on the Moche.

These papers are concerned specifically with the relationship between the visual arts and political representation in Moche culture. Several recent archaeological discoveries, at Sipán and at San José de Moro, in particular, have prompted a renewed inquiry into the nature and purposes of Moche art. The personages known from the intricate fine-line paintings that appear on Moche ceramics were suddenly found to have correlates in the archaeological record, but what was the relationship between figures buried with the regalia and those figures seen in the iconography,

and what was their significance? On a broader level, the papers in this volume address the relationship between Moche visual imagery and what we tend to think of as "objective" knowledge gained from the archaeological record. In what areas are the two sources of information at odds with each other? In what ways do the visual representations accord with evidence of political hegemony in the archaeological record? How were the visual arts used in the maintenance of political authority? In light of these new findings, how have our views of Moche political organization changed?

Information on the Moche comes from a number of sources. The Moche themselves left no written record, as alphabetic writing systems were not used in the ancient Andes. They did leave behind a remarkable artistic corpus, full of rich detail of ritual, supernatural and perhaps daily life. Most of our data on Moche, however, come from archaeological studies, both in the form of settlement pattern surveys and excavations of Moche sites. To a limited degree, historical sources, from the colonial period or later, have been used to elucidate Moche practices (Hocquenghem 1987). Glenn Russell and Margaret Jackson, for example, argue in this volume that early colonial administrative records may shed light on the structure of social and political organization in antiquity. As these authors acknowledge, however, such an endeavor is not without risk. Nearly a millennium separates

Moche IV stirrup-spout bottle
Staatliches Museum für Völkerkunde, Munich

9

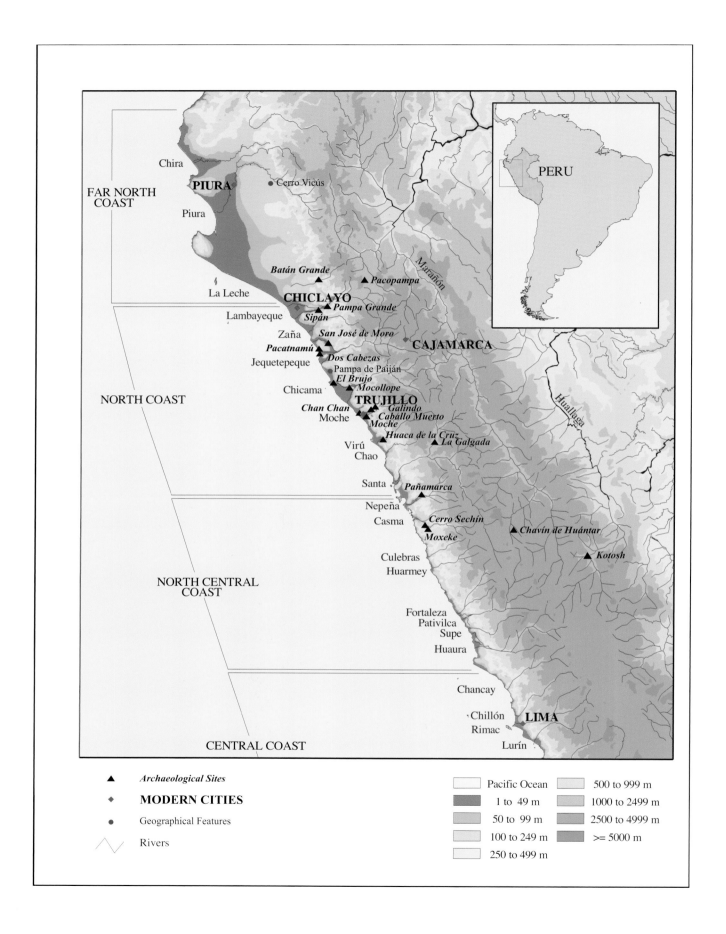

FAR NORTH
COAST

Chira

PIURA

Cerro Vicús

Piura

Batán Grande ▲ ▲ *Pacopampa*

La Leche

CHICLAYO

Lambayeque ▲ *Pampa Grande*

Sipán ▲

Zaña ▲ *San José de Moro*

Pacatnamú ▲ **CAJAMARCA**

Jequetepeque ▲ *Dos Cabezas*

Pampa de Paiján

NORTH COAST *El Brujo* ▲
 ▲ *Mocollope*

Chicama **TRUJILLO**

Chan Chan ▲ ▲ *Galindo*
Moche ▲ *Caballo Muerto*
 ▲ *Moche*

▲ *Huaca de la Cruz*
Virú ▲ *La Galgada*
Chao

Santa ▲ *Pañamarca*

Nepeña

Casma ▲ *Cerro Sechín*

▲ *Moxeke* ▲ *Chavín de Huántar*

Culebras
Huarmey ▲ *Kotosh*

NORTH CENTRAL
COAST

Fortaleza
Pativilca
Supe
Huaura

Chancay

·Chillón **LIMA**
Rimac

Lurín

CENTRAL COAST

PERU

Marañón

Huallaga

▲ *Archaeological Sites*

◆ **MODERN CITIES**

● Geographical Features

／\／ Rivers

	Pacific Ocean		500 to 999 m
	1 to 49 m		1000 to 2499 m
	50 to 99 m		2500 to 4999 m
	100 to 249 m		>= 5000 m
	250 to 499 m		

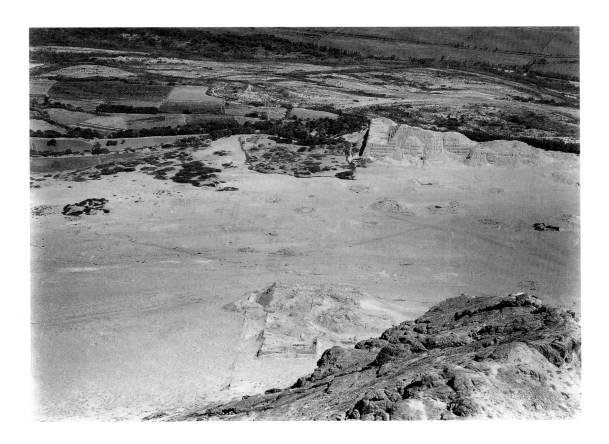

1. Map of the north coast of Peru
Map by Gisela Sunnenberg and Jean-François Millaire

2. Aerial view of the site of Moche (Cerro Blanco and Huaca de la Luna in the foreground, Huaca del Sol in the upper portion of the image)
Shippee-Johnson photograph from the 1930s, Department of Library Services, American Museum of Natural History (negative 334917)

some of these reports from the Moche, and in the intervening years the region was dominated by distinct cultures. On occasion, scholars have looked to the ethnographic present for analogies with Moche cultural practices (Donnan 1976, 1978; Sharon and Donnan 1974). As with the use of historical sources, such approaches must confront the problem of disjunction and profound cultural change.

Until recently, the prevailing view of Moche political organization was that of a centralized state with a capital at the site of Moche. It was assumed that the polity extended 500 km along the coastal desert, from the Piura Valley, near the modern border with Ecuador, to the Huarmey Valley (fig. 1). Moche settlements were largely confined to the fertile flood plains of the valleys; few remains have been found beyond 50–80 km inland, where the flood plains narrow and the jagged Andean cordillera rises. The majority of archaeological research concerning Moche centered on the Chicama, Moche, and Virú valleys, the three valleys considered the core area of the Moche state. As more field research is carried out in this area and other

valleys, however, finer distinctions are becoming evident in the archaeological record. The Moche occupation of the north coast was not uniform, and in some of the southern valleys, such as Huarmey, evidence for Moche is more in terms of objects rather than major sites. Not only is the Moche presence uneven over this territory, there appear to be distinct configurations of material remains between the northern and southern extremes of this area. Christopher Donnan (1990) and Luis Jaime Castillo (Castillo and Donnan 1994) have proposed two principal Moche spheres, separated by the desert zone of the Pampa de Paiján. The northern sphere extended from the Jequetepeque Valley north to Piura, and the southern sphere from the Chicama Valley south to Nepeña or Huarmey. A number of cultural features distinguish the two areas, including ceramic assemblages, architecture and urbanism.

The coastal strip the Moche occupied is characterized as a hyperarid desert, where under normal conditions there is little or no rainfall. The population centers were generally clustered along the river valleys, where

the run-off from the Andean mountains provides water for agriculture and other uses. This region also benefits from the presence of the Peruvian Coastal Current, commonly known as the Humboldt Current. Its cold waters offer a particularly rich marine biomass, providing another essential resource for the populations. Periodically, however, there are perturbations in the normal climate, known as El Niño–Southern Oscillation or ENSO events, which create dramatic shifts in the environment. Warm tropical waters then make incursions into the Peruvian waters, setting off a series of changes that in severe cases lead to torrential rains, flooding, and related catastrophes. A number of archaeologists have been studying the impact of environmental disasters on the cultural landscape in prehistory (*inter alia* Craig and Shimada 1986; Moseley 1987; Moseley et al. 1983; Uceda and Canziani 1993). Several of the authors in this volume consider the implications of ENSO events, both in terms of settlement patterns, as in Tom Dillehay's paper, "Town and Country in Late Moche Times: A View from Two Northern Valleys," and in terms of ritual behavior, as in Steve Bourget's paper, "Rituals of Sacrifice: Its Practice at Huaca de la Luna and Its Representation in Moche Iconography."

Within the broader Andean chronological sequence, most of the Moche occupation of the north coast dates to the period known as the Early Intermediate period, or roughly from the beginning of the common era to A.D. 650. Moche follows the Initial period and Early Horizon period cultures of the coast and highlands, and ends in the Middle Horizon period. The Middle Horizon period, linked to the expansion of the Wari polity of the south-central highlands, is still poorly understood on the north coast. As Luis Jaime Castillo notes in this volume, the Moche culture, which up to this time had remained relatively insular, began to participate in a broader cultural sphere. By c. A.D. 800, Moche becomes difficult to recognize in the archaeological record, and the region comes to be dominated the Lambayeque (Sicán) and Chimú cultures.

Although clear continuities exist with both the predecessors and successors of Moche, in many ways this culture remains quite distinct from other Andean traditions. Certainly in the visual arts, the emphasis on verism and

narrative sets the Moche apart. Jeffrey Quilter takes up these issues in his paper "Moche Mimesis: Continuity and Change in Public Art in Early Peru." Beginning with an examination of pre-Early Intermediate period architectural ornament and sculpture of the central Andes, he points out that, at first glance, Moche art appears relatively understandable, identifiable. Plants, animals, and ceremonies seem easily recognizable. But this apparent "naturalism" appears side-by-side with considerable abstraction. Even what appears to be straightforward often becomes a remarkable world of animated objects and impossible creatures when one examines the details of the subject matter. The art of the Moche is in some ways closer to one of the other greatly favored artistic traditions of the ancient Americas, the Maya, than to that of their neighbors in the southern Andes. For all of the apparent attractions of Moche art, however, it remains an artistic tradition that is still poorly understood.

Chronology was a major subject at one of the first meetings on the Moche, organized by Rafael Larco Hoyle in 1946 at Hacienda Chiclín in the Chicama Valley. Larco (1948) proposed a five-phase ceramic sequence, based on changes in the form of stirrup-spout vessels (fig. 3), the majority of which were from the Chicama Valley. This sequence was later associated with absolute dates, as more data were gathered (Donnan 1973, 1978; Kaulicke 1992). In Moche I (A.D. 50–100), the vessel form is compact, with a short spout and thickened lip. Moche II (A.D. 100–200) is characterized by a longer spout and thinner lip, and in Moche III (A.D. 200–450) the spout becomes slightly flared. Moche IV (A.D. 450–550) has a long, straight-sided spout, and finally in Moche V (A.D. 550–800) the spout tapers toward the top. The Moche sequence is preceded by two ceramic styles, Salinar and Gallinazo (also known as Virú), originally considered indicative of separate, earlier cultures. This sequence provided the standard method for the relative dating of Moche sites, and is still used with great frequency, particularly in the southern Moche region.

Recent research, however, has shown that the full Larco sequence is not entirely applicable in all valleys. Moche IV vessels, for example, are rare in the north. Furthermore, it is unclear whether the relative associations

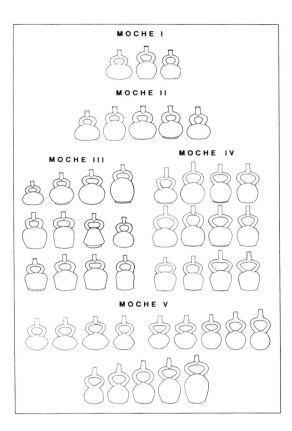

3. Seriation of stirrup-spout vessels developed by Rafael Larco Hoyle

Drawing by Izumi Shimada

imply the same absolute dates in all valleys. Christopher Donnan (personal communication, 1999) has exceedingly late dates for Moche I at the site of Dos Cabezas in the Jequetepeque Valley, perhaps as late as A.D. 450–550. Finally, what was once considered to be an orderly evolution of ceramic styles, linked with distinct cultural groups, now appears to be more complex. A smooth transition between Salinar, Gallinazo and Moche I–V clearly did not prevail across all valleys, or perhaps even in one. Gallinazo ceramics have been found alongside Moche ceramics at Dos Cabezas (Christopher Donnan, personal communication, 1999), calling into question our previous assumptions about ceramic style and cultural affiliation.

A greater number of papers in this volume are concerned with the end of Moche than with its rise. Christopher Donnan's new work at Dos Cabezas will be an important source for the early period.[1] Luis Jaime Castillo touches on both ends of the Moche chronological spectrum in his paper "The Last of the Mochicas: A View from the Jequetepeque Valley" Drawing upon a rich and complex

ceramic sequence at San José de Moro in the Jequetepeque Valley, Castillo brings up a host of questions on the demise of Moche, and on the nature of cultural evolution in general. Tom Dillehay also looks at broad chronological changes in the same region, but from the perspective of settlement pattern surveys of the Jequetepeque and Zaña valleys. Although Dillehay's work (with his coprincipal investigator, Alan Kolata) is still in its early stages, preliminary evidence suggests that the end of Moche may have been characterized by unrest. Garth Bawden, in his paper "The Symbols of Late Moche Social Transformation," analyzes the late Moche period at the site of Galindo, inland from the site of Moche. It is clear, in any case, that the final years of Moche are characterized by profound changes. Both Castillo and Alana Cordy-Collins, in her paper "Labretted Ladies: Foreign Women in Northern Moche and Lambayeque Art," reflect on incursions of foreign traditions in the Moche area.

In the spirit of Rafael Larco Hoyle, Santiago Uceda, Elías Mujica and their colleagues have continued to organize colloquia in Trujillo. These meetings have provided an important forum for the presentation of new research and the reconsideration of models and ideas concerning Moche archaeology (Uceda and Mujica 1994, in press). One of the major developments in Moche archaeology in the past ten years has been the range of projects. Important new data on rural and urban households (Gumerman 1991, 1994), and on settlement patterns (Billman 1996, 1999; Dillehay, this volume; Russell and Leonard 1990a, 1990b; Wilson 1988) have been gathered.

These studies are complemented by a number of long-term projects that focus on specific monumental architectural complexes. In an endeavor that can only be described as herculean, Santiago Uceda and Ricardo Morales began a project at Huaca de la Luna at the site of Moche in 1990 that has transformed our understanding of one of the largest architectural complexes in the prehispanic New World (fig. 2). Uceda's paper in this volume "Investigations at Huaca de la Luna, Moche Valley: An Example of Moche Religious Architecture" summarizes some of their recent findings. Platform I at Huaca de la Luna, once thought to be a solid, massive structure erected in a single construction

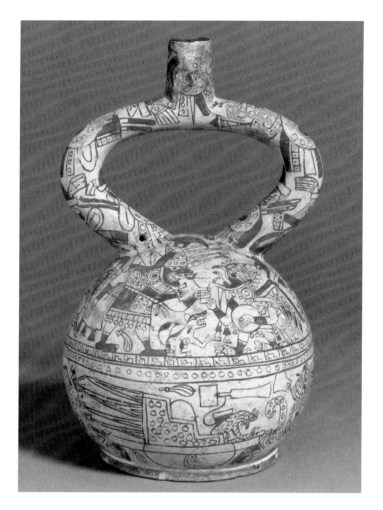

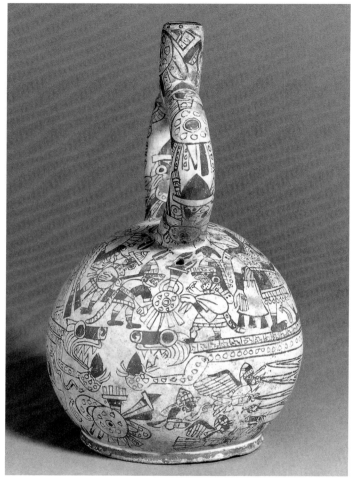

4. Moche IV stirrup-spout bottle
Staatliches Museum für Völkerkunde, Munich

phase, is now recognized as a complex series of plazas, patios and rooms, constructed in five major phases over the course of centuries. As part of the Huaca de la Luna project, Claude Chapdelaine excavated through the wind-blown sand and cementlike overburden of the floodplain between Huaca de la Luna and Huaca del Sol to reveal the remains of an extensive urban settlement. His paper "The Growing Power of a Moche Urban Class" dispels the notion that the Moche site was simply a ceremonial center with a relatively small retainer population. Régulo Franco, Segundo Vásquez, and César Gálvez have also been directing a large-scale project at the El Brujo complex in the Chicama Valley. In their paper "The Moche in the Chicama Valley," César Gálvez and Jesús Briceño analyze the monumental Huaca Cao Viejo, an architectural complex with a number of similarities to Huaca de la Luna in the Moche Valley, and place that monument within the larger context of Moche constructions in the Chicama Valley.

Craft production was clearly an important element at a number of these major sites. Based on data from his long-term study of the site of Pampa Grande in the Lambayeque Valley, Izumi Shimada's paper "Late Moche Urban Craft Production: A First Approximation" examines the nature and role of craft production in Moche sociopolitical organization. In a similar vein, Glenn Russell and Margaret Jackson analyze the ceramic workshop at Cerro Mayal, a large production area most likely attached to the monumental site of Mocollope, in "Political Economy and Patronage at Cerro Mayal, Peru." As Heather Lechtman (1984) has pointed out, the study of technology—the analyses of craft production —can be an illuminating source of information on abiding cultural values. Julie Jones,

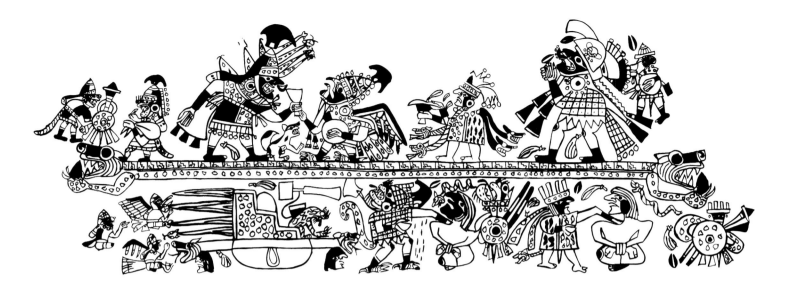

in her paper, "Innovation and Resplendence: Metalwork for Moche Lords" considers Moche metallurgy in light of the new finds at Sipán and new research on the Loma Negra material.[2]

With certain exceptions, archaeological and iconographic studies were conducted relatively independently until the recent finds forced a more integrated approach to Moche studies. Projects such as the Virú Valley Project of 1946 (*inter alia* Strong and Evans 1952; Willey 1953) and the Chan Chan–Moche Valley Project of 1969–1974 (*inter alia* Moseley and Cordy-Collins 1990; Moseley and Day 1982) were landmark studies, with implications for Andean archaeology and beyond, but the visual arts were never a major focus of their research design. These projects, however, provided important data on Moche settlement patterns, urbanism and architecture. Studies of Moche iconography were an important component of scholarly gatherings organized by Elizabeth Benson at Dumbarton Oaks over the years, and a number of detailed studies were published there, as well as others in Europe and Peru (Benson 1974, 1975; Donnan and McClelland 1979; Kutscher 1950). In 1968, Christopher Donnan established the Moche Archive at the University of California, Los Angeles, as a repository of photographs of the tens of thousands of Moche objects that have survived to the present day. This comprehensive resource has enabled major strides to be made in the study of Moche iconography and culture. Following

Gerdt Kutscher (1950, 1983) and Rafael Larco Hoyle (1948), Christopher Donnan, Donna McClelland and their colleagues have created roll-out drawings of many of the fine-line paintings found on over 2,300 vessels (Donnan and McClelland 1999).

Research has shown that despite the thousands of ceramics that have survived, the number of iconographic themes that appear on the vessels is relatively small (Donnan 1976, 1978). This thematic approach to Moche iconography has yielded a number of studies on specific narrative sequences. Certain figures seem to represent specific individuals with well-defined roles, and have been distinguished by capitalized names, such as Wrinkle Face. In a similar fashion, certain themes that are repeated frequently with little variation are also distinguished by capital letters. One of the first themes identified was the Presentation Theme (Donnan 1976, 1978), now more frequently referred to as the Sacrifice Ceremony (Alva and Donnan 1993; Donnan and McClelland 1999).[3] One of the most complete versions of this scene appears on a stirrup-spout bottle now in the collections of the Museum für Völkerkunde, Munich (fig. 4). A roll-out drawing of this painting (fig. 5) shows four larger figures on the upper register. The large figure on the left, holding a goblet, has been identified as the Warrior Priest, the figure to his right as the Bird Priest, and the figure behind them as the Priestess, shown wearing a headdress with plumes; the fourth figure wears a headdress with what is

probably a feline emblem on the front. In the lower register, two individuals appear to be drawing blood from the necks of two nude prisoners. They are flanked by a weapons bundle on the right and a litter on the left.

What was the relationship between such imagery and real life? Tombs at Sipán (Alva, this volume; Alva and Donnan 1993; Donnan 1988) and San José de Moro (Castillo, this volume; Donnan and Castillo 1992, 1994) have brought this issue to the forefront of Moche studies. At Sipán, the individual buried in Tomb 1 was found with items associated with the Warrior Priest of the Sacrifice Ceremony. Tomb 2 contained regalia that would link that individual with the Bird Priest. At San José de Moro two women were interred with headdresses and goblets similar to those of the Priestess in the Sacrifice Ceremony. Were the paintings depictions of mythological or supernatural events that were then reenacted by earthly protagonists? Or was there a closer correlation? Christopher Donnan, in his paper "Moche Ceramic Portraits" argues that the relatively naturalistic vessels in the shape of human heads were portraits of specific individuals. Donnan suggests that some of these portraits were a means of commemorating the capture and sacrifice of individuals whose role, status, and appearance were well known in Moche society.

The study of Moche iconography and archaeology in tandem has proven to be extremely fruitful in recent years. These diverse sources may tell us different things, but they do on occasion converge in rather startling ways, as Steve Bourget shows in his paper "Rituals of Sacrifice: Its Practice at Huaca de la Luna and Its Representation in Moche Iconography." Bourget's excavations of a sacrificial site at Huaca de la Luna have contributed new evidence on practices that were once considered speculative extrapolations from the iconography. The subject of sacrifice and warfare prompted the greatest amount of discussion at the symposium, and is a topic that a number of authors chose to address in their papers. Were the battles depicted on Moche vessels intra-Moche, ritual affairs? Or do they speak of large-scale battle, with territorial intentions? John Verano takes up these questions in his paper "War and Death in the Moche World: Osteo-logical Evidence and Visual Discourse," drawing upon evidence from his physical anthropological studies of Moche skeletal remains, as well as on analogies from other ancient American cultures. Verano brings up a critical issue in his paper—to what extent can we rely on the visual arts as an accurate or complete representation of Moche practices? In our enthusiasm for the discovery of archaeological correlates, we may be neglecting the realms of mythology and propaganda in the visual arts.

In spite of the large amount of new data, or perhaps as a result of this, there is no consensus on the nature of Moche. Few conclusive statements can be made regarding its political organization, as these new studies, while refuting earlier unitary models of Moche, have yet to draw precise characterizations of the Moche polity or polities, as the case may be. Future research will contribute new data and new perspectives, perhaps allowing for the development of models of valleywide city-states, or enabling, with greater chronological refinement, changes to be tracked in political evolution from kin-based community organizations to hegemonic polities. While the papers in this volume represent an admirable step forward in Moche studies, it is clear that they have also raised a series of questions that must be answered in future research.

This volume is organized in a roughly chronological, thematic and geographical manner, beginning with a consideration of the traditions that preceded Moche (Quilter), and following on with new research concerning, in whole or in part, the Moche site (Uceda, Chapdelaine, Bourget, Verano, Donnan). Turning northward to the Chicama Valley, there are two papers, one on the developments across the valley (Gálvez and Briceño), and one on the ceramic production site of Cerro Mayal (Russell and Jackson). Continuing on with the theme of craft production, Izumi Shimada's paper addresses this subject in the context of Pampa Grande in the Lambayeque Valley. This is followed by Walter Alva's paper on Sipán, also in the Lambayeque Valley, and a discussion of Moche metallurgy (Jones). The last four papers (Cordy-Collins, Dillehay, Bawden, Castillo) touch, at least in part, on the end of Moche.

NOTES

The author would like to thank Edward de Bock, Steve Bourget, Michael Brandon-Jones, Lisa DeLeonardis, Christopher Donnan, Edward Harwood, Pat Hewitt, Ricardo Luna, Donald McClelland, Donna McClelland, Carol Mackey, Elías Mujica, Margaret Pillsbury, Mary Pye, Michael Raeburn, Lucia Santistevan-Alvarez, Flora Vilches, and especially Jean-François Millaire for their help in the completion of this volume.

1. For recent research on early Moche see also Castillo (1999), Kaulicke (1992, 1994), Makowski et al. (1994) and Narváez (1994). Brian Billman was unfortunately unable to contribute a paper to the volume, but addresses the issue of the development of the Moche state in his dissertation (1996) and elsewhere (1999).

2. Little is known of the original contexts of the Loma Negra metal ornaments, which are thought to come from the far northern reaches of the Moche sphere, in the Piura region. See Makowski et al. (1994) and Kaulicke (1991, 1992, 1994) on recent research in the area, and for ideas on the interaction with groups to the south.

3. There is no universal agreement on this terminology, however, and some authors prefer to use more descriptive indicators.

BIBLIOGRAPHY

Alva, Walter, and Christopher B. Donnan
1993 *Royal Tombs of Sipán* [exh. cat., Fowler Museum of Cultural History, University of California]. Los Angeles.

Benson, Elizabeth P.
1974 *A Man and a Feline in Mochica Art.* Dumbarton Oaks Research Library and Collections, Studies in Pre-Columbian Art and Archaeology 14. Washington.

1975 Death-Associated Figures on Mochica Pottery. In *Death and the Afterlife in Pre-Columbian America* [A Conference at Dumbarton Oaks, October 27th, 1973], ed. Elizabeth P. Benson, 105–144. Washington.

Billman, Brian R.
1996 The Evolution of Prehistoric Political Organizations in the Moche Valley, Peru. Ph.D. dissertation, Department of Anthropology, University of California, Santa Barbara.

1999 Reconstructing Prehistoric Political Economies and Cycles of Political Power in the Moche Valley, Peru. In *Settlement Pattern Studies in the Americas: Fifty Years since Virú*, ed. Brian R. Billman and Gary M. Feinman, 131–159. Smithsonian Series in Archaeological Inquiry. Washington.

Castillo, Luis Jaime
1999 Los Mochicas y sus antecesores: Las primeras civilizaciones estatales de la costa del Perú. In *Tesoros del Perú antiguo* [exh. cat., Museo Arqueológico Rafael Larco Herrera, Lima], 141–176. Córdoba (Spain).

Castillo, Luis Jaime, and Christopher B. Donnan
1994 Los Mochica del norte y los Mochica del sur. In *Vicús*, by Krzysztof Makowski, Christopher B. Donnan, Iván Amaro Bullón, Luis Jaime Castillo, Magdalena Diez Canseco, Otto Eléspuru Revoredo, and Juan Antonio Murro Mena, 143–181. Colección Arte y Tesoros del Perú. Lima.

Craig, Alan K., and Izumi Shimada
1986 El Niño Flood Deposits at Batán Grande, Northern Peru. *Geoarchaeology* 1: 29–38.

Donnan, Christopher B.
1973 *Moche Occupation of the Santa Valley, Peru.* University of California Publications in Anthropology 8. Berkeley and Los Angeles.

1976 *Moche Art and Iconography.* UCLA Latin American Center, Latin American Studies 33. Los Angeles.

1978 *Moche Art of Peru: Pre-Columbian Symbolic Communication* [exh. cat., Museum of Cultural History, University of California; rev. ed. of Donnan 1976]. Los Angeles.

1988 Iconography of the Moche: Unraveling the Mystery of the Warrior-Priest. *National Geographic* 174 (4): 550–555.

1990 Masterworks of Art Reveal a Remarkable Pre-Inca World. *National Geographic* 177 (6): 16–33.

Donnan, Christopher B., and Luis Jaime Castillo
1992 Finding the Tomb of a Moche Priestess. *Archaeology* 45 (6): 38–42.

1994 Excavaciones de tumbas de sacerdotisas Moche en San José de Moro, Jequetepeque. In *Moche: Propuestas y perspectivas* [Actas del primer coloquio sobre la cultura Moche, Trujillo, 12 al 16 de abril de 1993], ed. Santiago Uceda and Elías Mujica, 415–424. Travaux de l'Institut Français d'Etudes Andines 79. Trujillo and Lima.

Donnan, Christopher B., and Donna McClelland
1979 *The Burial Theme in Moche Iconography.* Dumbarton Oaks Research Library and Collections, Studies in Pre-Columbian Art and Archaeology 21. Washington.

1999 *Moche Fineline Painting: Its Evolution and Its Artists.* Fowler Museum of Cultural History, University of California, Los Angeles.

Gumerman, George IV
1991 Subsistence and Complex Societies: Diet Between Diverse Socio-Economic Groups at Pacatnamú, Peru. Ph.D. dissertation, Department of Anthropology, University of California, Los Angeles.

1994 Feeding Specialists: The Effect of Specialization on Subsistence Variation. In *Paleonutrition: The Diet and Health of Prehistoric Americans*, ed. Kristin D. Sobolik, 80–97. Southern Illinois University at Carbondale, Center for Archaeological Investigations, Occasional Paper 22. Carbondale.

Hocquenghem, Anne-Marie
1987 *Iconografía Mochica.* Lima.

Kaulicke, Peter
1991 El período Intermedio Temprano en el Alto Piura: Avances del proyecto arqueológico "Alto Piura" (1987–1990). *Bulletin de l'Institut Français d'Etudes Andines* 20 (2): 381–422.

1992 Moche, Vicús Moche y el Mochica Temprano. *Bulletin de l'Institut Français d'Etudes Andines* 21 (3): 853–903.

1994 La presencia Mochica en el Alto Piura: Problemática y propuestas. In *Moche: Propuestas y perspectivas* [Actas del primer coloquio sobre la cultura Moche, Trujillo, 12 al 16 de abril de 1993], ed. Santiago Uceda and Elías Mujica, 327–358. Travaux de l'Institut Français d'Etudes Andines 79. Trujillo and Lima.

Kutscher, Gerdt
1950 *Chimu: eine altindianische Hochkultur.* Berlin.

1983 *Nordperuanische Gefässmalereien des Moche-Stils.* Materialien zur allgemeinen und vergleichenden Archäologie 18. Munich.

Larco Hoyle, Rafael
1948 *Cronología arqueológica del norte del Perú* [cat., Museo de Arqueología Rafael Larco Herrera]. Buenos Aires.

Lechtman, Heather N.
1984 Andean Value Systems and the Development of Prehistoric Metallurgy. *Technology and Culture* 25 (1): 1–36.

Makowski, Krzysztof, Christopher B. Donnan, Iván Amaro Bullón, Luis Jaime Castillo, Magdalena Diez Canseco, Otto Eléspuru Revoredo, and Juan Antonio Murro Mena
1994 *Vicús.* Colección Arte y Tesoros del Perú. Lima.

Moseley, Michael E.
1987 Punctuated Equilibrium: Searching the Ancient Record for El Niño. *The Quarterly Review of Archaeology* 8 (3): 7–10.

Moseley, Michael E., and Alana Cordy-Collins
1990 (Editors) *The Northern Dynasties: Kingship and Statecraft in Chimor* [A Symposium at Dumbarton Oaks, 12th and 13th October 1985]. Washington.

Moseley, Michael E., and Kent C. Day
1982 (Editors) *Chan Chan: Andean Desert City.* School of American Research Advanced Seminar Series. Albuquerque, N.M.

Moseley, Michael E., Robert A. Feldman, Charles R. Ortloff, and Alfredo Narváez
1983 Principles of Agrarian Collapse in the Cordillera Negra, Peru. *Annals of the Carnegie Museum* 52 (article 13): 299–327.

Narváez, Alfredo
1994 La Mina: Una tumba Moche I en el valle de Jequetepeque. In *Moche: Propuestas y perspectivas* [Actas del primer coloquio sobre la cultura Moche, Trujillo, 12 al 16 de abril de 1993], ed. Santiago Uceda and Elías Mujica, 59–81. Travaux de l'Institut Français d'Etudes Andines 79. Trujillo and Lima.

Russell, Glenn S., and Banks L. Leonard
1990a Preceramic through Moche Settlement Pattern Change in the Chicama Valley, Peru. Paper presented at the 55th Annual Meeting of the Society for American Archaeology, Las Vegas.

1990b Chicama Valley Archaeological Settlement Survey, Peru. *Backdirt: Newsletter of the Institute of Archaeology, University of California, Los Angeles*, Spring (1): 7–8.

Sharon, Douglas, and Christopher B. Donnan
 1974 Shamanism in Moche Iconography. In
 Ethnoarchaeology, ed. Christopher B.
 Donnan and C. William Clewlow, 51–77.
 University of California, Institute of
 Archaeology Monograph 4. Los Angeles.

Strong, William Duncan, and Clifford Evans
 1952 *Cultural Stratigraphy in the Virú Valley,
 Northern Peru: The Formative and
 Florescent Epochs.* Columbia Studies in
 Archeology and Ethnology 4. New York.

Uceda, Santiago, and José Canziani
 1993 Evidencias de grandes precipitaciones en
 diversas etapas constructivas de la Huaca
 de la Luna, costa norte del Perú. In *Regis-
 tros del fenómeno El Niño y de eventos
 Enso en América del Sur*, ed. José Macharé
 and Luc Ortlieb, 313–343. *Bulletin de l'In-
 stitut Français d'Etudes Andines* 22 (1).

Uceda, Santiago, and Elías Mujica
 1994 (Editors) *Moche: Propuestas y perspectivas*
 [Actas del primer coloquio sobre la cultura
 Moche, Trujillo, 12 al 16 de abril de 1993].
 Travaux de l'Institut Français d'Etudes
 Andines 79. Trujillo and Lima.

 in press (Editors) [Actas del II coloquio sobre la
 cultura Moche, Trujillo, 1 al 6 de agosto
 de 1999]. Travaux de l'Institut Français
 d'Etudes Andines. Trujillo and Lima.

Willey, Gordon R.
 1953 *Prehistoric Settlement Patterns in the
 Virú Valley, Perú.* Smithsonian Institution,
 Bureau of American Ethnology Bulletin
 155. Washington.

Wilson, David J.
 1988 *Prehispanic Settlement Patterns in the
 Lower Santa Valley, Peru: A Regional
 Perspective on the Origins and Develop-
 ment of Complex North Coast Society.*
 Smithsonian Series in Archaeological
 Inquiry. Washington.

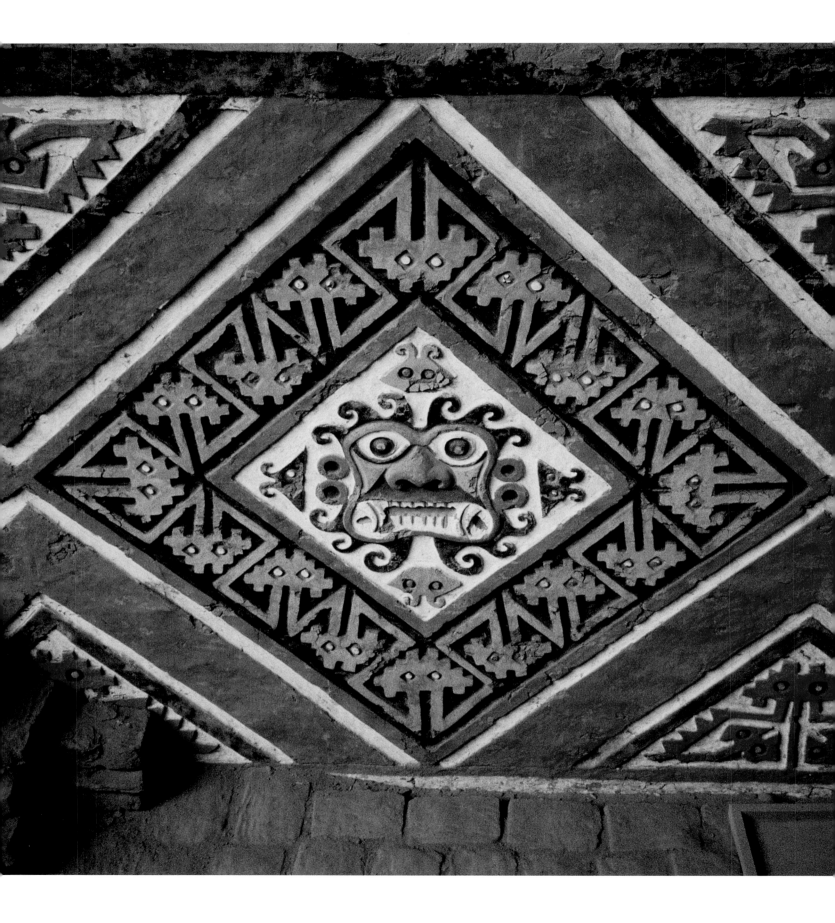

JEFFREY QUILTER
Dumbarton Oaks

Moche Mimesis: Continuity and Change in Public Art in Early Peru

The great appeal of Moche art to lay people and scholars alike is its quality of mimesis. What we see as verism or imitation in the representation of animals, plants, and humans, delights the uninitiated and lures the student into attempting to understand the seemingly straightforward meanings of the images. Mimetic art of the kind done by Moche is rare in pre-Columbian America and perhaps unique in the Andes (Pasztory 1998). Mimesis is a quality often associated with the well-known Moche ceramic portrait vessels (see Donnan, this volume). In this essay, however, I consider Moche architectural art, and how it differs from its predecessors.

Grouped under the rubric of public art, the corpus in question encompasses architectural complexes and associated sculpture. Public here refers to groups of people, large or small, who view art outside their own domestic contexts, often viewing such art as members of a group rather than as individuals. The advantage of discussing public art is that it offers rich interpretive opportunities. As many portable art objects were looted, their original contexts are unknown. Architecture, on the whole, however, is found in its original context, where it was intended by its creators to be viewed. This provides the opportunity to consider how people experienced the settings and perceived the art as part of a complex whole of images, architectural constraints, and movement through space (see Moore 1996). Public art also tends to be more programmatic than portable art, giving us a better understanding of the interests of the dominant groups behind the creation of the works.

The public art I discuss in this essay was made on the walls of buildings interpreted as temple complexes. The majority of public art in the Andes is architectural. Freestanding sculpture and other kinds of public art were not erected to the same degree as elsewhere in the ancient Americas. Examining this art and its evolution may contribute to understanding the changing roles of these architectural complexes and the political and ideological systems that were used to erect and maintain such elaborate buildings, plazas, and courtyards, as well as informing us about the art itself.

In this paper I first review our current knowledge of public art in the Preceramic and Initial periods and in the Chavín Horizon period. Moche art will then be examined in regard to the way it broke with its immediate predecessor, Chavín, renewing some earlier conventions while at the same time broadcasting a very different social message. Moche artisans also introduced entirely new conventions, such as an emphasis on narrative. Essential to this is the Moche interest in mimesis. Broadly speaking, Moche art appears to be more accessible to viewers than the earlier art style, yet it conveyed perhaps a harsher message of social inequality.

Detail of painted reliefs from Platform 1, Huaca de la Luna

Public Art before Moche – the Terminal Preceramic Period

Only in the Late Preceramic period does architecture appear that suggests a public sphere with a separate existence from a private one (Quilter 1991). That is to say, prior to about 1800 B.C., social formations were probably based on kinship links, and there were no sharp distinctions between private and public realms of human behavior.

The sunken or enclosed circular chamber with central fireplace of the Kotosh Religious Tradition (Burger and Salazar-Burger 1985, 1986) partakes of ideas that probably stretch back to the Paleolithic campfire (fig. 1). The benches that often encircle these chambers leave little room for hierarchy, as all those seated are equidistant from the sacred hearth. These small, kiva-like structures of the Terminal Preceramic period (c. 1800–1600/1500 B.C.), continuing into the Initial period (c. 1600/1500–600 B.C.), were designed to hold several people, but the walls were generally unadorned. Other sites, such as Bandurria (Fung Pineda 1988: 77–78) were arranged with central standing stones or other devices to organize people in ceremonial activities, often in a circular arrangement.

Little architectural ornament survives, if indeed it ever existed, at these early sites. At Kotosh itself, the reliefs flanking the entrance to a ceremonial chamber are among the earliest public art in the Andes (Izumi and Terada 1972). The reliefs consist of two pairs of molded arms, one right-over-left, the other with arms reversed. Their location under niches suggests they may have related to figures placed in the spaces above.

Frédéric Engel (1967; see Quilter 1985) noted traces of red and black pigment on the exterior wall plaster of Unit I, El Paraíso, but not enough remained to infer design motifs. While El Paraíso is technically a Preceramic site, it marks the beginning of the tradition of U-shaped ceremonial complexes on the Peruvian central coast that survived into the succeeding Initial period. It is from that era that public art and architecture begin to be found in quantity.

Rectilinear platforms and sunken circular courts are the building blocks of public architecture in the Late Preceramic and Early Initial periods. As Michael Moseley (1992: 110)

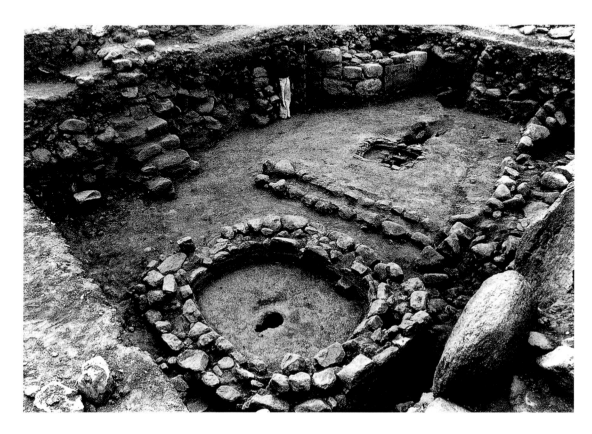

1. Chamber of the Kotosh Religious Tradition, Huaricoto
After Burger 1992: 119, fig. 109

2. Reconstruction of stairway with "mouth-band" frieze in the central atrium, Cardal
After Burger 1992: 67, fig. 52

notes, solid platform mounds reflect the basic notion that elevation confers status and segregates extraordinary from ordinary space. In contrast, the circular, sunken courtyard evokes sentiments of inclusion. These spaces suggest a shared, egalitarian community.

Often the builders of terrace and platform complexes incorporated circular courts within their overall plans, for example at Salinas de Chao (Alva 1986) and Cardal (Burger 1987). This combination suggests attempts to include egalitarian principles within emerging hierarchical architectural and social structures. Richard Burger (1987) proposes that the numerous sunken chambers on one of the "arms" of the U-shaped structure at Cardal may have been for rites of particular social groups, held under the general auspices of the Cardal complex and its managers.

Late Preceramic and Early Initial period building complexes thus seem to express somewhat contradictory principles: hierarchy and rank versus egalitarianism. Over time, the upward-reaching platform constructions came to dominate Andean architecture for the rest of prehistory. Subterranean chambers, however, maintained a highly sacred role in many places, often holding the ultimate religious mysteries.

The Initial Period

Initial period architectural complexes manifest more public art than Preceramic sites.[1] As with other periods and areas in Peru, the data set is contingent on factors of preservation and the extent to which large sections of buildings have been cleared. Richard Burger (1992) has provided a systematic review of Initial period sites investigated. There are

regionally consistent patterns of construction and design for Initial period civic-ceremonial centers, of which the best understood is that followed on the central coast. Following the work of Carlos Williams (1971, 1980, 1985), Burger notes the consistent use of U-shaped architectural complexes in the valleys north and south of modern Lima (1992: 60–61). This pattern, combined with a suite of other traits, is so consistent along the central coast of Peru, stretching from the Lurín Valley to the Chancay Valley (and possibly Pativilca), that Burger and Salazar-Burger (1999) recently proposed that the culture it typifies should be referred to as the Manchay culture.

Manchay culture architectural complexes are laid out in a U-shaped plan. Usually, one arm of the U is shorter. At Cardal, the complex that has been studied in most detail, a road extended through the central axis of the U, leading to a staircase on the central mound. The central mound and its flanking mounds went through a number of rebuilding stages. The succeeding building phases entombed the earlier structures as they grew larger. As noted above, Cardal architecture included both sunken circular courts and platform mounds. Access to the central mound was probably restricted to a few people, while ceremonies for larger groups were held in the plaza area.

The general pattern of U-shaped architecture, accretional growth of mounds, and the use of painted wall friezes as public art holds throughout the Manchay culture area. Details of this public art, however, are only available for Cardal and Garagay, although Burger (personal communication) reports evidence of a frieze at Manchay Bajo.

The evidence of public art at Cardal is in the penultimate atrium built at the top of the stairs on the central mound and dating to about 1100 B.C. Renovated up to six times using different colors, the last version of the low-relief clay frieze was painted with red and yellow pigment, and depicts a huge mouth band with interlocking teeth and large fangs (fig. 2). Anyone entering the chamber beyond the atrium would have passed through the mouth of this ferocious deity. Presumably, entry into the mouth was a symbolic death, and those who reemerged from the temple had undergone a rite of passage, reborn in a new social and symbolic state. This intimate

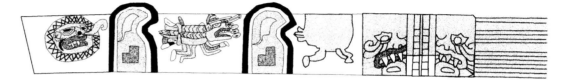

0 10 20 30
meters

relationship to the divine presages the religious experience at Chavín.

The most extensive remains of Manchay public art were found at Garagay, in the lower Rímac Valley (Ravines and Isbell 1975), a site now surrounded by modern Lima. Structure B, the central mound at the apex of the U-shaped complex, follows the pattern of a central stairway leading to an atrium. The most recent atrium was destroyed, but an older one, known as the Middle Temple, was ornamented with polychrome low-relief friezes (fig. 3). These show monstrous supernaturals, rendered in profile, facing towards stairs. The imagery includes an anthropomorphic fanged head and a zoomorphic form that combines spider and possibly feline attributes. These figures are framed by large, repeating step-design elements, similar to a profile view of one of the altars found in the summit building at Cardal (Burger and Salazar-Burger 1991: 280), with a featherlike design above it. Burger (1992: 68) found a variant of this motif at Cardal, which suggests that this symbolism was widespread in Manchay culture.[2]

On Mound A, the smaller arm of the Garagay U, parts of two reliefs were found, placed as if to guard the entrance to an atrium (fig. 4).[3] They appear to represent warriors or warriorlike supernaturals, as indicated by the presence of circular shields. Similar imagery has been found on petroglyphs at Alto de las Guitarras in the Moche Valley (Ravines 1984: 36, fig. 18). The relatively representational style of these figures stands in contrast to the mythological creatures shown in the Middle

3. Drawing of the atrium frieze, Garagay. Two fanged-mouth creatures facing each other, at right, were matched by a similar pair to the far right of the stairs (not shown here)
After Burger 1992: 64, fig. 43

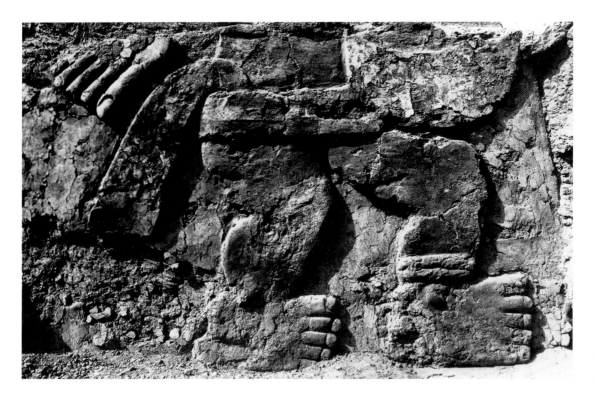

4. Detail of a modeled clay relief of a warrior, Garagay
After Burger 1992: 65, fig. 45

Temple and seems to foreshadow the later Moche style. Another low relief found on Mound A consists of a design resembling a net (Ravines 1984: 35, fig. 16).

Offerings were found in pits immediately in front of three of the Middle Temple friezes. Small figurines with painted, fanged faces were dressed in textiles. Burger (1992: 64) notes that one of the figurines had two spines of the hallucinogenic San Pedro cactus on its back. Spines were also found in mud adobes in the fill of the Middle Temple. Burger suggests that a drink made from San Pedro may have been consumed in rituals at Garagay to facilitate contact with the supernatural realm.

Somewhat different architectural traditions were followed on the north coast of Peru in this period. The greatest amount of work in the region has been done in the Casma Valley, where there were at least five public centers, with a sixth developing near the end of the Initial period. Three have been investigated extensively: Cerro Sechín, Sechín Alto, and Pampa de las Llamas-Moxeke (Pozorski and Pozorski 1987; Tello 1956).

Whereas U-shaped architecture was the style of the Manchay culture of the central coast, compact, quadrangular mounds dominated Casma architecture. Cerro Sechín and Moxeke were both built as square platform mounds with rounded corners. Although Sechín Alto has been studied only recently (Pozorski and Pozorski 1999), the preliminary observations show that the huge principal mound is also roughly square, with a series of rectangular plazas. Sunken circular courts are found in plazas in front of the main mound; Tello (1956) observed a similar circular depression in front of Cerro Sechín. Perhaps such sunken circular courts were remnants or reinterpretations of the chambers of the Kotosh Religious Tradition, as they may have been at Cardal. These and the use of bilateral symmetry in overall plan, including details such as bipartite central stairways, link the Casma tradition to the Manchay culture and general practices throughout Peru in the Initial period.

At Cerro Sechín there are four hundred or so incised granite blocks set into the outermost wall of the principal structure. The rectangular stones, set vertically, show warriors marching toward a central staircase, which is flanked by banners at the head of each line of troops.[4] Interspersed among these warriors are smaller stones with depictions of the defeated army. Naked, writhing figures are shown headless, cut in two, or with blood and entrails pouring from their bodies. Decapitated heads are rendered with eyes closed or hemorrhaging.

This scene was the latest public art made at the site. An earlier phase seems to show a scene similar to the later carvings, with an upside-down human figure, eyes closed, and blood streaming from the skull. The first construction phase, however, contains a central room the entrance to which is flanked by a mural of large black felines.

Public art at Sechín Alto has been discovered recently (Pozorski and Pozorski 1999). The evidence uncovered so far is fragmentary and consists of about twenty to thirty centimeters

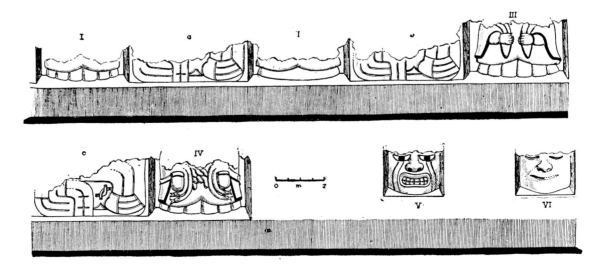

5. Drawing of reliefs from Moxeke
After Tello 1956: 61, fig. 27

of what appears to be the bottom of a wall. Two large-scale symmetrical designs of what look like eccentric eyes (though presumably representing something else), in a style resembling Chavín, have been found in low, flat relief. As best as can be determined, the general design and bold colors conform to Initial period styles.

The site known as Pampa de las Llamas-Moxeke is dominated by two large mounds, Moxeke and Huaca A. At Moxeke, a number of high-relief figures and massive sculpted heads (fig. 5) were discovered on the principal mound earlier in the twentieth century by Julio C. Tello. The figures were located in niches some ten meters above ground level. They probably stood about three meters in height, perhaps higher, as the heads were missing by the time they were excavated. The figures were dressed in tunics, skirts, and mantles, with slight differences among them. Such slight differences are also evident in the large heads, found in niches on the side of the building: one has its eyes and mouth closed, while another has bared teeth.

Twelve hundred meters from Moxeke, across an expanse of plain with large plazas in it, Huaca A is aligned close to the main axis of the platform just described. Huaca A is a rectangular, multiroomed structure, composed of small quadrangular rooms arranged in a symmetrical pattern. The form and organization suggest an agglomeration of standardized versions of the Kotosh Religious Tradition chambers, lacking sunken floors and hearths. Shelia and Thomas Pozorski (1987: 34), who excavated Huaca A, interpret the structure as a public storehouse, although the relative cleanliness of the floors suggests ritual functions for these rooms, fitting more neatly with the characteristics of the architecture. Low-relief clay felines decorate the main entrance of the building, but otherwise no public art was found. The only exception to this is a cut and polished stone about 45 cm in length. On one side a double-bodied snake was inscribed, while on the other side a depression resembling a handprint was carved into the rock (fig. 6).

The handprint at Huaca A resembles a similar "imprint" sculpture found at the Initial period site of Pacopampa, in the northern highlands. An image very similar to the Huaca A double-bodied snake is on one side of the stone, while two footprints are found on the upper surface (fig. 7). The feet are arranged as if someone had stood on the spot, sinking into the stone. Although only these two examples are known, the specific imagery of "impressed" body parts in stone above a double-bodied-snake-like being suggests that both drew upon a similar myth.[5]

The public art found at the architectural complex of Huaca de los Reyes, at Caballo Muerto in the Moche Valley (Conklin 1985; Pozorski 1975, 1980), is similar in many ways to that of Moxeke in the Casma Valley; both sites date to roughly the same time period (c. 1300 B.C.). At both sites, the primary construction material is river cobbles, set in mud mortar and covered with thick coasts of adobe plaster. At Huaca de los Reyes, three large heads (when complete they would have been over two meters high), with grimacing faces, are reminiscent of the friezes at Moxeke (Moseley and Watanabe 1974). As with the Casma heads, the Huaca de los Reyes heads are distinguished, one from another,

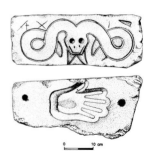

6. Incised stones from Huaca A, Pampa de las Llamas-Moxeke
After Burger 1992: 175, fig. 176

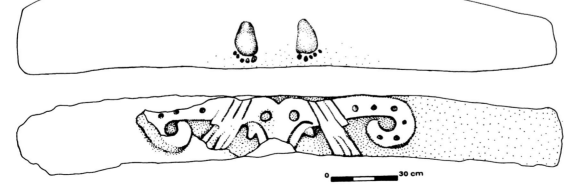

7. Incised stone from Pacopampa
After Burger 1992: 175, fig. 176

8. Plan of Chavín de Huántar
After Burger 1992: fig. 120; drawing
by Annick Peterson

by slight variations in the form and details. The same is true of the lower fragments of a frieze that, when complete, probably depicted frontal anthropomorphic, possibly human, figures. Three pairs of feet and lower legs have been preserved. Once again, each set is slightly different from the others within a fairly rigid, overall uniform design. The variation within standardized forms at both Moxeke and Huaca de los Reyes suggests a kind of transition between the more free-floating figures at sites such as Garagay and the highly standardized forms of Chavín de Huántar. The gods and other supernaturals at the earlier sites appear to be relatively individualistic, not yet codified in a standardized system of representation. Individual deities are distinguished at Chavín, but the rigidity of the art style frames them within a common conceptual framework. These ranges of stylistic conventions

and the variations within them may reflect the kinds of social units which interacted with deities and the cult centers where these were worshipped.

Initial period art thus demonstrates a great degree of diversity within recognizable styles. Stylistic unity is evident largely through the emphasis on line in these wall friezes and murals. Lines dominate even when the medium is modeled clay, as at Garagay. From what we can reconstruct of color use, this seems to have been employed more to produce a bright effect than to demarcate space or volume. A further characteristic is the apparent predominance of architecture over painted and modeled art.

Donald Lathrap (1985) suggested that U-shaped complexes symbolized the mouth of a cosmic cayman. If so, it was stylized to the point that such references were either known only to a select few or, if a wider audience was aware of such symbolism, they were well known enough to be manifest in a highly abstract manner. So too, the two "imprint" sculptures suggest that the people who visited temple sites brought with them at least a partial comprehension of the symbolic system in which they were to participate at these centers. The commonly occurring motif of a stylized monster head on ceramics contemporary with this architecture (Cupisnique style pottery) suggests that the emblems displayed on Initial period temple walls were well known to the general populace.

We do not fully understand the antecedents to the Initial period symbolic system as manifested in architecture. There are no known precedents: it appears fullblown, and without the expected precursors in other media, such as pyro-engraved gourds. It is clear, however, that Initial period sources inspired Chavín.

Chavín de Huántar

The people who built the ceremonial center of Chavín de Huántar in the central highlands took the familiar forms of Initial period centers and synthesized and transformed them into something new and extremely powerful. The monumental sector of Chavín de Huántar consists of several major architectural features, built at different times (fig. 8). The major buildings include the Old Temple, with a circular sunken court in front of it, and

contiguous to this, the New Temple, which was added on to the Old Temple. The interiors of these buildings are labyrinths of narrow corridors and chambers.

Chavín de Huántar drew upon coastal architectural forms and iconography. Initial period centers in the highlands are integrated into the surrounding landscape: sites such as Pacopampa feature terraces formed by modifying natural hills. Chavín, however, follows the coastal pattern of standing out from the landscape. Further, the U-shape of the original Old Temple and its circular court clearly follow coastal formats. But by the time the New Temple was built onto this structure, the population of Chavín was inventing a new tradition.

Ephemeral adornments to the architecture at Chavín, if they ever existed, have disappeared, but the beautiful carved stone monuments that once graced the temple complexes (some of which are still in their original positions) convey an idea of the grandeur of the site. White granite and black limestone, quarried kilometers away, were shaped into blocks, and intricate designs were crisply incised into the polished stone. Much of the sculpted architectural ornament is on the exteriors of buildings and courts. Three-dimensional heads were tenoned into the architecture (fig. 9), and some low-relief carving was used on the façades of buildings and along the sides of courts.

In contrast to the Initial period preference for bold colors, there is little evidence for paint at Chavín de Huántar. The rainy highland environment may be partly to blame. The highly polished surfaces of many sculptures do not necessarily preclude the possibility that they were painted, since at Chavín and other sacred sites polishing or other special efforts were apparently done for the eyes of the gods, not mortals: the backs and other unseen areas were also carefully finished. Nevertheless, polished surfaces would be unlikely to retain paint well. Burger (1992: 179) notes traces of pigment on carved stone slabs in the Chamber of the Ornamental Beams, but the stone surfaces there are rough. It is probable that if paint was used on highly polished carvings, it was applied to the incisions to accent them.

Some conventions of Initial period art were continued in Chavín times. The ring of

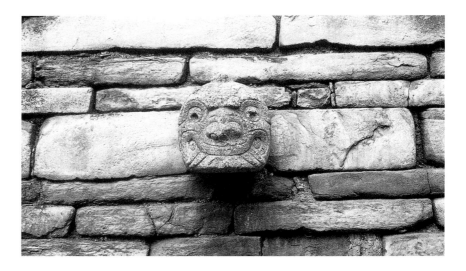

9. Tenoned head, Chavín de Huántar

warriors carved in low relief on blocks in the circular court in front of the Old Temple may have derived from Initial period art, as suggested by remains at Garagay, but, for the most part, Chavín invented itself, magnifying and complicating the styles employed to present mystifying supernaturals. In formal terms, however, one important characteristic does seem to continue on from the Initial period: the emphasis on line. Stone and other media are treated as surfaces for engraving: other than the tenoned heads, there is little interest in three-dimensional form and space. The emphasis on line was taken to new extremes at Chavín de Huántar. Exquisite stone engravings are found throughout the site, sometimes in unexpected places, such as the underside of lintels.

Chavín artistic conventions have been studied by a number of scholars (Roe 1974; Rowe 1962; Tello 1960; see Burger 1992). Tello noted the practice of elimination and substitution, as when snakes replace whiskers on a jaguar. John Rowe calls this a form of visual metaphor, comparable to kennings in Old Norse poetry. Peter Roe has pointed out an architectural conception of design in Chavín art, in which a complex depiction was treated as a composite of autonomous units drawn from a finite repertoire of elements—a pattern that was noted above as perhaps having its origins in Initial period art. Another convention is anatropism, in which a figure can be rotated 180° and still have visual meaning. This is particularly evident in the Raimondi Stela (fig. 10), which when viewed

upright, depicts an anthropomorphic figure, holding staves and wearing an elaborate headdress. When turned upside-down, the headdress appears to become a zoomorphic creature. Finally, Chavín art emphasizes modular width and bilateral symmetry. The former refers to a standardized field of organization, so that the carvings appear to have been made on an imaginary graph of parallel bands of equal width. Bilateral symmetry provides balance in relation to a vertical axis, whether within an image itself or in a field of images grouped together.

The convention of modular width is an innovation at Chavín, instituting a certain rigid standardization of design. Initial period art employed modular units, but the renderings were much more rounded, less crisp and exacting. Although, to a certain extent, medium may have played a role in this, mud plaster can also be shaped with a high degree of precision, indicating that the rigidity of stone carving at Chavín de Huántar was a matter of choice. So too, bilateral symmetry was used occasionally in Initial period art, but it was never adopted as rigorously and consistently as at Chavín. The ingenuity of Chavín art lay not simply in what was portrayed but how the portrayal was carried out. Cautious, experimental practices first seen in Initial period art are elaborated and codified at Chavín de Huántar.

10. Two drawings (one upside-down) of the Raimondi Stela, from Chavín de Huántar
After Burger 1992: 175, fig. 176

We may assume that all of the art so far discussed was designed to produce an emotional response in the viewer as part of a religious experience. Initial period art was meant to impress and to awe, and it does so by the power of the imagery of supernaturals, brightly painted, projecting from the walls of sacred precincts. Chavín art took those same objectives and increased the emotional response by presenting powerful, visually confusing images within the framework of a highly regularized, patterned means of representation. Chavín art unites two contradictory realities, perhaps as a way to emphasize the sanctity of the imagery and the experience of the architectural spaces. The visual program is at the same time highly chaotic and highly ordered.

Richard Burger (1992: 147) has noted how Chavín art is visually confusing to the uninitiated. For example, features of different animals are combined in one being, a practice also found in the Initial period. At Chavín the mixing includes flora and fauna from different Andean environments, such as tropical forest plants and animals, highland jaguars and eagles, and coastal dwellers such as *Strombus* and *Spondylus* molluscs. These mixtures and combinations created a sense of awe and confusion to the uninitiated, but could be read by the initiated as symbolic of the transformative nature of supernaturals. Transformation was emphasized in the tenoned heads found on the exterior of the New Temple at Chavín de Huántar, where an anthropomorphic head is in the process of becoming a fanged monster (fig. 9; Burger 1992: 157–159).

Chavín art may have confused and bewildered the uninitiated, but its underlying message was that differences can be unified into a single form. Different animal parts or substitutions in art of one thing for another replicated and reinforced belief in the role assumed by Chavín to bind together diverse peoples and places in ancient Peru within the unifying system of the temple cult.

Perhaps only the elites of distant communities were allowed access to the most holy shrines at Chavín, but it seems likely that large numbers made the journey to the site and experienced at least part of its mystique. Much of the imagery, present as it was on the exterior of architecture, was potentially available to great numbers of viewers. Thus, some

of the most elaborate art ever produced in the Americas was made at a high aesthetic level not to please a royal family or a handful of aristocrats, but to impress outsiders. These were outsiders who, having been to Chavín, would have been incorporated into the select group of individuals who had made the pilgrimage, strengthening even more the power of the religious center to attract more visitors and adherents. The prosperity of the larger enterprise, including the support population living around the New Temple, was tied to maintaining the site as simultaneously restricted and sacred and, to a certain degree, open and accessible.

The Context of Moche Public Art

Previous conceptions of a monolithic Moche culture are giving way to alternative models positing two or more distinct political entities, which quite likely varied in the ways they utilized a widely shared symbol system (see Shimada 1994b). Recent and continuing work will provide a more fine-grained view of changes in artistic styles and shifts in ideology. Nevertheless, Moche seems to have been a culture in which a consistent, relatively narrow set of artistic conventions was used across a distinct temporal and geographical range by peoples sharing similar ideologies and sentiments. These people also shared common subsistence economies, warfare practices, and other social behavior, including generally similar patterns of social and political organization. Even if there were distinct political entities within what we consider Moche culture, a common art style and ideology appear to have been shared by them.

By the time Moche culture developed on the north coast of Peru, Chavín de Huántar lay in ruins. Its religious and political authority had collapsed, as had stable social and economic systems. The exact timing and pattern of the dissolution of Chavín influence or hegemony still remain to be documented, but no matter how many years separated the collapse of Chavín and the rise of Moche and other Early Intermediate period cultures, the drastic change in art styles which occurred seems to have been more a deliberate rejection of past conventions rather than a forgetting of them.

In the highlands, in the general area of the Chavín heartland, the subsequent Recuay style emphasized a simplified rendering of anthropomorphic and human forms in what appears to be an almost rustic mode of carving compared to the precision stonework of Chavín (fig. 11). This could be read as a diminution in the skill level of artisans or as the inability of an elite, reduced in power, to mobilize human and other resources to produce elaborate art. But it also can be read as a conscious elevation of a more simple, straightforward artistic style and ideology, one that concurred with the bellicose warrior ethic represented in Recuay sculpture, in contrast to the baroque twists and turns of an esoteric Chavín religious cult.

On the coast, some Chavín influence appears to have lingered in the Salinar style, but the rulers of Moche dominated north coast culture partly by employing new visual ideas, expressed in a different manner. The creators of Moche art and architecture rejected many Chavín conventions, while continuing to elaborate certain Initial period ideas, many of which had never completely faded from coastal art.

Whereas Initial period and Chavín art tend to confront the viewer with larger-than-life portrayals of supernaturals, Moche architectural art emphasizes human forms, rendered on a human scale. Moche figures traverse the plane in which they are depicted rather than coming out of that plane—narrative

11. Recuay stone carvings

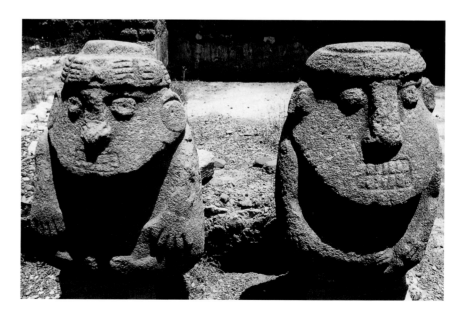

sequences are painted or rendered in low relief across an expanse of wall. Moche figures often float on a plain, light-colored background, with little or no indication of a ground line or contextual setting, in nonconfrontational poses (figs. 12, 13; see Gálvez and Briceño, this volume; Uceda, this volume). Even scenes depicting warfare have low emotional impact, as the viewer's position is perpendicular to the plane of action. The viewer observes figures interacting with one another, whereas with Initial period architectural art, the viewer is often directly confronted by the gaze of towering supernatural figures.

This is not to say that the preference for profile figures, such as those seen at the Huaca Cao Viejo of the El Brujo complex (Gálvez and Briceño, this volume), is entirely new in Moche art. This traversing of the plane of representation, and the placement of figures so as to float in space, can be seen in Initial period art at Garagay and elsewhere. A painted column at Casa Grande, La Libertad (Bonavia 1985: 30, fig. 18), for example, shows a human figure in Chavín style, but painted in profile. Nevertheless, even though there are shared conventions of representation in the Initial and Moche periods, the intentions were different.

Moche public art and the ritual spaces where it was found were, as with Chavín, innovative, yet they harked back to earlier traditions. Flat-topped pyramidal structures, first seen in the Preceramic period, were emphasized, while the Initial period and Chavín convention of sunken circular plazas was rejected. The concept of monumental architecture itself may also have shifted. At Chavín, the hollow core of the Old Temple contained the Lanzón, a sculpted monolith probably representing a living presence deep in the bowels of the earth (Burger 1992: 136–137). For the Moche, however, their adobe structures contained dead potentates instead of evocations of living gods. The sequential entombment of kings or aristocracy in platforms, such as at Sipán (see Alva, this volume) and Huaca de la Luna (Uceda, this volume), may have increased the sanctity of the place and those buried in it—a conception radically different from previous eras.

The personal confrontation with and transformation by the divine, hinted at by the mouth-band frieze at Cardal and the labyrinths of the temples at Chavín de Huántar, seem to have no equivalents among the Moche. When Moche priests moved from the profane world of everyday life or plazas in lower temple precincts to the holiest shrines of the divine, they moved upward and in plain view. Many Moche platforms boast elaborate ramps, perhaps designed to extend the process of approaching the holy. Those privileged to enter the New Temple at Chavín de Huántar disappeared into it and then reappeared, as if by magic, to those watching below, through the use of carefully hidden stairs (Burger 1992). But Moche priests could be viewed gradually ascending to the sacred heights.[6]

If pilgrimage was a central, unifying aspect of the Chavín cult, resulting in one major center, in the Moche culture there were multiple centers of comparable size and elaboration. We are still unclear how Moche religious centers were organized in terms of larger constituencies in the Moche world and beyond, but the evidence suggests a more regional, perhaps polity-based, system of worship and attendance at sacred sites. In any case, pilgrimage to Chavín meant journeying from afar to enter, if one was deemed worthy, deep into the ultimate mystery enclosed by the massive stone temple at Chavín de Huántar. For the Moche, the replication of the pilgrim's journey may have been transformed into the movement of priests or supplicants within the temple complex itself, out in the open until the final rites high on the temple top. Pilgrimage in such a setting was not to an autochthonous core of an ultimate reality, but to the heights from which the gods looked down on mortals. Even if the holiest Moche rites were secluded in shrines on temple summits, rituals occurred in front of numbers of people, and the imagery of these activities appears to have been widely disseminated. The mass slaughter of warriors at Huaca de la Luna (see Bourget, this volume; Verano, this volume) might not have been witnessed by just anyone, but its staging in a plaza suggests that there were more than a few onlookers. Scenes showing sacrificial acts, prisoners, and implements of war are found in several media, including ceramics (Alva and Donnan 1993: 127–141).

This explicit representation of military and sacrificial practices is in contrast to most Initial period, Chavín, and Andean art in general.

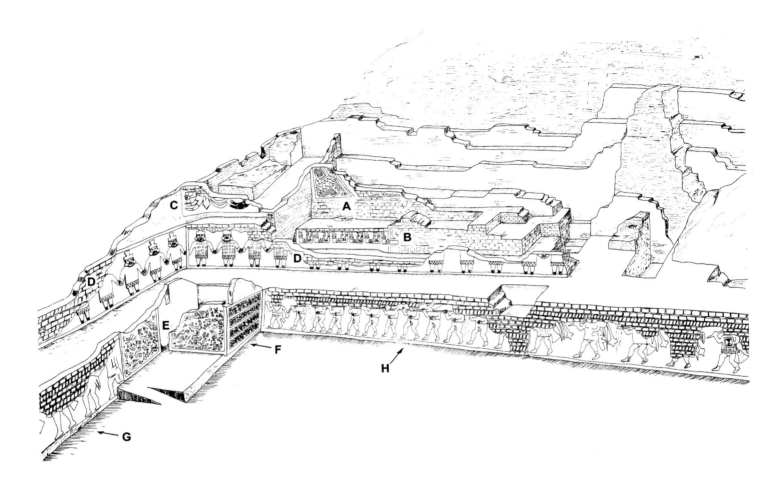

12. Reconstruction drawing of Huaca Cao Viejo
After Franco, Gálvez, and Vásquez 1994: fig. 4.12

Although some reference to warriors is present at Garagay, Cerro Sechín, and Chavín de Huántar, the emphasis on these themes is relatively minor. In most Andean art, references to violence also are relatively muted. Even among the exceptions, such as some Nasca art, symbols of sacrifice are intertwined with clear indications of fertility. Furthermore, the cultures we might expect to be most bellicose in art, if it mirrored life, are the conquest states of Wari and the Inca, yet these have the fewest overt indications of warfare and sacrifice in public art.[7]

The Moche stand out from other Andean cultures in the emphasis they placed on war and related cults of sacrifice. The closest parallels are to be found not in the Andes but in Mesoamerica, particularly the Maya and the Aztecs. Public representations of sacrifice and warfare may help us understand the unique contours of Moche religious thought and the principles by which their society operated.

While the scale and nature of Moche warfare is still a topic of debate (see Verano, this volume), their art depicts violence in a very direct way. No interpretive key is needed to understand the basic events occurring in much of Moche art, as the scenes are rendered in what we see as a more veristic or representational style. This use of representation and the related phenomenon of narrative exposition are unique to Moche. Considering the reasons why this choice of art style was made may help us understand Moche statecraft as one that relied on a program in which the representation of ritualized violence was central.

Huaca Cao Viejo, Pañamarca and Huaca de la Luna as Case Studies

Huaca Cao Viejo, Pañamarca and Huaca de la Luna may serve as case studies of Moche public art. These sites have received considerable study and are relatively well published,

although the amount of work at them has varied. Public art at each of these sites will be briefly described before comparative discussion.

Huaca Cao Viejo, part of the El Brujo complex, is located less than a kilometer from the Pacific Ocean, near the mouth of the Chicama River and close to the important Preceramic site of Huaca Prieta. The monumental platform mound is oriented to the north, with a large plaza extending out in front of the ornamented façade. Ongoing work at the site is uncovering new evidence of architectural ornament on the summit and elsewhere, which will undoubtedly alter our impressions of the nature of this complex monument. Recent work there has revealed terraces at the front of the main structure, dating to the penultimate and last building phases of this part of the site (Gálvez and Briceño, this volume; Franco, Gálvez, and Vásquez 1994). The clearing of several different walls here provides us with the possibility of insights into how these renderings may have looked as an ensemble to those gathered in the plaza and on the terraces (fig. 12).

A complex structure, encompassing several enlargements and other renovations, Huaca Cao Viejo contains architectural reliefs dating to different periods (see Gálvez and Briceño, this volume, for a detailed description). One of the earliest reliefs to have survived pertains to the third-to-last phase of construction. Found in a corner on the upper part of the structure (fig. 12, A), a fragment of the relief shows a geometric design of interlocking motifs. Narrative reliefs are also known from this phase (fig. 12, B). Although these reliefs are in poor condition, they show six repetitions of pairs of figures framed in a panel. On the left, a profile figure, with a crescent-shaped knife in one hand, grasps another figure, rendered on a smaller scale, by the hair.

The majority of the extant reliefs at Huaca Cao Viejo date to the final construction phase. Figure 12, C, is a fragment of a relief depicting a creature with human and invertebrate (arachnid?) traits and holding a sacrificial knife (Franco, Gálvez, and Vásquez 1994: 170–171). Executed in a style resembling Garagay, it becomes clear not only that the Moche drew upon a considerable variety of styles concurrently, but that archaism may also have played a part in their artistic repertoire.

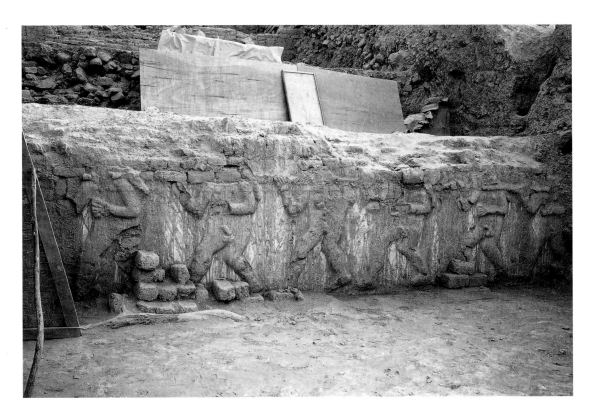

13. Detail of prisoner reliefs, Huaca Cao Viejo
Photograph by Edward Ranney (©)

The two most striking reliefs, readily visible and from a considerable distance, are found on two levels at the base of the façade of Huaca Cao Viejo (fig. 12, D, H). Both reliefs emphasize repetitions of human forms, in a scale slightly larger than lifesize. The preserved sections cover both the long (north) walls facing the plaza and a section of the side (east) walls. Section D shows at least eighteen frontal human forms, in similar costume, clasping hands. Section H (fig. 13) depicts a victorious warrior leading ten or eleven naked, bound prisoners, a common scene in Moche art. Five warriors follow the prisoners, apparently carrying the weapons and costumes of their victims. On the east wall of this same level (fig. 12, G), four other figures, in a poor state of preservation, may also represent warriors.

In the corner between the north and east wall, the prisoner scene is broken by the presence of a small patio and rectangular chamber (fig. 12, E). The exterior of the west wall (fig. 12, F) is divided into four registers, filled with small-scale representations of pairs of warriors. Each register has six pairs of armed warriors facing and apparently fighting each other. Distinctions in dress and armaments are present and are highlighted in the arrangement of figures. The north wall, where the entrance to the chamber is located, and the adjacent east wall are both covered with a complex composition made up of numerous small figures with no clear organized pattern (fig. 14). The motifs relate to fishing, navigation, and combat, and include depictions of terrestrial and aquatic fauna as well as flora.

Pañamarca (fig. 15), in the Nepeña Valley, is mentioned in the travel account of Ephraim George Squier (1877) and was discussed by Wendell Bennett (1939). The most detailed study of the site was conducted by

14. Detail of reliefs, Huaca Cao Viejo
Photograph by Edward Ranney (©)

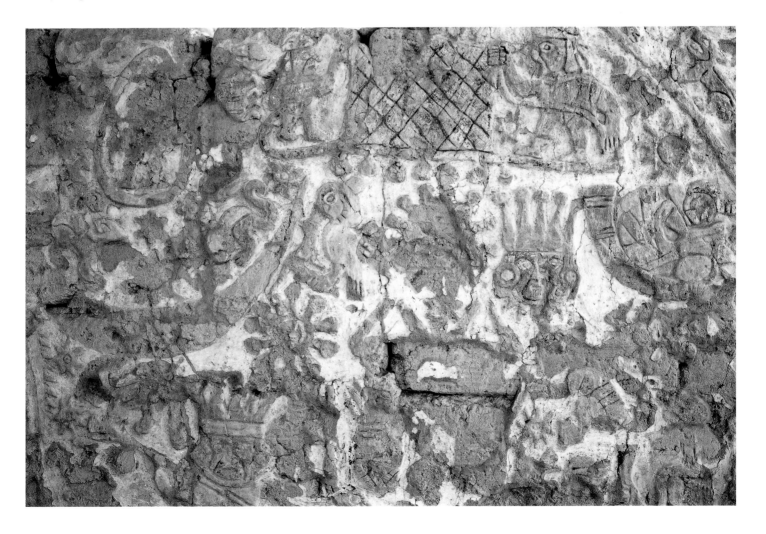

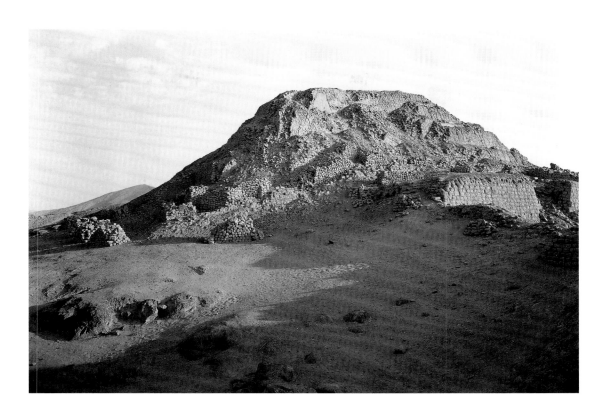

15. View of platform with the zigzag ramp, Pañamarca
Photograph by Edward Ranney (©)

Richard Schaedel (1951; reprinted 1967), with subsequent investigations by Duccio Bonavia (1985). The principal ceremonial area at the site consists of an arrangement of plazas and buildings (fig. 16). Only a portion of the wall paintings and other works that undoubtedly graced much of the architectural complex has been exposed. The largest plazas and buildings are located on the northern side of the site, and smaller rooms and courts are found on the south, adjacent to a platform with a zigzag ramp. It seems reasonable to suggest that the large, northern areas were designed to hold great numbers of people, while the smaller spaces in the south held fewer. Even so, what may have been a forecourt in front of the platform with a zigzag ramp has an area of about 200 m^2, ample space to hold a sizable gathering. Except for a single wall painting (Mural C), found in a large northern plaza, most of the public art at Pañamarca has been identified in or near this forecourt. Most of the figures were rendered in bright polychrome against a white background.

Mural C (fig. 17) is located on the western end of the largest plaza in the complex. Twelve meters of painting were uncovered by Schaedel, but it clearly extended much far-

ther in antiquity. The top of the wall had been cut horizontally, long ago, but its present maximum height is 1.5 m (Bonavia 1985: 55). Eight large anthropomorphic figures are shown in this space.[8] The heads of all the major figures are absent due to apparent cutting of the wall in the past. The figures are portrayed in typical Moche style, in procession from right to left in relation to the viewer. One of the figures, the third from the left, is turned in the opposite direction to the general flow of the scene. Most figures have their hands raised. Two appear to be attended by smaller figures in simple dress. The principal figures wear backflaps (ornamented elements of sheet metal suspended from the waist of warriors), suggesting a military theme, although the figures do not appear to be engaged in combat.

A small quadrangular structure is located close to the entrance of the plaza to the south (fig. 16, F). All of the walls here were painted, but only one motif could be identified by Bonavia (1985: 68). This image (fig. 18), known as Mural F, represents a spotted male feline. Other elements may have been present at one time; unfortunately the poor condition of the mural has prevented any other identifications.

16. Plan of Pañamarca, indicating the location of mural paintings. Lower right inset: detail of shaded area northwest of the platform with the zigzag ramp
After Bonavia 1985: figs. 28 and 29; drawing by Margaret MacLean

Turning to the small court northwest of the monumental platform with the zigzag ramp, a number of paintings have survived. Two paintings (fig. 16, Murals D and B), were found on the exterior walls of the entryway into the court proper. Schaedel (1951: 153; 1967: 113) describes Mural D (fig. 19) as an "anthropomorphic bird figure." Now destroyed, the figure had an anthropomorphic body with a bird head. It is a creature rare in Moche art. Mural B (fig. 20), adjacent to Mural D, is a profile painting of a zoomorph, combining features of both a feline and a snail.

Inside the court, in the southeast wall is a remnant of an earlier construction phase (fig. 16, A). Preserved through the entombing actions of subsequent renovations, Mural A (fig. 21) is a fragment of a larger painting. The preserved section shows two men, in profile, facing each other and grasping each other's hair at the forehead. They are dressed in identical tunics, snake belts, and a kind of feline-head hat or hair decoration. Bonavia (1985: 49) notes that this scene has a long tradition on the Peruvian coast and may represent some kind of ceremonial contest.

Mural E (fig. 22), also located in the court, is one of the most discussed, studied, and reproduced examples of Moche art. The section of the painting under consideration, no longer extant, was nearly three meters in length and a meter and a half in height. It has been analyzed at length, most notably by Christopher Donnan (1976), who related it to

17. Drawing of Mural C, Pañamarca
After Bonavia 1985: fig. 36; reconstruction drawing by Pedro Azabache

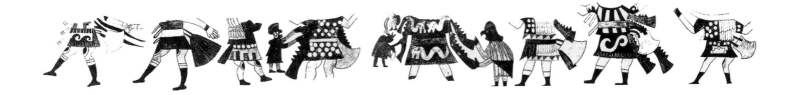

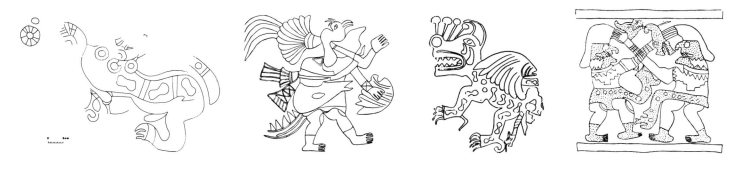

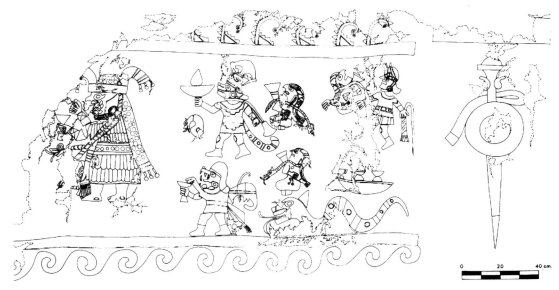

18. Drawing of Mural F,
Pañamarca
After Bonavia 1985: fig. 52;
drawing by Rogger Ravines

19. Drawing of Mural D,
Pañamarca
After Bonavia 1985: fig. 35;
drawing by Pedro Azabache

20. Drawing of Mural B,
Pañamarca
After Bonavia 1985: fig. 34;
drawing by Pedro Azabache

21. Drawing of Mural A,
Pañamarca
After Bonavia 1985: fig. 32;
drawing by Pedro Azabache

22. Reconstruction of Mural
E, Pañamarca
After Donnan 1978: fig. 243;
drawing by Patrick Finnerty

other examples of the Presentation Theme.[9] The scene depicts what appears to be a religious procession. On the left, and rendered in larger scale, is a female priestess with an elaborate headdress and a goblet, followed by two attendants, also carrying vessels. Behind them are depictions of seated, nude prisoners with ropes around their necks, and mythological animals. The last figure on the right appears to be in charge of the prisoners. On the extreme right is a large-scale representation of a bundle of weapons. Bonavia (1985: 59–64) notes that the mural originally continued beyond the weapons bundle, to the right, suggesting that the Presentation Theme may have been more extensive. The corner location of this fragment might also suggest that the scene presented may have been less important than other imagery that would have been more prominently placed for viewers in the court.

Huaca de la Luna has been investigated by a number of scholars, including Squier (1877),

Max Uhle (1913) and members of the Chan Chan–Moche Valley Project (Mackey and Hastings 1982, among others). Most recently, however, the monument and surrounding area have been the focus of a long-term project directed by Santiago Uceda and Ricardo Morales, involving the collaboration of an international team of researchers (Uceda, this volume; Uceda et. al. 1994).

As with Huaca Cao Viejo and many other Moche monuments, Huaca de la Luna was in use over a long period of time and was remodeled many times (see Uceda, this volume, for a more detailed discussion). The majority of the architectural ornament dates to later phases of the architectural sequence (fig. 23). With the exception of the most recently excavated reliefs found on the north façade of Platform 1, facing a large plaza known as the Great Plaza, the reliefs and paintings discussed here are located in interior spaces. These most recent reliefs, similar in many

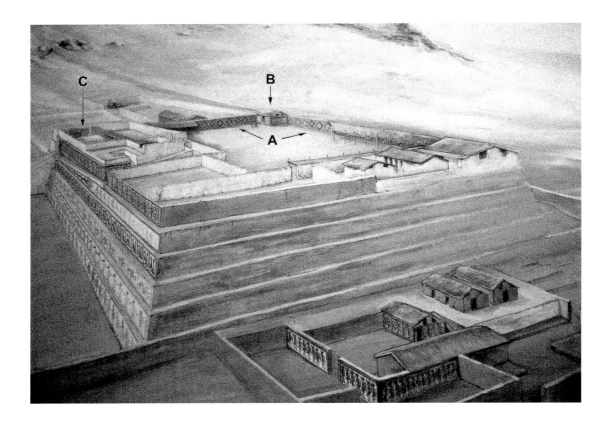

23. Reconstruction of Huaca de la Luna (final phases)
Painting by Jorge Solórzano
© Proyecto Huaca de la Luna, used with permission

ways to those seen at Huaca Cao Viejo, are discussed in detail by Uceda (this volume). On Platform 1, a court with decorated walls known as the Great Patio, probably dating to the penultimate building stage, was found placed on top of earlier constructions (fig. 23, A). The walls were covered with a composition dominated by diamond shapes that serve as frames for a frontal fanged deity head with curly hair and figure-8 ears (fig. 24). The frames of the diamond panels are composed of a stylized interlocking zoomorphic design. The reliefs are boldy polychrome, with vivid reds and yellows, as well as white and black.

In the southeast corner of the platform (fig. 23, B), researchers have identified an area they call the *recinto sacerdotal* (priests' enclosure) (Campana and Morales 1997: 40, fig. 4). In several ways, this area is reminiscent of the chamber at Huaca Cao Viejo (fig. 12, E, F), in that it is stylistically quite distinct from the adjacent walls, with small-scale imagery (fig. 25). The composition is similar to a textile design in its division into design blocks with repetitions and reversals of imagery. Two basic square design blocks are alternated and reversed: one shows a zoomorphic head

with catfishlike whiskers, while the other is divided diagonally into two sections, one side repeating the zoomorphic head, the other bearing the image of a profile bird. A similar textilelike patterning has also been noted on a series of superimposed paintings elsewhere at Huaca de la Luna (fig. 23, C; Bonavia 1985: 85–97; Garrido 1956; Mackey and Hastings 1982). The earliest phase depicts a frontal anthropomorphic figure often referred to as the Staff God; this painting was then covered over, in two successive phases of remodeling, with compositions based on a checkerboard pattern. In the second phase the blocks contain an image of a supernatural visage, similar to the one seen in the plaza area. In the third and final phase, the design is based on alternating blocks, one with zoomorphic motifs, and the other with an anthropomorphic figure with zoomorphic forms on either side.

A mural painting known as the Revolt of the Objects, was found on a nearby structure, Platform III, early in the twentieth century. This mural has been discussed at length by a number of scholars (for example Bonavia 1974, 1985: 72–84; Kroeber 1930: 71–33; Lyon 1981;

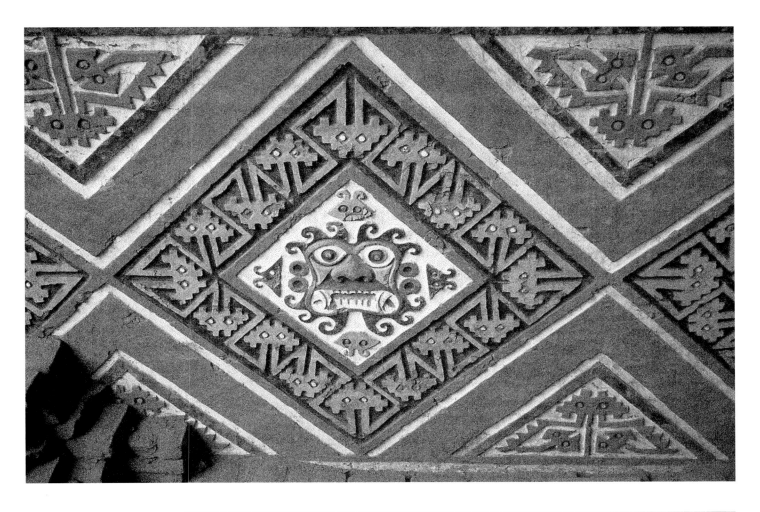

24. Detail of painted reliefs from Platform 1, Huaca de la Luna

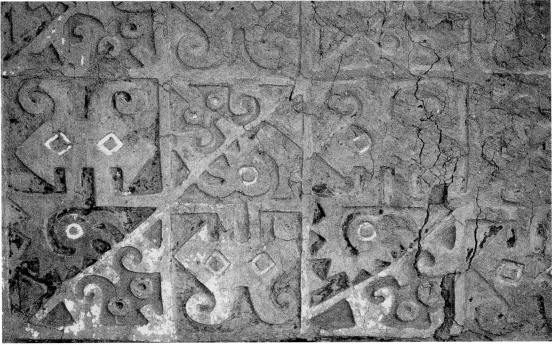

25. Detail of painted reliefs from the *recinto sacerdotal*, Platform 1, Huaca de la Luna

Quilter 1990, 1997) and will be mentioned only briefly here. The painting shows a scene of animated military regalia and weapons attacking humans. Interestingly, the style of these figures resembles nothing else found at Huaca de la Luna or at Huaca Cao Viejo. It does resemble, however, the procession murals at Pañamarca, particularly Mural C.

The Mimetic Moche

Moche architecture was embellished with ambitious, large-scale programs of public art not previously seen in the Andean region. Wall paintings and reliefs appear on the exteriors and interiors of buildings, suggesting both potentially large as well as more restricted audiences. Most are vividly painted in bright colors, insuring that the exterior imagery would have been visible from considerable distances. To our understanding, the imagery, with its emphasis on anthropomorphic forms and clear action, appears straightforward and relatively free of esoteric meanings. The imagery seems direct and to the point, depicting supernaturals and humans in easy-to-read styles. Mythic beings, or composite figures, are present, as they were in Initial period art, but in Moche art they seem clearer: they are isolated, outlined, and conventionalized.

The representational art style of Moche was in the service of a religion, and a political system tied to it, which differed greatly from earlier traditions in the Andes. In many ways, Moche religion and art were unique in the context of the Andes and were traditions not wholly followed by subsequent cultures. The Moche seem to have demystified religion as presented in the Early Horizon. In Moche art, humans and humanlike gods took center stage, literally and figuratively.

While there may have been restricted access to the most holy of rituals, overall, Moche ceremonies appear to have been more public than at Chavín.[10] Ritual actors, impersonating gods or other key religious figures, undoubtedly performed sacrifices and other practices in a very public realm. The findings from San José de Moro (Castillo, this volume) and Sipán (Alva, this volume) of individuals dressed in the regalia of figures we see depicted at Pañamarca and elsewhere reminds us of the extent to which these rituals were

dramatized. Sacrificial rites only have social efficacy if people know about them. In Aztec Mexico, the height of the platforms of Tenochtitlan ensured that vast numbers of the city's population could witness sacrifices taking place on their summits. Whatever the specific performance context of Moche sacrifice, it is likely that at least a portion of the ceremonies occurred in a place where a good-sized audience could view them. Our best evidence of sacrifice on a fairly large scale comes from Huaca de la Luna (Bourget, this volume). Although the bodies were ultimately deposited in a smaller, enclosed plaza, and not on Platform 1, from the iconographic depictions of sacrifice on Moche ceramics it seems that public ritual was an important component of at least part of the events. Spaces such as the newly excavated monumental plaza to the north of Platform 1 at the Huaca de la Luna may have provided a space for thousands to view specific events (Uceda, this volume).

Much of the monumental art found at Moche sites replicated and emphasized ritual actions by costumed priests. Murals C and E (and A?) at Pañamarca, and the march of prisoners at Huaca Cao Viejo, were renderings of events that probably took place near or in front of the art that depicted them. We may conclude that the adoption of a representational art style by the Moche was part of an integrated approach to demonstrate the power of rulers; a power centered on the action of humans in a recognized social matrix of relationships. The more esoteric, more intimate, individualized approach to religious experience of the Initial period and Chavín was set aside for a brutal, straightforward message. No more the transcendental confrontation with the divine in the cool darkness of the inner sanctum or tracing the solidified footprints of an immanent deity. Rather, Moche was about blood in the sand under a harsh sky and the murmur of the crowd; the flash of the sacrificial knife wielded by a god impersonator.

The Aztecs, too, followed similar principles, although the conventions of their art were somewhat different. Public rituals of sacrifice, priests in the skins of flayed victims, the display of scores or more of skulls on racks in plazas, and art celebrating warriors and grisly gods made the message of the

might of the Aztec state clear to friend and foe alike.

At Huaca de la Luna, the interior friezes and paintings of Platform 1 did not replicate human action but served as backdrops. Depictions of the deity, repeated across the expanse of the walls, diffused its power, reducing the confrontational experience with the divine.[11] At the same time, however, the redundancy of the deity image reinforced the centralized religious and political power in the ceremonial complex. The repetition of projecting heads from the wall may be a revival or continuance of the notion of the tenoned heads of Chavín de Huántar. But if every element of the total design had symbolic meaning, the redundancy drove home the ideology conveyed by the symbolism, but also visually and psychologically became design and scenery for actions in front of it.

At Huaca Cao Viejo and Huaca de la Luna, the northern orientation of the plazas, the small corner rooms and other architectural features suggest that, to a certain degree, there were standard architectural plans for Moche religious structures.[12] At both sites, the corner structures break the flow of the eye's movement, and this rupture is accentuated by the change in scale of wall decoration. The little patio with a ramp in front of the room at Huaca Cao Viejo suggests that it may not have been just a vestry or sacristy but a focal point for ritual activity. With only one way in and out, this was a place from which someone may have emerged for performances.

We thus have an interesting contrast in the rituals of Chavín and Moche. At Chavín de Huántar, mystifying art and architectural tricks, such as labyrinthine interiors, ensured that the visitor would be kept in a state of confusion. Rumblings and otherworldly noises from within the temple, created through the use of certain architectural features of the temples, must have heightened the sense of disorientation. A visitor would be offered a tantalizing glimpse, but rarely a complete view, of a supernatural world beyond his or her understanding and experience. Moche religion may have demystified esoteric knowledge to a certain degree, but the exposure of a critical ritual of sacrifice to a wider audience emphasized lines drawn between social ranks. There is no greater manifestation of power differential than that of sacrificer and sacrificed, no matter how much the act is cloaked in a sacred mantle.

The Moche retained or revived many artistic conventions of the Initial period, yet they put these old approaches to new social uses. The Initial period and Moche artists shared a love of bright colors, outlined figures, modeled relief, supernatural scale, and stylized forms. In both traditions, figures are often in profile, floating on light-colored backgrounds, with little or no indication of specific context. But the Moche added a human dimension to art, offering a more direct referent to ritual. The Moche supernatural world was intimately and expressly tied to the earthly social one. All the major gods of the Moche pantheon have anthropomorphic or zoomorphic traits that bring them much closer to the experiences of everyday humans than the gods which had previously presided over Peruvian realities.

The high degree of artistry and craftsmanship of Chavín and the more utilitarian, straightforward presentational style of Moche public art do not represent the linkage of stair-step evolutionary progress in the arts one might expect to find with increased political complexity. Political power and elaboration of art style appear to be inversely related: the larger and more complex the polity, the greater the need for a simplified art style that is "readable" by vast numbers of people.[13] Moche society was probably much more hierarchical than Chavín, yet its architectural art was less "complex." Moche art and religion were didactic, meant to impress upon their audience who was victorious and who was vanquished, who was sacrificer and who was victim, who was ruler and who was ruled. It is for this reason also that the narrative tale of Moche mythology, itself expressed in ritual, was repeated in various media and saw its strongest expression when Moche society was at its most vulnerable, near its end. While the mythology, ideology, and practice of human sacrifice were controlled, manipulated, and broadcast by an elite for centuries, they eventually succumbed to new social forces which arose late in the Early Intermediate period.

NOTES

I thank many for aid and comfort. Joanne Pillsbury gave excellent advice in the final editing process of the paper. My fellow conferees were generous and open in sharing their knowledge, with many kindly offering opportunities to publish versions of their illustrations. Michel Conan was very influential in encouraging me to consider the art from the perspective of the viewer. Richard Burger was his usual kind and generous self in sharing much with me on details and larger ideas. Sarah Quilter offered much to consider as well, including commentary on a draft of the paper and, in particular, reference to Mohammed's footprints in Jerusalem (size 18 according to Mark Twain). Karen Stothert also kindly provided useful commentary. Ingrid Gibson is thanked for her help in translating the abstract. Janice Williams was of great aid in editorial work to produce the final paper. I wish to offer my special thanks to all of my Peruvian colleagues who gave tours of the Huaca de la Luna and the Huaca Cao Viejo in August 1999. That experience greatly enriched and increased my appreciation of those who have lived and worked on the north coast of Peru, both in the distant past and in the present.

1. For the purposes of this essay, finer chronological considerations are set aside, and the Initial period is treated as a single moment in time.

2. A dual altar at Cardal consists of what appear to be a pair of short 3-step stairs on either side of a wall. The design in the Garagay emblem is shown as a single "step" (or a double one if the top is counted). Although this is speculative, the use of extensive terraces in Andean architecture, such as those slightly earlier at El Paraíso, and later uses of terraces in agriculture, suggests that the design might be associated with mountains.

3. Only one photograph is available of the original pair. The second frieze was destroyed before it could be recorded but, according to Ravines (1984), was similar to the preserved one.

4. The banners at Cerro Sechín, the emblems on the frieze at Garagay, and a similar emblem reported by Burger at Cardal suggest distinct icons of group identity or at least allegiance to a common ideology. In the case of the central coast, this identity or common ideology may have extended beyond a single valley system.

5. A review of the monumental study of Peruvian rock art by Antonio Núñez Jiménez (1986) found no petroglyphs similar to the ones discussed for Pacopampa and Huaca A, suggesting that if more are to be found they would be excavated in temple complexes. It would interesting to consider from a comparative perspective how such carvings may have been related to larger programs of pilgrimage and worship at such centers. For example, there is a huge "footprint" carved in rock atop Adam's Peak in Sri Lanka, near the town of Dalhousie. A place of pilgrimage for centuries, Muslims attribute the footprint to Adam, Buddhists say it was Buddha, and Hindus, Lord Shiva. There is also the rock in the center of the Mosque of Omar in Jerusalem discusssed by Mark Twain (1990 [1869]: 375). This boulder is believed to have been the place where Abraham almost sacrificed Jacob, where David persuaded an angel not to destroy Jerusalem, and where Mohammed ascended to heaven. Footprints claimed to be Mohammed's are on the rock, as are the fingermarks of the Angel Gabriel, who seized the boulder to prevent it ascending to heaven with The Prophet.

6. See for example the zigzag ramp which prolongs the climb to the top of the mound at Pañamarca and a similar ramp at Huaca Grande, at the site of Pampa Grande (Shimada 1994a). Moore (1996: 58) notes that the access pattern at Huaca Grande was more restrictive than earlier Moche platforms, including a long approach through a corridor and an uppermost platform enclosed by a wall (see Haas 1985). Even if later Moche platform summits were enclosed and views restricted, they were being cordoned off on the basis of an earlier architectural plan designed for public view, thus sending a contradictory message of openness and closure at the same time.

7. We must be cautious, however, about how we view seemingly abstract art styles. Future research may alter this view. As Tom Cummins (in press) has shown, a distinct *t'oqapu* (a term referring to abstract designs found on textiles and other objects) symbol may be a stylized rendering of skulls and bones, alluding to the power and fearfulness of Inca military might. So too, the small gold and silver Inca figurines, long delighted in for the skill of their manufacture, are now known to be companions of Inca *capac hucha* sacrificial victims. In both of these cases, modern investigators had previously missed the references to warfare and sacrifice, respectively, in these art works because of a lack of cultural reference points and, in the case of the *t'oqapu*, the highly stylized nature of the representation.

8. Bonavia (1985: 55) notes that after Schaedel's work unknown people cleared some more paintings revealing a few new figures. They are similar to the ones here described.

9. This is also known as the Sacrifice Ceremony (see Alva and Donnan, 1993: 127–141).

10. For Chavín to have maintained itself it is likely that public rituals were also held there. The issue is one of emphasis.

11. In the succeeding Chimú culture, stylized fretwork similar to the decorations around the heads at Huaca de La Luna come to dominate the walls of Chan Chan (Pillsbury 1993). Even though messages of power were integrated into friezes (Pillsbury 1996), the design element seems to dominate over didactic purposes.

12. Although I have not been able to examine a plan or picture of it, perhaps the small quadrangular room immediately outside of the courtyard at Pañamarca, on which Mural F was found, served the same purpose as the small rooms at the other two sites.

13. Esther Pasztory (1997) has argued that a similar phenomenon may have occurred at Teotihuacan.

BIBLIOGRAPHY

Alva, Walter
1986 *Las salinas de Chao: frühe Siedlung in Nord-Peru/ Las salinas de Chao: asentamiento temprano en el norte del Perú.* Materialien zur allgemeinen und vergleichenden Archäologie 34. Munich.

Alva, Walter, and Christopher B. Donnan
1993 *Royal Tombs of Sipán* [exh. cat., Fowler Museum of Cultural History, University of California]. Los Angeles.

Bennett, Wendell
1939 *Archaeology of the North Coast of Peru: An Account of Exploration and Excavation in Viru and Lambayeque Valleys.* Anthropological Papers of the American Museum of Natural History 37 (1). New York.

Bonavia, Duccio
1974 *Ricchata quellccani: pinturas murales prehispánicas.* Lima.

1985 *Mural Painting in Ancient Peru*, trans. Patricia J. Lyon. Bloomington, Ind.

Burger, Richard L.
1987 The U-Shaped Pyramid Complex, Cardal, Peru. *National Geographic Research* 3 (3): 363–375.

1992 *Chavín and the Origins of Andean Civilization.* London and New York.

Burger, Richard L., and Lucy Salazar-Burger
1985 The Early Ceremonial Center of Huaricoto. In *Early Ceremonial Architecture in the Andes* [A Conference at Dumbarton Oaks, 8th to 10th October 1982], ed. Christopher B. Donnan, 111–138. Washington.

1986 Early Organizational Diversity in the Peruvian Highlands: Huaricoto and Kotosh. In *Andean Archaeology: Papers in Memory of Clifford Evans*, ed. Ramiro Matos Mendieta, Solveig A.Turpin, and Herbert H. Eling, Jr., 65–82. University of California, Institute of Archaeology Monograph 27. Los Angeles.

1991 The Second Season of Investigations at the Initial Period Center of Cardal, Peru. *Journal of Field Archaeology* 18 (3): 275–296.

1999 The 1998 Investigations at Manchay Bajo, Lurin Valley, Peru. Paper presented at the 64th Annual Meeting of the Society for American Archaeology, Chicago.

Campana, Cristóbal, and Ricardo Morales
1997 *Historia de una diedad Mochica.* Lima.

Conklin, William J
1985 The Architecture of Huaca Los Reyes. In *Early Ceremonial Architecture in the Andes* [A Conference at Dumbarton Oaks, 8th to 10th October 1982], ed. Christopher B. Donnan, 139–164. Washington.

Cummins, Tom
in press Towards a Meaning of Objects in Tawantinsuyu: Querus and Aquillas. In *Variations in the Expression of Inka Power*, ed. Ramiro Matos Mendieta, Richard L. Burger, and Craig Morris. Forthcoming Dumbarton Oaks symposium volume. Washington.

Donnan, Christopher B.
1976 *Moche Art and Iconography.* UCLA Latin American Center, Latin American Studies 33. Los Angeles.

1978 *Moche Art of Peru: Pre-Columbian Symbolic Communication* [exh. cat., Museum of Cultural History, University of California; rev. ed. of Donnan 1976]. Los Angeles.

Engel, Frédéric A.
1967 El complejo el Paraíso en el valle del Chillón, habitado hace 3,500 años: Nuevos aspectos de la civilización de los agricultores del pallar. Universidad Agraria, Anales Científicos 5 (3–4): 241–280. [Lima].

Franco, Régulo, César Gálvez, and Segundo Vásquez
1994 Arquitectura y decoración Mochica en la Huaca Cao Viejo, complejo El Brujo: Resultados preliminares. In *Moche: Propuestas y perspectivas* [Actas del primer coloquio sobre la cultura Moche, Trujillo, 12 al 16 de abril de 1993], ed. Santiago Uceda y Elías Mujica, 147–180. Travaux de l'Institut Français d'Etudes Andines 79. Trujillo and Lima.

Fung Pineda, Rosa
1988 The Late Preceramic and Initial Period. In *Peruvian Prehistory*, ed. Richard W. Keatinge 67–96. Cambridge.

Garrido, José E.
1956 Decubrimiento de un muro decorado en la "Huaca de la Luna" (Moche). Chimor: *Boletín del Museo de Arqueología de la Universidad de Trujillo* 4 (1): 25–31.

Haas, Jonathan S.
1985 Excavations on Huaca Grande: An Initial View of the Elite at Pampa Grande, Peru. *Journal of Field Archaeology* 12 (4): 391–409

Izumi, Seiichi, and Kazuo Terada
1972 (Editors) *Andes 4: Excavations at Kotosh, Peru: 1963 and 1966.* Tokyo.

Kroeber, Alfred L.
1930 *Archaeological Explorations in Peru. Part II: The Northern Coast.* Field Museum of Natural History, Anthropology Memoirs 2 (2). Chicago.

Lathrap, Donald W.
1985 Jaws: the Control of Power in the Early Nuclear American Ceremonial Center. In *Early Ceremonial Architecture in the*

Andes [A Conference at Dumbarton Oaks, 8th to 10th October 1982], ed. Christopher B. Donnan, 241–267. Washington.

Lyon, Patricia J.
1981 Arqueología y mitología: La escena de "los objetos animados" y el tema de "el alzamiento de los objetos." *Scripta Ethnológica* 6: 105–108. [Buenos Aires].

Mackey, Carol J., and Charles M. Hastings
1982 Moche Murals from the Huaca de la Luna. In *Pre-Columbian Art History: Selected Readings*, ed. Alana Cordy-Collins, 293–312. Palo Alto, Calif.

Moore, Jerry D.
1996 *Architecture and Power in the Ancient Andes: The Archaeology of Public Buildings.* New Studies in Archaeology. Cambridge and New York.

Moseley, Michael E.
1992 *The Incas and Their Ancestors: The Archaeology of Peru.* London and New York.

Moseley, Michael E., and Luis Watanabe
1974 The Adobe Sculptures of Huaca de los Reyes. *Archaeology* 27 (3): 154–161.

Núñez Jiménez, Antonio
1986 *Petroglifos del Perú: Panorama mundial del arte rupestre* (4 vols.). Havana.

Pasztory, Esther
1997 *Teotihuacan: An Experiment in Living.* Norman, Okla.

1998 *Pre-Columbian Art.* Cambridge.

Pillsbury, Joanne
1993 Sculpted Friezes of the Empire of Chimor. Ph.D. dissertation, Department of Art History and Archaeology, Columbia University, New York.

1996 The Thorny Oyster and the Origins of Empire: Implications of Recently Uncovered *Spondylus* Imagery from Chan Chan, Peru. *Latin American Antiquity* 7 (4): 313–340.

Pozorski, Shelia, and Thomas Pozorski
1987 *Early Settlement and Subsistence in the Casma Valley, Peru.* Iowa City.

1999 The Place of the Sechin Alto Complex in Early Casma Valley Polity Development. Paper presented at the 64th Annual Meeting of the Society for American Archaeology, Chicago.

Pozorski, Thomas
1975 El complejo Caballo Muerto: Los frisos de barro de la Huaca de los Reyes. *Revista del Museo Nacional* 41: 211–251. [Lima].

1980 The Early Horizon Site of Huaca de Los Reyes: Societal Implications. *American Antiquity* 45 (1): 100–110.

Quilter, Jeffrey
1985 Architecture and Chronology at El Paraíso, Peru. *Journal of Field Archaeology* 12 (3): 279–297.

1990 The Moche Revolt of the Objects. *Latin American Antiquity* 1 (1): 42–65.

1991 Late Preceramic Peru. *Journal of World Prehistory* 5 (4): 387–438.

1997 The Narrative Approach to Moche Iconography. *Latin American Antiquity* 8 (2): 113–133.

Ravines, Rogger
1984 Sobre la formación de Chavín: Imágenes y símbolos. *Boletín de Lima* 35: 27–45.

Ravines, Rogger, and William H. Isbell
1975 Garagay: Sitio ceremonial temprano en el valle de Lima. *Revista del Museo Nacional* 41: 253–275. [Lima].

Roe, Peter G.
1974 *A Further Exploration of the Rowe Chavín Seriation and Its Implications for North Central Coast Chronology.* Dumbarton Oaks Research Library and Collections, Studies in Pre-Columbian Art and Archaeology 13. Washington.

Rowe, John Howland
1962 *Chavin Art: An Inquiry into its Form and Meaning.* The Museum of Primitive Art, New York.

Schaedel, Richard P.
1951 Mochica Murals at Pañamarca. *Archaeology* 4 (3): 145–154.

1967 Mochica Murals at Pañamarca. In *Peruvian Archaeology: Selected Readings*, ed. John Howland Rowe and Dorothy Menzel, 104–114. Palo Alto, Calif.

Shimada, Izumi
1994a *Pampa Grande and the Mochica Culture.* Austin, Tex.

1994b Los modelos de la organización sociopolítica de la cultura Moche: Nuevos datos y perspectiva. In *Moche: Propuestas y perspectivas* [Actas del primer coloquio sobre la cultura Moche, Trujillo, 12 al 16 de abril de 1993], ed. Santiago Uceda and Elías Mujica, 359–387. Travaux de l'Institut Français d'Etudes Andines 79. Trujillo and Lima.

Squier, Ephraim George
1877 *Peru: Incidents of Travel and Exploration in the Land of the Incas.* New York.

Tello, Julio C.
1956 *Arqueología del valle de Casma. Culturas: Chavín, Santa o Huaylas Yunga y Sub-Chimú. Informe de los trabajos de la expedición arqueológica al Marañón de 1937.* Publicación Antropológica del Archivo "Julio C. Tello" (Universidad Nacional Mayor de San Marcos) 1. Lima.

1960 *Chavín: Cultura matriz de la civilización andina,* rev. Toribio Mejía Xesspe. Publicación Antropológica del Archivo "Julio C. Tello" (Universidad Nacional Mayor de San Marcos) 2. Lima.

Twain, Mark

1990 *The Innocents Abroad, or, The New*
[1869] *Pilgrims' Progress; Being Some Account of the Steamship Quaker City's Pleasure Excursion to Europe and the Holy Land.* Pleasantville, N.Y.

Uceda, Santiago, Ricardo Morales, José Canziani, and María Montoya

1994 Investigaciones sobre la arquitectura y relieves polícromos en la Huaca de la Luna, valle de Moche. In *Moche: Propuestas y perspectivas* [Actas del primer coloquio sobre la cultura Moche, Trujillo, 12 al 16 de abril de 1993], ed. Santiago Uceda and Elías Mujica, 251–303. Travaux de l'Institut Français d'Etudes Andines 79. Trujillo and Lima.

Uhle, Max

1913 Die Ruinen von Moche. *Journal de la Société des Américanistes de Paris* n.s. 10 (1): 95–117.

Williams León, Carlos

1971 Centros ceremoniales tempranos en el valle de Chillón, Rimac y Lurín. *Apuntes Arqueológicos* 1: 1–4. [Lima].

1980 Complejos pirámides con planta en U, patrón arquitectónico de la costa central. *Revista del Museo Nacional* 44 [1978–1980]: 95–110. [Lima].

1985 A Scheme for the Early Monumental Architecture of the Central Coast of Peru. In *Early Ceremonial Architecture in the Andes* [A Conference at Dumbarton Oaks, 8th to 10th October 1982], ed. Christopher B. Donnan, 227–240. Washington.

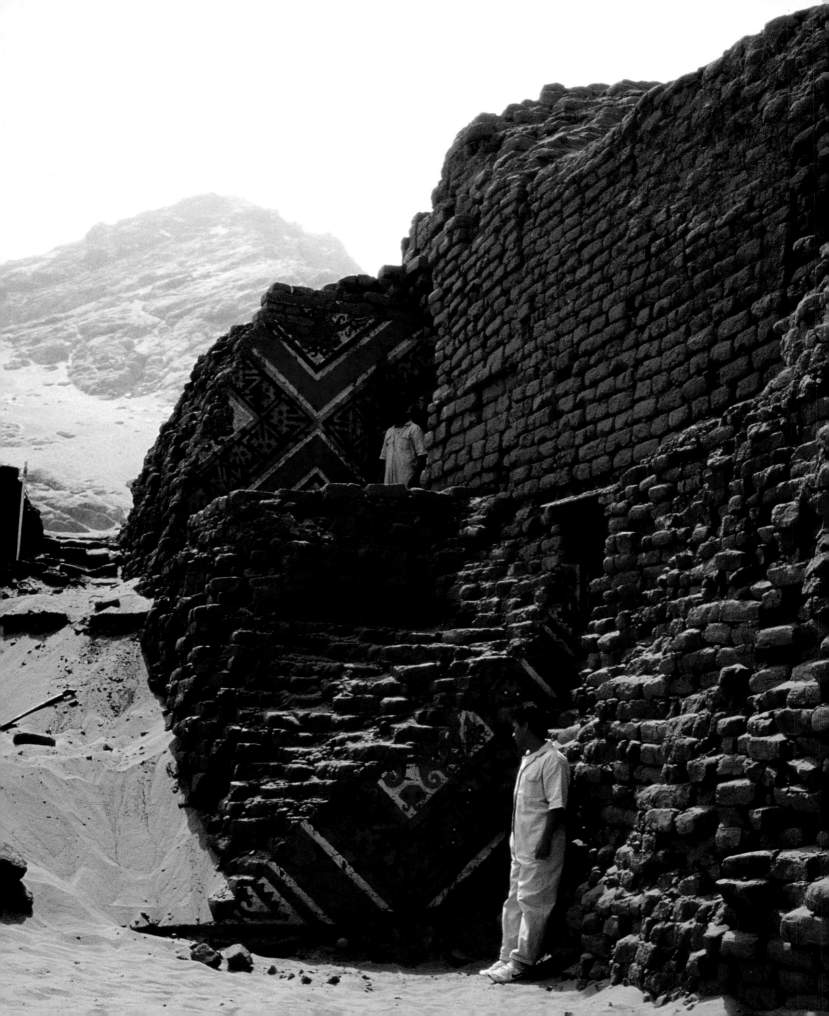

SANTIAGO UCEDA
Universidad Nacional de Trujillo

Investigations at Huaca de la Luna, Moche Valley: An Example of Moche Religious Architecture

The site of Moche is located at the foot of Cerro Blanco on the south bank of the Moche River, some 5 km from the coast. This large settlement is dominated by two monumental architectural complexes, known as Huaca del Sol and Huaca de la Luna[1]. These platform mounds are 500 m apart, and in between them lies a wide plain where both residential and craft production areas have been identified (fig. 1). The Moche occupation of this site lasted into the second half of the first millennium A.D., or from Moche Phase I to Phase IV. Since 1991, the Universidad Nacional de Trujillo has been conducting a long-term investigation at the site. This project has three main objectives: the architectural and archaeological study of Huaca de la Luna; the conservation of its extensive architectural reliefs; and the promotion of local and regional tourism.[2] This paper is an overview of the architecture and function of Huaca de la Luna (figs. 2, 3), understood today as the main ceremonial center at Moche.

The Site of Moche

On the western edge of the site lies Huaca del Sol (fig. 4), one of the largest structures known from the ancient Americas (340 m × 160 m). It consists of a series of four ascending platforms, reaching the height of 40 m in the southern section. Its plan was originally that of a giant cross, but only one third of the monument remains today due to intensive looting carried out during colonial times. At the beginning of the seventeenth century, the course of the Moche River was changed so that it would wash out the structure, making it easy to recover precious metal objects from burials encased within the platform. In modern times this monument has received relatively little scholarly attention, apart from sporadic surveys and exploratory trenches.

Claude Chapdelaine of the Université de Montréal has recently studied the urban plain between the *huacas* at Moche (Chapdelaine, this volume, and 1998). This area was previously thought to have been destroyed completely by torrential rains and flooding associated with an ENSO event (Moseley 1992: 167). Chapdelaine's excavations, however, have revealed the existence of a large residential area composed of a series of architectural compounds. These compounds contain patios and storage facilities; a number of them also contain workshops. These compounds are connected by a system of plazas and streets.

East of this settlement, on the lower slopes of Cerro Blanco, lies Huaca de la Luna. This complex consists of three large platforms on different levels, linked by adjacent plazas of varying size. The Huaca de la Luna complex extends 290 m from north to south and 210 m from east to west.

Investigators have studied the Moche site since the turn of the twentieth century

View of Huaca de la Luna during excavations
Photograph by Ricardo Morales

(Bennett 1939; Kroeber 1925, 1944; Larco Hoyle 1948; Uhle 1913; see also Kaulicke 1998). The most intensive period of investigation of this site, prior to the present research, was carried out between 1969 and 1974 by members of the Chan Chan–Moche Valley Project, directed by Michael Moseley and Carol Mackey (Moseley and Day 1982). Excavations were conducted near the *huacas* (Donnan and Mackey 1978) and in the residential sector (Topic 1977, 1982). At Huaca de la Luna itself, however, only small-scale excavations were carried out. One of the major contributions of the Chan Chan–Moche Valley Project was the discovery of a series of superimposed mural paintings in the northeast corner of Platform I (fig. 5; Mackey and Hastings 1982; see also below).

In 1990 the author and Ricardo Morales initiated a long-term program of architectural study and archaeological excavations at Huaca de la Luna. This project involves the cooperation of numerous Peruvian and international scholars, as well as students from the Universidad Nacional de Trujillo and the Université de Montréal. During the first years of our investigation at the site, our primary objectives were (1) to define the architectural

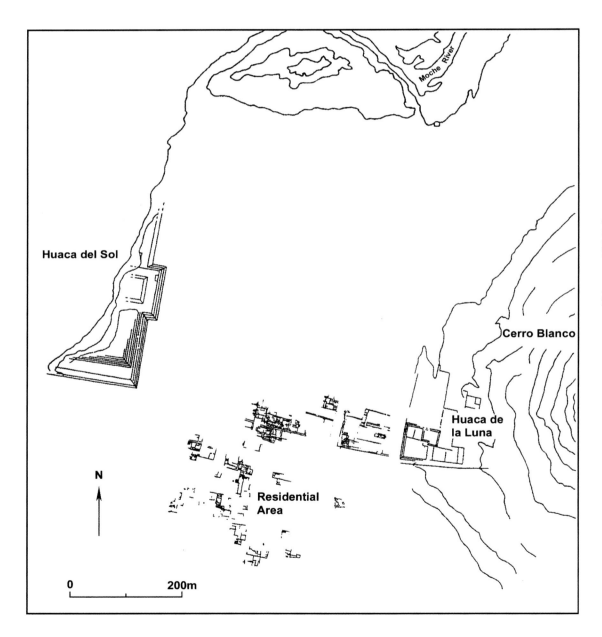

1. Map of the Moche site

OPPOSITE PAGE:
2. View of Huaca de la Luna, prior to recent excavations
Photograph by Edward Ranney (©)

3. Plan of Huaca de la Luna
Drawing by Carlos Ayesta

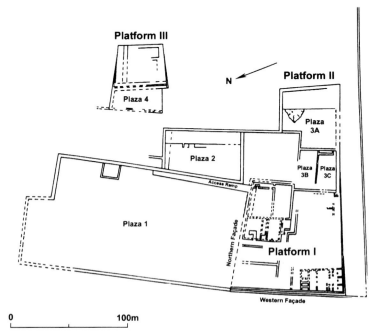

Platform III

Plaza 4

N

Platform II

Plaza 3A

Plaza 2

Plaza 3B | Plaza 3C

Access Ramp

Plaza 1

Northern Façade

Platform I

Western Façade

0 100m

sequence of the *huaca*; (2) to uncover and conserve the polychrome murals and reliefs associated with the architecture; and (3) to ascertain the function or functions of the different areas, particularly that of the main platform (Platform I). In subsequent years, Plazas 2 and 3 became the focus of our attention. In this paper I will first give an overview of the architectural layout of Huaca de la Luna. This will be followed by a study of the architectural sequence of Platform I. In the final section, I discuss the activities carried out at Huaca de la Luna, in order to help us assess the nature and function of this monument in prehispanic times.

Architecture of Huaca de la Luna

Huaca de la Luna consists of the following three architectural components (fig. 3): a large, elevated platform located in the southwest

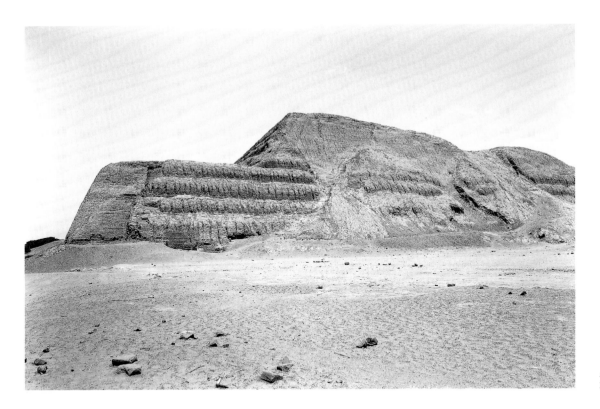

4. View of Huaca del Sol
Photograph by Edward Ranney (©)

corner of the complex (Platform I); a smaller platform in the southeastern corner (Platform II); and a third platform in the northeastern corner (Platform III). The latter is detached from the main architectural compound and located on higher ground.

Four plazas, at varying levels, are adjacent to the platforms. These are arranged as follows: Plaza 1, also known as the Great Plaza, is by far the largest of the three plazas (180 m × 90 m), and is located immediately to the north of Platform I (fig. 6). Contiguous to the east wall of this large open space is a long ramp, oriented north-south, that would have provided access to Platform I from the Great Plaza. Located to the east of Plaza 1, Plaza 2 is smaller and located at a higher level (3.5 m above Plaza 1). Plaza 3 is located in the southern part of the complex, between Platforms I and II. It is divided into three sectors (3A, 3B, and 3C) and is characterized by the presence of a rocky outcrop that was incorporated into Platform II and Plaza 3A. Plaza 4 is located to the west of Platform III. The plaza spaces are delimited by the platforms and by free-standing, high, thick adobe walls. The western wall of Plaza 1, together with the western façade of Platform I, formed a sort of southern

perimeter wall, separating the *huaca* from the urban plain. On the south side of the *huaca*, the perimeter wall extends to the east, up the hill toward Cerro Blanco. The space between this wall and the southern façade formed a wide corridor (18 m in width and at least 180 m in length).

Platform II and Plaza 3A, the location of a sacrificial site, have been studied by Steve Bourget (this volume, and 1998a, 1998b). Plazas 1, 2 and 3C are the subject of ongoing studies under the direction of the author. We have focused the majority of efforts, however, on the Platform I. In broad terms, Platform I consists of a massive platform with an Upper and Lower Level (fig. 7). To date no remains of a kitchen or domestic debris have been uncovered on Platform I. Given the absence of residential evidence, and the character of the architecture itself, we suggest that Platform I was largely ritual in orientation.

Platform I

Platform I at Huaca de la Luna is a complex structure, built over the course of several centuries. In its final form, the *huaca* was a roughly square platform (95 m × 95 m),

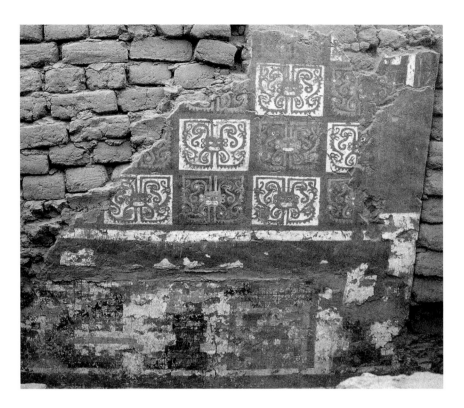

5. Mural fragment, Platform I, Upper Level, Structure B, at Huaca de la Luna

reaching some 32 m above the level of the residential plain. The exterior of the *huaca* is stepped (fig. 6). Remains of mural paintings and sculpted reliefs on the exterior of the *huaca* are similar to those found recently on Huaca Cao Viejo at the El Brujo complex (Gálvez and Briceño, this volume). Lines of warriors carrying shields and war clubs were sculpted in low relief on the northern façade of Huaca de la Luna, the façade facing the Great Plaza (fig. 8). As the tier where these reliefs are found narrows to accommodate the inclination of a ramp, the warriors are replaced by a serpent. Remains of mural paintings from an earlier north façade have also been found, including the depiction of a frontal anthropomorphic figure holding a *tumi* or crescent-shaped knife, with a grimacing mouth and curvilinear extensions terminating in profile bird heads (fig. 9).

Deep excavations on the *huaca* revealed at least five different construction stages, each involving the ritual burial of earlier structures. Our most complete data on the architectural layout of Platform I come from the last construction phases. Apart from some modifications noted below, it seems that the building largely kept the same layout over most of its history.

As indicated earlier, the principal access to Platform I was by means of a large ramp, the base of which has been found in Plaza 1. This ramp had an incline of 45°, and an approximate length of 60 m. It was 3.5 m in width and was flanked by a small low balustrade, 50 cm high (fig. 8). This ramp would originally have led to the fifth platform step, where it turned west and followed the *huaca* façade, reaching the top of the structure roughly at the center of the north façade (fig. 6).

The Upper and Lower Level of Platform I are connected by a small L-shaped access ramp (fig. 7). After arriving at the summit of the platform from the plaza, one could follow this ramp to reach the Upper Level. Alternatively, one could follow a narrow, zigzagging corridor and eventually gain access to the Great Patio, which was decorated with impressive painted reliefs (figs. 10, 11), or other sectors of the Lower Level.

Upper Level

The Upper Level is a roughly square construction (40 m × 50 m), approximately 5 m above the Lower Level of Platform I. The Upper Level was badly damaged by intensive looting during colonial times. Nevertheless, the remains of walls indicate that it was originally divided into four rooms.

The small L-shaped ramp—documented in three of the five successive structures—provided access to the Upper Level through a small room or terrace (16 m × 20 m) facing the Great Plaza to the north. This terrace provided access to the other three rooms. The southwestern room contained a long bench against the north wall, and there is evidence of partial roofing. In the southeast corner there was a second room, a patio of 27 m × 16 m, with walls painted in white. A passageway on the north wall of this patio provided access to the third room.

The walls of this third room were decorated with the mural paintings discovered in 1972 by members of the Chan Chan–Moche Valley Project mentioned above (fig. 5). This patio may have been one of the most important spaces on the platform, given its restricted access, and the quality of the mural decoration. Measuring 19 m × 16 m, the space

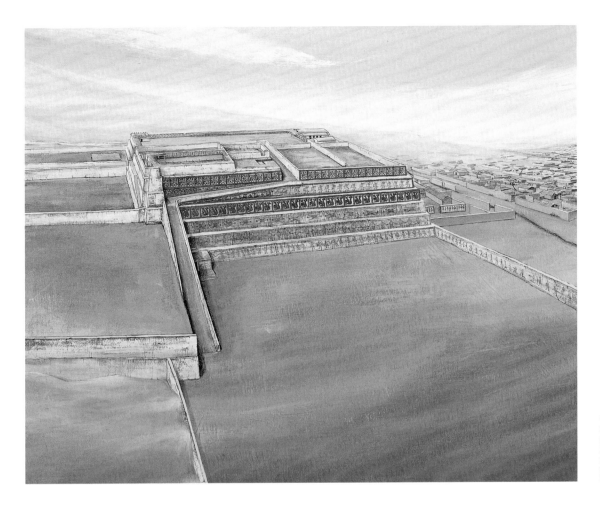

6. Hypothetical
reconstruction of Plaza 1
and Platform I, at Huaca de
la Luna
Painting by Jorge Solórzano
© Proyecto Arqueológico Huaca de
la Luna

had undergone multiple modifications. At one point, a long bench was constructed against the north wall. Evidence suggests that these modifications were carried out either for structural reasons, or possibly for the ritual burial of an older construction.

The murals found in this precinct were repainted three times (Bonavia 1985: 85–97; Mackey and Hastings 1982). The earliest mural shows an anthropomorphic figure rendered in a rigid, textilelike fashion, apparently laid out over a grid. The figure is frontal, and holds a staff in each hand. The staves terminate in profile zoomorphic heads, of either a two-headed serpent or stylized feline. The figure wears a loincloth, decorated with a stylized serpent head, similar to that found framing each rhombus in the reliefs of the Great Patio of the Lower Level (fig. 11). This image, 3.4 m in height and 2.4 m in width, was repeated. Only the lower part of one of the figures is still visible today (fig. 5, lower section).

A second mural was painted over the first (fig. 5, upper section). The format of the second phase mural is quite different, and follows an overall checkerboard composition, with design blocks rendered in alternating colors. The basic design is of a disembodied supernatural face, with appendages extending outward that terminate in profile bird heads. The motif was painted alternately in red over white, and yellow over blue. The eyes of the supernatural personage were detailed in black.

The third and latest mural (Bonavia 1985: figs. 67–70; Mackey and Hastings 1982: figs. 4, 5) is a combination of the two earlier versions: the subject matter of the first mural, but rendered in the checkerboard fashion of the second. As with the earlier murals, the forms are defined by the lines of an incised grid over the surface of the painting. The checkerboard composition here contains two design motifs arranged alternately on the

wall. One is the anthropomorphic figure with zoomorphic staves, similar to the first painting. The body of this figure is frontal, and the head is shown in profile. The headdress of the figure has volutes, and terminates in what may be representations of fox heads. The staves in the hands of the figure also terminate in zoomorphic forms, in this case serpent heads, with what are perhaps profile fox heads at the sides. The second motif is rectilinear, with stylized zoomorphic forms interspersed with anthropomorphic faces.[3]

Lower Level

The Lower Level of Platform I is composed of three distinct sectors: (1) the Great Patio with painted reliefs; (2) a restricted area in the southwest corner, with rooms covered with sloping roofs; and (3) a smaller articulated court in the northwest corner (fig. 7).

The Great Patio is a large open space measuring c. 2,400 m², encompassing over a third of the structure and almost half of the Lower Level. The south, west and east walls were decorated with impressive painted

reliefs (figs. 10, 11). The composition consists of a supernatural image, with a menacing, cross-fanged mouth, figure-8 ears, and volutes encircling the face. Abbreviated zoomorphic forms, with whiskerlike barbels resembling those of a catfish, are above, below and to either side of the face. This in turn is enclosed within rhomboid borders, including one composed of interlocking stylized zoomorphic forms, repeated across the walls. The rhombi were 2.70 m × 2.80 m, vertex to vertex, thus covering most of the available surface of the walls (3 m in height). Similar depictions are known in other media in northern Moche art. Alva (1994) identifies the figure, seen in metal artifacts from Sipán, as the Decapitator. Lumbreras (1979: 121–123) notes that this image is frequently found in northern ceramics as well.

The reliefs were probably made by a number of artisans, as variations exist among them. The mineral-oxide pigments used included red, yellow, white, black, and blue. The reliefs were protected by an elaborate roof structure supported by *algarrobo* wood posts. Reeds were plastered and painted with

7. Plan of Platform I, Huaca de la Luna
Drawing by Carlos Ayesta

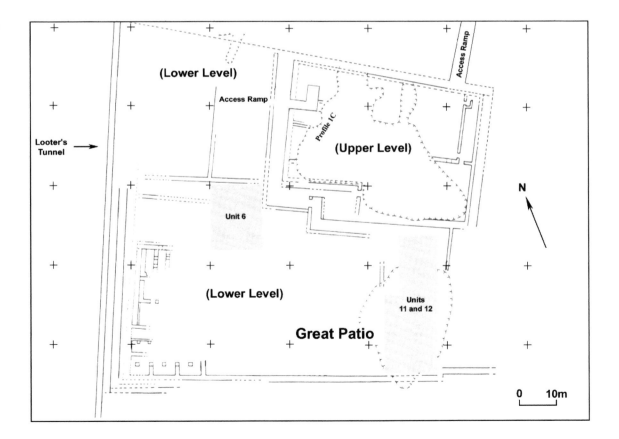

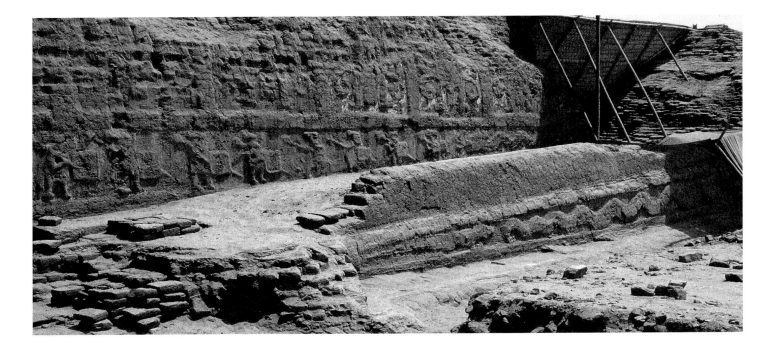

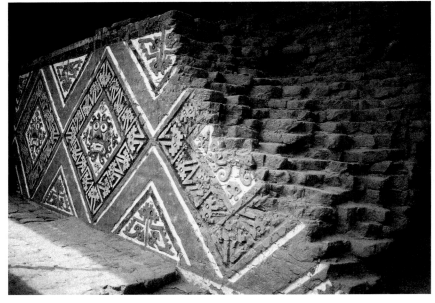

the same motifs found on the walls. The roof was decorated with war clubs made out of fired clay.

Two small contiguous rooms in the southeast corner of the Great Patio were also ornamented.[4] The decoration consisted of motifs based on marine birds and fish (figs. 12, 13). Two basic designs alternate, with reversals in form and color. One shows a zoomorphic head with catfishlike whiskers, similar to those seen around the supernatural face in the larger reliefs in the main area of the Great Patio. The other is divided diagonally into two sections, one side repeating the zoomorphic head, the other half bearing the image of a profile bird. Originally covered with a pitched roof, the interior floors and walls of these spaces had been painted white. Doorways with high thresholds provided access to these precincts from the Great Patio.

8. View of the north façade of Platform I, Structure A, Huaca de la Luna

9. Detail of mural fragment from the north façade of Platform I, Structure B–C, Huaca de la Luna

10. View of painted reliefs from the Great Patio, Lower Level, Platform I, Structure D, Huaca de la Luna

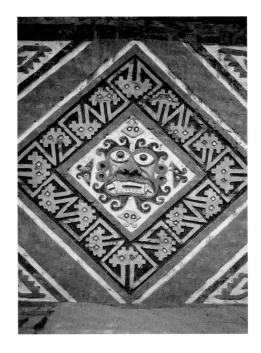

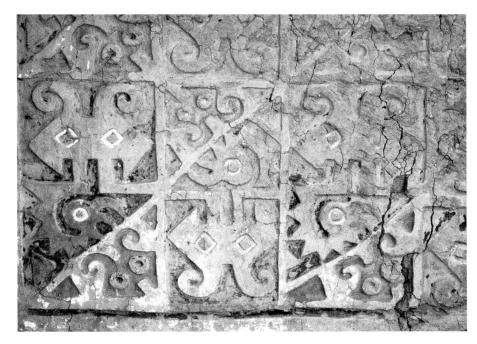

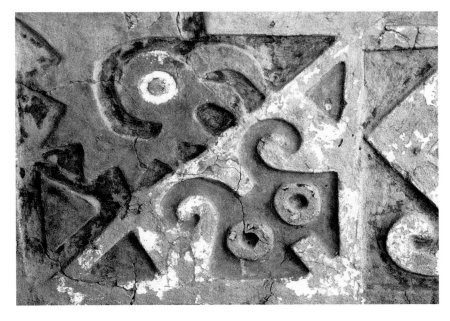

11. Detail of painted reliefs from the Great Patio, Lower Level, Platform I, Structure D, Huaca de la Luna

12, 13. Details of painted reliefs from the southeast corner of the Lower Level, Platform I, Structures B–C, Huaca de la Luna

West of the Great Patio, in the southwest corner of Platform I, a series of rooms were found in what may have been one of the most private areas of the complex (fig. 7). Against the south wall were three contiguous small rooms. To the north were two relatively large rooms (6 m × 17.60 m and 19 m × 9 m). These spaces were originally covered with double sloping roofs, supported by pillars and pilasters. At Huaca Cao Viejo in the El Brujo complex, a large wooden post with a carved anthropomorphic figure was recovered from a similar type of room (see Gálvez and Briceño, this volume). The wooden figure from El Brujo wears a headdress with representations of two profile foxes. This finding in a similar and roughly contemporaneous site hints at the sacred character of these rooms.

Finally, to complete the circuit of the Lower Level of Platform I, we arrive at the northwest corner. Here two large rectangular courts were located, overlooking the Great Plaza.

Archaeological Evidence: Profile 1C, Units 6, 11, 12 and the Looter's Tunnel

Excavations carried out in recent years have shown that the architecture and ornament at Huaca de la Luna have been reconfigured over the years. The monument as we know it today, described above, corresponds to the last phases of construction. Five earlier construction phases have been identified, for a total of six major renovations. These superimposed structures have been designated A–F, from latest to earliest. A certain homogeneity in design was maintained throughout the construction sequence. Evidence for the architectural sequence comes from three

sources (fig. 7): Profile 1C, cleaned during the excavation of a looter's trench; a series of excavation units (6, 11, and 12); and from findings during the study of a major, long looter's tunnel in the western façade of the *huaca*.

Profile 1C

A large colonial-era looter's pit on the Upper Level of Platform I provided an occasion for studying the architectural sequence in this sector. Profile 1C, located in the area of the small access ramp providing access between the Lower and Upper Levels, shows evidence of considerable architectural continuity between the later architectural phases. For example, the ramp maintained the same orientation and incline over the last three construction phases (from Structures C to A). Evidence of an earlier construction phase (Structure D) was found, showing a corridor in this area at that time, indicating that a reconfiguration of this sector occurred between Structure D and Structure C. This was probably the time when the basic configuration of an Upper and a Lower Level on the summit of the platform was devised.

A second key element seen in Profile 1C has to do with construction methods. New building phases began with the burial of the previous construction; the existing building was covered with a thick layer of adobe bricks (approx. 2.5 m). Each new construction completely buried the previous one. The one exception to this was Structure B, which suggests that this may represent a minor renovation rather than a complete reconstruction.

Unit 6

The excavation of Unit 6 also provided important information on the construction sequence. Located in the western part of the Great Patio, this unit is the second deepest (8.5 m) trench excavated on top of Platform I. Three floors, associated with Structures A, B–C, and D, were identified. Important architectural details of Structure D were defined, including a corridor with niched wall and a pillar. Fragments of a ceramic vessel known as a *canchero* (dipper) (fig. 14) were found on the floor of the corridor, providing a possible chronological indicator (see below).

Units 11 and 12

The exploration of a large colonial-era looter's pit inside the Great Patio also yielded important data on the architectural sequence. Units 11 and 12 were relatively deep, cutting through the floors of Structures A–D. Evidence for painted reliefs from these last four phases were found along the eastern wall. Earlier remains, associated with Structure E, were also found in these units. To date, of all the excavation units, these are the only ones where almost all of the superposed constructions have been documented (Montoya 1998: fig. 3).

The Looter's Tunnel

Beginning in the second half of the nineteenth century, many large-scale clandestine excavations were carried out on the western side of the *huaca* in order to discover precious metals included in the burials in the platform. In several locations, looters had penetrated horizontally into the monument, creating a series of tunnels of different size and extent.[5] These tunnels provided a critical opportunity to analyze the earliest phases of the architectural sequence of the monument. A major looter's tunnel into the western

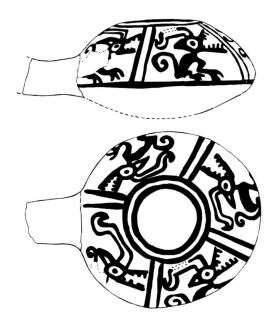

14. *Canchero* (dipper) found on Floor 3, Unit 6, Structure D, at Huaca de la Luna Diameter (body): 15.7 cm; height: 8.5 cm; diameter (rim): 5.4 cm
Museo de Arqueología, Antropología e Historia, Universidad Nacional de Trujillo Drawing by Carlos Ayesta

15. Profile of Platform I
(east–west) of Huaca de la
Luna
Drawing by Carlos Ayesta

16. Profile of Platform I
(north–south) of Huaca de la
Luna
Drawing by Carlos Ayesta

17. North profile of looter's
trench, Unit 11, Platform I,
Huaca de la Luna
After Montoya 1998: fig. 3

façade of the *huaca* (fig. 15) provided access to the earliest construction phase encased deep within Platform I.

The entrance to this tunnel is located near the center the western façade of the *huaca*, and extends nearly 40 m underneath the monument. At its eastern end are two branches, one heading north for 10 m and the second heading south for 20 m. We were able to observe the existence of plastered walls and floors corresponding to the earliest construction stages of the *huaca*, as well as data on the transformations of the western façade over time.

As we made our way inside the tunnel, a valuable piece of evidence came from the discovery of a succession of three outer walls corresponding to the western façade of earlier structures. These three plastered facings, painted with yellow pigment, were found at varying distances from the tunnel's entrance (at 15.6 m, 25.4 m and 35.2 m respectively). In other words, each time the platform was enlarged during these three construction phases, approximately ten meters of adobe bricks were added to the girth of the platform on this side, extending the western façade outward toward the urban plain. In keeping with the evidence encountered above, there appears to have been considerable architectural continuity in the last three phases, with no major changes in layout or ornamentation of the western façade.

The Sequence of Architectural Superpositions

The archaeological evidence demonstrates that Platform I was in use for a long period of time, with periodic reconfigurations. Here we may step back and consider the transformation of the monument from its earliest history (Structure F) to its latest incarnation (Structure A)[6]. The five major construction phases will be discussed in chronological order, from oldest to most recent (figs. 15, 16).

Combining the evidence from the looter's tunnel and the excavations on the summit of the platform, some observations can be made regarding the nature of the sequential constructions. The *huaca* increased in size with each phase, both in its horizontal and vertical dimensions. In addition to the ten meters added on to the sides of the construction, up

Table 1: Heights of Upper and Lower Levels of Platform I in relation to the plain.

	Upper Level	Lower Level
Structure A	32.20 m	28.35 m
Structure B	29.80 m	23.25 m
Structure C	27.60 m	23.00 m
Structure D	24.20 m	19.70 m
Structure E	?	16.75 m
Structure F	?	10.70 m

to several meters of adobe bricks were placed on top of previous structures, as part of the new construction process. Table 1 shows the relative heights of the Upper and Lower levels of Platform I during its different construction phases. The heights are measured from the residential plain, which is in turn about 70 m above sea level.

Structure F

Relatively little is known about Structure F, the earliest construction known at Platform I. As indicated above, the only evidence available for this structure comes from the looter's tunnel on the western façade of the *huaca*. This evidence has allowed us to define the western extent of the Structure F, as well as some floors. The western façade of Structure F was located some 35 m inside the tunnel, indicating that this structure was substantially smaller than the one visible today, less than a third of its present size. The height of the platform was only 10.7 m above the residential plain. We have no information yet on the interior layout or decoration of Structure F.

Structure E

Evidence for Structure E, representing the second phase of the construction sequence, comes from the looter's tunnel and the deepest levels of Unit 11 (Montoya 1998). The western façade of this structure was identified some 25 m from the entrance of the looter's tunnel, indicating that this building

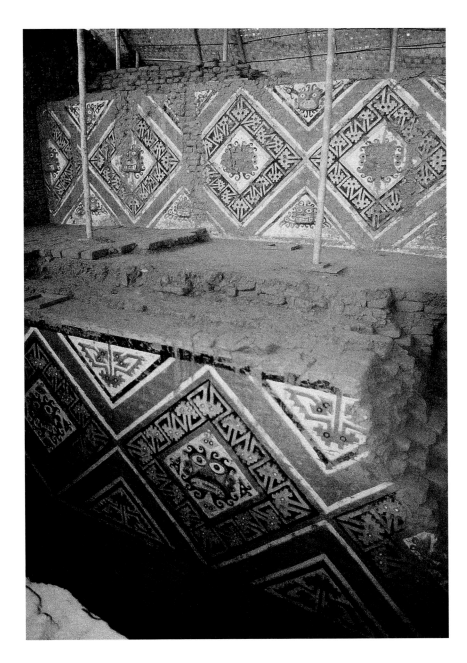

18. View of the Great Patio, Structures D (lower section) and B–C (upper section), Huaca de la Luna

Structure D

The façade of Structure D was found 15.6 m from the entrance of the looter's tunnel, again indicating an increase of about 10 m from the previous building. Evidence from Profile 1C suggests that at this time a ramp between the Upper and Lower levels of the platform may have been constructed (at 24.2 m and 19.7 m in relation to the residential plain). The first evidence of painted reliefs in the Great Patio comes from Structure D (fig. 17 and fig. 18, lower section). In keeping with the later versions of Great Patio reliefs, these show an anthropomorphic face in a rhombus, with zoomorphic motifs, either fish heads or stylized serpents, in the vertices of the rhombus. This central diamond-shaped form is then encased in a border of interlocking stylized zoomorphic forms, perhaps another version of the same creature seen in the vertices of the interior rhombus. This stylized creature is also repeated in the triangular spaces between the rhomboids.

The discovery of the *canchero* or dipper in Unit 6 (fig. 14), mentioned above, has enabled us to suggest a relative date for this construction.[7] On the basis of this find, we tentatively propose that Structure D was in use during Moche Phase III.

Structure C

As with the earlier constructions, Structure C increased the size of the monument (the Upper and Lower Levels were respectively at 27.6 m and 23 m in relation to the residential plain). At this point, a standard orientation and incline of the access ramp between the Upper and Lower levels was established; this was maintained until the platform was abandoned. An anthropomorphic figure with zoomorphic appendages (fig. 9) was found on the north façade of this building, near the ramp.

The Great Patio was rebuilt following a similar plan and its walls were adorned with painted reliefs (fig. 17 and fig. 18, upper section). Minor differences are apparent between the two stages (Paredes 1993; Uceda and Canziani 1998: 155). The basic format is retained, with the exception of the inclusion of what appears to be the same central face in the triangular spaces as well as in the rhomboids. The anthropomorphic face here

was 10 m larger than the previous one. Structure E was approximately six meters higher than the earlier structure, at 16.75 m above the residential plain.

Associated with Structure E is a feature not seen in the later architectural stages, namely a type of altar whose retaining walls were painted with parallel bands of red, black, and yellow (fig. 17; Montoya 1998: 20). The data available suggest that the walls of Structure E were not decorated but simply plastered and painted white.

includes zoomorphic appendages. The small rooms with pitched roofs and ornamented walls in the southeastern (figs. 12, 13) and southwestern corner of Platform I were both associated to Structure C (cf. Navarro, Paredes, and Rodas 1993: 54–59).

Structure B

In many respects, Structure B represents a minor renovation of Structure C rather than a full-scale rebuilding of the platform. The western façade of Structure C was retained, and there is little evidence that the overall size of the monument was dramatically increased in this phase.

The murals found by members of the Chan Chan–Moche Valley Project (fig. 5) can be associated with this construction phase. They are located in a room in the northeastern section of the Upper Level, where the floor is 29.8 m above the residential plain. On the Lower Level, excavations in the Great Patio showed that the floor of this structure (23.25 m above the residential plain), in contrast to earlier constructions, had been laid immediately above the previous one, without any evidence of fill. Moreover, this new floor was associated with the wall with painted reliefs of Structure C. There is evidence of only minor remodelling and repainting of the figures (Paredes 1993).

Structure A

Structure A, the last construction phase, increased the size of the monument for the final time. A layer of adobe bricks, approximately five meters thick, covered Structure B, increasing the height of the *huaca*. A new western façade was constructed, with a series of terraces (four of which are reasonably well preserved). Three of these had evidence of decoration, probably a continuation of the same lines of imagery seen on the north façade. On the northern façade, the ramp with a serpent in relief, and the reliefs of the warriors with shields and war clubs (fig. 8) was created.

The general layout of both the Upper and Lower levels established in the earlier phases was largely maintained in Structure A. The Upper Level, now reaching a height of 32.2 m above the residential plain, was badly damaged by colonial and modern-era looting. Of the few remains of this construction, we have evidence of the access ramp and a corridor. The Lower Level (28.35 m above the residential plain) was also largely destroyed, but remains of a floor were found, together with part of the decorated wall of the Great Patio. From what has been preserved, it is clear the general format of the earlier reliefs was continued. A section with the frontal face in the triangular space has survived, along with a section of the stylized zoomorphic border.

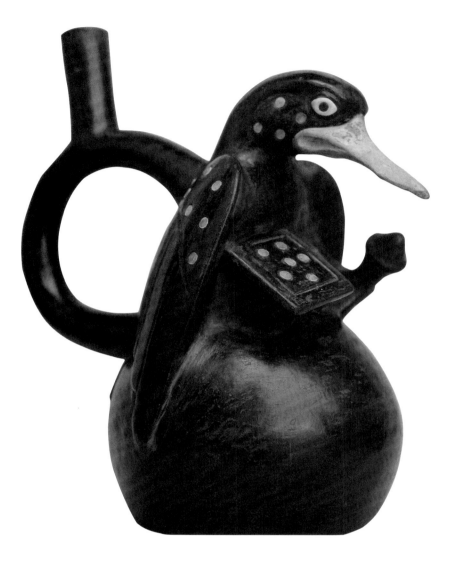

19. Ceramic duck-effigy bottle from Huaca de la Luna, Tomb II, Structure A
Museo de Arqueología, Antropología e Historia, Universidad Nacional de Trujillo Proyecto Arqueológico Huaca de la Luna

Structure	Correlation between ceramic phases and structures	Diagnostic features
Structure A	Moche V	
	Moche IV	**Tomb II - Moche IV** **419-610 A.D. (Calibrated)**
Structure B		
Structure C		
Structure D		
Structure E	Moche III	*Canchero* (dipper) Moche III
Structure F	Moche I/II ?	

20. Correlation of structures with C-14 dates, ceramics

In the fill underneath the floor of Structure A, a number of burial chambers were discovered. These graves have been discussed elsewhere (Tello 1997; Uceda et al. 1994). They have provided a means for assessing the relative date of Structure A. Grave goods found in Tomb II include a blackware stirrup-spout vessel representing a Muscovy duck holding a war club (fig. 19). The shape and decoration of this vessel are both typical of the Moche IV period in Larco Hoyle's chronology (1948). Ceramic vessels found in the other graves also pertained to the Moche IV phase, indicating that the last construction event at Platform I dates to this time.

We were also able to obtain absolute dates for Structure A (fig. 20). Samples of organic material from the reed coffin of Tomb II, and from a wooden post associated with the floor of the Great Patio were submitted to the Gif-sur-Yvette laboratory in France. The reed sample from Tomb II (Gif-9530) gave an age of 1,540 ± 50 years; the calibrated date, after Pazdur and Michczyńska (1989), corresponds to between A.D. 419 and 610, with a 95% confidence interval (2 sigmas). The sample from the wooden post (Gif-9529) produced a greater

age of 1,640 ± 40 years; the calibrated date fell between A.D. 271 and 522, with a 95% confidence interval (2 sigmas).

These dates are in general agreement with others from Moche IV contexts at the Moche site (Chapdelaine, this volume, and 1998). The calibrated date of A.D. 419 to 610 from the reed coffin is rather late but acceptable. As for the date obtained from the post, A.D. 271 to 522 (calibrated), one possible explanation for its relative antiquity could be that this post had been taken from a previous structure and reused. If that was the case, this second date would have to be rejected. Therefore, it is proposed that Structure A was built during the Moche IV phase, in the sixth century A.D.

To summarize, Platform I at Huaca de la Luna contains evidence of five major construction phases (Structures E, F, D, C, and A), with a less extensive renovation between Structures C and B. Over the years, it appears that Platform I generally maintained a consistent architectural layout with two main areas: an Upper and a Lower level, connected via a small ramp. The Upper Level was badly damaged by looting, so very little is known regarding its evolution over time, apart from the mural paintings from the northeast room discussed above. As for the Lower Level, its architectural history can be traced over the five main construction phases. The Great Patio in particular maintained its essential character through the various phases. From Structure E to Structure A, this space was continuously enlarged, but the relief ornament varied little from phase to phase. Structures C, B, and A all retained the central supernatural visage first established in Structure D. This continuity in iconographic content and stylistic treatment continued over the course of the two centuries or more that separated the construction of Structure D from Structure A. The presence of this personage, perhaps the Decapitator known from Moche III and IV ceramics (and occasionally found in Phase II), reinforces the association of these structures with Moche III and IV.

Renovation of Power at Huaca de la Luna

Study of the architecture of Platform I at Huaca de la Luna has shown that the monument consists of a series of superposed

structures, largely following the same essential layout over time. Access to the Upper Level remained relatively restricted, and the Great Patio was continually rebuilt as a large, open space decorated with impressive painted reliefs. In this section I consider possible motivations for the renovation of the temple at different moments in its history.

As indicated above, each time Platform I at Huaca de la Luna was rebuilt, it involved the burial of earlier construction under a thick layer of adobe bricks. In a previous work (Uceda and Canziani 1993), it was postulated that torrential rain during ENSO events could have triggered successive reconstruction of this monument. Layers of sediment containing remnants of paint were found in relation to different structures, indicating that the rain had washed the walls of this temple at various points in history. At these times, the disfigured murals on the outside façades and the painted reliefs of the Great Patio needed to be redone. New exterior facings were built and a thick layer of adobe bricks was laid on top of existing structures, maintaining the existing layout. In other words, an event like El Niño could have been the occasion for part of the process that resulted in the "regeneration" of Moche society.

Nevertheless, recent excavations on Platform I, together with the study of earlier finds, have lead us to consider alternative explanations or perhaps complimentary factors to the above interpretation of the renovations. We now feel that the rebuildings were linked to veneration of ancestors, and that the architectural renovations served to reinforce ancestral and priestly power at Huaca de la Luna. Following this hypothesis, each new structure was not a mere refurbishing event but a "reedition" of the whole structure.

It is our view that in Moche society power came from the ancestors, and that the latter materialized themselves through their representatives, the priests. When a priest died, his replacement would have undertaken the construction of a new structure, where the deceased priest was then buried. The deceased priest would become a powerful ancestor, the monument would be energized by his presence and the new priest would gain respect as the new living representative of the ancestors. This new working hypothesis may be

linked to the phenomenon of ritual burial of architecture known for some time in various parts of the Andes. This tradition, extending from the Archaic period to the Late Horizon, is characterized by the successive architectural renovations of ceremonial structures. This practice has been noted at Kotosh (Izumi and Terada 1972), Piruru (Bonnier, Zegarra, and Tello 1985), La Galgada (Grieder et al. 1988), as well at Formative period sites in Lambayeque (Shimada, Elera, and Shimada 1982) and Ica (Canziani 1992).

Support for this hypothesis of the regeneration of the temple at Huaca de la Luna was found during excavations on Platform I. Analysis of Tombs I and II showed that both individuals buried were priests (Bourget 1994, 1995; Uceda 1997a). The placement of their bodies within the temple may be seen as an action closely linked to the renovation of ancestors and, by extension, the renovation of power at Moche. In Andean cosmogony, the ceremonial burial of the dead forms part of the process of renovation, germination, and creation. This concept, widespread in the Andean region from the first agricultural societies, is a clear allusion to the germination of seeds. Thus, the burial of the dead should bring germination in the form of the creation of ancestors.

Both burial acts, human as well as architectural, fulfill a basic function of social reproduction, and served to legitimate the power of the ruling elite. Nevertheless, questions remain. Did the renovation of power have a cyclical character as it did in various ancient Mesoamerican cultures? Were the renovations concerned principally with a single paramount priest, or did they involve a group of priests? Although our current data are insufficient to answer these questions, future research may illuminate these issues.

Ceremonies and Rituals

Ideology and power in Moche society were strongly linked to the performance of ceremonies and rituals. Careful study of Moche religious practice should thus help us understand how the Moche articulated and constructed power. Nearly a decade of excavations at Huaca de la Luna has provided a considerable amount of data clearly indicating that this architectural complex was mainly

used for the performance of religious activities (Uceda 1997b; Uceda and Paredes 1994).

Excavations on Platform I have showed that the construction process was closely linked to the renovation of power through the burial of priests in Tombs I and II. Other burials have been identified within the fill covering the last structure, again indicating the close link that existed between the construction of the temple and the renovation of priestly power. It is important to emphasize that the priest's graves were not found in a distant cemetery but underneath the floor of the Great Patio. This large, open court was undoubtedly used as a ceremonial space for the performance of sacred rituals. Other spaces of Platform I were also devoted to ritual; rooms of different sizes were probably used as restricted areas for the priests and their attendants. Outside Platform I, other ceremonial precincts have also been identified. Currently under study, Plaza 2 and Plaza 3B bear evidence of ritual practice (Baylón et al. 1997; Montoya 1997).

Steve Bourget's excavations of Plaza 3A and Platform II have documented the existence of a complex sacrificial site. According to Bourget (this volume, and 1998a, 1998b), rituals carried out in this space were overseen by a specific group of priests, a number of whom were eventually buried within Platform II. The skeletons that were found in Plaza 3A were all adult males who had suffered fractures prior to their death (Verano, this volume). Victims had been put to death following a precise ritual sequence. Some bodies had been dismembered.[8] Large, unbaked clay figures of nude prisoners, perhaps depicting the sacrificed individuals, were also found in the plaza. Two similar sculptures were also found in Plaza 3B to the west, indicating that this area was probably functionally connected to the sacrificial site. Recent excavations in Plaza 3C revealed the existence of another space where sacrificial practices were carried out. Although study of Plaza 3C has not been completed, some differences from Plaza 3A are evident: the bodies in this plaza were not dismembered, although some were decapitated and then defleshed.

The general layout of Platform I at Huaca de la Luna, with its long access ramp leading to the Great Patio, would have offered an ideal space for the performance of rituals preceding the sacrifice of prisoners in Plazas 3A and 3C (see also Uceda and Paredes 1994). We hypothesize that the different spaces identified at Huaca de la Luna were used for the performance of different types of rituals, some of which may have been related to the Sacrifice Ceremony, known from Moche iconography (Introduction to this volume, fig. 5; Alva and Donnan 1993: 127–141). This complex scene depicts the presentation of a goblet, presumably containing the blood of sacrificed prisoners, to a central individual. As a number of scholars have shown, this ceremony has clear correlates in the archaeological record. Graves of priests bearing the regalia of personages in the Sacrifice Ceremony have been found at Sipán (Alva, this volume), San José de Moro (Castillo, this volume; Donnan and Castillo 1994) and Huaca de la Cruz (Arsenault 1994; Strong and Evans 1952). Undoubtedly historic individuals played the roles of specific priests seen in the depictions of this ceremony and were eventually buried with the accouterments of their office.

Until recently, however, there has been little speculation about where the ceremonies actually took place. We suggest that rituals bearing a strong resemblance to the Sacrifice Ceremony took place at Huaca de la Luna, and perhaps at other sites. Not only do we have the archaeological evidence of the culmination of the scene, the final dispatch of the prisoners in the plazas, we may also have indirect references to the earlier sequences of the ceremony depicted on the architecture itself. Representations of a parade of bound prisoners are found on the façade of Huaca Cao Viejo of the El Brujo complex (Gálvez and Briceño, this volume; Quilter, this volume), a structure that is in many ways similar to Huaca de la Luna, particularly in the pattern of architectural ornament. The north façade of Platform I at Huaca de la Luna is very damaged, but we hypothesize that similar prisoners were depicted on the façade here. Thus, the architectural ornament of the façade may refer to the very rituals that took place on and within the monumental architecture.

Undoubtedly other types of rituals also took place at Huaca de la Luna. Evidence for other practices, however, is still slim. Coca seeds were found on a bench in front of a decorated wall in Plaza 2, suggesting some sort of propitiatory act. As yet, however, we

do not have the remarkable level of detail of specific rituals that we have for the Sacrifice Ceremony.

Huaca de la Luna as Ritual Center

The Moche site bears some of the largest constructions of the prehispanic New World. The Huaca de la Luna complex was the major ritual center at the site, built and used over the course of centuries. It served as a locus for dramatic sacrificial ceremonies, interment of key ritual performers, and other activities. Platform I, the largest construction of the complex, contains evidence of five major construction phases, the last dating from the sixth century A.D.

Huaca de la Luna has provided us with an unprecedented view into Moche ritual. Excavations at the site have confirmed that certain practices known from the narrative scenes in Moche iconography indeed took place. The study of this monument, however, has expanded our understanding of Moche ritual practice, contributing data on aspects of Moche life that are not addressed in the fine-line paintings on Moche ceramics. Until recently, there has been little study of specific Moche sites or monuments over time; we had developed a fairly good understanding of chronological change in Moche ceramics, but knew comparatively little about change over time in architecture. The evidence from Huaca de la Luna on the sequential construction of the monument, and on the inclusion of burials linked to these constructions, has allowed us a new perspective into the meaning of Moche architecture and ritual.

NOTES

This project would not have been possible without the funding of Unión de Cervecerías Peruanas Backus & Johnston. In particular we would like to thank Ing. Elías Bentín, President of the Board, Don Carlos Bentín, General Director, and Gilberto Domínguez, Regional Director. We are also grateful for the support of the municipality of Trujillo, especially Ing. José Murgia, mayor of Trujillo, and the regional government of the province of La Libertad, including Ing. Huber Vergara, and the corporation of public works of this province. The Universidad Nacional de Trujillo managed and administered the funds for the project. Our thanks to Dr. Guillermo Malca, past Rector, and to Mg. Eduardo Achútegui, Dean of the Faculty of Social Sciences, of this institution.

My deepest and most sincere thanks are to the personnel of the Project, especially Ricardo Morales, Co-Director, archaeologists María Montoya, Ricardo Tello, José Armas, Moisés Tufinio, and artist, Carlos Ayesta.

1. The Quechua term *huaca* has a variety of meanings, including a sacred place, a temple, an ancestor, or a mummy. *Huaca* is most often used to refer to sites traditionally held to be sacred in nature. The names Huaca del Sol and Huaca de la Luna are not ancient, appearing only in travellers' accounts at the end of the nineteenth century.

2. Conservation and tourism issues have been discussed elsewhere (Uceda and Mujica 1997, 1998).

3. It is our view that these reliefs are entirely Moche in style as well as iconographic content. Previously scholars maintained that a checkerboard composition suggested an influence from the Wari culture of the southern highlands (Bonavia 1985: 85–97). As checkerboard compositions have been discovered painted on the sides of a Moche I tomb at La Mina in the Jequetepeque Valley (Narváez 1994), it appears that such ornament was found throughout the Andes and is not specifically indicative of Wari culture.

4. This space is also referred to as the *recinto sacerdotal* (priests' enclosure) (Campana and Morales 1997).

5. In 1986–1987, the Instituto Nacional de Cultura, La Libertad, cleaned out and sealed these tunnels. Results of these interventions have not yet been published.

6. Structures A, B, C, and D correspond respectively to the First, Second, Third, and Fourth Stages in earlier publications (Uceda and Canziani 1993; Uceda et al. 1994).

7. This good-quality ceramic vessel is missing part of its base and handle. The body, slightly flattened and streamlined, measures 15.7 cm in diameter and 8.5 cm in height, with a diameter of 5.4 cm at the mouth. Finished in a cream slip, the upper part of the vessel is decorated with four panels containing a depiction of a zoomorphic form known as the Moon Animal, painted in red slip. Donnan (1973) studied

approximately fifty examples of this type of vessel, although unfortunately only four came from scientific excavations. He identified two distinct body forms. One type is characterized by continuously curving sides without a distinct shoulder angle. The others have a sharp carination at their midpoint. Donnan also identified two types of handles: one is conical and tapers toward the tip; the second type is decorated with sculpted heads. Nevertheless, Donnan could not relate body form to handles, or the *canchero* form to a Moche stylistic phase. In the Virú Valley, William Duncan Strong and Clifford Evans documented four *cancheros*, three of which were from the tomb of the Warrior Priest (1952: Plate XXVII E and XXVIII J and L), one of the most elaborate Moche tombs known outside of Sipán. These three examples all correspond to the Late Moche period (Phase IV of the Larco sequence), and pertained to the Huancaco Red, White, Black (Strong and Evans 1952: 162–166), Red and White, and Gloria Polished Plain styles. The fourth *canchero* identified by Strong and Evans was a Carmelo Negative vessel from Burial 1 at the Gallinazo site (1952: 73 and Plate VII G). It is interesting to note that of these four vessels, two have carinated bodies, while two have continuously curving sides. Seven examples of *cancheros* were published by Donnan and Mackey, all pertaining to Phase IV and all having streamlined bodies (Donnan and Mackey 1978: 108, 126, 135, 156, 166 [M-IV 3, 27; M-IV 5, 26; M-IV 7, 6; M-IV 11, 1; and M-IV 13, 4]). No diagnostic elements suggest an affiliation with ceramic phases in Larco's sequence (1948). Nevertheless, some elements of the *canchero* found in our excavations could be relevant for chronological purposes: (1) the size of the body is slightly smaller than all the forms described for Moche IV *cancheros*; and (2) the designs are made with a thick brush and the colors are medium red. In size they would be similar to the Salinar and Gallinazo *cancheros*, while the color and use of thick brush—after Larco (1948)—would correspond to Moche III. A third element (3) is the presence of the Moon Animal. It has always been assumed that this representation comes from the Ancash highlands (Recuay style) and that it appears first in Moche Phase III (Luis Jaime Castillo, personal communication, 1994).

8. The rituals carried out in Plaza 3A would correspond to what Hocquenghem (1987) defined as the "punished" skeletons.

BIBLIOGRAPHY

Alva, Walter
1994 *Sipán*. Colección Cultura y Artes del Perú. Lima.

Alva, Walter, and Christopher B. Donnan
1993 *Royal Tombs of Sipán* [exh. cat., Fowler Museum of Cultural History, University of California]. Los Angeles.

Arsenault, Daniel
1994 Symbolisme, rapports sociaux et pouvoir dans les contextes sacrificiels de la société mochica (Pérou précolombien). Une étude archéologique et iconographique. Ph.D. dissertation, Département d'anthropologie, Université de Montréal.

Baylón, J., L. Burgos, R. Díaz, C. Pardo, and V. Rodríguez
1997 Excavaciones en la Plaza 2 de la Huaca de la Luna. In *Investigaciones en la Huaca de la Luna 1995*, ed. Santiago Uceda, Elías Mujica, and Ricardo Morales, 39–49. Facultad de Ciencias Sociales, Universidad Nacional de La Libertad, Trujillo.

Bennett, Wendell C.
1939 *Archaeology of the North Coast of Peru: An Account of Exploration and Excavation in Viru and Lambayeque Valleys*. Anthropological Papers of the American Museum of Natural History 37 (1). New York.

Bonavia, Duccio
1985 *Mural Painting in Ancient Peru*, trans. Patricia J. Lyon. Bloomington, Ind.

Bonnier, Elizabeth, Julio Zegarra, and Juan Carlos Tello
1985 Un ejemplo de crono-estratigrafía en un sitio con superposición arquitectónica. Piruru, Unidad I/II. *Bulletin de l'Institut Français d'Etudes Andines* 14 (3–4): 80–101.

Bourget, Steve
1994 Bestiaire sacré et flore magique: Écologie rituelle de l'iconographie de la culture Mochica, côte nord du Pérou. Ph.D. dissertation, Département d'anthropologie, Université de Montréal.

1995 Los Sacerdotes a la sombra del Cerro Blanco y del arco bicéfalo. *Revista del Museo de Arqueología, Antropología e Historia* 5 [1994]: 81–125. [Trujillo].

1998a Pratiques sacrificielles et funéraires au site Moche de la Huaca de la Luna, côte nord du Pérou. *Bulletin de l'Institut Français d'Etudes Andines* 27 (1): 41–74.

1998b Excavaciones en la Plaza 3A y en la Plataforma II de la Huaca de la Luna durante 1996. In *Investigaciones en la Huaca de la Luna 1996*, ed. Santiago Uceda, Elías Mujica, and Ricardo Morales,

43–64. Facultad de Ciencias Sociales, Universidad Nacional de La Libertad, Trujillo.

Campana, Cristóbal, and Ricardo Morales
1997 *Historia de una deidad Mochica.* Lima.

Canziani, José A.
1992 Arquitectura y urbanismo del período Paracas en el valle de Chincha. *Gaceta Arqueológica Andina* 6 (22): 87–117.

Chapdelaine, Claude
1998 Excavaciones en la zona urbana de Moche durante 1996. In *Investigaciones en la Huaca de la Luna 1996*, ed. Santiago Uceda, Elías Mujica, and Ricardo Morales, 85–115. Facultad de Ciencias Sociales, Universidad Nacional de La Libertad, Trujillo.

Donnan, Christopher B.
1973 *Moche Occupation of the Santa Valley, Peru.* University of California Publications in Anthropology 8. Berkeley and Los Angeles.

Donnan, Christopher B., and Luis Jaime Castillo
1994 Excavaciones de tumbas de sacerdotisas Moche en San José de Moro, Jequetepeque. In *Moche: Propuestas y perspectivas* [Actas del primer coloquio sobre la cultura Moche, Trujillo, 12 al 16 de abril de 1993], ed. Santiago Uceda and Elías Mujica, 415–424. Travaux de l'Institut Français d'Etudes Andines 79. Trujillo and Lima.

Donnan, Christopher B., and Carol J. Mackey
1978 *Ancient Burial Patterns of the Moche Valley, Peru.* Austin, Tex.

Grieder, Terrence, Alberto Bueno Mendoza, C. Earl Smith, and Robert M. Molina
1988 *La Galgada, Peru: A Preceramic Culture.* Austin, Tex.

Hocquenghem, Anne-Marie
1987 *Iconografía Mochica.* Lima.

Izumi, Seiichi, and Kazuo Terada
1972 (Editors) *Andes 4: Excavations at Kotosh, Peru: 1963 and 1966.* Tokyo.

Kaulicke, Peter
1998 (Editor) *Max Uhle y el Perú antiguo.* Lima.

Kroeber, Alfred
1925 *The Uhle Pottery Collections from Moche.* University of California Publications in American Archaeology and Ethnology 21(5): 191–234, plates 50–69. Berkeley.

1944 *Peruvian Archaeology in 1942.* Viking Fund Publications in Anthropology 4. New York.

Larco Hoyle, Rafael
1948 *Cronología arqueológica del norte del Perú* [cat., Museo de Arqueología Rafael Larco Herrera]. Buenos Aires.

Lumbreras, Luis G.
1979 *El arte y la vida Vicús.* Lima

Mackey, Carol J., and Charles M. Hastings
1982 Moche Murals from the Huaca de la Luna. In *Pre-Columbian Art History: Selected Readings*, ed. Alana Cordy-Collins, 293–312. Palo Alto, CA.

Montoya, María
1997 Excavaciones en la Plaza 3B. In *Investigaciones en la Huaca de la Luna 1995*, ed. Santiago Uceda, Elías Mujica, and Ricardo Morales, 61–66. Facultad de Ciencias Sociales, Universidad Nacional de La Libertad, Trujillo.

1998 Excavaciones en la Unidad 11, Plataforma 1 de la Huaca de la Luna. In *Investigaciones en la Huaca de la Luna 1996*, ed. Santiago Uceda, Elías Mujica, and Ricardo Morales, 19–28. Facultad de Ciencias Sociales, Universidad Nacional de La Libertad, Trujillo.

Moseley, Michael E.
1992 *The Incas and Their Ancestors: The Archaeology of Peru.* London and New York.

Moseley, Michael E., and Kent C. Day
1982 (Editors) *Chan Chan: Andean Desert City.* School of American Research Advanced Seminar Series. Albuquerque, N.M.

Narváez, Alfredo
1994 La Mina: Una tumba Moche I en el valle de Jequetepeque. In *Moche: Propuestas y perspectivas* [Actas del primer coloquio sobre la cultura Moche, Trujillo, 12 al 16 de abril de 1993], ed. Santiago Uceda and Elías Mujica, 59–81. Travaux de l'Institut Français d'Etudes Andines 79. Trujillo and Lima.

Navarro, Jeisen, Hildebrando Paredes, and William Rodas
1993 Estudio de la arquitectura de la Plataforma 1 y de la Huaca de la Luna: Una aproximación a su diseño arquitectónico. Informe de prácticas pre-profesionales. Universidad Nacional de Trujillo.

Paredes, Arturo
1993 Los relieves polícromos. In *Proyecto de investigación y conservación Huaca de la Luna. Informe temporada 1993* 1(Texts): 89–98. Trujillo.

Pazdur, Mieczysław F., and Danuta J. Michczyńska
1989 Improvement of the Procedure for Probabilistic Calibration of Radiocarbon Dates. *Radiocarbon* 31 (3): 824–832.

Shimada, Izumi, Carlos Elera, and Melody Shimada
1982 Excavaciones efectuadas en el centro ceremonial de Huaca Lucía-Chólope del Horizonte Temprano, Batán Grande, costa norte del Perú: 1979–1981. A*rqueológicas* 19: 109–210. [Lima].

Strong, William Duncan, and Clifford Evans

1952 *Cultural Stratigraphy in the Virú Valley, Northern Peru: The Formative and Florescent Epochs.* Columbia Studies in Archeology and Ethnology 4. New York.

Tello, Ricardo

1997 Excavaciones en la unidad 12 de la Plataforma I de la Huaca de la Luna. In *Investigaciones en la Huaca de la Luna 1995*, ed. Santiago Uceda, Elías Mujica, and Ricardo Morales, 29–37. Facultad de Ciencias Sociales, Universidad Nacional de La Libertad, Trujillo.

Topic, Theresa Lange

1977 Excavations at Moche. Ph.D. dissertation, Department of Anthropology, Harvard University, Cambridge, Mass.

1982 The Early Intermediate Period and Its Legacy. In *Chan Chan: Andean Desert City*, ed. Michael E. Moseley and Kent C. Day, 255–284. School of American Research Advanced Seminar Series. Albuquerque, N.M.

Uceda, Santiago

1997a El poder y la muerte en la sociedad Moche. In *Investigaciones en la Huaca de la Luna 1995*, ed. Santiago Uceda, Elías Mujica, and Ricardo Morales, 177–188. Facultad de Ciencias Sociales, Universidad Nacional de La Libertad, Trujillo.

1997b Huaca de la Luna: La arquitectura y los espacios ceremoniales. *Arkinka* 2 (20): 104–112. [Lima].

Uceda, Santiago, and José Canziani

1993 Evidencias de grandes precipitaciones en diversas etapas constructivas de la Huaca de la Luna, costa norte del Perú. In *Registros del fenómeno El Niño y de eventos Enso en América del Sur*, ed. José Macharé and Luc Ortlieb, 313–343. Bulletin de l'Institut Français d'Etudes Andines 22 (1).

1998 Análisis de la secuencia arquitectónica y nuevas perspectivas de investigación en la Huaca de la Luna. In *Investigaciones en la Huaca de la Luna 1996*, ed. Santiago Uceda, Elías Mujica, and Ricardo Morales, 139–158. Facultad de Ciencias Sociales, Universidad Nacional de La Libertad, Trujillo.

Uceda, Santiago, Ricardo Morales, José Canziani, and María Montoya

1994 Investigaciones sobre la arquitectura y relieves polícromos en la Huaca de la Luna, valle de Moche. In *Moche: Propuestas y perspectivas* [Actas del primer coloquio sobre la cultura Moche, Trujillo, 12 al 16 de abril de 1993], ed. Santiago Uceda and Elías Mujica, 251–303. Travaux de l'Institut Français d'Etudes Andines 79. Trujillo and Lima.

Uceda, Santiago, and Elías Mujica

1997 Investigaciones en la Huaca de la Luna: A manera de introducción. In *Investigaciones en la Huaca de la Luna 1995*, ed. Santiago Uceda, Elías Mujica, and Ricardo Morales, 9–15. Facultad de Ciencias Sociales, Universidad Nacional de La Libertad, Trujillo.

1998 Nuevas evidencias para viejos problemas: A manera de introducción. In *Investigaciones en Huaca de la Luna 1996*, ed. Santiago Uceda, Elías Mujica, and Ricardo Morales, 9–16. Facultad de Ciencias Sociales, Universidad Nacional de La Libertad, Trujillo.

Uceda, Santiago, and Arturo Paredes

1994 Arquitectura y función de la Huaca de la Luna. *Masa: Revista cultural del Indes* 7: 42–46. [Trujillo].

Uhle, Max

1913 Die Ruinen von Moche. *Journal de la Société des Américanistes de Paris*, n.s. 10 (1): 95–117.

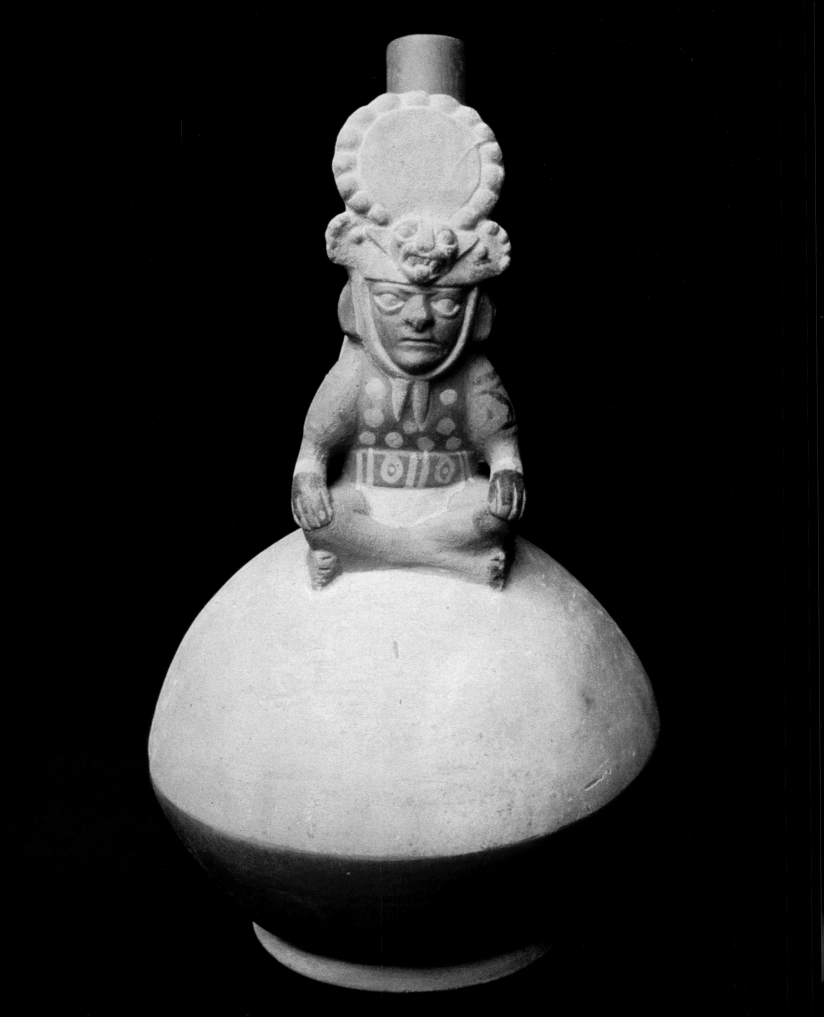

CLAUDE CHAPDELAINE
Université de Montréal

The Growing Power of a Moche Urban Class

Recent archaeological research has yielded new data from domestic contexts at the Moche site, an archaeological complex in the lower Moche Valley (fig. 1). This site, dominated by the monumental platforms of Huaca del Sol and Huaca de la Luna, has long been admired for its public architecture, but it is only recently that the extensive remains of a true city were uncovered below the layers of hardened clay of past floods and the shifting sand dunes of the arid plain. Beginning in the fourth century A.D., the area in between the two *huacas* was developed into a well-planned city with a complex of streets, plazas, residences, workshops, and water canals (fig. 2). Before its decline in the eighth century A.D., the Moche site was probably the most important urban center on the north coast of Peru.

By the Moche IV period, the population of Moche was increasing and becoming more stratified. What was the nature of this urban class or classes? What was the relationship between the members of the urban classes and the ruling elite associated with the *huacas*? Was there social variability present within each class? If an individual was born into a specific social class, was there still room for movement, politically and economically, within the limits of that particular class? Would it have been possible for an individual to achieve as well as inherit status? This paper is an endeavor to address these questions on the basis of new archaeological

data from a project I have been directing in the urban zone of Moche.

The project, known as ZUM (Zona Urbana Moche, or the urban zone of Moche), began in 1995, with four field seasons to date. The goals of the project have been to understand the growth and development of the urban population of Moche, and their political, economic and social role within the larger polity. The site of Moche is considered the capital of the Moche state; the extent and complexity of this state, however, is still the subject of considerable debate (see for example Bawden 1996; Castillo and Donnan 1994; Haas, Pozorski, and Pozorski 1987; Schaedel 1985, 1987; Shimada 1994a, 1994b). Our excavations were based in the south-central area of the site of Moche, between Huaca del Sol and Huaca de la Luna. Our research design favored horizontal excavations, in order to study contemporaneous rooms and compounds.

This central zone was strategically located between the two *huacas*, the presumed seats of governance for Moche. Contrary to the earlier assumption that this area was sparsely populated, we uncovered such urban features as streets and plazas, both of which were used to organize a network of household compounds or complexes.[1] There is clear evidence of urban planning: the compounds are not the isolated constructions of individual families or other kin-based households. The construction of these large and complex

Moche stirrup-spout bottle
from tomb intruding into
Plaza 1
Museo de Arqueología,
Antropología e Historia,
Universidad Nacional de Trujillo
Photograph by Steve Bourget

69

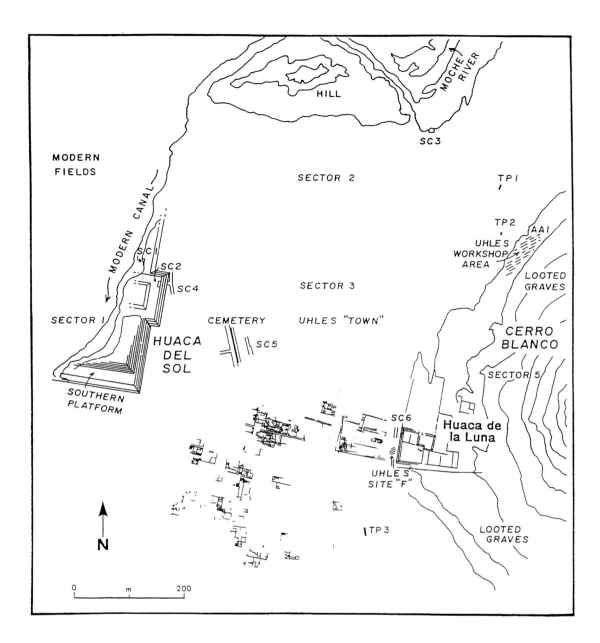

1. General plan of the Moche site
Modified from Shimada 1994a: 17, fig. 2.1

multifunctional buildings with restricted access, containing areas for habitation, production and storage, suggests the existence of corporate groups exercising tight control over the creation of these spaces and the activities that were carried out within them.

These compounds were connected to Huaca de la Luna by narrow streets. Direct access into the compounds was not possible, however, as the streets form more of a labyrinth, screening, to a certain degree, the private wealth stored inside the compounds. Over time, access to these compounds became increasingly restricted, as evidenced by the

number of sealed doors, a common feature in this urban zone. Our best evidence for these changes over time comes from Complex 9 (fig. 2, AA 9; fig. 3), a large compound that we were able to excavate in its entirety. This complex will be discussed at length below.

A number of these compounds may have been organized by occupational specialty (Chapdelaine 1997). A ceramic workshop was found by a team under the direction of Santiago Uceda (fig. 2; Uceda and Armas 1997), and we were able to identify a compound (Complex 9) dedicated to textile production, as evidenced by the concentration of spindle

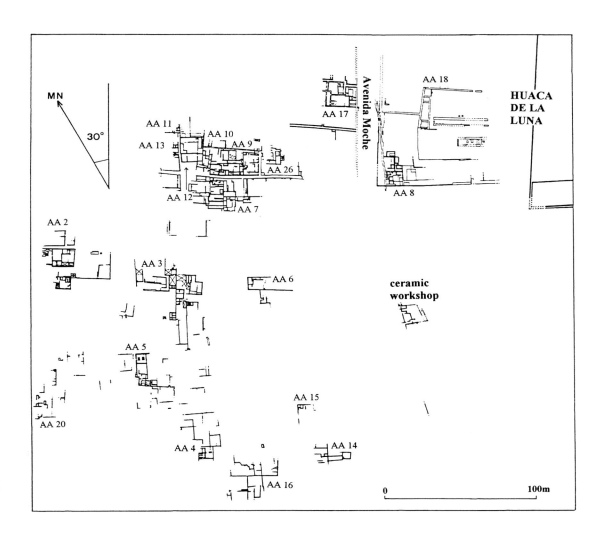

2. Plan of the excavated area
of the urban sector of Moche
Redrawn by Hélène Bernier from
original drawing by Carlos Ayesta

whorls. A small metal workshop was found in Complex 7 (fig. 2, AA 7), and an area for *chicha* (maize beer) production was located in at least two compounds (Complexes 7 and 9). Other compounds contained evidence of fishing (marine animal remains and fishing equipment), camelid husbandry (Vásquez and Rosales 1998), and other activities.

The Chronological Framework

A major goal of this project has been the refinement of the chronology of the Moche occupation of the site, particularly for the later periods. As our field strategy favored horizontal excavations down to the first well-preserved plastered clay floor, it was not possible to date the earliest occupations. We were, however, able to develop a new chronology for the later occupations of the urban sector and the Huaca de la Luna complex itself (fig. 4).

This new chronology has yielded some provocative results pertaining to the growth and development of the Moche site. The almost complete absence of Moche V ceramic vessels in domestic or funerary contexts suggests that the Moche IV phase occupation is the latest. In the stratigraphy, this Moche IV occupation appeared close to the present surface. The radiocarbon dates, coherent internally and stratigraphically, are surprising in that they suggest the site was occupied as late as A.D. 600–700 (Table 1). The majority of these late radiocarbon dates are associated with a Moche IV occupation. There is no apparent decline in ceramic production or architectural construction in this period, suggesting that the Moche IV population continued to occupy the site at the same time

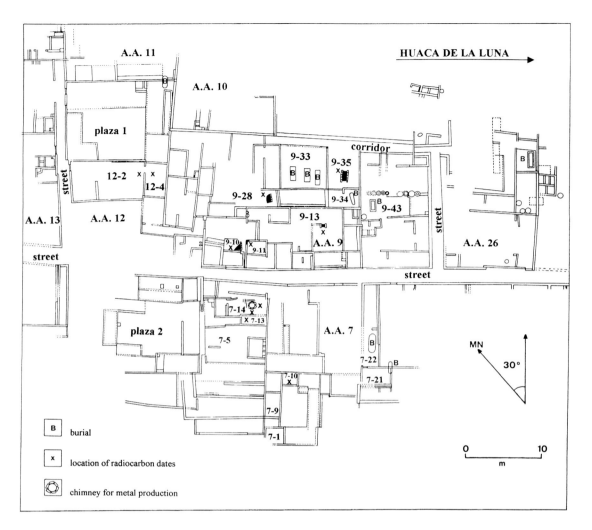

3. Plan of the south-central sector between the two *huacas*
Redrawn by Hélène Bernier from original drawing by Carlos Ayesta

4. Calibrated dates from the ZUM Project

Table 1. Contextual data for radiocarbon dates from the Moche site by the ZUM Project (1995-1998)

Lab Number	Date BP	Calibration (2 sigmas)	Material	Context	Depth below surface	Relative depth to datum[1]	Remarks
Beta-96025	20 ± 70	1680-1745	charcoal	AA 11-1: kitchen room	±25 cm	2.21 m	rejected as too late
Beta-96026	1430 ± 50	555-680	charcoal	AA 14-1: post on floor	±60 cm	3.53 m	multi-function room
Beta-96027	1280 ± 60	650-885	charcoal	AA 15-3: kitchen room	±15 cm	2.67 m	hearth with burnt adobes
Beta-96028	1530 ± 60	415-650	charcoal	AA 9-10: kitchen room	±40 cm	1.41 m	hearth with burnt adobes
Beta-96029	1400 ± 60	560-720; 735-760	charcoal	AA 9-10: kitchen room	±20 cm	1.21 m	hearth without adobes
Beta-96030	1480 ± 60	440-665	charcoal	AA 7-14	±104 cm	2.28 m	inside the chimney
Beta-96031	1490 ± 60	435-665	charcoal	AA 7-14	±140 cm	2.63 m	outside the chimney under associated floor
Beta-96032	1460 ± 60	465-475; 515-675	charcoal	AA 9-13: kitchen room	±30-40 cm	1.59 m	lens of ash deposited after room's abandonment
Beta-96033	1520 ± 50	430-645	charcoal	AA 8	?	± 2.75 m	west bench of south patio
Beta-96034	1380 ± 70	560-785	charcoal	Huaca de la Luna: Platform I	---	---	reed mat in fill of building stage 4-5
Beta-96035	1470 ± 80	425-690	wood	Huaca de la Luna: Platform II	---	---	post from the roof of a burial chamber
Beta-84843	1410 ± 60	600-780	charcoal	AA 7-10: kitchen room	±60 cm	1.96 m	lens of ash deposited after room's abandonment
Beta-84844	510 ± 60	1400-1515	charcoal	AA 4-1: kitchen room	30 cm	3.15 m	hearth constructed directly on sand
Beta-84845	1370 ± 50	640-790	charcoal	AA 7-13: kitchen room	±40 cm	1.34 m	lens of ash deposited after room's abandonment
Beta-84846	1500 ± 60	465-480; 520-675	charcoal	AA 6-1: kitchen room	±30 cm	2.17 m	lens of ash deposited after room's abandonment
Beta-108279	1330 ± 60	630-855	charcoal	AA 12-2: kitchen room	±30 cm	2.90 m	below first floor inside a hearth
Beta-108280	1510 ± 60	425-655	charcoal	AA 12-4: kitchen room	±50 cm	3.08 m	below second floor inside a hearth
Beta-108281	1790 ± 40[2]	145-370	charcoal	AA 16-3	±80 cm	----	AMS on human bones inside a burial chamber
Beta-111544	1360 ± 60	605-785	charcoal	AA 9-28	±70 cm	1.66 m	hearth with burnt adobes
Beta-111545	1360 ± 70	590-800	charcoal	AA 9-35	±80 cm	1.74 m	hearth with burnt adobes

[1] The provisional datum is an arbitrary level set up with a theodolite in 1995; the larger the number the deeper the feature.
[2] This early date is discussed in Chapdelaine et al. 1998.

that Galindo, a Moche V center, developed on the northern side of the Moche valley (Chapdelaine, in press). This new chronology gives the Moche IV phase a longer time period, extending it between A.D. 400 and 700. New radiocarbon dates of Moche III contexts at the site support the idea of an A.D. 250–450 correlation for this phase. By this time, the site was extensively occupied. Moche clearly developed into a city earlier than previously assumed.

These chronological refinements suggest that the expanding Moche state was linked to the development of a powerful elite supported by a prosperous urban class. The Moche site should be classified as a true city, contrary to earlier views that no true cities existed in the prehispanic Andes. Considering the density of population and buildings, presence of monumental architecture, and diversity of economic, political and religious functions (the majority of the site's inhabitants were non-food-producers), the site is urban in character. This urban character is further underscored by the absence of agri-

cultural tools in this zone, a key detail given that Moche was largely an agrarian economy. The hoe is absent in the archaeological inventory of the site, for example, but has been found in households in secondary and tertiary Moche centers elsewhere in the valley.

Looking for Inequality among City Dwellers

What was the nature of urban society at Moche during its heyday? The study of residential households and mortuary practices can help determine the degree of social variability within the urban population. A homogenous group might reflect the extensive power of the elite residing on and around the Huaca de la Luna, including our excavated sectors. This would imply that a large segment of the population at Moche was part of a single noble class of warrior-priests and state bureaucratic officials. Alternatively, if the central polity's power was more restricted, noble families and other corporate groups would have the opportunity to develop

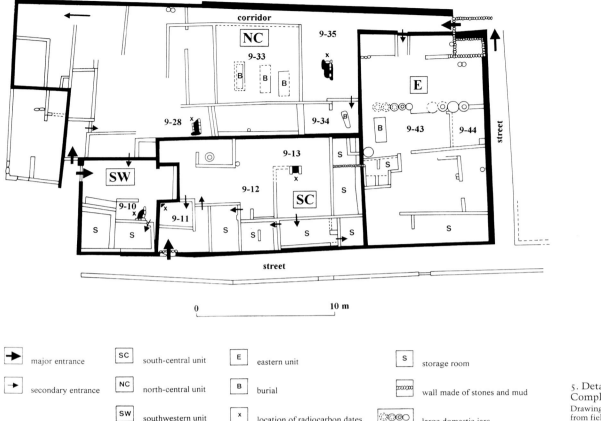

5. Detailed plan of
Complex 9
Drawing by Hélène Bernier
from fieldwork original

→ major entrance	SC south-central unit	E eastern unit	S storage room
→ secondary entrance	NC north-central unit	B burial	░░░ wall made of stones and mud
	SW southwestern unit	x location of radiocarbon dates	◎◎◎ large domestic jars

independent power and status. This second option would result in greater variability within and among residential compounds—reflecting a more diverse urban population, one embracing an administrative elite living alongside craftsmen and merchants.

Is it possible to go so far as to distinguish an upper, middle and lower class? This type of tripartite system usually includes a constantly shifting intermediate class that is key to the maintenance and reproduction of the socioeconomic and religious organization. This group of individuals has some privileges over the lower class, and they act as the intermediaries between the lower class and the ruling elite. The flexibility of this middle class allows its members to gain more privileges during their lifetime through personal actions—they might acquire a higher status. A middle class may be subdivided into lower-middle, middle-middle, and upper-middle classes. These divisions may be relatively fluid, and could be structured as a continuum between the elite and peasants.

Based on our research, we have developed a preliminary model of the social structure at Moche. According to this model, members of the lower class, at the base of the social structure, lived and were buried outside the urban sector. They were engaged in the production of adobe bricks, the creation and maintenance of canals and roads, and in the construction of public monuments and residential houses. To a limited extent they may also have provided foodstuffs to the urban center.

There is currently no evidence to suggest that the urban sector contained lower-class housing. The proximity to the *huacas* and other features, as well as the overall quality of construction of the houses in this urban zone, indicate that this was an area for elite residences. Based on household and mortuary evidence from our project, we argue that this sector was inhabited largely by an urban middle class. At least some members of the highest echelon lived in the urban sector, in Complex 8, at the foot of the Huaca de la Luna (fig. 2, AA 8). The highest-status burials

found to date at the site of Moche were found on the *huaca* itself, and it may be that certain elite individuals lived on the *huaca*, although no data have yet been found to support this idea.

The Households

The size and quality of residential construction are two variables that can be used to assess gradations in rank between different sectors of the archaeological site. Theresa Topic (1977, 1982) first proposed the idea that distinct social groups inhabited Moche. The range of features evident in the residences we excavated suggests that such refinements in the identification of social groups are indeed possible. For example, an elite residence can be inferred by the type of burial, size of storage facilities, and the presence of a large room, presumably used to conduct ceremonies or feasts to display power. We have found a greater percentage of nonutilitarian items in these compounds, including items of gold, silver, and copper. To date we have identified at least thirty elite residences, but there are perhaps a few hundred more at the site of Moche. Few of the excavated residences pertain to the lower levels of the middle class. Even with this relatively small representation of lower-middle-class housing, it is clear that there is sufficient variability between households, manifested in differences in size, as well as quality and organization of construction, to warrant the conclusion that social distinctions existed and that they were a major characteristic of the Moche capital.[2]

Most of the residential complexes are multifunctional. There are clear domestic zones, identified by the presence of grinding stones, hearths, and benches (probably used as sleeping platforms). Craft production areas are also evident. One unusual feature apparent in these residences is the extent of storage facilities. Storage, which is present in all of the excavated areas, was more extensive than required for a very large household, indicating that production in this sector exceeded domestic needs. Complex 9 (fig. 5), for example, contains several storage rooms suggesting economic activities beyond a domestic scale.

When we started our project, one of our pragmatic goals was to delimit and study at least one residential complex, both synchronically and diachronically. We had difficulty delimiting one entire complex. The thick sand layer and hard clay sediment slowed the excavation considerably. The accumulation of sand and clay was unequal in various sectors of the dig, and the depth of the first floor varied from 30 cm to more than 150 cm below the present surface. Furthermore, the fragile adobe walls and plastered floors required horizontal excavation. The buildings are also very large (on average 25 × 15 m), another challenge for our limited logistical capacity. Nevertheless, we managed to excavate totally the large (32 × 17 m) Complex 9, stopping at the first good, well-preserved plastered clay floor.

The excavation of Complex 9 allowed us to create a detailed analysis of the growth of this compound over the course of two centuries. Complex 9 is comparable in terms of size with those found in other sectors in the south-central area between Huaca del Sol and Huaca de la Luna, suggesting that this type of compound was not unique. Complex 7, located immediately south of Complex 9, is even larger (c. 56 × 23 m) (fig. 2, AA 7; fig. 3). Unfortunately, as the excavations in the other complexes were limited, an extensive comparative analysis of the complexes is not possible at this time, and Complex 9 will serve *de facto* as the test case.

It is possible to recognize four subunits in Complex 9, each with its own history, giving an idea of the complexity of this single residential unit. At its greatest extent the complex comprised more than forty rooms of different shapes, functions and access (fig. 5). We were able to recognize four chronological phases in the construction of the complex, representing approximately two hundred years of architectural modifications. Our first three phases all correlate to the Moche IV period. Based on five radiocarbon dates and stratigraphic data, we can associate the core area of the compound with phase 1. This core area is comprised of the south-central and north-central subunits, and possibly the subunit consisting of the southwest corner of the residential complex. Phase 2 marks the expansion beyond the core area and the construction of the eastern subunit which is interpreted as a center of production. At this time the major entrances to the complex are

relocated to allow access to the newly constructed narrow street separating Complex 9 and Complex 26. Phase 3 marks the decline of the south-central core, indicated by the abandonment of rooms 9-12 and 9-13, which became middens. At the same time, there is new construction in the north-central unit in the northwestern corner. These additions include a funerary platform (9-33) and hearths in rooms 9-28 and 9-35, both of which attest to the growing power of the inhabitants of this compound, as these modifications imply acquisition of new spaces and an expansion of activities such as feasting and storage. Phase 4 signals the abandonment of the complex by its Moche IV phase inhabitants. This phase is characterized by a small amount of new building, principally in stone and mud (as opposed to the adobes used prior to this time), by an unknown group. This very late, post-Moche occupation was brief and the area was not used intensively. This unknown group has been recognized elsewhere in the urban sector, although no attempt at a cultural identification has yet been made.

A number of changes attest to the dynamic nature of the Moche IV occupation of Complex 9. Access to this compound became increasingly restricted: the number of entryways was reduced, from three to two, and they were reoriented away from a main street which connected to a plaza, to a secondary, narrow street. The new northeastern entryway is itself made narrower, and access to the interior of the compound is further restricted by the addition of a ten-meter corridor just beyond the new entrance. The addition of a chicha (maize beer) production area is suggested by the presence of a line of nine large vessels, found in an inverted position for drying. The compound also contained spaces for the production of textiles and storage. A low platform in room 9-44, located by the eastern wall, may have played a role in the distribution of goods produced in this compound. In a painting on a Moche vessel illustrated by Cristóbal Campana (1983: 20–21, 1994: 452, 455), there is a representation of an individual seated on an elevated bench, controlling textile production and receiving goods. The leader of Complex 9 may have fulfilled such a role. The question remains, however – was this individual a high-status functionary of a centralized political authority or was he the

leader of a powerful and independent corporate group? This question is not entirely answerable with our current data, but some observations are still possible.

Were the mortuary data complete, we would be in a better position to assess the nature of the relationship between the elite of the huaca and the inhabitants of the urban sector. Unfortunately, the three burial chambers in the funerary platform of Complex 9 have been completely looted, as was the tomb in room 9-43. The burial platform fill, however, provided enough evidence to make a preliminary identification of the individuals buried in the chambers. Burial 1 contained an adult male, interred with a finely sculpted piece, possibly of bone, probably once inlaid, representing a human head, complete with a feline headdress (fig. 6). Burial 2 is possibly that of an adult; few remains were recovered. Burial 3 was a complex inhumation of two young children with adult human long bones included as offerings, a practice also recorded elsewhere (Chapdelaine 1997: 41, 50; Hecker and Hecker 1992: 43–46; Uceda 1997: 186). Burial 3 contained two ceramic vessels, a flaring bowl and a jar (fig. 7). The jar, which has a rope motif around the neck, probably once indicated the top of the burial chamber. This type of motif has been found on ceramic vessels in several tombs and caches at Moche, and it may have been used to identify membership in a particular group. The central position of these burials within such a large complex is indicative of the social position of the deceased, at the summit of the household. The individuals buried in the platform were probably of the same kin group. The individual interred in Burial 1 was most certainly the leader of Complex 9, and a member of the highest rank of the Moche urban class. The presence of children in the burial platform suggests that they inherited their rank and privileges as members of an important family, and therefore had the right to be interred in this central and prestigious area of Complex 9.

Mortuary data from Complex 9 alone are insufficient to determine the precise sociopolitical position of its leaders. The Complex 9 funerary platform is the only one yet known from the urban sector of Moche. Although the mortuary offerings, along with other features of the compound mentioned above clearly indicate that Complex 9 was an elite

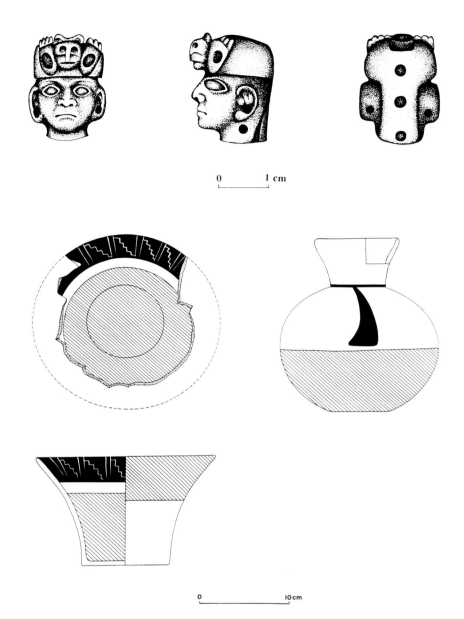

0 1 cm

0 10 cm

6. Miniature head (c. 2 cm in height) sculpted in bone (?) From Tomb 1 in funerary platform 9-33
Museo de Arqueología, Antropología e Historia, Universidad Nacional de Trujillo
Drawing by Hélène Bernier

7. Drawing of painted vessels from Tomb 3 in funerary platform 9-33
Museo de Arqueología, Antropología e Historia, Universidad Nacional de Trujillo
Drawing by Hélène Bernier

residence, a more precise identification must await further research, when a detailed comparative analysis of several compounds can be made.

Burial Patterns

The investment of energy visible in the Moche mortuary rituals will be examined in light of the theoretical principle that human beings behave toward their dead according to the social importance of the deceased and the beliefs of the community regarding death and the soul (Binford 1972; Carr 1995; Hertz 1907;

Huntington and Metcalf 1979). There is no doubt the Moche constituted a hierarchical society, with different types of burials corresponding to distinct social classes. The upper class was represented by a supreme chief or king, and his extended family fulfilled the roles of dignitaries or noblemen. These roles may have included priests, military leaders, provincial rulers and the like. They were interred inside temples or funerary platforms located close to public buildings. Large rectangular burial chambers were made of adobe brick, and contained niches in the walls for offerings of ceramic vessels or other objects. The burial chambers themselves were sufficiently large to contain other offerings, such as human and llama sacrifices. Tomb furnishings included rare objects, as well as objects in large quantity, including gold and silver ornaments, which are assumed to have accompanied the deceased in royal burials. The acquisition of such items underscores the power and authority of the deceased and his or her extended kin group. The royal tombs at Sipán (Alva, this volume; Alva and Donnan 1993) serve as our best example of the type of burial allowed to individuals at the apex of the social pyramid.

At Moche, a number of tombs have been excavated recently in several sectors of the architectural complex of Huaca de la Luna (Bourget 1998a, 1998b; Uceda, Mujica, and Morales 1997, 1998). Similar Moche burials have been documented in neighboring coastal valley sites such as Huaca Cao Viejo of the El Brujo complex in the Chicama Valley (Franco, Gálvez, and Vásquez 1998), and at Huaca de la Cruz in the Virú Valley (Strong and Evans 1952). These tombs may be attributed to the upper class, but not to a paramount ruler of the Moche state. We will probably never know specific details of any royal tombs that were once in the Huaca de la Luna, as the complex was extensively looted in the colonial period. It can be postulated, however, that any royal tombs at Moche were certainly as rich as the royal tombs of Sipán, a site that was considered a secondary center before the impressive discoveries were made there in 1987 (see Alva, this volume). With Sipán as a yardstick, the tombs found recently on the Huaca de la Luna and in the urban sector of Moche would pertain to members of the lower upper class, perhaps priests and members of

Table 2. Mortuary data on Moche burials excavated during the ZUM project

Status[1]	i.d.	Sex	Encasing of corpse	Funerary chamber	Goods (Ql. & Qn.)[2]	Context
?	5-2	infant	splint reinforced	simple pit	none (grave indicator?)	under floor, domestic room
M	7-9	adult female	shroud wrap?	simple pit	moderate	sand layer, domestic room
L	7-21	adult male	shroud wrap?	simple pit	none (?)	sand layer, on the floor, domestic room
L?	7-21	juvenile?	shroud wrap?	simple pit	low Ql. & Qn.	sand layer, domestic room
L-M	7-22	adult male	shroud wrap?	simple pit	moderate Ql. & Qn.	sand layer, on the floor, domestic room
M	9-33-1	adult male?	-?-	small rectangular chamber	(few) ? 1 high Ql. piece	funerary platform, domestic complex
M?	9-33-2	adult?	-?-	small rectangular chamber	(few) ?	funerary platform, domestic complex
M?	9-33-3	2 infants?	-?-	small rectangular chamber	(few)? human bones	funerary platform, domestic complex
L	9-34	adult female	splint reinforced ?	simple pit in the floor	low Ql. & Qn.	within the floor, domestic room
?	9-43	adult?	-?-	small rectangular chamber	(few) ?	under the floor, domestic room
H	Plaza	adult female	cane tube?	rectangular chamber ?	high (Ql. & Qn.)	under a bench, public plaza
M	15-4	adult male (III)	splint reinforced	simple pit	moderate Ql./low Qn. with human sacrifice	sand layer above floor, domestic room?
M	16-3	adult female	-?-	external rectangular chamber	moderate Ql.?/high Qn.	isolated structure, domestic complex
M	26-5	adult male	shroud wrap?	small rectangular chamber	moderate Ql./high Qn.	under the floor, domestic room

[1] L = Lower class, M = Moderate class, H = Higher class
[2] Ql. = Quality, Qn. = Quantity

the ruling elite, but not the royal family (Uceda et al. 1994).

The variability encountered in the tombs may reflect socioeconomic distinctions. The following discussion is based on several assumptions: first, the lower class is not represented in the urban sector between the *huacas*; second, members of the upper class, a relatively large group, not only the ruler and his family, might have occupied some if not all the residential complexes so far excavated in the urban sector; and third, members of the middle class might also have lived and been buried in the urban sector. The problem is to specify the exact status of the individuals in the burials, and through this, their role in this urban society.

Essential to this analysis is the classification of the energy/expenditure investment evident in the tombs. In addition to this, one must consider the symbolic importance of the tomb offerings, particularly concerning symbols of authority and power as well as membership in particular groups. Variability may be assessed using criteria Christopher Donnan outlined in a previous study on Moche mortuary practices (1995). These variables are: 1) preparation of the corpse; 2) encasing the corpse; 3) funerary chambers; 4) quantity and quality of grave goods; and 5) location.

Burial Data from the Urban Sector

This study incorporates data from several burials excavated prior to the start of the ZUM project, including data from fifteen burials excavated by members of the Chan Chan–Moche Valley Project of the early 1970s (Donnan and Mackey 1978; Topic 1977), and twenty-three burials excavated in the urban sector under the direction of Santiago Uceda in the 1990s (Chapdelaine et al. 1997; Tello 1998). Excavations from the ZUM project contribute another fourteen burials to this set of data. This evidence has increased our understanding of the diversity of Moche burial practices, and has underscored the marked social stratification apparent in this society (Table 2). Each individual had the privilege of being interred in an elite residential complex, indicating that these downtown compounds were inhabited by members of the middle or upper social classes. It is assumed that most members of the lower class, those responsible for agricultural production,

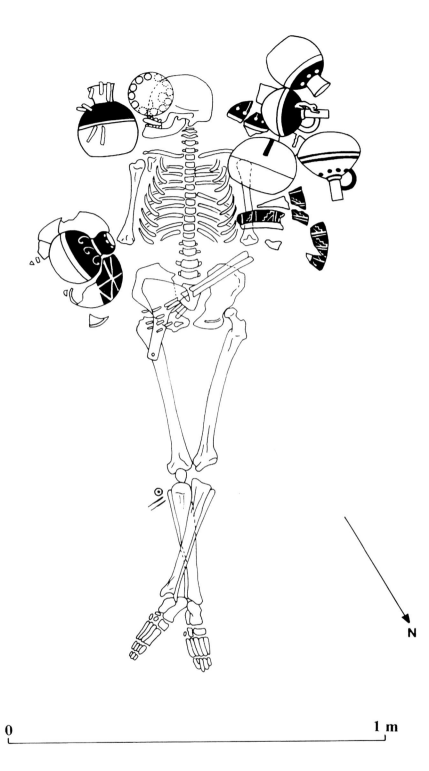

During the Chan Chan–Moche Valley Project, Theresa Topic reported two burials from domestic contexts in the urban sector (Donnan and Mackey 1978: 175–182; Topic 1977: 195). The residential context of the burials, along with their offerings, indicates that the two individuals were from different classes. The first, lower-status burial was of an adult. The grave goods included one broken stirrup-spout bottle with an image of a warrior modeled on the body of the vessel, two spindle whorls, an *olla*, or cooking pot, a few llama bones and two pieces of copper (one in the mouth and one in the left hand). The offerings accompanying the individual in the second burial, that of a male of about thirty-five years old, indicate a higher status. The offerings include two earspools of a gold/copper alloy, with inlaid shell and stone, and three copper disks covering the face. The burial also contained Moche IV pottery; however, the burials were placed in an *abandoned* Moche IV compound. Based on our stratigraphic studies, and other similar burials, we suspect that this intrusive burial is related to the very last phase of the Moche occupation, that is, the last moment of Moche IV.

Of the other thirteen tombs excavated by members of the Chan Chan–Moche Valley Project, a unusual group of nine adult male burials comes from a mud-brick platform in an area they called the cemetery (Trench B), located between the two *huacas* and north of sector excavated by the ZUM project (fig. 1; Donnan and Mackey 1978: 66, map 5). Donnan and Mackey (1978: 208) note that the individuals buried here were of a high status: "... many [...] have large copper disk head-dresses similar to those worn by certain individuals shown in Moche art... The concentration of these burials on the mud-brick platform suggests that this was a cemetery reserved exclusively for high-status adult males who apparently shared an affiliation to a specific Moche ceremony." The copper disks had borders of embossed circles, and were placed on the face of the deceased. These disks, according to Donnan and Mackey (1978: 74), are invariably found in the graves of adult males. The elite males associated with these insignia are thought to have served as ritual specialists or priests. The disk with embossed circles resembles part of a headdress associated with runners in Moche

8. Burial 7-9
Redrawn by Hélène Bernier from fieldwork original

were living in villages located nearby in the lower Moche Valley. In certain instances, however, it appears that members of the lower class could acquire the privilege of interment in these elite complexes.

art (Donnan 1978: 74–76). A similar copper disk was found in the funerary chamber of the Warrior Priest at Huaca de la Cruz in the Virú Valley (Strong and Evans 1952: 160, Plate XXVI, D).

We excavated a burial in Complex 7 (fig. 3, room 7-9) similar to the high-status burials in the mud-brick platform mentioned above, and similar to one reported by Theresa Topic in architectural area 2 (fig. 2, AA 2; Donnan and Mackey 1978: 180–182; Topic 1977: 192–195). These burials all had Moche IV ceramic vessels, and a copper disk edged with embossed circles over the face of the deceased, and they were placed in a Moche IV room after its abandonment. The striking difference is that our burial is that of an adult female, interred with a ceremonial copper knife in her left hand, and a spindle whorl with two needles, also of copper, close to her right knee (fig. 8). The ceremonial knife and copper disk (fig. 9 a, b) might indicate that she once played a role in sacrificial rituals. Prior to this find, metal disks have only been found in graves of adult males; this burial suggests that women of a certain rank could also achieve the right to be buried with symbols of high status.

A second female burial, an intrusive feature in the northeastern corner of Plaza 1 (fig. 3), may also be linked to this group. Twenty-two ceramic vessels were placed on top of the body. Most of vessels, including bottles, flaring bowls, small carinated bowls and jars, are of very good quality. Of particular interest is a well-made stirrup-spout bottle with an effigy of a male seated cross-legged. This individual wears a headdress that includes a disk with raised circles around the edge, over a feline head (fig. 10). This figure, with his arms tattooed and feet painted, is similar to a number of other figures published by Benson (1992: 313, fig. 17) and Donnan (1978: 74, fig. 119). These four modeled vessels, depicting a human, a supernatural figure, a fox and a bird, all show the figure in question attaching a headdress with a disk complete with raised circles along the edge. In our example, this action is already completed. Although no copper disk was found in this burial, there were five copper offerings: a spindle whorl and four plates associated with each extremity of her arms and legs. The deceased woman also received a spout-and-handle bottle, with a representation of the arms and tunic of an elite male warrior, further complicating our usual assumptions on gender and burial goods (fig. 11).

Of the twenty-two ceramic vessels in this burial, one other item deserves our attention. A small (17 cm high) jar was placed close to

9. Ceremonial copper knife (left, a) and a copper circular disk (right, b) from burial 7-9
Museo de Arqueología, Antropología e Historia, Universidad Nacional de Trujillo
Drawings by Hélène Bernier

10. Stirrup-spout bottle from tomb intruding into Plaza 1
Museo de Arqueología, Antropología e Historia, Universidad Nacional de Trujillo
Drawing by Hélène Bernier

11. Spout-and-handle bottle, with a depiction of warrior weapons and regalia, from tomb intruding into Plaza 1
Museo de Arqueología, Antropología e Historia, Universidad Nacional de Trujillo
Drawing by Hélène Bernier

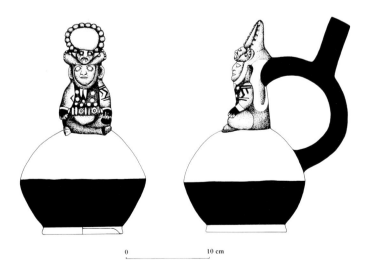
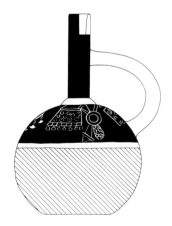

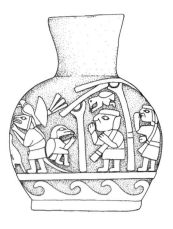

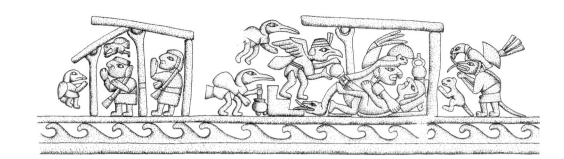

0 1cm

12. Ceramic jar from tomb intruding into Plaza 1
Museo de Arqueología, Antropología e Historia, Universidad Nacional de Trujillo
Drawing by Jorge Sachún

the stirrup spout bottle with the runner. This jar has a motif in relief depicting a ceremony involving sexual intercourse (fig. 12). This scene is similar to motifs on three vessels now in the British Museum, the Museo Nacional de Historia Natural, Santiago, Chile, and the Ganoza collection in Trujillo, Peru (Donnan 1978: fig. 10; Hocquenghem 1987: fig. 14). The scene is related to a figure in Moche iconography known as the "anthropomorphic figure with snake belt" (Castillo 1989: 142). This scene shows an ornithomorphic figure preparing a liquid that will be administered in an unusual way to the individual with the snake belt and feline headdress. This figure is shown mounted on what is presumably a female figure. This intercourse may be part of a fertility or ancestor cult (Bourget 1994: 210). Bourget has suggested that the sequence begins with two females instructing the ornithomorphic figure, followed by the preparation of the liquid and its application in the presence of a few attendants (1994: 216–221). Anne-Marie Hocquenghem has proposed that this scene was part of a fertility cult—a purification rite similar to the Coya Raimi celebration of the Inca, which promoted the restoration of social order (Hocquenghem 1987: 61). It is tempting to speculate that the funerary chamber and associated events commemorated the actual participation of the entombed female in the very scene shown on the small jar.

Considering the religious importance of this scene, it could be postulated that the woman interred in this burial, located in a main plaza, was part of the highest class inhabiting this specific sector of the city. Unanswered questions as to the nature of this class remain, however. What was the relationship of its members to the paramount power? Did they maintain a separate power base? How strong ultimately was this class? What were its links to the inhabitants of other Moche sites? In light of these questions it is interesting to note that this burial in Plaza 1 included a stirrup-spout bottle with a modeled figure shown transporting a bag on his back (Chapdelaine 1998: 101, fig. 103b). This vessel, placed close to the head of the female in our burial, is similar to another vessel found in a tomb of high-ranking ruler at Huaca Cao Viejo at the El Brujo complex (Franco, Gálvez, and Vásquez 1998: 16, fig. 6).

The intrusive location of the burial chamber in the plaza and the type of offerings included in it suggest that it was part of a specific ritual. We do not have a precise date for the burial, but as no other construction succeeded it in this sector, we believe that this event took place very late in the Moche IV sequence, perhaps after A.D. 600. Even at this late date, the quality of the offerings remains high, and the standard burial pattern of the site, with the head to the south, is maintained. The energy investment and the symbols of prestige and authority evident in her burial indicate the woman was of the highest rank of those who lived in the urban sector of Moche.

This burial underscores the persistence of a Moche IV occupation of the site into the seventh century A.D. The sacrificial site excavated by Steve Bourget (this volume, and 1998a, 1998b) might also date from this same period. This was a time when the Moche went into a long and gradual decline but maintained their temples and their cultural traditions (Uceda and Canziani 1998). The burial of this woman may reflect the necessity of one particular leader to hold together the urban class in the face of changing natural and cultural conditions, by creating a prominent statement in a public space. In order to create the tomb in this part of the plaza, the builders needed first to destroy the northern wall delimiting a residential complex from the plaza and remove the plaza's eastern platform and clear the area down to the previous plastered clay floor. We do not know why this site was chosen over other possibilities, including the cemeteries within the city (on the edge of Cerro Blanco) or beyond its confines. The rejection of these alternatives, however, suggests that a prominent statement was intended.

Two of the fourteen burials we excavated in the urban sector can be considered of lower status. Evidence suggests that individuals of a lesser social class could achieve some status during their lifetime and earn the right to be buried in a residential complex. Such is the case of a young woman of about fifteen years of age who died from a wound on the left side of her head. She was interred in a small room of Complex 9 (fig. 5, 9-34) that was sealed after burial. She had a ceramic sherd in her mouth, instead of the copper usually associated with a member of the higher classes, and a necklace of over 400 beads around her neck, two spindle whorls, one fragmented bone needle and one copper awl, but not a single ceramic vessel.

Individuals of different status were on occasion buried in the same area of the urban sector. For example, two male burials, of different status levels, were buried near each other in Complex 7. In one burial, an adult male was interred directly on the floor with no offerings except half a domestic jar deposited on his face (fig. 3, 7-21). This individual was located a few meters from another adult male, also placed directly on the floor, but who had at least ten ceramic vessels and a few

copper objects with him, including a piece of copper in his mouth (fig. 3, 7-22). The copper piece found close to his right shoulder was analyzed by neutron activation revealing the use of arsenical bronze (Chapdelaine n.d.). This suggests a late date for this burial, as this alloy is rare in Moche metalworking. The extensive use of arsenical bronze started around A.D. 900 (Lechtman 1996, 1991; Shimada and Merkel 1991). The ceramic vessels are all Moche IV phase. We argue that this burial, located very close to the present surface, is very late, probably after A.D. 600. This placement is coherent with the late radiocarbon dates obtained from similar stratigraphic contexts in the urban sector.

One unusual burial was found in Complex 16, south of the *huacas* (fig. 2, AA 16). The burial was in a new type of funerary chamber: an above-ground one made of adobe bricks (Chapdelaine et al. 1998). Earlier burials were usually, but not always, placed in a pit below ground, or directly on the floor. Unfortunately, the tomb was looted, but we were able to establish that a single adult female was buried in the chamber along with at least thirty-three ceramic vessels. This unusual example of an above-ground burial chamber, from the latest phase, is the highest-status burial in this sector. This indicates that the southern part of the urban center was also occupied by leaders of important groups, who developed new ways of interring their dead. The location of this burial demonstrates that high-status burials were also found at some distance from the *huacas*.

Evidence suggests that successful warriors may also have been accorded high-status burials, and their graves may have been revisited after initial interment. An adult male was interred in the southeast corner of a room in Complex 26 (fig. 3, AA 26). A six-month-old child was buried approximately 30 cm away from this burial. The child was surrounded by figurines, musical instruments and llama bones. The adult suffered a broken left arm at one point in his life, perhaps indicating that he was once a warrior. The quantity (twenty-six) and quality of the ceramic vessels, and the below-ground rectangular adobe chamber, clearly indicate a high social status for this individual. The individual was disinterred during Moche times, a practice also known at Huaca Cao Viejo (Franco,

Gálvez, and Vásquez 1998). Were the Moche looking for bones or specific artifacts? Preliminary analyses suggest that they took two clavicle bones and a large portion of the skull, leaving aside the ceramic vessels. Metals and other items may have been removed as well. Only two copper awls were found in the burial, a relatively small number of metal artifacts for such a high-status individual. Mario Millones (n.d.), who has analyzed the bones in this burial, has noted that in comparison with other Moche males he was particularly robust. Healed wounds on his left arm, a common trait among warriors, suggest that he may have played a role in military and perhaps civic or ritual affairs, although no weapons were found in the burial to confirm his identity as a warrior.

Other burials have been found recently on the plain between the two *huacas* by members of Santiago Uceda's team (Tello et al. 1999; Uceda and Armas 1997, 1998). Two burials were found in a room of a ceramic workshop (fig. 2). The burials seem to be of ceramic specialists, based on a detailed osteological analysis suggesting certain repetitive activity patterns consistent with ceramic production (Mario Millones, personal communication, 1999). One, a female, was accompanied by fifty-two vessels; the second, a male, was interred with only five vessels. They were buried at almost the same time and the difference in number of vessels included is puzzling.[3]

Theresa Topic argued in her doctoral dissertation that potters should be considered members of the lower class and that they did not gain social and political prestige with the increased control of their production by the elite (1977: 329–330). She suggested that specialized artisans such as weavers, metalworkers, jewelers and potters never reached the upper ranks of Moche society. These new data from the ceramic workshop indicate that at least some of the specialized artisans achieved a relatively high standing in Moche society. How far an individual could move within Moche society remains open to debate, and there seems to be evidence to suggest that there may have been at least some sort of ceiling or separation in status level. The female ceramic specialist was buried with three metal objects, including a nose ornament, an item commonly associated with the elite. Neutron activation analyses of the items show that two of the three are made of very pure copper (Chapdelaine n.d.). In other tombs at the site of Moche the objects are of a gold-copper alloy, suggesting a higher status. The absence of gold-copper alloy offerings in the ceramic specialists' tombs might be an indication of their somewhat lower status among members of the urban class. Thus, the artisan was of sufficient status to be buried with a nose ornament, but with the distinction that it was of a lesser material. This evidence suggests that there are greater complexities in the status distinctions at Moche than previously thought.

Conclusion

The data on mortuary practices in the urban sector of Moche support the idea of a heterogeneous urban population. The location of burials, the quality and quantity of goods and their symbolic meaning suggest the presence of diverse, non-food-producing groups residing in this sector. Precise identification of the specific socioeconomic groups must await further study, but some preliminary observations can be made. For example, we know now that ceramic specialists were interred inside their residential/workshop compounds, and it is possible that weavers, warriors, ritual specialists, servants, and leaders of corporate households were also interred in their respective compounds. Our data indicate that interment within residential complexes was a popular custom, but one reserved only for individuals of a certain status, for individuals who had particularly distinguished themselves in their lifetimes, or who served in a noble household. More data on the individuals buried in the cemeteries will help fill in the picture of Moche social and economic distinctions. This preliminary research suggests that there is a possibility that at least some individuals achieved the right to be buried in the compounds, and that in Moche society status could be achieved, at least to a limited degree, as well as inherited.

A comparison of burials in the urban sector with those of the Huaca de la Luna itself indicates that there are a number of characteristics the two areas have in common, including ceramic vessel styles, types of copper-based artifacts, and funerary chambers. The highest-

ranking individuals buried in the urban center may actually have been members of the ruling elite of Moche. To date, no domestic areas have been identified on Huaca de la Luna, suggesting that perhaps even the highest echelon lived in this urban sector. I propose that several individuals of the highest urban class were acting as leaders of each quarter of the city's urban nucleus, as members of a state council, heads of noble families, or leaders of large economic and/or social corporate groups. The middle class residing in the urban sector was composed of skilled craftsmen, bureaucrats, and heads of small corporate groups, all working for the governing body. A third class, residing principally outside the urban sector was composed principally of food producers, and the labor force necessary for various operations in the city.

It is thus possible that each complex in the nucleus of the city was inhabited by a member of the upper class, and that the extent of his retinue was the reflection of his relative power compared to other leaders of the same elite group. The mortuary and household data support the idea of a certain degree of distinction between the different corporate groups, be they kin-based or occupation-based in their composition. These distinctions give weight to the idea of a more heterogeneous urban population within the town's nucleus. More research is needed before conclusive statements may be made regarding the existence of entire compounds dedicated to a single occupational specialty. The ceramic workshop is a good candidate, but we must wait for more excavation in order to determine if its production center is part of a single, rather small compound, or of a large multifunctional compound like Complex 9. Craftsmen were probably attached to the courts of the ruling elite, but again more research on their physical and social position within the city and vis-à-vis the *huaca* might help clarify the nature of their relationship with the ruling powers.

The complex nature of Moche society and the variability of its archaeological record make it challenging to determine the relative power of individuals inhabiting the urban sector of the city. To understand fully its social stratification, it is worth looking at the Moche site's periphery as well as secondary and tertiary centers in the Moche Valley. The leaders of each large and multifunctional compound were most certainly members of the ruling elite and as such were probably also engaged in the expansionist politics of the Moche state in neighboring valleys. Were these compound leaders members of a centralized noble class originating at the site of Moche, or were they representatives of ruling families from other valleys? Intervalley analysis and comparison should shed light on this problem. In the urban nucleus, the leaders of these compounds were viewed as active members of the ruling group and were testing the supreme leader by accumulating private wealth. This internal conflict between elites could be one consequence of the growing power of the urban classes and possibly a factor in the decline of the Moche polity.

NOTES

Data used in this paper were obtained through a long-term project on the urban character of the Moche site. This project was funded by the Social Sciences and Humanities Research Council of Canada. The fieldwork was facilitated by Santiago Uceda through a long-term cooperative agreement between the Universidad Nacional de Trujillo and the Université de Montréal. I would like to express my deep gratitude for his generosity and scientific support. We would like also to thank all the Peruvian archaeologists and students from the Université de Montréal who have contributed to the success of the ZUM project. The illustrations were made or updated for publication by Hélène Bernier, a graduate student at the Anthropology Department of the Université de Montréal, and I would like to thank her for contributing in many ways to the ZUM Project. I would also like to thank André Costopoulos for editing the first version of this paper. Nevertheless, I remain solely responsible for the ideas expressed in this paper as well as for any errors and omissions.

1. Theresa Topic excavated portions of these compounds and recorded the findings in her dissertation (1977). As she did not excavate or map the full extent of the individual structures, she designated them simply "architectural areas." We retained her designations, and in our plans indicated sections with "AA" numbers. Where we have reason to believe we have isolated largely discrete clusters or compounds, we have designated them by a "Complex" number.

2. Analysis of economic activities carried out in these compounds has not yet been completed, but these data may also help identify the social classes residing in this sector.

3. This large number of vessels, and the discrepancy between burials, is not unique. Complex 25, just north of architectural area 17, contained three burials in a single room (Tello et al. 1999). These three burials contained a total of 99 vessels (55 in one, 34 in the second, and 20 in the third). The burials date to Moche IV, and were found very close to the present surface.

BIBLIOGRAPHY

Alva, Walter, and Christopher B. Donnan
1993 *Royal Tombs of Sipán* [exh. cat., Fowler Museum of Cultural History, University of California]. Los Angeles.

Bawden, Garth L.
1996 *The Moche*. Oxford and Cambridge, Mass.

Benson, Elizabeth P.
1992 The World of Moche. In *The Ancient Americas: Art from Sacred Landscapes* [exh. cat., Art Institute of Chicago],. ed. Richard F. Townsend, 302–315. Chicago.

Binford, Lewis R.
1972 Mortuary Practices: Their Study and Their Potential. In *An Archaeological Perspective*, by Lewis R. Binford, 208–243. Studies in Archaeology Series. New York.

Bourget, Steve
1994 Bestiaire sacré et flore magique: Écologie rituelle de l'iconographie de la culture Mochica, côte nord du Pérou. Ph.D. dissertation, Département d'anthropologie, Université de Montréal.

1998a Pratiques sacrificielles et funéraires au site Moche de la Huaca de la Luna, côte nord du Pérou. *Bulletin de l'Institut Français d'Etudes Andines* 27 (1): 41–74.

1998b Excavaciones en la Plaza 3A y en la Plataforma II de la Huaca de la Luna durante 1996. In *Investigaciones en la Huaca de la Luna 1996*, ed. Santiago Uceda, Elías Mujica, and Ricardo Morales, 43–64. Facultad de Ciencias Sociales, Universidad Nacional de La Libertad, Trujillo.

Campana, Cristóbal
1983 *La vivienda Mochica*. Trujillo.

1994 El entorno cultural en un dibujo Mochica. In *Moche: Propuestas y perspectivas* [Actas del primer coloquio sobre la cultura Moche, Trujillo, 12 al 16 de abril de 1993], ed. Santiago Uceda and Elías Mujica, 449– 473. Travaux de l'Institut Français d'Etudes Andines 79. Trujillo and Lima.

Carr, Christopher
1995 Mortuary Practices: Their Social, Philosophical-Religious, Circumstantial, and Physical Determinants. *Journal of Archaeological Method and Theory* 2 (2): 105–200.

Castillo, Luis Jaime
1989 *Personajes míticos, escenas y narraciones en la iconografía Mochica*. Lima.

Castillo, Luis Jaime, and Christopher B. Donnan
1994 Los Mochica del norte y los Mochica del sur. In *Vicús*, by Krzysztof Makowski, Christopher B. Donnan, Iván Amaro Bullón, Luis Jaime Castillo, Magdalena Diez Canseco, Otto Eléspuru Revoredo,

and Juan Antonio Murro Mena, 143–181. Colección Arte y Tesoros del Perú. Lima.

Chapdelaine, Claude
n.d. Neutron Activation Analysis of Metal Artifacts from the Moche Site, North Coast of Peru. Manuscript in possession of the author.

1997 Le tissu urbain du site Moche, une cité péruvienne précolombienne. In *À l'ombre du Cerro Blanco: Nouvelles découvertes sur la culture Moche, côte nord du Pérou*, ed. Claude Chapdelaine, 11–81. Université de Montréal, Département d'anthropologie, Les Cahiers d'Anthropologie 1. Montréal.

1998 Excavaciones en la zona urbana de Moche durante 1996. In *Investigaciones en la Huaca de la Luna 1996*, ed. Santiago Uceda, Elías Mujica, and Ricardo Morales, 85–115. Facultad de Ciencias Sociales, Universidad Nacional de La Libertad, Trujillo.

in press Struggling for Survival: The Urban Class of the Moche Site, North Coast of Peru. In *Environmental Disaster and the Archaeology of Human Response*, ed. Garth L. Bawden and Richard M. Reycraft. Forthcoming in Maxwell Museum of Anthropology, Anthropology Papers Series 7. Albuquerque, N.M.

Chapdelaine, Claude, Mary I. Paredes, G. Florencia Bracamonte, and Victor Pimentel
1998 Un tipo particular de entierro en la zona urbana del sitio Moche, costa norte del Perú. *Bulletin de l'Institut Français d'Etudes Andines* 27 (2): 241–264.

Chapdelaine, Claude, Santiago Uceda, María Montoya, C. Jauregui, and Ch. Uceda
1997 Los complejos arquitectónicos urbanos de Moche. In *Investigaciones en la Huaca de la Luna 1995*, ed. Santiago Uceda, Elías Mujica, and Ricardo Morales, 71–92. Facultad de Ciencias Sociales, Universidad Nacional de La Libertad, Trujillo.

Donnan, Christopher B.
1978 *Moche Art of Peru: Pre-Columbian Symbolic Communication* [exh. cat., Museum of Cultural History, University of California]. Los Angeles.

1995 Moche Funerary Practice. In *Tombs for the Living: Andean Mortuary Practices* [A Symposium at Dumbarton Oaks, 12th and 13th October 1991], ed. Tom D. Dillehay, 111–159. Washington.

Donnan, Christopher B., and Carol J. Mackey
1978 *Ancient Burial Patterns of the Moche Valley, Peru*. Austin, Tex.

Franco, Régulo, César Gálvez, and Segundo Vásquez
1998 Desentierro ritual de una tumba Moche: Huaca Cao Viejo. *Revista Arqueológica SIAN* 6: 9–18. [Trujillo].

Haas, Jonathan S., Shelia Pozorski, and Thomas Pozorski
1987 (Editors) *The Origins and Development of the Andean State*. New Directions in Archaeology. Cambridge.

Hecker, Giesela, and Wolfgang Hecker
1992 Ofrendas de huesos humanos y uso repetido de vasijas en el culto funerario de la costa norperuana. *Gaceta Arqueológica Andina* 6 (21): 33–53.

Hertz, Robert
1907 Contribution à une étude sur la représentation collective de la mort. *Année sociologique* 10: 48–137.

Hocquenghem, Anne-Marie
1987 *Iconografía Mochica*. Lima.

Huntington, Richard, and Peter Metcalf
1979 *Celebrations of Death*. Cambridge.

Lechtman, Heather N.
1991 The Production of Copper-Arsenic Alloys in the Central Andes: Highland Ores and Coastal Smelters? *Journal of Field Archaeology* 18 (1): 43–76.

1996 Arsenic Bronze: Dirty Copper or Chosen Alloy? A View from the Americas. *Journal of Field Archaeology* 23 (4): 477–514.

Millones, Mario
n.d. Informe técnico de osteología humana del conjunto arquitectónico #26 de la temporada de campo 1998. Manuscript in possession of the author.

Schaedel, Richard P.
1985 The Transition from Chiefdom to State in Northern Peru. In *Development and Decline: The Evolution of Sociopolitical Organization*, ed. Henri J.M. Claessen, Peter van de Velde, and M. Estellie Smith, 156–169. South Hadley, Mass.

1987 Naissance des grandes cités andines. In *Le Grand Atlas de l'Archéologie*, ed. Christine Flon, 368–369. Paris.

Shimada, Izumi
1994a *Pampa Grande and the Mochica Culture*. Austin, Tex.

1994b Los modelos de la organización sociopolítica de la cultura Moche: Nuevos datos y perspectiva. In *Moche: Propuestas y perspectivas* [Actas del primer coloquio sobre la cultura Moche, Trujillo, 12 al 16 de abril de 1993], ed. Santiago Uceda and Elías Mujica, 359–387. Travaux de l'Institut Français d'Etudes Andines 79. Trujillo and Lima.

Shimada, Izumi, and John F. Merkel
1991 Copper-Alloy Metallurgy in Ancient Peru. *Scientific American* 265 (1): 80–86.

Strong, William Duncan, and Clifford Evans
1952 *Cultural Stratigraphy in the Virú Valley,*

Northern Peru: The Formative and Florescent Epochs. Columbia Studies in Archaeology and Ethnology 4. New York.

Tello, Ricardo

1998 Los conjuntos arquitectónicos 8, 17, 18, y 19 del centro urbano Moche. In *Investigaciones en la Huaca de la Luna 1996*, ed. Santiago Uceda, Elías Mujica, and Ricardo Morales, 117–135. Facultad de Ciencias Sociales, Universidad Nacional de La Libertad, Trujillo.

Tello, Ricardo, M. Chrioque, D. Jordan, M. Nuñez, A. Ponce, and C. Zevallos

1999 Conjunto arquitectónico 25. In *Investigaciones en el centro urbano de las huacas de Moche*, ed. Santiago Uceda, 39–67. Final report submitted to the Fundación Bruno. Trujillo.

Topic, Theresa Lange

1977 Excavations at Moche. Ph.D. dissertation, Department of Anthropology, Harvard University, Cambridge, Mass.

1982 The Early Intermediate Period and Its Legacy. In *Chan Chan: Andean Desert City*, ed. Michael E. Moseley and Kent C. Day, 255–284. School of American Research Advanced Seminar Series. Albuquerque, N.M.

Uceda, Santiago

1997 El poder y la muerte en la sociedad Moche. In *Investigaciones en la Huaca de la Luna 1995*, ed. Santiago Uceda, Elías Mujica, and Ricardo Morales, 177–188. Facultad de Ciencias Sociales, Universidad Nacional de La Libertad, Trujillo.

Uceda, Santiago, and José Armas

1997 Los talleres alfareros en el centro urbano Moche. In *Investigaciones en la Huaca de la Luna 1995*, ed. Santiago Uceda, Elías Mujica, and Ricardo Morales, 93–104. Facultad de Ciencias Sociales, Universidad Nacional de La Libertad, Trujillo.

1998 An Urban Pottery Workshop at the Site of Moche, North Coast of Peru. In *Andean Ceramics: Technology, Organization, and Approachestion, and Approaches*, ed. Izumi Shimada, 91–110. MASCA (Museum Applied Science Center for Archaeology) Research Papers in Science and Archaeology, Supplement to Volume 15. University of Pennsylvania Museum of Archaeology and Anthropology. Philadelphia.

Uceda, Santiago, and José Canziani

1998 Análisis de la secuencia arquitectónica y nuevas perspectivas de investigación en la Huaca de la Luna. In *Investigaciones en la Huaca de la Luna 1996*, ed. Santiago Uceda, Elías Mujica, and Ricardo Morales, 139–158. Facultad de Ciencias Sociales, Universidad Nacional de La Libertad, Trujillo.

Uceda, Santiago, Ricardo Morales, José Canziani, and María Montoya

1994 Investigaciones sobre la arquitectura y relieves polícromos en la Huaca de la Luna, valle de Moche. In *Moche: Propuestas y perspectivas* [Actas del primer coloquio sobre la cultura Moche, Trujillo, 12 al 16 de abril de 1993], ed. Santiago Uceda and Elías Mujica, 251–303. Travaux de l'Institut Français d'Etudes Andines 79. Trujillo and Lima.

Uceda, Santiago, Elías Mujica, and Ricardo Morales

1997 (Editors) *Investigaciones en la Huaca de la Luna 1995*. Facultad de Ciencias Sociales, Universidad Nacional de La Libertad, Trujillo.

1998 (Editors) *Investigaciones en la Huaca de la Luna 1996*. Facultad de Ciencias Sociales, Universidad Nacional de La Libertad, Trujillo.

Vásquez, Víctor, and Teresa Rosales

1998 Zooarqueología de la zona urbana Moche. In *Investigaciones en la Huaca de la Luna 1996*, ed. Santiago Uceda, Elías Mujica, and Ricardo Morales, 173–193. Facultad de Ciencias Sociales, Universidad Nacional de La Libertad, Trujillo.

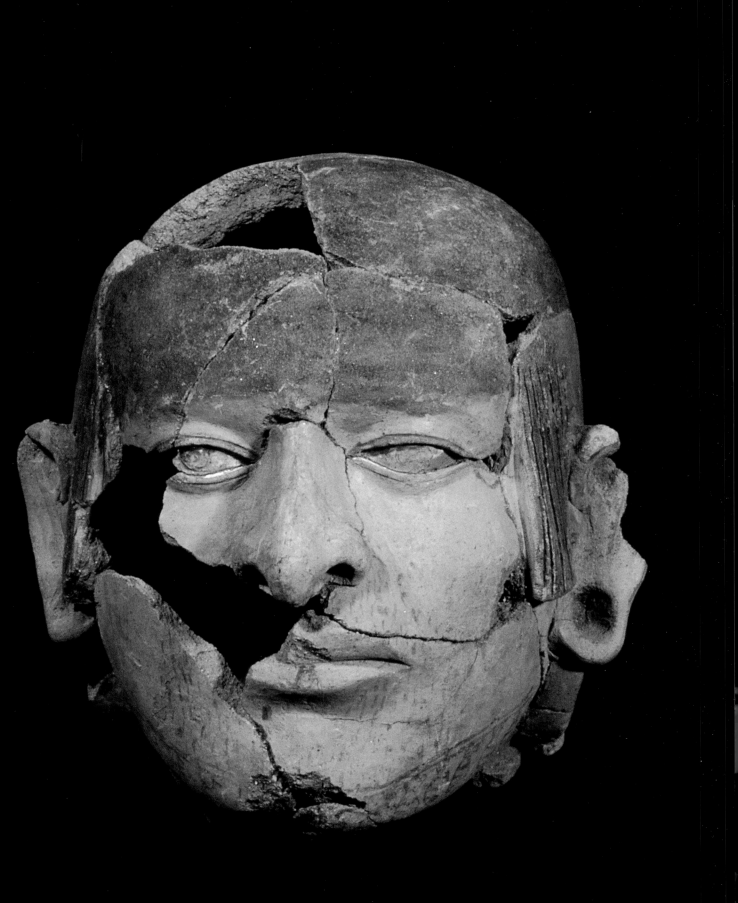

STEVE BOURGET

University of Texas at Austin and University of East Anglia, Sainsbury Research Unit
for the Arts of Africa, Oceania and the Americas

Rituals of Sacrifice: Its Practice at Huaca de la Luna and Its Representation in Moche Iconography

Until recently most of our information on the subject of human sacrifice in the Moche culture came from the study of its iconography (Donnan 1978; Hocquenghem 1987). Depictions of various types of torture and sacrifice were modeled and painted on ceramic vessels. Individuals are shown strapped to wooden structures, where they would be tormented by vultures, mutilated, and ultimately decapitated and dismembered (see, for example, Berrin 1997: 152, fig. 93). One of the most complex scenes painted on Moche vessels is known as the Sacrifice Ceremony (Introduction, this volume, fig. 5; Alva and Donnan 1993: figs. 132, 143). In this scene, naked men are sacrificed by having blood drawn from their necks; their hearts may also have been removed. On the upper register, a goblet, presumably filled with the blood of the victims, is being exchanged between human and what appear to be supernatural individuals.

In the last fifteen years, a number of major archaeological discoveries have transformed our perception of Moche society and our understanding of their system of representation. Many of these new finds contain clear evidence of human sacrifice, giving us archaeological confirmation that at least some of the practices known from the iconography were indeed carried out. Perhaps the most important of these finds occurred in 1987, with Walter Alva's discovery of the Sipán tombs in the Lambayeque Valley (Alva, this volume, and 1988, 1990; Alva and

Donnan 1993). For the first time, not only was it possible to see the complete, complex burial chambers of some of the highest-ranking individuals of Moche society, but it was also possible to link these individuals with the Sacrifice Ceremony. For example, the individual in Tomb 1 at Sipán was recognized as one of the main protagonists of the ceremony, while Tomb 2 was seen as the resting place of his counterpart, a figure identified as the Bird Priest. A third personage of the Sacrifice Ceremony, a female, was found at San José de Moro in the Jequetepeque Valley a few years later by Christopher Donnan and Luis Jaime Castillo (1992, 1994). Furthermore, Daniel Arsenault (1994: 217) suggests that a female burial at Huaca de la Cruz in the Virú Valley, originally excavated in the late 1940s by members of the Virú Valley Project, is also linked to the Sacrifice Ceremony. He argues that a wooden staff found alongside her is similar to an anthropomorphized staff on the lower right of the rollout drawing of the Sacrifice Ceremony (Introduction, this volume, fig. 5). In this scene, the anthropomorphic staff is shown drawing blood from a captive. It has therefore become clear that individuals attired in the same regalia as the figures of the Sacrifice Ceremony were interred in various places in the Moche region, and over several generations, suggesting that this sort of ritual may indeed have occurred as something of a regular practice in Moche culture.

Fragment of a Moche clay effigy, Plaza 3A, Huaca de la Luna (height: 18 cm)
Museo de Arqueología, Antropología e Historia, Universidad Nacional de Trujillo

1. View of Cerro Blanco and the Huaca de la Luna, Moche Valley, Peru

2. Plan of Plaza 3A and Platform II, Huaca de la Luna. T1–T4 mark the positions of tombs

These excavations have also provided specific evidence of extensive and complex sacrificial practices among the Moche. In many instances human sacrifice was part of elaborate funerary rituals. At Sipán, San José de Moro, and Huaca de la Cruz, individuals appear to have been sacrificed and placed over tombs of high-status individuals to act as guardians (Alva and Donnan 1993; Strong and Evans 1952).[1] The practice of interring a male directly above a principal burial is known from Tomb 1 and Tomb 2 at Sipán, and the tomb of the Warrior Priest at Huaca de la Cruz (Alva and Donnan 1993; Strong and Evans 1952). Moreover, at Sipán the guardians' feet were missing, further underscoring the sacrificial nature of these burials. Other examples of sacrifice have been found at Huanchaco in the Moche Valley, Huaca Cao Viejo in the Chicama Valley, and Dos Cabezas in the Jequetepeque Valley (Cordy-Collins, in press; Donnan and Foote 1978; Franco, Gálvez, and Vásquez 1995, 1996).

In 1995 the single largest sample of human sacrifice known for the Moche was found at the site of Huaca de la Luna in the Moche Valley (fig. 1) (Bourget 1997a, 1997b, 1998a, 1998b). More than seventy individuals were

3. View of Plaza 3A and
Platform II at the beginning
of excavations

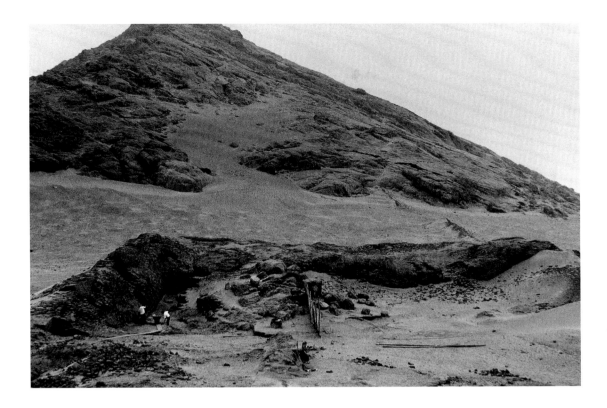

sacrificed during at least five episodes. The
sacrifices were carried out in Plaza 3A, lo-
cated to the east of the principal platform of
Huaca de la Luna, Platform I (fig. 2). The
sacrificed individuals were found to the north
of a natural rocky outcrop, a feature that may
have been the impetus for the construction of
Plaza 3A and its adjacent platform, Platform
II, in this area (fig. 3). High adobe walls on the
north and south sides of platform/plaza con-
nect this area with the rest of the Huaca de la
Luna complex. These walls, even in their
current eroded state, reach eight meters in
height. At least two of the sacrificial episodes
appear to be closely linked with the phenome-
non of El Niño, an often severe geoclimatic
perturbation that can result in downpours,
massive flooding, famine, and disease on this
normally arid coast. The sacrificial victims of
Plaza 3A were found embedded in clay, indi-
cating that the rituals were performed during
spells of torrential rains brought by El Niño.

The sequence of events and, in many in-
stances, the precise positioning of the human
remains suggest a high degree of ritual orga-
nization. After each ritual, the mutilated re-
mains of the victims were left in the plaza,
exposed to the sun and the wind, where they
played host to countless flies who deposited
their eggs in the rotting flesh (fig. 4). Ritual
specialists must have conducted these prac-
tices according to strict guidelines. The evi-
dence from Huaca de la Luna and other Moche
sites indicates that these practices formed an
integral part of Moche religious and ideo-
logical organization.

In the first part of this contribution, I will
consider Moche warfare, capture and sacri-
fice, comparing visual representations with
archaeological data obtained from various
Moche sites. Emphasis will be given to the
Huaca de la Luna, as it provides our most
extensive data set on this subject. Using a
comparative approach, it will be possible to
evaluate how closely the visual representation
of warfare and sacrificial practices matches
evidence from the archaeological record.

In the second part of this paper, symbolic
dimensions of these practices will be ex-
plored, such as the close associations between
the sacrificial victims of Plaza 3A of Huaca de
la Luna and sea lions. Moche practices and
beliefs about death will also be investigated,
especially aspects regarding natural processes
such as decay and insect infestation. Finally, I
will discuss the ways in which the events at

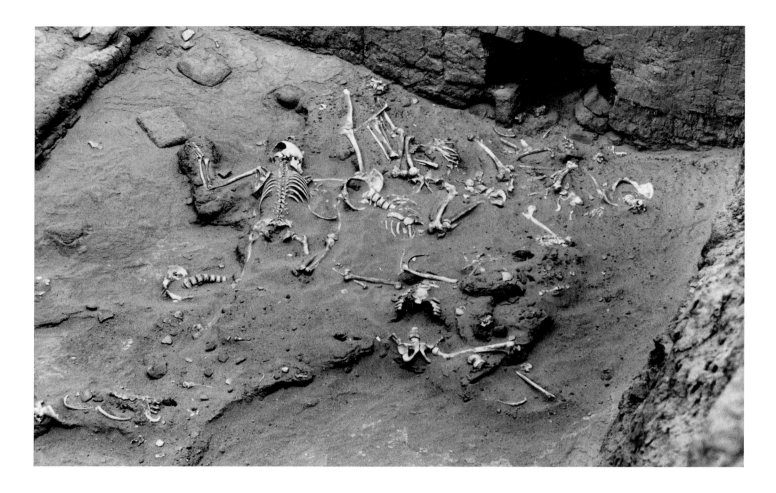

Huaca de la Luna shed light on Moche beliefs about the natural world.

Ritual or Secular Warfare?

The nature of Moche warfare is still a matter of debate (Topic and Topic 1997; Verano, this volume). Various authors have discussed the problem of demonstrating secular warfare during the Moche period, and have used the fine-line depictions of battle scenes as corroborating evidence for full-scale battles for territorial expansion. For example, David Wilson (1988: 66) mentions that the Moche achieved integration of the north coast valleys through warfare, although the physical evidence of such practices is lacking. He argues that "there is clear iconographic evidence in pottery and murals both for interregional warfare and for conquest." Did the Moche engage in large-scale battles? Are the fine-line depictions of bellicose activities such as armed combats or taking prisoners on

Moche ceramics indicative of military campaigns, perhaps for territorial gain? Certainly it is difficult to try to separate artificially "ritual" and "secular" warfare. Armed conflicts and wars often have ritualized aspects, thus blurring the line between this distinction. This said, it is worthwhile to consider whether the depictions of Moche battles were intended to represent more mundane, perhaps territorial conflict, or whether they were intended to evoke conflict that was an integral part of religious practices.

The seventy individuals found in Plaza 3A at Huaca de la Luna were a select group. All were male, between the ages of fifteen and thirty-nine, with an average age of twenty-three (Verano 1998). Their skeletal morphology indicates that they were healthy, strong individuals who were physically very active. Many of them had well-healed fractures, and at least eleven of them had fresh injuries, suggesting that they were probably warriors captured during violent encounters. Although

4. Human remains in Plaza 3A. The disintegrated mud bricks in the upper left are evidence of heavy rainfall during an El Niño episode

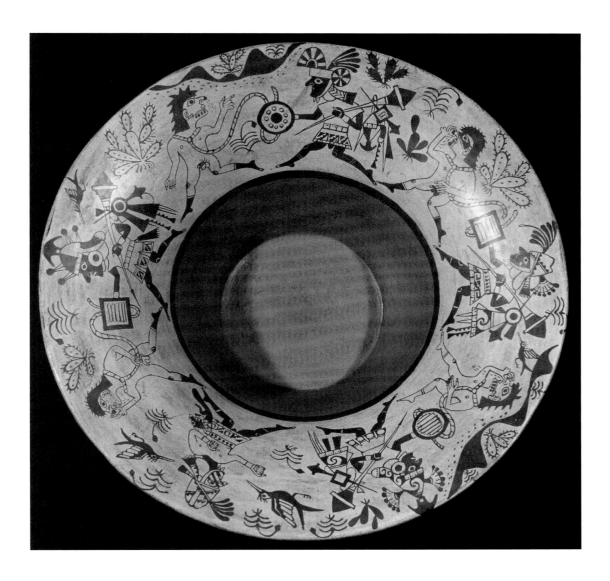

5. Interior view of a flaring
bowl showing a procession
of captured warriors
Museum für Völkerkunde, Berlin
(VA-48171)

warriors are frequently depicted in Moche art,
where they are recognizable through their
protective helmets, backflaps,[2] shields, and
warclubs, this is the first archaeological evi-
dence of such a large number of warriors.

Christopher Donnan (1997) has suggested
that the main objective of battle was not to
kill the opponent but to incapacitate him by
a blow to the face or to the legs. Afterward,
the victors stripped the vanquished and led
them back to temples. A number of painted
representations on ceramics suggest that these
battles were performed under the guidance or
supervision of high-ranking individuals, such
as the one represented on a flaring bowl now
in the Museum für Völkerkunde in Berlin (fig.
5). Flanked by a bird on each side, he is seen
running amidst a group of four warriors with

prisoners. Birds are closely associated with
scenes of combat and are frequently shown
accompanying warriors to the battlefield.
Elsewhere I have proposed that these birds
could have functioned as metaphoric devices,
representing the verbal orders given to war-
riors by their chief (Bourget 1989: 121).

On the basis of representations of attire
and accoutrements, it appears that warriors
on both sides of the battle are Moche: foreign-
ers are rarely depicted. Apart from a few
exceptions, all warriors wear a conical hel-
met, or a more elaborate headdress, and a
backflap, and carry a round or square shield
and a long club. There is no discernable pat-
tern in the distribution of symbols on their
attire and accoutrements. For example, in Fig-
ure 5, each of the victorious warriors wears a

different outfit (headdress, tunic, shield), and when one of them holds a square shield, the victim's shield represented in the weapon bundle slung over his shoulder is circular, and vice versa. If this represented secular warfare, one would expect the victorious soldiers to be dressed in the same style, adorned with the same designs, and equipped with similar headdresses and distinctive shields.

This alternation between round and square shields has also been noted on an architectural relief at Huaca Cao Viejo. In one panel, twenty-four pairs of warriors are organized into four registers, with twelve combatants in each. In the top register the left figure of each pair holds a square shield, and the right figure holds a round shield. This is reversed on the next register; the third register returns to the same sequence as the top band, and so forth. Representations of combat scenes on diverse media, therefore, appear to show Moche warriors engaged in a form of intra-Moche ritualized warfare.

Recent discoveries at Dos Cabezas and Huaca Cao Viejo have provided additional evidence as to the ritual nature of Moche warfare. In a Moche burial at Dos Cabezas, Christopher Donnan and Alana Cordy-Collins found three wooden shields, each about 30 cm in diameter and covered with metal plaques (Christopher Donnan, personal communication, 1999). At Huaca Cao Viejo, two wooden maces were found deposited at the base of a wall (fig. 6) (Franco, Gálvez, and Vásquez 1999). The maces, carved from a single piece of wood, were originally covered with sheet metal. Although these weapons must have measured at least 120 cm in length, their shafts were less than 3 cm thick. As can be observed in Figure 5, the forms and sizes of these objects closely match those represented in the iconography. Several morphological features of these items suggest that they were more appropriate for ritual battle than for any kind of large-scale warfare. The shields, probably tied to the left wrist of the combatant, are too small to have offered much protection. The long, slender shafts of the maces make them relatively fragile and ineffective against an enemy. After the maces were broken, possibly in battle, they were deposited at the base of a wall at Huaca Cao Viejo, emphasizing once more the sacred and ritual dimensions of these objects. The metal coverings of

the shields and the maces also underscore the ritual nature of these accoutrements.

This does not mean that the Moche did not engage in more secularized, full-scale or all-out warfare. Such a subject, however, was clearly deemed unsuitable, or perhaps unnecessary, for depiction. If large-scale warfare were depicted, one would expect to see the type of weapons generally used in such battles, including slingshots, lances, and spear-throwers. Almost none of these are shown outside of deer hunting scenes.[3] The Moche were more interested in showing details of what appears to have been a warrior cult or class. Moche artists and their patrons chose to emphasize the *ritual* of combat, most likely a specific ritual sequence culminating in the sacrifice of prisoners. The ritualized nature of Moche warfare is constantly reiterated in scenes that portray the adoration of the warrior's bundle (Kutscher 1983: abb. 278), the display of a warrior's tunic and war implements (Berrin 1997: 138, fig. 77), and the anthropomorphization of the warrior's regalia (Kutscher 1983: abb. 271).

There is currently no evidence to suggest that the victims sacrificed at Huaca de la Luna were foreigners. Their apparent good health, their strength (based on the indices of muscle attachments), and the numerous old injuries suggest that they could have been part of a select group of Moche males specifically trained and prepared for these ritual activities (Verano, this volume, and 1998: 161).

6. Wooden clubs deposited at the base of a wall at Huaca Cao Viejo, El Brujo complex, Chicama Valley
Collection: Huaca Cao Viejo Archaeological Project

Blood and Sacrifice

As mentioned earlier, the main objective of battle was not to kill but to defeat opponents by capturing them and bringing them to the temple. The depiction of cactus, epiphytic plants, and what appear to be sand dunes or hills in the battle scenes has led authors to propose that these combats took place in unpopulated areas, away from human settlements (Alva and Donnan 1993: 129; Bawden 1996: 66; Shimada 1994: 110; Wilson 1988: 338). It is not clear to me where these ritual confrontations took place. Such plants, often shown with their root systems (fig. 5), are also present in other contexts, and could signify something other than a geographical location. They may refer to a subterranean world, and therefore to concepts of fertility and death (Bourget 1994). Upon arrival at the temples, captured warriors were presented to high-status individuals and eventually sacrificed by having their throats cut (Benson 1972: 46). Presumably their spurting blood was collected in a goblet and consumed by high-ranking individuals such as those represented in the Sacrifice Ceremony. Alva and Donnan proposed that this ritual really took place:

"When the Sacrifice Ceremony, with its distinct priests and symbolic elements, was first identified in Moche art in 1974, we wondered whether this ceremony was actually enacted by the Moche or whether it was played out by deities in some mythical setting. Since the only evidence of the ceremony was in the artistic depictions, we had no way of knowing whether it was a mythical or real event. The anthropomorphized bird and animal figures certainly seemed mythical, but perhaps these were artistic means to imply the supernatural aspects of real people who were enacting prescribed roles. Could it be that the Moche actually sacrificed their prisoners of war and consumed their blood? Not until the excavation of Tomb 1 [at Sipán] did we have archaeological evidence that this ceremony actually took place, with living individuals enacting the roles of the priests depicted in the art" (Alva and Donnan 1993: 141).

The discoveries at Sipán and San José de Moro provided evidence that details in the depictions of the Sacrifice Ceremony, particularly the regalia, had close correspondences with the archaeological record. Evidence for the actual collection of blood, however, remained elusive and conjectural until recently. In 1996 and 1997, Margaret Newman and I selected two Moche ceramic goblets, similar in form to those represented in the Sacrifice Ceremony, from museum collections for analyses. One goblet from the Museum für Völkerkunde, Berlin (fig. 7), and one from the Museo de Arqueología, Antropología e Historia de la Universidad Nacional de Trujillo, were tested by immunological analysis. Samples taken from the inside of each container showed a very strong positive reaction to human antiserum. The samples were also tested against a range of ten animal antisera, and human blood was the only positive result (Bourget and Newman 1998). We can, therefore, assume with confidence that at least some of these cups once contained human blood. To our knowledge, it represents the first conclusive evidence that the Moche did fill goblets with human blood, possibly to be drunk by religious attendants. The scene modeled in bas-relief around the body of the Berlin vessel implies that the blood was obtained from victims captured in battle.

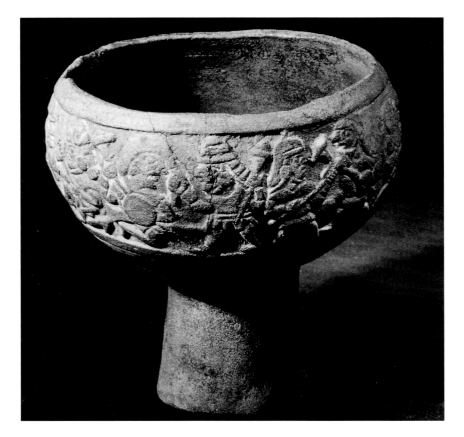

7. Ceramic goblet containing traces of human blood
Museum für Völkerkunde, Berlin (VA-47985)

Four pairs of warriors are shown engaged in one-on-one combat. Three of the pairs are exchanging blows to the face or the legs; in the fourth pair, one warrior is grasping his adversary by the hair, a sign of capture in Moche iconography (Alva and Donnan 1993: 129).

I do not mean to suggest a direct relationship between the Sacrifice Ceremony, the goblets, and the sacrificial site at Huaca de la Luna. We currently have no evidence that these rituals were linked. On the basis of archaeological and iconographical data, it is conceivable that a number of discrete rituals with sacrificial components could have been performed by the Moche, for different purposes. These may include rituals relatively well known to us through iconography and at least partially through archaeology, such as the Sacrifice Ceremony, as well as others that are less well understood and documented. For example, one type of ritual, called the Mountain Sacrifice, is known to us only through iconography at the moment (Bourget 1995; Zighelboim 1995). Others are known to us only through archaeology, such as the El Niño-linked sacrifice at the Huaca de la Luna. Representations of this ritual have yet to be properly identified in Moche iconography.

The Huaca de la Luna Sacrificial Site

The Huaca de la Luna is found at the foot of Cerro Blanco, and is composed of three platforms linked together by a series of terraces, corridors, and plazas (Uceda, this volume). The focus of my research has been Platform II and its associated plaza, designated Plaza 3A. This area is a prolongation of the main platform (Platform I) toward Cerro Blanco, and was completed during one of the last architectural phases of the site. Platform II and Plaza 3A represents a single architectural project constructed between the sixth and seventh centuries. Although Platform II has been badly damaged by looting activities and natural processes over the centuries, we were able to identify four tombs in this structure (fig. 2). These tombs are grouped together, on the northern side of the platform. A natural rocky outcrop is located toward the center of the complex, contiguous with the platform and the adjacent plaza. The sacrificial victims were found in the plaza, to the north and west of this feature.

Over the course of three field seasons we excavated fifteen strata of human remains in the plaza, representing at least five distinct rituals. We estimate that the remains of at least seventy individuals were in this 60 m² area. Few of the skeletons were complete; many disarticulated body parts were scattered across the area. In addition to the human remains, we found fragments of at least fifty unfired clay effigies of nude males with ropes around their necks, shown seated cross-legged with their hands usually resting on their knees (fig. 8).[4]

Plaza 3A provides evidence for a type of ritual that was heretofore undocumented in the archaeological record. It is now clear, however, that elements of this ritual were

8. Clay effigy from Plaza 3A, Huaca de la Luna
Museo de Arqueología, Antropología e Historia, Universidad Nacional de Trujillo

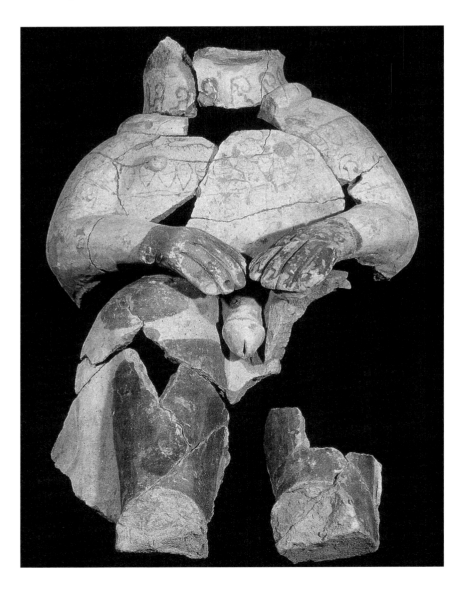

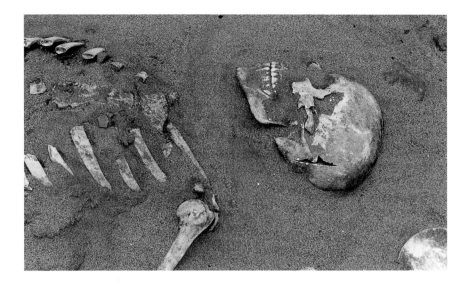

in Figure 9 have been found in burials at several Moche sites. These include the burials of two females in the urban sector of the Moche site (Chapdelaine et al. 1997: 82; Uceda and Armas 1997: 102), Tomb 1 at Sipán (Alva and Donnan 1993: 96) and the burial of a male at Dos Cabezas (Cordy-Collins, in press). Numerous representations of similar knives are seen on ceramics, in scenes of throat slashing and decapitation (see, for example, Berrin 1997: 150, no. 91).

A wooden club covered with black residue was found in Tomb I, on Platform II, adjacent to Plaza 3A (fig. 10). This tomb, partly looted, contained the remains of two males, one in his sixties, the other an adolescent. Immunological analysis of the residue on the club indicated that it had been repeatedly drenched in human blood (Bourget and Newman 1998). Approximately 70 cm in length, the club could have been used to break crania or other bones of victims. Figure 11 shows an individual with the sort of fracture that could have been inflicted by such a weapon. The sexagenarian male buried with the club could have been one of the official sacrificers associated with the plaza.

Body parts were removed from the victims and scattered around the plaza, as evidenced by the disarticulated skeletal remains of heads, arms, and legs (fig. 12). This practice may also have a counterpart in iconography. Depictions of severed arms and legs are found on a number of ceramic vessels, including a bottle

9. Detail of a human skeleton from Plaza 3A. The left temporal lobe shows evidence of a knife wound

10. Wooden club from Tomb 1, Platform II, Huaca de la Luna
Museo de Arqueología, Antropología e Historia, Universidad Nacional de Trujillo

11. Cranium with evidence of a blow to the occipital region, Plaza 3A, Huaca de la Luna

represented in Moche iconography. In this section I will discuss the physical and artifactual evidence discovered at Huaca de la Luna and compare it with the iconographical record.

Although most of the sacrifice tools were not found in the plaza, we can infer their use through the study of the skeletal remains. Knives and clubs were among the principal tools used. Figure 9 shows the remains of the upper torso and cranium of an individual who was dispatched by a knife wound on the left temporal region; the cut was deep enough to pierce the skull. This fatal wound was delivered with what appears to have been a crescent-blade copper knife at least 7 cm in width. We assume knives were also used to cut throats or decapitate victims. Knives of the type and size to deliver the wound shown

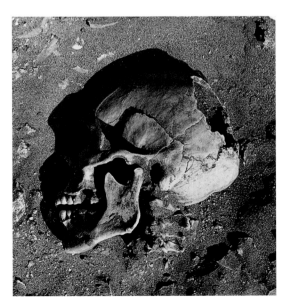

in the collections of the Museo Nacional de Antropología, Arqueología e Historia in Lima (fig. 13). In such depictions, ropes are often shown attached to disarticulated limbs and decapitated heads. In Plaza 3A, by the wrist of a victim, we found the imprint of a rope in the hardened clay. On one side of the Lima bottle, a phallus and testicles are painted between two nude individuals with ropes around their necks. The genitals appear to have been separated from the body. This practice is, of course, much more difficult to document archaeologically.

Other treatments of the body have been recorded. For example, we documented the insertion of body parts and other materials into the victims. At least four individuals were subjected to this type of activity. A rib and a human jaw were inserted respectively into the sacrum and thoracic cage of one victim; a toe was introduced into the pelvis of another, and a finger bone was forced between the ribs of a third. A rock, probably from the rocky outcrop, was tightly squeezed into the pelvis of the fourth victim (fig. 14).[5] In order to insert some of these objects, organs undoubtedly would have to be removed first.

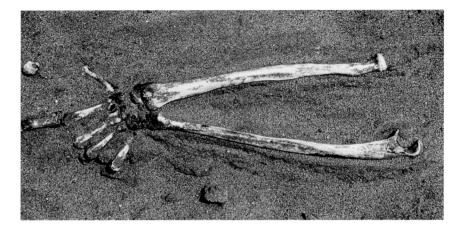

The victims' genitalia may have been a preferred area of torture, as underscored by a vessel found in Tomb 2 on Platform II (fig. 16). This vessel represents a seated prisoner, with zoomorphized rope (a snake) biting his penis. The image may be more than metaphor; it could signal the eventual removal of the sexual organs from the warriors.

Rocks were used as weapons in the plaza and were depicted in the iconography as well. Figure 13 shows an individual on the right

12. Remains of a disarticulated left arm, Plaza 3A

13. Ceramic bottle with a depiction of a sacrificial ritual
Museo Nacional de Antropología, Arqueología e Historia, Lima (C-04339)

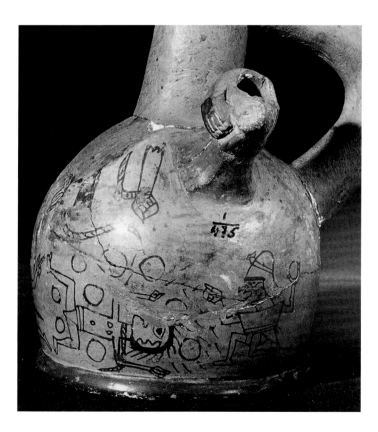

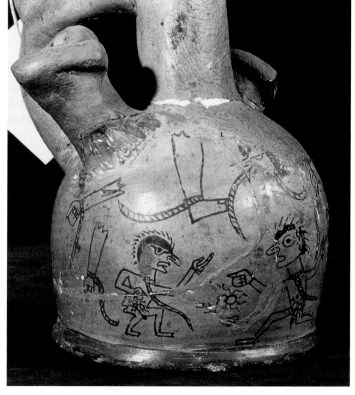

14. Detail of a human skeleton with a rock in its pelvis and a sea lion canine on its chest, Plaza 3A

15. Two human lower jaws side by side, Plaza 3A

16. Three vessels in the shape of captured warriors from Tomb 2, Platform II, Huaca de la Luna
Museo de Arqueología, Antropología e Historia, Universidad Nacional de Trujillo

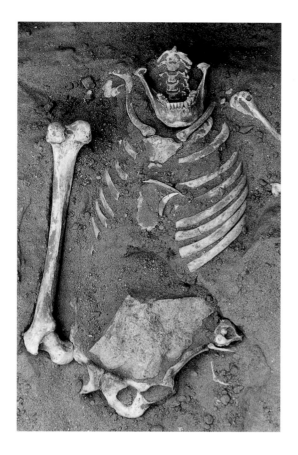

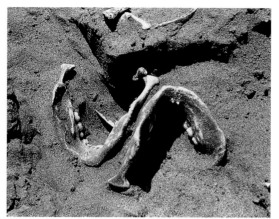

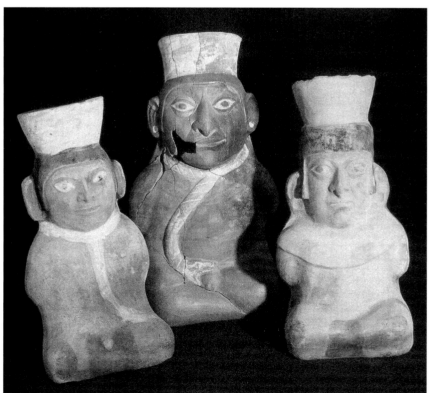

throwing a rock at a victim lying on the ground. In Plaza 3A numerous fragments of stone, probably from the rocky outcrop itself, were used as projectiles. These were thrown at the individuals in the plaza and at the clay effigies that were scattered amongst the victims. In a number of scenes in Moche iconography, fanged or skeletonized individuals are often shown about to hurl a stone (Donnan 1982: 120). This gesture is usually associated with funerary scenes or sacrificial rituals.

Another practice carried out on the victims at the Huaca de la Luna was the removal of the lower jaw. As mentioned earlier, in one instance a jaw was inserted in the thoracic cage of an individual; just to the side of him, two disarticulated lower jaws were placed next to each other, back to front (fig. 15). Jaws are often singled out in iconography. This anatomical part is also stressed in most of the clay effigies from the site. These figures have a design painted on their jaws, extending from cheek to cheek (fig. 17). In several fine-line paintings of combat and defeat, individuals are shown with their jaw decorated. A mural found early last century on Platform III of Huaca de la Luna represents a warrior pursued by an animated headdress (Bonavia 1985: fig. 59b). The marks on the warrior's jaw may represent similar designs. In one final example, the base of a Mountain Sacrifice scene from the Amano collection has been transformed into a gigantic skeletonized jaw and the victim is falling into it (Bourget 1994: fig. 3.14).

Another important aspect of sacrificial practices seen in the iconography is the

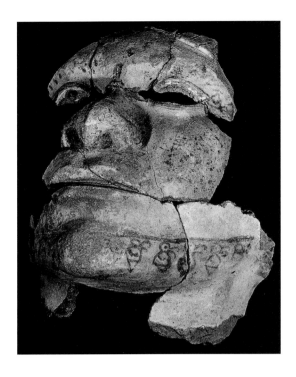

Tomb 1, we found the vertebra of an adult sea lion (*Otaria byronia*), along with some sherds of domestic ceramics, in a small recess at the bottom of a posthole (fig. 18, arrow). From a contextual perspective, these elements seem to indicate that sea lions are somehow associated with one of the victims of the sacrificial site, the clay effigies, and some of the activities performed on the platform.

A ceramic vessel in the collection of the Museum für Völkerkunde, Berlin, may shed light on this association (fig. 19). The ceramic vessel represents a person strapped to a rack. The vertical and horizontal elements of the rack terminate in sea lion heads. The face and hairstyle of the prisoner in the rack is similar to those of the clay effigies from the plaza (fig. 20). When seen from the back, one can see that the victim is firmly holding the lower jaws of the sea lion heads (fig. 19). The vessel links a captured male with sea lions, lower jaws, racks, and sacrifice.

17. Fragment of a clay effigy with a painted design on the lower jaw, Plaza 3A
Museo de Arqueología, Antropología e Historia, Universidad Nacional de Trujillo

18. Tomb 1, Platform II. The arrow (at right) points to the posthole

removal of the skin from the face (Larco Hoyle 1966: 22). At least one individual in Plaza 3A may have had one of these "face lifts," judging from the cut marks on the forehead and on the right orbit. To a certain extent, the physical evidence of sacrificial practices appears to match closely those represented in the iconography, but ritual sacrifices are more than just manipulations of the body. These physical practices were embedded in a complex web of beliefs. Turning to the symbolic aspects of human sacrifice, I will now focus on the relationship between the victims of Plaza 3A and sea lions and sarcosaprophagous insects.

Sea Lions

There seems to be a symbolic linkage between the victims of the plaza, an individual buried in Tomb 1 on Platform II, and sea lions. The canine tooth of a sea lion pup was found resting on the sternum of an individual in the plaza, the same individual who had a fragment of the rocky outcrop tightly inserted into his pelvis (fig. 14). This canine was not part of a necklace, but had been intentionally deposited on the body. Just next to this individual was a clay effigy with an image of a sea lion painted on its chest. On Platform II, by the side of

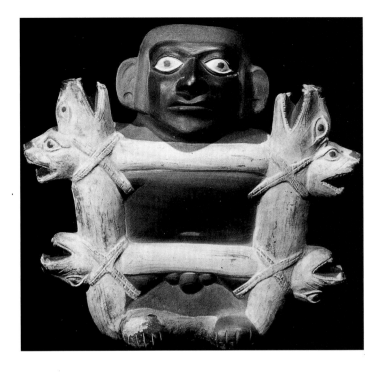

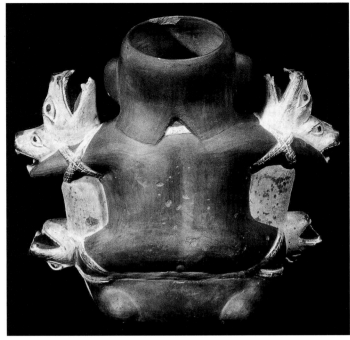

19. Front and back views of a
ceramic effigy of a victim in
a sacrificial rack
Museum für Völkerkunde, Berlin
(VA-48078)

Platform II was heavily looted in colonial and modern times, so that much has been lost. Nevertheless, despite the damage to the platform, we have been able to identify four postholes, three of them along the north side of the platform, and one near the south wall. A speculative, but intriguing possibility is that some of these postholes served to anchor wooden sacrificial racks. If this was the case, the sea lion vertebra deposited in the posthole could fulfil a metonymic function and underscore the symbolic relationship between sacrificial victims and sea lions.

The location of the posthole beside Tomb 1 may be significant. To continue in this speculative vein for a moment, it is tempting to suggest that sacrifices involving a rack were performed during the burial of high-ranking individuals such as the occupant of Tomb 1, the fellow with the bloody club. Christopher Donnan and Donna McClelland (1979) noted similar racks in the depictions of the Burial Theme, but the vertical and horizontal elements of the rack in this scene terminate in black vultures (*Coragyps atratus*). Similar racks are also represented in front of a stepped platform (Donnan 1978: 81, fig. 137). These racks clearly seem to be associated with funerary rituals, human sacrifice, and ceremonial architecture. Furthermore, the

Berlin vase (figs. 19), stylistically dated to Moche IV, could represent a form of *pars pro toto* for the Burial Theme, imagery which is more commonly associated with the Moche V period. Donnan (1978: 172) has shown that Moche artists could break down complex themes into constituent parts, and choose to represent only one or two aspects of a larger scene. These isolated subjects, usually

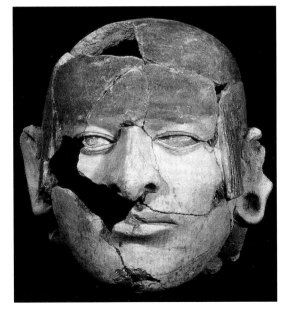

20. Fragment of a clay effigy,
Plaza 3A, Huaca de la Luna
Museo de Arqueología, Antropología
e Historia, Universidad Nacional de
Trujillo

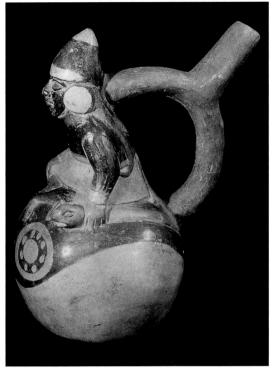

21. Stirrup-spout bottle in the shape of a warrior with conical helmet and club, Tomb 1, Platform II, Huaca de la Luna
Museo de Arqueología, Antropología e Historia, Universidad Nacional de Trujillo

22. Stirrup-spout bottle in the shape of a warrior with conical helmet and zoomorphic club
Museo Nacional de Antropología, Arqueología e Historia, Lima (C-03244)

rendered in three-dimensional form, could stand for the larger theme.

A stirrup-spout vessel found in Tomb 1 also appears to be associated with the theme of sea lions (fig. 21). The modeled figure on the vessel is a seated warrior, shown wearing a conical helmet and holding a bulbous club. This type of club is often shown in hunting scenes, including deer, fox, and sea lion hunts. In a fine-line depiction of a sea lion hunt (fig. 23), the sea lions are clubbed in the face, in

the same manner that warriors are in other painted scenes. The hunter on the left of Figure 23 is depicted with a black design on his jaw. Alongside this hunter, on the very far left of the scene, a female is seated in front of a small structure, preparing funerary offerings. The sea lion hunters wear headdresses that are typical for fishermen in Moche maritime scenes. In a depiction of a sea lion hunt on a vessel in the Museo Arqueológico Rafael Larco Herrera, Lima, one hunter also carries a small

23. Sea lion hunt on a painted Moche vessel from the Linden-Museum, Stuttgart
Redrawn from Kutscher 1983: 89

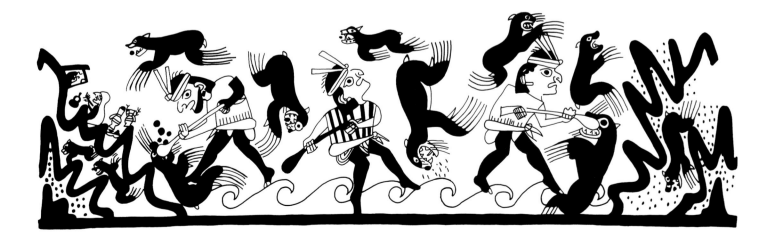

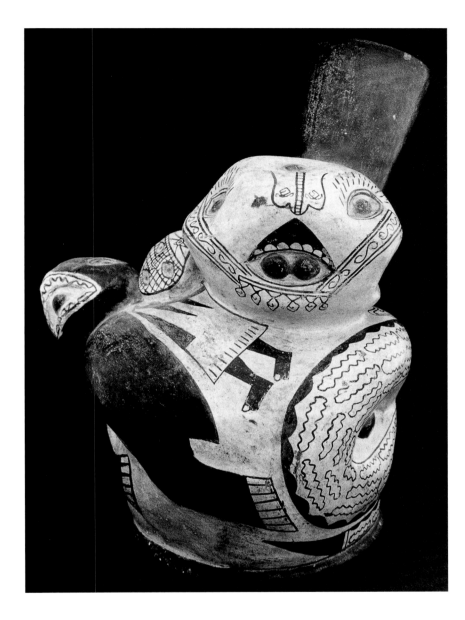

24. Jar in the shape of a potato with zoomorphic and anthropomorphic representations
Museo Nacional de Antropología, Arqueología e Historia, Lima (C-02923)

round shield, suggesting that this is no ordinary seal hunting expedition but an activity possibly associated with ritual warfare (Berrin 1997: 113, no. 47). In one painting known as the Revolt of the Objects, sea lions are associated with anthropomorphized warrior regalia taking captives (Quilter 1990: fig. 3).

In a vessel from the Lima Museo Nacional de Antropología, Arqueología e Historia (fig. 22), the warrior's club terminates in a sea lion's head. He also has a round shield resting just in front of him. This conflates the hunter and the hunted; the club and the sea lion. It is not possible at the moment to demonstrate that sea lions were perceived as surrogate

victims and were symbolically associated with the sacrificed warriors of the plaza. More research will be needed, but could it be possible that it is instead the hunters themselves that are associated with the victims of the plaza? Indeed, the hair of the hunters is disheveled much like representations of captured warriors. One other inconclusive but intriguing detail is a rounded depression on the earlobes of the clay effigies. Such a mark may indicate that these effigies represent in considerable detail the identifying elements of hunters and warriors—the depression undoubtedly connotes where an individual of such status would have worn tubular earplugs, that is, would have worn them before he was captured. The victims depicted in the sacrificial rack (fig. 19) and on vessels found in Tomb 2 (fig. 16) also have similar depressions in their earlobes.

A number of funerary contexts reinforce the mortuary and liminal associations of sea lions, one of the larger marine mammals found off the coast of Peru (Bourget 1990). At Huaca de la Cruz in the Virú Valley, a large sea lion effigy jar was buried with the attendant of the Warrior Priest burial (Strong and Evans 1952: 151). In the tomb of the female identified by Daniel Arsenault as linked to the Sacrifice Ceremony, two polished pebbles were found at the bottom of a flaring bowl (Strong and Evans 1952: 147). This tomb was situated just a few meters from the Warrior Priest burial. Marine biologists have noted that pebbles are swallowed by sea lions (Schweigger 1947: 210), and the Moche clearly knew this as well. Donnan has pointed out that sea lions are frequently represented with stones in their mouths (1978: 136). Figure 24, a potato effigy jar, shows a sea lion with two pebbles in its mouth.

A number of ceramics in the form of sea lion heads have been found in burials at Huaca de la Luna and Huaca Cao Viejo (Donnan and Mackey 1978: 113, 187; Franco, Gálvez, and Vásquez 1998: 15). At Pacatnamú, a site in the Jequetepeque Valley, a boot-shaped chamber filled with nine cane coffins contained the offering of a sea lion cranium (Hecker and Hecker 1992: 45, Tomb E I; Ubbelohde-Doering 1983: 53). Elsewhere in the Jequetepeque Valley, a sea lion scapula was found in a burial at San José de Moro (Donnan 1995: 147). Two gilded copper beads with sea lion facial

features were recovered from the looted tomb at Sipán; a necklace consisting of ten smaller sea lion beads was excavated from Tomb 3 as well (Alva 1988: 511; Alva and Donnan 1993: 200).[6]

Sea lions may have been associated with the victims of the sacrificial plaza at Huaca de la Luna because during El Niño events the Moche had to compete against these marine mammals for diminished resources. Sea lions also destroy fishing nets and poach fish in the process (Schweigger 1947: 209). Sea lions, symbolically speaking, are also liminal creatures. As their very name implies, they cross territorial boundaries of land and sea: they swim like fish, yet are covered with fur (Bourget 1994). This liminality probably had important symbolic ramifications in Moche beliefs about sacrifice, death, and the afterlife.

Sarcosaprophagus Insects

Most of the clay effigies from the plaza had designs painted on their lower jaws (fig. 17). Painted jaws are also indicated in fine-line depictions of warriors taking prisoners (Alva and Donnan 1993: 128, fig. 137). The larger scale of the designs on the plaza effigies, however, allows us to study these designs in greater detail. The lower jaws of the effigies are painted with a band of oval-shaped motifs, extending from ear to ear. The oval-shaped motifs appear to have heads and two appendages. I propose that these represent muscoid flies emerging from their pupal cases. Such a symbol would reiterate the transforming aspects of bodily decay, literally through insect infestation, that occurs in the liminal state of death.

Muscoid flies are usually the first to detect the presence of death. The flies will rapidly alight on the corpse and lay eggs or living larvae. The eggs will then hatch into larval forms and undergo successive molts before entering the inactive pupal stage (Smith 1986). The pupa is simply the hardened outer skin of the last larval stage, and the adult will develop inside this protective skin. In order to break free from the pupal case, the adult fly, while still inside the case, begins to fill with fluid a structure on top of its head, just between the eyes. The inflated head breaks the end of the pupal case and the fly begins to extract itself with its anterior legs. Thus the

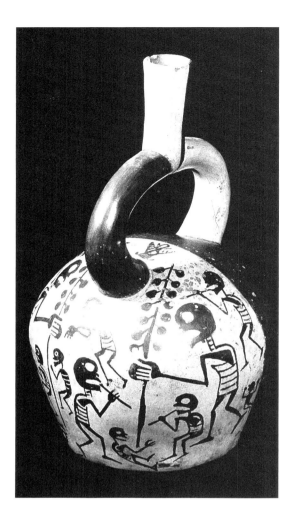

25. Stirrup-spout bottle with depictions of skeletons and a fly
Museum für Völkerkunde, Berlin (VA-62199)

design on the chin precisely depicts the anterior legs and the inflated head of the fly, with what appears to be an eye in the center, but which is more likely to be the large organ used to pop open the extremity of the pupal case.

Textual sources from the early colonial period and other evidence suggest that the soul took on the form of a fly after death. Anne-Marie Hocquenghem (1981) has suggested that the painting on a vessel in the collection of the Museum für Völkerkunde, Berlin (fig. 25) represents a "welcoming party" of skeletons greeting the arrival of the "soul" of a deceased individual, which takes on the form of a fly. The fly is located on top of the body of the vessel, just under the stirrup spout. In the Huarochirí Manuscript, a document dating to the end of the sixteenth century, flies and maggots are associated with the vital essence of the dead. Great caution must be exerted when using documents of a

26. Stirrup-spout bottle in
the form of a human head
Museum für Völkerkunde, Berlin
(VA-32567)

brought. She'd sit there for a long while. As soon as those maggots called *huancoy* worms left the corpse, the woman would say, 'Come on, let's go to the village.' And as if to say, 'This is him,' she'd pick up a small pebble and come back" (Salomon and Urioste 1991: 130–131).

In a footnote to this text, Frank Salomon and George Urioste mention that the *huancoy* could refer to maggots: "The point would then be that the cadaver must be left long enough to breed worms so its *anima* can emerge and escape in the form of flies" (1991: 131). This process would take at least eighteen to twenty days, from the time of the deposit of eggs or larvae to the departure of the adult flies.

The removal of the jaw of some victims in the plaza might in some fashion have been seen to accelerate the liberation of the soul or *anima* from the rotting corpse. A portrait vessel in the collection of the Berlin Museum für Völkerkunde (fig. 26) shows painted designs on the lower jaw and chin similar to those on the clay effigies of the plaza.[7] We can see a similar string of flies emerging from their pupae in association with a different sort of insect, shown immediately below the line of pupae, above the pair of figures with headdresses. I propose that these represent a species of carrion beetle, another insect that feeds on dead tissue. At this moment it is not possible to determine the exact species, but they could represent members of the Histeridae or Dermestidae families commonly found on corpses in the later stages of decomposition (Faulkner 1986; Smith 1986). Larvae of dermestids do not occur before the body is dry. Larvae and adults feed on dry skin, hair, and other dry dead organic matter. The representation of these insects and the integration of them into the symbolic domain of the Moche reiterate once more their pervasive interest in the human body and in the processes of death and decay in all its details. I suspect that the victims of Plaza 3A were intentionally left exposed for the flies to complete the ritual process. The departure of hundreds of new flies would have signaled the end of the sacrificial ceremony.

The practice of intentionally leaving disarticulated corpses to rot in the open air has been noted elsewhere on the north coast of Peru. During the Lambayeque occupation of

later period in the discussion of Moche iconography, but in this case, it is worth mentioning, as it shows the degree of pragmatism that may be part of the symbolic domain of ancient Andean cultures:

"In very ancient times, they say, when a person died, people laid the body out until five days had gone by. The dead person's spirit which is the size of a fly, would fly away saying, 'Sio!' When it flew away, people said, 'Now he's going away to see Paria caca, our maker and our sustainer'" (Salomon and Urioste 1991: 129).

Leaving the body exposed for five days would indeed have attracted a number flies, and it is likely that larvae or maggots could have been seen feeding, especially around orifices of the body such as the eyes, nose, or mouth:

"At Yaru Tini, as the sun was rising, the dead spirit would arrive. In the old times, two or three big flies—people call them *llacsa anapalla*—would light on the garment she

Pacatnamú (the cultural phase following the Moche occupation of the site), fourteen males were sacrificed and left exposed for some time in a trench alongside the northern entrance of one of the principle complexes (Verano 1986). Although these sacrifices appear to have been conducted for different reasons, striking similarities can be seen between this context and the Huaca de la Luna sacrificial site. All of the victims were between fifteen and thirty-five years of age. Further analyses of their skeletal material revealed that they were robust individuals, and a number of them showed evidence of old injuries. Verano (1986: 133) suggests that these victims were soldiers who had been taken prisoners of war. Some dismemberment also took place, although to a lesser extent than at Huaca de la Luna. Based on entomological evidence from the site, the mutilated corpses were left exposed for a number of weeks, if not months (Faulkner 1986).

Returning to the Museo Nacional de Antropología, Arqueología e Historia vessel (fig. 24), we can begin to appreciate more fully the complexity of the iconography of this piece and see the linkage of the victims of Plaza 3A, sea lions, and flies. Two sea lions are modeled and painted on the body of the vessel. One is visible on the side of the body of the vessel, his tail and flippers rendered two-dimensionally and his head three-dimensionally. The second takes the general form of the potato effigy, with his head on the top of the body of the vessel. He is shown with his upper lip cut out, two pebbles in his mouth, and the characteristic designs painted on his lower jaw. The very shape of the jar, a potato, further emphasizes the association with the earth and the subterranean (Bourget 1990).

Moche Rituals of Human Sacrifice

To the extent that we understand Moche ritual behavior, human sacrifice appears to have been an important and widespread component of Moche ritual life. Sacrificial practices involved a complex liturgy and were central to Moche religious activities, both in a physical sense, at the site of Moche, and in a conceptual sense. The various types of sacrificial rituals—those sacrifices that occurred at the moment of interment of important individuals, as well as larger sacrifices carried out for specific community purposes—were so widely represented and performed that we must assume that they were not rare or isolated occurrences, but formed a significant component of Moche religious life.

I suspect that the sacrificial site in the plaza of Huaca de la Luna is not the only one of its type and that others will be found in the future. In essence and transcendence the sacrificial site of Huaca de la Luna is intimately associated with the El Niño phenomenon and, by extension, the world of the sea—the destruction associated with El Niño is first and foremost associated with the changing sea current. Could the high walls of the plaza have contained a symbolic microcosm of the sea? Was the sacrifice of warriors in pools of mud during torrential rains symbolically related to sea lion hunts?

The practice of human sacrifice has profound implications for the social fabric and religious praxis of a society. In Moche culture, human sacrifice permeated most of their religious and symbolic performances. The social and political implications of this behavior are still poorly understood. More sacrificial contexts and more research will be needed before we fully comprehend the ramifications of these rituals not only for the Moche but for the Andean world as a whole.

NOTES

The Plaza 3A and Platform II Project was made possible by the generous support of The British Academy, The Leverhulme Trust and the Sainsbury Research Unit for the Arts of Africa, Oceania and the Americas of the University of East Anglia. The author would like to thank Santiago Uceda and Ricardo Morales for the opportunity to join the Huaca de la Luna Archaeological Project.

1. Great care must be exerted when determining if these accompanying burials were those of sacrificed individuals. At Sipán, for example, the disarticulated remains of three women found in Tomb 1 indicate that these were more likely secondary burials, perhaps relatives of the principal individual in the tomb who had died at a different time and were added to the tomb (Verano 1995: 197).

2. "Backflap" is a term used to refer to a thin sheet of metal, often ornamented at the top in bas-relief and inlay, and terminating in a curved edge. Backflaps were shown suspended from the waists of warriors in Moche iconography (see also Alva, this volume).

3. For a detailed analysis of ritual warfare and deer hunting, see Donnan (1997).

4. This number was arrived at by calculating the minimum number of penises, or MNP.

5. The manner in which these items were tightly embedded in the skeletons suggests that these were intentional placements by humans rather than the accidental scatter left by animal scavengers or the shifting of remains after the sacrificial events. Although small rocks were used as projectiles in the plaza, the large rock in the pelvis of the fourth individual is probably not the result of this type of action. The rock is too tightly fitted in the cavity, and there is no bone breakage as one would expect from the force of such a blow.

6. Alva has suggested that these were faces of felines, but on the basis of the form of the face, the shape of the mouth, the canines, the nose, and the eyes, I would argue that not only are these facial features consistent with those of living sea lions (*Otaria byronia*), but also with the way these marine mammals are represented on the ceramics. Furthermore, in this same tomb, these effigies are not the only ones that can be associated with the world of the sea. For example, elements associated with marine birds, octopus, crab, and two species of fish have been identified.

7. Christopher Donnan (this volume) makes a compelling case for the association between some of these vessels and the depiction of sacrificial victims in Moche iconography. Although more research is needed, the possible relationship between these portrait vessels and the clay effigies found in the site would reinforce the hypothesis that the human victims were a select group of individuals.

BIBLIOGRAPHY

Alva, Walter
1988 Discovering the New World's Richest Unlooted Tomb. *National Geographic* 174 (4): 510–549.

1990 New Tomb of Royal Splendor. *National Geographic* 177 (6): 2–15.

Alva, Walter, and Christopher B. Donnan
1993 *Royal Tombs of Sipán* [exh. cat., Fowler Museum of Cultural History, University of California]. Los Angeles.

Arsenault, Daniel
1994 Symbolisme, rapports sociaux et pouvoir dans les contextes sacrificiels de la société mochica (Pérou précolombien). Une étude archéologique et iconographique. Ph.D. dissertation, Département d'anthropologie, Université de Montréal.

Bawden, Garth L.
1996 *The Moche*. Oxford and Cambridge, Mass.

Benson, Elizabeth P.
1972 *The Mochica: A Culture of Peru*. New York and London.

Berrin, Kathleen
1997 (Editor) *The Spirit of Ancient Peru: Treasures from the Museo Arqueológico Rafael Larco Herrera* [exh. cat., Fine Arts Museums of San Francisco]. New York.

Bonavia, Duccio
1985 *Mural Painting in Ancient Peru*, trans. Patricia J. Lyon. Bloomington, Ind.

Bourget, Steve
1989 Structures magico-religieuses et idéologiques de l'iconographie Mochica IV. Master's thesis, Département d'anthropologie, Université de Montréal.

1990 Des tubercules pour la mort: Analyses préliminaires des relations entre l'ordre naturel et l'ordre culturel dans l'iconographie Mochica. *Bulletin de l'Institut Français d'Etudes Andines* 19 (1): 45–85.

1994 Bestiaire sacré et flore magique: Écologie rituelle de l'iconographie de la culture Mochica, côte nord du Pérou. Ph.D. dissertation, Département d'anthropologie, Université de Montréal.

1995 Los sacerdotes a la sombra del Cerro Blanco y del arco bicéfalo. *Revista del Museo de Arqueología, Anthropología e Historia* 5 [1994]: 81–125. [Trujillo].

1997a La colère des ancêtres: Découverte d'un site sacrificiel à la Huaca de la Luna, vallée de Moche. In *À l'ombre du Cerro Blanco: Nouvelles découvertes sur la culture Moche, côte nord du Pérou*, ed. Claude Chapdelaine, 83–99. Université de

Montréal, Département d'anthropologie, Les Cahiers d'Anthropologie 1. Montréal.

1997b Las excavaciones en la Plaza 3A de la Huaca de la Luna. In *Investigaciones en la Huaca de la Luna 1995*, ed. Santiago Uceda, Elías Mujica, and Ricardo Morales, 51–59. Facultad de Ciencias Sociales, Universidad Nacional de La Libertad, Trujillo.

1998a Pratiques sacrificielles et funéraires au site Moche de la Huaca de la Luna, côte nord du Pérou. *Bulletin de l'Institut Français d'Etudes Andines* 27 (1): 41–74.

1998b Excavaciones en la Plaza 3A y en la Plata-forma II de la Huaca de la Luna durante 1996. In *Investigaciones en la Huaca de la Luna 1996*, ed. Santiago Uceda, Elías Mujica, and Ricardo Morales, 43–64. Facultad de Ciencias Sociales, Universidad Nacional de La Libertad, Trujillo.

Bourget, Steve, and Margaret E. Newman
1998 A Toast to the Ancestors: Ritual Warfare and Sacrificial Blood in Moche Culture. *Baessler Archiv* N.F. 46: 85–106. [Berlin].

Chapdelaine, Claude, Santiago Uceda, María Montoya, C. Jauregui, and Ch. Uceda
1997 Los complejos arquitectónicos urbanos de Moche. In *Investigaciones en la Huaca de la Luna 1995*, ed. Santiago Uceda, Elías Mujica, and Ricardo Morales, 71–92. Facultad de Ciencias Sociales, Universidad Nacional de La Libertad, Trujillo.

Cordy-Collins, Alana
in press Decapitation in Cupisnique and Early Moche Societies. In *Ritual Sacrifice in Ancient Peru: New Discoveries and Interpretations*, ed. Elizabeth P. Benson and Anita Cook. Austin, Tex.

Donnan, Christopher B.
1978 *Moche Art of Peru: Pre-Columbian Symbolic Communication* [exh. cat., Museum of Cultural History, University of California]. Los Angeles.

1982 Dance in Moche Art. *Ñawpa Pacha* 20: 97–120.

1995 Moche Funerary Practice. In *Tombs for the Living: Andean Mortuary Practices* [A Symposium at Dumbarton Oaks, 12th and 13th October 1991], ed. Tom D. Dillehay, 111–159. Washington.

1997 Deer Hunting and Combat: Parallel Activi-ties in the Moche World. In *The Spirit of Ancient Peru: Treasures from the Museo Arqueológico Rafael Larco Herrera* [exh. cat., Fine Arts Museums of San Francisco], ed. Kathleen Berrin, 51–59. New York.

Donnan, Christopher B., and Luis Jaime Castillo
1992 Finding the Tomb of a Moche Priestess. *Archaeology* 45 (6): 38–42.

1994 Excavaciones de tumbas de sacerdotisas Moche en San José de Moro, Jequetepeque. In *Moche: Propuestas y perspectivas* [Actas del primer coloquio sobre la cultura Moche, Trujillo, 12 al 16 de abril de 1993], ed. Santiago Uceda and Elías Mujica, 415–424. Travaux de l'Institut Français d'Etudes Andines 79. Trujillo and Lima.

Donnan, Christopher B., and Leonard J. Foote
1978 Appendix 2. Child and Llama Burials from Huanchaco. In *Ancient Burial Patterns of the Moche Valley, Peru*, by Christopher B. Donnan and Carol J. Mackey, 399–407. Austin, Tex.

Donnan, Christopher B., and Carol J. Mackey
1978 *Ancient Burial Patterns of the Moche Valley, Peru*. Austin, Tex.

Donnan, Christopher B., and Donna McClelland
1979 *The Burial Theme in Moche Iconography*. Dumbarton Oaks Research Library and Collections, Studies in Pre-Columbian Art and Archaeology 21. Washington.

Faulkner, David K.
1986 The Mass Burial: An Entomological Perspective. In *The Pacatnamu Papers. Volume 1*, ed. Christopher B. Donnan and Guillermo A. Cock, 145–150. Museum of Cultural History, University of California, Los Angeles.

Franco, Régulo, César Gálvez, and Segundo Vásquez
1995 Programa arqueológico complejo "El Brujo." Programa 1994, informe final. Fundación A. N. Wiese. Report submitted to the Instituto Nacional de Cultura, Lima.

1996 Programa arqueológico complejo "El Brujo." Programa 1995, informe final. Fundación A. N. Wiese. Report submitted to the Instituto Nacional de Cultura, Lima.

1998 Desentierro ritual de una tumba Moche: Huaca Cao Viejo. *Revista Arqueológica SIAN* 6: 9–18. [Trujillo].

1999 Porras Mochicas del complejo El Brujo. *Revista Arqueológica SIAN* 7: 16–23. [Trujillo].

Hecker, Giesela, and Wolfgang Hecker
1992 Ofrendas de huesos humanos y uso repetido de vasijas en el culto funerario de la costa norperuana. *Gaceta Arqueológica Andina* 6 (21): 33–53.

Hocquenghem, Anne-Marie
1981 Les mouches et les morts dans l'icono-graphie mochica. *Ñawpa Pacha* 19: 63–69.

1987 *Iconografía Mochica*. Lima.

Kutscher, Gerdt
1983 *Nordperuanische Gefässmalereien des Moche-Stils*. Materialien zur allgemeinen und vergleichenden Archäologie 18. Munich.

Larco Hoyle, Rafael
1966 *Checan: Ensayo sobre las representaciones eróticas del Perú precolombino.* Geneva.

Quilter, Jeffrey
1990 The Moche Revolt of the Objects. *Latin American Antiquity* 1 (1): 42–65.

Salomon, Frank, and George L. Urioste
1991 (Translators) *The Huarochirí Manuscript: A Testament of Ancient and Colonial Andean Religion.* Austin, Tex.

Schweigger, Erwin
1947 *El litoral peruano.* Lima.

Shimada, Izumi
1994 *Pampa Grande and the Mochica Culture.* Austin, Tex.

Smith, Kenneth G. V.
1986 *A Manual of Forensic Entomology.* British Museum (Natural History), London.

Strong, William Duncan, and Clifford Evans
1952 *Cultural Stratigraphy in the Virú Valley, Northern Peru: The Formative and Florescent Epochs.* Columbia Studies in Archeology and Ethnology 4. New York.

Topic, John R., and Theresa Lange Topic
1997 Hacia una comprensión conceptual de la guerra andina. In *Arqueología, antropología e historia en los Andes: Homenaje a María Rostworowski,* ed. Rafael Varón Gabai and Jorge Flores Espinoza, 567–590. Instituto de Estudios Peruanos, Historia Andina 21. Lima.

Ubbelohde-Doering, Heinrich
1983 *Vorspanische Gräber von Pacatnamú, Nordperu.* Materialien zur allgemeinen und vergleichenden Archäologie 26. Munich.

Uceda, Santiago, and José Armas
1997 Los talleres alfareros en el centro urbano Moche. In *Investigaciones en la Huaca de la Luna 1995,* ed. Santiago Uceda, Elías Mujica, and Ricardo Morales, 93–104. Facultad de Ciencias Sociales, Universidad Nacional de La Libertad, Trujillo.

Verano, John W.
1986 A Mass Burial of Mutilated Individuals at Pacatnamu. In *The Pacatnamu Papers, Volume 1,* ed. Christopher B. Donnan and Guillermo A. Cock, 117–138. Museum of Cultural History, University of California, Los Angeles.

1995 Where Do They Rest? The Treatment of Human Offerings and Trophies in Ancient Peru. In *Tombs for the Living: Andean Mortuary Practices* [A Symposium at Dumbarton Oaks, 12th and 13th October 1991], ed. Tom D. Dillehay, 189–227. Washington.

1998 Sacrificios humanos, desmembramientos y modificaciones culturales en restos osteológicos: Evidencias de las temporadas de investigación 1995–96 en la Huaca de la Luna. In *Investigaciones en la Huaca de la Luna 1996,* ed. Santiago Uceda, Elías Mujica, and Ricardo Morales, 159–171. Facultad de Ciencias Sociales, Universidad Nacional de La Libertad, Trujillo.

Wilson, David J.
1988 *Prehispanic Settlement Patterns in the Lower Santa Valley, Peru: A Regional Perspective on the Origins and Development of Complex North Coast Society.* Smithsonian Series in Archaeological Inquiry. Washington.

Zighelboim, Ari
1995 Mountain Scenes of Human Sacrifice in Moche Ceramic Iconography. In *Current Research in Andean Antiquity,* ed. Ari Zighelboim and Carol Barnes, 153–188. Journal of the Steward Anthropological Society 23 (1, 2).

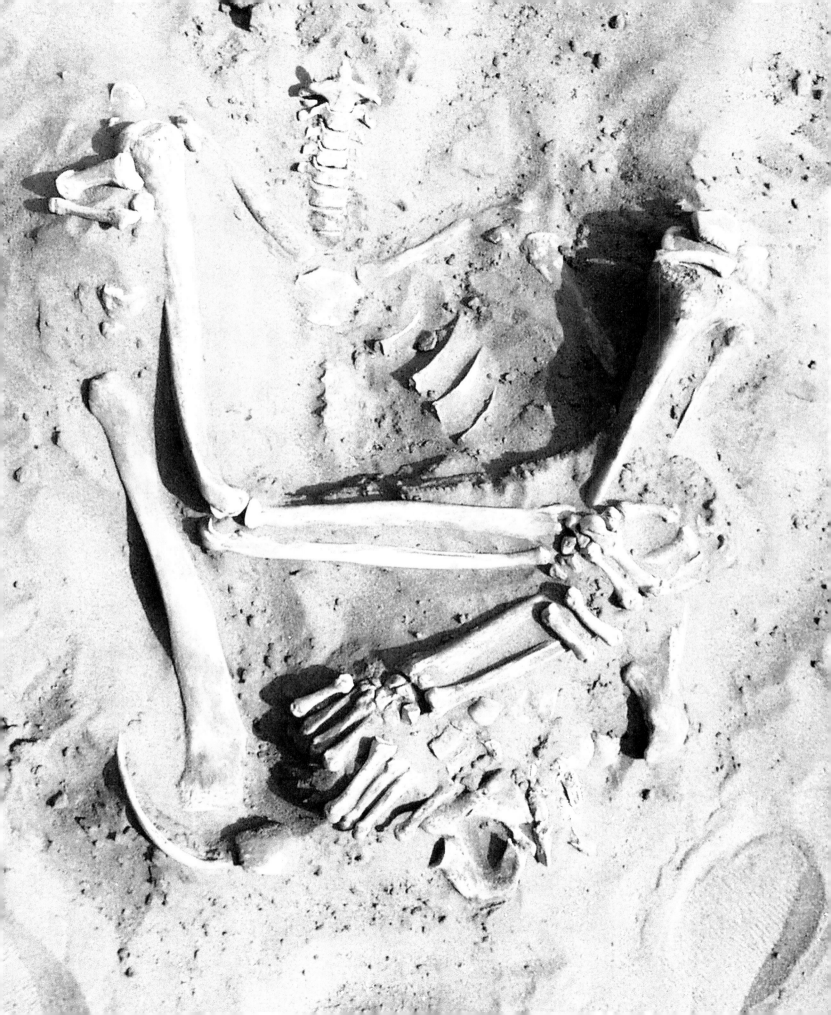

JOHN W. VERANO
Tulane University

War and Death in the Moche World: Osteological Evidence and Visual Discourse

There has long been active debate about the political organization of Moche society. Some scholars propose that the Moche were rather loosely organized as a confederation of valley polities linked by ideology and political alliances, somewhat analogous to the royal courts of Europe (Alva and Donnan 1993: 220). Others argue that Moche was a centralized state-level society, ruled from the site of Moche (Billman 1996; Moseley 1992; Wilson 1988). A third model proposes that state-level organization was achieved only in terminal Moche times (Moche V), with the establishment of a capital at Pampa Grande in the Lambayeque Valley (Shimada 1994). These competing models draw support from diverse sources of evidence. A central issue, however, is the nature of Moche expansion and control —whether military or otherwise—over the coastal valleys of northern Peru, and the relationships between Moche elites in these valleys. If Moche was indeed a state-level society that expanded and maintained control by force of arms, one would expect to see archaeological evidence of warfare, population displacement, and the construction of defensive sites and administrative centers. One also might expect Moche iconography to include scenes of combat, conquest, and the subjugation of defeated enemies.

Most scholars would agree that convincing archaeological evidence of Moche warfare and military conquest has yet to be found, but the apparently rapid spread of the Moche into the Virú, Santa, and Nepeña valleys (Donnan 1973; Proulx 1982; Willey 1953) indicates some form of territorial expansion, and evidence of dramatic settlement pattern shifts and the construction of defensive sites in some north coast valleys (Bawden, this volume, and 1982; Dillehay, this volume) suggests periods of conflict and instability. There is no question, however, that armed combat is a common theme in Moche art. The issue I would like to explore in this paper has long been a familiar one to students of Moche iconography: whether Moche combat scenes depict a form of ritualized combat among the elite class, or secular warfare and conquest. Although this question is an old one, it has been brought back to the forefront recently by a series of important archaeological discoveries at the sites of Sipán, San José de Moro, and the Huaca de la Luna, which provide new insight into the nature of Moche warfare.

Moche Warriors and Warfare

Modeled ceramic figures of warriors, and combat scenes in fine-line slip painting on ceramic vessels are common in Moche art. Fine-line combat scenes appear on some Moche III ceramic vessels, but they are most numerous—and appear in most detailed form—on Moche IV vessels (Shimada 1994: 108). Most scholars who have described these scenes (Donnan 1973, 1997; Hocquenghem 1987; Kutscher 1950, 1954) interpret them as

Decapitated and defleshed sacrificial victim from Plaza 3C, Huaca de la Luna
Photograph courtesy of the Huaca de la Luna Project

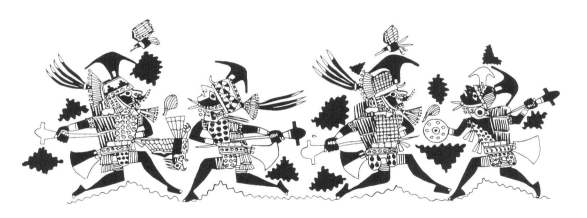

1. Moche one-on-one combat scene. Roll-out drawing from a painting on a vessel in the collection of Mr. and Mrs. Nicholas Gessler, Los Angeles
Drawing by Donna McClelland

some form of ritualized combat among the Moche elite—not as depictions of conquest or warfare with non-Moche polities. This interpretation is based on a number of common elements in these scenes, such as the number and placement of figures, their clothing, ornamentation and weapons, the location in which combat takes place, and the apparent focus on taking captives rather than killing the enemy. Scenes showing the display of captives and their sacrifice at rituals presided over by Moche supernaturals provide additional support for the hypothesis that Moche combat was formalized and ritual in nature.

Donnan sees similarities between the iconography of combat and of deer hunting, a ritualized activity that appears to have been reserved for the Moche elite (Donnan 1997). Hocquenghem (1987), and more recently John and Theresa Topic (Topic and Topic 1997) see similarities with historical accounts of ceremonial combat among the young nobles of Inca Cuzco, and with ritual battles among modern highland groups in Ecuador (*pucara*) and Peru (*tinku*). A significant distinction between these ritual battles and the Moche case, however, is that most injuries incurred in ritual battles are minor (although deaths can occur), and prisoners, if taken, are later returned. In the Moche case, the stakes were considerably higher, as prisoners apparently did not return home. Whether these ritual battles are appropriate analogies for Moche combat can be questioned on a number of grounds. Let us first examine the principal iconographic elements of Moche combat and related scenes involving the presentation and sacrifice of captives.

Combat Scenes

Kutscher, Donnan, Hocquenghem, and others have noted a number of common themes in Moche combat scenes. First, combat is presented almost invariably as a face-to-face encounter between paired opponents who fight with close-range weapons—typically clubs (fig. 1). Although individuals occasionally carry longer-range arms such as spear-throwers and slings, these are rarely shown being used against an opponent. This is in clear distinction to Moche deer hunting scenes, in which the spear-thrower is the principal weapon used. Some combat scenes show slings apparently lying on the ground near figures engaged in combat, suggesting that these longer-range weapons may have been used initially and later abandoned (fig. 2). However, discarded spears or sling stones are not shown in these scenes. Overall, the proximity of opponents and the weapons they hold emphasize close-in fighting.

Donnan (1997) notes that women, children or other noncombatants do not appear in

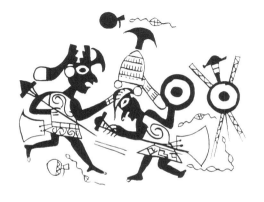

2. Combat scene showing scattered slings and ceramic vessels as background elements. Roll-out drawing from a painting on a vessel in the Museum für Völkerkunde, Berlin (VA-18397)
Drawing after Hocquenghem 1987: fig. 84

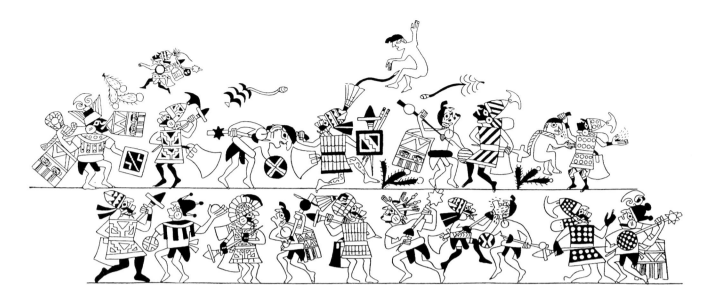

Moche combat scenes, and that other indications of organized warfare, such as fortified sites under siege, destroyed villages, or large numbers of soldiers are absent. The location of fighting appears to be out in the open—not within or around architecture. Mountains are often shown in the background, and plants, birds, and occasionally other objects like ceramic vessels may appear "floating" around the combatants. Donnan points out that most of the plants are desert species, suggesting that conflict took place away from agricultural fields and settlements. Hocquenghem (1987: 117) notes, however, that some of the plants are cultigens, and suggest that battles may have been part of some agrarian ritual.

Combatants are typically shown in full ceremonial regalia, including metal and feather headdress ornaments, elaborate tunics, metal backflaps, and even nose ornaments (fig.1). Such elaborate dress and ornamentation clearly marks the participants as elites, given that commoners would probably not have access to such items (Alva and Donnan 1993; Donnan 1995). Many of the objects worn by these individuals, such as complex headdresses and nose ornaments, would be impractical, if not annoying, in an actual physical confrontation—yet they appear to be standard combat dress. This would tend to support the hypothesis that Moche combat, like deer hunting, was a ritual activity limited to the elite class.

A final and important observation regarding dress and weaponry is that with few exceptions all opponents appear to wear Moche attire and carry Moche style weapons. One of the exceptions to this rule, shown in Figure 3, is frequently illustrated simply because it stands out as an anomaly. In this scene, one group of fighters is wearing classic Moche warrior attire: conical helmets, often with crescent-shaped ornaments, tunics in classic Moche style, and crescent-shaped backflaps. They wield long war clubs with conical heads that are typically Moche as well. Their opponents are dressed in a more diverse fashion, but all sport a distinctive waistband/loincloth, and many carry a banner-like object suspended from the neck or shoulders. Their weapons are different from the first group—most carry a star-headed mace—and two are shown about to launch stones at their opponents. Star-head maces and slings are not foreign to the Moche, but they are infrequently used as weapons in combat scenes. It is primarily the *dress* of the second group, however, that makes them distinctive. Other examples of combat scenes with exotically dressed warriors are known, but they are rare. Most combat shown in Moche art involves opponents dressed in Moche style and carrying Moche weapons.

Taking Prisoners

Judging from what is shown in Moche iconography, the taking of captives appears to have been the principal objective of combat.

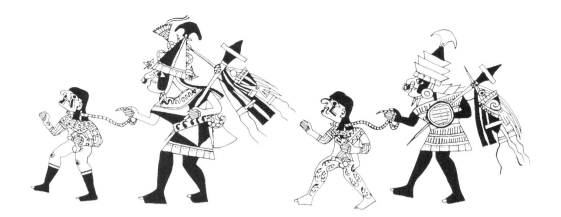

4. Prisoners, stripped of their clothing and weapons, are led from the field of battle. Roll-out drawing from a painting on a Moche vessel in a private collection
Drawing by Donna McClelland

Although splayed (presumably dead) figures occasionally appear in combat scenes, they are rare. There are no examples of victims pierced by spears—something commonly seen in deer hunting—nor are there any illustrations showing the dispatching, decapitating or dismembering of victims on the battlefield. What *is* typically shown is the overpowering or stunning of an opponent, who frequently loses his helmet, headdress, and other items, and is grabbed by the hair and taken captive. The victor strips the vanquished of his weapons and elaborate clothing, which he then hangs from his own war club. The victor then places a rope over the captive's neck and parades him away (fig. 4).

Captives are later shown being presented before elaborately dressed individuals, who frequently sit under roofed structures or atop elevated architecture. In one of the most complex presentation scenes there is a clear status hierarchy among the captives (fig. 5). Some captives are carried in litters by other captives, and even among the litter-borne there appear to be indications of differential rank—the individual in the first litter is distinguished by a stepped seat, and only the third litter rider has a rope around his neck. This explicit hierarchy is unusual, however; captives are generally shown simply as nude individuals with ropes around their necks or with their hands bound behind their backs.

5. An arraignment of prisoners. Roll-out drawing of a painting on a vessel in the American Museum of Natural History, New York
Drawing by Donna McClelland

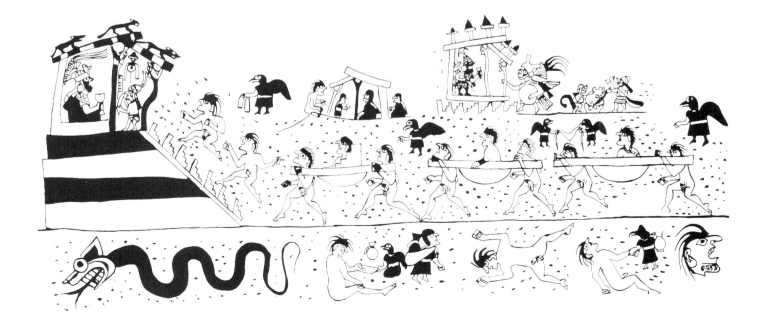

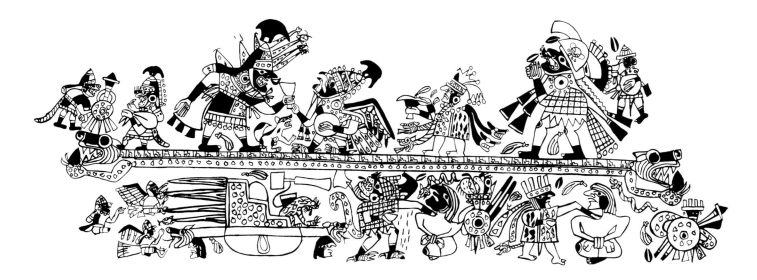

6. The Sacrifice Ceremony scene. Roll-out drawing of a painting on a vessel in the Staatliches Museum für Völkerkunde, Munich (see Introduction, fig. 4)
Drawing by Donna McClelland

Sacrifice

The fate of warriors captured in battle is also depicted with clarity in Moche iconography. In scenes adjacent to the presentation of prisoners, bound captives are shown having their throats slit and their blood collected by attendants. The blood appears to be collected and then presented in a goblet to a principal figure who presides over this event. Depictions of what has become known as the Sacrifice Ceremony (Alva and Donnan 1993: 127–141) have been found in fine-line and low relief on ceramic vessels (fig. 6), in painted wall murals, and in abbreviated form in metalwork. The Sacrifice Ceremony was apparently a standardized ritual that involved a cast of supernatural figures. Although the iconography of this ritual had been known for years (Donnan 1978: 158–173), its supernatural participants (fanged deities, anthropomorphized birds and felines), implied a ritual narrative rather than an actual ceremony with human actors.

Beginning in 1987, a series of archaeological discoveries at the sites of Sipán and San José de Moro (1991–1992) would provide evidence that the Sacrifice Ceremony was in fact performed by human actors—dressed as supernaturals. Chamber tombs at Sipán contained the remains of elite individuals buried with the diagnostic headdresses and ornamentation of the two principal figures in the Sacrifice Ceremony, the Warrior Priest and the Bird Priest, according to Donnan (Alva and Donnan 1993). A third major figure in the ceremony, the Priestess, was to be linked to two high-status female burials excavated at the site of San José de Moro several years later (Donnan and Castillo 1994). The discoveries at Sipán and San José de Moro, and the insight they provided into iconography found in other north coast valleys, led to several important conclusions: (1) members of the Moche elite—impersonating deities or supernaturals—indeed presided over ceremonies involving the sacrifice of captives; (2) these ritual offices were passed on through time, as indicated by the tombs of two priestesses at San José de Moro, and perhaps multiple warrior priests at Sipán; (3) the Sacrifice Ceremony was not enacted in only one location, but apparently at multiple sites extending from the Lambayeque Valley in the north to the Nepeña Valley (based on a painted mural of the Sacrifice Ceremony at the site of Pañamarca) to the south.

Recent discoveries at the sites of El Brujo complex in the Chicama Valley, and the Huaca de la Luna in the Moche Valley serve to complete the picture. Painted friezes showing combat scenes, the arraignment of prisoners, and supernatural spider "decapitators" adorn the north façade of the Huaca Cao Viejo in the El Brujo complex (Gálvez and Briceño, this volume; Franco, Gálvez, and Vásquez

1994). The proximal end of a human femur, with cut marks indicating that it was taken from a fleshed body, was incorporated into one of these friezes (Verano, Anderson, and Lombardi 1998), suggesting that the prisoner display and decapitation scenes are not simply metaphorical. Skeletal remains of possible sacrificial victims were also found under the north courtyard of Huaca Cao Viejo in 1995 (Franco, Gálvez, and Vásquez 1996).

Evidence of the sacrifice of captives is more dramatic at the Huaca de la Luna. Excavations by Steve Bourget in 1995–1996 uncovered the most extensive evidence to date: the remains of more than seventy adolescent and young adult males who were killed and deposited around the base of a rock outcrop on Platform II of the Huaca de la Luna (Bourget, this volume, and 1997a, 1997b). Osteological analysis of these remains provides, for the first time, information on the age, sex, and physical characteristics of sacrificed captives, as well as evidence of injuries they suffered in combat, how they were sacrificed, and some details about the postmortem treatment of their remains (Verano 1998). These observations will be discussed further below.

Integrating the Iconographic and Archaeological Evidence

Breakthroughs in understanding the iconography of combat, prisoner capture and human sacrifice by the Moche have come largely through these recent archaeological discoveries, which provide physical evidence of such activities. Integrating the two sources of information, scholars can now reexamine previous hypotheses about the nature of Moche warfare and the performance of sacrificial ritual. However, beyond the simple revelation that the Moche indeed "did these things" (took captives and sacrificed them in an elaborate ritual presided over by a deity-impersonating priesthood), there remain many unresolved questions. Was Moche combat simply an elite activity analogous to deer hunting? Was it fundamentally a ritual activity closely tied to Moche religious practices, or could political motives also have driven this activity? Most scholars who have studied the iconography of Moche combat make the implicit assumption that Moche artists were

being accurate and realistic in their depictions. The very plausible alternative that Moche artists were presenting intentionally simplified and idealized images of "noble combat" among the elite has been largely ignored. The recent discoveries at Sipán and San José de Moro may have had the unfortunate effect of overextending the notion that the Moche were depicting "events that really happened," leading to a search for undue realism and literality in Moche iconography.

If most armed combat shown in Moche iconography is indeed Moche against Moche —as has been deduced from costuming and weapons—the question remains as to who the players were, and where they came from. Archaeological evidence now indicates that prisoner sacrifice rituals were performed at Moche ceremonial complexes up and down the north coast. This suggests several possibilities. Valleys may have competed against one another to obtain captives for their respective temples. Alternatively, combat may have been arranged between different centers within a single valley or perhaps between different warrior societies at a single ceremonial/population center. Finally, it is possible that the Moche were obtaining some of their captives through conflicts with neighboring non-Moche polities.

The Moche's Highland Neighbors: What Kind of Neighbors *Were* They?

Archeological surveys conducted by Christopher Donnan, Donald Proulx and David Wilson indicate that there were shifting and probably conflict-prone boundaries between the highland Recuay and the middle/lower valley Gallinazo (pre-Moche) polities of the Virú, Santa, and Nepeña valleys. Billman's more recent survey of the Moche Valley found similar evidence of shifting boundaries between middle and upper valley populations prior to Moche consolidation of the valley (Billman 1997). The nature of Moche-Recuay interaction is poorly understood, but some scholars have suggested that combat scenes such as that in Figure 4 may depict battles between the Moche and Recuay (Disselhoff 1956; Proulx 1982). Shimada suspects that territorial conflicts may also have existed between the Moche and the highland Cajamarca polity, and suggests that "future studies may

well reveal that some of the Mochica battle scenes also depict conflict with the Cajamarca polity." (1994: 93).

Unfortunately, combat scenes showing individuals dressed in non-Moche style are rare, and to my knowledge the dress and weaponry of these "outliers" has yet to be identified unequivocally as either Recuay or Cajamarca. It is notable, however, that the best-known example of combat involving "exotic" participants adheres to the standard Moche artistic conventions of one-on-one combat, the capture, stripping and binding (rope around the neck) of captives, and other details like the presence of cacti and other plants as background elements. If the scene depicted in Figure 3 indeed shows conflict between the Moche and an outside group, it suggests one of two possibilities: (1) Moche warfare waged against "others" was ritualized to the same degree as intra-Moche combat; or that (2) Moche artists simplified this scene so as to emphasize only the classic "one-on-one" theme.

Archaeological Evidence for Warfare

If the Moche were involved in frequent warfare with their neighbors, one might expect to see archaeological evidence in the form of abandoned settlements, fortified sites along territorial frontiers, or skeletal remains showing signs of violence. To date, such evidence has been largely elusive, but many archaeological sites have been destroyed or seriously damaged by erosion, construction, and looting, and site survey and excavation has been limited in many of the areas where such conflicts may have occurred. It must also be remembered that military encounters may not leave evidence that is obvious or easy to find. For example, the military confrontation that resulted in the conquest of the Chimú state by the Inca in the late fifteenth century is invisible in the archaeological record. Nevertheless, if warfare was common in the Moche domain, evidence of fractures and other trauma should be found in Moche cemeteries.

Unfortunately, until recent years the study of Moche skeletal remains has been largely neglected, due to a focus by archaeologists on grave goods rather than on the remains of the dead. The situation has gradually improved, however, so that a number of samples of Moche skeletal remains have now been analyzed and published (Verano 1994a, 1994b, 1997a, 1997b). Examination of skeletal remains from both elite and common Moche burials has shown that evidence of violent injuries, such as fractures or projectile wounds, is rare. This is in contrast to the high frequency of healed skull fractures found in some central Peruvian highland samples from the late pre-contact period (Verano and Williams 1992). Although more cemetery samples need to be studied, my impression is that the average Moche man and woman on the street had little experience with violent encounters.

The Huaca de la Luna Sacrificial Site

The discovery of a Moche sacrificial site at the Huaca de la Luna in 1995 is of great importance because it is the first archaeological evidence of large-scale sacrifice of captives by the Moche (Bourget, this volume, and 1997a, 1997b). It is important also because the skeletal remains of the victims are well preserved and have now been studied (Bracamonte 1998; Verano 1998). The discovery provides a rare opportunity to compare the iconography of prisoner sacrifice with archaeological and osteological evidence. Results of these preliminary analyses are consistent with a number of details presented in the iconography.

As an outgrowth of an iconographic study of Moche sacrificial scenes in the context of mountain shrines, Steve Bourget began survey and excavations at the Huaca de la Luna, a site at the base of Cerro Blanco in the Moche Valley in 1995. His excavations focused on a walled plaza and small platform that had been built around a natural rock outcrop on the west flank of Cerro Blanco, part of a late construction phase (Moche IV; c. A.D. 500–600) at the Huaca de la Luna. Excavations of the area surrounding the outcrop revealed a deposit of multiple layers of silt, hardened mud, and sand that contained abundant human skeletal remains and broken unfired ceramic vessels in the form of seated male figures. The deposit appears to represent multiple events in which the bodies of sacrificial victims were deposited around the base of the rock outcrop and left to decompose on the

7. Healed fractures of left radius and ulna and left rib. Huaca de la Luna ARP-II, Individual 1

surface before being buried by silt and wind-blown sand.

In 1996, archaeologist Clorinda Orbegoso conducted limited excavations in an adjacent plaza, designated Plaza 3C, under the auspices of the Huaca de la Luna Project (Orbegoso 1998). These excavations recovered additional skeletal remains.

In the spring of 1995, at the invitation of Bourget, I began an osteological analysis of the Plaza 3A remains, with the assistance of Florencia Bracamonte of the Universidad Nacional de Trujillo and Laurel Anderson of Tulane University (Verano 1998). The Plaza 3C material was studied in 1996. The objective of the analysis was to determine age at death, sex, and physical characteristics (stature, general health) of the remains, and to examine them for evidence of cause of death.

The skeletal remains from Plaza 3A include complete articulated skeletons, partial skeletons, isolated limbs, hands, feet, or other clusters of articulated elements, and individual isolated bones (Bourget, this volume, and 1997a, 1997b). The high frequency of disarticulation complicates the task of estimating the total number of individuals present, but skeletal element counts indicate a minimum of seventy. All remains for which sex can be determined are clearly male; no remains of females or children are present. In terms of age, all fall into the adolescent to middle adult (fifteen to thirty-nine year) age range, with most individuals estimated to have died in their early to mid twenties. Overall, the demographic composition indicates a highly selective sample of individuals.

The Plaza 3A individuals were healthy and physically active, as indicated by pronounced muscle attachment areas, general bone size, and some early arthritic changes suggesting intense physical activity. Very little evidence of nutritional or infectious disease was found, but healed fractures are quite common. Healed fractures of ribs, long bones, and depressed fractures of the skull were seen in eighteen individuals, and several of these had suffered multiple fractures (fig. 7). This is a very high frequency in comparison to Moche cemetery samples I have studied. Moreover, many of these injuries, especially skull fractures and broken ribs, are more typical of wounds incurred through interpersonal violence than from accidents. Overall, the fracture data suggest that this was a group with a history of violent encounters.

Perimortem Injuries

Perimortem injuries are those that occur at or around the time of death, when bone is flexible and responds to trauma in a different manner than dry or ancient bone (Sauer 1998). The two most common perimortem injuries

8. Cut marks on second cervical vertebra. Huaca de La Luna ARP-II, Individual XVIII a

9. Fractured left ulna in process of callus formation at time of death. HG96-102

10. Skull fracture. Huaca de La Luna ARP-II, HG96-102

show captives having their throats slit to collect blood.

The skull fractures indicate massive head trauma, typically with breakage of a large portion of the cranial vault (fig. 10). Most appear to have been produced by blows from blunt objects, although in a few cases the margins of broken areas suggest a weapon with sharp protuberances, such as a star-headed mace. In Moche iconography captives are typically not shown being dispatched with clubs in sacrifice scenes, so there is not a close correspondence here. However, a wooden club was

seen in the Plaza 3A victims are cut marks on the cervical (neck) vertebrae and skull fractures. Approximately 75 percent of individuals with fully observable cervical spines show cut marks. These vary in number from one to more than nine distinct cuts, located on the anterior surface of the vertebral bodies or on the transverse processes (fig. 8). Cuts to the throat deep enough to mark bone would have been mortal wounds; the likely cause of death for most individuals, therefore, was exsanguination. The location of cut marks implies that the objective was to cut the throat of victims, not to decapitate them. Cut marks on anterior surfaces of the cervical vertebrae are precisely what would be expected to be found, based on Moche sacrifice scenes that

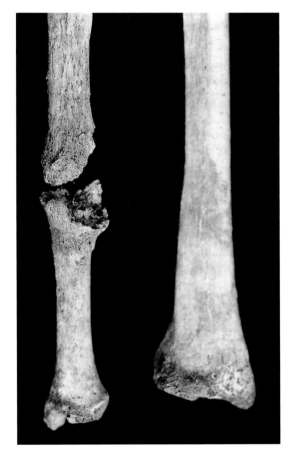

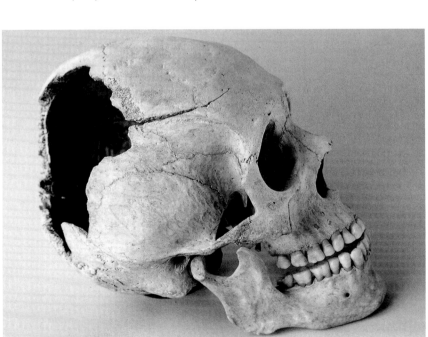

found by Bourget in 1997 in an elaborate tomb in Platform II, just above the sacrifice deposit. It was recently tested for organic residue, and was found to have a strong positive reaction to human antiserum. Bourget and Newman (1998) conclude that the residue on the club is human blood. Bourget also found evidence that rocks had been thrown at ceramic vessels, and has suggested that the

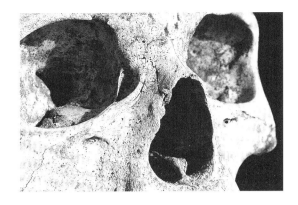

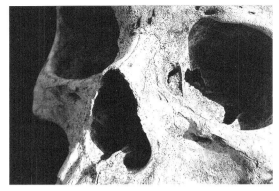

11. Fractures and bone reaction around margins of nasal aperture. Individual XVII

bodies, as well as some parts of the sacrificial victims may have been manipulated and intentionally arranged following death (Bourget 1997a, 1997b). Perhaps some of the skull breakage resulted from these activities.

Healing Injuries

An important detail that emerged from our osteological analysis is that in addition to peri-mortem trauma, at least twelve individuals had injuries that were in the early stages of healing at time of death. These include fractured ribs, shoulder blades, bones of the forearm (fig. 9), and in two cases, the margins of the nasal aperture (fig. 11). The fractures show various degrees of bone reaction, indicating survival for at least several weeks to perhaps a month, based on comparisons with documented clinical cases (Sledzik and Murphy 1990). Presumably these injuries were sustained either during combat or following capture. Three examples were found (fig. 9) of classic "parry" fractures of the left ulna (one of the bones of the forearm), a fracture that commonly occurs when the arm is used to block a blow (Merbs 1989). The small marginal fractures and bone reaction around the nasal aperture seen in Figure 11 appears to

reflect blows to the face. Moche prisoner-capture scenes sometimes show victors striking their captives on the nose; an example can be seen in the lower right corner of Figure 3.

Fractures in the process of healing at the time of death suggests that a significant period of time (weeks to perhaps a month or more) elapsed between the time an individual was captured and the moment of death at the Huaca de la Luna. Processions of prisoners shown in Moche art may therefore be illustrating extended rituals involving the public display of captives. Alternatively, captives may have been brought to the Huaca de la Luna from some distant location.

Osteological analysis indicates that some of the sacrificial victims were physically mistreated. Small, repeated cut marks are present on hand and foot bones of several individuals (fig. 13); one skull shows multiple cut marks around the margin of the right eye socket, and one victim appears to have had a sharp object inserted between his toes. None of these injuries appear to be wounds inflicted in hand-to-hand combat; they suggest intentional mistreatment of some captives. As previously mentioned, bound captives are sometimes shown being struck by their captors, but other evidence of the mistreatment of captives is rare, although punishments such as mutilation of the nose and lips (Urteaga-Ballon 1991) and flaying of the face are known from Moche iconography.

Skeletal Remains from Plaza 3C

In 1995–1996, limited excavations in an adjacent courtyard, designated Plaza 3C, uncovered the largely disarticulated remains of seven individuals (Orbegoso 1998; Verano

12. Cut marks distal third of shaft of left fibula. Huaca de La Luna, Plaza 3C, burial 1

13. Cut marks on first metacarpal (thumb); Huaca de La Luna ARP-II

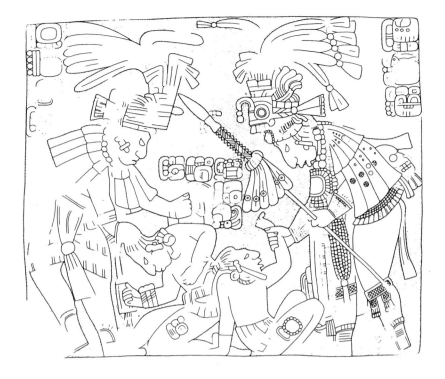

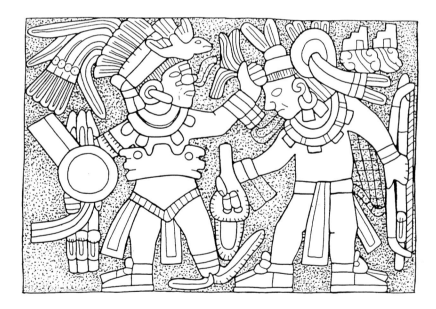

14. Bird Jaguar capturing Jeweled Skull. Lintel 8, Yaxchilan, Chiapas, Mexico
Drawing by Ian Graham

15. Detail from the sacrificial stone of Motecuhzoma I, showing the conquest of Tenayuca by the Aztec ruler
Drawing by Emily Umberger

1998). These remains are distinct from those in Plaza 3A because they show cut marks suggesting dismemberment and intentional defleshing (fig. 12). Cut marks are present on nearly all bones recovered from Plaza 3C. The location of the cuts corresponds in most cases to areas of muscle attachment—often in the midshaft region of long bones, for example—implying that the objective was not simply to disarticulate, but to *deflesh* the skeletons.

Although the Plaza 3C sample is small, the remains are similar in age and sex to those in Plaza 3A—adolescent and adult males. The Plaza 3C excavations, although limited in extent, suggest that some sacrificial victims at the Huaca de la Luna received more complex treatment than was observed in Plaza 3A. Why they were defleshed is a subject for speculation, although depictions of dismembered captives are known from Moche art. Further excavation and analysis are needed to address this question.

An Emerging Picture

Archaeological discoveries on the north coast of Peru over the past ten years have resulted in significant revelations about both the iconography and practice of warfare, prisoner capture, and human sacrifice among the Moche. These discoveries have demonstrated that a common sacrificial ceremony was practiced at multiple ceremonial centers along the north coast, presided over by individuals who impersonated Moche deities as they toasted one another with the blood of their captives. Royal tombs at Sipán and San José de Moro contain the mortal remains and insignia of some of those who presided over these rituals, and the skeletons of sacrificial victims litter the plaza floors of the Huaca de la Luna. One essential missing piece in this puzzle remains, however: the identities of the sacrificial victims. At present these individuals stand as shadowy players in a game of "ritual combat," with no clear function other than to provide the necessary captives and blood for the Sacrifice Ceremony. In the absence of a Moche written history or even reliable ethnohistorical sources on Moche religion and political organization, the identity of captives and the motivations for their capture are difficult questions to approach. One avenue of investigation we are currently following is an attempt to identify the population origin of the Huaca de la Luna victims using genetically determined skeletal traits, mitochondrial DNA, and bone chemistry. We have previously used several of these techniques with some success at a mass burial site dating to the Late Intermediate period in the Jequetepeque Valley (Verano and DeNiro

1993). However, such analyses require reference populations with which to compare the unknowns, and there are surprisingly few adequate skeletal samples available for Moche, Recuay or Cajamarca. One hopes the situation will improve in future years.

Cautionary Tales

Despite recent breakthroughs in interpreting the iconography of Moche warfare and human sacrifice, there remain some potential pitfalls in the interpretive scenarios generated from them. Research on Moche iconography and archaeology is often characterized by an intense inward focus, with limited appreciation of parallels beyond the north coast of Peru. Examples of similar iconography from pre-hispanic central Mexico and the Maya area provides a warning against unqualified acceptance of Moche combat as strictly "ritual."

Maya and central Mexican depictions of warfare and the capture of prisoners are strikingly similar to Moche iconography. Features such as stereotyped one-on-one confrontations, the elaborate dress and ornamentation of the combatants, the use of short-range weapons, and the taking of captives all closely parallel what is seen in Moche art. Details such as grasping captives by the hair and stripping them of their elaborate clothing and weapons are also similar. In Maya iconography, the presentation of captives before an elaborately dressed figure seated atop elevated architecture is a frequent theme. Finally, the fate of captives is often ritual sacrifice on the summit of the temple.

In the absence of other sources of information, one could use examples such as Figures 14 and 15 to argue that Maya and Aztec warfare was a ritualized activity limited to members of the elite class, and that its principal objective was to acquire captives for sacrifice. One could extend the argument to conclude that Maya and Aztec iconography depicts only ritual combat and not the conquest of one polity by another. In fact, the latter is *precisely what these figures record*. Figure 14, Lintel 8 from Yaxchilan, Chiapas, Mexico, shows Bird Jaguar (on the right) taking his most prized captive—Jeweled Skull—on May 9, A.D. 755 (Schele and Miller 1986: fig. V.3). Figure 15, a detail from the sacrificial stone of Motecuhzoma I (c. A.D. 1455–1469), docu-

ments the conquest of the Tenayuca polity by the Aztec ruler Motecuhzoma I, shown in the guise of the Aztec war god Huitzilopochtli, grasping the god of Tenayuca by the hair (Umberger 1996). These images communicate elegantly the essential information intended by the artist, without the need for details such as the military campaigns that led to victory, the number of soldiers involved, or the methods used to defeat the enemy. As in Moche art, there are no women, children or other noncombatants shown, nor are there fields of soldiers, buildings under siege, destroyed villages, or any other indications of organized warfare.

This is not to argue that Maya and Aztec warfare did not have ritualized elements, or that the taking of captives for human sacrifice was not an important part of warfare. The principal distinction is that in the Maya and Aztec case we know that *specific historic conquests* are recorded, because associated inscriptions give the names of the polities, the leaders, and in some cases, the dates when these events occurred. This kind of information is lacking in Moche iconography. Indeed, our interpretation of scenes such as Figure 5 would be dramatically enhanced if we knew the identities of the prisoners and the events preceding and following their capture. While little can be done to remedy this lack of knowledge, such difficulties underscore the need to avoid an oversimplistic approach to interpreting Moche iconography.

Given the comparative examples above, it should be evident that iconography alone cannot be used to conclude that Moche combat was principally a ritual activity of the elite. It is likely, as in the Maya and Aztec cases, that warfare indeed had ritualized elements, but we can also assume that its iconographic representation was highly formalized —and therefore cannot be interpreted literally. Given our lack of contextual knowledge, combat and prisoner arraignment scenes in Moche art must be interpreted with caution. In my opinion, many of these scenes probably depict specific events, with known participants. Whether these events recorded ritualized conflict between polities—such as competition between ceremonial centers or the periodic renewal of territorial boundaries—or whether they documented the conquest of one polity by another, cannot be answered

from the iconography. Nevertheless, the existence of multiple ceremonial centers such as Sipán, San José de Moro, El Brujo, Moche, and Pañamarca—all showing evidence of participation in combat and the sacrifice of prisoners—would tend to support the model of Moche society as composed of a number of competing "royal courts" rather than a centralized state ruled from the Moche Valley.

The sacrificial site recently excavated at the Huaca de la Luna confirms that captives were indeed sacrificed in a manner consistent with that shown in Moche art. It is likely that skeletal remains of more sacrificial victims remain undiscovered at other ceremonial centers. Osteological analysis of the Huaca de la Luna victims indicates that they were a very select group—young males whose healed injuries indicate previous experience with combat. Their age profile, physical characteristics, and evidence of previous wounds suggest that they may have been "professionals" and not simply occasional weekend warriors. The lack of older males (forty-plus) in this sample is interesting, as it suggests either that older men did not participate directly in combat, or that they received different treatment if captured.

Much remains to be understood about Moche armed conflict. This brief attempt to explore the nature of war and death in the Moche world underlines the significant challenges we face in attempting to reconstruct Moche society, political structure, and religion from iconographic and archaeological evidence alone.

NOTE

Field research reported here was made possible by funding from the Tulane University Committee on Research, The Council for the International Exchange of Scholars (Fulbright Commission), and Tulane University's Center for Latin American Studies.

BIBLIOGRAPHY

Alva, Walter, and Christopher B. Donnan
1993 *Royal Tombs of Sipán* [exh. cat., Fowler Museum of Cultural History, University of California]. Los Angeles.

Bawden, Garth L.
1982 Galindo: A Study in Cultural Transition During the Middle Horizon. In *Chan Chan: Andean Desert City*, ed. Michael E. Moseley and Kent C. Day, 285–320. School of American Research Advanced Seminar Series. Albuquerque, N.M.

Billman, Brian R.
1996 The Evolution of Prehistoric Political Organizations in the Moche Valley, Peru. Ph.D. dissertation, Department of Anthropology, University of California, Santa Barbara.

1997 Population Pressure and the Origins of Warfare in the Moche Valley, Peru. In *Integrating Archaeological Demography: Multidisciplinary Approaches to Prehistoric Population*, ed. Richard R. Paine, 285–310. Southern Illinois University at Carbondale, Center for Archaeological Investigations, Occasional Paper 24. Carbondale.

Bourget, Steve
1997a La colére des ancêtres: Découverte d'un site sacrificiel à la Huaca de la Luna, vallée de Moche. In *À l'ombre du Cerro Blanco: Nouvelles découvertes sur la culture Moche, côte nord du Pérou*, ed. Claude Chapdelaine, 83–99. Université de Montréal, Département d'anthropologie, Les Cahiers d'Anthropologie 1. Montréal.

1997b Las excavaciones en la Plaza 3A de la Huaca de la Luna. In *Investigaciones en la Huaca de la Luna 1995*, ed. Santiago Uceda, Elías Mujica, and Ricardo Morales, 51–59. Facultad de Ciencias Sociales, Universidad Nacional de La Libertad, Trujillo.

Bourget, Steve, and Margaret E. Newman
1998 A Toast to the Ancestors: Ritual Warfare and Sacrificial Blood in Moche Culture. *Baessler Archiv* N.F. 46: 85–106. [Berlin].

Bracamonte, G. Florencia
1998 Los sacrificios humanos en la Plaza 3A afloramiento rocoso Plataforma II Huaca de la Luna: La evidencia de cultos de crisis. M.A. thesis, Universidad Nacional de Trujillo.

Disselhoff, Hans Dietrich
1956 Hand- und Kopftrophäen in plastischen Darstellungen der Recuay-Keramik. *Baessler Archiv* N.F. 4 (1): 25–32. [Berlin].

Donnan, Christopher B.
1973 *Moche Occupation of the Santa Valley, Peru*. University of California Publications

in Anthropology 8. Berkeley and Los Angeles.

1978 *Moche Art of Peru: Pre-Columbian Symbolic Communication* [exh. cat., Museum of Cultural History, University of California]. Los Angeles.

1995 Moche Funerary Practice. In *Tombs for the Living: Andean Mortuary Practices* [A Symposium at Dumbarton Oaks, 12th and 13th October 1991], ed. Tom D. Dillehay, 111–159. Washington.

1997 Deer Hunting and Combat: Parallel Activities in the Moche World. In *The Spirit of Ancient Peru: Treasures from the Museo Arqueológico Rafael Larco Herrera* [exh. cat., Fine Arts Museums of San Francisco], ed. Kathleen Berrin, 51–59. New York.

Donnan, Christopher B., and Luis Jaime Castillo
1994 Excavaciones de tumbas de sacerdotisas Moche en San José de Moro, Jequetepeque. In *Moche: Propuestas y perspectivas* [Actas del primer coloquio sobre la cultura Moche, Trujillo, 12 al 16 de abril de 1993], ed. Santiago Uceda and Elías Mujica, 415–424. Travaux de l'Institut Français d'Etudes Andines 79. Trujillo and Lima.

Franco, Régulo, César Gálvez, and Segundo Vásquez
1994 Arquitectura y decoración Mochica en la Huaca Cao Viejo, complejo El Brujo: Resultados preliminares. In *Moche: Propuestas y perspectivas* [Actas del primer coloquio sobre la cultura Moche, Trujillo, 12 al 16 de abril de 1993], ed. Santiago Uceda and Elías Mujica, 147–180. Travaux de l'Institut Français d'Etudes Andines 79. Trujillo and Lima.

1996 Los descubrimientos arqueológicos en la Huaca Cao Viejo complejo "El Brujo." *Arkinka* 1 (5): 82–94. [Lima].

Hocquenghem, Anne-Marie
1987 *Iconografía Mochica*. Lima.

Kutscher, Gerdt
1950 Iconographic Studies as an Aid in the Reconstruction of Early Chimu Civilization. *Transactions of the New York Academy of Sciences* Series II 12 (6): 194–203.

1954 Nordperuanische Keramik. Monumenta Americana 1. Berlin.

Merbs, Charles F.
1989 Trauma. In *Reconstruction of Life From the Skeleton*, ed. Mehmet Yaşar İşcan and Kenneth A. R. Kennedy, 161–189. New York.

Moseley, Michael E.
1992 *The Incas and Their Ancestors: The Archaeology of Peru.* London and New York.

Orbegoso, Clorinda
1998 Excavaciones en el sector sureste de la Plaza 3C de la Huaca de la Luna durante 1996. In *Investigaciones en la Huaca de la Luna 1996*, ed. Santiago Uceda, Elías Mujica, and Ricardo Morales, 67–73. Facultad de Ciencias Sociales, Universidad Nacional de La Libertad, Trujillo.

Proulx, Donald A.
1982 Territoriality in the Early Intermediate Period: The Case of Moche and Recuay. *Ñawpa Pacha* 20: 83–96.

Sauer, Norman J.
1998 The Timing of Injuries and Manner of Death: Distinguishing Among Antemortem, Perimortem and Postmortem Trauma. In *Forensic Osteology: Advances in the Identification of Human Remains*, 2d ed., ed. Kathleen J. Reichs, 321–331. Springfield, Ill.

Schele, Linda, and Mary E. Miller
1986 *The Blood of Kings: Dynasty and Ritual in Maya Art* [exh. cat., Kimbell Art Museum]. Fort Worth, Tex.

Shimada, Izumi
1994 *Pampa Grande and the Mochica Culture.* Austin, Tex.

Sledzik, Paul S., and Sean P. Murphy
1990 Bone Remodeling After Trauma [Abstract]. In Section 4: Round Table Discussions. In *Papers on Paleopathology Presented at the Seventeenth Annual Meeting of the Paleopathology Association. Miami. Florida. 3–4 April 1990*, 10, ed. Eve Cockburn. Detroit, Mich.

Topic, John R., and Theresa Lange Topic
1997 La guerra Mochica. *Revista Arqueológica SIAN* 4: 10–12. [Trujillo].

Umberger, Emily
1996 Aztec Presence and Material Remains in the Outer Provinces. In *Aztec Imperial Strategies*, by Frances Berdan, Richard E. Blanton, Elizabeth Hill Boone, Mary G. Hodge, Michael E. Smith, and Emily Umberger, 151–179. Washington.

Urteaga-Ballon, Oscar
1991 Medical Ceramic Representation of Nasal Leishmaniasis and Surgical Amputation in Ancient Peruvian Civilization. In *Human Paleopathology: Current Syntheses and Future Options* [A Symposium held at the International Congress of Anthropological and Ethnographical Sciences, Zagreb, 24–31 July 1988], ed. Donald J. Ortner and Arthur C. Aufderheide, 95–101. Washington.

Verano, John W.
1994a Material osteológico recuperado por el Proyecto 'La Mina,' valle de Jequetepeque: Informe preliminar. In *Moche: Propuestas y perspectivas* [Actas del primer coloquio

sobre la cultura Moche, Trujillo, 12 al 16 de abril de 1993], ed. Santiago Uceda and Elías Mujica, 83–84. Travaux de l'Institut Français d'Etudes Andines 79. Trujillo and Lima.

1994b Características físicas y biología osteológica de los Moche. In *Moche: Propuestas y perspectivas* [Actas del primer coloquio sobre la cultura Moche, Trujillo, 12 al 16 de abril de 1993], ed. Santiago Uceda and Elías Mujica, 307–326. Travaux de l'Institut Français d'Etudes Andines 79. Trujillo and Lima.

1997a Physical Characteristics and Skeletal Biology of the Moche Population at Pacatnamu. In *The Pacatnamu Papers, Volume 2*: The Moche Occupation, ed. Christopher B. Donnan and Guillermo A. Cock, 189–214. Fowler Museum of Cultural History, University of California, Los Angeles.

1997b Human Skeletal Remains from Tomb I, Sipán (Lambayeque River Valley, Peru); and their Social Implications. *Antiquity* 71 (273): 670–682.

1998 Sacrificios humanos, desmembramientos y modificaciones culturales en restos osteológicos: Evidencias de las temporadas de investigación 1995–96 en la Huaca de la Luna. In *Investigaciones en la Huaca de la Luna 1996*, ed. Santiago Uceda, Elías Mujica, and Ricardo Morales, 159–171. Facultad de Ciencias Sociales, Universidad Nacional de La Libertad, Trujillo.

Verano, John W., Laurel S. Anderson, and Guido P. Lombardi
1998 Análisis osteológico de los restos humanos Moche hallados en la Huaca Cao Viejo por el Proyecto Arqueológico Complejo "El Brujo." Manuscript on file, Fundación A. N. Wiese, Lima.

Verano, John W., and M. J. DeNiro
1993 Locals or Foreigners? Morphological, Biometric and Isotopic Approaches to the Question of Group Affinity in Human Skeletal Remains Recovered From Unusual Archaeological Contexts. In *Investigations of Ancient Human Tissue: Chemical Analysis in Anthropology*, ed. Mary K. Sandford, 361–386. Langhorne, Pa.

Verano, John W., and J. Michael Williams
1992 Head Injury and Surgical Intervention in Pre-Columbian Peru [Abstract]. *American Journal of Physical Anthropology*, Supplement 14: 167–168.

Willey, Gordon R.
1953 *Prehistoric Settlement Patterns in the Virú Valley, Perú*. Smithsonian Institution, Bureau of American Ethnology Bulletin 155. Washington.

Wilson, David J.
1988 *Prehispanic Settlement Patterns in the Lower Santa Valley, Peru: A Regional Perspective on the Origins and Development of Complex North Coast Society.* Smithsonian Series in Archaeological Inquiry. Washington.

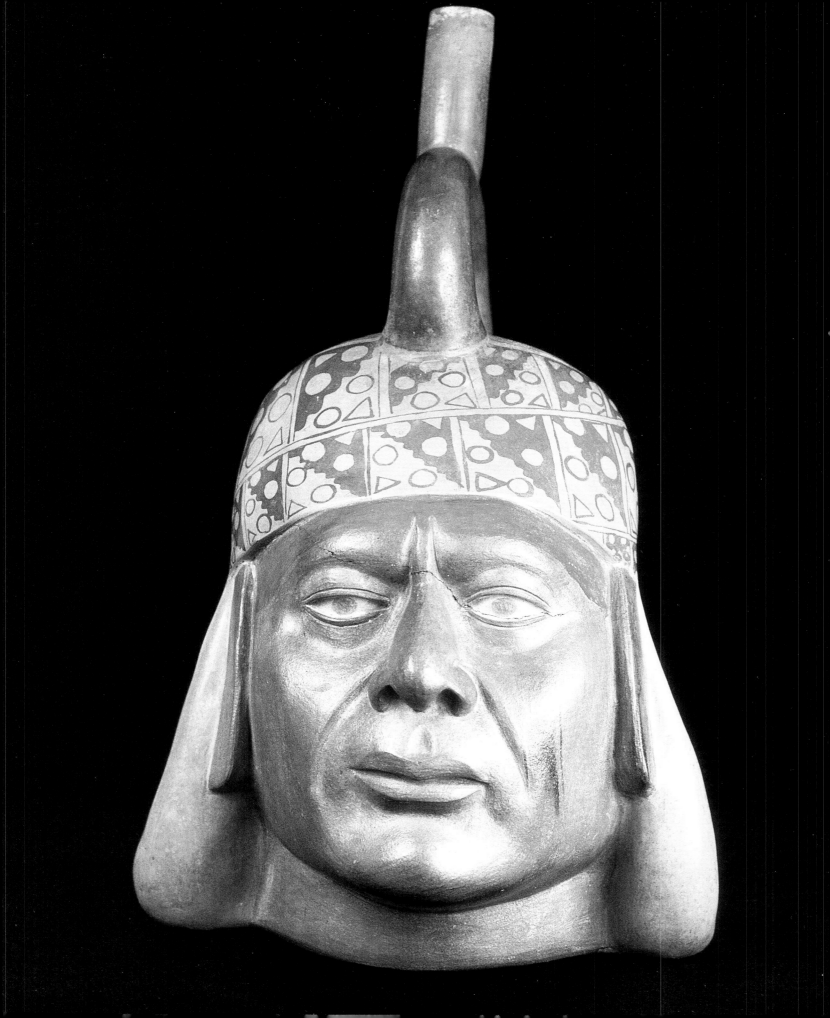

CHRISTOPHER B. DONNAN
University of California, Los Angeles

Moche Ceramic Portraits

One of the great achievements of Moche civilization was the production of true portraits of individuals in three-dimensional ceramic sculpture. These were made as functional ceramic vessels that could contain liquid. Moche portrait vessels are well known and widely appreciated today, but the nature of their production and distribution, and the ways in which they functioned in Moche society are not well understood. Moreover, there is little knowledge of who was portrayed in the portraits, and why. This study provides insights recently gained from a systematic analysis of a large sample of Moche ceramic portraits in museums and private collections throughout the world. [1]

Geographic and Temporal Distribution of Moche Portraits

Although portraiture is often considered a hallmark of Moche civilization, its production was very limited, both geographically and temporally. Moche portrait vessels were made only in the southern Moche region—south of the Pampa de Paiján (fig. 1). Within this region, most have been found in the Chicama, Moche, and Virú valleys, and this is probably where they were produced. A few have been found in the Santa Valley (Larco Hoyle 1939: fig. 192), and it is possible that some were actually produced there. To date, there have been no documented examples of portrait vessels from the Nepeña, Casma, or Huarmey valleys, and it is unlikely that any were produced there.

There have been no documented examples of ceramic portraits in the northern Moche region, north of the Pampa de Paiján, which includes the valleys from Jequetepeque in the south to Piura in the north. It should be noted, however, that our current perception of the distribution of Moche portraiture is based on limited archaeological evidence. Less than half of the valleys occupied by the Moche have been systematically surveyed for Moche habitation and burial sites, and very few Moche sites have been excavated. Nevertheless, based on the information available today, it appears that the production of Moche ceramic portraits occurred in only three of the fifteen river valleys occupied by the Moche, and that the overall distribution of ceramic portraits only included these valleys and one or two neighboring valleys to the south.

The time period in which Moche portraits were produced was also very limited. Ceramic vessels in the form of human heads were made by Moche potters during the early phases of Moche civilization, but these were generic depictions of human heads, with no attempt to render facial features accurately in order to portray specific individuals (figs. 2, 3).[2] Nearly all of the truly lifelike Moche portraits were made during Phases III and IV (figs. 4, 5). The potters of these phases excelled at rendering facial features accurately, and did

Moche portrait head bottle
Art Institute of Chicago

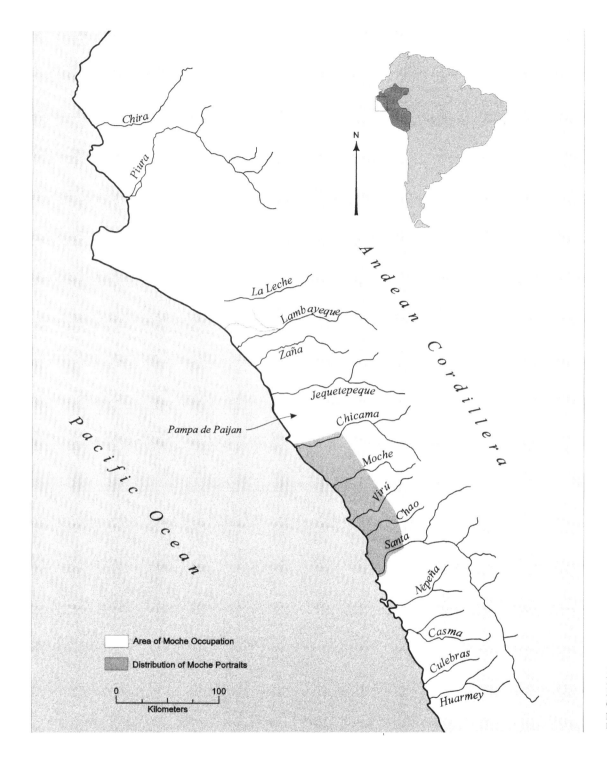

1. Map of the north coast of Peru showing the area of Moche occupation and the distribution of Moche portraits
Drawing by Donald McClelland

so with such skill that the portraits often provide a sense of the individual's personality.

Given the florescence of true portraiture in Phases III and IV, it is curious that it did not continue into Phase V. Yet the Moche suddenly stopped producing true portraits at the end of Phase IV, and during Phase V only standard, generic human head representations were made (figs. 6, 7).

During Phases I and II, the predominant subjects of Moche art were supernatural figures and activities. This began to shift during

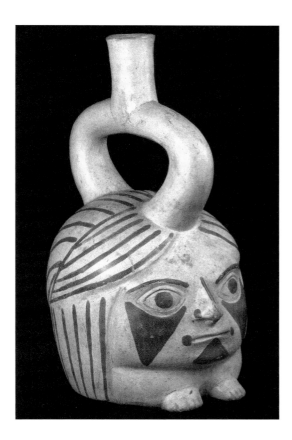

2. Head bottle, Phase I
Museo de Arqueología,
Antropología e Historia,
Universidad Nacional de Trujillo

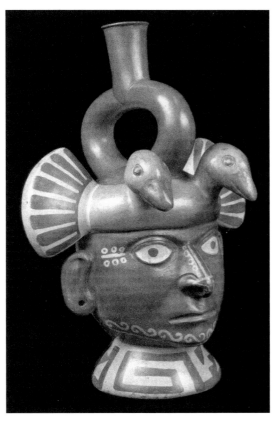

3. Head bottle, Phase III
Linden-Museum Stuttgart, Staat-
liches Museum für Völkerkunde

Phase III to a greater emphasis on human fig-
ures and activities. This emphasis peaked
during Phase IV at the same time that real-
istic human portraits were produced. The art
of Phases III and IV focused heavily on the
activities of high-status adult males—deer
hunting, ritual running, combat, and the
bleeding, parading, and sacrifice of prisoners
were among the most frequently depicted
activities (Donnan and McClelland 1999). At
the end of Phase IV the predominant focus of
Moche art suddenly returned to supernatural
figures and activities—and at the same time
the production of portraiture ended. This
strongly implies that Moche portraiture was
closely linked to the frequent portrayal of
high-status males in Moche art during Phases
III and IV.

The cause of the sudden shift in Moche art
between Phase IV and Phase V is not clear,
but it is interesting that it correlates with
other indications of a severe disruption of
Moche culture. At this time the Moche sud-
denly abandoned major settlements that had
been occupied for centuries, and they estab-
lished new centers of power. It has been pro-
posed that a severe and prolonged drought
occurring between A.D. 562 and 594 played
a major role in the disruption (Shimada 1994;
Shimada et. al. 1991). Whatever the cause,
it is clear that Moche portaiture was not
immune to the turbulent upheaval within the
Moche world that marks the transition be-
tween Phases IV and V.

Multiple Portraits of Individuals

Portrait head vessels were made in molds,
thus facilitating the production of multiples.
The molds were made of fired clay and con-
sisted of two pieces. One formed the front half
of the head, while the other formed the back
half (Donnan 1992). To produce a portrait ves-
sel, the two halves were lined with moist clay
and joined together. An opening at either the
bottom or top of the mold allowed the potter
to reach inside to bond and smooth the seam
between the front and back. The opening was
then closed. Next, the two halves of the mold
were removed and the seams on the exterior
were smoothed. Figure 8 illustrates the front
half of the mold that was used to create
the portrait head bottle shown in Figure 9.
It would have produced a finished portrait

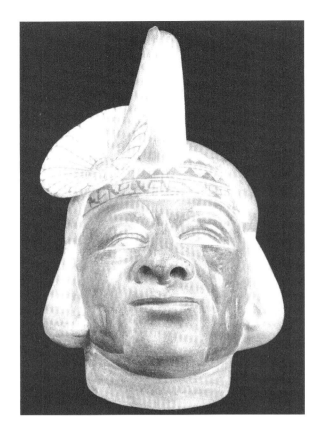

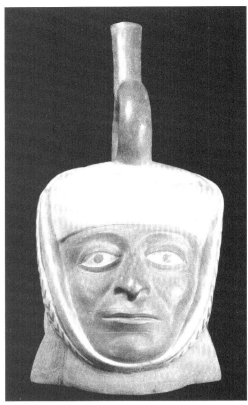

4. Portrait head bottle,
Phase IV
Art Institute of Chicago

5. Portrait head bottle,
Phase IV
Museum für Völkerkunde, Berlin

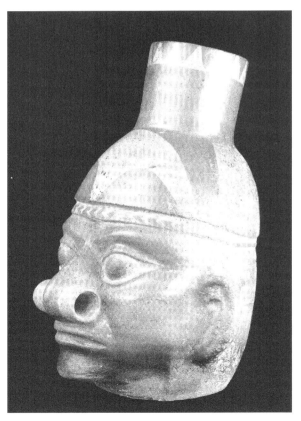

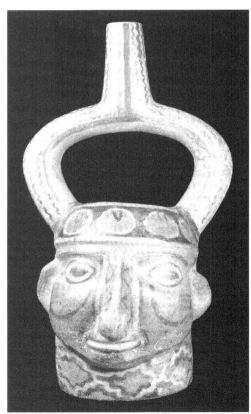

6. Head jar, Phase V
Museo Amano, Lima

7. Head bottle, Phase V
Museo Arqueológico "Horacio H.
Urteaga," Universidad Nacional
de Cajamarca

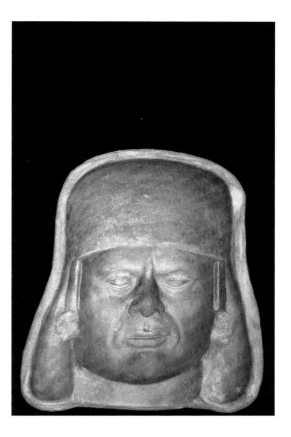

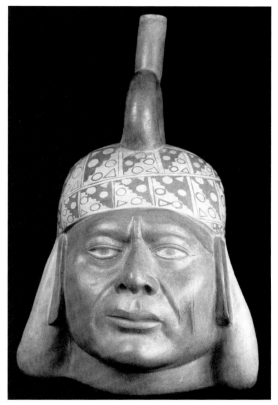

8. Ceramic mold for producing a portrait head vessel
Private collection, Lima

9. Portrait head bottle, made in the mold illustrated in Figure 8
Art Institute of Chicago

except for the areas of the ear lobes, which were left rough and unfinished. The potter would have added ear ornaments or, as in the case of the impression in Figure 9, simply portrayed the individual with a lock of hair in front of the ear. If the portrait vessel was to have a stirrup spout or jar neck, these parts were made separately and added subsequently.

In collections today it is possible to identify multiple portraits of the same individual, some of which appear to have been produced in the same mold. It is very difficult, however, to find two portraits of the same individual that are identical. The potters frequently added or removed ornaments, or altered the headdress. They also painted the sculpted portraits of the same individual in different ways, generally by altering the face paint and design or the degree of elaboration of the head cloths.

Individuals Portrayed at Different Ages

In some instances it is possible to identify portraits that show the same individual at different ages.[3] The best example of this is the person illustrated in Figure 10, of whom more than forty-five portraits exist today. Key to his identification are distinctive facial scars. The most diagnostic of these is an irregular scar on the left side of his upper lip (fig. 11), a feature that is clearly indicated in nearly all portraits of him.[4] The three portraits illustrated in Figures 12–14 exhibit this scar, and thus are of the same individual. One of the portraits shows him as an adolescent, at perhaps ten years of age (fig. 12). Another shows him somewhat older, at around fifteen years of age (fig. 13), and the third portrays him as a young man, perhaps in his early twenties (fig. 14). Most of his portraits, however, show him as an adult, at about thirty years of age (fig. 10).

As the youngest portrait of this individual is at about age ten, his status was probably inherited rather than achieved: it is unlikely that he would have done anything at such a young age to earn a position of importance in Moche society. It is much more likely that he was part of an elite family, and as such was ascribed high status in his youth. Only later, as he matured into adulthood, would he assume important roles.

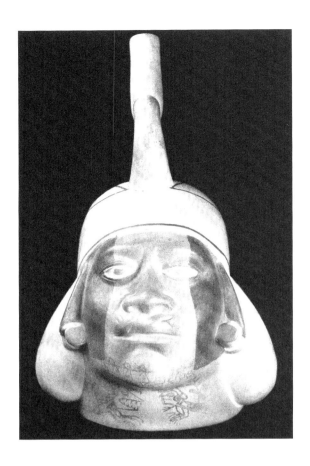

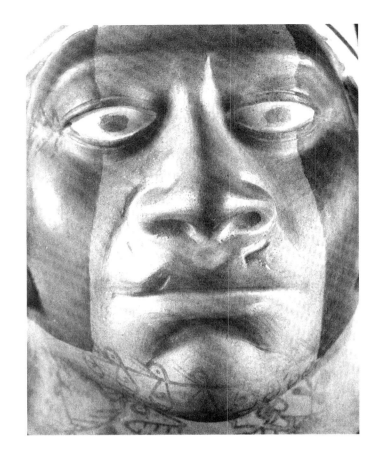

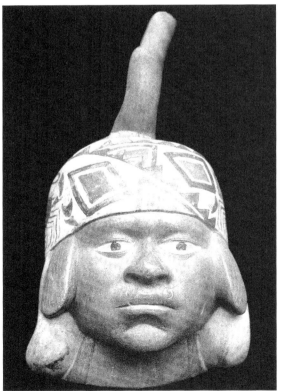

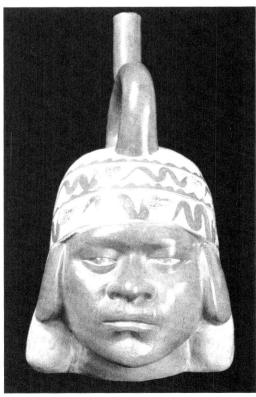

10, 11. Portrait head bottle
Museum für Völkerkunde, Berlin
(VA-32567)

12. Portrait head bottle
Museo Arqueológico Rafael Larco
Herrera, Lima

13. Portrait head bottle
Private collection, Munich

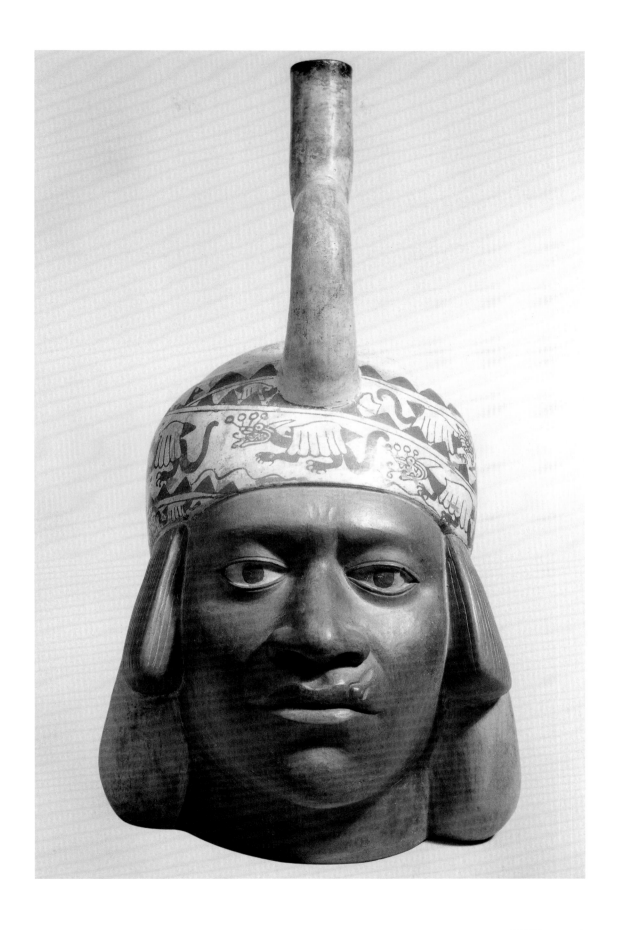

14. Portrait head bottle
Museum Rietberg, Zürich

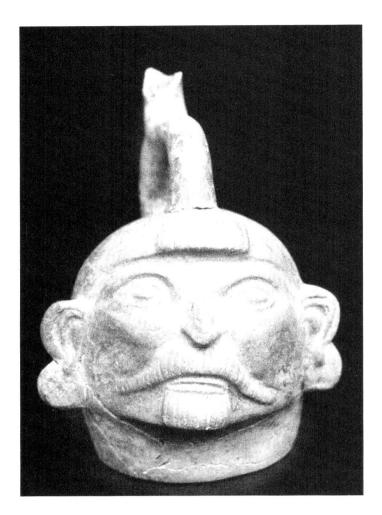

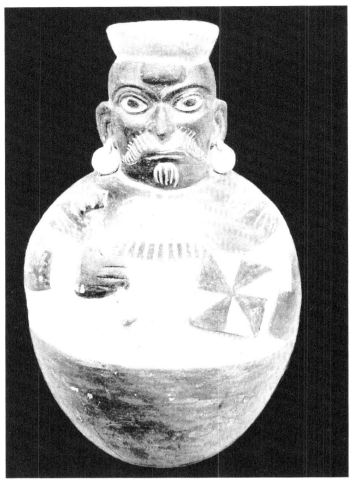

Activities Portrayed in Sculpture

In addition to portrait head vessels, there are portraits that portray the individual's full figure, either seated or standing. In some cases, the same person is portrayed in both portrait head and full-figure vessels. Since full-figure representations sometimes show the individual wearing distinctive garments and holding objects, they can provide valuable information about the roles or activities in which that individual participated.

As with portrait head vessels, full-figure portraits were made in molds. Generally one half of the mold produced the front of the figure, and the other produced the back. In some instances, however, two molds were employed —one to produce the front and back of the body, and the other to produce the front and back of the head. The head was then attached to the body.

Figure 15 illustrates a portrait head of an individual who can easily be recognized by his large bushy mustache, round goatee, and tuft of hair projecting forward over the center of his forehead. He usually wears disk ear ornaments that are suspended with wire loops from his earlobes. Figure 16 illustrates the same individual in a full-figure portrait, dressed as a warrior and holding a club and shield. Another full-figure portrait shows him at what must have been a somewhat later time, as a captive who had been defeated in combat (fig. 17). Here he is seminude, with his hands tied behind his back and a rope around his neck. Another full-figure portrait (fig. 18) shows him as a fully nude captive, with his hands tied behind his back and a rope around his neck. The two portraits of him as a captive imply that he was ultimately sacrificed at a ceremony where his throat was cut and his blood was consumed by attendant

15. Portrait head bottle
Museo Arqueológico Rafael Larco Herrera, Lima

16. Full-figure portrait jar
Museo Nacional de Antropología, Arqueología e Historia, Lima

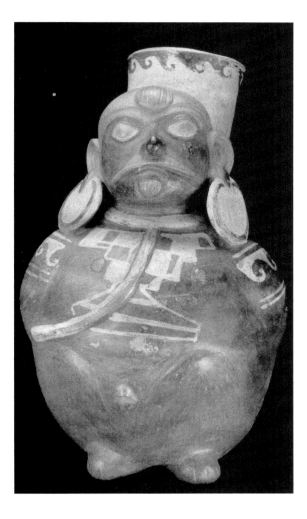

17. Full-figure portrait jar
Museum of Man, San Diego,
California

18. Full-figure portrait bottle
Museo Arqueológico Rafael Larco
Herrera, Lima

19, 20. Portrait head bottle
Museo de la Nación, Lima

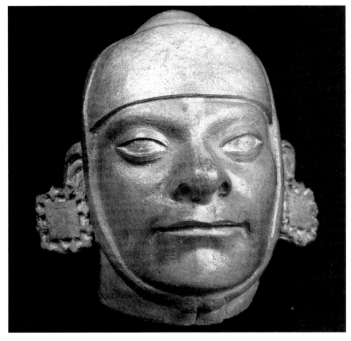

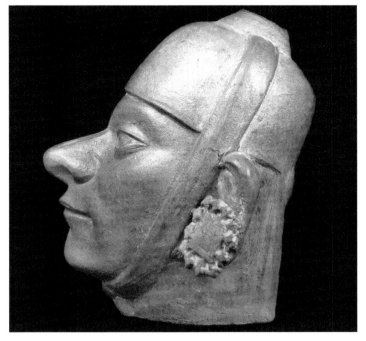

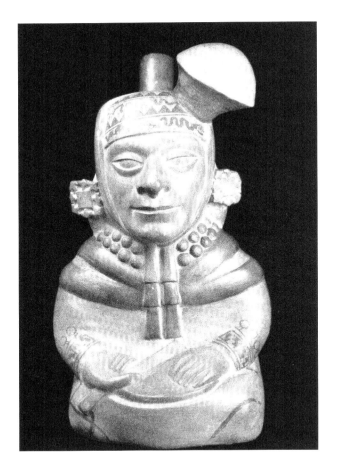

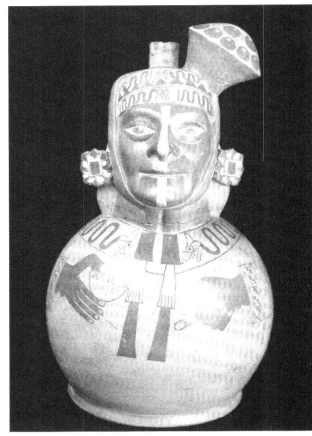

21. Full-figure portrait bottle
Art Institute of Chicago

22. Full figure portrait bottle
Museo Nacional de Antropología,
Arqueología e Historia, Lima

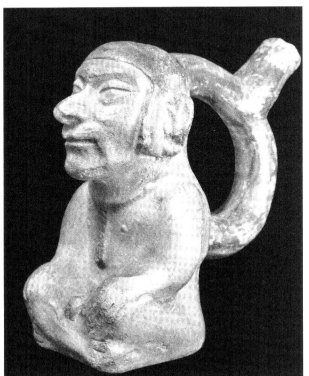

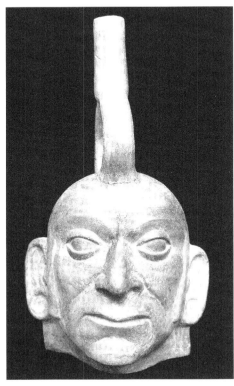

23. Full figure portrait bottle
Private collection, Vancouver

24. Portrait head bottle
Museo Arqueológico Rafael Larco
Herrera, Lima

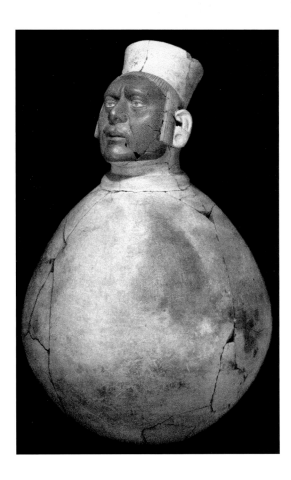

25. Portrait jar
Museo de Arqueología,
Antropología e Historia,
Universidad Nacional de Trujillo
Proyecto Arqueológico Huaca de
la Luna

priests and priestesses (Alva and Donnan 1993; Bourget, this volume; Donnan 1978; Verano, this volume).

Figure 19 shows another individual for whom we have both portrait head and full-figure portraits. Perhaps his most recognizable characteristic is his unusually long pointed nose (fig. 20). He also has a narrow face and lenticular eyes. His ear ornaments are usually square, with warclubs around the periphery. Some full-figure portraits show him holding a cloth in his lap containing a round bowl, and a spatula in one hand above the bowl (fig. 21).[5] In another full-figure portrait his body is implied by the globular shape of the vessel chamber, and his arms and hands are depicted in fine-line painting (fig. 22). He holds a cup in his right hand, while his left hand is shown with the index finger extended. Another full-figure portrait shows him as a nude captive with a rope around his neck (fig. 23). His elaborate head cloth and characteristic ear ornaments have been removed, and a lock of hair hangs down in front of each ear.

A portrait head bottle (fig. 24) also depicts this individual without his head cloth and ear ornaments—presumably as a captive who has been defeated in combat and is about to be sacrificed. Circular depressions in his ear lobes clearly indicate large perforations where the ear ornaments were inserted, and a lock of hair hangs down in front of each ear. This is uncommon in portrait head representations—the individual's head is usually wrapped in a head cloth or wearing a headdress, and if the ears are seen, they are with ear ornaments.

In 1994, a large portrait jar was excavated in a tomb at the site of Moche, in the urban sector near the Huaca de La Luna (figs. 25, 26). It portrays the same individual illustrated in Figure 9. In this instance, however, he appears to be shown as a captive. His head cloth has been removed and a lock of hair hangs down in front of each ear. Circular depressions in his ear lobes clearly indicate large perforations for the insertion of ear ornaments. The ridge around the upper part of the jar chamber is probably meant to indicate a rope around his neck.

It is interesting to consider why high-status individuals who were portrayed in portrait head vessels were subsequently shown as nude or seminude captives with ropes around their necks and hands tied behind their backs. One might suggest that these individuals were captured by an enemy group during a military engagement, and artists of that group subsequently commemorated their capture by producing portraits of them as prisoners. The difficulty with this explanation is that the production of portraiture appears to have been limited to the Chicama, Moche, and Virú valleys, which were unified at least as early as Phase III. Portraits were not produced in peripheral regions that may have been engaged in warfare with these valleys during Phase IV. Moreover, the large portrait jar was found in a pottery-making community at Moche, and was almost certainly produced at that site. All evidence strongly suggests that the portraits of individuals as prisoners were produced by the same potters that made the other portraits of them—not by a foreign group.

It is more likely that the combat in which the individuals engaged was not military, but ceremonial, and took place within the three

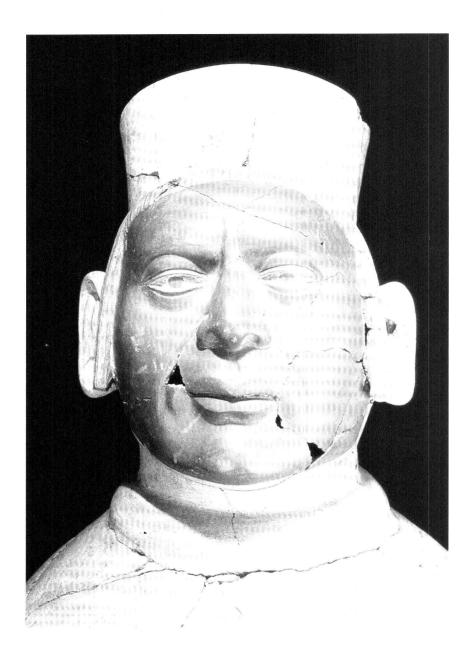

valleys where the portraits are known to have been produced. The ceremonial rather than militaristic nature of Moche combat has been proposed by various scholars (Alva and Donnan 1993; Donnan 1978; Hocquenghem 1987; Topic and Topic 1997). Capture and sacrifice of some of the participants would have been the predictable outcome of involvement in this activity. The Moche appear to have been using portraiture as a means of commemorating the capture and sacrifice of specific individuals whose role, status, and appearance were well known in Moche society.

As we can now demonstrate that Moche portraits were made of individuals at different stages in their lives, scholars should make every effort to locate all representations of particular people. Not only will this provide fascinating insights into the life histories of specific Moche individuals, but it also will help us to understand further the production, distribution, and function of portraiture in Moche society.

26. Detail of portrait jar, Figure 25

NOTES

I would like to thank Donna McClelland for her help in developing the Moche Archive at the University of California, Los Angeles, Smiley Karst for her assistance in organizing the sample of portraits that the archive contains, and José Armas for allowing me to photograph and publish the portrait jar that he excavated at Moche (figs. 25, 26). Support for this research has come from the the Harry and Yvonne Lenart Foundation, the Elbridge and Evelyn Stuart Foundation, the Committee on Research of the Academic Senate at the University of California, Los Angeles, and from the University of California President's Research Fellowships in the Humanities.

1. This study is based on photographs taken by the author of Moche art in museums and private collections during the past three decades. The photographs, now numbering more than 160,000, are kept in the Moche Archive at the University of California, Los Angeles.

2. Ceramic vessels in the form of human heads date back to the Formative period (c. 1500 B.C.), and continued to occur in most of the ceramic styles that preceded the Moche.

3. Both Rafael Larco (1939: 136) and Alan Sawyer (1966: 37–38) stated that this was the case, but neither provided illustrations to document it.

4. Also seen in many of his portraits are two short parallel scars above his right lip, and/or a short scar on the left side of his lower lip.

5. Similar containers with spatulas are portrayed in Moche art in the laps of various human and anthropomorphic creatures who are depicted as warriors. The spatulas appear to be used to transfer the contents of the bowl to the mouth of the seated figure, but unfortunately we do not know what the bowl contains (Donnan 1996: 140–141).

BIBLIOGRAPHY

Alva, Walter, and Christopher B. Donnan
1993 *Royal Tombs of Sipán* [exh. cat., Fowler Museum of Cultural History, University of California]. Los Angeles.

Donnan, Christopher B.
1973 *Moche Occupation of the Santa Valley, Peru.* University of California Publications in Anthropology 8. Berkeley and Los Angeles.

1976 *Moche Art and Iconography.* UCLA Latin American Center, Latin American Studies 33. Los Angeles.

1978 *Moche Art of Peru: Pre-Columbian Symbolic Communication* [exh. cat., Museum of Cultural History, University of California; rev ed. of Donnan 1976]. Los Angeles.

1992 *Ceramics of Ancient Peru* [exh. cat., Fowler Museum of Cultural History, University of California]. Los Angeles.

1996 Moche. In *Andean Art at Dumbarton Oaks*, ed. Elizabeth Hill Boone, 1: 123–162. Pre-Columbian Art at Dumbarton Oaks 1. Washington.

Donnan, Christopher B., and Donna McClelland
1999 *Moche Fineline Painting: Its Evolution and Its Artists.* Fowler Museum of Cultural History, University of California, Los Angeles.

Hocquenghem, Anne-Marie
1987 *Iconografía Mochica.* Lima.

Larco Hoyle, Rafael
1939 *Los Mochicas.* Tomo 2. Lima.

Sawyer, Alan R.
1966 *Ancient Peruvian Ceramics: The Nathan Cummings Collection* [cat., The Metropolitan Museum of Art, New York]. New York.

Shimada, Izumi
1994 *Pampa Grande and the Mochica Culture.* Austin, Tex.

Shimada, Izumi, Crystal B. Schaaf, Lonnie G. Thompson, and Ellen Mosley-Thompson
1991 Cultural Impacts of Severe Droughts in the Prehistoric Andes: Application of a 1,500-Year Ice Core Precipitation Record. *World Archaeology* 22 (3): 247–270.

Topic, John R., and Theresa Lange Topic
1997 La guerra Mochica. *Revista Arqueológica SIAN* 4: 10–12. [Trujillo].

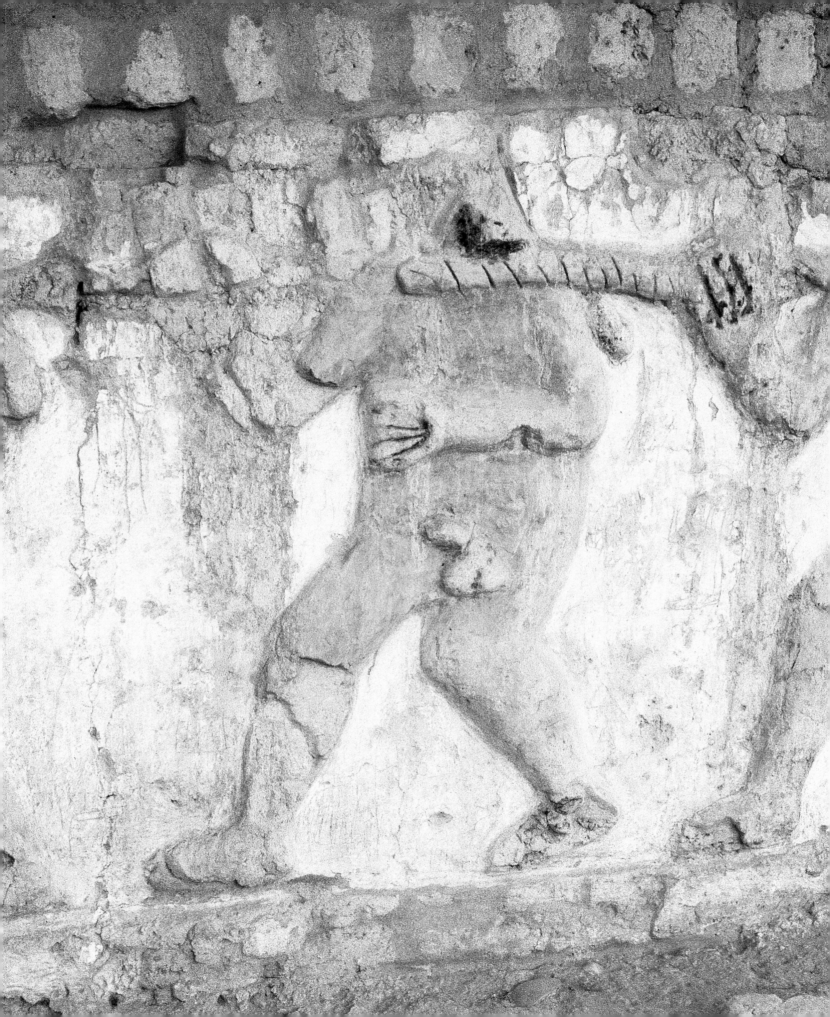

CÉSAR GÁLVEZ MORA AND JESÚS BRICEÑO ROSARIO
Instituto Nacional de Cultura, La Libertad

The Moche in the Chicama Valley

The Chicama Valley, located between the Jequetepeque and Moche valleys on the north coast of Peru, has long been thought to be part of the Moche culture heartland. Early excavations in this region by members of the Larco family provided the first extensive collections of Moche ceramic vessels for the study of this complex society (Berrin 1997; Larco Hoyle 1938, 1939, 1963, 1966). Nevertheless, apart from a few studies of monumental architectural and funerary contexts, very little was known about the Moche occupation of the Chicama Valley until recently. This paper provides an overview of Moche sites in the valley, followed by a summary of the recent investigations at the El Brujo complex, a major site located close to the Pacific Ocean (fig. 1). A decade of excavations and conservation at Huaca Cao Viejo, a large platform mound at the El Brujo complex, has led to the discovery of polychrome friezes and murals, providing exceptional information on Moche ritual practices, use of space and ideology.

The Moche established sites throughout the Chicama Valley from the Andean foothills, at some 1000 m above sea level, down to the middle valley and the Pacific coast, where the most important settlements are found (fig. 1). This large area offers a range of ecosystems, including coastal lagoons and plains along the Chicama River, hillsides and mountain peaks in the middle and upper valley areas, and deserts.

The Upper Chicama Valley

In a desert area located toward the upper Chicama Valley, some 39 km away from the Pacific Ocean and 500 m above sea level, lies the site of San Nicolás (fig. 2). This Moche settlement occupies the south and west sides of a rocky slope forming part of the extreme west of Cerro Serrucho, at the confluence of the *quebrada* San Nicolás and Santa María. The site consists of two sectors, the first of which is located on the south side of the slope and characterized by terraces and stone retaining walls. The other sector is an elevated terrace above the dry riverbeds and consists of a group of structures with stone foundations.

At San Nicolás, Moche IV fineware and ceramics of a style known as Cajamarca *cursivo* were found (fig. 3). The latter suggests that the inhabitants of this site were in contact with the highland Cajamarca culture. Additionally, petroglyphs depicting anthropomorphic and geometric representations were identified at the site near a spring. It seems likely that San Nicolás was contemporaneous with middle to late Moche sites in the middle and lower Chicama Valley, and may have been occupied during an episode of climatic upheaval related to an El Niño–Southern Oscillation (ENSO) event.

Another relatively important Moche settlement in the upper valley was found at Pampas de Jaguey. This site occupies the northeastern side of Cerro Peña del Gallinazo-Gashpa, in

Detail of relief H, Huaca Cao Viejo

the narrowest section separating the middle and upper valley (fig. 4). It lies at the confluence of the Chicama and Quirripano rivers (to the south of Pampas de Jaguey), over 400 m above sea level and 54 km away from the ocean. At Pampas de Jaguey, Moche III and IV phase ceramics vessels were found as well as Cajamarca ceramics (fig. 5). There is evidence for ceramic production at this site, including the creation of mold-made ceramics. Nonresidential structures were constructed with adobe bricks. The residential units are located on tiered terraces with stone and clay retaining walls (fig. 6). Elite tombs were constructed within the monumental sector of the site. Construction techniques of the buildings and adobe types suggest that Pampas de Jaguey was contemporaneous with the later phases at the El Brujo complex and Mocollope.

A third major Moche site in the upper valley is Cerro Grande, located over 1000 m above sea level, and 62 km east of the ocean. This settlement would have occupied a strategic position in terms of coast-highland contacts. Both Moche IV fineware and Cajamarca domestic vessels have been found (fig. 7). As with the site of Galindo (Bawden, this volume, and 1977), a large wall seems to have separated elite from commoner architecture (fig. 8). Elite architecture consists of small residential units (fig. 9) with quadrangular precincts connected to each other, with openings, narrow passages, benches, and niches. In some cases, stone grinding tools are found. Commoner architecture consists of simple structures occupying a terrace south of the large wall.

These three sites from the upper Chicama Valley—San Nicolás, Pampas de Jaguey and Cerro Grande—are interesting in that they all document occupation during the Middle and Late Moche periods and indicate contacts with communities of the highlands, as evidenced by ceramic artifacts recovered. These sites may have served as places of refuge when the valley floor, the usual location of agricultural production, was adversely affected by ENSO flooding. Licapa, discussed below, also in a desert setting, may have served a similar purpose.

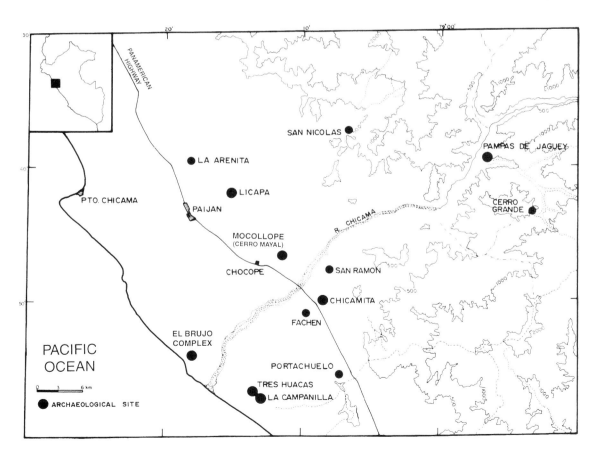

1. Principal Moche sites in the Chicama Valley

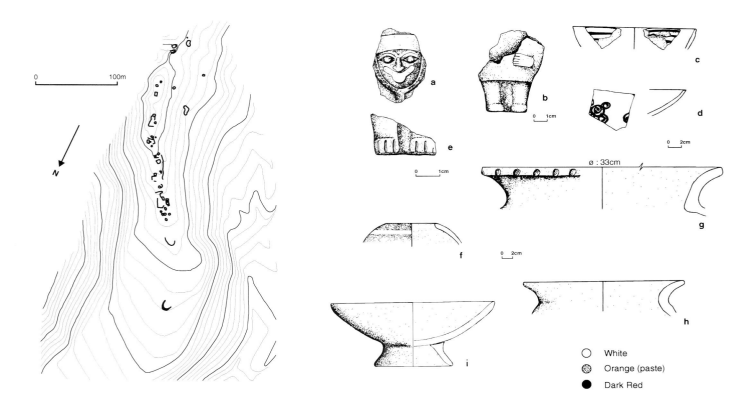

2. Plan of the north sector of San Nicolás

After Chauchat et al. 1998: 112, fig. 50

3. Diagnostic ceramic sherds from San Nicolás and the *quebrada* Santa María (a, b: Moche IV figurine fragments from San Nicolás; c, d: low bowls of the Cajamarca *cursivo* style, San Nicolás; e: Moche IV figurine fragment, *quebrada* Santa María; f–h: Cajamarca jars, *quebrada* Santa María; i: Moche IV low bowl, San Nicolás)

Instituto Nacional de Cultura, La Libertad, Trujillo

4. View of the monumental sector of Pampas de Jaguey

Our ethnographic data indicate that in normal climatic conditions it is impossible to live in the desert due to the complete lack of water resources. During an El Niño, however, the valley is dramatically affected: strong rains prompt the appearance of springs in the desert, and dry ravines like San Nicolás are converted into rivers, making cultivation possible during periods as long as a year after the end of the ENSO event. Thus, in January 1999, agriculturists seeded maize along the banks of normally dry rivers, which carried water as a consequence of the intense precipitation of the 1998 El Niño. For example, in the typically dry Quirripano River area corn had been harvested for the second time, with a yield of 4,000–5,000 kilos per hectare, without the use of the insecticides or chemical fertilizers that are common in normally fertile areas, where the yield reaches 6,000 kilos per hectare.

Additionally, such catastrophic events may have led to some sort of ritual practices regarding sites in places considered to be close to the origins of water, particularly up-valley sites near springs and hills. This short-term contact may have led to a renewal of Moche beliefs: a special exchange with the ancestors in their "natural" temples.

The Middle Chicama Valley

Our understanding of the Moche occupation in the middle Chicama Valley mainly comes from investigations around Cerro Mocollope, located at the center of the lower valley. A number of other sites with Moche occupations such as Fachén, Chicamita, San Ramón, Portachuelo and La Arenita have been identified, but these are of a smaller scale and are not discussed here.

The site of Mocollope occupies the hillsides and summit of Cerro Mocollope and the hillside of Cerro Mayal, over 200 m above sea level and 22 km from the ocean (fig. 10). Mocollope is one of the largest settlements in the valley, representing c. 500,000 m³ of construction (Attarian 1996: 6–9). The monumental architecture at Mocollope was further enhanced by incorporating the natural topography of the *cerro* (hill) and ridges as platforms for construction. As with other Moche sites such as Huaca de la Luna (Moche Valley), Huancaco (Virú Valley), and Pañamarca (Nepeña Valley), *cerros* appear to be the

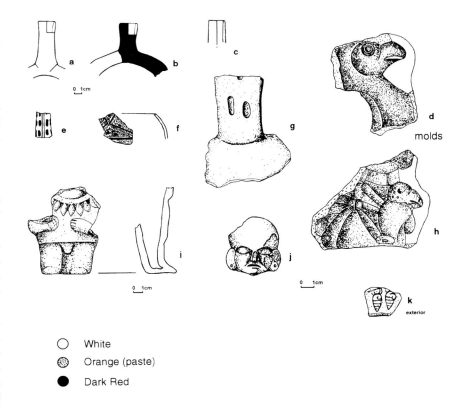

○ White

◉ Orange (paste)

● Dark Red

focus of the site's planning, with structures located along the foot and sides of the peak. The principal group of buildings was erected on the western side of Cerro Mocollope and contains large precincts and structures on natural terraces projecting towards the coastal plain. Two isolated mounds, dense domestic occupations and cemeteries have also been identified at the site. The site was inhabited from the earlier Gallinazo period, and probably extended through Moche V (fig. 11, a). The settlement included a large ceramic production area, c. 1.5 km from the ceremonial center of Mocollope, on the flanks of Cerro Mayal (Russell and Jackson, this volume; Russell, Leonard, and Briceño 1994a, 1994b).

Polychrome murals have been documented at Mocollope, although they are in poor state of preservation (Reindel 1993: fig. 106; Glenn Russell, personal communication, 1990). Traces of white, gray, yellow, red, and black paint have been documented. From what can be discerned, the best-preserved mural documented to date represents a frontal anthropomorphic figure.

5. Diagnostic ceramic sherds from Pampas de Jaguey (a, c, e, f: Moche IV; b: Moche III; d, h, k: Moche mold fragments; g: Cajamarca jar; i, j: Moche figurine fragments)
Instituto Nacional de Cultura, La Libertad, Trujillo

6. Residential architecture
built on low terraces,
Pampas de Jaguey

7. Diagnostic ceramic sherds
from Cerro Grande (a, c, d, e,
i: Cajamarca jars; b, f, g:
Moche jars; h, j: Moche
sculpted vessels; k: Moche
flaring vase)
Instituto Nacional de Cultura,
La Libertad, Trujillo

The site of Licapa is another settlement associated with the Moche culture in the middle valley (Reindel 1993). It is located on a plain below the southeastern flank of Cerro Azul, some 23 km from the ocean and over 130 m above sea level. Two principal structures dominate the landscape, around which residential areas and a cemetery were found (fig. 12). The practice of erecting two major monuments at an architectural complex appears to be a pattern at a number of Moche sites, including the El Brujo complex and the site of Moche. After the abandonment of Licapa by the Moche, the site was used as a cemetery by the later Lambayeque culture.

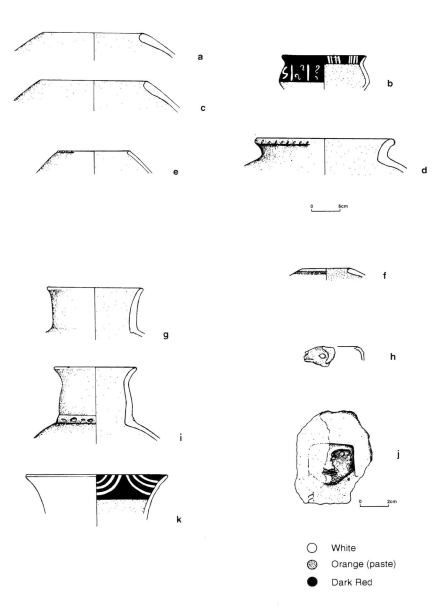

○ White
◉ Orange (paste)
● Dark Red

The Lower Chicama Valley

Moche occupation of the lower Chicama Valley has recently been documented at the La Campanilla and El Brujo complexes, as well as other sites not discussed here, such as Tres Huacas. In contrast with the Moche constructions in the upper valley, the construction materials in the lower valley were largely earthen, as less stone is available in this area. La Campanilla is located c.10m above sea level and 4km east of the Pacific Ocean. This settlement consists of a group of structures, dating to the Middle Moche period, the outer façades of which were originally decorated with clay war clubs (fig. 11, b; see also Uceda, this volume). The residential area of this site was unfortunately destroyed by modern agricultural activities.

The Moche occupation of the lower Chicama Valley, however, is best seen at the large El Brujo complex in the littoral. This site occupies a natural terrace, triangular in shape, 17 m above sea level and close to the seashore (fig. 13). The site is close to the important

8. Cerro Grande

9. Detail of an elite
residence, Cerro Grande

Preceramic settlement of Huaca Prieta (Bird, Hyslop, and Skinner 1985). Since 1990, Régulo Franco, César Gálvez, and Segundo Vásquez have directed a long-term study of the Moche occupation of the site (1994, 1996, 1998a, 1998b, 1998c, 1999).

Two monumental constructions, Huaca El Brujo (also known as Huaca Cortada) (fig. 14) and Huaca Cao Viejo (Huaca Blanca) (fig. 15) dominate the site. Huaca Cortada lies close to the ocean and its important marine resources. The monumental platform was severely

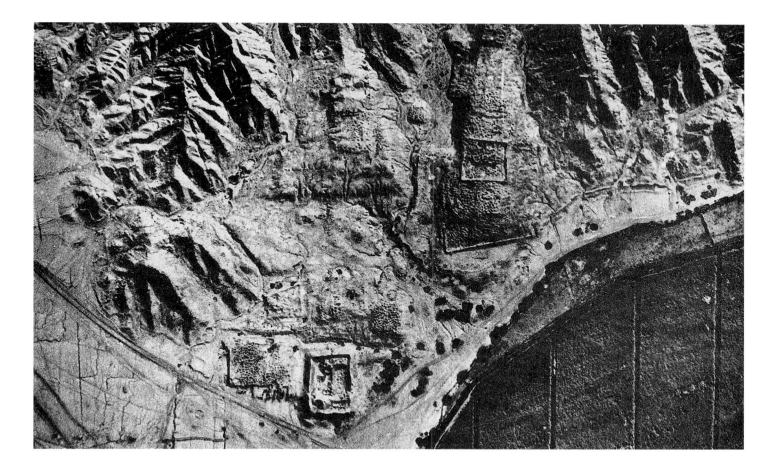

10. Aerial view of Mocollope
After Kosok 1965: 108, fig. 28

11. Ceramics from
Mocollope and La
Campanilla (a: fragment of a
Moche V polychrome bottle,
Mocollope; b: ceramic war
club, La Campanilla)
Instituto Nacional de Cultura,
La Libertad, Trujillo

damaged in the early twentieth century, when an enormous cut was made into the heart of the structure in an attempt to extract treasure.

The other major monument, Huaca Cao Viejo, is located further inland, in an area of ancient lagoons, today dominated by cultivated fields. Between these two components is an extensive area where smaller structures thought to represent elite and commoners' residences have been identified. Additionally, production areas, cemeteries, and a deep well have also been identified (Franco, Gálvez, and Vásquez 1998b). Interestingly, no ceramic production areas have been identified at this site yet, which is in marked contrast to Mocollope and Moche, sites comparable in size. Proximity to the sea and its effect on production may have played a role in this, or it is also possible that local production was unnecessary if such goods could be obtained through offerings. It seems likely that the El Brujo complex was the major religious center of the valley over the course of centuries, if not millennia.

a

○ White
◉ Dark Red
● Black

0 2cm

b

0 5cm

12. View of Licapa

13. Plan of the El Brujo complex

Huaca Cao Viejo

Huaca Cao Viejo is an architectural complex composed of two main components: a platform mound and a large plaza (fig. 16). The platform mound is a roughly square, tiered structure. The plaza, located to the north of the platform, is 140 m long and 80 m wide, and is delimited by high structures and walls to the north, east and west. As of now, the only structure identified within this large space is a small room located in the southeast corner, adjacent to the northern façade of the main building and defined as Precinct 1.

The platform mound has six tiers or terraces, originally decorated with reliefs painted in bright colors. On the summit of the mound was a smaller platform, also ornamented. Access to the platform mound was possible through a long, steep ramp leading to the eastern edge of the northern façade. Another ramp led to the top, zigzagging along the façade tiers. A third ramp provided access to the small upper structure from the top of the main platform.

Excavations on the top of the platform and along the façades, together with a careful study of adobe brick types and manufacture marks, revealed that the building had been built in at

14. View of Huaca Cortada,
El Brujo complex
Photograph by Edward Ranney (©)

15. View of Huaca Cao Viejo,
El Brujo complex

found in association with the architecture and burials, and Moche V ceramics have been found only in burials.

It is clear that this monument maintained a standard layout for at least the last four construction phases. Additionally, we now know that each of the seven successive buildings was decorated. The earliest façades were decorated with simple mural paintings. In the later phases, at least on the north façade, relief ornament was preferred (fig. 17). A fragment of a geometric relief with interlocking motifs (fig. 17, A) dates to Phase C, or the fifth construction phase. These motifs may represent a stylized fish or serpent, and are typically seen in the earlier phases of Moche iconograpy. Similar reliefs have been noted from the earlier phases of Huaca Cortada (Kroeber 1930: 84). Another relief (fig. 17, B), also associated with Phase C, is composed of a panel of at least six pairs of figures. The figures on the left brandish ceremonial knives and grasp smaller figures, perhaps children, on the right by the hair.

Most of the information available on the architecture and decoration of Huaca Cao Viejo comes from the last construction phase (Phase A). The northern façade, the focus of investigations, was decorated with a series of

least seven successive phases, dating from around the first century A.D. to the seventh century A.D. (Franco 1998: 104). These have been designated Phase A (the most recent) to Phase G (the oldest construction identified so far). Seven corresponding phases were also identified in the excavation of the plaza (Franco, Gálvez, and Vásquez 1996: 88).[1] Moche I, II, III, and IV ceramics have been

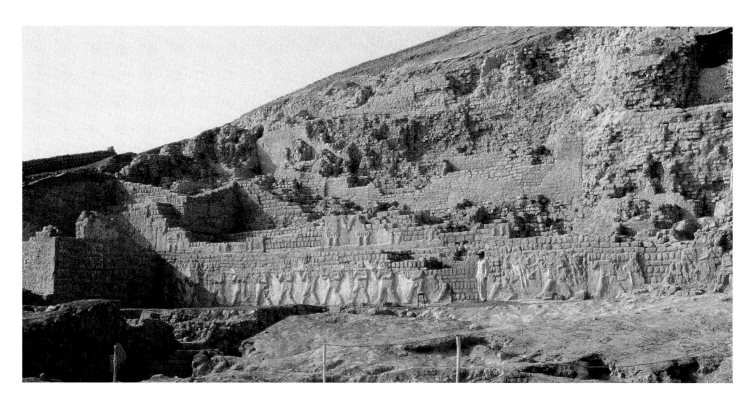

bold, brightly painted reliefs, which would have been visible from a considerable distance. The reliefs were made by carving designs on the existing adobe bricks walls, or by applying designs made out of modeled clay (Morales 1994). Subsequently these reliefs were painted white, and eventually they were decorated with bright colors. The first three stepped tiers of the main façade facing the plaza were decorated with some of the most impressive painted reliefs known from any Moche site.

The first tier of the platform facing the plaza contains the most arresting imagery: a lifesize depiction of the procession of prisoners. A Moche warrior is shown leading ten naked prisoners bound together by a rope at their necks (fig. 17, H; fig. 18). Behind this group, to the west, other warriors are depicted carrying garments and weapons, presumably those of the defeated prisoners. Although the east wall is badly damaged, another line of lifesize figures can be discerned (fig. 17, G). The figures appear to be warriors, marching in the direction of the north end of the

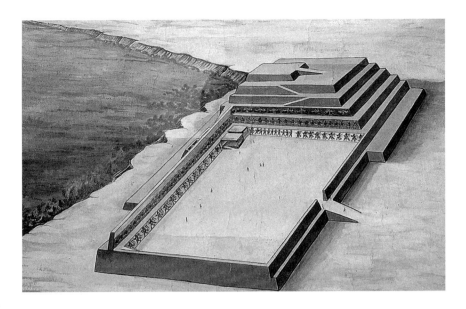

16. Hypothetical reconstruction of Huaca Cao Viejo
Based on Franco, Gálvez, and Vásquez 1996: fig. 1

17. Reconstruction drawing of Huaca Cao Viejo indicating the location of the principal reliefs.
After Franco, Gálvez, and Vásquez 1994: fig. 4.12

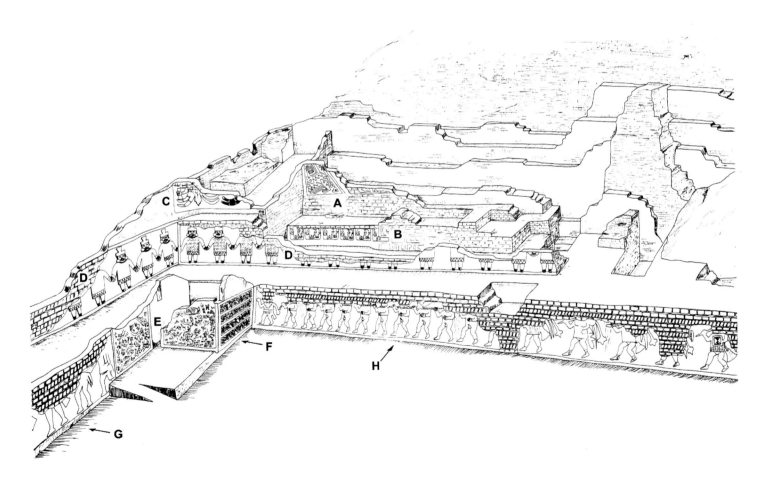

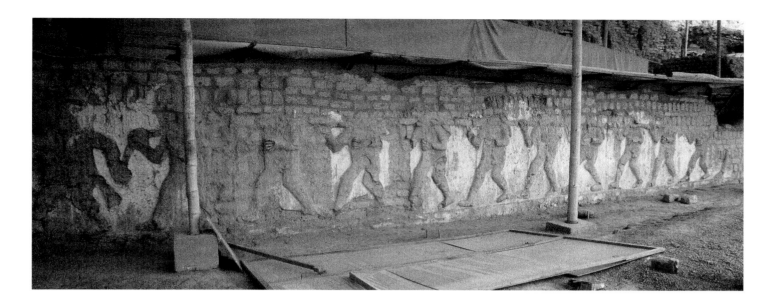

18. View of relief H, Huaca Cao Viejo

19. Ceramic war clubs, Huaca Cao Viejo. Instituto Nacional de Cultura, La Libertad, Trujillo
After Franco 1998

plaza. This theme is also seen in ceramics (Hocquenghem 1987: 116, figs. 87, 90–91). Depictions of wounds in the junctures between the penises and the testicles and on the legs of the reliefs suggest that these scenes relate to sacrificial practices where the collection of blood was a key element. This relief may represent a portion of an extended ritual, perhaps culminating in the sacrifice of these prisoners (see Bourget, this volume).

In the southeast corner of the large plaza that extends to the north of the main platform was a small room (3.8 m × 4 m) defined as Precinct 1. Adjacent to Precinct 1 was a small platform (3.8 m × 5 m) with an access ramp. Originally both the precinct and the small platform were roofed. The roof was decorated with ceramic *porras* or war clubs (fig. 19), an architectural feature seen in certain buildings in the Chicama Valley (La Campanilla) and elsewhere (see Uceda, this volume).

Precinct 1 and a section of wall adjacent to it were decorated with unusual painted reliefs. These were in a style very different to the ones found on the main platform façade. In contrast to the lifesize figures on the adjacent walls, the precinct is covered with compositions made up of repetitions of small figures, either aligned in registers or arranged seemingly randomly. On the west wall of Precinct 1 (fig. 17, F, fig. 20) are polychrome reliefs presenting what Hocquenghem (1987:

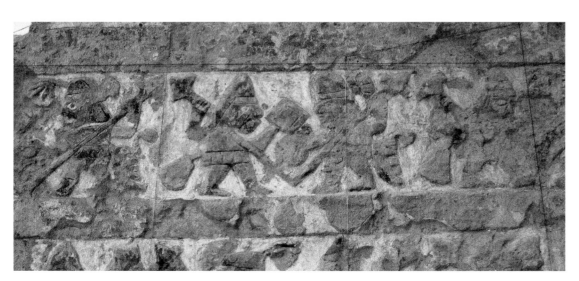

20. Detail of relief F, Huaca Cao Viejo

120–121) has called an allegorical ritual battle. Forty-eight warriors appear in four registers separated by red borders. In each panel there are six pairs of warriors, armed with war clubs and shields, apparently engaged in face-to-face combat. Distinctions in costumes suggest that these pairings represent two distinct groups of warriors (Franco, Gálvez, and Vásquez 1996: 91).

The reliefs on the north wall of Precinct 1, however, are more difficult to interpret. Here a plethora of small-scale figures appear to be scattered loosely about the composition (fig. 17, E, fig. 21). The flora and fauna of different ecological zones are represented, including river shrimp of the coastal lagoons and river mouths, squirrels of the lower valley, and snakes, owls, deer and fox of the desert and interior valley zones. Mythical animals are also depicted, as are reed boats and nets. Combat scenes are present, as are depictions of figures wearing crowns and carrying maces (fig. 22).

On the second tier of the platform above the plaza are depictions of elaborately dressed human figures holding hands, facing outward toward the plaza (fig. 17, D, fig. 23). The figures are shown wearing headdresses, ear ornaments, and red tunics and loincloths with yellow circles, probably representing gold ornaments that would have been sewn to actual garments. Their faces, hands, and feet are painted black, and their feet project out over a red lower border. In an unusual detail, human and mammal bones were placed in the feet of one of the figures. The human bone was a fragment of a femur, and had clear cut marks on it (Verano and Anderson 1996: 151). The bone may have been taken from a combat or sacrificial victim when the body was "fresh."

The reliefs on the third tier above the plaza are mostly destroyed, but show an anthropomorphized arachnid (fig. 17, C, fig. 24). This figure is often identified as the Decapitator in Moche iconography (Cordy-Collins 1992:

21. Relief E, Huaca Cao Viejo

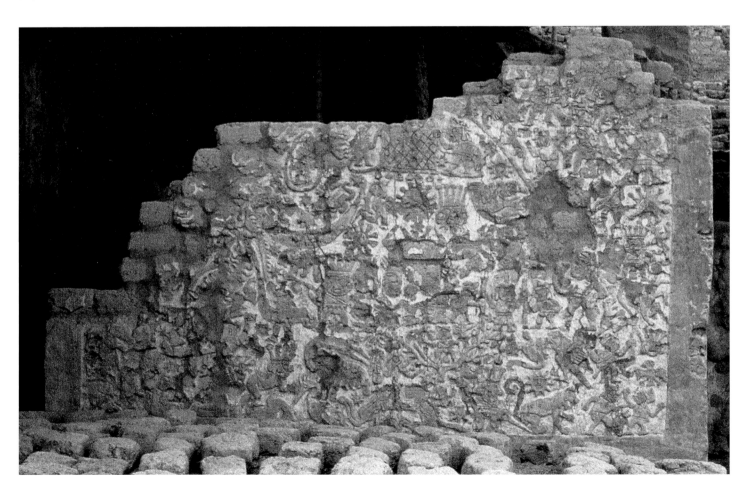

217). These reliefs were painted white, black, yellow, and grayish blue. Although partially destroyed, the figure appears half human, half spider, with two appendages on each side of the body, and carries a *tumi* (ceremonial knife) in the right hand.

Excavations on the summit of the main building revealed the existence of a small platform with a ramp oriented east–west (17.6 m long by 1.5 m wide). The remains of several wooden posts were found, indicating the existence of a roofed structure, long since destroyed. Ceramic *porras* or war clubs were also found here, suggesting that again these may have been used to ornament the roof of this important space. Painted reliefs, also dating to the last construction phase, once graced the walls of the summit structure (fig. 25; Franco et al. 1999). These reliefs show a high degree of similarity with those of the Great Patio at Huaca de la Luna in the Moche Valley (Uceda, this volume). As with the Huaca de la Luna reliefs, the composition was

22. Detail of relief E

23. Detail of relief D, Huaca Cao Viejo
Photograph by Edward Ranney (©)

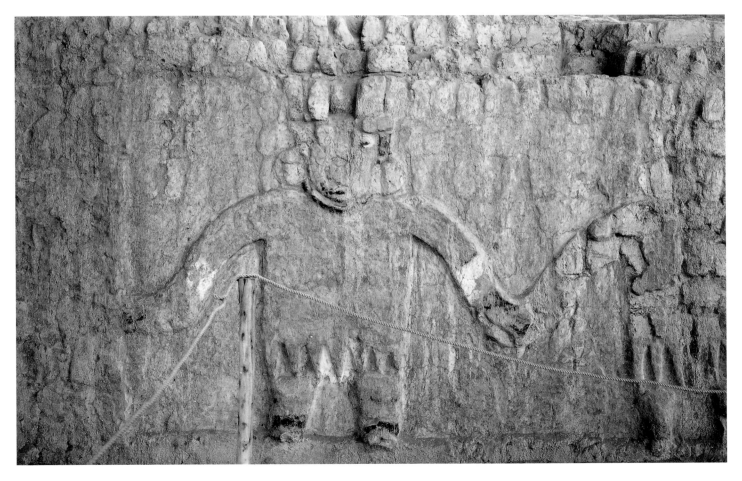

organized around rhombi and triangles. The rhombi are encased within several borders, but here the thickest border is rendered as undulating serpents with felinelike heads. The interior spaces of the rhombi were filled with supernatural visages, with volutes extending from the face, bulging eyes, figure-8 ears, wide and prominent noses, and mouths with feline fangs. The supernatural faces in the triangular spaces created between the rhombi also have serpentlike appendages. The color patterning is similar to the Huaca de la Luna reliefs, with prominent use of red, black, yellow, and white, with some grey.

In general terms, there seems to be an evolution in the formal treatment of painted reliefs at Huaca Cao Viejo, from the lowest tier to the summit. At the lower levels, the representations are essentially naturalistic— the parade of prisoners and warriors, the combat scenes, the murals decorating the walls and ceiling of Precinct 1—and almost all the elements can be identified with equivalents in the real world (Franco et al. 1999). Moving up the tiered structure, the personages holding hands and the arachnid Decapitator are more abstract, and appear to be more of the supernatural world. The murals decorating the summit are even more disembodied or abstracted, and seem heavily charged with symbolic content.

Other interesting features were found on top of Huaca Cao Viejo. In the southwest corner of the monument, large rooms with interior subdivisions, walls with niches, and pillars of adobe bricks were recently excavated. These rooms – all associated with Phase D – were painted white, as were the rooms with pillars and pilasters in the corresponding location on Platform I at Huaca de la Luna (see Uceda, this volume). In one of these rooms, a sculpted and painted wooden post was found (fig. 26), probably deliberately buried during Moche times. A male figure is sculpted in high relief on the front of the post, surmounted by a band on which two supernatural animals are perched, face-to-face. The creatures, often referred to as Moon Animals, have felinelike bodies with long curling tails and prominent sharp claws. Their heads are rendered with enormous maws with interlocking fangs (the one on the figure on the right is now missing), and headdresses with a stepped design terminating in volutes. They

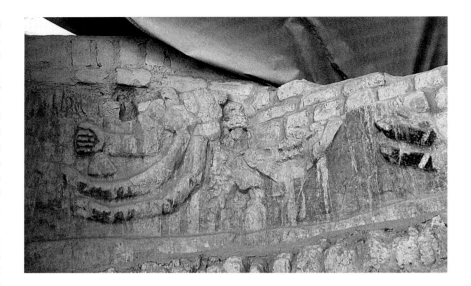

both appear to hold some sort of staff. The figures were painted red, with details in black.

A number of burials were also found during excavations. In the southwest corner of the main platform, two large funerary chambers were identified (Tomb 1 and Tomb 2). The careful excavation of these features clearly indicated the existence of complex funerary practices during Moche times, involving the reopening of certain graves (Franco, Gálvez, and Vásquez 1998c, 1999). Tomb 1, built within the fill covering Phase D, contained evidence related to two distinct funerary events (Tomb 1A and Tomb 1B). The

24. Relief C, Huaca Cao Viejo

25. Detail of reliefs from the summit of Huaca Cao Viejo

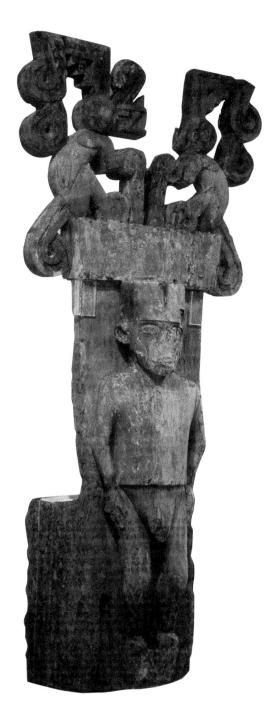

26. Sculpted wooden post, Huaca Cao Viejo
Instituto Nacional de Cultura, La Libertad, Trujillo

together with Moche III ceramics.[2] Tomb 2 was a large funerary chamber, which also contained evidence of grave reopening.[3] This chamber—also located in the fill covering Phase D—originally contained at least thirteen individuals buried with both Moche III and IV ceramic vessels. A long cane stalk (*Guadua angustifolia*) was found inside the grave, and may once have served as a grave marker. Finally, a single individual, missing its head, was found buried on top of the main platform in association with Phase D (Franco 1998).

The Moche settlement at the El Brujo complex was abandoned during the Moche IV period. Our study revealed that this abandonment occurred only after the occupants had dismantled parts of the *huaca* (Franco, Gálvez, and Vásquez 1998c). Subsequently, heavy rains destroyed parts of the monument. Huaca Cao Viejo later served as a burial ground during the Middle Horizon and Late Intermediate periods. A series of Lambayeque burials was found interred in the rubble of the *huaca*. In contrast to Moche burials, the Lambayeque individuals were buried in a seated position, wrapped in textiles. The bundles contained ceramic vessels from the coastal Lambayeque culture, but highland artifacts were also found, together with *Spondylus* shells and semiprecious stones (Franco, Gálvez, and Vásquez 1996: 94). Detailed studies of these bundles is still underway by physical anthropologist John Verano and textile specialist Amy Oakland Rodman, but a preliminary analysis shows that most of the individuals exhibit evidence of cranial deformation.

The End of the Moche Occupation in the Chicama Valley

It appears that the abandonment of the El Brujo complex in the Moche IV period was contemporaneous with the abandonment of other sites in the Chicama Valley. Few Moche V sherds have been reported from scientific excavations in the valley.[4] As noted above, a small number have been found in burials at Huaca Cao Viejo, and a few have been found at Cerro Mayal/Mocollope, but these do not appear to have been produced there (Glenn Russell, personal communication, 1992). It is possible that these ceramics were brought in

first interment contained the remains of at least eleven individuals (Verano and Lombardi 1999). At a certain point it was reopened and partially emptied. A new chamber was built inside the previous one. Two individuals were buried together inside this new chamber

from elsewhere, such as the Jequetepeque Valley, and included in burials at the sites after their principal occupation. It is clear that a number of these sites maintained their prestige after the abandonment in the Moche IV period, as attested to by their use as sacred burials grounds in subsequent periods. The El Brujo complex, perhaps the most important ritual center in the valley, may even have maintained its role as a sacred center into the colonial period: a Dominican convent was built in the great plaza in front of Huaca Cao Viejo (Franco, Gálvez, and Vásquez 1996: 94). Church authorities may have recognized the power of the place, and inserted themselves into the history of a site that had endured for millennia.

NOTES

The authors acknowledge Lic. Ana María Hoyle, Director of the Instituto Nacional de Cultura-La Libertad, for her help and the resources to present part of our report in the Inventario de Sitios Arqueológicos del Chicama. We would like to thank the Proyecto Arqueológico Complejo El Brujo for facilitating the publication of photographs and graphics of Huaca Cao Viejo, as well as Jorge Sachún, who produced the ceramic drawings.

1. Two circles, one inside the other, were incised into the plaster of the plaza floor in front of the north façade, and associated with Phase B (the penultimate phase). The outside circle was 5.12 m in diameter, and a number of straight lines cut across the circles as well as pass nearby. These lines may have been oriented towards specific points (Franco, Gálvez, and Vásquez 1996: 88).

2. For a complete description of this complex feature, see Franco, Gálvez, and Vásquez 1999b.

3. This burial is described in detail in Franco, Gálvez, and Vásquez 1998.

4. A number of Moche V vessels have been reported to have come from the Chicama Valley (de Bock 1998; Larco Hoyle 1938, 1939, 1963, 1966), but in the absence of scientific documentation of their original contexts, these data must be put aside.

BIBLIOGRAPHY

Attarian, Christopher J.
1996 Plant Foods and Ceramic Production: A Case Study of Mochica Ceramic Production Specialists in the Chicama Valley, Peru. Master's thesis, Department of Anthropology, University of California, Los Angeles.

Bawden, Garth
1977 Galindo and the Nature of the Middle Horizon in Northern Coastal Peru. Ph.D. dissertation, Department of Anthropology, Harvard University, Cambridge, Mass.

Berrin, Kathleen
1997 (Editor) *The Spirit of Ancient Peru: Treasures from the Museo Arqueológico Rafael Larco Herrera* [exh. cat., Fine Arts Museums of San Francisco]. New York.

Bird, Junius B., John Hyslop, and Milica D. Skinner
1985 *The Preceramic Excavations at the Huaca Prieta, Chicama Valley, Peru.* Anthropological Papers of the American Museum of Natural History 62 (1). New York.

Bock, Edward K. de
1988 *Moche: Gods, Warriors, Priests.* Collecties van het Rijksmuseum voor Volkenkunde 2. Leiden.

Chauchat, Claude, César Gálvez, Jesús Briceño, and Santiago Uceda
1998 *Sitios arqueológicos de la zona de Cupisnique y margen derecha del valle de Chicama.* Patrimonio Arqueológico Zona Norte/4. Travaux de l'Institut Français d'Etudes Andines 113. Trujillo and Lima.

Cordy-Collins, Alana
1992 Archaism or Tradition?: The Decapitation Theme in Cupisnique and Moche Iconography. *Latin American Antiquity* 3 (3): 206–220.

Franco, Régulo
1998 Arquitectura monumental Moche: Correlación y espacios arquitectónicos. *Arkinka* 3 (27): 100–110. [Lima].

Franco, Régulo, César Gálvez, and Segundo Vásquez
1994 Arquitectura y decoración Mochica en la Huaca Cao Viejo, complejo El Brujo: Resultados preliminares. In *Moche: Propuestas y perspectivas* [Actas del primer coloquio sobre la cultura Moche, Trujillo, 12 al 16 de abril de 1993], ed. Santiago Uceda and Elías Mujica, 147–180. Travaux de l'Institut Français d'Etudes Andines 79. Trujillo and Lima.

1996 Los descubrimientos arqueológicos en la Huaca Cao Viejo, complejo "El Brujo." *Arkinka* 1 (5): 82–94. [Lima].

1998a Un cielorraso Moche polícromo. *Medio de Construcción* 144: 37–42. [Lima].

1998b Un pozo ceremonial Moche en el complejo arqueológico "El Brujo." *Revista de la Facultad de Ciencias Sociales, Universidad Nacional de Trujillo* 5: 307–327.

1998c Desentierro ritual de una tumba Moche: Huaca Cao Viejo. *Revista Arqueológica SIAN* 6: 9–18. [Trujillo].

1999 *Tumbas de cámara Moche en la Plataforma superior de la Huaca Cao Viejo, complejo El Brujo.* Programa Arqueológico "El Brujo" Boletín 1 (July).

Franco, Régulo, César Gálvez, Segundo Vásquez, and Antonio Murga

1999 Reposición de un muro Mochica con relieves polícromos, Huaca Cao Viejo, complejo El Brujo. *Arkinka* 4 (43): 82–91. [Lima].

Hocquenghem, Anne-Marie

1987 *Iconografía Mochica.* Lima.

Kosok, Paul

1965 *Life, Land and Water in Ancient Peru.* New York.

Kroeber, Alfred L.

1930 *Archaeological Explorations in Peru. Part II: The Northern Coast.* Field Museum of Natural History, Anthropology Memoirs 2 (2). Chicago.

Larco Hoyle, Rafael

1938 *Los Mochicas. Tomo 1.* Lima.

1939 *Los Mochicas. Tomo 2.* Lima.

1963 *Las épocas Peruanas.* Lima.

1966 *Perú.* Archaeología Mundi. Barcelona.

Morales, Ricardo

1994 La conservación de relieves de barro polícromos en la costa norte del Perú. In *Moche: Propuestas y perspectivas* [Actas del primer coloquio sobre la cultura Moche, Trujillo, 12 al 16 de abril de 1993], ed. Santiago Uceda and Elías Mujica, 477–492. Travaux de l'Institut Français d'Etudes Andines 79. Trujillo and Lima.

Reindel, Markus

1993 *Monumentale Lehmarchitektur an der Nordküste Perus. Eine repräsentative Untersuchung nach-formativer Groß-bauten vom Lambayeque-Gebiet bis zum Virú-Tal.* Bonner Amerikanistiche Studien 21. Bonn.

Russell, Glenn S., Banks L. Leonard, and Jesús Briceño

1994a Cerro Mayal: Nuevos datos sobre la producción de cerámica Moche en el valle de Chicama. In *Moche: Propuestas y perspectivas* [Actas del primer coloquio sobre la cultura Moche, Trujillo, 12 al 16 de abril de 1993], ed. Santiago Uceda and Elías Mujica, 181–206. Travaux de l'Institut Français d'Etudes Andines 79. Trujillo and Lima.

1994b Producción de cerámica Moche a gran escala en el valle de Chicama, Perú: El taller de Cerro Mayal. In *Tecnología y organización de la producción de cerámica prehispánica en los Andes*, ed. Izumi Shimada, 201–227. Lima.

Verano, John W., and Laurel S. Anderson

1996 Análisis del material osteológico. In *Informe del Programa Arqueológico complejo El Brujo, temporada 1996*, 137–161. Manuscript on file, Instituto Nacional de Cultura, La Libertad, Trujillo.

Verano, John W., and Guido P. Lombardi

1999 Apéndice 3: Análisis del material Oseo. In *Tumbas de cámara Moche en la Plataforma superior de la Huaca Cao Viejo, complejo El Brujo*, by Régulo Franco, César Gálvez, and Segundo Vásquez, 48–51. Programa Arqueológico "El Brujo" Boletín 1 (July).

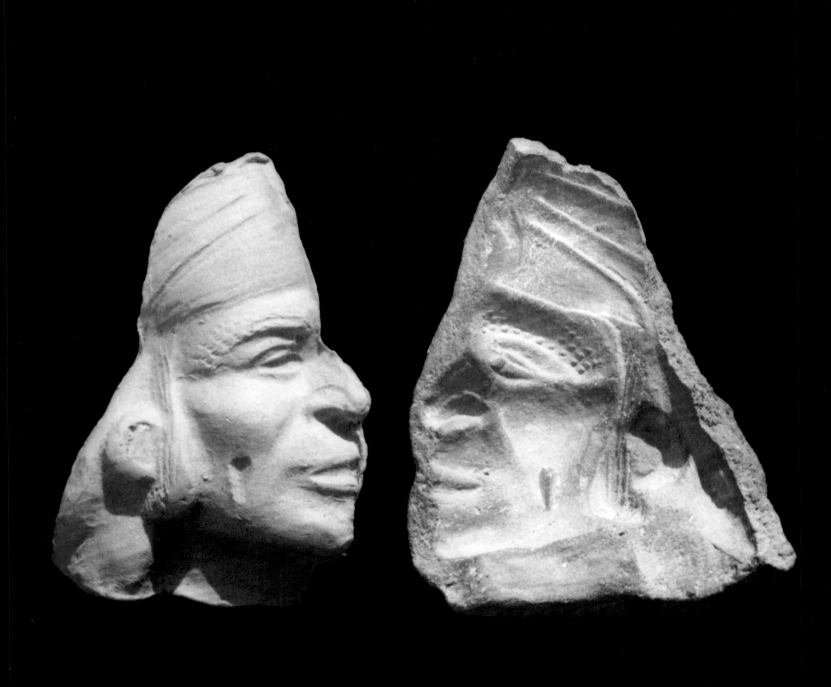

GLENN S. RUSSELL AND MARGARET A. JACKSON
University of California, Los Angeles

Political Economy and Patronage at Cerro Mayal, Peru

The Moche were a complex, stratified society in which ideology, primarily visible through an elaborate elite art style, served as an important component of political power. Excavations of tombs during the last decade have established a clear relationship between rulership and ideological themes found in Moche art. There is no doubt that Moche elite participated in politically charged rituals embedded in an ideological framework, which were reiterated throughout the works of art. What has remained underdeveloped in Moche studies is an understanding of the relationship of the production of art to political organization. This paper explores the relationship from the perspective of the Moche ceramic workshop located at Cerro Mayal, in the Chicama Valley (fig. 1).

We will present data concerning the organization and affiliation of ceramic manufacture at Cerro Mayal to suggest how production was part of the broader political strategies of ruling elite. Next, we review the kinds of ceramics manufactured at Cerro Mayal and how they were used. Finally, contextualizing the workshop's organization and sociopolitical affiliation, we postulate the manner in which ceramics were distributed and address relationships of patronage and imagery.

Cerro Mayal appears to have been an attached workshop enjoying some form of patronage support for the manufacture of ceramics. Our evidence points to the adjacent civic-ceremonial center of Mocollope as the probable locus of Cerro Mayal's support. Archaeological evidence from these sites, in combination with data from colonial-era documentary sources, allows us to suggest the nature of the relationship between Moche leaders at Mocollope and Moche artisans at Cerro Mayal.

Situated on a rocky outcrop approximately 4 km from the Chicama River, Cerro Mayal lies in the center of the lower valley amidst fields watered by a complex system of irrigation canals (fig. 2). Mocollope itself includes a series of platforms and enclosures nestled into the side of a mountain known as Cerro Mocollope (Gálvez and Briceño, this volume, fig. 10). Evidence for monumental architecture at this site dates at least as early as Gallinazo times, roughly 200 B.C.–A.D. 200, when massive terraced platforms layering the lower mountain slopes were erected (Leonard and Russell 1992; Russell, Attarian, and Becerra, 1999; Russell, Leonard and Briceño 1994, 1997). Cerro Mocollope was undoubtedly the focus of religious beliefs for the inhabitants of the area, visible as it was for miles across the fertile floodplain of the Chicama Valley. At the time of the workshop's occupation (A.D. 550–800), Mocollope must have been a sprawling urban or semiurban center with the ceramic workshop located on its periphery.

It is difficult to arrive at an understanding of the nature of political organization in Moche times because of the lack of contemporary texts. For the Moche, we must rely

Moche portrait vessel mold (right) and impression
Instituto Nacional de Cultura, La Libertad, Trujillo

1. Cerro Mayal in the Chicama Valley. The archaeological site is now surrounded by sugarcane fields and modern constructions (foreground)

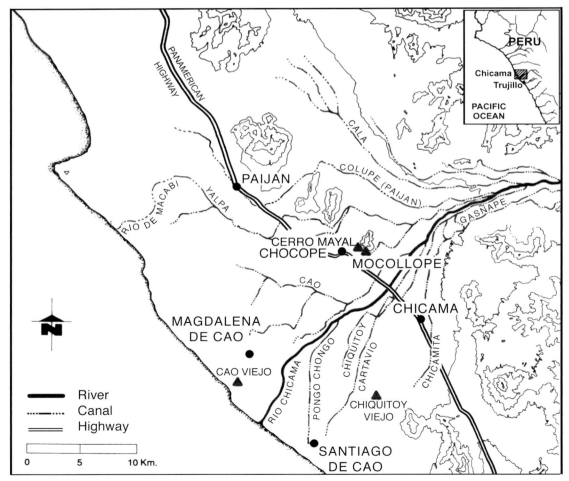

2. Map of Chicama Valley, showing location of major prehispanic sites and irrigation canals

Map by Genaro Barr, reconstruction of canals based on Netherly 1984

more heavily on archaeological data. We argue in this paper, however, that evidence from documents dating to the sixteenth and seventeenth centuries pertaining to this region may be used to aid in the construction of a general model outlining Moche social and political organization. We know from archaeological evidence that canal irrigation came early to the Chicama Valley, probably by Cupisnique times, approximately 900–800 B.C., and was well established by the Moche period (Kus 1972: 47–48; Lanning 1967: 109; Pozorski 1987: 111; Willey 1953: 362). This system of canal irrigation was fundamental to the development of complex, stratified society in the valley. Additionally, we believe that extended clans, analogous to highland *allyus*,[1] were the basic social units in the Chicama Valley, as they were throughout much of the Andes. We suggest that the territorial lands associated with each group were defined to large extent by the outlines of the irrigation canals and other prominent landmarks. We know that this was true for the Chicama Valley in the period immediately preceding, and just after, the Spanish conquest, and it seems reasonable that some similar system, although perhaps more limited in scale, was also in place during Moche times.

Political Economy and Context

Extended clans and their associated lands translated into political units, which are here referred to by their colonial designation, *parcialidades*. Data from early colonial administrative records indicate how the *parcialidades* may have been hierarchically arranged. For example, we know that families of elites ruled specific territories by well-established custom and tradition, entitling them to a variety of special privileges (Cabello Valboa 1951 [1586]; Rostworowski de Diez Canseco 1961). Lineage clans controlled the valleys in a pyramidal hierarchy. Common farmers were obligated to make tribute payments to their local lord, who was called a *principal*, who in turn owed tribute to a higher level lord, or *cacique*,[2] who himself usually owed tribute to an even higher-status paramount lord, or *cacique principal* (Larco Hoyle 1939: 132; Netherly 1977: 131; Rostworowski de Diez Canseco 1961). Although these relationships can only be documented to the near-

conquest period, the model they provide can be applied to the earlier Moche period and helps us to contextualize the production of specialized products like ceramics.

Rostworowski de Diez Canseco (1961) points out that political succession was hereditary, but not strictly linear. Possession of a territory (or *cacicazgo*) was usually passed to a brother or son. In cases where no obvious candidate was apparent, however, leadership could be passed to another capable person, though at the highest levels it is doubtful how often this may have occurred. Netherly (1977: 183–191) notes that it was common for high level *caciques* to assign leadership of smaller *parcialidades* under their control to brothers and sons as a means of reinforcing political control. The uncertainty of succession must have played some part in what appear to have been frequent armed conflicts. It may also have underscored an ongoing or continual need for a system of reciprocal kinship obligations.

Simultaneously, the hierarchy, with its built-in system of enforced social responsibilities and kinship ties, allowed for overall social continuity even in the face of uncertain transitions of political power. Intravalley dynamics for the Chicama Valley are described in detail by Netherly (1977, 1984) as having been subdivided along a complex pattern of dominant and lesser social units (or paired moieties), whose boundaries were generally defined by the irrigation canals, and whose hierarchy ascended in a dual pyramid fashion. Translated into political units, each territory was conceptually paired with a second territory, forming a moiety. Paramount lords of each polity were complemented by a "second" lord, the ruler of the lesser moiety (also called a *segunda persona*, or *segundo*) who functioned as a "first lieutenant" in dealing with the affairs of specific territories. Each of these lords, in turn, was owed allegiance by a pair of lesser moieties, or *parcialidades*, and so on. The term *parcialidad* was applied to almost any coherent group of people, yet a *parcialidad*'s position within the hierarchy, and hence the status of its leader, was determined by the number of its members and the type of craft specialization they possessed (Netherly 1977: 160–162). Tribute was marked by taxation in the form of labor or goods, and goods were redistributed in reciprocal fashion.

	FIRST MOIETY	SECOND MOIETY					
	Don Juan de Mora "Cacique Principal of Chicama V."	Don Pedro Mache "Segunda Persona of Chicama V."					
Don Alonso Chuchinamo 2nd Lord of First Moiety	Don Juan de Mora Lord of First Moiety	Don Pedro Mache Lord of Second Moiety		Don Gonzalo Sulpinamo 2nd Lord of Second Moiety			
Don Diego Sacaynamo 2nd Lord of Parcialidad 1:4	Don Alonso Chuchinamo Lord of Parcialidad 1:4	Unknown Name 2nd Lord of Parcialidad 1:4	Don Juan de Mora Lord of Parcialidad 1:4	Don Pedro Mache Lord of Parcialidad 1:4	Don Diego Martin Conaman 2nd Lord of Parcialidad 1:4	Don Gonzalo Sulpinamo Lord of Parcialidad 1:4	Unknown Name 2nd Lord of Parcialidad 1:4
Don Diego Sacaynamo Lord of Parcialidad 1:8	Don Alonso Chuchinamo Lord of Parcialidad 1:8	Unknown Name Lord of Parcialidad 1:8	Don Juan de Mora Lord of Parcialidad 1:8	Don Pedro Mache Lord of Parcialidad 1:8	Don Diego Martin Conaman Lord of Parcialidad 1:8	Don Gonzalo Sulpinamo Lord of Parcialidad 1:8	Unknown Name Lord of Parcialidad 1:8

3. Diagram of the hierarchy of Chicama Valley moieties in 1565
Based on Netherly 1984: table 1

Thus, in common with other parts of the Andean region, economic integration was achieved by the reciprocal exchange of goods and services, rather than by a system of markets. This type of social organization created unified valleywide polities capable of sustaining long-lasting alliances with neighboring valleys even when specific leaders changed (Castillo and Donnan 1994). As these alliances were not necessarily voluntary, and some valleys appear to have been annexed as a result of military conquests, it also created a built-in system of checks and balances, thus making continuous jockeying for political ascendancy both necessary and endemic.

Netherly was able to identify specific sections of lands in the Chicama Valley that were associated with specific lords and clarify their relationships. Figure 3 is a diagram of the hierarchy of Chicama moieties in 1565 based on Netherly's research. As she describes it, the Chicama polity, the overarching corporate group, encompassed most of the Chicama Valley, with the exception of certain areas such as the lands near Licapa and Paiján, in the northern part of the valley (fig. 4). We suggest that Mocollope was the seat of the paramount lord of the Chicama polity during the period associated with Moche I–IV ceramics. The Chicama polity was divided into four subgroups, or *parcialidades*, organized into two paired moieties: the dominant moiety to the north of the Chicama River, and the lesser moiety to the south. These moieties were bounded and defined by major canal arteries whose maintenance and waters were the responsibility and entitlement of the associated landholders.[3]

Using the parameters laid out by Netherly in her description as to which lords were associated with what territories in the early conquest period (Netherly 1984: 231–232), Mocollope and Cerro Mayal would have been in the northern moiety of the Chicama polity. Further, it appears that they would have been part of the personal lands of the paramount lord, or *cacique principal*, of the Chicama polity. In Figure 4 we present a hypothetical reconstruction of the major four *parcialidades* comprising the Chicama polity.[4] Beginning with Netherly's diagram of the main canals in the sixteenth century, we have modified the map by adding shaded areas roughly corresponding to the locations of the four main political subdivisions that she describes. Although the number, hierarchical relationships and general locations of these *parcialidades* can be reconstructed, the exact location of the boundaries between them are unclear.

We know that *parcialidades* were organized principally by economic activity. Given the agricultural basis of the economy, most *parcialidades* were made up of farmers and their dependents. Occupational specialists such as fishermen and artisans, however, were also grouped into such units under their own

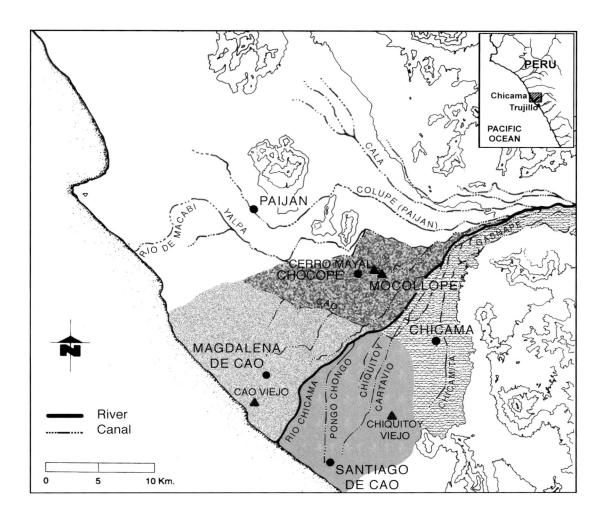

4. Map showing a hypothetical reconstruction of the major four *parcialidades* comprising the Chicama polity

leaders (Netherly 1984: 231). The ceramic specialists of Cerro Mayal, for example, probably constituted their own *parcialidad*. Shimada's data from Pampa Grande may indicate a similar type of organization of artisans in the Late Moche period (Shimada 1994, 1998), as does the evidence from the ceramic workshop at the site of Moche (Armas, Chamorro, and Jara 1993; Uceda, Mujica, and Morales 1997). Christopher Donnan's recent excavation of a fisherman's village at Dos Cabezas is further evidence of the existence of such economically specialized kin groups in early Moche times (Donnan and Cock 1997).

A polity would have been governed by dual leaders (fig. 3). As every polity leader also had his or her own *parcialidad*, a paramount ruler commanded numerous sublieutenants and their territories, as well as having direct control of at least one *parcialidad*. A paramount leader therefore exerted power at a micro level in addition to the general management rights he had over other *parcialidades* below him in the polity hierarchy. For those *parcialidades* that were not part of his own personal lands, tribute payments were received based on and through relationships established with the leaders of the other units. Such relationships could have been based on relatively peaceful social structures of reciprocity, obligation and exchange, but we also know that on occasion warfare and human sacrifice played a significant role in the sociopolitical balance.

Under what was essentially a form of patronage, rulers, as patrons, had a responsibility to provide goods and services to those under their protection. In exchange, as clients, the farmers and artisans produced whatever goods were required for the fulfillment of their taxation obligations. A workshop of

ceramic specialists, for example, would have kinship obligations to exchange goods with those of their own social level. They would also have a responsibility to give over a portion of their output to the next higher-level lord. In the case of Cerro Mayal, it appears that this would have been Mocollope's paramount lord, who was also the paramount lord of the Chicama polity. He, in turn, would redistribute the ceramics according to his own reciprocal obligations with others of his status level and lower. In other words, power and political relationships extended both vertically and horizontally, and patronage of art production was systemically embedded.

As mentioned earlier, according to Netherly's identification, territorial divisions in the Chicama Valley were defined by the major canals that bounded them. We also know that canal irrigation has significant time-depth in this valley. It is almost certain that these major canals were in use by Moche times and were associated with a system of hierarchically arranged corporate kin-based landholding units similar to those still in existence in later times.

The application of a model generated from sixteenth-century data to a culture a millennium earlier is not without risk, but it provides a useful framework for the interpretation of archaeological data. The model proposed here should be considered as hypothetical. Further substantiation will require archaeological testing, such as the excavation of canals and settlements to establish time-depth and continuity between the Moche, Chimú, and early Conquest periods.

The Site of Cerro Mayal

With this socioeconomic model in mind, it is useful to review the data from excavations of the workshop itself. The workshop consists of an area of approximately 9,000 m², with a central area of dense debris in excess of 5,000 m². It was clearly a large nucleated workshop. Carbon-14 samples indicate that the ceramic workshop was a single-phase production site in use only during the mid to late Moche period, from roughly A.D. 550 to 880 (Attarian 1996: 15–16, Table 2.1). Based on our fieldwork, it is possible to describe the nature and spatial organization of activities at the workshop (fig. 5). These data, along with the arti-

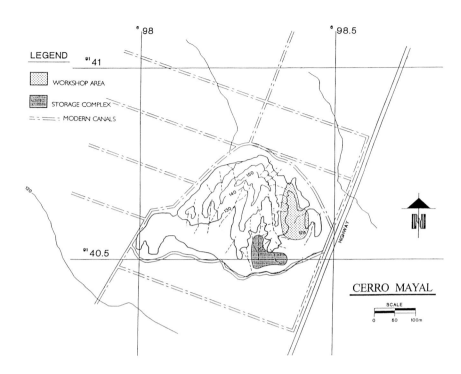

5. Site map of Cerro Mayal

facts and features recovered, allow us identify the products manufactured, interpret the affiliation of the producers and the intensity of production.

Aided by the use of cesium magnetometry and ground-penetrating radar surveys (Russell 1998), we were able to determine the location of kilns. The kilns were primarily of an open-pit type, sometimes with evidence of surrounding rudimentary adobe brick walls of two or three courses. Additionally, one example of a simple chamber kiln was excavated, which consisted of two parallel rows of adobe bricks set on end with a central chamber approximately 50 cm wide by 1 m long. Kilns were located across the central area of the workshop to take advantage of the wind, which funnels through the small ravine. Interspersed among the kilns were a variety of domestic features, including hearths, floors, deposits of domestic refuse, and evidence of ephemeral structures consisting of adobe brick footings and *quincha* or plastered mat walls. This arrangement clearly indicates that the workshop area was also a domestic area.

Analysis of botanical remains at Cerro Mayal indicates that the bulk of the agricultural products consumed consisted of maize and beans; both are high-value storable foods

Forms			Diagnostic sherds	
	Total	Percent	Total	Percent
Musical instruments				
rattle handle	117	81.82%		
rattle pod (chamber)	16	11.19%		
whistle	10	6.99%		
Total musical instruments			143	1%
Figurines and talismans				
bead	39	27.27%		
figurine (hollow)	714	57.91%		
figurine (solid)	480	38.93%		
Total figurines and talismans			1,233	11%
Ritual serving and consumption vessels				
basin	1,479	16.50%		
bottle	310	3.46%		
dipper	6	0.07%		
florero	337	3.76%		
jar/bottle (body fragment)	868	9.68%		
jar/bottle/*florero* base	1,171	13.06%		
jar/olla	4,357	48.59%		
jar neck appliqué	95	7.70%		
jar/bottle appliqué element	103	8.35%		
kero with straight sides	18	0.20%		
lid	175	1.95%		
oval cup (no handle)	31	0.35%		
plate	16	0.18%		
Total ritual serving and consumption vessels			8,966	76%
Tools and other				
clay (baked lump)	22	1.52%		
clay (raw)	2	0.14%		
grater	32	2.21%		
mold (whole or fragment)	1,271	87.59%		
spindle whorl	21	1.45%		
spoon	103	7.10%		
other	215	14.82%		
Total tools and other			1,451	12%
Total of diagnostic sherds			11,793	100%

6. Diagnostic sherds, Cerro Mayal, 1992 field season

(Attarian 1996, 1998). In addition, preliminary analysis of faunal remains suggests that camelid meat was also a significant component of the diet. It seems likely, therefore, that Cerro Mayal was being provisioned with foodstuffs from other groups' taxation payments. Given that Cerro Mayal is located in the *parcialidad* that also includes Mocollope, and because these food payments would have been collected and redistributed by a high-level *cacique*, it is logical to conclude that the paramount lord at Mocollope was the patron of Cerro Mayal. Provisioning a workshop such as Cerro Mayal would have represented a sizable economic burden, and in exchange for such a heavy level of economic patronage, the majority of the ceramic output from the

site may have been given over directly to the lord of Mocollope.

Cerro Mayal was a large specialized workshop where the potters both lived and worked. Although it is not clear if their production was full- or part-time, the only evidence for craft production of any kind was of ceramic manufacture. This pattern continued for a period of approximately two hundred years in late Moche times. While there is no obvious physical restriction of access to the workshop, this should not be confused with restriction of access to its products. Based on the evidence of provisioning, the nature of ceramics produced, and its physical proximity to Mocollope, it is reasonable to assume that much of the production there was embedded in a system of patronage, and that the workshop at Cerro Mayal was an attached workshop.

Cerro Mayal Ceramics

A closer consideration of the variety and relative quantities of ceramic forms produced provides insight into the nature and purpose of their creation and use. The ceramics manufactured at Cerro Mayal were typically made from a very fine orange paste, which we refer to as fineware. There was little or no apparent production of coarse-tempered cooking ware or large storage vessels. While the ceramics were clearly not utilitarian, in the sense that they were not used for everyday cooking and storage, only a small percentage of the ceramics produced at Cerro Mayal could be classified among the finest of Moche wares. These very fine Moche wares characteristically show an increased attention to iconographic and formal detail, multiple layers of slip paint with a high degree of surface polish, and thin-wall construction techniques. Most of the ceramics produced at Cerro Mayal were made of a high-quality paste, but demonstrate a less labor-intensive manufacturing process than the highest-end ceramics. The majority, if not all, of the Cerro Mayal ceramics were probably used in ritual activities; the ceramic production center here was essential in providing appropriate vessels and figurines for the ritual cycles of Moche life.

We recovered and analyzed 139,240 sherds from the 1992 field season. Of these, 91.5 percent were fragments of undetermined

ceramic forms. The remaining 8.5 percent, or 11,793 sherds, had some type of diagnostic characteristic, such as a rim or handle, which allowed us to assign them to a form category. As Figure 6 shows, these included basins, bottles, jars, *floreros* (flaring vases), figurines, tools and other items. No whole vessels were found, although we did find some whole figurines and molds.

We suggest that the workshop at Cerro Mayal produced ceramic objects suitable for a variety of special events and rituals. The ceramics themselves, combined with our understanding of Moche social structures, give clues as to what some of those events may have been. Accordingly, we have divided the ceramics into four main groups, which we believe correlate to different functions within Moche rituals. These are the music and musical instrument group, the figurines and talismans group, ritual serving and consumption vessels, and a final group of tools and "other."

The ceramic forms most obviously tied to ritual practices are the musical instruments (figs. 7–10). These include rattles, whistles, trumpets, and drums, as well as depictions of people playing those instruments. Overall, the music cluster comprises just over 1 percent of all diagnostic sherds. Even though these sherds represent only a small proportion of the overall production, we believe this category is significant in terms of understanding how ceramics were used. We suggest they were intended for use in various rituals during life, and then ultimately interred.[5]

Colonial period sources from both the coast and the highlands suggest that music and dancing were important aspects of Andean ritual life. In Moche iconography, musicians are often shown as members of processions. The depictions seem to represent specific types of processions, which scholars have named the Dance of the Dead and the Ribbon Dance (Donnan 1982; Hocquenghem 1987; Jiménez Borja, 1938, 1951; Muelle 1936). A number of the figurines from Cerro Mayal appear to depict individuals similar to those seen in the processions (fig. 7). In other musically related examples, male or female individuals are shown with their eyes closed, as if in a trance, holding or playing rattles or drums. One such person, a female, is shown in Figure 8. Males are also

7. Fancy ceramic whistles depicting opulently dressed persons engaged in ritual activities; left, a musician playing pan pipes, and right, a Ribbon Dancer
Instituto Nacional de Cultura, La Libertad, Trujillo

8. Hollow figurine (above center) depicting person playing a rattle. Hollow rattles are on the left and right
Instituto Nacional de Cultura, La Libertad, Trujillo

9. Male rattle-player figurines
Instituto Nacional de Cultura, La Libertad, Trujillo

depicted as rattle-players, as in Figure 9. Trumpets and drums complete the musical instrument assemblage (fig. 10).

The items in the group we identify as figurines and talismans were probably used in life prior to final placement in graves. This group numbers 1,233 sherds or whole specimens, or 11 percent of the total diagnostic

10. Ceramic trumpet mold fragment of snarling creature, and impression (right)
Instituto Nacional de Cultura, La Libertad, Trujillo

sample. Larger versions (10 cm and taller) are generally hollow while the smaller ones are solid. The majority of the Cerro Mayal figurines represent females, shown both clothed and nude (figs. 11–13). In absence of visible genitalia, determination of gender is based on formal characteristics previously established within the Moche iconographic corpus, generally costume elements. For example, males are usually associated with warrior paraphernalia, loincloths, short tunics and elaborate headdresses. Clothed females generally do not wear headdresses, and are shown wearing long tunics with a rounded neckline, with their hair in two long hair braids, and often with pendant earrings (Hocquenghem and Lyon 1980; Jackson 2000: 75). Male figures comprise only about 4 percent of the total sample of figurines from Cerro Mayal (fig. 14). Males are represented as warriors and occasionally as bound prisoners.

Some of the figurines were extremely small. The tiniest ones, 3 cm or less in height,

11. Large hollow female figurine
Instituto Nacional de Cultura, La Libertad, Trujillo

12. Solid nude female figurines
Instituto Nacional de Cultura, La Libertad, Trujillo

typically had holes punched in them, allowing them to be suspended as pendants. Most of these miniature perforated forms depict humans in abbreviated form—that is, they are usually rendered as just a head with tiny feet and minimal reference to the body's midsection (fig. 15). Tiny representations of animals and fruits are also present in the sample.

We have grouped figurines with pendants because we see a conceptual similarity in terms of how both types of item were probably used. It is possible that these ceramics were destined to be part of a shaman's *mesa* (collection of objects for healing rituals), or

perhaps they were intended for use by local-level religious practitioners. They may have functioned at the household level, in petitions to deities for protection, fertility or health, prior to their ultimate use as grave goods. Their modest form and diminutive scale suggest that they were intended for personal ritual use.

The majority of vessels produced at Cerro Mayal are ritual serving and consumption vessels. These represent 76 percent of all diagnostic sherds. We suspect that most of the nondiagnostic sherds were also once part of hollow vessel forms. As complete vessels are rare in workshops, we have approximated the form range of the Cerro Mayal assemblage using the Virú Valley typology formulated by Strong and Evans (1952). Figure 16 is a reconstruction of the basic forms present at Cerro Mayal. Medium to tall necked jars are the

most common ceramic form in the ritual serving and consumption vessel group. These were usually anthropomorphized through the addition of a press-molded or appliquéd face in the area of the vessel neck (fig. 17). Globular jars with short everted necks were common (fig. 18). We also found lids of an appropriate size for these jars. These lids were typically pierced to facilitate tying. Another

frequent vessel type is a straight-neck bottle with strap handle, a form that was commonly decorated with a scowling face (fig. 19).

In other cases, entire vessel bodies were sculpted to represent both human heads and bodies, perhaps as portraits of individuals (fig. 20; see also Donnan, this volume). In many cases vessels were embellished through the addition of separately modeled appliqué elements, as evinced by numerous appliqué molds at Cerro Mayal. These figures are among the most delicately detailed ceramics. They wear elaborate headdresses, distinctive costumes, and refer to the larger iconographic repertory of Moche nobility, warriors and prisoners (figs. 21–24). Other vessel forms included dippers (also known as *cancheros*), goblets, *keros* (cylindrical drinking vessels), and *floreros* (fig. 25).

It should be noted that although we call these serving and consumption vessels, not all would have been particularly useful for eating and drinking. Vessels such as *floreros* or stirrup-spout bottles are impractical for ordinary use—the *floreros* tip easily and the stirrup-spout bottles are difficult to fill and pour—and may have been intended mainly for funerary rituals or other limited ceremonial activity. Their role may have been more liturgical within the context of specific rituals.

13. Solid clothed female figurines
Instituto Nacional de Cultura, La Libertad, Trujillo

14. Solid male warrior figurine
Instituto Nacional de Cultura, La Libertad, Trujillo

15. Small figurines with perforations for suspension as pendants
Instituto Nacional de Cultura, La Libertad, Trujillo

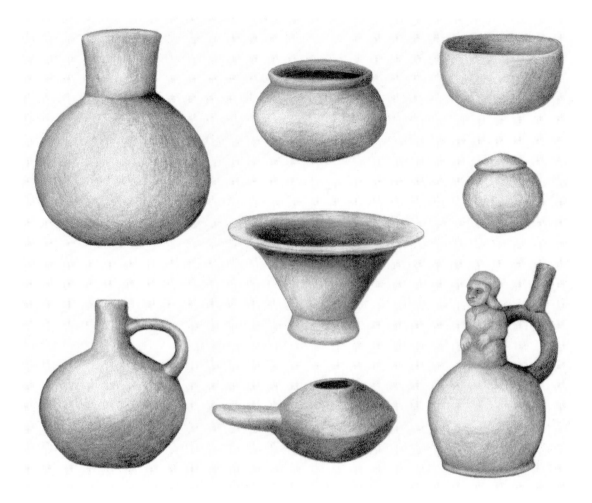

16. Assemblage of principal ceramic forms at Cerro Mayal: (top left) straight-neck jar, (bottom left) straight-neck bottle with strap handle, (top center) short everted-neck jar, (middle) flaring vase (*florero*), (bottom center) dipper; (top right) open bowl/basin, (center right) small jar with convex lid, (bottom right) stirrup-spout bottle with appliquéd figure

The fourth category of items produced at Cerro Mayal is made up of miscellaneous tools. This group, consisting of 1,451 sherds, represents 12 percent of the total sample. Molds are the dominant form in this category, with molds or mold fragments making up 88 percent of this category. Other ceramic crafting tools include turnettes (sometimes called "bats"), and clay mixing vessels. Also in this category are a small number of specialized domestic forms such as spoons and spindle whorls, which were probably for the personal use of the potters.

Mold use at Cerro Mayal was more complex and technically sophisticated than we first imagined, given the evidence of the published literature available in the 1980s and 1990s. It has long been known that two-piece molds were used to produce some types of Moche ceramics (Donnan 1992; Larco Hoyle 1945). These molds essentially comprised the front and back sides of a vessel's main chamber. Yet, based on the evidence from Cerro Mayal, it is clear that in addition to one or two-part molds, Moche artists were combining a variety of other molding and hand-modeling techniques to achieve an impressively high degree of complex artistry (Jackson 1993). Molds were an integral part of a long hand-building tradition on the north coast, a tradition refined by the Moche to include multiple-part molds and complex joinery. Our findings concur with Sergio Purin's (1983) x-ray analyses of several Moche vessels, indicating multiple-part construction. At Cerro Mayal, bottles, jars, figurines, musical instruments, pendants, and masks were constructed either partially or entirely with the aid of molds.

It is notable that Moche ceramists employed molds for many of the finest items. One important motivation of attached

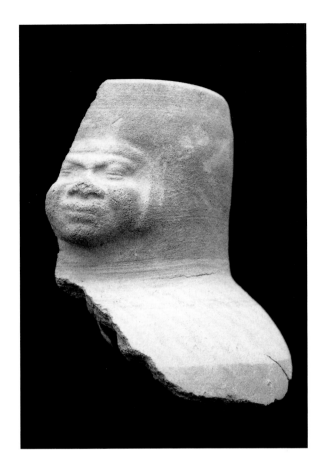

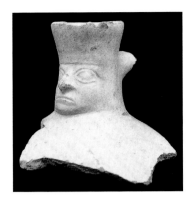

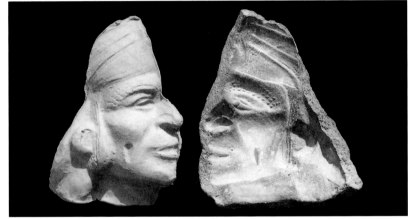

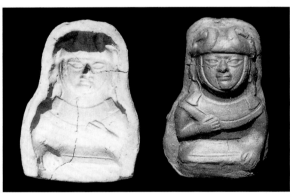

AT LEFT:

21. Appliqué mold, producing elaborately dressed, seated figure. Impression on right
Instituto Nacional de Cultura, La Libertad, Trujillo

22. Appliqué mold, producing captive figure, possibly dead, with one eye missing. Impression on right
Instituto Nacional de Cultura, La Libertad, Trujillo

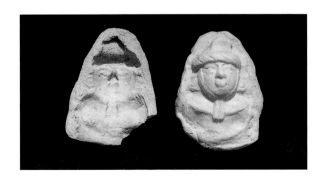

23. Appliqué mold, producing figure wearing turban headdress and nose ornament. Impression on right
Instituto Nacional de Cultura, La Libertad, Trujillo

24. Appliqué mold, producing warrior holding club and wearing cylindrical crown headdress. Impression on right
Instituto Nacional de Cultura, La Libertad, Trujillo

specialization is the desire of elites to control critical symbols and other elements of cosmology (Brumfiel and Earle 1987). In addition to economy of scale and mass production, molds allow for the standardization and control of iconographic information. Although mold technology probably did simplify certain aspects of ceramic production, molds were apparently not used as a means to increase production speed. In fact, in many cases, mold use actually *added* steps to the production process. Molded items may have been especially prized for the inclusion of specific iconic motifs. A "master" artist's status was doubtless tied to his or her level of access to special esoteric knowledge and his or her ability to translate that knowledge into visual form correctly. Molds played a critical role in assuring that an icon's essential pictorial elements were included in any given depiction and allowed for the widespread dissemination of ideologically linked imagery. Therefore, the use of molds was integral to the construction of representation and meaning, rather than a secondary by-product resulting from technical processes.[6]

Patronage Relationships

Finally, we wish to consider how the production and distribution of ceramics from Cerro Mayal may be understood in terms of strategies of power. Based on what we know about Andean ancestor veneration, the living were never really separated from the spirit world; the two worlds were envisioned as constantly intersecting (Ramírez 1996). Ceramics were undoubtedly critical in the maintenance of symbolic communication between two worlds. Ritual ceramics may have been intended to serve multiple functions and carry multiple meanings. That is, they were intended to be used among the living while simultaneously carrying messages to the spirit world. While the majority of fancy Moche ceramics extant were found in funerary contexts, we cannot assume that this type of ceramic was made for the sole purpose of funerary offerings.

The model of sociopolitical organization of the valley suggests that the system was somewhat competitive and decentralized, with ongoing maintenance of human and spirit

relationships a key element in legitimation of political leadership. Individual *caciques* maintained a measure of autonomy, while ideology and ritual served as a powerful glue to hold the system together. It was a system made up of a series of reciprocal and hierarchical relationships that were codified in ritual. The reciprocal relationships operated both vertically and horizontally; between the rulers and the ruled, as well as between the living and the ancestors. In order to maintain the hierarchy it was necessary for all to follow properly the correct protocols and ritual structures. By making offerings of food, drink, and music to the ancestors on ritual occasions the reciprocal relationship between the dead and the living was maintained. The rulers stressed their link with the ancestors, whose favor was considered necessary for the continued wellbeing of the community.

Because leadership's role included successful maintenance of sociopolitical relationships, as well as maintenance of the community's religious obligations to the ancestors, it is perhaps not surprising that the manufacture and distribution of ceramic objects, as one of the most important classes of ritual paraphernalia, was worthy of economic investment. As Susan Ramírez (1996: 162) points out, the relationship between temporal and supernatural legitimacy was politically linked to religious and economic sponsorship of artisans.

Using the sociopolitical model described previously, we can propose that the distribution of ceramics was embedded within the hierarchy. For example, the local-level leader of Cerro Mayal would have owed a production quota to the higher-level lord of Mocollope, who in turn supported production. The lord of Mocollope would then redistribute these products down the hierarchy through reciprocal obligations and status-display at ritual events. Labor and goods flowed up the hierarchy; ceramics and other items flowed down the hierarchy.

Patronage relationships in various cultures generally conform to one of four arrangements (Thapar 1992; Williams 1981). Patronage can be a deliberate act of choice, as when a community decides to donate wealth and labor toward the building of a religious monument and where the patron is not a single person but a group. Patronage can also be a public activity where the material value of the object is determined by the patrons. In some instances, patronage can be a service exchange, where the recipient becomes a retainer or is directly commissioned by a patron to produce an object of value. Or, patronage can be an exchange system that is embedded in a society; patrons and recipients are built into the system. Hence, under a political strategy involving obligatory reciprocity, artistic patronage at Cerro Mayal would have been systemically embedded.

Based on what we know of other pre-Columbian polities whose strategies of power involved the use of ideologically loaded imagery, we might expect to see an iconography of patronage involving relatively overt manipulation of imagery. This would include, for example, the commissioning of artworks whose purpose was to give direct testimony of the ruler's fulfillment of obligations associated with leadership—glorifying and legitimating the ruler or patron in a relatively straightforward way. We see this in certain contexts, such as in the warfare iconography on the architectural reliefs at the El Brujo complex (Gálvez and Briceño, this volume) and elsewhere (Jackson 2000: 35–60). Data from Cerro Mayal, however, show us that at this workshop such references were relatively rare. Even though some examples of portraits, captive prisoners, and elaborately costumed elites were retrieved there, they were not the principal subject at Cerro Mayal. For whatever reason, iconographic references to individuals or glorious deeds, if present, remain relatively oblique.

Status displays among subpolities, while supporting the creation of political hierarchies, would also serve to create hierarchies internal to the various professional disciplines of craft specialists; in other words, this type of patronage arrangement created a situation whereby "master" artisans could arise. It seems likely that these master artisans, bound by the ties and obligations of their respective clans, would have necessarily remained attached to specific patrons, and the products of their clientage would have been available to the patron for redistribution, thereby serving to reinforce the leadership of the dominant polity.

We hypothesize that the dominance of various clans was formalized in the hierarchy of

parcialidades, which was both self-sustaining as well as self-adjusting over time. The waxing and waning fortunes of any given *parcialidad* or *cacique* would have given rise to, and been fed by, ongoing rivalries. Elites of Mocollope may have compared themselves to elites at the El Brujo complex, Moche or Pañamarca as part of a hierarchy of polities engaged in subtle competition with each other. In instances where outright conflict was inappropriate, this competition would have been most visible in the production, acquisition and maintenance of art and architecture, and in the production of lavish feasts and ritual celebrations. Individual leaders' successes in achieving dominance bred further triumphs, leading, in turn, to increased demand for elite-status objects such as the fineware ceramics produced at Cerro Mayal.

NOTES

1. The term *allyu* refers to lineage structures of individual families who claim descent from a common ancestor, as well as to group lineages associated with specific geographic territories (Harrison 1989; Netherly 1977: 162).

2. Roughly analogous to the highland designation, *curaca*, *cacique* described individuals of widely differing levels of ranked status, governing both locally and regionally. Netherly (1977: 3, 131) points out that *cacique* and *cacicazgo* are Antillian terms adopted by Spaniards during the colonial period and used to refer to local and middle-level leaders and their territories.

3. The El Brujo complex, located on the coast just north of the Chicama River, was contemporaneous with Mocollope. Following on from Netherly (1984: 233), El Brujo may have been the seat of an allied or complementary moiety within the valley hierarchy. Both sites depended on water from the Cao canals, suggesting a complex relationship in need of further investigation.

4. According to Netherly, the section of lands to the north of the Chicama River from approximately Chocope to the west along the Cao canal, were ruled by a *cacique* named Alonso Chuchinamo. His *segundo*, Diego Sacaynamo, is mentioned as pertaining to a smaller *parcialidad* somewhere within the Cao territory. Chuchinamo owed primary allegiance to Juan de Mora, the paramount lord of the Chicama polity. Netherly suggests that Juan de Mora's personal territory was north of the Chicama River and east (up valley) from Chocope, an area that would have included Cerro Mocollope. Pedro Mache, mentioned as Juan de Mora's *segunda persona*, along with his vassal, Gonzalo Sulpinamo, is assumed by Netherly to have controlled the lands south of the Chicama River (1984: 231–232).

5. The majority of ceramics excavated under scientific conditions have been found in funerary contexts. We assume, however, that some of these objects were used prior to interment, based on use-wear evidence.

6. Tom Cummins (1994: 159) states that this was also true for the Ecuadorian ceramic traditions of Jama-Coaque, La Tolita, and Bahía.

BIBLIOGRAPHY

Armas, José, Violeta Chamorro, and Gloria Jara
 1993 Investigaciones arqueológicas en el complejo Huacas del Sol y la Luna: Talleres alfareros de la sociedad Moche. Thesis, Pre-Professional Practices in Archaeology. Facultad de Ciencias Sociales, Universidad Nacional de Trujillo.

Attarian, Christopher J.
 1996 Plant Foods and Ceramic Production: A Case Study of Mochica Ceramic Production Specialists in the Chicama Valley, Peru. Master's thesis, Department of Anthropology, University of California, Los Angeles.

 1998 Diet, Status, and Affiliation in Moche Society: Ethnobotanical Data from the Chicama Valley. Paper presented at the 63rd Annual Meeting of the Society for American Archaeology, Seattle.

Brumfiel, Elizabeth M., and Timothy K. Earle
 1987 (Editors) *Specialization, Exchange, and Complex Societies.* Cambridge.

Cabello Valboa, Miguel
 1951 *Miscelánea antártica. Una historia del*
 [1586] *Perú antiguo.* Lima.

Castillo, Luis Jaime, and Christopher B. Donnan
 1994 Los Mochica del norte y los Mochica del sur. In *Vicús,* by Krzysztof Makowski, Christopher B. Donnan, Iván Amaro Bullón, Luis Jaime Castillo, Magdalena Diez Canseco, Otto Eléspuru Revoredo, and Juan Antonio Murro Mena, 143–181. Colección Arte y Tesoros del Perú. Lima.

Cummins, Tom
 1994 La tradición de figurinas de la costa ecuatoriana: Estilo tecnológico y el uso de moldes. In *Tecnología y organización de la producción de cerámica prehispánica en los Andes,* ed. Izumi Shimada, 157–171. Lima.

Donnan, Christopher B.
 1982 Dance in Moche Art. *Ñawpa Pacha* 20: 97–120.

 1992 *Ceramics of Ancient Peru* [exh. cat., Fowler Museum of Cultural History, University of California]. Los Angeles.

Donnan, Christopher B., and Guillermo A. Cock
 1997 Excavaciones en Dos Cabezas, valle del Jequetepeque, Perú. Tercer informe parcial, tercera temporada de excavaciones (Julio–Agosto, 1996). Report submitted to the Instituto Nacional de Cultura, Lima.

Harrison, Regina
 1989 *Signs, Songs, and Memory in the Andes: Translating Quechua Language and Culture.* Austin, Tex.

Hocquenghem, Anne-Marie
 1987 *Iconografía Mochica.* Lima.

Hocquenghem, Anne-Marie, and Patricia J. Lyon
 1980 A Class of Anthropomorphic Supernatural Females in Moche Iconography. *Ñawpa Pacha* 18: 27–48, plates III, IV.

Jackson, Margaret A.
 1993 Mold Use at Cerro Mayal, Chicama Valley, Peru. Paper Presented at the 33rd Annual Meeting of the Institute for Andean Studies, Berkeley [in program as Icon and Narrative: An Analysis of Moche IV Ceramics from Cerro Mayal, Peru.]

 2000 Notation and Narrative in Moche Iconography, Cerro Mayal, Perú. Ph.D. dissertation, Department of Art History, University of California, Los Angeles.

Jiménez Borja, Arturo
 1938 *Moche.* Lima.

 1951 Instrumentos musicales peruanos. *Revista del Museo Nacional* 19–20: 37–189. [Lima].

Kus, James S.
 1972 Selected Aspects of Irrigated Agriculture in the Chimu Heartland, Peru. Ph.D. dissertation, University of California, Los Angeles.

Lanning, Edward P.
 1967 *Peru Before the Incas.* Englewood Cliffs, N.J.

Larco Hoyle, Rafael
 1939 *Los Mochicas, Tomo 2.* Lima.

 1945 *Los Mochicas (Pre-Chimu, de Uhle y Early Chimu, de Kroeber).* Buenos Aires.

Leonard, Banks L., and Glenn S. Russell.
 1992 Informe preliminar: Proyecto de reconocimiento arqueológico del Chicama, resultados de la primera temporada de campo, 1989. Report submitted to the Instituto Nacional de Cultura, Lima.

Muelle, Jorge C.
 1936 Chalchalcha (Un análisis de los dibujos muchik). *Revista del Museo Nacional* 5 (1): 65–88. [Lima].

Netherly, Patricia J.
 1977 Local Level Lords on the North Coast of Peru. Ph.D. dissertation, Department of Anthropology, Cornell University, Ithaca.

 1984 The Management of Late Andean Irrigation Systems on the North Coast of Peru. *American Antiquity* 49 (2): 227–254.

Pozorski, Thomas
 1987 Changing Priorities within the Chimu State: the Role of Irrigation Agriculture. In *The Origins and Development of the Andean State,* ed. Jonathan S. Haas, Shelia Pozorski, and Thomas Pozorski, 111–120.

New Directions in Archaeology. Cambridge.

Purin, Sergio
1983 Utilisation des rayons-x pour l'observation des traces de fabrication sur cinq vases Mochicas. *Bulletin des Musées Royaux d'Art et d'Histoire* 54 (2): 5–20. [Brussels].

Ramírez, Susan E.
1996 *The World Upside Down: Cross-Cultural Contact and Conflict in Sixteenth-Century Peru.* Stanford, Calif.

Rostworowski de Diez Canseco, María
1961 *Curacas y Sucesiones: Costa Norte.* Lima.

Russell, Glenn S.
1998 Remote Sensing, Excavation Strategy, and Interpretation at Cerro Mayal, Perú. Paper presented at the 63rd Annual Meeting of the Society for American Archaeology, Seattle.

Russell, Glenn S., Christopher J. Attarian, and Rosario Becerra Urtega
1999 Informe parcial: Excavaciones en Mocollope, valle de Chicama, Perú, temporada de excavaciones (junio–agosto, 1998). Report submitted to the Instituto Nacional de Cultura, Lima.

Russell, Glenn S., Banks L. Leonard, and Jesús Briceño
1994 Cerro Mayal: Nuevos datos sobre la producción de cerámica Moche en el valle Chicama. In *Moche: Propuestas y perspectivas* [Actas del primer coloquio sobre la cultura Moche, Trujillo, 12 al 16 de abril de 1993], ed. Santiago Uceda and Elías Mujica, 181–206. Travaux de l'Institut Français d'Etudes Andines 79. Trujillo and Lima.

1997 Primer informe parcial: Excavaciones en Cerro Mayal, valle de Chicama, Perú, primera temporada de excavaciones, junio–agosto 1992. Report submitted to the Instituto Nacional de Cultura, Lima.

Shimada, Izumi
1994 *Pampa Grande and the Mochica Culture.* Austin, Tex.

1998 (Editor) *Andean Ceramics: Technology, Organization, and Approaches.* MASCA (Museum Applied Science Center for Archaeology) Research Papers in Science and Archaeology, Supplement to Volume 15. University of Pennsylvania Museum of Archaeology and Anthropology, Philadelphia.

Strong, William Duncan, and Clifford Evans
1952 *Cultural Stratigraphy in the Virú Valley, Northern Peru: The Formative and Florescent Epochs.* Columbia Studies in Archeology and Ethnology 4. New York.

Thapar, Romila
1992 Patronage and the Community. In *The Powers of Art: Patronage in Indian Culture*, ed. Barbara Stoler Miller, 19–34. Delhi, Oxford, and New York.

Uceda, Santiago, Elías Mujica, and Ricardo Morales
1997 (Editors) *Investigaciones en la Huaca de la Luna 1995.* Facultad de Ciencias Sociales, Universidad Nacional de La Libertad, Trujillo.

Willey, Gordon R.
1953 *Prehistoric Settlement Patterns in the Virú Valley, Perú.* Smithsonian Institution, Bureau of American Ethnology Bulletin 155. Washington.

Williams, Raymond
1981 *Culture.* London.

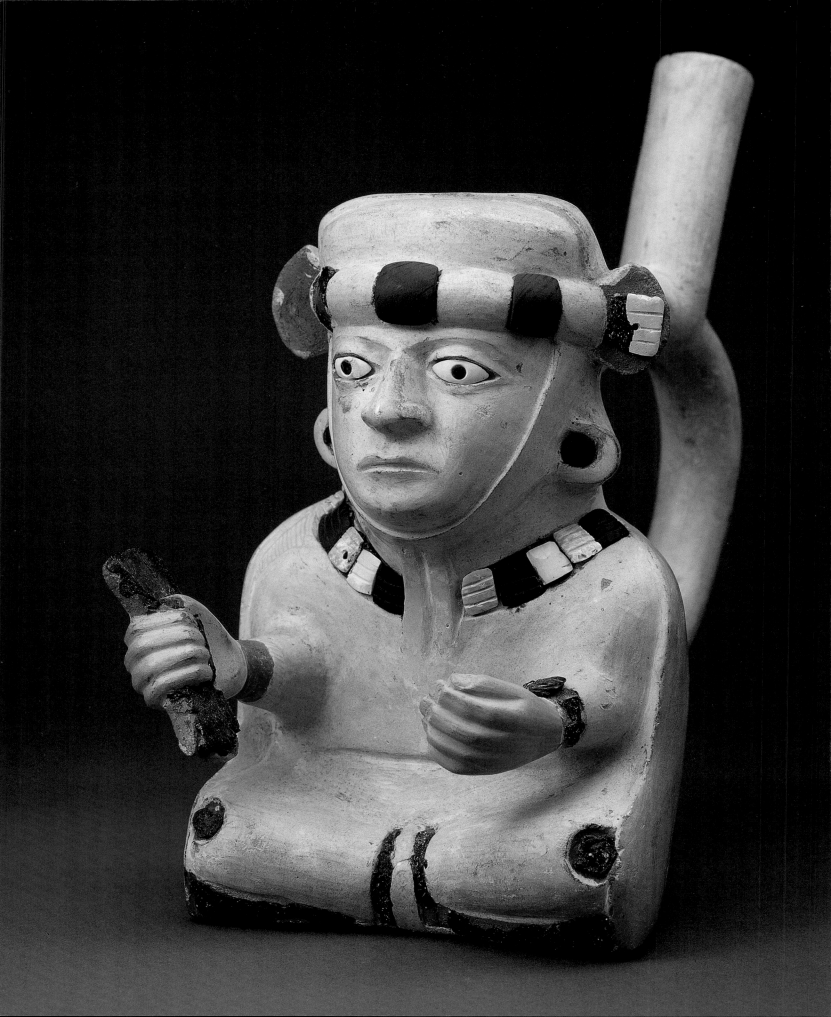

IZUMI SHIMADA
Southern Illinois University

Late Moche Urban Craft Production: A First Approximation

Much of our conception and perception of the archaeological culture we call Moche or Mochica has been built on the artistic and technical aspects of their ceramics and metalwork. These Moche crafts were unprecedented in their innovative character, sophistication, virtuosity, and other qualities, and remained largely uneclipsed by later crafts, not only in the prehispanic Andes, but in the entire prehispanic New World. Further, the Moche crafters and their elite patrons were largely responsible for the formalization of distinct and persistent artistic and technical traditions that characterized the arts and crafts of subsequent north coast cultures such as the Sicán (also known as Lambayeque) and Chimú (Shimada 1999a). Distinct ceramic and metallurgical traditions have been identified for the north Peruvian region (Willey 1964; Shimada 1999a; also see Lechtman 1979, 1988). These traditions had specific repertoires and preferences in raw materials and technologies, as well as artistic conventions and features that were persistent in time and widespread in space (that is, pannorth coast).

While the artistic and technical qualities of craft products are invariably mentioned in characterizing the Moche culture, not much is known about the crafters themselves or the technology, organization, and social context of their production, or the social values of their products. Outside of the *chaînes opératoires*, sequences of specific manufacturing steps, that have been partially reconstructed from analyses of finished products, tools (primarily molds), and replication experiments (for example, Donnan 1965, 1992; Parsons 1962; Purin 1983, 1985; Tello 1938; Willey 1949), available data on these issues are woefully inadequate. Moche art has proven to be informative about many aspects of the culture through its naturalistic representations of diverse subjects, yet it has not told us much about craft activities, which were rarely depicted. A well-known fine-line drawing depicting supervised weaving (fig. 1) and a sculptural representation of annealing activity (presumably of copper objects; Donnan 1973) are rare examples.

In spite of the above limitations, we must undertake the task of identifying craft goods, characterizing crafters and their relationship with elite sponsors, and explicating the organizational and social dimensions of their production, as well as the manners in which products were distributed and consumed, particularly by the social elite. Elucidation of these issues is critical for an understanding of the roles played by crafters and their products in the creation, legitimization, and/or reinforcement of social inequalities and political control. Obligations or contractual arrangements between producers and consumers or sponsors, as well as the differentiated usage and distribution of craft goods of varied artistic and technical qualities, all inform us of the sociopolitical reality. Helms (1993: 14)

Moche IV sculpted stirrup-spout bottle representing a seated man. From Tomb 1, Huaca de la Luna
Museo de Arqueología, Antropología e Historia, Universidad Nacional de Trujillo Photograph by Yutaka Yoshii with permission of Santiago Uceda

focused on "skilled crafting" precisely because it was "associated with politically influential individuals and political leaders."

Yet, the task is not an easy one given the aforementioned paucity of focused and sustained studies of Moche craft production. There are many questions to be answered. What constituted "wealth" and "status" items (Brumfiel and Earle 1987; Prentice 1987), and how were their social values determined? Prentice (1987: 198) defined status items as "those items which are restricted in use to a specific social segment," and thus access to them "is determined solely by social position, *regardless of economic wealth*." Wealth items are not limited to a particular social status and "are valued by everyone because they give the owner prestige," as they pay social obligations or are scarce. Who produced them and how was access to their products managed? Who were their patrons? Did crafters specialize in a single medium or multiple media? Were specialists recruited along kinship lines and trained through formal apprenticeship? How were specialists supported and managed? What were the specific obligations of the artisans to their patrons? What role did artisans and patrons play in the creation and transformation of images on finished craft goods? How were the images selected out of the total iconographic repertoire? In fact, if elite individuals were involved in control of the manufacturing process, what form did such control take? What sorts of interaction took place among different crafts and adjacent and/or distant workshops? Overall, concerted inquiry focused on these questions directly contributes to our understanding of Moche sociopolitical organization and the broader significance of the art that decorated so many craft goods.

It is the aim of this paper to begin this long-term inquiry by shedding some light on what has come to be called "production by attached specialists" (Brumfiel and Earle 1987; Earle 1987) or "sponsored production" (Hayashida 1995) and to stimulate active discussion and critical rethinking of existing conceptions of Moche craft production. In particular, I will examine the ethnic identity of crafters and their organization and products, interaction among themselves, and principles governing their relationship with elite sponsors. These issues will be considered from both the

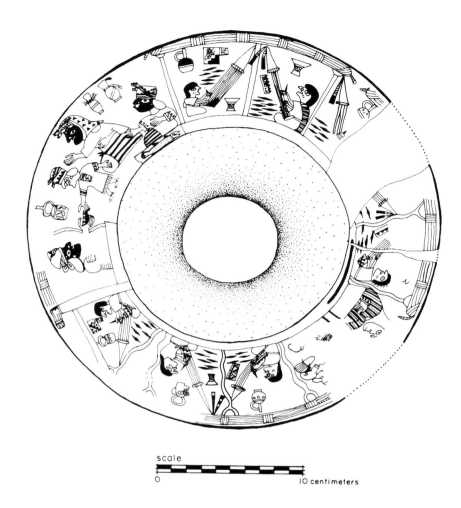

scale
0 10 centimeters

crafters' and sponsors' perspectives. Throughout this paper, the term crafts denotes skilled manual arts producing portable artifacts of utilitarian or symbolic nature ("wealth" and "status" items) and food and drink, particularly *chicha* or maize beer. Excavations of craft workshops and kitchens and their broader contexts are particularly useful in this regard. Thus, I will summarize relevant data from extensive excavations of workshops and kitchens in 1975 and 1978 at Pampa Grande in the Lambayeque Valley, the urban capital of the northern Moche V polity that was rapidly established c. A.D. 600 and lasted until c. A.D. 700–750 (Shimada 1978, 1982, 1994a). Extensive excavations tracing latest floors and access patterns were conducted to elucidate the synchronous pattern of interaction among different activity areas. The resultant model of late Moche urban craft production is compared with similar models from later

1. Weaving scene painted on a Moche IV *florero* (flaring bowl) in the British Museum
Drawing by Charles Sternberg

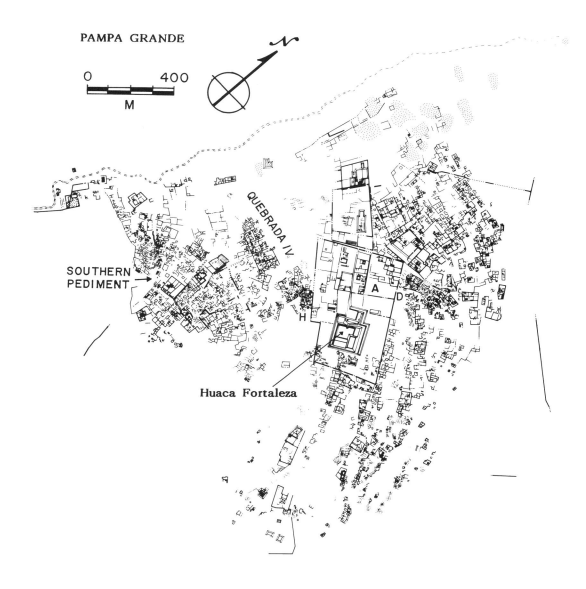

PAMPA GRANDE

0 — 400
M

QUEBRADA IV

SOUTHERN PEDIMENT

A D

H

Huaca Fortaleza

2. Architectural map of the
site of Pampa Grande
Drawing by Japhet Rosell and Izumi
Shimada

Sicán and Chimú sites. I have opted for a diachronic rather than synchronic comparison as the only comparable Moche V data are from a limited excavation at Galindo in the Moche Valley (Bawden, this volume, and 1982, 1990, 1996). Comparison between Pampa Grande and Galindo is presented elsewhere (Bawden 1996; Shimada 1994a). Further, this volume offers updated summaries of Moche IV cases from the sites of Moche and the Cerro Mayal-Mocollope complex (see, respectively, Chapdelaine, this volume; Russell and Jackson, this volume). Historical data, including wills of indigenous lords detailing their varied retainers, provides another comparative perspective.

Physical Setting and Social Context of Craft Production at Moche V Pampa Grande

The site of Pampa Grande (figs. 2, 3), with dense architectural buildup covering c. 6 km², is situated in a dramatic and strategic location. It occupies much of an extensive alluvial fan and talus formed at the base of the towering Cerro de los Gentiles (over 1,100 m in elevation) and adjacent lower mountains. It overlooks the constricted neck of the Lambayeque Valley, Chancay River, and the main intakes for valleywide and intervalley canals. The sight of the monumental platform mound of Huaca Fortaleza (fig. 4; c. 270 × 180

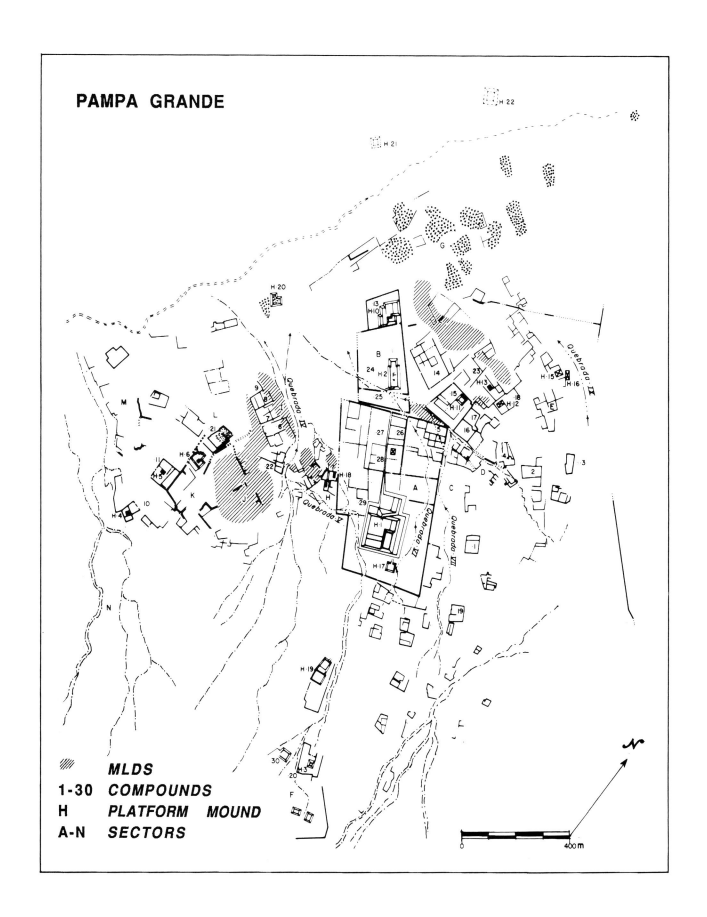

PAMPA GRANDE

MLDS

1-30 COMPOUNDS

H PLATFORM MOUND

A-N SECTORS

4. View of Huaca Fortaleza, Pampa Grande
Photograph by Edward Ranney (©)

× 38 m in height with a 290 m long ramp) rising above the blanket of early morning fog against the clifflike face of Cerro de los Gentiles is indeed inspiring and highly visible from many kilometers away on both banks of the valley (Haas 1985; Shimada 1994a). Clearly the site was intended to impress beholders and embody physical and symbolic linkage to the mountains above and water below.

Huaca Fortaleza and its gigantic enclosure, Compound 1 (600 × 400 m; together called Sector A), were the focus of the physical and social organization of the city, which had an estimated resident population of 10,000 to 15,000 (Shimada 1994a: 141). The *Huaca* and its enclosures were not only far and away the dominant structure of the site, but were centrally placed. A series of much smaller multi-level platform mounds, each with its own rectangular enclosure, was built on the sloping pediment surface along extensions of Fortaleza's longitudinal axis. These monumental structures divided the site physically and asymmetrically into Northern and Southern pediments.

The larger Northern area was predominantly occupied by rectangular adobe compounds of varying size with attached cluster(s) of small, irregular masonry structures just outside their perimeter walls. The smaller Southern Pediment was largely occupied by densely built, small domestic masonry structures in which the majority of the city's population is believed to have resided. The northern end of the Southern Pediment was occupied by a series of five contiguous rectangular enclosures, while the southern end contained a later Chimú occupation.

The city layout also took advantage of topography. The alluvial fan was dissected into a series of *mesa*-like flat areas by six major gullies and their branches. The boundaries of many of the fourteen recognized sectors coincide with these gullies and/or their branches. We have designated each sector by a capital letter. The sectors are characterized by distinct architectural and artifactual compositions and internal unity. The edges of many dry gullies had been modified to serve as streets or corridors to guide traffic within the city. Wider gullies appear to have served as major avenues, probably allowing llama caravans access to the city center. Quebrada IV is the widest and deepest gully within the city. As seen below, it was not only a

significant physical feature separating Compound 1 from the Southern Pediment, but was also a social boundary between the two divisions of the city. Access from the Southern Pediment to Compound 1 and the Northern Pediment was restricted to one controlled point some 5 m above the bed of Quebrada IV.

Not surprisingly, paralleling the spatial segregation of distinct architecture noted above, artifact composition differed significantly between the two divisions of the city (Shimada 1994a; Shimada and Maguiña 1994). A wide variety of bichrome Moche ceramics (for example, *floreros* or flaring-rim bowls, stirrup-spout bottles, and effigy vessels) and reduced-ware serving vessels was found in the Northern Pediment with only limited quantities in the aforementioned five contiguous compounds on the Southern Pediment.

On the other hand, utilitarian vessels such as *ollas* (globular, short-necked cooking vessels), neck jars, and urns dominated ceramics on the Southern Pediment. Many of the unslipped jars found there had their necks decorated with highly stylized human faces that were rendered by means of appliqué (nose, hand, ears), incision or gouging (mouth), pinching (nose) and/or punching (eyes), very much in the style of the Gallinazo (also known as the Virú) stylistic tradition (fig. 5 a, b; see Bennett 1950: 80–83; Strong and Evans 1952: 309–316 for descriptions of the Castillo Modeled style, a well-documented, local Gallinazo style in the Virú Valley). In contrast, the faces that decorated the necks of jars of the Moche stylistic tradition, found in abundance throughout the Northern Pediment, were naturalistic and quite varied (fig. 5, c–h). They were invariably made with either small, hand-held single-piece molds or two-piece vertical molds. Additionally, certain types of stone tools such as large teardrop-shaped bifaces (flaked and ground) and donut-shaped river cobbles are overwhelmingly concentrated in the Southern Pediment. Shape, size and use-wear suggest that the bifaces functioned as cutting implements. The paucity of these stone knives in the Northern Pediment suggests that its inhabitants enjoyed use of copper implements. The donut-shaped stones with battered perimeters are believed to have been clod busters, suggesting that many residents of the Southern Pediment were in-

house out-field farmers. The factors and processes responsible for bringing the inferred farming population to Pampa Grande are discussed in detail elsewhere (Shimada 1994a: 117–134; Shimada et al. 1991).

What the preceding suggests is a politically and socially asymmetrical, dualistic urban social landscape, and the existence of a moiety

5. A and B are examples of Gallinazo style neck jars decorated with highly simplified human faces. C–H are examples of Moche style neck jars decorated with press-molded faces of humans, animals and mythical creatures
Museo Arqueológico Nacional Brüning de Lambayeque

system. Ethnic Moche inhabitants of the Northern Pediment, though probably constituting a minority, dominated a majority ethnic Gallinazo population confined to crammed living quarters on the Southern Pediment. In this regard, Quebrada IV was far more than a natural feature; it symbolized the tremendous social gulf that separated the subordinate Gallinazo population from the dominant Moche residents. It is crucial that the above physical separation and social duality and asymmetry be kept in mind in discussing the identity, status, and nature of articulation among crafters, consumers, and sponsors at Moche V Pampa Grande.

Workshops and Organization of Craft Production

I. Spondylus Shell Workshops

There are at least six documented or inferred craft workshops at Moche V Pampa Grande. Not surprisingly, the north–south asymmetry defined earlier is also seen in the distribution of craft tools (for example, stone hammers and ceramic and ingot molds) and workshops. All definite workshops were found in compounds of Sector D in the Northern Pediment (figs. 6–8) and in Sector H along the west wall of Compound 1 (fig. 10). Sector D, an elongated area of c. 300 × 120 m and Sector H, a trapezoidal area of c. 140 × 280 m, were symmetrically placed, on either side of Compound 1. Both Sectors had direct access to Compound 1 and its four large-scale storage facilities.

A *Spondylus* shell workshop was discovered at the southeast corner of a small platform mound (Huaca 11) within spacious Compound 15 (also called *Spondylus* House; 130 × 125 m), one of the largest compounds north of Compound 1 (Shimada 1982, 1994a; Shimada and Shimada 1981). This single-room masonry structure (c. 7.5 × 7.8 m) yielded thirty-two whole *Spondylus princeps*, as well as hundreds of small spines, splinters, and roughly trapezoidal pieces (typically 5–6 cm long, 3–3.5 cm wide), a fist-sized oval cobblestone, and fragments of constricted-neck jars.

The intensity and scale of production, or even products of this workshop, are difficult to ascertain. There is no evidence of bead making. The trapezoidal pieces are similar in size and shape to ninety-eight polished "pendants" found in two caches atop Huaca Fortaleza (Haas 1985: 404). The only shell working tool was the aforementioned cobble, which preserved tiny shell fragments on one of its battered ends. It was probably used to break spines. Hocquenghem and Peña (1994) offer their reconstruction of the *Spondylus* ornament making process based on stone tools and shell remains surface-collected at the Late Intermediate period (Late Sicán and Chimú?) site of Cabeza de Vaca in Tumbes. They suggest that the manufacturing steps are relatively few and simple and the necessary tools correspondingly few in number and kind. According to their reconstruction (Hocquenghem and Peña 1994: 221–222), processing begins with breaking off spines with large cobblestones and filing with abrasive stones to smooth the shell exterior surface. Then, using ground stone knives, the outlines of the desired pieces or blanks are cut into the prepared surface. Both at Compound 15 and Cabeza de Vaca, the entire manufacturing process, which required relatively few steps and resources, a simple tool kit, and limited storage and working area, is believed to have taken place within a single workshop.

At the workshop and, in fact, in entire Compound 15, there was no evidence of domestic activity or structures. The presence of jars at the workshop suggests water storage; food and drink were probably brought in from elsewhere, perhaps prepared at a small cluster of inferred habitational structures situated immediately outside the compound perimeter wall. Similarly, it is argued that crafters commuted to their workshop from outside the compound, though the location of their residences remain undetermined.

A surface scatter of *Spondylus* fragments was also noted adjacent to the multilevel platform mound in each of three other compounds in the Northern Pediment (Compounds 10, 11, and 13), suggesting that there were dispersed, small, supervised *Spondylus* workshops. The location within compounds and the close association with the platform mounds further allude to the high status and religious concern with the *Spondylus* ornament production. As in Compound 15, none of these compounds contain recognizable residential structures.

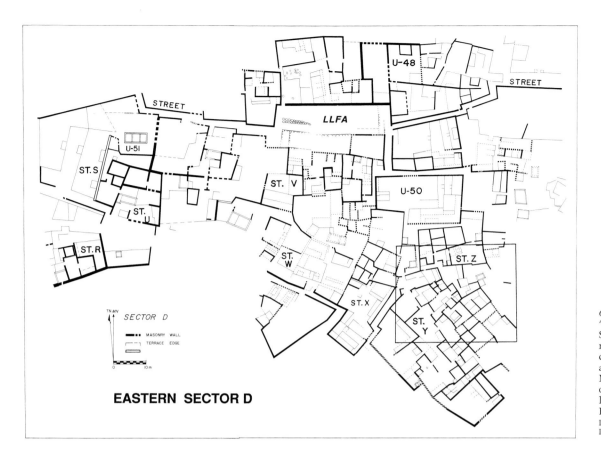

6. Eastern half of Sector D. "ST" and "U" refer to Structure and Unit, respectively. "LLFA" corresponds to a large open area where streets meet. Note the central placement of Structures R and S (Box at lower right is enlarged in Figure 7)
Drawing by César Samillán and Izumi Shimada

7. Detail of eastern half of Sector D
Drawing by César Samillán and Izumi Shimada

II. Cotton Processing and Weaving Workshops

An overwhelming percentage of Moche textiles found on the north coast was woven with cotton yarns (see Prümers 1995: 357–363, Table 1, for an updated list of known Moche textiles). Although no textiles were found in our excavations, Compound 14 (95 × 155 m; known also as Deer House), situated just east of Compound 15 and north of Compound 1, yielded evidence of large-scale cotton processing. A layer of charred cotton fiber up to 10 cm thick was found covering much of the plastered floor of a burnt interior courtyard. Clearly, the charring helped preservation of cotton. The adjacent courtyard with open access and a higher floor level had a west wall with six niches, two complete sets of deer antlers, and a large drum frame, attesting to the high status and ceremonial character of the general setting. The association of deer with elite rituals is quite clear in Moche art (Donnan 1997).

We suspect the cotton had been laboriously ginned, and beaten with switches to form a thin, homogenous, compacted layer (fig. 9; see also Vreeland 1986 for a description of traditional cotton fiber preparation by women in Lambayeque). The drum in the adjacent courtyard may have provided rhythmic sounds for beating. The spacious courtyard with a smooth plastered floor in Deer House would have been ideally suited for spreading out cotton for separation by fiber

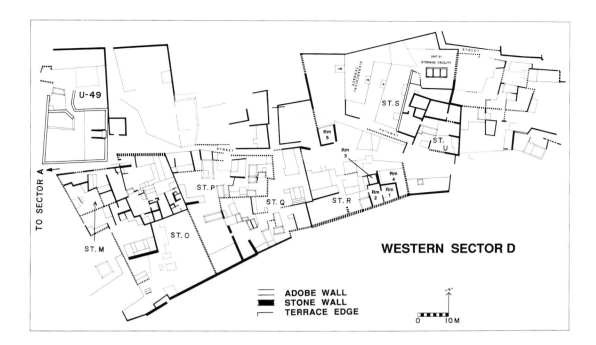

WESTERN SECTOR D

ADOBE WALL
STONE WALL
TERRACE EDGE

0 10 M

8. Western half of Sector D. "ST" and "U" refer to Structure and Unit, respectively
Drawing by César Samillán and Izumi Shimada

color and quality, ginning and beating with switches. We suspect the similarly spacious and well-plastered main courtyard of Compound 16, contiguous to the east side of *Spondylus* House, may also have been used for cotton processing. A jar stuffed with seedcotton was found at the back of a small platform at the west end of this courtyard. Occupants of that room could readily have supervised such activity.

Though the cotton fiber in Deer House was ready to be spun, no evidence of spinning (for example, spindle whorls), weaving and/or sewing (for example, battens and needles) was found within the compound. It is suggested that the spacious courtyard in the compound served as a major collecting and initial processing center of cotton brought there as tribute, and as a distribution center of processed cotton ready for spinning and weaving elsewhere in the city. This hypothesis is based on the appreciable quantity of processed cotton fiber found in Compound 14 and evidence of spinning, weaving and/or sewing in Sectors D and H.

A total of fifteen spindle whorls were found singly or in small clusters on floors or in fill between floors in various areas of Sector D. These ceramic and stone spindle whorls were truncated cone or truncated cone with tapering base in form, 0.9 to 2.0 cm in

height, 1.4 to 2.4 cm in diameter, and often decorated with incised geometric designs. In Room 4 of a set of interlinked rooms designated as Structure R, a cluster of four copper needles (10.8–13.8 cm in length) was found on the floor. Adjacent Room 2 had two stone

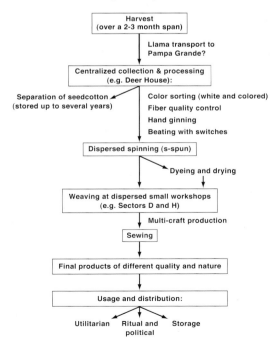

9. Flow diagram of cotton processing and weaving at Pampa Grande
Graphic by Steve Mueller

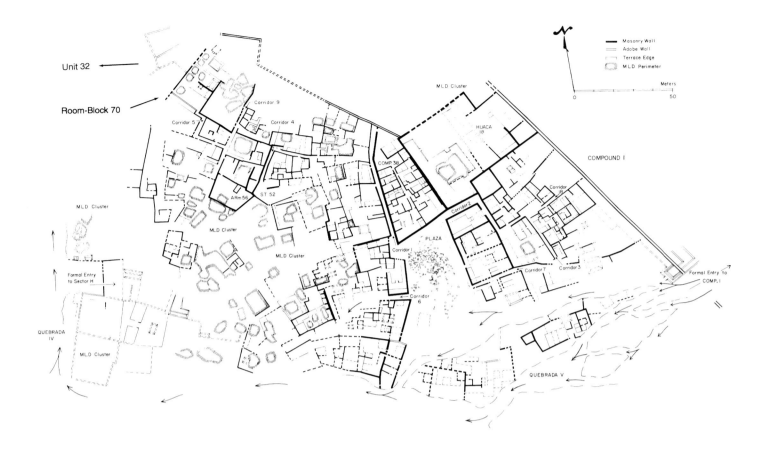

10. Map of Sector H along the west wall of Compound 1. "ST" and "MLD" refer to Structure and Multi-Lateral Depression, respectively. Note the centrality of Compound 38
Drawing by Izumi Shimada

spindle whorls on the floor. The intriguing situation of a coexistence of weaving and metalworking in Structure O near the west end of the Sector will be elaborated on later.

In Sector H, an unusual set of architectural, artifactual and floor features leads us to hypothesize that Room-Block 70, at the west end of a narrow street, was a weaving workshop (figs. 10, 11). The Room-Block largely consisted of a small, low platform with a short ramp and solid roof, and a nearby roofed room with low adobe walls on three sides and a bench on the fourth side. The occupant(s) of the platform would have had a clear view of activities in the adjacent three-sided room. One of the postholes of the platform had a dedicatory macaw (*Ara* sp.) burial, the only such case documented at Pampa Grande, attesting to the importance of the setting.

The most telling evidence for weaving is a large fragment of what is believed to be a carefully shaped (wedge-shape in cross section) and smoothed hardwood batten (also known as a sword or beater), one of the most important and cherished weaving tools used to open sheds so that a weft may be inserted. The working edge was polished from use. Traditionally, in the Andes and elsewhere, the batten is made of hardwood. It must be hard to separate tight warp threads and, at the same time, polished to a very smooth finish so as not to snag threads.

In addition, the Room Block revealed a ceramic drum frame and a set of ceramics: a painted *florero* or flaring-rim bowl, fragments of at least two neck jars, and a buried *olla*. The drum here, too, may have provided the rhythmic beats to pace the weavers nearby.

The detailed scene of supervised weaving painted on a Moche IV *florero* in the British Museum (fig. 1) is valuable in interpreting the significance of the Room Block 70 features. Eight weavers (paintings of two of them are only partially preserved; all seem to be women) are shown in verandalike structures (similar to the three-sided room described above), operating backstrap looms anchored

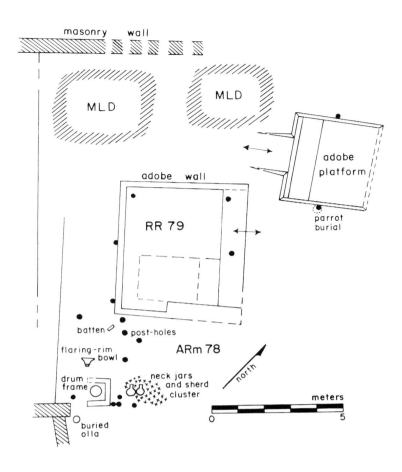

11. Floor plan and artifact distribution of inferred weaving workshop in Room-Block 70, Sector H
Drawing by Izumi Shimada

zation of the Room-Block and the painted scene. Close elite supervision of high quality (decorated) textile production would be expected from the clearly differentiated distribution of such products depicted in Moche paintings and found in burials at Sipán (Prümers 1995), Pacatnamú (Ubbelohde-Doering 1967, 1983), and elsewhere (for example, Conklin 1979). In the case of Room Block 70, the presence of the macaw burial, *florero*, drum frame, and well-made platform, as well as adobe brick constructions and restricted access at one end of a corridor (Corridor 5) all argue for the importance of the occupants and their activities. The macaw burial may well reflect the use of its feathers in some woven products (see O'Neill 1984: 148).

Interestingly, the east end of the corridor providing access to Room-Block 70 was a kitchen (Rm 54 and the adjacent space) and *chicha*-preparation and storage area (ARm 56). The latter area yielded a variety of evidence indicative of *chicha* making: charred maize kernels (but no cobs or any other parts of maize), a *batán* (a large stone anvil used for crushing and grinding various materials), evidence of fire use (ash, charcoal and discolored soil), many large broken urns showing heat damage, a large everted basin, and numerous neck jars believed to have been used to decant and distribute *chicha*.

Overall, it is argued that Room-Block 70 was a small, supervised weaving workshop manned by commuting artisans who were supplied with necessary yarns that were prepared elsewhere in the city. Further, the occupants of the Room-Block were provided with food and drink prepared in a nearby location readily accessible by a corridor.

III. Metal Workshops

Copper was the mainstay of Moche metallurgy; it was used not only in pure form as a utilitarian metal, but also formed the primary component of *tumbaga*, low karat gold-copper or gold-silver-copper alloys that held important symbolic and social value (Lechtman 1984a, 1984b, 1988; Shimada 1999b). In-depth understanding of the chemical properties of copper and *tumbaga* led to metallurgical innovations such as depletion gilding (Lechtman 1973, 1984a, 1984b) and proto-brazing,

to posts. Contiguous to the weavers and rendered on a larger scale on the right and left sides of this drawing of the *florero* are two elaborately dressed men seated on raised platforms. One, on the right, is wearing a striped tunic, and part of his head has been abraded and is now incomplete. The other, on the left, is holding a cup. The man seated on the low platform on the left is apparently entertaining two visitors seated to his right. The two neck jars shown in between the two visitors probably held *chicha*, which is apparently being served by the standing individual between the host and the guests. The female weavers depicted to the right and left of the men are associated with stirrup-spout bottles, *floreros*, and various shuttles, as well as cloth pieces whose patterns they are replicating on the looms. The elaborate dress, larger scale, and raised position all argue that the two men seated on the low platforms are patrons and/or supervisors of the weaving.

Though not conclusive, there are definite parallels between the content and organi-

an ingenious but very precise joining technique relying on a diffusion process related to eutectic bonding (see Shimada and Griffin 1994; see also Jones, this volume).

In terms of material evidence, copper working is the best-documented craft at Pampa Grande. Surface surveys and excavations in Sectors D and H yielded appreciable numbers of small, utilitarian copper implements, as well as fragmentary and complete hammerstones with highly polished flat and/or slightly convex facets (for planishing). Indeed, given their symmetrical and proximate placements relative to Compound 1, suggesting a service orientation toward the elite residing in the latter, we anticipated finding evidence of metalworking in these sectors. No evidence of smelting (for example, crushed copper oxide ores, smelting slag and furnaces) was found in the city. One would expect to find smelting sites close to fuel sources and copper mines, identified in the middle to upper reaches of the Lambayeque and the adjacent (just to the south) Zaña valleys (Shimada 1994a, 1994b; see also Lechtman 1976; Oehm 1984). Three thin, circular, crude convex ingots of pure copper were found in a looted Moche cemetery (Phases III–V) near Cerro Pan de Azucar on the north bank of the mid-Zaña Valley (Shimada 1994a: fig. 8.19; Shimada 1994b).

One copper workshop (consisting of ARm 57, 60, 61, 64, and 85, Rm 81, and RR 84) was excavated in Structure 52, Sector H (fig. 13). This is the only Moche copper workshop found to date. The workshop was situated at one end of narrow Corridor 4 and consisted of four interlinked but functionally differentiated areas. Excavated evidence suggests a *chaîne opératoire* (fig. 12) starting with melting of ingots to form blanks, alternating annealing and forging to produce copper sheets, and cutting and forming them into component parts or complete products. Imported prills (tiny metal droplets normally melted to form ingots) extracted from smelting conducted elsewhere may have been used directly to form blanks without an intermediate step of making ingots. One area close to the corridor had two unusually large, clay and stone-lined braziers (70–80 cm in diameter, over 20 cm deep), a broken mold (4 × 6.5 × 4 cm high, c. 50–60 cc capacity) for a small rectangular blank, and a broken tuyère (ceramic tip of the

blowtube) in association. The compacted earthen floor was covered with ash and charcoal bits.

The two adjacent rooms (ARm 61 and 64) with clean plastered floors contained faceted stones of varied size and shape (Shimada 1994a: fig. 8.21), a large anvil set atop a worktable, and a narrow perforated copper strip. There is one set of four hammerstones with convex working faces, while the remainder have flat faces that may have been used as anvils for bending, cutting and/or flattening sheet metal. Undoubtedly, these hammers and anvils were used in producing copper sheets. The separation of annealing braziers from the sheet-metal working area may seem odd, but, in reality, the latter had to be kept clean of sand and other extraneous particles that could easily pit or otherwise damage sheet metal.

That these workers were supplied with food and drink is suggested by the presence of a small storeroom (Rm 81) with in situ vessels and constricted neck jars, sooted *ollas*, and serving dishes in another room (ARm 85) adjacent to the metalworking area. The presence of a decorated bowl, *florero*, and stirrup-spout bottle in the workshop is seen to reflect the presence of high-status super-

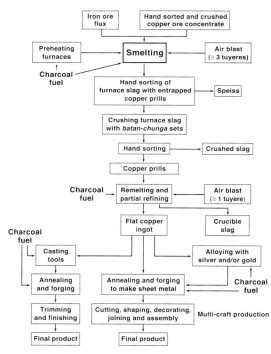

Moche Copper Production

12. Flow diagram for Moche copper production
Graphic by Steve Mueller

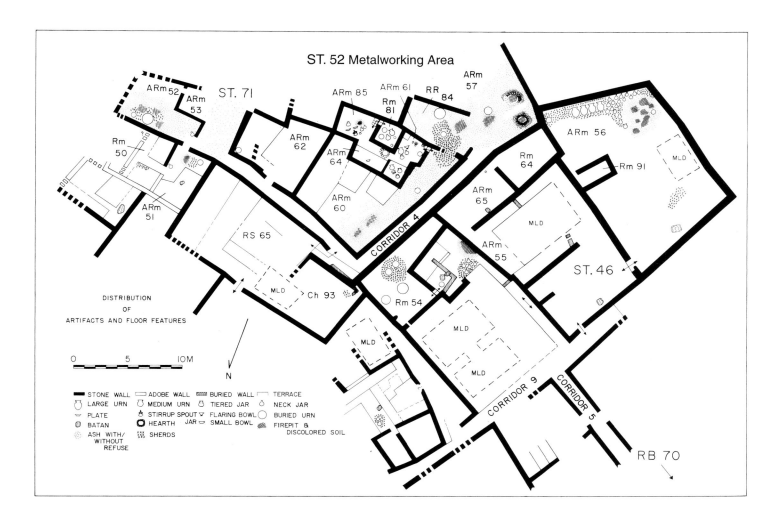

ST. 52 Metalworking Area

DISTRIBUTION
OF
ARTIFACTS AND FLOOR FEATURES

0 5 IOM

N

▰ STONE WALL ▭ ADOBE WALL ▨ BURIED WALL ⌐ TERRACE
◡ LARGE URN ◡ MEDIUM URN ⌣ TIERED JAR ◊ NECK JAR
▽ PLATE ⚱ STIRRUP SPOUT ▽ FLARING BOWL ◯ BURIED URN
◉ BATAN ◖ HEARTH JAR ◡ SMALL BOWL ▨ FIREPIT &
░ ASH WITH/ ░ SHERDS DISCOLORED SOIL
 WITHOUT
 REFUSE

13. Map showing metalworking area and associated artifacts and floor features in Structure 52 and its immediate surroundings in central Sector H
Drawing by Izumi Shimada

visory personnel and/or the importance accorded to metalworkers and their products. The inferred supervisor could well have been a master metalworker. In many societies, excellence in crafts or what Helms (1993: 14) calls "skilled crafting" is accorded prestige and high social status as it is "associated with politically influential individuals and political leaders" and as the ability to bring about exceptional transformation of raw materials is seen to reflect cosmic power.

The reconstruction above suggests that metalworking involved a few skilled specialists and a handful of assistants or apprentices who probably undertook the tasks of keeping the braziers going by charging with charcoal fuel, stoking it with blow tubes, and ferrying sheet metal between braziers and anvils. We must also consider the probable presence of some individuals who prepared food and drink. In other words, though it is relatively

small, the workshop is believed to have been manned by six or more metalworkers and support personnel of diverse skill and expertise.

There are a number of broader organizational features to note here. There were no indications of other metal workshops or storage of necessary supplies in the immediate surroundings. Ingots and other raw materials (particularly charcoal fuel, which would have been used in large quantities) had to be brought in from as yet unidentified source(s) inside and/or outside the city. It is uncertain whether the metalworkers lived in Structure 52. Structure 71 occupying the east end of Corridor 4 was a well-built, spacious residence with plastered floors and adobe walls with traces of yellow and red paints. The size and these architectural features imply the relatively high status of the occupants. Traffic to and from the copper workshop (Structure 52)

and Structure 71 was restricted through a room with a multilevel terrace (RS 65 in fig. 13). Accounting of raw materials such as food, ingots, and charcoal fuel, and finished copper products could have been readily monitored by the occupant of the terrace, who may well have lived in the afore-mentioned residence.

Structure 52 was a self-contained work-shop equipped to deal with most of the metal-working stages that follow smelting, perhaps with on-site supervision. It is unclear whether the workshop indeed produced finished objects, or whether components were assembled into final form elsewhere. The recovered tools would have been sufficient to produce simple utilitarian objects such as pins, tweezers, and needles fashioned out of sheet metal utilizing mechanical joinings (for example, staples and wires). We did not find small chisels and punches, templates and other tools expected for fine chasing-repoussé decorative work. Similarly, the intensity and output of the copper working there remain undetermined. It is certain, however, that the copper smelting that provided ingots (and perhaps prills) was carried out in spatially segregated loci, most likely close to mines well outside of the city. Though the workers were apparently fed by food prepared within the workshop, some of them may have commuted in from the Southern Pediment. Wherever their residences were, their movements as well as those of the metal products were tightly controlled. To date we have no indications of the whereabouts of the workshop that produced the seven matched hollow, gold jaguars reportedly found at Pampa Grande (Lechtman, Parsons, and Young 1975; see Shimada 1994a: 200, fn. 120 for clarification). Overall, copper working in Structure 52, like the crafts already examined, appears to have been characterized by dispersed, segmented or modular production. Intriguing situations in Sector D, where there is evidence of the close association of two or more craft activities, is discussed later.

IV. Ceramic Production

A city of the size and importance of Pampa Grande would have had a considerable demand for both fine and utilitarian ceramics. Given the different nature of demands (ritual, wealth, status, and domestic utilitarian items), technologies (mold-based and coil, and/or paddle-anvil), and stylistic traditions (Moche and Gallinazo), we expected to find various ceramic workshops in different areas of the city. Yet, our surveys and excavations did not locate any large waster piles or single large-scale, mold-based production centers like those at Cerro Mayal in the Chicama Valley (Russell, Leonard and Briceño 1994, 1998; see also Russell and Jackson, this volume), or smaller workshops similar to that near the Huaca de la Luna at Moche, which was apparently dedicated to production of fine vessels and figurines for funerary and ritual use at this temple (Uceda and Armas 1998). What we found at Pampa Grande raises questions regarding the simple dichotomy of fine versus utilitarian wares without their social contexts of production and usage being taken into consideration.

The best evidence for ceramic production at Pampa Grande comes from a cluster of small, contiguous rooms that together occupied a c. 10 × 15 m area in Structure Y near the southeastern end of Sector D (figs. 6, 7). Room 13, a small, rectangular masonry room c. 2 × 3 m, with thick dark ash fill and heat-damaged walls, is believed to have been a kiln (Shimada 1997a). The ash deposit yielded numerous sherds, predominantly of reduced-ware plates, incurving bowls, castellated *floreros*, and constricted-neck *ollas*, as well as five stone burnishers and a broken stamp (a representation of a skull) with an oblong grip, molds (including one of a llama head with harness straps), and figurines. The same fill contained a face-neck jar fragment with a press-molded representation of a skull that perfectly matched the stamp. The reduced wares exhibit varying degrees of burnishing. On the floor of Room 2, one of the nearby rooms, whole vessels were found with no apparent signs of use, including thirteen *ollas* identical in shape and size but distinct in decoration. Other vessels matching the form and size of vessels represented by sherds from the inferred kiln were also found on the floor. The adjacent room on the other side yielded whole and broken potters' plates, a stone burnisher and a pointed bone tool.

Though productive output of the inferred workshop is difficult to determine, homogeneity in decoration, finish, and paste, as

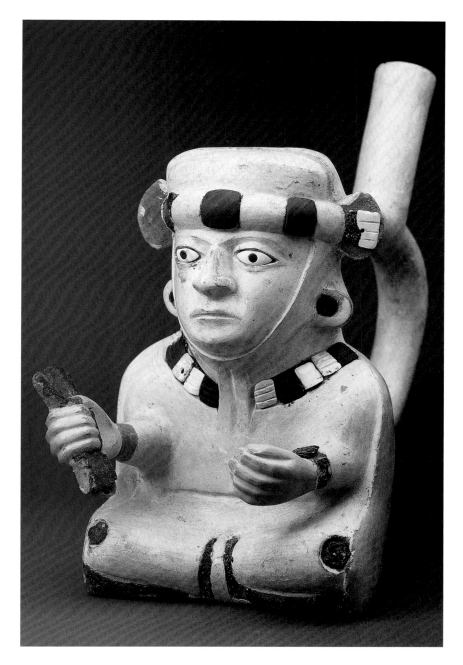

14. An example of a multicraft artifact, a well made Moche IV sculpted stirrup-spout bottle representing a seated man. Note the elaborate post-firing inlay work using shell and an undetermined black substance (bitumen?). From Tomb 1, Huaca de la Luna
Museo de Arqueología, Antropología e Historia, Universidad Nacional de Trujillo
Photograph by Yutaka Yoshii with permission of Santiago Uceda

Inter- and Multicraft Interaction and Production

Sector D offers other important insights into the organization of late Moche craft production: that of inter- and multicraft interaction and production. These terms describe the intentional or unintentional transfer, adaptation, blending of and/or competition for materials, knowledge, styles and/or techniques between two or more coexisting crafts (Shimada 1998, 1999a, 1999b; see also McGovern 1989: 1). Multicraft products utilize component products from more than one craft in the final assembly of items being manufactured; for example, a ceramic vessel with shell inlay (fig. 14). There are many sculpted vessels in museum collections that have lost their original inlays. In numerous cases, it appears that the component pieces were not necessarily made for particular objects; rather, generic stock pieces were partially modified to satisfy need. On the other hand, inter-craft products are the result of continuous, creative interplay among crafters of different media, from conception and design to final assembly (Shimada 1998: 45). These terms may be said to occupy the two ends of the continuum of coordination and collaboration among crafters with different expertise. To a varying degree, both cases require at least knowledge of the expected appearance of the final products.

Many of the most striking Moche objects are inter- and multicraft in nature. Were these made by different crafters each working in his or her workshop and responsible for completion of a given stage or facet of the overall manufacturing process? Or were they designed and produced by the same crafters skilled in what we would analytically distinguish as separate crafts working in a single workshop? Alternatively, a single workshop may have housed individuals skilled in different crafts. What end(s) did they serve? These and other worthwhile questions have not been adequately considered as the current perspectives and models of craft production are compartmentalized and medium-specific; that is, studies are conducted within the confines of a specific medium, such as ceramics or weaving, and usually do not consider the relationship of the craft under study to other crafts that were being practiced concurrently at local or regional levels (Shimada 1998: 29).

well as size and shape of reduced-ware vessels found throughout Sector D, argues that they were produced by this workshop. The stylistic and technical homogeneity of reduced-ware vessels, both utilitarian (cooking and serving vessels) and fine (primarily stirrup-spout bottles), are not found in other sectors and are believed to reflect their supervised production and distribution. The nature of such control and the elite sponsor-artisan relationship is discussed later.

In urban settings such as Pampa Grande, artisans of different skill, expertise, age, gender and social background are likely to have been working in close proximity. Factors such as administrative and/or logistical efficiency, sociopolitical ties and obligations, and space constraints would have contributed to this situation. At the same time, we should be aware of the widespread practice, known from other parts of the world, of the sending or loaning of skilled crafters among elite individuals (for example, Brumfiel 1987: 110; Helms 1993: 34). Attached specialists could have practiced their crafts in different locales. The resultant aggregation would have offered both elite sponsors of crafts and artisans unique opportunities for inter- and multicraft interaction. In this sense, the innovative quality of Moche V material culture at Pampa Grande may have owed its genesis to the synergy of skilled artisans of different geographical and ethnic origins coming together at the city.

In Structure O, a burnt area near the west end of Sector D (fig. 8), and close to the east entrance to Compound 1, an array of weaving-related artifacts was found on the floor of a spacious room with an elaborate, multilevel terrace complex. The finds included three stone spindle whorls and two bone spindle fragments, a broken bone awl, a copper *tumi* knife, and a cluster of eight small ovoid lumps of chalk. The terrace also had two broken face-neck jars. The back wall of the terrace had remnants of reddish paint, and was situated so as to control traffic between the interior of the structure and a street. In essence, the architectural features and artifactual composition suggest supervised spinning and weaving in this structure.

The adjacent area further in, however, had three small storerooms and the remains of copper working and lapidary. One small room contained two shells (*Mexicardia procera*) incised in preparation for cutting rectangular pieces, a copper chisel in direct association with two small fragments of a curving ornamental copper strip, and a metallic spindle whorl (galena?). A large, polished anvil stone, a turquoise bead, and three cobblestone hammers with battered ends were found in an adjacent room. Another room yielded a polished, prismatic stone with many fine striations, together with small amorphous copper lumps,

probably scraps. All these remains suggest the cutting, shaping and decorating of copper or *tumbaga* sheets.

The observed concentration of a diverse range of artifacts in a relatively small area suggests either a coexistence of artisans skilled in weaving, copper working and lapidary and/or their inter- and/or multicraft collaboration within Structure O. Though actual identity of products or output of the workshop remains undetermined, one distinct possibility is inlaid metal ornaments such as those that formed part of the regalia of the Moche elites excavated at Sipán (Alva 1994; Alva and Donnan 1993). Could the wives of the crafters involved in metalworking and/or lapidary have been engaged in the complementary tasks of spinning and weaving? We know that textiles were often embellished with metal and other ornaments. Textiles thus produced, in turn, may have been decorated with other workshop products. A high level concern with control over production is apparent in the proximity to Compound 1 and restricted access monitored by occupant(s) of the multilevel terrace with painted back wall.

Other areas of Sector D also yielded remains indicative of the close association of multiple crafts. For example, Room 4 of Structure R (fig. 8) contains evidence of copper working and is situated adjacent to Room 2, where a stone spindle whorl and set of four copper needles were found. A crudely made, oval (6.9 × 5 × 1.9 cm high) ceramic crucible with greenish oxidized copper encrustation, a small "anvil" with two flat polished working faces (9.25 × 8.2 × 3.7 cm thick), and a broken hammerstone were found in association with abundant ash, charcoal bits, and burnt soil in Room 4. This inferred copper workshop may have supplied small tools, such as needles and chisels, to be used in nearby workshops.

Integrating varied raw materials (including exotic materials such as turquoise, sodalite, gold, and marine shells) and expertise, objects resulting from inter- and multicraft are likely to have been considered higher-status than single-medium products. This inference is supported by their restricted distribution in funerary contexts (for example, Alva 1994; Donnan 1995; Donnan and Mackey 1978; Ubbelohde-Doering 1983).

Aside from conferring prestige value and greater artistic potential with wider color and textural ranges, what did inter- and multicraft products offer to their owners? For example, why use shell inlay to represent eyes and fangs instead of painting them on metal masks or wooden heads? Did its use carry any special symbolic message? Elucidation of such significance remains a future task.

Chimú Inter- and Multicraft Interaction and Production

Inter- and multicraft production is by no means restricted to the Moche culture (Shimada 1999a). Not surprisingly, the practice was continued by the later Sicán and Chimú cultures on the north coast (Shimada 2000). Both were characterized by a high degree of economic specialization and status differentiation, allowing mobilization of restricted resources and skilled artisans to meet the personal and political needs of the social elites. Sicán examples are described elsewhere (Shimada 1998, 1999b).

At the Chimú capital of Chan Chan, excavations in "barrios" and "retainer areas" with good artifactual preservation provided ample evidence of inter- and multicraft production (Topic 1990). The barrios were aggregations of commoner residence-workshops, each composed of a set of interlinked, small, masonry rooms. There were four barrios with an estimated 26,400 persons, representing the bulk of the urban Chan Chan population (Topic 1990: 152). It is estimated that there were over 10,000 full-time adult barrios artisans (male and female) at Chan Chan during the fifteenth century, mostly dedicated to weaving and metalworking (Topic 1990: 152). Topic (1990: 155–156) observed that "most houses contained evidence of both metalworking and the weaving of elaborate textiles, suggesting that both the adult males and females were artisans." In addition, metalworking meant preliminary fabrication of sheet metal and small, utilitarian or ornamental items that were presumably available to a wide segment of Chan Chan residents. Topic (1990: 155) concludes that in the barrios, "workshops were specialized spaces but did not necessarily specialize in one product."

The retainer areas are better built, more formally arranged, and closely associated with ciudadelas, enormous, rectangular, walled compounds believed to have been royal administrative, residential, and burial centers. Topic (1990: 161) considers that retainer area production was manned by specialists who enjoyed higher social status than those in the barrios and that it was geared more toward finishing-work or final assembly. The close proximity to ciudadelas and more centralized arrangements for food preparation for the specialists suggest that these artisans were attached to and directly served the royal residents of the ciudadelas (Topic 1990: 161). Yet, the retainer areas also revealed "the same mixture of weaving and metalworking activity" as the barrios (Topic 1990: 158–159). Overall, Topic (1990: 164–165) explains that inter- and multicrafts, or what he called "horizontal organization," allowed ". . . for more immediate cooperation between [diverse artisans] to produce compound products such as the copper-inlaid carved-wood hand . . . and pieces of clothing that combine feathers, metal, and cloth. Additionally, horizontal integration allowed for direct contact between woodworkers, who probably made many weaving and spinning tools, and the weavers and spinners who used them." I concur with his conclusion that "horizontal integration is, in fact, the most logical manner of organizing craft production . . . to produce complex elite products" (Topic 1990: 165). It appears that such organization dates back at least to Moche V times.

This organization offers (1) considerable productive flexibility in responding to changing demands for different products (for example, fewer utilitarian items and more wealth and status goods); and, at the same time, (2) artistic and technical potential for creating products that are distinctive and unique. As noted earlier, the ability to produce and use such items often confers considerable prestige and even higher status on both the artisans and elite sponsors. The first point highlights a good deal of variability in the productive role of the attached specialists and the uncertainties surrounding independent versus attached specialists (see Brumfiel and Earle 1987; Earle 1987; see also Hayashida 1995: 12). To what degree were the barrios artisans contractually obliged to and

supported by the elite? Were their productive activities strictly dictated by elites' demand? If so, how could they produce utilitarian items for the bulk of the urban Chan Chan population? Though supervisory personnel are said to have occupied three-sided structures called *arcones* interspersed among houses and workshops in the *barrios* (Topic 1990: 155–156), the nature of their role is not clear. *Barrio* artisans could well have produced utilitarian, wealth and/or status goods depending on the demand. Costin (1991: 13) points to the importance of characterizing "the demand before trying to define and explain the organization of production." Though this is a logical recommendation, empirical determination of the demand for any product for a specific time period and region in the prehispanic world is a daunting task. Resolution of the above questions hinges on future clarification of the nature of control of artisans and product-demand they faced. In addition, the validity of the distinction between "retainers" focusing on "finishing-work" and *barrios* artisans producing component parts or stock materials needs to be firmly established.

Segmented, Modular Production and Labor Organization

The above distinction of basic manufacture or preparatory processing in *barrios* versus finishing-work in retainer areas seems applicable to craft production at Pampa Grande. In particular, weaving and metalworking appear to have involved segmentation and spatial separation of different stages of the manufacturing process, accompanied by different supervisory setups. A corollary observation is that workshops involved in different stages were dispersed and typically small in size and, presumably, output. However, redundancy in workshops engaged in similar tasks implies that the overall output of the city as a whole was respectable.

Collection and initial processing of cotton appear to have been centralized within a supervised, high-status and ceremonial setting. Subsequent spinning, weaving, and sewing, on the other hand, seem to have been carried out at a series of dispersed, small, supervised workshops in Sectors D and H that were supplied with prepared cotton, as

well as with food and drink from nearby kitchens and *chicha*- making areas readily accessible via corridors or streets. In the case of metalworking, smelting of prills and preparation of ingots occurred offsite close to mines, while manufacture of sheet metals and their subsequent processing, such as cutting, shaping, decoration, and assembly, occurred in a number of small workshops in Sectors D and H. The spacious open areas at the ends of major streets near the center of Sectors D and H are believed to have been loading and unloading areas for the porters and llama caravans that brought in ingots,

15. The standardized vertical segments of adobe bricks that form the west buttressing wall of the Huaca Fortaleza platform mound
Photograph by Izumi Shimada

clay, charcoal, and other basic supplies necessary for urban craft production. Much of the *chaîne opératoire* of reduced-ware pottery production, including a kiln, was localized in Sector D, but the manufacturing locations of other wares still remain unidentified. In part due to its ritual importance and the technical simplicity, the entire *chaîne opératoire* of the *Spondylus* processing occurred at single locations within elite compounds.

The basic organizational features of urban craft production at Pampa Grande, such as segmented, modular production, redundancy of workshops and additive approach, are in principle identical to those documented for the Moche corporate projects of erecting monumental architecture and digging major canals (Moseley 1975a, 1975b). Major adobe walls at Pampa Grande, including the exterior buttressing walls of the Huaca Fortaleza pyramid were built in a segmentary manner incorporating varying quantities of marked bricks (fig. 15; Shimada 1990, 1994a, 1997b; Shimada and Cavallaro 1986). It is well documented that earlier platform mounds at Moche (Hastings and Moseley 1975; Kroeber 1926, 1930; see also Uceda, this volume), Huaca Cao Viejo at the El Brujo complex (Franco, Gálvez, and Vásquez 1994), Pacatnamú (McClelland 1986), Pampa de los Incas (Wilson 1987), Sipán (Alva 1994), and other sites (for example, Bennett 1949; Willey 1953), all manifest the same segmentary, additive format. In fact, the same format is also seen among contemporary Gallinazo and later Sicán, Chimú and early colonial corporate constructions (Moseley 1975a, 1975b; Netherly 1984; Shimada 1994a, 1997b; Shimada and Cavallaro 1986).

The modular, additive approach is also seen in post-Moche V craft production, for example, among Late Sicán (A.D. 1100–1375) and Sicán-Chimú (A.D. 1375–1470) arsenical copper-smelting workshops in the northwestern basal area (Sector III) of Cerro Huaringa (also called Cerro Cementerio) in the middle La Leche Valley. Here, a series of well-ventilated workshops, each equipped with a row of three to four smelting furnaces and several *batanes* and companion *chungas* (heavy rocking stones), were built in close proximity (Epstein and Shimada 1984; Shimada, Epstein, and Craig 1983; Shimada and Merkel 1991). Metallurgical debris found in these work-

shops indicates that they were all dedicated to the smelting of arsenical copper.

The abundance of faceted stone hammer fragments and inferred braziers, and the contrasting paucity of *batán-chunga* sets and associated ground slag suggest that much of the metalworking occurred at the northeastern base (Sector I) of Cerro Huaringa. Sectors I and III are separated by nearly a kilometer and an extensive habitational area (Sector II). Importantly, all three sectors are linked by a raised road that runs along the lower slope of the *cerro*, or hill.

In sum, it can be argued that the modular, additive approach and the associated labor organization and management not only characterized many Moche productive activities, but also appears to have been a persistent and widespread north coast style of production. The approach is antithetical to modern Western mass production, which typically brings together many workers at a single location for high productive efficiency. However, it afforded some important advantages. A small, discrete work force could have been recruited according to extant kinship and economic specialization (that is, *parcialidades*, indigenous, endogamous guildlike social groups organized by occupational specialty and asymmetrical moieties), preserving a sense of group identity, unity and continuity. In fact, by respecting traditional roles and organization, this approach would have promoted integration of the different ethnic and social groups that rapidly aggregated at Pampa Grande around A.D. 600 to form the Moche V urban capital. In regard to the social organization of craft production at Chan Chan, Topic (1990: 164) suggests that the *barrios* craftsmen were members of *parcialidades* (relocated from conquered provinces), and operated under their traditional leaders. The fact that each *barrioo* was associated with its own cemetery adds credence to this interpretation.

Sponsor-Crafter Relationship and Redistributive Economy

The notion of attached specialists emphasizes the binding contractual obligations of crafters to elite sponsors in the production of wealth, status and ritual items that were imbued with political and religious symbolism. As we have seen above, however, this

Simplified Late Prehispanic Sociopolitical and Economic Organization of the Northern North Coast of Peru

16. Simplified late prehispanic sociopolitical and economic organization of the northern north coast of Peru based on historical data (Netherly 1977, 1990; Ramírez 1996, 1998)
Graphic by Steve Mueller

conception does not necessarily apply well to Chimú artisans, many of whom could and may well have spent a substantial amount of their efforts on the production of utilitarian items and "yard goods"—bulk quantities of finished basic supplies (such as sheet metal) ready to be cut into whatever size and shape one needed. Likewise, we should be careful not to assume blanket, absolute "elite control" over productive activities; rather, archaeological and historical evidence suggests that there was a good deal of situational give and take between crafters and leaders at different levels of the sociopolitical hierarchy of late prehispanic *señoríos*, regional ethnic polities on the north coast. As shown in Figure 16, the *señorío* was fundamentally organized by the principles of hierarchy and moiety (Netherly 1977, 1990; Ramírez 1996, 1998). Below the apex, each successive level of the hierarchy was organized into pairs of ranked, asymmetrical social divisions. The *curacas* or heads of these divisions or moieties were correspondingly grouped in ranked pairs at each level. These leaders of successively lower levels, II to V, were called *segundas personas*, *principales*, *mandones*, and *mandoncillos*, respectively. *Curaca* A, as the highest leader of the higher ranked moiety at Level II, assumed the paramount lordship (*cacique principal*) of the entire *señorío*. *Curacas* had hegemony over both human and natural resources within their dominions, and their rank and status correlated with the size of the population that each controlled.

Each *curaca*, at least at the top three levels, appears to have had a corps of skilled workers in his court, such as cooks, *chicha* makers, guards, gold- and silversmiths, fine-cloth weavers, messengers and litter bearers (Susan Ramírez, personal communication, 1998). Widows and orphans for whom the *curaca* cared in his court appear to have taken on some of these roles. In addition, the high-ranking *curacas* had direct access to the services of crafters at lower levels of organization down to those in *parcialidades* at the bottom of the hierarchy. What may be classified as sumptuary goods production appears to have occurred on a small scale at lords' courts.

In reality, access to the service of these workers was neither automatic nor absolute. Without skillful dispensing of a variety of "incentives" by the *curaca* (for example, plentiful *chicha*, gifts, and/or honors), subjects would not render service. Particularly

important in the *curaca*'s largess was the offering of *chicha*, as discussed later. Not surprisingly, the *curaca* who did not live up to his subjects' expectations was removed by popular rebellion and murder (Ramírez 1996: 25; Rostworowski de Diez Canseco 1961: 55). Clearly, our conception of the relationships between crafter and elite patron cannot be monolithic or overly rigid.

There are various lines of evidence that shed light on the nature of elite-crafter articulation and the structural principles that bound them to each other at Moche V Pampa Grande. One important shared feature of all workshops (with the possible exception of the copper workshop in Structure 52, Sector H) is the provisioning of crafters with food and drink prepared in kitchens that were readily accessible via corridors or streets and situated outside of their workshops. The placement of varied workshops in Sector D (fig. 8) must be understood relative to the centrally situated, three-level terrace complex and storage facility in Structure S, and the nearby major food and *chicha*-preparation area between Structures R and S. The storage structure (Unit 51) consisted of three contiguously built, standardized cells (each having interior measurements of c. 2.55 × 2.00 m, height of c. 1.5–2.0 m and capacity of over 5m³) made of adobes and having high thresholds, thick well plastered walls, and solid roofs (Anders 1981; Shimada 1982, 1994a). Two of the cells contained evenly sized and shaped maize kernels; the third cell contained beans. The terrace complex was the largest and most elaborate of the entire sector, with ramps, seats, and a painted back wall, and was positioned to control access to the storerooms.

Additionally, its central placement afforded control of traffic through the sector. Structures R and S straddle one of the main east–west streets of the sector at the point where a north–south street branches off. This centrality is also well suited for distribution of food and drink. Room 5 (5.3 × 5.5 m) of Structure R contained a mixture of ash, charcoal bits and carbonized kernels, and a wide range of ceramic vessels including at least four large urns over a meter high and 60 cm in diameter, a large basin with everted rim (45 cm in diameter and 27 cm high), several constricted-neck jars, some with animal or human face decorations, as well as fragments

of a fine-line painted stirrup-spout bottle. In addition, areas around Room 5 yielded fragments of at least seventeen constricted-neck jars (predominantly with painted, modeled and molded decoration of Moche style) to the near exclusion of other vessel types.

These remains match well with a Moche ceramic representation (Shimada 1994a: fig. 8.41), and with early colonial and ethnographic descriptions of traditional *chicha* making equipment (for example, Camino 1987: 30–32, 39–42; Cobo 1964 [1653]: 242; Moore 1989; Morris 1979; Nicholson 1960; Shimada 1976: 215–218, 1994a: 221–222). For example, uniform kernels such as those found in the storeroom are crucial in assuring even germination and later fermentation, and thus good *chicha* quality. The everted basin has long been used for mixing mashed maize kernels with water before cooking the mixture in large urns and fermenting it. Also, in this respect, we should not forget the 2:1 ratio of kernels to beans in this storage facility. Room 3, adjacent to Room 5 in Structure R, was a well-built storeroom, with a high threshold, six large urns set in the floor, and several broken neck jars.

Structure R also yielded a substantial quantity and variety of food remains in association with firepits, ash, and charcoal, suggesting food preparation. The organic debris near Room 3 included bird, dog, guinea pig, deer and llama bones, various shellfish, corn cobs and an avocado seed, while adjacent Room 4 yielded a concentration of *Donax* shells (some seven hundred), crab shell and llama bone fragments. No serving vessels were found in this area, a curious situation given that reduced-ware serving vessels were produced nearby and distributed throughout the sector. A logical explanation is that the observed food refuse represents remains of food preparation and that the prepared food was consumed elsewhere.

In sum, it appears that a considerable amount of human and material resources as well as space (Structures R and S) was directed to preparation of food and *chicha* for the supervisory personnel manning terrace complexes and for crafters in workshops within Sector D. We cannot neglect occasional feasts as well (Gumerman 1997). It is also suggested that widely distributed neck jars were used to decant and distribute

chicha. In essence, we are speaking of a reciprocal arrangement between the artisans and their elite supervisors and sponsors. Provisioning of the inferred weavers in Room Block 70 in Sector H at one end of Corridor 5 by the kitchen/*chicha*-preparation area at the other end of the corridor also suggests the same reciprocal principle in operation.

There are, nonetheless, some major differences between Sectors D and H in regard to the crafter-sponsor relationship. There is no readily recognizable, centralized food and drink preparation and distribution in Sector H. Unit 32, a formal storage facility consisting of four cells containing maize kernels and one with beans (estimated total capacity of c. 185 m³; Anders 1981; Shimada 1982; Shimada and Shimada 1981), was situated at the northwest corner of Sector H, separated from the rest of the sector by a series of adobe walls (fig. 10). The centrally-placed structure of the sector instead is Compound 38, which contained four elite residences and auxiliary rooms (including a *chicha*-preparation area). It was guarded by 80 cm thick masonry perimeter walls with access restricted to a single entry reachable by a long corridor. Its architectural and artifactual features clearly set it apart from the western half of the sector where all evidence of craft production in this sector was found. In this regard, it is notable that face-neck jars in the western half are predominantly Gallinazo in style, while those found in the eastern half, including Compound 38, are mostly Moche in style. Thus, it would appear that, in spite of the reciprocal arrangement, the Moche elites had much less direct or routine face-to-face interaction with the crafters in Sector H, who are hypothesized as being Gallinazo in their ethnicity.

In this interethnic and socially unequal context, we suspect generous servings of *chicha* and food were particularly important in establishing and perpetuating the image of Moche elite largess and hospitality to those rendering services to them. Sharing of *chicha* also helped to establish and reinforce the unwritten but binding reciprocal relationship between crafters and sponsors or ruler (Moche) and ruled (Gallinazo). Further, we cannot underestimate the effects of intoxication that may well have lessened the burden of what might otherwise have been onerous, imposed tasks.

Writing about what it meant to be a *curaca*, or paramount lord or leader, in the immediately prehispanic north coast, Ramírez (1996: 15) points to the importance of distinguishing *curacas'* "position and hegemony over human resources from a territorial base" and to the fact that their rank and status directly correlated with the number of their subjects. Fundamentally, it was their skill in managing human resources that gave them power, prestige, and respect, as well as ensuring compliance to their orders and requests by their subjects. Thus, in spite of their recognized power over the life and death of their subjects, they had to seek continuing or greater loyalty from their subjects by means of "beer [*chicha*], banquets, and other ceremonies and festivities" (Ramírez 1996: 21). Various lords of communities in the Jequetepeque Valley testified to Spanish officials that their subjects would not obey them unless they gave them *chicha* (Ramírez 1996: 21). In other words, "The obligations between ruler and ruled were mutually reinforcing and interdependent" and "the more the [*curaca*] gave away, the greater was his subjects' obligation to reciprocate with labor service and the easier it was to 'request' aid and manipulate, coax, and cajole them into obeying his commands" (Ramírez 1996: 21–22). Ramírez (1996: 25, 26) concludes that, for the *curaca*, to share or redistribute goods was "as much for his own self-interest as for the material benefit of his people."

The preceding amply illustrates the critical importance of food and, in particular, *chicha*, for a productive relationship between crafter and elite sponsor. It also points to the importance of considering the perspectives of both the crafter and the sponsor. In fact, far from the sponsor dominating and demanding absolute obedience, the relationship seemed to have involved a good deal of diplomacy and give and take. Figure 16 is a graphic representation of late prehispanic socio-political and economic organization on the north coast of Peru, outlining the hierarchical levels, from the overarching policial entity or *señorío*, down through the smallest political units. In this sense, Moche urban craft production may be best seen in patron-client terms. This conception reflects an interdependent but variable relationship between artisans' loyalty and productivity, on the one hand, and their

elite patrons' largess, hospitality, and direction, on the other. In a city such as Pampa Grande, which had grown rapidly since its founding, the crafters-elite sponsor relationship probably remained quite dynamic until the city's abrupt, violent demise around A.D.700–750.

Diversity of Crafts

The list of crafts documented at Pampa Grande is rather short: cotton spinning, weaving and sewing, copper working, pottery making (utilitarian and fine wares), lapidary (including *Spondylus* ornaments), *chicha* making and cooking. Evidence for on-site production of feather, wood, and precious metal goods has not yet been found, although it is likely to have existed. Production of prestige goods would be expected, given the capital status of the city and architectural evidence indicating the presence of various levels of elites. Throughout world history, skilled artisans have been recruited or obliged to work at urban centers.

A glimpse at the potential range of crafts and specialists at Pampa Grande can be gained from historical sources. Consider, for example, the retinue of courtiers that accompanied the legendary folk hero, Naymlap, who is said to have founded a dynasty in the Lambayeque Valley long before Chimú conquest of the valley (Cabello Valboa 1951 [1586]; Rubiños y Andrade 1936 [1782]). Among Naymlap's forty retainers were eight functionaries each with a specific duty: a conch-shell trumpeter, a litter and throne master, a royal face painter, a royal bath steward, a chef, a beverage (probably *chicha*) maker, a clothier (feather-cloth maker), and a shell (probably *Spondylus princeps*) purveyor. As Cordy-Collins (1990: 394) points out, this list accords well with what has been deduced from archaeological (particularly elite burials and iconography) and other historical data. A list of specialists compiled from early colonial documents by Ramírez (1981, 1982; see also Netherly 1977; Rostworowski de Diez Canseco 1975, 1989) includes twenty-four categories, but may not be a good approximation to the late prehispanic situation. Makers of feather-cloth and ornaments that held considerable ritual and prestige value from at least Moche times are not on the list. Similarly, metalworking is represented in this list only by *plateros* (silver workers), not by copper workers or smelters. Further, this list does not specify who commanded their service.

Wills are one corpus of documents that not only list specific and detailed information on retainers and the services they provided, but also provide a measure of the power and status of the *curacas* and "the essence of traditional Andean society from the emic point of view" (Ramírez 1998: 220). One will described by Ramírez (1998: 220–223, 237–245) is that of Don Melchior Carorayco written in 1565. He was "a high lord of the peoples of Cajamarca [and] was personally responsible for the *guaranga* (unit of administration, theoretically equal to a thousand households) of Guzmango and two more *parcialidades . . .*" Guzmango is situated on the cis-Andean slope between the Chicama and Jequetepeque valleys. Ramírez (1998: 221) believes Don Melchior governed about 6,000 people, most of whom subsisted by farming and herding camelids. His will lists a minimum of 152 retainers dispersed in his soveignty, including ten potters and their *mayordomo* or overseer in a hamlet in Cajamarca, a beekeeper, twenty workers at the silver mine of Chilete in the upper Jequetepeque Valley, at least twenty maize farmers and twenty-two pages in the town of Contumasá, nine subjects caring for chili peppers, and maize in Cascas or Junba, and fifty-six Indians with unspecified residence. In addition, six towns (including two in dispute) are described as guarding his coca, chili peppers and maize. Material goods of Andean origin mentioned in his will include a hammock (litter), a copper trumpet, and four large wooden *cocos* or ceremonial drinking vessels used on formal occasions.

The will of Don Diego Farquep (also known as Don Diego Mocchumí) was written in 1574. He was a *principal* or "lesser lord" of fishermen, perhaps numbering some 100 households or tributary units (*pachacas*) of the valley of Túcume or valley of La Leche (Ramírez 1998: 219). He was subordinate to the paramount lord of the valley residing at Túcume and perhaps to the *principal* of Illimo (Ramírez 1996: 15). The will lists forty-three categories of animate and inanimate possessions, mostly indigenous in character, including three ceremonial drinking cups (one of gold and two of silver), *cocos* (two

pairs of gold and four of silver), nine silver crowns with which they danced, 600 strings of *chaquira* or beads, nineteen sets of women's clothes, one maize *chacra* or agricultural plot, and fifty tunics (Ramírez 1998: Table 9.2). Here "possessions" means use right of items created or worked by his retainers and loyal followers, not their ownership in the Western sense (Ramírez 1996: 47–59; 1998: 232).

Though in passing, Don Diego's will names some of his retainers including "a potter, an unknown number of "widows," five subjects who kept seven thousand salted sardines in their care, and seven lesser lords who had been charged with dyeing various numbers of skeins of wool (totaling six hundred and thirty)" (Ramírez 1998: 224). Ramírez (1998: 233) suspects that each of these "lesser lords" probably had at least a *parcialidad* or lineage under his administration.

In their historical and cultural contexts (Ramírez 1996: 233–234), it becomes apparent that these wills should be regarded only as an approximation of the human and material resources commanded by late prehispanic leaders.

Conclusion

Though we cannot simply project insights gained from historical information back in time to the Moche V period, it is evident that we have only scratched the surface of late Moche crafts and their numerous material and human dimensions. A brief characterization of what can be said with some confidence about late Moche urban craft production at Pampa Grande can be summarized in nine points.

(1) Craft production in the city included copper working, pottery making, cotton weaving and sewing, cooking, *chicha* making, lapidary, and shell working. Distribution of the crafters' products has not been well defined. Precious metalworking, feather-cloth making and woodworking, though expected, have not been documented as yet.

(2) At least some workshops were engaged in multiple crafts, or produced goods that relied upon close collaboration and coordination of crafters with different expertises (intercraft) and/or component parts made of different raw materials and technologies (multicraft).

(3) Workshops were spatially dispersed, typically one or two workshops per structure (an enclosed set of agglutinated rooms, patio[s] and a court with one or two openings to street[s]).

(4) Crafts were carried out in small, compact workshops, each manned by a handful of artisans, who either resided within the same or a nearby structure or commuted diurnally from another sector of the site.

(5) Organizationally, craft production was segmented and modular in the sense that each workshop was responsible for a certain stage(s) of more complex production. Such organization appears to have characterized much of Moche productive activities and may relate to lineage-based social life and leadership.

(6) Many crafters working in Sector H are believed to have been Gallinazo in ethnicity, while those in Sector D were predominantly Moche. Only the occupants of Compound 1, presumably the paramount lord and his sizable retinue, enjoyed the services and products of craft specialists from both Gallinazo and Moche artisans.

(7) Craft production was supervised within the workshop and in some cases at the structure level by individual(s) seated in a raised area of the court; *Spondylus* processing was confined to elite compounds.

(8) Craftsmen were provided with *chicha* and food, prepared using maize and beans from nearby large storage facilities with controlled access. The principle of reciprocity, or the largess and hospitality of elites, established and perpetuated crafters' loyalty and service.

(9) Some of the goods thus produced appear to have been deposited in tightly controlled formal storage complexes in Compound 1.

The subject matter is highly complex, particularly if we attempt, as we should, to encompass both the material and human aspects, as well as both crafters' and sponsors' perspectives. As discussed earlier, we should be cautious about considering craft production in light of a specific medium. In reality, Moche and other prehispanic cultures produced a wide array of composite objects that integrated varied materials, technologies, and expertise. We must explore the human aspects of such products. Questions were also raised regarding concepts of attached and

independent specialists and their relationships with elite sponsors and/or general consumers. There may well be much more overlap between the products and services they offered than is commonly assumed. Though the crafter-elite sponsor relationship is typically described in terms of a superior-subordinate relationship and perceived as invariable, it is well worth examining their dynamic and reciprocal qualities. The allegiance of crafters had to be carefully cultivated through institutionalized generosity. I end this paper with the hope that the data and ideas presented here will stimulate discussion and lead to the refinement of our models of Moche craft production.

BIBLIOGRAPHY

Alva, Walter
1994 *Sipán*. Colección Cultura y Artes del Perú. Lima.

Alva, Walter, and Christopher B. Donnan
1993 *Royal Tombs of Sipán* [exh. cat., Fowler Museum of Cultural History, University of California]. Los Angeles.

Anders, Martha B.
1981 Investigation of State Storage Facilities in Pampa Grande, Peru. *Journal of Field Archaeology* 8 (4): 391–404.

Bawden, Garth L.
1982 Community Organization Reflected by the Household: A Study of Pre-Columbian Social Dynamics. *Journal of Field Archaeology* 9 (2): 165–181.

1990 Domestic Space and Social Structure in Pre-Columbian Northern Peru. In *Domestic Architecture and the Use of Space: An Interdisciplinary Cross-Cultural Study*, ed. Susan Kent, 153–171. Cambridge.

1996 *The Moche*. Oxford and Cambridge, Mass.

Bennett, Wendell C.
1949 Engineering. In *Handbook of South American Indians, Volume 5: The Comparative Ethnology of South American Indians*, ed. Julian H. Steward, 53–65 Smithsonian Institution, Bureau of American Ethnology Bulletin 143. Washington.

1950 *The Gallinazo Group, Viru Valley, Peru*. Yale University Publications in Anthropology 43. New Haven, Conn.

Brumfiel, Elizabeth M.
1987 Elite and Utilitarian Crafts in the Aztec State. In *Specialization, Exchange, and Complex Societies*, ed. Elizabeth M. Brumfiel and Timothy K. Earle, 102–118. Cambridge.

Brumfiel, Elizabeth M., and Timothy K. Earle
1987 Specialization, Exchange, and Complex Societies: An Introduction. In *Specialization, Exchange, and Complex Societies*, ed. Elizabeth M. Brumfiel and Timothy K. Earle, 1–9. Cambridge.

Cabello Valboa, Miguel
1951 *Miscelánea antártica. Una historia del*
[1586] *Perú antiguo*. Lima.

Camino, Lupe
1987 *Chicha de maíz: Bebida y vida del pueblo Catacaos*. Centro de Investigación y Promoción del Campesinado, Piura.

Cobo, Bernabé
1964 *Historia del nuevo mundo, Tomos 1–2*.
[1653] Biblioteca de Autores Españoles, 91–92. Madrid.

Conklin, William J

1979 Moche Textile Structures. In *The Junius B. Bird Pre-Columbian Textile Conference, May 19th and 20th, 1973*, ed. Ann P. Rowe, Elizabeth P. Benson, and Anne-Louise Schaffer, 165–184. The Textile Museum and Dumbarton Oaks, Washington.

Cordy-Collins, Alana

1990 Fonga Sigde, Shell Purveyor to the Chimu Kings. In *The Northern Dynasties: Kingship and Statecraft in Chimor* [A Symposium at Dumbarton Oaks, 12th and 13th October 1985], ed. Michael E. Moseley and Alana Cordy-Collins, 393–417. Washington.

Costin, Cathy L.

1991 Craft Specialization: Issues in Defining, Documenting, and Explaining the Organization of Production. In *Archaeological Method and Theory* 3, ed. Michael B. Schiffer, 1–56. Tucson, Ariz.

Donnan, Christopher B.

1965 Moche Ceramic Technology. *Ñawpa Pacha* 3: 115–134, plates I–IV.

1973 A Pre-Columbian Smelter from Northern Peru. *Archaeology* 26 (4): 289–297.

1992 *Ceramics of Ancient Peru* [exh. cat., Fowler Museum of Cultural History, University of California]. Los Angeles.

1995 Moche Funerary Practice. In *Tombs for the Living: Andean Mortuary Practices* [A Symposium at Dumbarton Oaks, 12th and 13th October 1991], ed. Tom D. Dillehay, 111–159. Washington.

1997 Deer Hunting and Combat: Parallel Activities in the Moche World. In *The Spirit of Ancient Peru: Treasures from the Museo Arqueológico Rafael Larco Herrera* [exh. cat., Fine Arts Museums of San Francisco], ed. Kathleen Berrin, 51–59. New York.

Donnan, Christopher B., and Carol J. Mackey

1978 *Ancient Burial Patterns of the Moche Valley, Peru.* Austin, Tex.

Earle, Timothy K.

1987 Specialization and the Production of Wealth: Hawaiian Chiefdoms and the Inka Empire. In *Specialization, Exchange, and Complex Societies*, ed. Elizabeth M. Brumfiel and Timothy K. Earle, 64–75. Cambridge.

Epstein, Stephen M., and Izumi Shimada

1984 Metalurgia de Sicán: Una reconstrucción de la producción de la aleación de cobre en el Cerro de los Cementerios, Peru. *Beiträge zur allgemeinen und vergleichenden Archäologie* 5 [1983]: 379–430.

Franco, Régulo, César Gálvez, and Segundo Vásquez

1994 Arquitectura y decoración Mochica en la Huaca Cao Viejo, complejo El Brujo: Resultados preliminares. In *Moche: Propuestas y perspectivas* [Actas del primer coloquio sobre la cultura Moche, Trujillo, 12 al 16 de abril de 1993], ed. Santiago Uceda and Elías Mujica, 147–180. Travaux de l'Institut Français d'Etudes Andines 79. Trujillo and Lima.

Gumerman, George IV

1997 Food and Complex Societies. *Journal of Archaeological Method and Theory* 4 (2): 105–139.

Haas, Jonathan S.

1985 Excavations on Huaca Grande: An Initial View of the Elite at Pampa Grande, Peru. *Journal of Field Archaeology* 12 (4): 391–409.

Hastings, Charles M., and Michael E. Moseley

1975 The Adobes of Huaca del Sol and Huaca de la Luna. *American Antiquity* 40 (2): 196–203.

Hayashida, Frances M.

1995 State Pottery Production in the Inka Provinces (Peru). Ph.D. dissertation, Department of Anthropology, University of Michigan, Ann Arbor.

Helms, Mary W.

1993 *Craft and the Kingly Ideal: Art, Trade, and Power.* Austin, Tex.

Hocquenghem, Anne-Marie, and Manuel Peña

1994 La talla del material malacológico en tumbes. *Bulletin de l'Institut Français d'Etudes Andines* 23(2): 209–229.

Kroeber, Alfred L.

1926 *Archaeological Explorations in Peru, Part I: Ancient Pottery from Trujillo.* Field Museum of Natural History, Anthropology Memoirs 2 (1). Chicago.

1930 *Archaeological Explorations in Peru, Part II: The Northern Coast.* Field Museum of Natural History, Anthropology Memoirs 2 (2). Chicago.

Lechtman, Heather N.

1973 The Gilding of Metals in Precolumbian Peru. In *Application of Science in Examination of Works of Art* [Proceedings of the Seminar at the Museum of Fine Arts, Boston: June 15–19, 1970], ed. William J. Young, 38–52. Boston.

1976 A Metallurgical Site Survey in the Peruvian Andes. *Journal of Field Archaeology* 3 (1): 1–42.

1979 Issues in Andean Metallurgy. In *Pre-Columbian Metallurgy of South America* [A Conference at Dumbarton Oaks, October 18th and 19th, 1975], ed. Elizabeth P. Benson, 1–40. Washington.

1984a Pre-Columbian Surface Metallurgy. *Scientific American* 250 (6): 56–63.

1984b Andean Value Systems and the Development of Prehistoric Metallurgy. *Technology and Culture* 25 (1): 1–36.

1988 Traditions and Styles in Central Andean Metalworking. In *The Beginning of the Use of Metals and Alloys* [Papers from the Second International Conference on the Beginning of the Use of Metals and Alloys, Zhengzhou, China, 21–26 October 1986], ed. Robert Maddin, 344–378. Cambridge, Mass.

Lechtman, Heather N., Lee A. Parsons, and William J. Young

1975 *Seven Matched Hollow Gold Jaguars from Peru's Early Horizon.* Dumbarton Oaks Research Library and Collection, Studies in Pre-Columbian Art and Archaeology 16. Washington.

McClelland, Donald

1986 Brick Seriation at Pacatnamu. In *The Pacatnamu Papers, Volume 1,* ed. Christopher B. Donnan and Guillermo A. Cock, 27–46. Museum of Cultural History, University of California, Los Angeles.

McGovern, Patrick E.

1989 Ceramics and Craft Interaction: A Theoretical Framework, with Prefatory Remarks. In *Cross-Craft and Cross-Cultural Interactions in Ceramics,* ed. Patrick E. McGovern, 1–11. Ceramics and Civilization 4. Westerville, Ohio.

Moore, Jerry D.

1989 Pre-Hispanic Beer in Coastal Peru: Technology and Social Context of Prehistoric Production. *American Anthropologist* 91: 682–695.

Morris, Craig

1979 Maize Beer in the Economics, Politics, and Religion of the Inca Empire. In *Fermented Beverage Foods in Nutrition,* ed. C. Gastineau, W. Darby, and T. Turner, 21–34. New York.

Moseley, Michael E.

1975a Prehistoric Principles of Labor Organization in the Moche Valley, Peru. *American Antiquity* 40 (2): 191–196.

1975b Secrets of Peru's Ancient Walls. *Natural History* 84: 34–41.

Netherly, Patricia J.

1977 Local Level Lords on the North Coast of Peru. Ph.D. dissertation, Department of Anthropology, Cornell University, Ithaca.

1984 The Management of Late Andean Irrigation Systems on the North Coast of Peru. *American Antiquity* 49 (2): 227–254.

1990 Out of Many, One: The Organization of Rule in the North Coast Polities. In *The Northern Dynasties: Kingship and Statecraft in Chimor* [A Symposium at Dumbarton Oaks, 12th and 13th October 1985], ed. Michael E. Moseley and Alana Cordy-Collins, 461–487. Washington.

Nicholson, G. Edward

1960 Chicha Maize Types and Chicha Manufacture in Peru. *Economic Botany* 14: 290–299.

Oehm, Victor P.

1984 *Investigaciones sobre minería y metalurgia en el Perú prehispánico: Una visión crítica actualizada.* Bonner Amerikanistische Studien 12. Bonn.

O'Neill, John P.

1984 Introduction: Feather Identification. In *Costumes and Featherwork of the Lords of Chimor: Textiles from Peru's North Coast,* by Ann P. Rowe, 144–150. The Textile Museum, Washington.

Parsons, Lee A.

1962 An Examination of Four Moche Jars from the Same Mold. *American Antiquity* 27 (4): 515–519.

Prentice, G.

1987 Marine Shells as Wealth Items in Mississippian Societies. *Midcontinental Journal of Archaeology* 12 (2): 193–223.

Prümers, Heiko

1995 Un tejido Moche excepcional de la tumba del "Señor de Sipán" (valle de Lambayeque, Perú). *Beiträge zur allgemeinen und vergleichenden Archäologie* 15: 338–369.

Purin, Sergio

1983 Utilisation des rayons-x pour l'observation des traces de fabrication sur cinq vases Mochicas. *Bulletin des Musées Royaux d'Art et d'Histoire* 54 (2): 5–20. [Brussels].

1985 Construction de trois vases noirs Mochicas. *Bulletin des Musées Royaux d'Art et d'Histoire* 56 (1): 95–104. Brussels].

Ramírez, Susan E.

1981 La organización económica de la costa norte: Un análisis preliminar del período prehispánico tardío. In *Etnohistoria y Antropología Andina,* ed. Amalia Castelli, Marcia Koth de Paredes, and Mariana Mould de Pease, 281–297. Lima.

1982 Retainers of the Lords or Merchants: A Case of Mistaken Identity? In *El hombre y su ambiente en los Andes centrales,* ed. Luis Millones and Hiroyasu Tomoeda, 123–136. National Museum of Ethnology, Senri Ethnological Studies 10. Suita, Osaka.

1996 *The World Upside Down: Cross-Cultural Contact and Conflict in Sixteenth-Century Peru.* Stanford, Calif.

1998 Rich Man, Poor Man, Beggar Man, or Chief: Material Wealth as a Basis of Power in Sixteenth-Century Peru. In *Dead Giveaways: Indigenous Testaments of Colonial Mesoamerica and the Andes*, ed. Susan Kellogg and Matthew Restall, 215–248. Salt Lake City, Utah.

Rostworowski de Diez Canseco, María
1961 *Curacas y Sucesiones: Costa Norte*. Lima.

1975 Pescadores, artesanos y mercaderes costeños en el Perú prehispánico. *Revista del Museo Nacional* 41: 311–349. [Lima].

1989 *Costa Peruana prehispánica*. Lima.

Rubiños y Andrade, Justo Modesto de
1936 *Succesión cronológica: O serie historial*
[1782] *de los curas de Mórrope, y Pacora en la Provincia de Lambayeque de Obispado de Truxillo del Perú . . .*, ed. Carlos A. Romero. Revista Histórica 10 (3): 289–363. [Lima].

Russell, Glenn S., Banks L. Leonard, and Jesús Briceño
1994 Producción de cerámica Moche a gran escala en el valle de Chicama, Perú: El taller de Cerro Mayal. In *Tecnología y organización de la producción de ceramica prehispánica en los Andes*, ed. Izumi Shimada, 201–227. Lima.

1998 The Cerro Mayal Workshop: Addressing Issues of Craft Specialization in Moche Society. In *Andean Ceramics: Technology, Organization and Approaches*, ed. Izumi Shimada, 63–89. MASCA (Museum Applied Science Center for Archaeology) Research Papers in Science and Archaeology, Supplement to Volume 15. University of Pennsylvania Museum of Archaeology and Anthropology. Philadelphia.

Shimada, Izumi
1976 Socioeconomic Organization at Moche V Pampa Grande, Peru: Prelude to a Major Transformation to Come. Ph.D. dissertation, Department of Anthropology, University of Arizona.

1978 Economy of a Prehistoric Urban Context: Commodity and Labor Flow at Moche V Pampa Grande, Peru. *American Antiquity* 43 (4): 569–592.

1982 Horizontal Archipelago and Coast-Highland Interaction in North Peru: Archaeological Models. In *El hombre y su ambiente en los Andes centrales*, ed. Luis Millones and Hiroyasu Tomoeda, 185–257. National Museum of Ethnology, Senri Ethnological Studies 10. Suita, Osaka.

1990 Cultural Continuities and Discontinuities on the Northern North Coast of Peru, Middle-Late Horizons. In *The Northern Dynasties: Kingship and Statecraft in Chimor* [A Symposium at Dumbarton Oaks, 12th and 13th October 1985], ed. Michael E. Moseley and Alana Cordy-Collins, 297–392. Washington.

1994a *Pampa Grande and the Mochica Culture*. Austin, Tex.

1994b Prehispanic Metallurgy and Mining in the Andes: Recent Advances and Future Tasks. In *In Quest of Mineral Wealth: Aboriginal and Colonial Mining and Metallurgy in Spanish America*, ed. Alan K. Craig and Robert C. West, 37–73. Geoscience and Man 33. Baton Rouge, La.

1997a The Variability and Evolution of Prehispanic Kilns on the Peruvian Coast. In *Prehistory and History of Ceramic Kilns*, ed. Prudence M. Rice, 103–127. Ceramics and Civilization 7. Columbus, Ohio.

1997b Organizational Significance of Marked Adobe Bricks and Associated Construction Features on the North Peruvian Coast. In *Arquitectura y civilización en los Andes prehispánicos/Prehispanic Architecture and Civilization in the Andes*, ed. Elisabeth Bonnier and Henning Bischof, 62–89. Völkerkundliche Sammlungen der Stadt Mannheim im Reiss-Museum, Archaeologica Peruana 2. Mannheim.

1998 Sicán Metallurgy and Its Cross-Craft Relationships. *Boletín Museo del Oro* 41 [1996]: 26–61. [Bogotá].

1999a Technological Developments and Fuel Competition: Cross-Craft Interaction on Coastal Peru. Paper presented at the 64th Annual Meeting of the Society for American Archaeology, Chicago.

1999b The Evolution of Andean Diversity: Regional Formations (500 B.C.E.–C.E. 600). In *Cambridge History of Native Peoples of the Americas*, ed. Frank Salomon and Stuart B. Schwartz, 350–517. Cambridge.

2000 The Late Prehispanic Coastal States. In *The Inca World: The Development of Pre-Columbian Peru, A.D. 1000–1534*, ed. Laura Laurencich Minelli, 49–110. Norman, Okla.

Shimada, Izumi, and Raffael Cavallaro
1985 Monumental Adobe Architecture of the Late Prehispanic Northern North Coast of Peru. *Journal de la Société des Américanistes* 71: 41–78. [Paris].

Shimada, Izumi, Stephen M. Epstein, and Alan K. Craig
1983 The Metallurgical Process in Ancient North Peru. *Archaeology* 36 (5): 38–45.

Shimada, Izumi, and Jo Ann Griffin
1994 Precious Metal Objects of the Middle Sicán. *Scientific American* 270 (4): 82–89.

Shimada, Izumi, and Adriana Maguiña
1994 Nueva visión sobre la cultura Gallinazo y su relación con la cultura Moche. In *Moche: Propuestas y perspectivas* [Actas del primer coloquio sobre la cultura Moche, Trujillo, 12 al 16 de abril de 1993], ed. Santiago Uceda and Elías Mujica, 31–58. Travaux de l'Institut Français d'Etudes Andines 79. Trujillo and Lima.

Shimada, Izumi, and John F. Merkel
1991 Copper-Alloy Metallurgy in Ancient Peru. *Scientific American* 265 (1): 80–86.

Shimada, Izumi, Crystal B. Schaaf, Lonnie G. Thompson, and Ellen Mosley-Thompson
1991 Cultural Impacts of Severe Droughts in the Prehistoric Andes: Application of a 1,500-Year Ice Core Precipitation Record. *World Archaeology* 22 (3): 247–270.

Shimada, Melody, and Izumi Shimada
1981 Explotación y manejo de los recursos naturales en Pampa Grande, sitio Moche V: Significado del análisis orgánico. *Revista del Museo Nacional* 45: 19–73. [Lima].

Strong, William Duncan, and Clifford Evans
1952 *Cultural Stratigraphy in the Virú Valley, Northern Peru: The Formative and Florescent Epochs.* Columbia Studies in Archeology and Ethnology 4. New York.

Tello, Julio C.
1938 Arte antiguo Peruano: Album fotográfico de las principales especies arqueológicas de cerámica existentes en los museos de Lima, primera parte: Tecnología y morfología. *Inca* 2: 1–280. [Lima].

Topic, John R.
1990 Craft Production in the Kingdom of Chimor. In *The Northern Dynasties: Kingship and Statecraft in Chimor* [A Symposium at Dumbarton Oaks, 12th and 13th October 1985], ed. Michael E. Moseley and Alana Cordy-Collins, 145–176. Washington.

Ubbelohde-Doering, Heinrich
1967 *On the Royal Highways of the Inca: Archaeological Treasures of Ancient Peru*, trans. Margaret Brown. New York.

1983 *Vorspanische Gräber von Pacatnamú, Nordperu.* Materialien zur allgemeinen und vergleichenden Archäologie 26. Munich.

Uceda, Santiago, and José Armas
1998 An Urban Pottery Workshop at the Site of Moche, North Coast of Peru. In *Andean Ceramics: Technology, Organization and Approaches*, ed. Izumi Shimada, 91–110. MASCA (Museum Applied Science Center for Archaeology) Research Papers in Science and Archaeology, Supplement to Volume 15. University of Pennsylvania Museum of Archaeology and Anthropology. Philadelphia.

Vreeland, James M.
1986 Cotton Spinning and Processing on the Peruvian North Coast. In *The Junius B. Bird Conference on Andean Textiles, April 7th and 8th, 1984*, ed. Ann P. Rowe, 363–383. The Textile Museum, Washington.

Willey, Gordon R.
1949 Ceramics. In *Handbook of South American Indians, Volume 5: The Comparative Ethnology of South American Indians*, ed. Julian H. Steward, 139–204. Smithsonian Institution, Bureau of American Ethnology Bulletin 143. Washington.

1953 *Prehistoric Settlement Patterns in the Virú Valley, Perú.* Smithsonian Institution, Bureau of American Ethnology Bulletin 155. Washington.

1964 Diagram of a Pottery Tradition. In *Process and Pattern in Culture: Essays in Honor of Julian H. Steward*, ed. R. A. Manners, 156–174. Chicago.

Wilson, David J.
1987 Reconstructing Patterns of Early Warfare in the Lower Santa Valley: New Data on the Role of Conflict in the Origins of Complex North-Coast Society. In *The Origins and Development of the Andean State*, ed. Jonathan S. Haas, Shelia Pozorski, and Thomas Pozorski, 56–69. New Directions in Archaeology. Cambridge.

JULIE JONES
Metropolitan Museum of Art

Innovation and Resplendence: Metalwork for Moche Lords

Until recent years, Moche metalwork has had a very modest presence both within the known archaeological remains of this powerful and artistically gifted ancient American people and within Moche scholarship. The modest presence began approximately a hundred years ago with the work of Max Uhle at Huaca del Sol and Huaca de la Luna in the Moche Valley, where metalwork objects that subsequently came to be understood as Moche in style were discovered during the excavations of 1899–1900 (Uhle 1913). Unearthed at Sites A and F, the metal objects were few. In 1913 Uhle published only two of them, a small hollow gold figure, one of three, and an "end piece" of a neck ornament inlaid with turquoise (Uhle 1913: pl. 5, f and g). The two pieces were part of a cache found on the south platform of the Huaca del Sol together with other objects of gold and turquoise (Menzel 1977: 39).

More of Uhle's turn-of-the-century metal discoveries at Moche were not published for many years. Parts of his unpublished work reached print through the efforts of A.L. Kroeber only in the 1940s. The Moche metal objects among them were: gold ear ornaments with wide frontals and long shafts, hollow gold ornaments and beads joined at the sides and pierced with two pairs of suspension holes in the back or sides, copper "bells" in the form of small heads, cast copper chisels topped with images in the round, and copper and gold ingots, among other types of works (Kroeber 1944: pls. 44, 47, 48). They greatly increased the representative types of Moche metal objects known to modern researchers.

The 1940s generally were important years for the greater understanding of the ancient Moche peoples and for a clearer awareness of their handiworks. In the Chicama Valley, antiquities housed in the museum at Hacienda Chiclín were substantial in number and played a meaningful role in Moche studies. Inaugurated in 1926, the Chiclín museum collections were enlarged through the efforts of Rafael Larco Hoyle, who worked in various north coast valleys. Digging and purchasing widely, Larco collected antiquities and published extensively on archaeological aspects of the area.

One of Larco's publications, *Los Mochicas*, issued in 1945, was the first to illustrate major Moche works of art in metal. They included some of the most "lordly" of Moche metal object types: the great flared headdress ornaments with raised central image (Larco 1945: 29) and the elaborate nose ornaments (Larco 1945: 30). Both types—the wide, semicircular head ornaments made to be worn centrally over the forehead, and the ornaments that dangle from the septum of the nose thereby covering the mouth—had long been distinguished in Moche modeled and fine-line ceramic vessels. The head and nose ornaments illustrated by Larco were of gold, and although sizes were not published at the time, the headdress frontals were almost 30 cm across (Berrin 1997: cat. 139, 140) (fig. 1).

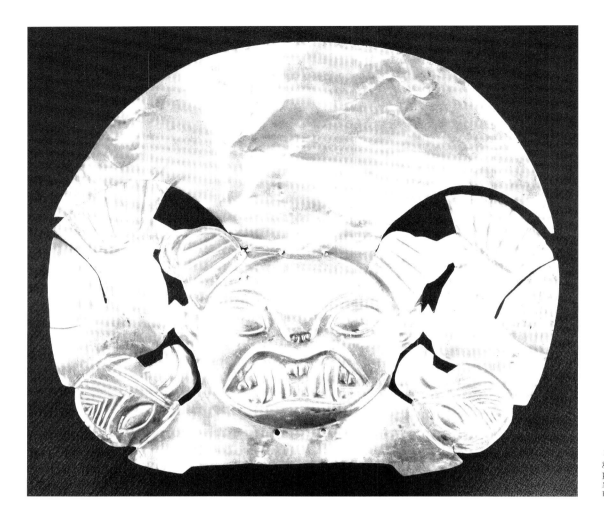

1. Headdress ornament of gold of unknown provenance, 24 × 28 cm
Museo Arqueológico Rafael Larco Herrera, Lima (XSB-004-029)

The nose ornaments, too, were elegantly conceived. One was of a particularly distinctive Moche shape, an upswept crescent that was rimmed at the bottom with a row of small dangles, a detail frequently seen in Moche fine-line drawing. All three gold nose ornaments in the 1945 publication appear to have been inlaid, perhaps with a malleable—and colorful—material. A cast chisel, said to be silver, with a rattle top in the shape of turbaned head with turquoise inlays was also illustrated (Larco 1945: 30). It too was an indication of the importance of the man (or men) with whom the objects had been buried. No source or context was published for these works; the author commented instead on the metals available to the Moche—gold, silver, copper, and lead—and the techniques such as alloying and soldering that had been observed among the objects themselves (Larco 1945: 17, 22).

Other important developments of the 1940s for both Peruvian and Moche archaeology were the excavations of the Virú Valley Project, a multicomponent endeavor that proposed an "intensive study of human cultural adaptation within the confines of a small area over a long period of time" (Strong and Evans 1952: 3). One significant result of the project was the 1946 discovery of what came to be known as the Tomb of the Warrior Priest at the Huaca de la Cruz site (Strong and Evans 1952: 150–167). An aged Moche "warrior priest" had been buried extended on his back in a cane coffin with all the accoutrements symbolic of high position about him. Many of these were objects of copper and/or gilded copper.

Since the discovery and publication of Virú's Warrior Priest burial, much more information has become available on Moche tombs, some of them of much higher status

(Alva and Donnan 1993; Donnan and Mackey 1978). Yet many of the features first observed in the Virú tomb have proved to be consistent with elite Moche burials as they are understood today (Donnan 1995). The presence in the tomb of multiple objects made of metal —including personal finery such as nose ornaments and the gilded copper headdress elements and clothing plaques—are salient features of lordly tombs. The placement of metal objects on the face and in the hands of the deceased (Donnan 1995: 143; Strong and Evans 1952: 156) is another. It is now clear that the higher the status of the personage, the greater the quantity and quality of metal objects buried with him/her. The highest-status burials have many objects of gold and silver, quantities of works made of copper, much of it gilded and/or silvered, adorning the honored lords in death.

The picture of Moche metalwork began to enlarge dramatically with the discovery in the 1960s of objects in Moche style in the far north of Peru in the Piura Valley. The discoveries, made by looters in the burial grounds in the vicinity of Cerro Vicús, included many ceramic vessels (Patellani 1970) and objects of gold, silver, and copper and their mixtures (Disselhoff 1971). A particularly large find of metal objects was reported at Vicús in 1969 (Disselhoff 1972; Lapiner 1976: 113–114). Labeled by the local name of Loma Negra, the metal finds consisted of personal ornaments of gold and silver such as ear ornaments (Lapiner 1976: pls. 380, 385, 389) nose ornaments (Lapiner 1976: pls. 390–392, 394–395, 397), and numerous objects of different size, shape, and function made of copper and gilded and silvered copper (Disselhoff 1971: figs. 1, 2, 7, 11–16, 19–20, 22; Lapiner 1976: pls. 349–355, 357–358, 360–361, 363, 369).

The imagery of this large group of metal objects was also consistent with Moche iconography. Themes of domination and sacrifice were prevalent, with many depictions of warriors (Disselhoff 1971: 1, 2, 7; Lapiner 1976: pl. 381) and Decapitators (Disselhoff 1972: fig. 15; Lapiner 1976: pls. 350, 360, 363, 382). Series of small masks (Disselhoff 1972: fig. 20), some with grimacing or snarling mouths and "feline" eyes (Lapiner 1976: pls. 351, 352, 355, 357–358), were present in the corpus. Style, too, was consistently Moche, but as Moche presence in the far north of Peru had not previously been documented archaeologically, judgements about the nature of the find, its purpose, and its relationships—temporal and spatial—were left open.

While many issues remained to be clarified about Loma Negra, the works of art themselves began to be studied. Hundreds of pieces had surfaced, and many in series of gilded or silvered copper—small masks and faces, warriors and sacrificers, scorpions, spiders, crabs, and more—were known in multiples, all hammered in low relief, all with attachment holes, indicating a role in ancient life that could only be conjectured. The sumptuous objects—the head ornaments, the ear ornaments, the nose pieces—were rarer. Made of gold and silver, they were individual in their imagery and lively in presentation. Nose ornaments were a particular favorite in the upper Piura Valley for they were the most numerous luxury item (see, for example, Donnan 1990: 24–25).

The aspects of Loma Negra metals that attracted attention were metallurgical ones. The Loma Negra metals are almost entirely made of hammered sheet metal. Copper was in greatest proportion. The early studies, undertaken at the Massachusetts Institute of Technology by Heather Lechtman and colleagues (Lechtman, Erlij, and Barry 1982), primarily addressed the issue of the gilded and silvered surfaces on copper. The Loma Negra gold and silver coatings were extremely thin and even, and while these qualities were particularly impressive, they proved to be very difficult to study. Precisely because of the thinness of the coatings, and the presence of extensive amounts of copper corrosion products, research into the ancient surfaces was challenging.

Many experiments and careful comparisons later, the MIT researchers concluded that the surfaces were achieved through an "electrochemical replacement process in which gold and silver were dissolved in an aqueous solution of corrosive minerals. The precious metals are then plated from solution onto the copper objects" (Lechtman, Erlij, and Barry 1982: 3). A sophisticated and ingenious process, electrochemical replacement plating had not previously been reported for the ancient Americas, and as metallurgical studies have since continued, it is a process that has only been reported for the upper Piura Valley.

It has not as yet been identified anywhere else on precious metal surfaced copper objects of the Moche era (Schorsch, Howe, and Wypyski 1998: 145, 153).

That the Moche metalsmiths gilded copper had been understood long before the studies mentioned above revealed one of the methods by which the ancient artisans accomplished it. Major works of art in gilded copper were known from the southern Moche region, but they were created using a method or methods other than electrochemical replacement plating. Famous among them is the "mask" (Jones 1979: 70; Schorsch 1998: fn. 78; Ubbelohde-Doering 1952: cat. 230), or gilded copper face, that was discovered in the early years of this century in a "subterranean chamber" of the Huaca de la Luna at Moche (Lehman and Doering 1924: 24, 39). First reported by the archaeologist Eduard Seler (1912: 222–223), the chamber is now known as the Seler Tomb. The mask, which is the major extant work of art from the tomb, is lifesize but was apparently not for use during life, as there are no seeing or breathing holes in it (Benson 1972: pl. 5). The mask might have been the funerary face covering for the ancient Moche lord or priest who was undoubtedly buried in the Seler Tomb. Alternatively, it could have been for attachment to a "crown or head-dress" (Ubbelohde-Doering 1952: 48), where the assertive face would have impressed all viewers.

The discoveries of the late 1980s at the site of Sipán in the Lambayeque Valley (Alva 1988, 1990) would revolutionize thinking about the ancient Moche, their rulers, their artisans, their metalwork, and countless other aspects of the Moche life and history. The graves that have been excavated at Sipán under the direction of Walter Alva of the Museo Arqueológico Nacional Brüning de Lambayeque (Alva 1994; Alva and Donnan 1993) have revealed a wealth of metalwork: personal ornaments and insignia of gold and silver; banners, clothing, and headdress elements of gilded and silvered copper; cast staves and scepters, other finery in shell, stone, feathers, and cotton textile. The excavations, which are ongoing, show that the greatest lord—known as the Lord of Sipán, found in Tomb 1—was buried with his entire extended body covered with objects of metal from the shallow gold dish or "cap" on his head to the silver sandals on his feet (Alva, this volume, and 1994: 43–145; Alva and Donnan 1993: 55–125).

It is instructive to look at the metal objects deemed worthy of the Lord of Sipán in death. They were many. Three large shrouds wrapped the lord completely, two of them sewn with gilded copper platelets; more gilded copper platelets and emblematic low-relief human figures covered the surface of four cloth banners (Alva 1994: fig. 49). Other items accompanying the deceased included a large gilt copper ornament—perhaps a pectoral or headdress ornament—with two large raised and extended hands (Alva 1994: figs. 60, 61); an outer tunic covered totally with gilded copper platelets; four nose ornaments, two of upswept crescent shape in gold and two round—one gold and one silver (Alva 1994: figs. 64, 65, 74); and three pairs of elaborate gold ear ornaments with long narrow shafts and wide frontals inlaid with gold and turquoise (Alva 1994: figs. 39–41, 44, 47).

The great lord's funerary mask was of gold, made in separate parts. One covered the lower face and mouth, other elements were a band of teeth and individual nose and eye coverings (Alva and Donnan 1993: figs. 90, 92). A gold caplike bowl was on the head; four necklaces of gold and silver were at the neck (Alva 1994: figs. 90, 92, 97, 99); cast chisel-bladed scepters of silver—one with a hammered gold top—were in the hands (Alva 1994: figs. 77, 83). Ingots of gold were in the mouth and right hand, a silver ingot in the left. Two head crests of hammered gold (Alva 1994: figs. 106, 124), one of which had such great size that it must have been difficult to support upright on the head, were underneath the body, as were two large backflaps—again one gold and one silver (Alva 1994: figs. 109–111). Other items included crescent-shaped bells of gold and/or gilded copper, gilded copper headdress elements, a necklace of gilt copper head-form beads, and copper objects such as belt finials, lance points, daggers, and straps.

While the works in metal were in the greatest array, they were not the only funerary offerings closely accompanying the body of the Sipán lord. Shoulder-width shell bead collars, shell and gold bead bracelets, and panaches of colorful feathers were also placed directly on, above, or below the body. The lord's important personal regalia were not

only part of his mortuary bundle, they were directly on his person, wrapped as he was within three burial shrouds.

Two hundred years earlier, another powerful ruler had been laid to rest in the Sipán necropolis (Alva 1994: 174–233; Alva and Donnan 1993: 167–217). Tomb 3 is thought to be that of a man of rank equal in his time to the Lord of Sipán in his. There are many similarities in the contents of the graves of the two rulers. The personal regalia in Tomb 3, including all of the metalwork, much of which was of gilded copper, were on or very close to the extended body of the lord as they had been in Tomb 1. While specific details of the tombs differ, significant elements are the same.

Banners with low-relief gilded copper images of considerable similarity were in both tombs, as were burial masks, headdress and pectoral ornaments, crescent-shaped bells, necklaces of gold and silver, numerous elaborate nose ornaments, pairs of ear ornaments of gold and silver, cast chisel-bladed scepters, and gold and silver ingots on head and hands. In Tomb 3, a silver nose ornament was distinctively held in the left hand, implying a significance to nose ornaments that goes beyond their ornamental form. The similarities of ritual burial practice had been maintained for at least two hundred years, and are but one indication of the persistence of belief and the codification of Moche burial practices. They also show how firmly established were the prerogatives and traditions of power.

The placement of metal objects in the mouth/face and in the hands of the deceased was clearly a major part of the burial ritual, whether the metals were gold, silver, or folded pieces of copper, as they had been in the Tomb of the Warrior Priest in the Virú Valley (Strong and Evans 1952: 156). The preciousness of the metals so placed increased with the power and rank of the interred, but the role played in death by the metal objects, however valuable, appears to have remained the same. Emblematic of what must have been a protective or empowering role or quality inherent in metals in Moche belief, the fact that the greatest lords of the land were buried totally covered with metal objects must have accorded them the maximum authority and protection in death.

The importance of the role metal objects had in burials, and the quantity buried with great men—as illustrated by the Sipán tombs, was to continue on the north coast of Peru for centuries. The continued inclusion of a myriad of valuable metal objects in the tombs of the mighty is demonstrated by a burial of some hundreds of years later, that of Huaca Loro at Batán Grande also in the greater Lambayeque Valley. Huaca Loro is associated with a later culture, known as Sicán or Lambayeque, dated to A.D. 700–1375, which was clearly the inheritor of the earlier Moche traditions in the valley. The Huaca Loro tomb was excavated in the early 1990s (Shimada 1995; Shimada and Griffin 1994), and contained the body of a lord, fully accoutered in ceremonial attire that consisted of a great gold mask and headdress (Shimada 1995: fig. 104), multiple sets of ear ornaments, a mantle originally sewn with nearly two thousand gold foil squares (Shimada 1995: fig. 36), as well as many other objects of gold, silver, gilded copper, and other precious materials. A hierarchy of placement is discernable within the funerary offerings. Gold and silver objects were closest to the body, works of gilded copper, other metals and materials farther from it. So rich was the Batán Grande lord that two different deposits of personal finery—of gold, silver, and gilded copper—were placed separately from the body, a considerable deviation from earlier practice. Thousands of pieces of gilt copper scrap in the Huaca Loro tomb were further evidence of the significance of metals. Of the approximately 1.2 tons of funerary offerings in the grave, nearly three quarters were of metal (Shimada and Griffin 1994: 83).

The earlier Moche discoveries at Sipán, however, now totaling twelve tombs, have shed much light on all Moche metal objects, those from Loma Negra included (Jones 1993a). Royal tombs, as well as the tombs of priests, warriors, guardians, attendants, and others, can be hypothesized to have existed, using the evidence of the Loma Negra metals corpus and the analogy of Sipán (Jones 1993b). As the wonders of Sipán were being revealed between 1987 and 1990, archaeological research was also being conducted in the upper Piura Valley under the auspices of the Pontificia Universidad Católica del Perú (Guffroy, Kaulicke, and Makowski 1989; Kaulicke 1991, 1992, 1994; Makowski 1994; Makowski et al. 1994), where the excavations finally revealed an actual presence for the Moche in

Piura. Even though no direct connection to southern Moche metalworking or metal-using circumstances was established, local Vicús memory did include information that "much material was obtained from the sacking of what seems to be a burial platform" (Kaulicke, personal communication, 1999) at Loma Negra, and that the bodies there were probably extended (Kaulicke 1992: 882).

The existence of a Moche burial platform in the area thought to be the source of the Loma Negra metals, and the possibility that it held a number of important Moche graves with multiple objects is credible if the corpus of Loma Negra metal objects is considered. The Loma Negra metals include objects of personal finery in gold and silver that were appropriate for Moche royalty, and there are the quantities of gilded and silvered copper works sufficient to cover lordly corpses in death. Variations in iconography and metal-working technology can further support hypothesized time differences among the Loma Negra pieces. For instance, two nose ornaments of gold and silver can serve to illustrate issues of iconography and technology that have implications for time differences among the Loma Negra works.

Nose ornaments are the most numerous of the regal Piura objects and it is probable that there were numbers of them in each major Loma Negra tomb. The two to be discussed here, an ornament with spiders and one in the shape of an anthropomorphic head, might have been placed in graves at about a generation apart, perhaps more. Hypothetically the earlier of the two is that with spiders (fig. 2). A particularly appealing object, it has small gold spiders—the backs and eyes of which originally held tiny inlays—on a rectangular gold "web." The gold spiders are visually set off by the silver plates to which they are attached, and these in turn are framed by the gold web. To join the whole, the six spiders were soldered to six individual silver backplates that were soldered to the gold grid. Soldering is a metallurgical joining method not often used for gold and silver objects at Loma Negra (Schorsch 1998: 118–119), but it is one in use in Cupisnique times in the central Andes (Lechtman 1996: 55–66).

Spiders are also known in the art of the north coast in Cupisnique times (Salazar-Burger and Burger 1982: 234). They continue in Moche art, where a major role as supernatural decapitator develops for them (Cordy-Collins 1992: 215–219). Sheet-copper spiders (Disselhoff 1972: fig. 22) from Loma Negra are rendered with round bodies and neatly encircling legs like those of the nose ornament. These spiders are straightforward depictions that do not have the overlay of decapitator symbolism that is so pervasive at Sipán, or at a later time at Loma Negra. The stylized naturalism of spider depiction on the nose ornament, taken together with the basic metallurgical features of its manufacture, indicates an early Loma Negra date for it.

The multiple metal plates of which the spider ornament is composed give the ornament a slightly heavy, solid air. This quality is not present in the second nose ornament to be considered, an anthropomorphic head with a plumed, turban headdress, undoubtedly depicting a Moche lord (fig. 3). It is of gold worked in low relief, and has a silver nose piece of its own. The hammered gold sheet of the ornament is physically and visually light in weight. The plumes are flexible and graceful, while the tiny nose ornament moves freely. Even now, with missing eye inlays and lacking many of the sparkly silver dangles from its surface, the ornament has a self-important air.

2. Nose ornament of gold and silver from Loma Negra, 6.6 × 8.6 cm
Metropolitan Museum of Art, New York, The Michael C. Rockefeller Memorial Collection, Bequest of Nelson A. Rockefeller, 1979 (1979.206.1230)

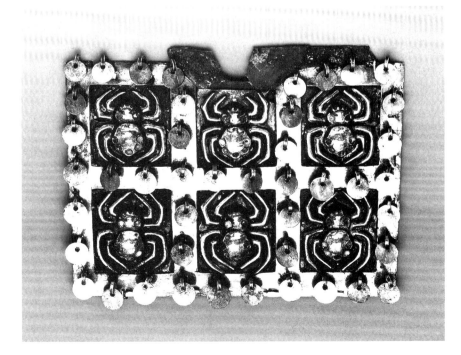

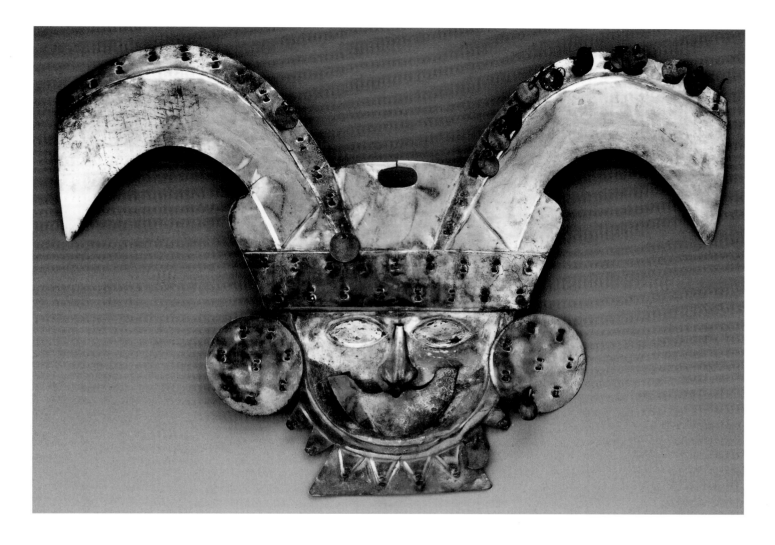

3. Nose ornament of gold and silver from Loma Negra, 12.7 × 18.9 cm

Metropolitan Museum of Art, New York, The Michael C. Rockefeller Memorial Collection, Bequest of Nelson A. Rockefeller, 1979 (1979.206.1223)

The manufacture of this nose ornament is particularly sophisticated, and it must have been the work of the master artist-metalsmith of the time. The gold anthropomorphic face has silvered elements in the headdress, ear ornaments, and collar. These details are emphasized with clarity and form a setting for the silver dangles. The means by which the details were silvered directly onto the gold is as yet undetermined. The silvering of gold is an uncommon practice anywhere in the world, and the method used by the ancient Loma Negra metalsmith has so far eluded determination by modern researchers (Schorsch 1998: 125–127). The elegant accomplishment of the method, however, is ideal for a gold and silver object that needs lightness to be worn comfortably. Perhaps depicting the lordly face of the wearer himself, the nose ornament successfully unites form, technique

and image, thus testifying to a Moche metallurgical tradition of breadth and imagination.

Moche metallurgical traditions continue to be studied today, and they have proved to be most revealing of the degree of technological ingenuity present, particularly within the Loma Negra metals (Centeno and Schorsch 1998; Diez Canseco 1994; Howe et al. 1993; Schorsch 1998; Schorsch, Howe, and Wypyski 1998). The skill the metalsmiths achieved in manipulating their material allowed for much refinement in the finished works of art. Coatings of gold and silver alloys on a copper base allowed for a notable range of colors, which were both inventive and subtle.

An example of the complexity of visual presentation achieved with the juxtaposition of different gold-silver color combinations on a copper support is a Loma Negra disk with a spread-wing owl in relief in the center (fig. 4).

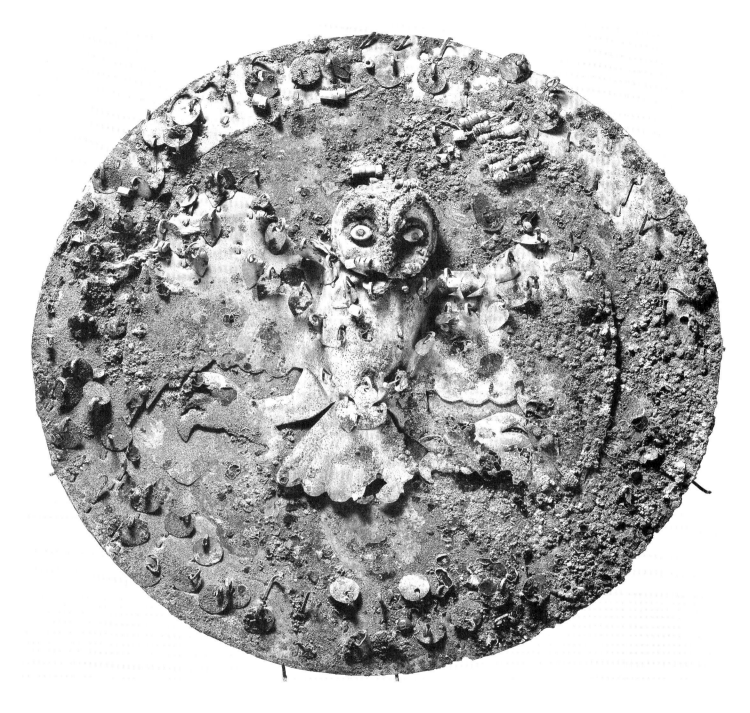

Made of individual parts of gilded and silvered copper sheet of closely hued color, the owl itself is golden and the background silver. The wide outlining rim of the disk is golden as are the two rows of dangles attached to it (Schorsch 1998: 114–116; Schorsch, Howe, and Wypyski 1998: 155). The "juxtaposition of similar metal colors and the illusion of movement elicited by variations in surface texture, coupled with the actual movement of formal components...contribute to their distinctive appearance" (Schorsch, Howe and Wypyski 1998: 156). Gold and silver alloys were used in numerous imaginative ways on the copper substrates of important ritual and personal objects of all sorts at Loma Negra.

The presence at Loma Negra of copper in quantity is highly significant. As a substrate

4. Disk ornament of gilded and silvered copper from Loma Negra, 28.2 cm. diam. Metropolitan Museum of Art, New York, Bequest of Jane Costello Goldberg, from the collection of Arnold I. Goldberg, 1986 (1987.394.56)

for surface coatings of gold and silver, copper offered the opportunity for the production and use of many sophisticated works of art. When new, and produced by the electro-chemical replacement plating process of Piura, which created the smooth, shiny metallic surfaces, the gilded and silvered works must have been barely distinguishable from objects of gold and silver themselves. While the relative value of the metal content of the two different kinds of works must have been clear to maker, owner, and ritual specialist, the visual

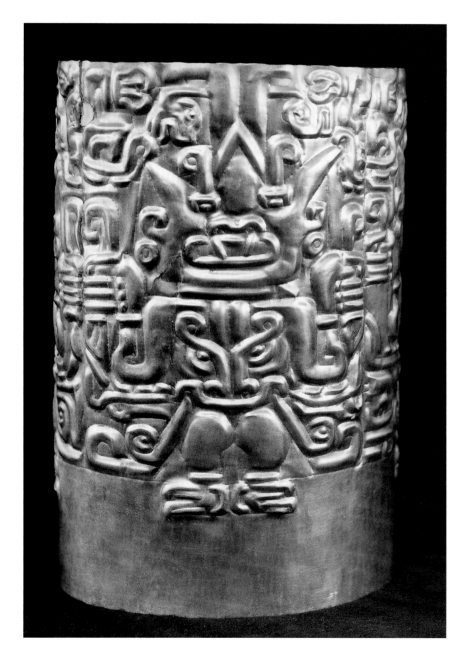

5. Crown of gold from Chongoyape, 23.5 cm. high
National Museum of the American Indian, Washington. (16/1972 B)

effect of the two types of works must have been much the same upon first view.

Gilded copper is, of course, also present in quantity, and in important objects, at Sipán. The presence of so many copper-based objects at both Loma Negra and Sipán raises questions about earlier finds that are considered to be major Moche tombs. For instance, did the graves from which the headdress frontals and nose ornaments published by Larco in 1945 contain objects of gilded or silvered copper? Or did the so-called Seler Tomb in the Huaca de la Luna, where a few such objects did survive (Jones 1979: 70–72), contain more? Is it possible that there was a difference in the quantities of metalwork objects available to rulers in the southern Moche region as opposed to those in the north, where both Loma Negra and Sipán were located?

Another possibility is that the gilded copper objects from known—and many unknown—tombs simply did not survive, or if they did survive were so little valued that they were not recorded. The experience of Ramiro Matos in 1963 when traveling in upper Piura is illuminating on this issue, as he reports: "Quisiéramos decir unas pocas palabras sobre los objetos metálicos que hallamos en nuestro recorrido. Son realmente considerables, tanto por su abundancia, cuanto por su contenido artístico y técnico. Cuando visitamos la casa...en Pabur, vimos un lote de piezas metálicas arrumadas en el suelo. Cuando preguntamos sobre el destino de ellas, nos repuso [sic], 'son objetos sin valor.' Es que eran objetos de cobre y otros de cobre bañado" (Matos 1969: 123).[1] The problem of perceived relative value of the copper and gilt copper objects is compounded by the difficulty of preserving the integrity of the inevitably thin sheet-metal archaeological pieces. Advanced age and the condition-after-burial of the Moche metalwork is especially troublesome for the gilded and/or silvered copper objects. The soils of the northern Peruvian coast are saline and therefore very corrosive for archaeological objects. The metal objects can be a difficult to maintain because they are very fragile and often highly mineralized. All three metals—gold, silver, and copper—interacted with each other and with their burial environment over a long period of time, and their surfaces can be all but obscured by the variety of materials on them. The conservation, storage,

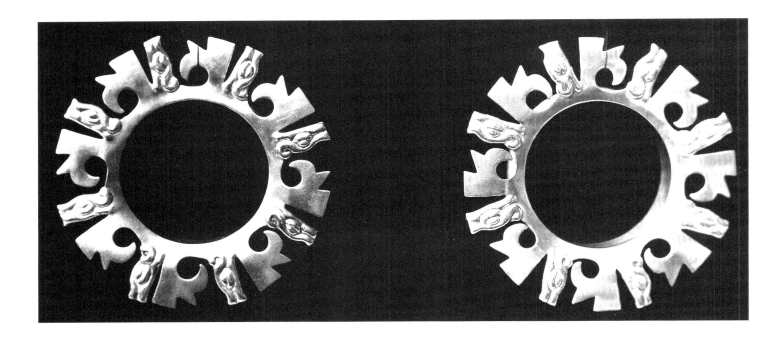

and display of Moche copper objects is a challenge under the best of circumstances (Howe et al. 1993).

While the inheritors and continuers of many Moche burial practices regarding metalwork, and the splendid outfitting of wealthy rulers in golden and silvery raiment are known, as the example of Huaca Loro at Batán Grande shows, the beginnings of the practices that were so well developed by Moche lords and their metalsmiths are more elusive. Personal ornaments of gold and silver exist from pre-Moche times (Alva 1992), but

there is some disjunction in specific object type between them and Moche works (Donnan 1992). Two well-known groups illustrate the precedents to Moche works. Considered to date to about the Janabarriu phase at Chavín de Huántar (Burger 1992: 203–206), or approximately 400 to 200 B.C., the first group was published in 1929 by Julio C. Tello. They were chance finds of the late 1920s made near Chongoyape in the upper Lambayeque Valley (Burger 1996: 47–52; Lothrop 1941). The second group was excavated in recent years from tombs at Kuntur Wasi in the upper reaches of

6. Pair of gold ear ornaments from Chongoyape, 10.2 cm. diam.
National Museum of the American Indian, Washington. (16/1972 G)

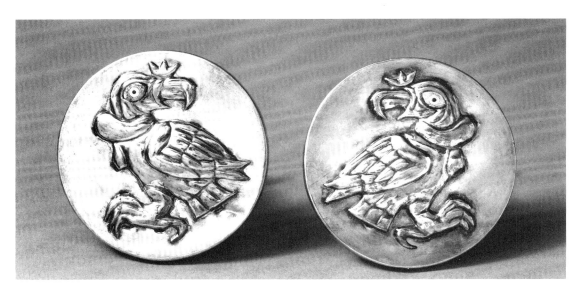

7. Pair of ear ornaments of gold, silver, and gilded copper from Loma Negra, 7.6 cm. diam.
Metropolitan Museum of Art, New York, The Michael C. Rockefeller Memorial Collection, Bequest of Nelson A. Rockefeller, 1979 (1979.206.1245,46)

the Jequetepeque Valley (Museo de la Nación 1999; Onuki 1995). Precious metal objects have been found in graves there dating from 800 to 250 B.C.

The major works of art in metal from both Chongoyape and Kuntur Wasi are gold crowns (Lothrop 1941: pl. 16; Onuki 1995: pl. 1; Tello 1929: 156). They are straight-sided, cylindrical shapes of hammered sheet gold with low relief decoration worked around the circumference of the crown (fig. 5). Ear ornaments are another important type, and pairs exist in both groups. They have short shafts and broad frontals with a central hole (Lothrop 1941: pl. 17; Onuki 1995: pl. 3; Tello 1929: 156). Kuntur Wasi pairs are without decoration, while a number from Chongoyape have repeated, patterned elements around the perimeter of the frontal (fig. 6). These precious metal embellishments were

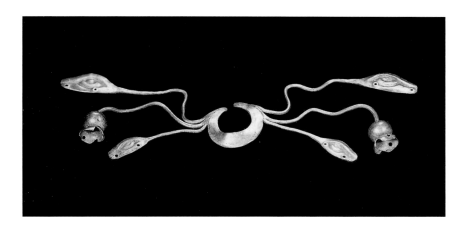

8. Nose ornament of gold from Chavín de Huántar, 3.2 × 9.6 cm
The Cleveland Museum of Art, 1999, Gift of Mr. and Mrs. Paul Tishman (58.181)

made for the head, including the crest/forehead, ears, and nose, but the shape of the ornaments deemed appropriate at these earlier sites is not that of later Moche examples.

The wide, flat, flared-out frontals with raised central image (see fig. 1) are not among the Chongoyape/Kuntur Wasi works, where headpieces are tall cylinders. Nor do the ear ornaments have the solid, circular frontal with centrally organized designs (fig. 7) and long, counterbalancing shaft of Moche examples. Nose ornaments of the earlier period, too, differ in shape, if comparisons are made to the gold find reportedly made at Chavín de Huántar (Lothrop 1951: 234). The Chavín nose ornaments are whiskerlike in their slender elegance (fig. 8) and do not have the

programmed outlines of the larger, flamboyant Moche works.

The early phase of Moche metalwork is considered to come from Loma Negra in upper Piura, and from the site of La Mina in the Jequetepeque Valley, because both sites are associated with ceramic vessels of Moche I style. La Mina, a unique tomb in the lower Jequetepeque Valley, was looted in the late 1980s, but underwent salvage excavation, so that various aspects of its physical properties are known (Donnan 1993; Narváez 1994). The gold and silver metal objects reported to be from this site are among the most visually arresting of all Moche works of art. Among them are the flared headdress crests with raised central image (Donnan 1992: figs. 116, 123, 142), and numerous nose ornaments of solidity and size (Donnan 1992: figs. 127–131).

Loma Negra metalwork objects, too, have both artistic and metallurgical complexity and exhibit the required Moche details of shape and size. Distinctively, few headdress crests are reported from Loma Negra, but nose and ear ornaments in classic Moche shape are among that corpus. Both ceramic and metal objects from La Mina and Loma Negra fit well into the Moche I iconographic canon, but if these sites are exemplars of the earliest Moche style in metalwork, then form, image, and technology were already firmly in place when they were made. Some identifiable, and meaningful, changes from earlier central Andean traditions in metalwork, as illustrated by comparisons with the Chongoyape/ Kuntur Wasi works, have occurred. What occasioned such changes remains to be discovered, but certain indications point to the northern Andes as a contributing factor as far as metalwork is concerned.

The gold objects unearthed in upper Piura at Cerro Callingará in the mid-1950s (Alva 1992; *La Industria* 1956 [?]), are a salient contributing factor. Known also by the name of the nearby town of Frías, the find included such significant gold objects that they survived the looters' melting pot and were seized by local Peruvian officials. Thus entering collections in Peru (Alva 1992: figs. 60–69), they became well known. The most important pieces were published within a very few years of discovery (Mujica 1959: 268–275). One of them, the so-called Venus de Frías (Alva 1992: figs. 60–61), has taken on a meaningful role in

the question of source. A hollow figure made of sheet gold, it is clearly in the Tolita-Tumaco style of northern Ecuador/southern Colombia (Jones 1979: 86–91). On the basis of formal comparisons with ceramic figures, the Venus de Frías can be dated within the period between the first century B.C. and the first century A.D. (Scott and Bouchard 1988). Other of the Frías gold objects are in the same Tolita-Tumaco style, but not all.

Since the time of the original Callingará find, apparently made by local farmers (Kaulicke, personal communication, 1999), other evidence of relationships to Ecuador have emerged through what are seen as ceramic associations (Amaro 1994: 78–80; Kaulicke 1991: 418–419; Lumbreras 1979: 22–25). Trade, most particularly for the much prized *Spondylus* shell, has been proposed as a vehicle for interaction between northern Peru and Ecuador (Hocquenghem et al. 1993: 453), and studies of the frontiers between the cultural areas of northern Peru and southern Ecuador have been undertaken (Hocquenghem 1991). The most substantial connection is the Callingará gold find, however, where gold objects from northern Ecuador were actually unearthed in northern Peru. Buried at such a considerable distance from their place of origin, the Ecuadorian gold objects are taken to indicate a possible trading location at Cerro Callingará (Kaulicke, personal communication, 1999). It must have been an important one if the high quality of the Frías goldwork is considered.

The nature of the contact between the central and northern Andes as it relates to metalwork is a long way from being understood. Yet some form of interaction with the northern Andes appears to have existed in the upper Piura Valley, perhaps in the centuries around the beginning of the common era. Such contacts between the two areas might explain some of the formal and technological changes that appear in early Moche metalwork, for both Ecuador, and Colombia even further north, had viable metalworking traditions at the time. The possibility has been proposed that the Moche style coalesced in the Piura-Upper Jequetepeque area (Kaulicke 1994: 358), and if this proves to be correct, it is probable that the northern Andean metalworking traditions made contributions to it.

If so, such contributions became part of singularly important developments in the central Andes, for the Moche were the originators of the greatest period in Andean metallurgy. The availability of copper, its new cultural significance, and the plethora of gilding techniques employed with it, lead to a virtual metallurgical "explosion," when "except for tin bronze, all the significant metals, all the significant alloys, and all the significant coloring techniques were invented. The tremendous originality, creativity, and real technical sophistication of the Moche was never surpassed in the Andes. In that sense, Andean metallurgy is Moche metallurgy" (Lechtman 1993).

NOTE

1. "We would like to say a few words about the metal objects we found on our trip. They were considerable, as much for their abundance as for artistic and technical content. When we visited the house . . . in Pabur, we saw a group of metal pieces stowed on the floor. When we asked what would happen to them, they responded, 'they are of no value.' It is because they were objects of copper and gilt-copper."

BIBLIOGRAPHY

Alva, Walter
1988 Discovering the New World's Richest
 Unlooted Tomb. *National Geographic* 174
 (4): 510–549.

1990 New Tomb of Royal Splendor. *National
 Geographic* 177 (6): 2–15.

1992 Orfebrería del Formativo. In *Oro del
 antiguo Perú*, ed. José Antonio de Lavalle,
 17–116. Colección Arte y Tesoros del
 Perú. Lima.

1994 *Sipán*. Colección Cultura y Artes del Perú.
 Lima.

Alva, Walter, and Christopher B. Donnan
1993 *Royal Tombs of Sipán* [exh. cat., Fowler
 Museum of Cultural History, University
 of California]. Los Angeles.

Amaro Bullón, Iván
1994 Reconstruyendo la identidad de un pueblo.
 In *Vicús*, by Krzysztof Makowski,
 Christopher B. Donnan, Iván Amaro
 Bullón, Luis Jaime Castillo, Magdalena
 Diez Canseco, Otto Eléspuru Revoredo,
 and Juan Antonio Murro Mena, 23–81.
 Colección Arte y Tesoros del Perú. Lima.

Benson, Elizabeth P.
1972 *The Mochica: A Culture of Peru*. New
 York and London.

Berrin, Kathleen
1997 (Editor) *The Spirit of Ancient Peru:
 Treasures from the Museo Arqueológico
 Rafael Larco Herrera* [exh. cat., Fine Arts
 Museums of San Francisco]. New York.

Burger, Richard L.
1992 *Chavín and the Origins of Andean
 Civilization*. London and New York.

1996 Catalogue entries for Chavín metalwork.
 In *Andean Art at Dumbarton Oaks*, ed.
 Elizabeth Hill Boone, 1: 47–75. Pre-
 Columbian Art at Dumbarton Oaks 1.
 Washington.

Centeno, Silvia A., and Deborah Schorsch
1998 Caracterización de depósitos de oro y plata
 sobre artefactos de cobre del valle de Piura
 (Perú) en el período Intermedio Temprano.
 Boletín Museo del Oro 41 [1996]: 165–185.
 [Bogotá].

Cordy-Collins, Alana
1992 Archaism or Tradition?: The Decapitation
 Theme in Cupisnique and Moche
 Iconography. *Latin American Antiquity* 3
 (3): 206–220.

Diez Canseco, Magdalena
1994 La sabiduría de los orfebres. In *Vicús*, by
 Krzysztof Makowski, Christopher B.
 Donnan, Iván Amaro Bullón, Luis Jaime
 Castillo, Magdalena Diez Canseco, Otto
 Eléspuru Revoredo, and Juan Antonio
 Murro Mena, 183–209. Colección Arte y
 Tesoros del Perú. Lima.

Disselhoff, Hans Dietrich
1971 *Vicús: Eine neu entdeckte altperuanische
 Kultur*. Monumenta Americana 7. Berlin.

1972 Metallschmuck aus der Loma Negra
 Vicús, (Nord-Peru). *Antike Welt* 3 (2):
 43–53. [Zurich].

Donnan, Christopher B.
1990 Masterworks of Art Reveal a Remarkable
 Pre-Inca World. *National Geographic* 177
 (6): 16–33.

1992 Oro en el arte Moche. In *Oro del antiguo
 Perú*, ed. José Antonio de Lavalle,
 119–193. Colección Arte y Tesoros del
 Perú. Lima.

1993 The Moche Royal Tomb at La Mina, Jeque-
 tepeque Valley. Paper presented at *Andean
 Royal Tombs, Works of Art in Metal*
 [Colloquium/Workshop, 9–10 May. The
 Metropolitan Museum of Art, New York].

1995 Moche Funerary Practice. In *Tombs for
 the Living: Andean Mortuary Practices* [A
 Symposium at Dumbarton Oaks, 12th and
 13th October 1991], ed. Tom D. Dillehay,
 111–159. Washington.

Donnan, Christopher B., and Carol J. Mackey
1978 *Ancient Burial Patterns of the Moche
 Valley, Peru*. Austin, Tex.

Guffroy, Jean, Peter Kaulicke, and Krzysztof
Makowski
1989 La prehistoria del departamento de Piura:
 Estado de los conocimientos y proble-
 mática. *Bulletin de l'Institut Français
 d'Etudes Andines* 18 (2): 117–142.

Hocquenghem, Anne-Marie
1991 Frontera entre "áreas culturales" nor y
 centroandinas en los valles y la costa del
 extremo norte peruano. *Bulletin de
 l'Institut Français d'Etudes Andines* 20
 (2): 309–348.

Hocquenghem, Anne-Marie, Jaime Idrovo, Peter
Kaulicke, and Dominique Gomis
1993 Bases del intercambio entre las sociedades
 norperuanas y surecuatorianas: Una zona
 de transición entre 1500 A.C. y 600 D.C.
 *Bulletin de l'Institut Français d'Etudes
 Andines* 22 (2): 443–466.

Howe, Ellen G., Deborah Schorsch, Mark T. Wypyski, Samantha Alderson, Sarah Nunberg, and Leesa Vere-Stevens
1993 Technical Overview of Loma Negra Metalwork. Paper presented at *Andean Royal Tombs, Works of Art in Metal* [Colloquium/Workshop, 9–10 May. The Metropolitan Museum of Art, New York].

Jones, Julie
1979 Mochica Works of Art in Metal: A Review. In *Pre-Columbian Metallurgy of South America* [A Conference at Dumbarton Oaks, October 18th and 19th, 1975], ed. Elizabeth P. Benson, 53–104. Washington.

1993a Loma Negra, A Moche Lord's Tomb. Paper presented at *Andean Royal Tombs, Works of Art in Metal* [Colloquium/Workshop, 9–10 May. The Metropolitan Museum of Art, New York].

1993b Welcome, and More on Loma Negra. Paper presented at *Andean Royal Tombs, Works of Art in Metal* [Colloquium/Workshop, 9–10 May. The Metropolitan Museum of Art, New York].

Kaulicke, Peter
1991 El período Intermedio Temprano en el Alto Piura: Avances del proyecto arqueológico "Alto Piura" (1987–1990). *Bulletin de l'Institut Français d'Etudes Andines* 20 (2): 381–422.

1992 Moche, Vicús Moche y el Mochica Temprano. *Bulletin de l'Institut Français d'Etudes Andines* 21 (3): 853–903.

1994 La presencia Mochica en el Alto Piura: Problemática y propuestas. In *Moche: Propuestas y perspectivas* [Actas del primer coloquio sobre la cultura Moche, Trujillo, 12 al 16 de abril de 1993], ed. Santiago Uceda and Elías Mujica, 327–358. Travaux de l'Institut Français d'Etudes Andines 79. Trujillo and Lima.

Kroeber, Alfred L.
1944 Appendix C: Nonceramic Mochica Grave Contents from the 1899 Type-Site. In *Peruvian Archaeology in 1942*, 121–136. Viking Fund Publications in Anthropology 4. New York.

La Industria
1956 [?] Una fortuna en oro de Comisaron a Huaqueros. 16 September. Chiclayo.

Lapiner, Alan
1976 *Pre-Columbian Art of South America.* New York.

Larco Hoyle, Rafael
1945 *Los Mochicas (pre-Chimu, de Uhle y early Chimu, de Kroeber).* Buenos Aires.

Lechtman, Heather N.
1993 Additional Perspectives on Moche Metallurgy. Paper presented at *Andean Royal Tombs, Works of Art in Metal* [Colloquium/Workshop, 9–10 May. The Metropolitan Museum of Art. New York].

1996 Technical descriptions of the metal objects. In *Andean Art at Dumbarton Oaks*, ed. Elizabeth Hill Boone, 1. Pre-Columbian Art at Dumbarton Oaks 1. Washington.

Lechtman, Heather N., Antonieta Erlij, and Edward J. Barry, Jr.
1982 New Perspectives on Moche Metallurgy: Techniques of Gilding Copper at Loma Negra, Northern Peru. *American Antiquity* 47 (1): 3–30.

Lehmann, Walter, and Heinrich [Ubbelohde-]Doering
1924 *The Art of Old Peru.* New York.

Lothrop, Samuel K.
1941 Gold Ornaments of Chavin Style from Chongoyape, Peru. *American Antiquity* 6 (3): 250–262.

1951 Gold Artifacts of Chavín Style. *American Antiquity* 16 (3): 226–240.

Lumbreras, Luis G.
1979 *El arte y la vida Vicús.* Lima.

Makowski, Krzysztof
1994 Los señores de Loma Negra. In *Vicús*, by Krzysztof Makowski, Christopher B. Donnan, Iván Amaro Bullón, Luis Jaime Castillo, Magdalena Diez Canseco, Otto Eléspuru Revoredo, and Juan Antonio Murro Mena, 82–141. Colección Arte y Tesoros del Perú. Lima.

Makowski, Krzysztof, Christopher B. Donnan, Iván Amaro Bullón, Luis Jaime Castillo, Magdalena Diez Canseco, Otto Eléspuru Revoredo, and Juan Antonio Murro Mena
1994 *Vicús.* Colección Arte y Tesoros del Perú. Lima.

Matos Mendieta, Ramiro
1969 Algunas consideraciones sobre el estilo de Vicús. *Revista del Museo Nacional* 34 [1965–1966]: 89–130. [Lima].

Menzel, Dorothy
1977 *The Archaeology of Ancient Peru and the Work of Max Uhle.* R. H. Lowie Museum of Anthropology, University of California, Berkeley.

Mujica Gallo, Miguel
1959 *The Gold of Peru: Masterpieces of Goldsmith's Work of pre-Incan and Incan Time and the Colonial Period,* trans. Roger Peniston-Bird. Recklinghausen.

Museo de la Nación
1999 *El Tesoro del Templo Kuntur Wasi.* [exh. brochure, Museo de la Nación, Museo Kuntur Wasi]. Lima.

Narváez, Alfredo
1994 La Mina: Una tumba Moche I en el valle de Jequetepeque. In *Moche: Propuestas y perspectivas* [Actas del primer coloquio sobre la cultura Moche, Trujillo, 12 al 16 de abril de 1993], ed. Santiago Uceda and Elías Mujica, 59–81. Travaux de l'Institut Français d'Etudes Andines 79. Trujillo and Lima.

Onuki, Yoshio
1995 (Editor) *Kuntur Wasi y Cerro Blanco: Dos sitios del formative en el norte del Perú.* Tokyo.

Patellani, Federico
1970 A New Source of Peruvian Pottery. *Illustrated London News* 257 (5 September): 24–25.

Salazar-Burger, Lucy, and Richard L. Burger
1982 La araña en la iconografía del Horizonte Temprano en la costa norte del Perú. *Beiträge zur allgemeinen und vergleichenden Archäologie* 4: 213–253.

Schorsch, Deborah
1998 Silver-and-Gold Moche Artifacts from Loma Negra, Peru. *Metropolitan Museum Journal* 33: 109–136. [New York].

Schorsch, Deborah, Ellen G. Howe, and Mark T. Wypyski
1998 Silvered and Gilded Copper Metalwork from Loma Negra: Manufacture and Aesthetics. *Boletín Museo del Oro* 41 [1996]: 144–163. [Bogotá].

Scott, David A., and Jean-François Bouchard
1988 Orfebrería prehispánica de las llanuras del Pacífico de Ecuador y Colombia. *Boletín Museo del Oro* 22: 2–16. [Bogotá].

Seler, Eduard
1912 Archäologische Reise in Süd- und Mittel-Amerika. *Zeitschrift für Ethnologie* 44: 201–242.

Shimada, Izumi
1995 *Cultura Sicán: dios, riqueza y poder en la costa norte del Perú.* Lima.

Shimada, Izumi, and Jo Ann Griffin
1994 Precious Metal Objects of the Middle Sicán. *Scientific American* 270 (4): 82–89.

Strong, William Duncan, and Clifford Evans
1952 *Cultural Stratigraphy in the Virú Valley, Northern Peru: The Formative and Florescent Epochs.* Columbia Studies in Archeology and Ethnology 4. New York.

Tello, Julio C.
1929 *Antiguo Perú, primera época.* Lima.

Ubbelohde-Doering, Heinrich
1952 *The Art of Ancient Peru.* New York.

Uhle, Max
1913 Die Ruinen von Moche. *Journal de la Société des Américanistes de Paris* n.s. 10 (1): 95–117.

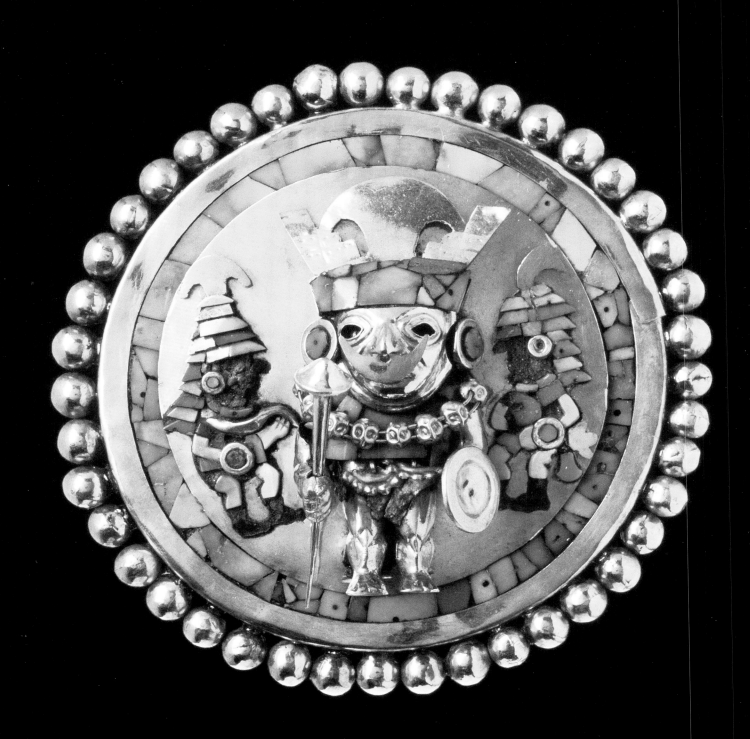

WALTER ALVA
Museo Arqueológico Nacional Brüning de Lambayeque

The Royal Tombs of Sipán: Art and Power in Moche Society

The discovery in 1987 of the first Sipán tomb led to a new understanding of the splendor and significance of burial for the highest echelon of Moche society. Tomb 1 contained the richest burial, in terms of both the variety and quality of the precious metal objects, ever scientifically excavated in the western hemisphere. Continuing excavations have demonstrated that Sipán was not just the site of a single majestic royal tomb, but a monument where many of the royalty of the Moche world were interred over time. To date, we have encountered twelve tombs that amplify our vision of the Moche social and political world. We now have a broader view of elite burial practices, which previously could only be conjectured from the painted representations on Moche architecture and ceramics.

The site of Sipán was named after a rural town in the Lambayeque Valley of northwestern Peru. The archaeological site consists of two large and eroded pyramidal structures of adobe (mud brick), and a third, lower and smaller, now known as the funerary platform (fig. 1). This rectangular platform was probably constructed in six phases, sometime between A.D. 1 and 300 (fig. 2; Meneses and Chero 1994). Each successive phase encapsulated the earlier constructions as the platform was enlarged. Although damaged by erosion and looting, the final structure resembles a long rectangular platform with a prominence located toward the center, where Tomb 1 was found. The principal tomb was in the center-west area, in the upper sector of the platform. The finding of the tomb was preceded by the discovery of a repository of offerings that included 1,137 ceramic vessels, among other objects.

The twelve tombs that we have excavated in the funerary platform pertain to various eras and ruling hierarchies. The inventory and comparison of these tombs have allowed us to infer the role and function of each of the buried individuals. Investigations to date indicate that these elite tombs can be divided into four broad categories: ruling lords, priests, military leaders, and finally the second-rank assistants to military leaders and priests. The presence of different ornaments, weapons, and ritual objects in each of the funerary contexts suggests the distinct social roles of the buried individuals.

The funerary space itself also seems to have been delimited by social role. The tombs of individuals related to political or military power are primarily in the northern section of the funerary platform, using Tomb 1 as the central referent. Most individuals buried in the southern part, in contrast, had other functions, principally ritual.

Tombs of the First Order: Lords and Priests

The most complex tombs at Sipán are Tombs 1, 2, and 3. The individual interred in Tomb 1 undoubtedly held considerable power in this north coast valley during the Moche reign,

Moche ear ornament with figure of a warrior, Tomb 1 (diameter: 9.4 cm)
Museo Arqueológico Nacional Brüning de Lambayeque
Photograph by Susan Einstein

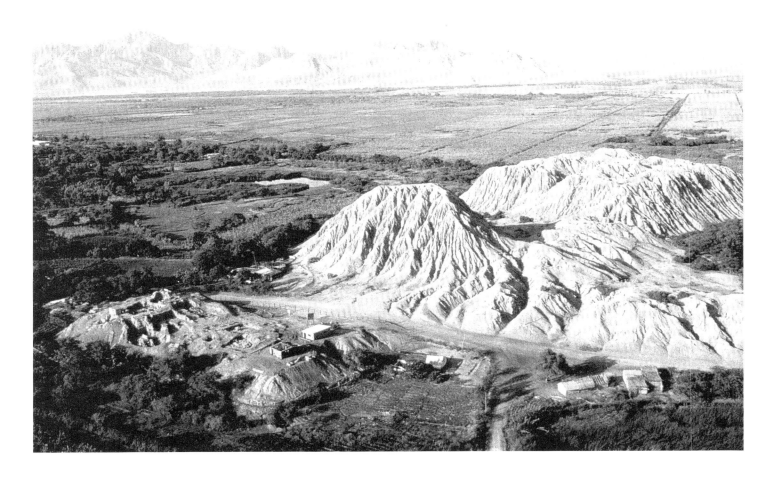

and he was dubbed the Lord of Sipán in 1987, alluding to both the native toponym and his rank as an ethnic lord of the area. The individuals buried in Tombs 2 and 3 are known as the Priest, and the Old Lord of Sipán, respectively. These tombs represent the highest rank of Moche culture, given the size and disposition of the funerary spaces, in addition to the number of buried retainers, the quantity and quality of the funerary goods, and the materials used to produce the ornaments and emblems. Together, these features set these tombs apart from the others at Sipán. For example, Tomb 1 consists of a very complex funerary chamber with the primary lord surrounded by eight accompanying individuals (fig. 3). The inclusion of retainers is very restricted in the Moche world, and this number emphasizes the status of the upper hierarchy of Moche society.

Another important index giving information on social categories and roles within Moche culture is provided by the principal ornaments pertaining to rank that are typically located with the remains of the individual. Finding information of this order, in its original context, provides a better idea of the relationships between the persons within the tombs and of the broader Moche sphere. In this preliminary study, I am concentrating on the most identifiable ornaments, specifically articles found near or on the principal personages in the tombs. Thus, we can begin to understand more clearly the use of social, ritual, and military symbols of power. In our investigations, we have noted the importance of certain details in the production of, and relationship between, ornaments. Several patterns have also emerged regarding the placement of ornaments in the tombs. For

1. View of the archaeological site of Sipán, Lambayeque Valley, Peru. The funerary platform is at lower left
Photograph by Bill Ballenberg

2. Reconstruction of the architectural phases of the funerary platform
After Meneses and Chero (1994) and a painting by Alberto Gutiérrez (Alva 1998: lám. 343)

3. Reconstruction of Tomb 1 at Sipán
Painting by Percy Fiestas
Photograph by Guillermo Hare

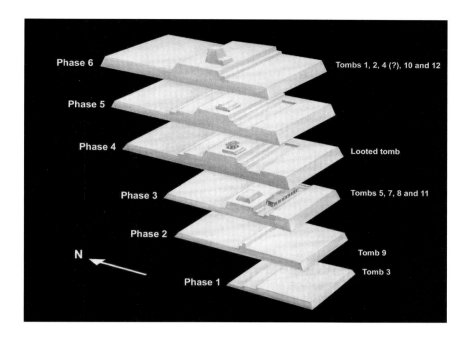

Phase 6 — Tombs 1, 2, 4 (?), 10 and 12

Phase 5

Phase 4 — Looted tomb

Phase 3 — Tombs 5, 7, 8 and 11

Phase 2

N — Tomb 9

Phase 1 — Tomb 3

example, it appears to have been important to include three types of necklaces in the tombs. A certain symbolic duality was also manifested by bimetallic articles or pairs of ornaments (one in gold and the other in silver).[1] There is even some evidence that there were specific relationships between the number of objects and their component parts and the rank or role of the individual with whom they were found. We have documented a long-lasting tradition of paired necklaces with ten beads per necklace in the tombs of the lords, while the number nine or other odd numbers seem to be associated with the Priest in Tomb 2.

Tomb 1

The funerary chamber of Tomb 1 measures approximately 5 m on each side and contains a coffin containing the primary lord; his

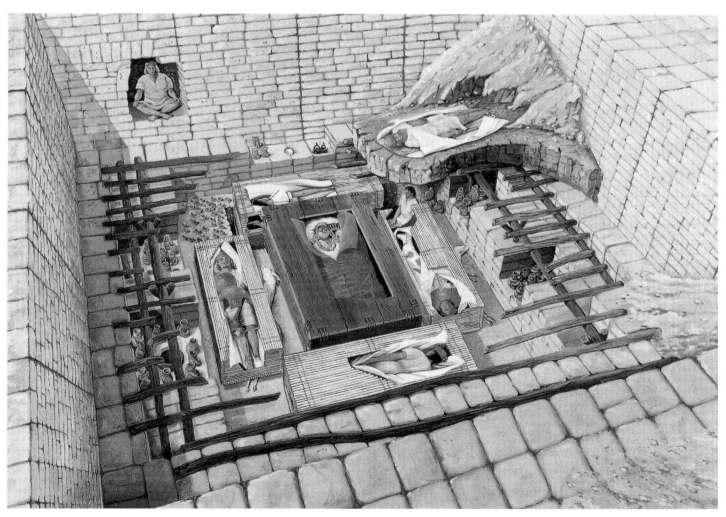

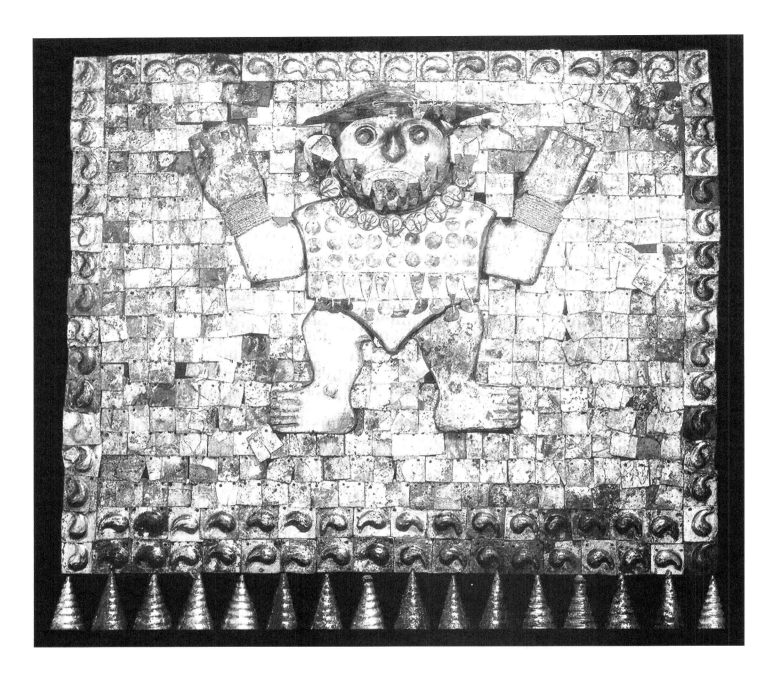

retainers and other offerings surround it. The body was enveloped in a rich and varied collection of emblems, metallic vestments, and ornaments (fig. 3). The principal coffin was made of wooden planks bound with copper ties. According to osteological studies by John Verano (1997), the person in the coffin was probably a relatively tall male, between thirty-five and forty-five years of age. Three adult males, three adolescent females, one child, and one adult female accompanied him.

After excavating to the bottom of the coffin, we registered 451 objects buried above and beneath the skeletal remains of the lord. Here, I will briefly discuss a few of the most important ornaments from this tomb.[2] The first critical elements were banners of gilded metal that may have been cult images (fig. 4). Found along the upper torso, these banners were made of small square metal plaques sewn onto a thick cotton cloth. Each of the banners has a central figure with extended arms, composed of metal plaques and larger

4. Gilded copper banner from Tomb 1, Sipán (height: 48.5 cm)
Museo Arqueológico Nacional Brüning de Lambayeque
Photograph by Carlos Rojas

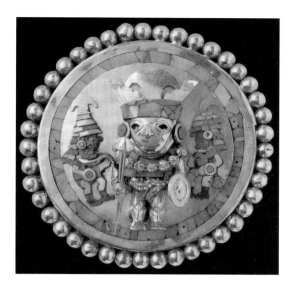

5. Ear ornament with figure of a warrior, Tomb 1 (diameter: 9.4 cm)
Museo Arqueológico Nacional Brüning de Lambayeque
Photograph by Susan Einstein (after Alva and Donnan 1993b: fig. 87)

rendered in the characteristic manner of Moche leaders: wearing a headdress, holding weapons, and flanked by two personages in profile. Also near the body was a necklace of gold and silver beads in the form of peanuts, the largest of which measures approximately nine centimeters in length (Alva and Donnan 1993b: fig. 96). The complete necklace has twenty peanut representations on the two strands, and extended from shoulder to shoulder. On the proper right half of the necklace, the peanuts were made of gold, while those on the left side were of silver. Over the ribcage were sixteen thick, slightly convex, gold disks integrated into another necklace (Alva and Donnan 1993b: fig. 97). Each disk has two perforations for fastening that exhibit

embossed pieces, which dominates the composition. These banners have a border of plaques with embossed paisley-shaped motifs thought to represent a plant form, and known in Moche studies as *ulluchu*. Later, in a surprising discovery of a similar banner in Tomb 3, we found the remains of an actual fruit encased within the embossed renderings.[3]

Under these banners was a metal ornament, composed of cut sheet gold, depicting an anthropomorphic silhouette, headless, with arms exaggeratedly outstretched and hands dramatically open (Alva and Donnan 1993b: figs. 64–67). In anatomical discordancy, probably symbolic, characteristics of the front and back of the hands are shown in the same view (that is, nails and palms together). At the center of this silhouette is a personage rendered in relief and similar to the depictions seen on the banners.

We also found various pectorals composed of hundreds of shell beads. One particularly fine example is composed of red and white shell beads (some beads now appear green due to the oxidation of copper objects around the pectoral), organized in a radiating pattern (Alva and Donnan 1993b: figs. 70–74).

Some spectacular ornaments were next to the body of the primary lord. At his head were three pairs of elaborate circular ear ornaments made of gold and turquoise. One pair depicts a duck, while another shows a deer with antlers (Alva and Donnan 1993b: figs. 79–85). The most exquisite pair (fig. 5), carries the image of a small human figure,

6. Gold and silver scepter from Tomb 1 (height: 34.1 cm)
Museo Arqueológico Nacional Brüning de Lambayeque
Photograph by Carlos Rojas

notable wear, suggesting that it was worn frequently.

Among the ornaments we excavated was the first Moche gold and silver scepter uncovered in an archaeological context (fig. 6). The scepter is composed of a silver handle surmounted by an inverted pyramidal box made of sheet gold. The scepter could have also functioned as a sacrificial knife, as the handle terminates in a chisellike edge. The upper section of the scepter is ornamented with five panels of sheet metal sculpted in low relief. The top of the chamber depicts a warrior, splendidly dressed, and in the act of subjugating a conquered prisoner. The warrior thrusts a war club toward the prisoner, who is nude and seated cross-legged, and is apparently restrained by a smaller individual behind him. The four sides of the chamber of the scepter are rendered in a similar fashion. These scenes shed light on the functional association of the object. The implication of the imagery is that the submission of prisoners is part of the military and political command of the individual who carried it.

Another element known from Moche iconography and found in the tombs at Sipán is a crescent headdress ornament. Located beneath the skeleton, it was made from a single gold sheet (Alva 1994: figs. 104, 106; Alva and Donnan 1993b: fig. 117). Headdresses with this sort of ornament are usually associated with individuals of the highest rank in Moche iconography. Next to the ornament were the remains of feather bundles attached to copper shafts, which may also have been used as headdress ornaments.

Two other key royal ornaments, known as backflaps, one in silver and one in gold, were found below the skeleton (Alva and Donnan 1993b: figs. 120, 122, 123). Backflaps are thin sheets of metal, often decorated at the top in bas-relief and inlay, which terminate in a curved edge, generally replicating the form of a *tumi* (a knife with a curved-edged blade, typically used in ceremonies). Backflaps may have served as a type of body armor (see also the looted tomb, below). In Moche iconography, warriors are shown wearing backflaps behind them, suspended from their belts. These objects are unique to the Moche and apparently were used only by warriors of rank. Backflaps of the size and quality found in Tomb 1 have no parallel outside of Sipán.

The gold backflap is among the most spectacular objects in Tomb 1. The image on the top of the backflap depicts a supernatural anthropomorphic being, in frontal view, holding a trophy head in one hand and a *tumi* in the other. This figure is also known as the Decapitator, and is found on various rattles also found in the tomb.

Beneath the backflaps, among other things, we found two more banners. In contrast to the banners in the upper half of the coffin, these banners were found face down. At the bottom of the coffin were three miniature war clubs and shields of sheet copper, and various copper points, probably for normal-sized spears. Finally, in the niches over benches along the walls were 212 simple, sculpted ceramic vessels.

Tomb 2

The second tomb excavated at Sipán was located in the southern part of the funerary platform and was also constructed during its last architectural phase (fig. 2); Tombs 1 and 2 are probably from the same era. The funerary chamber, slightly smaller than that of Tomb 1, measures approximately 4 m × 4m. As with Tomb 1, it contained a coffin of wooden planks with bindings of copper straps. The buried individual was a man between thirty-five and forty-five years of age, shorter than the individual in Tomb 1 (Verano in Alva and Donnan 1993b: 153; Verano 1997). Around the remains of the principal occupant were five retainers, various animals, and offerings. In addition, a young man with both feet amputated was located over the roof of the chamber, suggesting that he served as a guardian.

This tomb corresponds to an individual whom, by virtue of the characteristics of his garments and ornaments within the coffin, we have named the Priest, alluding to the Bird Priest represented in scenes known as the Sacrifice Ceremony (Alva and Donnan 1993b: fig. 143; Introduction to this volume. fig. 5). The most important difference between this burial and Tomb 1 is that the offerings are of lesser quality.

The Priest's tomb included a headdress ornament made of gilded copper, representing an owl with wings extended (fig. 7). The body of the owl is in high relief, and the eyes were

7. Gilded copper owl headdress from Tomb 2 (width: 59.5 cm)
Museo Arqueológico Nacional Brüning de Lambayeque
Drawing by Alberto Gutiérrez

inlaid with shell and turquoise. The feathers are made of dangling metal plaques that would have moved and shimmered in the light when worn. This elaborate headdress constituted the only headgear in the burial. The tomb also contained a backflap, the only defensive armament in the tomb, if in fact these backflaps were a sort of body armor (Alva 1994: fig. 153; Alva and Donnan 1993b: fig. 166). Made from two vertical halves, one of gold and the other of silver, the backflap has two perforations in its upper half allowing it to be suspended from a belt. The headdress and the backflap are very similar to the owl headdress and backflaps worn frequently by the Bird Priest in Moche art. Even more congruent with this image, the individual in

Tomb 2 was buried with a copper goblet in his right hand. This goblet is similar to the upper portion of the tall cups also seen in the Sacrifice Ceremony.

The person in Tomb 2 wore two necklaces, each with nine gilded copper beads in the shape of human heads (Alva 1994: figs. 143–144, 146–148; Alva and Donnan 1993b: fig. 163). The faces of the heads on one necklace are smiling, showing their white teeth of carved shell. The other necklace is made of head-shaped beads of the same metal and measurements, but the faces are frowning (fig. 8).

Tomb 3

Tomb 3 was located in the center-east section of the platform, and pertains to the oldest construction phase of the funerary platform (fig. 2). Due to its earlier chronological position—perhaps some four or five generations before the Lord of Sipán in Tomb 1—the individual interred here is often referred to as the Old Lord of Sipán. This tomb was much simpler and smaller (2.6 m in length and 1.7 m in width) and without a wooden coffin. The body was enveloped in reed mats and textiles and deposited with twenty-six ceramic vessels and copper objects, among other materials. This individual died between forty-five and fifty-five years of age (Verano in Alva and

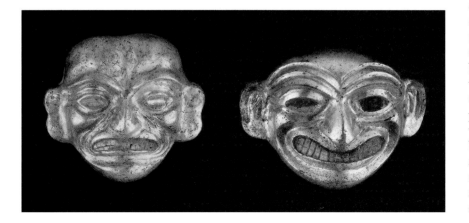

8. Detail of beads from necklaces in Tomb 2. Beads are made of gilded copper with shell inlay (average height of beads: 5.8cm)
Museo Arqueológico Nacional Brüning de Lambayeque
Photographs by Javier Ferrand

9. Gold spider bead necklace from Tomb 3 (average diameter of beads: 8.3cm)
Museo Arqueológico Nacional Brüning de Lambayeque
Photograph by Ignacio Alva

Donnan 1993b: 213). He was accompanied in the burial by a female attendant and a llama.

One of the first ornaments we found was a gold necklace, whose ten beads represent spiders with human faces on their backs (fig. 9). The spiders are delicately fixed to a web of gold wires, which forms the front of the beads. One of the most admirable pieces of Sipán workmanship, each spider was made from six sections, with more than a hundred points of soldering. The back of each bead is a convex disk of sheet gold with an exquisite design of swirls and zoomorphic heads rendered in low relief.

Among other notable items in the tomb were two gilded copper ornaments with shell inlays, perhaps originally attached to banners or headdresses. One represents an anthropomorphized feline with a bicephalic serpent headdress (Alva and Donnan 1993b: fig. 204),

and the other an anthropomorphized crab with a crescent headdress (fig. 10). Both wear necklaces with beads in the shape of owl heads. Tomb 3 also contained two small scepters (Alva and Donnan 1993b: figs. 193–195). One of silver, measuring 24.3 cm in height, has a finial depicting a male figure with a crescent headdress. Extending above the headdress is a rack extension from which representations of two human heads are suspended. The second scepter of gold measures 22.6 cm. Its finial is a spherical rattle.

Tomb 3 also contained banners similar to those found in Tomb 1. Three banners were found above the body. Against a backdrop of gilded copper plaques, each has an anthropomorphic figure with raised arms. Borders of embossed paisley-shaped *ulluchu* forms enclosed the figures. The figure on one banner was larger than the other two, and under the

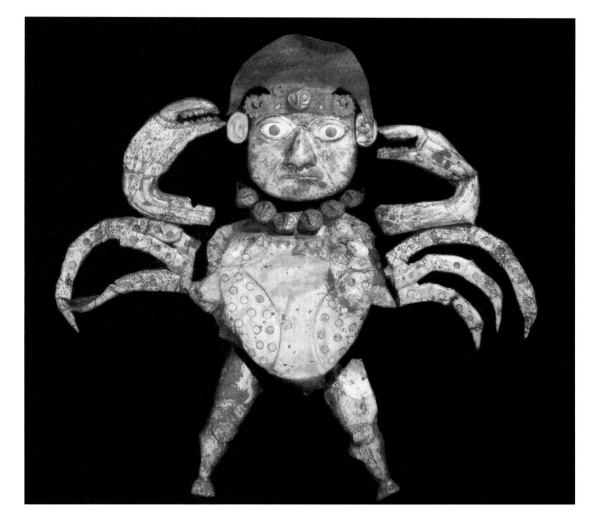

10. Anthropomorphic crab ornament of gilded copper with shell inlay from Tomb 3 (height: 62 cm)
Museo Arqueológico Nacional Brüning de Lambayeque

11. Copper burial mask with shell inlay (height: 23 cm) and necklace of owl heads. Gilded copper volute pectoral (width: 90 cm), all from Tomb 3
Museo Arqueológico Nacional Brüning de Lambayeque
Photograph by Carlos Rojas

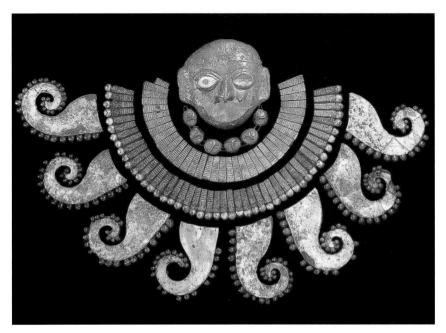

embossed *ulluchu* forms on this example actual *ulluchu* fruit were encased between the metal forms and their textile backing. Two more banners, of similar design, were found under the body, also facing downward, as they were in Tomb 1.

Closer to the body were multiple groups of personal ornaments, such as pectorals, necklaces, and ear and nose ornaments. Five necklaces were found, each with ten beads in the shape of anthropomorphic and zoomorphic heads. Two were of gold and three were of silver. Evidently the spider necklace completes a set of three bimetallic pairs. The most spectacular pectoral is composed of gilded copper volutes resembling the tentacles of an octopus (fig. 11). Over the face of the deceased was a lifesize burial mask, complete with a crescent-shaped nose ornament and a necklace of owl-head beads. The proper

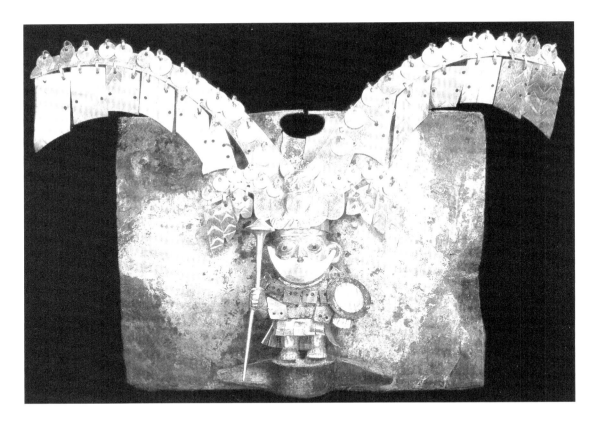

12. Nose ornament with figure of a warrior in silver, gold, and turquoise (height: 11 cm)
Museo Arqueológico Nacional Brüning de Lambayeque
Photograph by Carlos Rojas

right eye was inlaid with shell; the inlay for the left eye was absent.

Perhaps the most interesting nose ornament is a silver plaque with a marvelous miniature effigy of a warrior sculpted in gold and turquoise (fig. 12). The warrior wears a large headdress in the shape of an owl with extended wings, and his own nose ornament, and carries a war club. The figure is similar to the representation of warriors on ear ornaments from Tomb 1, but in this case, the owl headdress is distinct, and resembles the full-size headdress found in Tomb 2.

As with Tomb 1, Tomb 3 had groups of backflaps and rattles, some with representations of the Decapitator. In contrast to Tomb 1, this tomb had ten rattles of gold and ten of silver, as well as ten backflaps in silver, ten in gilded copper, and one in gold. The backflap of gold measures slightly less than the backflap of Tomb 1 (29 cm). Finally, as in Tomb 1, Tomb 3 had a group of weapons and spears, although many of the weapons seem to have been intentionally destroyed at the moment of interment. In addition, some emblems had likewise been dismantled before burial; for example, the head of a gilded copper feline

ornament was found in the upper half of the burial, while other body parts were found in various levels of the tomb.

The backflaps, the necklace sets, the weapons, and the ceramic offerings highlight a close relationship between Tomb 1 and 3. In some cases the scale is slightly different, as for example the gold backflaps. The necklaces occur in sets of three: three of gold and three silver that generally have ten units or beads each.

Although the form and characteristics of this burial show fundamental differences from Tomb 1—no coffin and fewer accompanying retainers—there still exists a set of ornaments, emblems, and goods that are similar. The disposition of the funerary goods of the Old Lord are reminiscent of the Lord of Sipán in Tomb 1, inasmuch as the deceased serves as the central axis of the burial. The two tombs demonstrate the same general order of items, with the most personal ornaments closest to the body. But more interesting is the idea that this order occurs not only over the body, but also beneath it. This sequence of ornaments and other goods, and their spatial orientation seem to have been

rigidly prescribed, and may allude to Moche beliefs and world views. For example, placement of the banners (those on top of the body are face up, while those beneath the body are face down) may suggest a division of conceptual space, a division of the world above and the world below, split on the axis of the royal body. A pervasive sense of dualism is also inherent in the placement of ornaments and their materials (gold with the proper right side of the body, silver with the left). Most interestingly, it is clear that these symbols of power, rank, and identity endured for generations.

The Looted Tomb

One of the most important tombs at Sipán was partially looted prior to the beginning of our scientific excavations. We can, however, deduce that the same type of ornaments and emblems found in Tombs 1 and 3 would have also been found in the looted tomb.[4] This

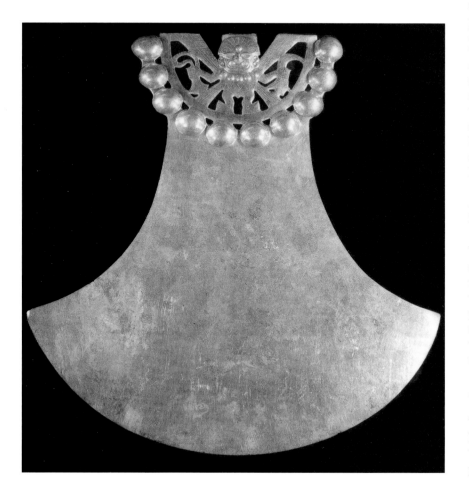

13. Gold backflap recovered by the Federal Bureau of Investigation in Philadelphia in 1998, believed to be from the looted tomb at Sipán (height: 68 cm)
Museo Arqueológico Nacional Brüning de Lambayeque
Photograph by Ignacio Alva

tomb would correspond to another lord of the same rank as the lords in Tombs 1 and 3. From the isolated pieces recovered by the police, and from knowledge of certain pieces that have ended up in private collections, it appears that the looted tomb of Sipán contained materials very similar to those ornaments and emblems of Tomb 1. For example, the tomb probably contained a scepter of gold and silver with a representation of a warrior in low relief (Alva 1994: fig. 240) and a necklace of gold beads in the form of peanuts (Alva 1994: fig. 245).

Nevertheless, excavation of what remained of the tomb suggests that the interment of the individual in this tomb was in a format intermediate between the bundle of the Old Lord in Tomb 3 and the funerary chamber of the Lord of Sipán in Tomb 1. In effect, the burial was not properly a coffin, but a set of wooden planks that enclosed a space. As one might imagine, the tomb was largely destroyed in the looting; we could only salvage evidence of some of the accompanying retainers of the principal occupant. To a limited degree, we have been able to identify a few items from this tomb that have entered the international art market. Among the pieces we have identified as coming from this tomb is a backflap recovered by the Federal Bureau of Investigation in Philadelphia in 1998 (fig. 13). Highly similar to those from Tombs 1 and 3, the gold backflap has the characteristic Decapitator on top, holding a *tumi* knife and a severed head.

Burials of Second Rank: Assistants of Warriors and Priests

We have located nine more tombs in the years since the discovery of Tombs 1, 2, and 3.[5] The inventory of subsequent tombs is less sumptuous than the first three, suggesting that they pertain to individuals of a lesser rank, but still connected with the elite. These tombs date to various chronological phases, as defined by the architectural sequence (fig. 2).

Tomb 5

Tomb 5 contained an individual who may have been a warrior of second rank (figs. 14, 15). The burial consisted of a funerary pit of approximately 4 m², located in the south-central

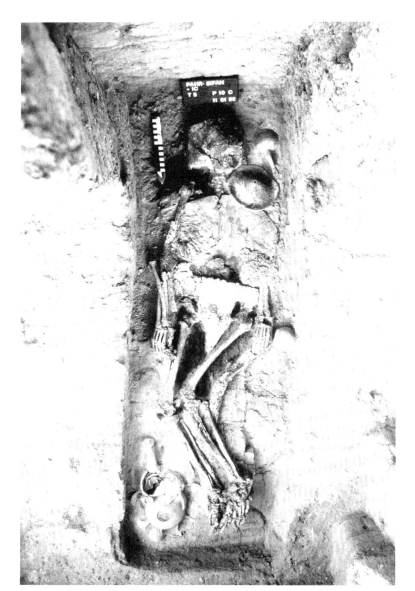

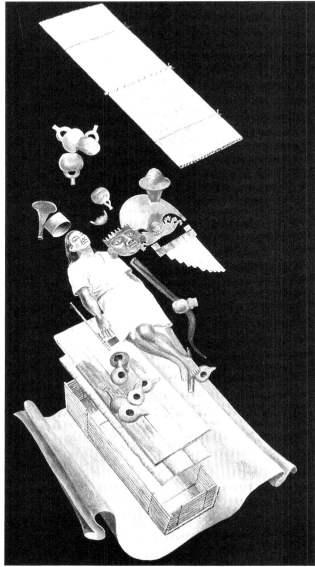

sector of the platform. A number of ceramic vessels were found dispersed in the fill over the remains of a reed coffin. The coffin contained the bones of an adult male in an extended position, and oriented with the head to the south. The individual had various offerings, such as a copper mask, nose ornaments, sheaths of combat weapons, a crescent headdress, ceramic pan pipes, thirty-two vessels and a singular wooden spear-thrower with shell and turquoise inlays. This burial probably pertained to an individual of the military elite, who perhaps also served as a musician, accompanying the lord and his entourage and playing the pan pipes.

Tomb 7

This funerary chamber, pertaining to the third phase of architectural construction, was located on the northern side of the platform, an area subjected to looting and erosion. The chamber measured 3.5 m by 1.7 m (fig. 16). At its center were the burials of two adolescents, one female, and one male, originally laid out in reed coffins. Over them were offerings of llama heads and gourd-shaped vessels. The male wore armbands of shell beads, a copper disk, and a headdress. Two sections of a metal disk replaced the bones of the feet, absent as a result of a ritual amputation.

14. View of Tomb 5 (shown head to top)

15. Reconstruction of Tomb 5
Painting by Alberto Gutierrez

Other metal pieces were found under the body.

The female's burial contained a copper headdress with an embossed face, a shell-bead necklace, a rectangular plaque, and three ceramic vessels. The headdress was similar to those worn by the principal women who accompanied the lord in Tomb 1 and the Priest in Tomb 3 (Alva 1994: fig. 132; Alva and Donnan 1993b: figs.132–133). The bodies of decapitated llamas and three ceramic bowls were dispersed between the reed coffins.

16. View of Tomb 7

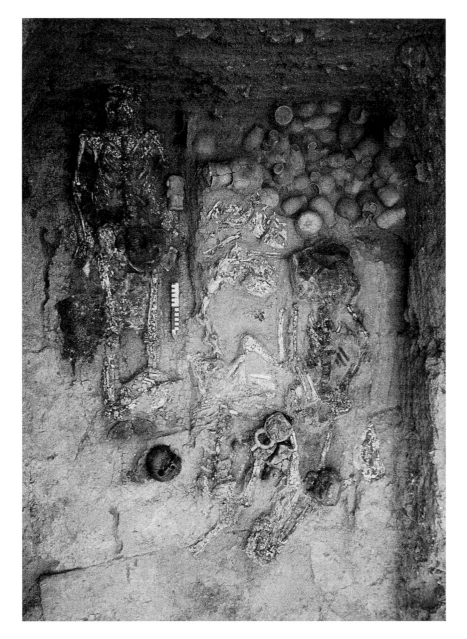

Tomb 8

Tomb 8 consisted of a fairly large funerary chamber (6.2 m × 4.4 m in the upper half), indicating that tomb size and layout is not a faithful reflection of the rank of individuals, as this chamber (fig. 17) is larger than that of Tomb 1. In a general way, the form of the chamber is similar to Tomb 1, but it dates somewhat earlier in the architectural sequence, to Phase 3. The funerary chamber had five wall niches. Four burials were found in the chamber, of which two, located in the center in cane coffins, were clearly the principal occupants. They were surrounded by 124 ceramic vessels. The more elaborate of the two, on the west, was an adult male skeleton covered by four layers of ornaments and emblems. Among these were a headdress made of sheet metal, which has a central embossed anthromorphic face, with a large crescent extending above it, flanked by two mythological animals (fig. 18). This individual's grave goods included a series of weapons, suggesting that he fulfilled military functions. Shields, sections of pectorals and war clubs, nose ornaments, spear points, and two remarkable metallic banners or cult images were part of his funerary assemblage. One of these copper ornaments (fig. 19), represents an anthropomorphic creature with fins dominating a man.

The skeleton of the second of the two principal individuals, located on the east, was found disarticulated. Evidently this individual had died earlier than his companion on the west side, and was removed from wherever he had originally been buried, and placed in position in this tomb. Care was taken, however, to place ornaments in the same order. His grave goods included a headdress with volutes, parts of other headdresses, a copper mask, a scepter, a war club, military emblems, and four ceramic vessels. One of the symbols of rank found with this buried individual is a scepter topped by a pyramidal boxlike chamber, similar in form to that found in Tomb 1 (fig. 20). As suggested above, these scepters appear to be linked with military command. This scepter, however, is of copper; individuals of lesser status tend to have ornaments of copper and gilded copper rather than gold or silver. Two other burials, probably retainers, were located on the western side of the chamber.

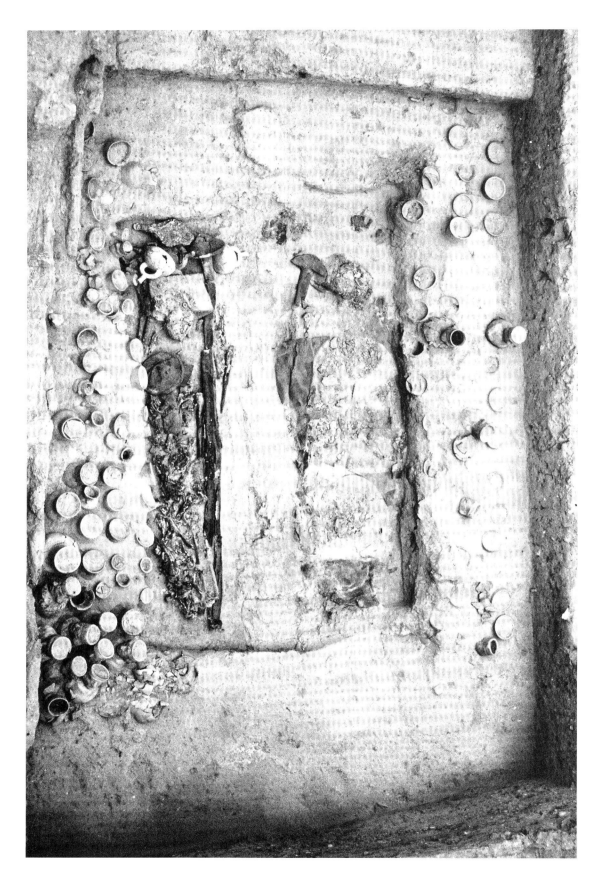

17. View of Tomb 8
(shown head to top)

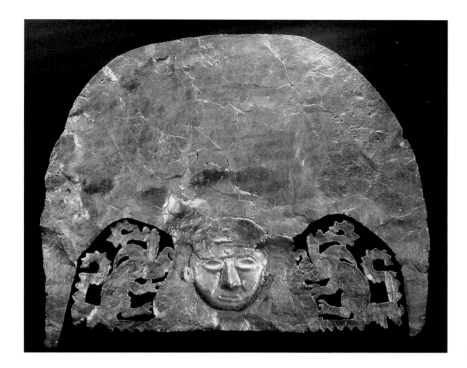

Tomb 9

Tomb 9 is associated with the second phase of construction, that is, a period slightly later than Tomb 3. The burial consisted of a funerary bundle placed in a pit measuring 2.05 m by 0.85 m. The skeleton of an adult male was covered by various layers of offerings and ornaments (fig. 21).

This individual was also probably linked to military activities, judging by the inventory of his funerary goods. Among these were three copper crescent headdresses, a war club, a mask inlaid with shell, a ceramic vessel, a rectangular banner of gilded metal plates, four headdresses, a rattle, and two copper ear ornaments. Closer to the body itself were five war clubs and two shell pectorals. Two silver and gold rectangular nose ornaments were found over the face. Cleaned and restored, they show an exceptional artistic and technical craftsmanship.

18. Copper headdress from Tomb 8 (height: 40.5 cm; width: 49 cm)
Museo Arqueológico Nacional Brüning de Lambayeque
Photograph by Ignacio Alva

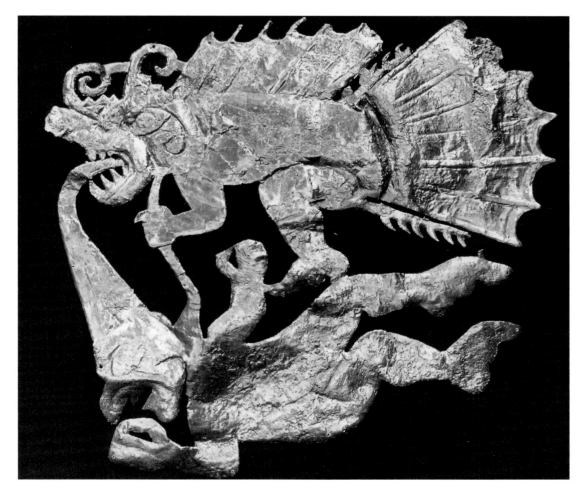

19. Copper ornament from Tomb 8 (height: 51.4 cm; maximum width: 56.7 cm)
Museo Arqueológico Nacional Brüning de Lambayeque
Photograph by Ignacio Alva

20. Scepter from Tomb 8
(length: 32.5 cm; maximum
width: 8.5 cm)
Museo Arqueológico Nacional
Brüning de Lambayeque
Photograph by Ignacio Alva

relief. Twenty-three ceramic vessels were included in the burial, and the stirrup-spout vessels among them correspond to the Moche III phase. Spear points, and other pieces yet to be identified, were also arranged around the individual. There were no human retainers accompanying this burial; one llama was included.

As in other tombs, many weapons were recovered, especially wooden war clubs covered with sheet metal. The quantity of weapons in this tomb could indicate that they were trophies captured in ritual combat. This burial highlights the quantity of goods needed for a

21. View of Tomb 9
(shown head to top)

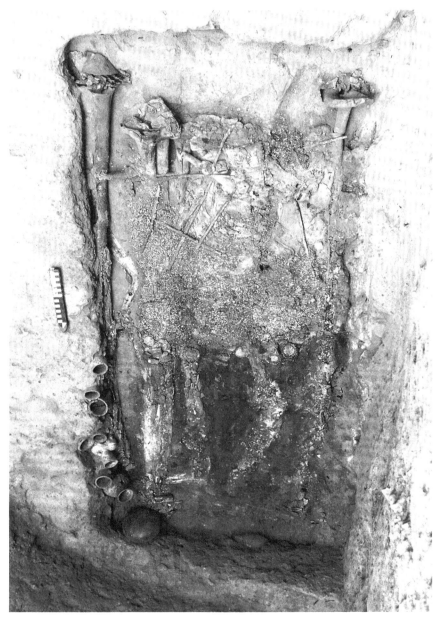

One of these nose ornaments (fig. 22) depicts two profile figures, a warrior with a crescent headdress on the left, facing a female figure with braids. The female figure is probably a representation of the Priestess, a personage seen in Moche iconography and linked with burials at San José de Moro (Castillo, this volume; Donnan and Castillo 1992, 1994). The other nose adornment (fig. 23) also represents two personages, again face-to-face, but this time they are horizontal, as if floating. A tree with dangling fruits appears to emerge from their backs, and the root system extends below their bodies. Among the other ornaments were necklaces, one of silver beads in the shape of anthropomorphic heads, another of beads in the shape of peanuts, and two unusual silver tubular pieces decorated in relief. The shaft of one of these tubular ornaments (fig. 24) is rendered with a design based on an abstracted zoomorphic form repeated in diagonal bands, and the end of the ornament is an anthropomorphic face, sculpted in higher

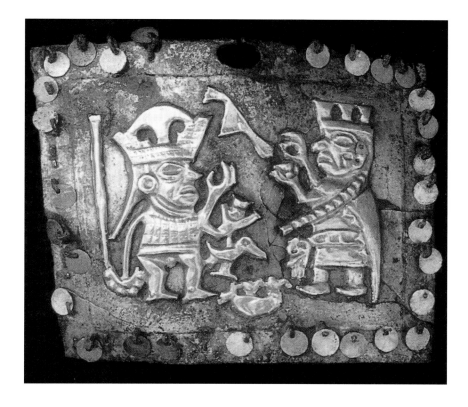

proper interment, and underscores the intense activity of artisans needed to meet these requirements.

Tombs 10, 11, 12

Located in the southern area of the funerary platform, Tombs 10 and 12, pertaining to the most recent architectural phase, contained ornaments and emblems clearly related to the religious cult. Tomb 10 is one of the few atypical burials at Sipán. It held an adolescent male of approximately twelve to fifteen years of age, oriented in a position opposite to that of the other burials, that is, with head to the north and the feet to the south. Among the few ornaments recovered were small metallic ornaments originally sewn onto a textile garment and *Spondylus* valves. To the north was a llama skeleton, while to the south were 103 simple globular vessels. Wall niches in the small funerary chamber contained other vessels, camelid bones, and ten small ceramic masks, each approximately 5 cm in height.

22. Silver and gold nose ornament from Tomb 9 (height: 9 cm; width: 11.2 cm)
Museo Arqueológico Nacional Brüning de Lambayeque
Photograph by Ignacio Alva

23. Silver and gold nose ornament from Tomb 9 (height: 8.9 cm; width: 11.3 cm)
Museo Arqueológico Nacional Brüning de Lambayeque
Photograph by Ignacio Alva

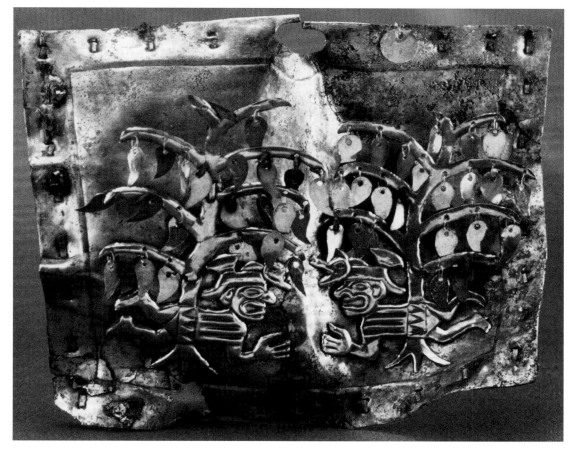

24. Silver ornament from Tomb 9. (length: 22 cm; maximum diameter: 3.6 cm)
Museo Arqueológico Nacional Brüning de Lambayeque
Photograph by Ignacio Alva

25. View of Tomb 12

Tomb 12 consisted of a burial whose goods could be related to the religious cult (fig. 25). Together with the skeleton were rattles and sacrificial knives, typically indicating ritual functions. A number of vessels were located at the sides of the body, while near the cranium were two tubular silver pieces that could be ear ornaments. The individual was covered by copper platelets, which may originally have formed a pectoral. At his side was the skeleton of a retainer with the feet amputated.

Tomb 11 was located on the north side of the platform, next to Tomb 8, and it was associated with the third architectural phase. It is a funerary chamber with two burials in reed coffins (fig. 26). The principal individual, an adult male, had a number of ornaments: two copper headdresses; a pair of copper sandals; a hexagonal plaque; four sheets of copper in the shape of a "T"; three copper scepters; two pieces of copper in the form of *pallares* or beans, twelve copper platelets sewn onto a thick textile; and much evidence of disintegrating textiles. The accompanying retainer again lacked feet and was covered by four copper plaques.

Given this evidence, it is possible to suggest that the burials at Sipán followed certain patterns, and individuals associated with specific roles in life and perhaps death were interred in distinct areas of the funerary platform. Military chiefs or warriors were generally buried toward the north side of the platform, while the burials of the priests and their assistants were located toward the south side, demonstrating the differential use of funerary space according to the social role of the individuals.

26. View of Tomb 11

Representations and Archaeological Correlations

The funerary platform of Sipán included interments of individuals who were clearly the supreme political and religious authorities of their times. These individuals are identifiable through the ornaments, emblems of rank, and symbols of command that accompanied them in their graves. The items, and their contexts, provide us with an unprecedented opportunity to draw comparisons between the archaeological record and the iconography found on ceramic vessels and other media known from the Moche world. By using both sources of data, we are able to form a more complete picture of Moche social hierarchy and ritual practice.

The principal set of ear ornaments found with the Lord of Sipán in Tomb 1 may serve as a point of departure for this discussion (fig. 5). The individual portrayed on these ear

spools seems to represent the primary individual of the tomb, who, like the image on the ornament, also appears in his military regalia, flanked by two warriors. The representation of a military procession known from a number of Moche ceramic vessels helps to illustrate the hierarchical order of the individuals buried at Sipán (fig. 27).

In this scene, the individual presiding over the procession, the third figure from the left, wears a crescent headdress similar to the one found in Tomb 1. The figure behind him, also wearing a headdress, but lacking the crescent ornament, may have an archaeological correlate in the individual buried with his shield and war club, located on the proper right of the primary lord in Tomb 1. The individual following him carries a banner, reminiscent of those found in Tombs 1 and 3. Also present in the procession are four other individuals, one carrying a shield, one carrying a scepter and two carrying batons with what may be

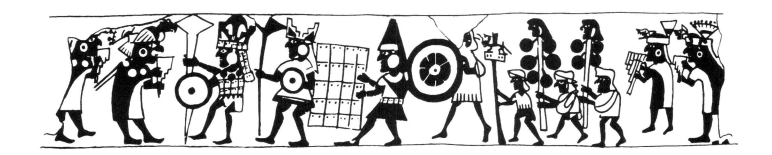

rattles dangling off the sides, surmounted by profile heads. The scepter is similar to that found in the looted tomb (Alva 1994: fig. 240; Alva and Donnan 1993b: fig. 153), while the heads could refer to certain metallic masks found in some of the tombs. The masks have perforations allowing for suspension, perhaps from a wooden staff or other support. Finally, pan pipe players are visible at both ends of the scene, recalling the individual in Tomb 5, who was interred with a such an instrument.

The iconography found on ceramic vessels reinforces our identification of the types of ornaments considered crucial to rulership by the Moche. Time and again, types of items found in the tombs at Sipán are represented in the fine-line paintings on Moche vessels. Ornaments important to the ruling lord are seen in numerous themes in Moche art, such as the headdresses worn by individuals in a scene of ritual running (Kutscher 1983: Abb. 135). Here figures wear zoomorphic head-dresses with chevron designs. In Tomb 1, a cotton textile with metal ornaments was found that resembles this headdress. The overall shape is zoomorphic, and the body contains a similar chevron motif (Alva 1994: 74, dib.17).

One of the shell pectorals from Tomb 1 has a triangle design, linking the individual buried with a personage known as the Radiant Being, seen in the Sacrifice Ceremony. Fine-line paintings on Moche ceramics give us a better idea of what the costumes and regalia would have looked like when complete, and in what sorts of contexts orna-ments would be worn. For example, garments embellished with metal platelets, such as the one found in Tomb 1, can be related to individuals seen in a number of scenes, including the Ribbon Dance (Hocquenghem 1987: fig.

95; Kutscher 1983: fig. 152). In this depiction, only the most important individual wears a complete metallic tunic. Interestingly, he also wears a necklace of disks similar to one found in Tomb 1.

One of the ornaments we found in Tomb 3 was a fox head made of gilded copper. This small ornament (12.5 cm in length) was proba-bly part of a headdress, such as those seen in the painted scenes of combat and ritual hunts (Alva and Donnan 1993b: 184; fig. 199). This type of headdress was also found in Tomb 8 and at other Moche sites, such as at Huaca de la Cruz in the Virú Valley, where Strong and Evans found one in the tomb of the Warrior Priest (Strong and Evans 1952: 154, pl. XVII, XXI, XXVI e–k). What is apparent from both the archaeology and the painted imagery is that there are items that are reserved for members of the highest echelon of the Moche elite, or governing rulers, and then there are items that may be used by the lower levels of the Moche elite. Whereas objects such as scepters and gold backflaps are exclusively for the rulers, fox headdresses may have been more widely used.

Art and Power in Moche society

In general terms the patterns and contents of the Sipán tombs establish a rigid hierarchy of social roles and functions among the Moche elite of the central Lambayeque Valley. The persistence of specific items of royal regalia over time, and the persistence of the proto-cols evident in their placement within tombs indicates the abiding character of these orna-ments of ritual and rulership, and their as-sociated beliefs. Some differences, however, are evident in the inventories of the lords' funerary goods over time. There is an early

27. Roll-out drawing of a military procession painted on a ceramic vessel now in the Staatliches Museum für Völkerkunde, Munich (D.1410)
After Kutscher 1983: Abb. 153A18.

preference for nose adornments, for example, and a later preference for ear ornaments and headgear. Some items, such as vestments adorned with metal platelets, seem to be a general characteristic for all Sipán elite burials, regardless of relative rank or role. Weapons, found in quantities and conditions suggesting they were combat trophies, were also extremely common among these burials.

Yet within this rigid hierarchy, it is clear that important political changes were developing over time. The evidence suggests that there was progression from a dual, balanced religious-military authority represented by the single figure of the Old Lord to a situation where there is a separation of roles and functions, evident in the tombs of the Lord of Sipán and the Priest. The burials of the priests and their assistants would indicate that they exercised largely religious functions, in contrast to the supreme political and military functions of the Lord of Sipán.

The Sipán tombs provide a remarkable array of evidence suggesting that much of the behavior depicted in the fine-line iconography on Moche ceramic vessels may indeed have occurred. The high degree of correspondence between the costumes and grave goods of these individuals and the elaborate narrative scenes depicted on vessels known from museum collections around the world implies that there was a visual and actual reiteration of key practices in Moche culture at the platform mound. Sipán contains graves of individuals who probably fulfilled the role of lord or priest, and were buried with the accouterments of these offices. The Sipán burial platform contained the remains of at least two individuals (Tomb 1, 3, and probably the looted tomb) who appear to have worn the regalia of a specific office, an office we know partially through depictions of the Sacrifice Ceremony on ceramic vessels. These lords may have presided over such ceremonies during their lives, aided perhaps by others such as the individual in Tomb 2, a man interred with regalia reminiscent of the Bird Priest of the Sacrifice Ceremony.

Whether what we see at Sipán are the remains of a limited or specific series of actions, or whether the inhabitants of Sipán were ritually reenacting commonly understood practices known from mythological or theological teachings is a question that remains to be answered. The San José de Moro Priestess burials, which date hundreds of years later, however, suggest that this was a ritual practiced periodically in Moche history, by numbers of individuals who donned the attire of their specific offices or roles to perform this ceremony and probably many others over the course of their lives (Alva and Donnan 1993b: 223–226).

The Sipán findings provide an unprecedented opportunity for the study of the highest levels of Moche society, and for the analyses of the maintenance of political authority. The overwhelming emphasis on domination in Sipán imagery, through such depictions as the submission of prisoners on the scepter from Tomb 1, to the depiction of the deer on the ear ornaments in the same tomb,[6] suggests that the display of such potential power was fundamental in the maintenance of political authority. We still do not know the extent of the realm of the lords of Sipán, and whether or not they dominated any regions beyond the Lambayeque Valley. Nor do we know precisely what their relationship was with the lords of other north coastal valleys, or to a centralized Moche state or states. For now, we propose an organization based on individual "lords" in each valley, whose economic management was based on irrigation and conditioned by the political units under a cultural pattern shared throughout the Moche world. The Sipán tombs have provided an unprecedented view of some of the spectacular tools and methods used by the Moche lords, as they presided over some of the most important events of their times.

NOTES

1. Gold objects were often found on the proper right side of the body, and silver objects on the proper left. According to early colonial-era documents, native people on the north coast believed in the duality and complimentarity of the halves and of the sexes. Gold was associated with masculinity and the right side, silver with femininity and the left side (Alva and Donnan 1993b: 223).

2. A detailed description of the complete tomb inventory, as well as inventories of Tombs 2 and 3, can be found in Alva (1994) and Alva and Donnan (1993a, b). See also Alva 1988, 1990, 1992, and 1998.

3. This green fruit, frequently represented in Moche iconography, pertains to the Meliaceae family. Contrary to what Henry Wassén has written (1987), this form may have nothing to do with papayas, nor with the use of anticoagulants. These fruits had different properties, perhaps tied to mortuary rituals, sacrifice, or combat.

4. In February 1987, a group of looters from the Sipán area broke into one of the richest undisturbed funerary chambers at the site. After removing and distributing a large part of the materials, one of the participants alerted the police, who solicited the aid of the Museo Arqueológico Nacional Brüning de Lambayeque. We immediately organized an archaeological salvage project with the goal of reconstructing all possible information on the context and contents of the looted tomb. We later extended the systematic excavations to other sectors of the pyramid, where the other remaining twelve tombs were discovered.

5. In addition to the tombs discussed in this article, there are two tombs, 4 and 6, which are still in the process of being studied and will not be described here. Tomb 4 represents a complex series of interments, including a re-opening of the grave during the last architectural phase of the platform. Tomb 6 has been located but has not been excavated.

6. The deer imagery appears to be related to themes seen on Moche painted vessels. Ritual deer hunts are analogous to the capture of warriors in battle (Alva and Donnan 1993b: 139; Donnan 1982, 1997).

BIBLIOGRAPHY

Alva, Walter
 1988 Discovering the New World's Richest Unlooted Tomb. *National Geographic* 174 (4): 510–549.

 1990 New Tomb of Royal Splendor. *National Geographic* 177 (6): 2–15.

 1992 El señor de Sipán. *Revista del Museo de Arqueología* 3: 51–64. [Trujillo].

 1994 *Sipán*. Colección Cultura y Artes del Perú. Lima.

 1998 *Sipán. descubrimiento e investigación.* Lima.

Alva, Walter, and Christopher B. Donnan
 1993a *Tumbas reales de Sipán* [exh. cat., Fowler Museum of Cultural History, University of California]. Los Angeles.

 1993b *Royal Tombs of Sipán* [exh. cat., Fowler Museum of Cultural History, University of California]. Los Angeles.

Donnan, Christopher B.
 1982 La caza del venado en el arte mochica. *Revista del Museo Nacional* 46: 235–251 [Lima].

 1997 Deer Hunting and Combat: Parallel Activities in the Moche World. In *The Spirit of Ancient Peru: Treasures from the Museo Arqueológico Rafael Larco Herrera* [exh. cat., Fine Arts Museums of San Francisco], ed. Kathleen Berrin, 51–59. New York.

Donnan, Christopher B., and Luis Jaime Castillo
 1992 Finding the Tomb of a Moche Priestess. *Archaeology* 45 (6): 38–42.

 1994 Excavaciones de tumbas de sacerdotisas Moche en San José de Moro, Jequetepeque. In *Moche: Propuestas y perspectivas* [Actas del primer coloquio sobre la cultura Moche, Trujillo, 12 al 16 de abril de 1993], ed. Santiago Uceda and Elías Mujica, 415–424. Travaux de l'Institut Français d'Etudes Andines 79. Trujillo and Lima.

Hocquenghem, Anne-Marie
 1987 *Iconografía Mochica*. Lima.

Kutscher, Gerdt
 1983 *Nordperuanische Gefässmalereien des Moche-Stils.* Materialien zur allgemeinen und vergleichenden Archäologie 18. Munich.

Meneses, Susana, and Luis Chero
 1994 La arquitectura. In *Sipán*, by Walter Alva, 248–257. Colección Cultura y Artes del Perú. Lima.

Strong, William Duncan, and Clifford Evans
 1952 *Cultural Stratigraphy in the Virú Valley, Northern Peru: The Formative and Florescent Epochs.* Columbia Studies in Archeology and Ethnology 4. New York.

Verano, John W.
 1997 Human Skeletal Remains from Tomb 1,
 Sipán (Lambayeque River Valley, Peru);
 and their Social Implications. *Antiquity*
 71 (273): 670–682.

Wassén, S. Henry
 1987 "Ulluchu" in Moche Iconography and
 Blood Ceremonies: The Search for
 Indentification. *Göteborgs Etnografiska
 Museum Annals* [1985/86], 59–85.

ALANA CORDY-COLLINS
University of San Diego

Labretted Ladies: Foreign Women in Northern Moche and Lambayeque Art

The eighth century on the north coast of Peru was a time of tremendous social oscillation and upheaval. Dramatic changes occurred, which markedly altered the cultural continuum in the region. In the late 700s A.D., the Moche population north of the Pampa de Paiján came into ever increasing contact with other peoples. Cajamarcans from the northern highlands, Nieverians from the south central coast (Castillo and Donnan 1994: 108), and—as this study shows—Tallanes from the area that is now the Ecuadorian borderlands, all brought new ideas, practices, and people to the region. Archaeological work in the Jequetepeque Valley over the last fifteen years has demonstrated that within the span of a few generations, these foreign contacts so altered the Moche tradition there that it ceases to be recognizable as such in the archaeological record.

It was at this moment—as the northern Moche V culture stood on the brink of metamorphosis into the Lambayeque culture—that a new personage appeared in the ceramic inventory, a female figure shown with an unusual-shaped head, a distinctive coiffure, and wearing a labret or lip plug (fig. 1). None of these characteristics is known in Moche art or archaeology prior to this time, suggesting that these are representations of females foreign to the northern Moche region. Of these characteristics, the labret is the most significant feature distinguishing these women from the usual portrayals of Moche and Lambayeque women. The decision to wear such an ornament is not a casual one, as the wearer's flesh must be opened surgically just under the lower lip so that the decoration can be inserted. Several lines of evidence suggest that these features are northern in origin, probably from the Piura region of the far north coast of Peru, bordering on Ecuador.

Twenty-two examples of this type of figure, stylistically dated to Moche V, have been identified in collections around the world. A greater number in the Lambayeque style have also been recorded. Although the majority of our most complete examples are known from museum collections and are unfortunately lacking in contextual data, four examples of labretted females, two dated to Moche V and two dated to the later Lambayeque period, have been excavated recently.

In the 1992 field season at San José de Moro, in the Jequetepeque Valley, archaeologists excavated two tombs containing representations of these females. One is a Moche figurine, which when complete would have been approximately 15 cm in length. Although it is poorly preserved, it shows the distinctive head shape that is part of the cluster of traits associated with this type of female representation. The second Moro piece is a Lambayeque style bottle (fig. 2). The third piece, also in Lambayeque style, was excavated there in 1996 (fig. 3). San José de Moro is an important site for our understanding of the end of Moche culture and the beginnings

Moche V figurine modeled with a prominent labret (height: 15.9 cm)
Metropolitan Museum of Art, New York, Gift of Nathan Cummings, 1965 (65.266.12)

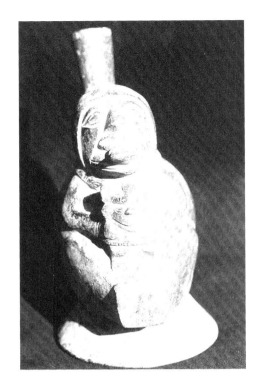

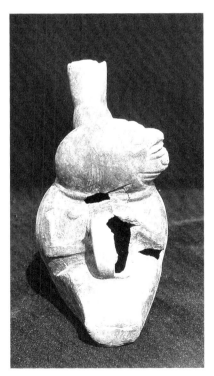

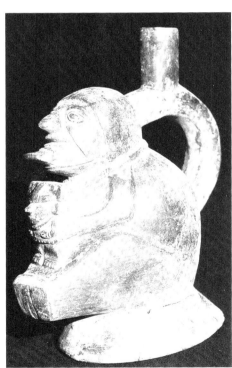

of the subsequent Lambayeque culture on the north coast (Castillo, this volume; Castillo and Donnan 1994; Cordy-Collins 1994; Rucabado in press). This site currently provides our best evidence of this transition, with its continuities and disjunctions. The San José de Moro pieces, along with evidence from textual accounts of the early colonial period, suggest

1. Two views (*above and below*) of a Moche V bottle modeled in the form of a labretted female drummer. Stirrup and spout missing
Former Raúl Apesteguia collection, Lima
Photographs by Christopher B. Donnan

2. Two views (*above and below*) of a Lambayeque stirrup-spout bottle modeled in the form of a labretted female drummer, excavated at San José de Moro (1992, U-105-E2-C2)
Instituto Nacional de Cultura, La Libertad, Trujillo

3. Two views (*above and below*) of a Lambayeque stirrup-spout bottle modeled in the form of a labretted female holding a small figure. Excavated at San José de Moro, 1996
Instituto Nacional de Cultura, La Libertad, Trujillo

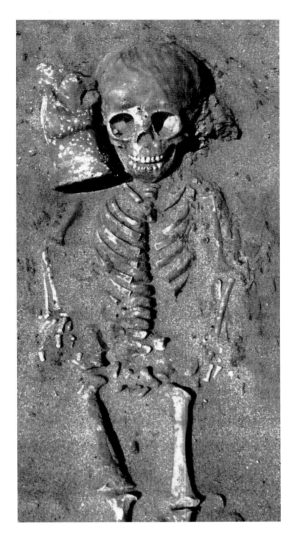

4. Burial of a child, c. three years of age, at Dos Cabezas in the Jequetepeque Valley (N-B1). Located adjacent to the child's face is a ceramic Moche V figurine (N-B1-C1), now in the collection of the Instituto Nacional de Cultura, La Libertad, Trujillo
Photograph by Christopher B. Donnan

5. View of Moche V figurine from grave seen in figure 4. The damage to its face indicates that it was not new when it was interred with the child
Photograph by Christopher B. Donnan

tations (thirteen), shows a female holding an hourglass-shaped drum under her arm (figs. 1, 6, 7).[1] This type of drum is distinct from the traditional Moche tambourine drum, and is not seen in Moche art before this period. The second variation, of which there are three examples, represents a female holding a conch-shell trumpet in one hand, the other hand across her chest.[2] In the third set, the women are shown with both hands to their chest (figs. 5, 8). There are six of this later type.[3]

It appears to be safe to assume that all of these representations, both Moche and Lambayeque, are of women, based on dress, and on occasion, the presence of secondary sexual characteristics. Several of the Lambayeque depictions of labretted females reveal breasts beneath the garments (fig. 2; Museo Arqueológico Nacional Brüning de Lambayeque 4513). Females with exposed breasts are rare in Peruvian north coast art; only one other example is known outside of this corpus.[4] In the Moche pieces, the women wear an ankle-length gown (that either has sleeves or is cut so generously as to appear sleeved), a three-to-four-strand beaded necklace, large earrings, and sometimes multiple-strand beaded bracelets.

Other features separate these women from

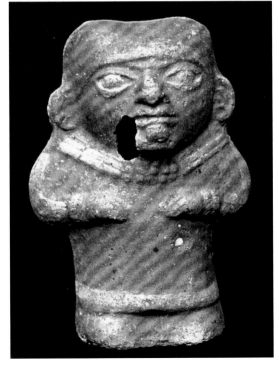

that after their initial appearance in late Moche times, labretted females continued to be important in the Jequetepeque Valley and elsewhere on the north coast until the early colonial period. This suggestion is supported by the discovery in 1996 of a second Moche labretted female figurine. The piece, illustrated in Figures 4 and 5, was excavated in the grave of a three-year-old child at Dos Cabezas, a site located near the southern end of the Jequetepeque Valley.

Moche Labretted Ladies

The depictions of the Moche labretted females can be grouped into three sets: drummers, conch-shell players and females with their hands across their torso. The first variation, by far the largest number of represen-

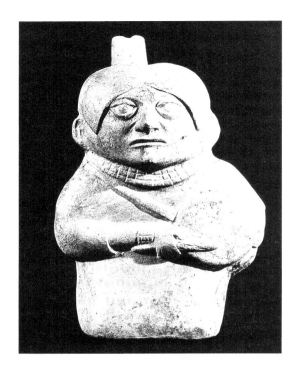

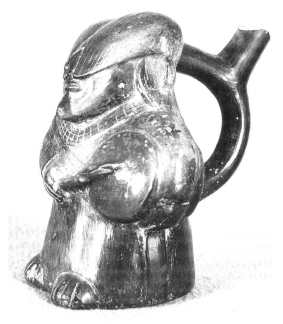

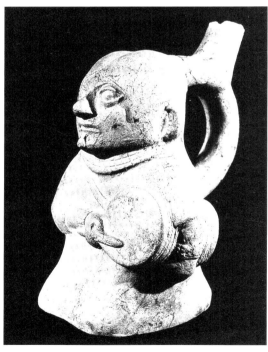

6. Two views (*above and below*) of a Moche V stirrup-spout bottle modeled in the form of a labretted female drummer
Former Frederick Landmann collection, New York
Photographs by Christopher B. Donnan

7. Moche V stirrup-spout bottle modeled in the form of a labretted female
Museo de Antropologia y Arqueologia de la Universidad Nacional de Trujillo
Photograph by Christopher B. Donnan

8. Moche V figurine modeled with a prominent labret
Metropolitan Museum of Art, New York, Gift of Nathan Cummings, 1965 (65.266.12)

standard depictions of Moche females. For example, most Moche women are shown with their hair in braids. The labretted women are shown with their hair worn long and loose down the back, but cut into short, angled bangs in front that are parted in the middle (figs. 1, 6, 8). Occasionally, the bangs even hide her eyes (fig. 7; Larco Hoyle 1965: 55). The style seems designed to accentuate the extremely broad—indeed heart-shaped—heads of the women, one of their exotic features. There are many examples of actual

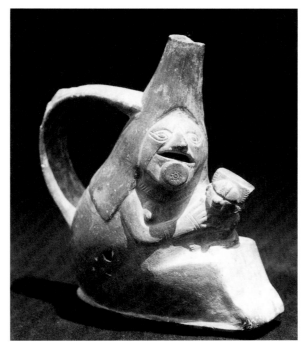

9. Two views (*above and below*) of a Lambayeque spout-and-handle bottle modeled in the form of a seated labretted female drummer. Spout missing
Museo Arqueológico Nacional Brüning de Lambayeque (2447)

10. Two views (*above and below*) of a Lambayeque spout-and-handle bottle modeled in the form of a labretted female holding a small figure
Museo Arqueológico Nacional Brüning de Lambayeque (2438)

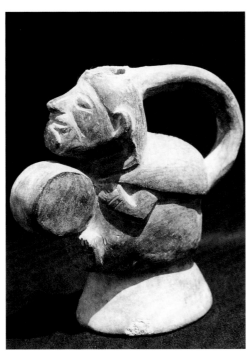

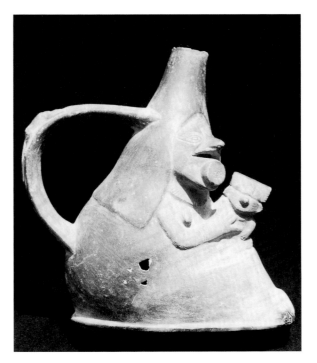

Moche crania deformed by cradleboarding, but none to this extent. The heart-shape prototype would have been created as a result of frontal and occipital compression that allowed the parietals to "billow" bilaterally outward of the sagittal suture.

Two of the three figural variants associate the labretted woman with music making. Although the shell trumpets were part of the traditional Moche musical realm, they are not associated with women (see Donnan 1978: figs. 98, 158, 166, 218, 226, 241). Also,

we know of only one depiction of Moche women with drums (Donna McClelland, personal communication, 1997).[5] This depiction, in a private collection, shows the female with the traditional tambourine-shaped drum (see Donnan 1978: 107 [3rd from bottom right], and fig. 167).

Hourglass-shaped drums are unknown in Moche culture prior to the eighth century, and then they appear only in the art north of the Pampa de Paiján. This new drum— gripped under the upper arm and secured by a lanyard over the opposite shoulder, and played with an indented drumstick—may have come from the north. Hourglass-shaped drums are seen in Vicús art, a tradition associated with the Piura Valley (Amaro 1994: figs. 13, 47, 49 [2nd from left, bottom row]; Donnan 1992: figs. 131, 132).[6] Vicús was largely contemporaneous with Moche, and the two cultures show some similarities in art styles. We still do not fully understand the nature of the relationship between the two, although we do know that there was at least some sporadic contact between them during the Moche I period. Jequetepeque style Moche I ceramics have been found at the site of Vicús in Piura, together with Vicús style copies of the Moche examples. Although Vicús is thought to have flourished in the Piura region in the earlier part of Moche history, Hans Disselhoff obtained a radiocarbon date of A.D. 655 ± 100 from a Vicús tomb he excavated in Piura (1969: 344). This date is compatible with the appearance of the foreign women in Moche ceramic art.

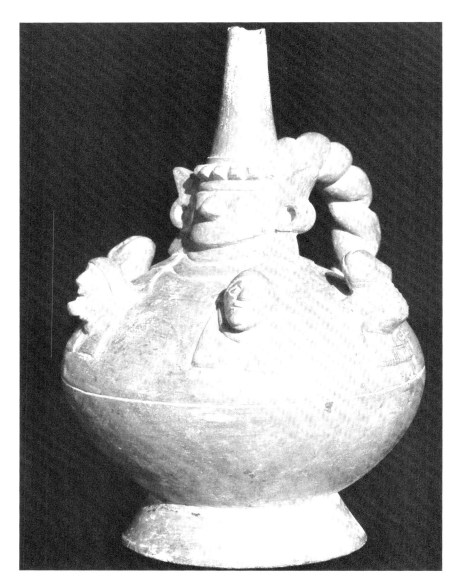

Lambayeque Labretted Ladies

By Lambayeque times, the number of depictions of labretted females on the north coast of Peru increased. This may suggest that these women, perhaps from Piura, became more important in this region, which was once part of the northern Moche domain. Whether or not northern women actually settled in this region, they became increasingly important as a subject in the ceramic corpus. Many of these women are shown with drums. Unlike the earlier Moche depictions, however, these women are shown with a tambourine, an instrument associated with the former Moche territories, not the hourglass-shaped drum of the north (figs. 2, 9).[7]

The Lambayeque style representations of labretted females continue to be associated with drums, although they are also shown engaged in other activities, such as holding a small figure, or in figural groups accompanying a central figure. Figure 3, found in the tomb of an elite male at San José de Moro in 1996, holds a small elaborately dressed figure with a headdress (see also fig. 10; de Lavalle 1989: 63). It is unclear, however, if this figure is intended to represent a child or a sculpted image. Costumed in a manner very similar to the Lambayeque Lord, (Cordy-Collins 1994: 199n, 213), a personage shown throughout Lambayeque art, the figure may represent a princeling. At least two of several examples of this type of ceramic portrayal show the

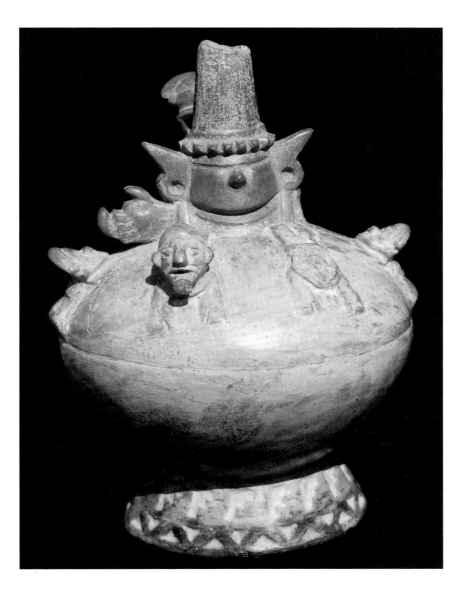

woman's breasts exposed, perhaps suggesting that she was the nursing mother of the young lord.

Several Lambayeque style ceramic bottles illustrate a pair of labretted females apparently swimming and towing a log raft on which appears the head, or occasionally the full figure, of the Lambayeque Lord (figs. 11, 12). A pair of males with headdresses assists at the back of the raft. Two early colonial accounts from the north coast recall a foundation myth where a leader arrived by sea aboard a log raft, with a host of retainers, settling in the Lambayeque Valley (Moseley and Cordy-Collins 1990). The myth is generally thought to refer to the foundation of a later polity, but it is possible that such an idea was part of north coast lore as early as the eighth century.

At this point we have insufficient data to identify the images of labretted females as those of a single mythical or historical individual. The range of activities depicted, however, may suggest that these images represent more than one personage, perhaps even members of a specific class.

The Northern Connection

Archaeological and historical evidence from the colonial period suggests that several of the attributes of these females are northern in origin. Females are shown wearing labrets in ceramics of the La Tolita (600 B.C.–A.D. 400) and Jama-Coaque (350 B.C.–A.D. 400) cultures of Ecuador (Museo del Banco Central de Ecuador 27.20.83R, 39.20.83R). Labrets have been excavated at a number of sites in the Piura-Chira region. George Petersen and Pedro Verástegui recorded twenty-three examples made of stone, copper, silver, and gold from two sites in the Piura Valley, at the Los Organos cemetery and at looted ruins on the right margin of the Chira River, near Sullana (Petersen 1955: lám. 1). Carlos Guzmán Ladrón de Guevara and José Casafranca Noriega excavated a site in the Vicús region of Piura that yielded a number of labrets (1964). [8]

Labrets have also been found in the Lambayeque region.[9] In 1996, an archaeological team from the Museo Arqueológico Nacional Brüning de Lambayeque excavated a triple burial at the Lambayeque Valley site of Illimo. One of the two females in the burial wore a small gold labret (Cordy-Collins 1996). In addition, both of the females were accompanied by an unusual face-neck jar (a ceramic vessel with a face molded on the neck): the molded face included a representation of a labret. Regrettably, the osteological material in the triple burial was in too poor a state of preservation to determine if the females' crania had been deformed in the style of the ceramic images.[10]

There is an interesting iconographic dichotomy between Moche and Lambayeque pottery effigies of women wearing labrets. Whereas the labrets that appear on the Moche images are plain and seem to be composed of a single element, many shown on the Lambayeque examples are fairly elaborate multicomponent ornaments. In this regard, it is noteworthy that the labrets recovered by Petersen and Verástegui are of two types: four are plain single-component pieces, and nineteen are composite examples. The plain ones are made of smooth, tapered stone, and range in size from 26 mm (height) × 19 mm (diameter), to 43 mm × 21 mm. The second, more elaborate, type is made of metal. Eight of these are made of copper, seven of silver, and four of gold. Their sizes range from 20 mm × 8 mm, to 37 mm × 26 mm. Except for one anomalous piece, all consist of—at least—a body and a cap; most also have a base. All of the caps are ornamented either with metal nodules, emeralds, lapis lazuli, or some combination thereof (Petersen 1955: 162–164). The ten labrets in the collection of the Museo del Banco de Crédito are at the lower range of the Petersen-Verástegui lot in terms of size, and are made of metal: two are silver, eight are gold. Their caps are embellished with nodules, spheres, and geometric or animal designs executed in repoussée and champlevé. One has a lapis lazuli setting, another a turquoise inlay. Although it is apparent that all had bases originally, only three do now. These three are intriguing because they are convex in relation to the wearer's teeth and gums, rather than concave as might be expected for comfort. The gold example excavated at Illimo is small, about 15 × 15 mm, and the base is missing. Although plain now, surface perforations suggest that originally it had some ornamentation. This dichotomy between plain stone and embellished metal labrets parallels those represented on the Moche and Lambayeque ceramic figures. The size ratios, too, of the actual labrets correspond well to those on the ceramic figures. Thus, it would appear that the labrets shown on the ceramics are direct translations from the actual objects. The two types, one corresponding to Moche and the other to Lambayeque, would seem to be linked to time and the development of Moche culture into Lambayeque. Therefore, it is worth special note that both types were found in the same archaeological context, the cemetery at Los Organos (Petersen 1955: 164), thus supporting a temporal continuum in the Piura-Chira region.

Cranial deformation of the type apt to create the heart-shaped head seen in the Moche representations of labretted females also seems to be a northern trait. The practice of tabular cranial deformation—flattening of both frontal and occipital bones—dates to at least 840 B.C. in the southern Ecuadorian region (Munizaga 1976: 688). Chorrera ceramics of the late Formative period in Ecuador (1500–300 B.C.) show similarities in both the type of head deformation and the coiffure to the later Moche examples. This is not to

suggest that there were direct, specific historical links between the Ecuadorian cultures and the Moche. Rather, it seems that some of these Ecuadorian traits were gradually adopted by the peoples of the far north coast of Peru (the Piura-Chira region) and by the eighth century, a period of greater openness or 'internationalism' for the Moche, they, too, apparently represented some of these northern traditions.

Historical Sources

When Spaniards arrived on the far north coast in the sixteenth century, several chroniclers described high-status women living in the Piura and Chira valleys. These women wore distinctive garb, including removable labrets and ankle-length, hooded gowns. Pedro Pizarro reported that "las mugeres... tienen ellas horadados los labios junto a la barba y metidos en los agujeros unas puntas de oro y plata redondas que les tapan agujeros; quitánselos y ponénselos cuando quieren" (quoted in Iribarren Charlín 1950: 88).[11]

These women were aristocratic members of the matriarchal Tallan culture. The Tallanes were one of the major ethnic groups of northern Peru in late prehistoric times. Occupying the coastal and riverine areas of the Piura and Chira valleys, they had their own distinct language, deities, and elaborate economy based on fishing, agriculture, ocean and river transport, crafts, and trade (Vega 1988: 2). The Tallanes may have been inheritors of the earlier, archaeologically known Vicús culture. The sixteenth-century chronicler Pedro de Cieza de León discussed the economically and politically powerful Tallan women, calling them *capullanas*, or the hooded ones (cited in Vega 1988:18).

Another early chronicler, Fray Diego de Ocaña, noted that they wore nothing under their hooded gowns—"quitado aquel capuz quedan desnudas" (cited in Vega 1988: 21). If indeed the *capullanas* were the latterday inheritors of a special category or class of women that formed by late Moche times, and if their dress remained largely unchanged, we can understand how the cloaklike neck opening could be loosened to reveal the bare breasts of the Lambayeque figures, while the gown's skirt covered the rest of the body to the ankles.

Pedro Gutiérrez de Santa Clara, writing around the end of the sixteenth century, describes the Tallan women's coiffure: "traen los cabellos sueltos por las espaldas sin trenzarlos...." [they wore their hair loose over the shoulders, without braiding it] (cited in Vega 1988: 20). This loose style must have been extremely uncommon or he would not have felt compelled to point it out. Furthermore, the description matches the style shown on the Moche figures and on the one hoodless Lambayeque piece (fig. 10).[12]

Northern Women in the South

I have argued that a foreign woman or, more likely, a group of them, came into the Moche territory, perhaps from the Piura-Chira region, during the early eighth century A.D. and received special recognition in the ceramic arts. In the Moche representations these women were musicians, and their most notable feature is a labret, but they often are shown with a heart-shaped head, a loose hairstyle, and an hourglass-shaped drum beaten with an indented drumstick. By Lambayeque times, her role, or their roles, may have broadened, and they may also have served as courtiers. If northern women actually came into the Moche territory and remained somewhat separate as a group, it is tempting to think that by Lambayeque times there was a certain amount of adoption of Moche traits, such as the Moche tambourine drum.

It is unclear why northern women may have come to this region, or rather, why women with northern traits were selected for depiction in the visual arts. We know little of their role in late Moche times, either as specific historical individuals, or as personages in any kind of narrative sequence. Moche potters depicted the labretted females three-dimensionally and in isolation, not as part of figural groups or painted narrative scenes. This leaves us with few clues as to their relative importance or the type of activities in which they were involved.

Yet, if we consider the entire corpus of Moche art, their very presence strikes us as unusual. Prior to the eighth century, women were rarely featured in Moche art. In the few instances when they appear, they are shown in secondary roles. The most prominent female in Moche art, the Priestess of the

Sacrifice Ceremony, does not appear until the eighth century (Cordy-Collins 1999; Donnan and Castillo 1994). Females in general may have gained in relative status by late Moche times, although more data are needed to support this idea. If northern women did indeed enter Moche society in the eighth century, they may have maintained an independent power base that endured for centuries.

In the sixteenth century, the Tallan *capullanas* were important both politically and economically. Cieza de León tells us that they were treated by their elite male counterparts as equals: "Todos los caciques trataban como 'señores' a las capullanas" (cited in Vega 1988: 18). These ceramic representations of labretted females in Moche and Lambayeque art may reflect a change in the status or role of women on the north coast of Peru. Originally closely associated with specific roles—musicians, for example, or ritual specialists (such as the Priestess)—they may have gained in power over time, becoming by the sixteenth century principal court players and finally *señores*, or members of the nobility, on a level equal to men.

NOTES

1. The thirteen examples are in the following locations: The American Museum of Natural History, New York (B/8517 and B/8195); Museo Cardoen, La Cruz, Colchagua, Chile; Museo de América, Madrid; Museo Arqueológico Rafael Larco Herrera, Lima; Museo de Antropología y Arqueología de la Universidad Nacional de Trujillo; Staatliches Museum für Völkerkunde, Munich; a private collection in Rotterdam; and two others whose present location is unknown (figs. 1, 6). Images are on file in the Moche Archive at the University of California, Los Angeles.

2. One of the three examples is in the Museum für Völkerkunde, Berlin, a second is in the collections of the Musées Royaux d'Art et d'Histoire, Brussels (A.AM.46-7-88, illustrated in Purin 1980: pl. XXI), and the present location of the third is unknown. Images are on file in the Moche Archive at the University of California, Los Angeles.

3. Two of these six, one excavated in 1992 at San José de Moro, the other in 1996 at Dos Cabezas (fig. 5) are in the collections of the Instituto Nacional de Cultura, La Libertad, Trujillo, and four are in The Metropolitan Museum of Art, New York: 65.266.10-13.

4. An early Moche modeled bottle depicts a woman with an exposed breast, but she holds a nursing infant against it (Donnan 1978: fig. 37).

5. Although Russell and Jackson (this volume) report figurines with musical instruments in the ceramic inventory of Cerro Mayal, none represents a female drummer.

6. Jar-shaped drums are noted in Nasca art to the south, while cylindrical drums are represented in Chorrera culture to the north.

7. An example derived from the Lambayeque labretted drummer pieces was excavated at the Transitional site of Supe on the central coast (Kroeber 1925: Pl. 71f; Phoebe Hearst Museum of Anthropology, University of California, Berkeley 4-7734).

8. The set of labrets excavated by Guzmán and Casafranca is unpublished and has not been available for study.

9. A collection of labrets acquired by the Museo del Banco de Crédito del Perú was associated with Lambayeque metal artifacts. This set is very similar in form, materials, and size to the other two collections excavated in the Piura-Chira region.

10. Andrew Nelson (personal communication, 1999) informs me that a Lambayeque female cranium in the Museum für Völkerkunde, Berlin, shows this type of deformation. The interment was excavated by Heinrich Ubbelohde-Doering at Pacatnamú, Jequetepeque Valley.

11. "The women had pierced lower lips, and in the perforations they wore rounded gold and silver labrets that covered the openings; they could remove and insert them as they pleased."

12. In comparison with the other Lambayeque labretted females, who have a tight-fitting cap or hood, this figure's hair spills loose over her shoulders, very much like the Moche examples. The fact that the bottle-spout emanates from her head gives it a confusing appearance.

BIBLIOGRAPHY

Amaro Bullón, Iván
1994 Reconstruyendo la identidad de un pueblo. In *Vicús*, by Krzysztof Makowski, Christopher B. Donnan, Iván Amaro Bullón, Luis Jaime Castillo, Magdalena Diez Canseco, Otto Eléspuru Revoredo, and Juan Antonio Murro Mena, 23–81. Colección Arte y Tesoros del Perú. Lima.

Castillo, Luis Jaime, and Christopher B. Donnan
1994 La ocupación Moche de San José de Moro, Jequetepeque. In *Moche: Propuestas y perspectivas* [Actas del primer coloquio sobre la cultura Moche, Trujillo, 12 al 16 de abril de 1993], ed. Santiago Uceda and Elías Mujica, 93–146. Travaux de l'Institut Français d'Etudes Andines 79. Trujillo and Lima.

Cordy-Collins, Alana
1994 Lambayeque. In *Andean Art at Dumbarton Oaks*, ed. Elizabeth Hill Boone, 1: 189–222. Pre-Columbian Art at Dumbarton Oaks 1. Washington.

1996 Los entierros de Illimo: Analysis osteológico preparado para Walter Alva, Director del Museo Arqueológico Nacional Brüning de Lambayeque, Lambayeque. Report submitted to the Museo Arqueológico Nacional Brüning de Lambayeque.

1999 La sacerdotisa y la ostra: ¿Queda resulto el enigma del Spondylus? In *Spondylus: Ofrenda sagrada y símbolo de paz* [exh. cat., Museo Arqueológico Rafael Larco Herrera], 17–33. Lima.

Disselhoff, Hans Dietrich
1969 Seis fechas radiocarbónicas de Vicús. *Verhandlungen des 38. internationalen Amerikanistenkongresses* [Stuttgart-München, 12. bis 18. August 1968], 341–345. Munich.

Donnan, Christopher B.
1978 *Moche Art of Peru: Pre-Columbian Symbolic Communication* [exh. cat., Museum of Cultural History, University of California]. Los Angeles.

1992 *Ceramics of Ancient Peru* [exh. cat., Fowler Museum of Cultural History, University of California]. Los Angeles.

Donnan, Christopher B., and Luis Jaime Castillo
1994 Excavaciones de tumbas de sacerdotisas Moche en San José de Moro, Jequetepeque. In *Moche: Propuestas y perspectivas* [Actas del primer coloquio sobre la cultura Moche, Trujillo, 12 al 16 de abril de 1993], ed. Santiago Uceda and Elías Mujica, 415–424. Travaux de l'Institut Français d'Etudes Andines 79. Trujillo and Lima.

Guzmán Ladrón de Guevara, Carlos, and José Casafranca Noriega
1964 *Vicús*. Comisión Nacional de Cultura, Informaciones Arqueológicas 1. Lima.

Iribarren Charlín, Jorge
1950 *Notas preliminares sobre la dispersión continental de un adorno del labio en los pueblos aborígenes, el bezote, labret, o tembetá*. Ovalle, Chile.

Kroeber, Alfred L.
1925 *The Uhle Pottery Collections from Supe*. University of California Publications in American Archaeology and Ethnology 21 (6): 235–264, plates 70–79. Berkeley.

Larco Hoyle, Rafael
1965 *Checan: Essay on Erotic Elements in Peruvian Art*. Geneva.

de Lavalle, José Antonio
1989 (Editor) *Lambayeque*. Colección Arte y Tesoros del Perú. Lima.

Moseley, Michael E., and Alana Cordy-Collins
1990 (Editors) *The Northern Dynasties: Kingship and Statecraft in Chimor* [A Symposium at Dumbarton Oaks, 12th and 13th October 1985]. Washington.

Munizaga, Juan R.
1976 Intentional Cranial Deformation in the Pre-Columbian Populations of Ecuador. *American Journal of Physical Anthropology* 45 (3, part 2): 687–694.

Petersen, George
1955 Adorno labial de oro usado por los Tallanes. *Revista del Museo Nacional* de Antropología y Arqueología 2 (2): 161–168. [Lima].

Purin, Sergio
1980 *Vases anthropomorphes Mochicas des Musées Royaux d'Art et d'Histoire*. 2 vols. Corpus Americanensium Antiquitatum. Brussels.

Rucabado, Julio
in press El período Transicional en San José de Moro. In [Actas del II coloquio sobre la cultura Moche, Trujillo, 1 al 6 de agosto de 1999], ed. Santiago Uceda and Elías Mujica. Travaux de l'Institut Français d'Etudes Andines. Trujillo and Lima.

Vega, Juan José
1988 Las capullanas. In *Los Tallanes*. Trujillo.

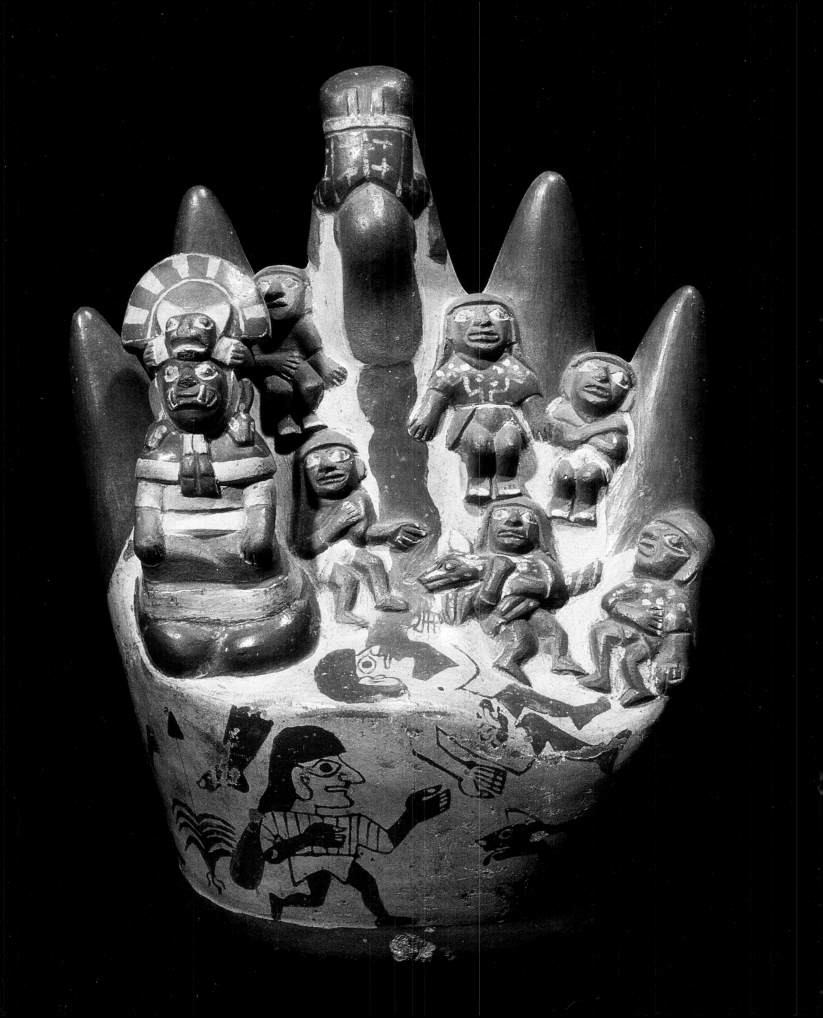

TOM D. DILLEHAY
University of Kentucky

Town and Country in Late Moche Times: A View from Two Northern Valleys

The Moche people brought new heights of creativity and complexity to Peruvian civilization during the fourth through eighth centuries A.D. Social and political organization advanced, with the proliferation of large monuments and urban settlements and with the appearance of sophisticated arts and technologies. Unlike many other complex Andean societies, the Moche exhibited varying degrees of political centralization, hierarchy, and heterarchy (situational and temporary ranking of different groups which are usually unranked) throughout their long history. The bulk of information about this history is drawn from architecture, mortuary practices, and the visual arts. Recently, extensive field surveys and excavations have begun to yield new data on successive settlement patterns, political formations, social constructions, and major cultural transformations. Yet Moche cultural transformations have unfortunately been kept out of the larger theoretical debate in anthropology about the rise and fall of early complex societies. This is in part because they are not well documented archaeologically, and in part because we know little about the political and economic structures of Moche culture.

To date, three competing models for explaining cultural transformations in Moche history have been proposed: (1) environmental catastrophe (Moseley, Feldman, and Ortloff 1981; Moseley, Satterlee, and Richardson 1992); (2) internal social and economic dynamics (Bawden 1995, 1996; Castillo and Donnan 1994a, 1994b; Donnan and Cock 1986, 1997; Schaedel 1951, 1966, 1972; Shimada 1986, 1990, 1994a, 1994b; Wilson 1988); and (3) invasion by foreign groups (Schaedel 1951; Shimada 1994a). With the exception of archaeological surveys in the Moche and Santa valleys (Billman 1996; Donnan 1973; Wilson 1988) and the Zaña (Dillehay, Eling, and Rossen 1989; Dillehay and Netherly 1977, 1979, 1984; Dillehay and Rossen 1989a, 1992), Jequetepeque (Dillehay and Kolata 1997; Dillehay and Rossen 1989b; Dillehay et al. 1998; Eling 1989; Eling, Dillehay, and Rossen 1990), and Chicama valleys (Gálvez and Briceño, this volume; Russell and Jackson, this volume), the reconstruction of Moche history has relied primarily on iconography (see Shimada 1994a), mortuary practices (Donnan 1995; Donnan and Mackey 1978), or excavation of elite architecture in large urban settlements (Quilter, this volume). Yet the two sources of data, surveys of the countryside and studies of monumental urban remains and portable arts, need to be studied in tandem. The archaeological history needs to be tempered by more information excavated from communities in the countryside and from environmental studies of changing landscapes, not just from urban elite architecture and commodities. Such an approach provides a much more comprehensive evaluation of our interpretive models and enhances the utility of the iconographic, mortuary, and

Moche modeled vessel with a representation of sacrifice in a mountain setting
Museum für Völkerkunde, Berlin (VA 48095)
Photograph by Steve Bourget

259

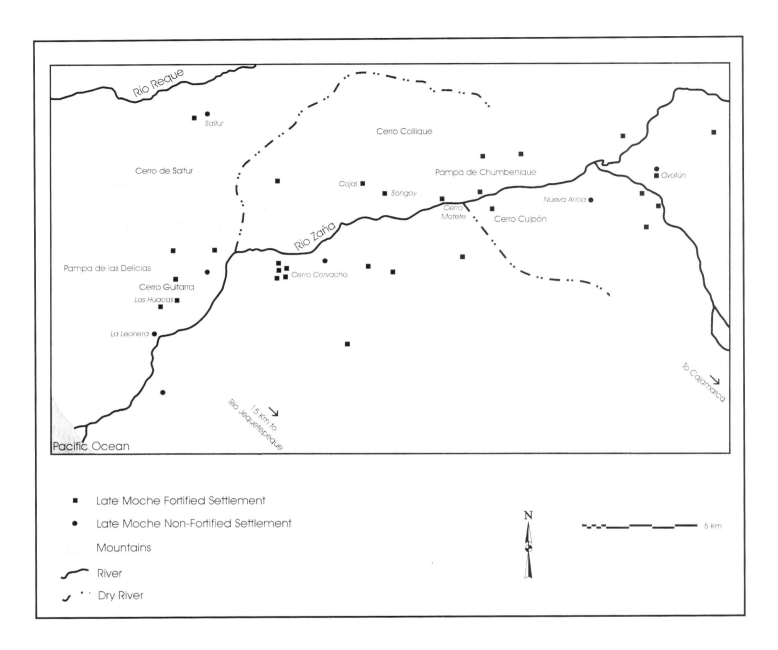

1. Map of the lower and middle Zaña Valley, showing location of major Moche IV and V sites

architectural data. One gains a broader and richer sense of a culture's history when one considers both the urban setting and the countryside.

Many cultural changes in Moche history may have been accelerated by environmental stress and/or by internal and external social events, either of which could have led to political turmoil and realignment, urban collapse and rural reorganization of the economy. Despite periodic crises at such large urban sites as Moche (Uceda, this volume), Pacatnamú, Pampa Grande, Batán Grande, and Galindo (Bawden, this volume), many communities in the countryside evidently continued to survive, most likely through significant restructuring of social organization and intercommunity relations and through shifts in their domestic and political economies. When societies "collapse" (Tainter 1988; Yoffee and Cowgill 1988), however, it is the political structure and the economy that ceases, not the populace at large.

In this paper, I am concerned with the political nature of Moche urban and countryside communities in the Zaña (fig. 1) and Jequetepeque (including the Río Seco) (fig. 2) valleys during the Moche IV and V periods

2. Map of the Jequetepeque and Río Seco or Chamán valleys, showing Moche sites

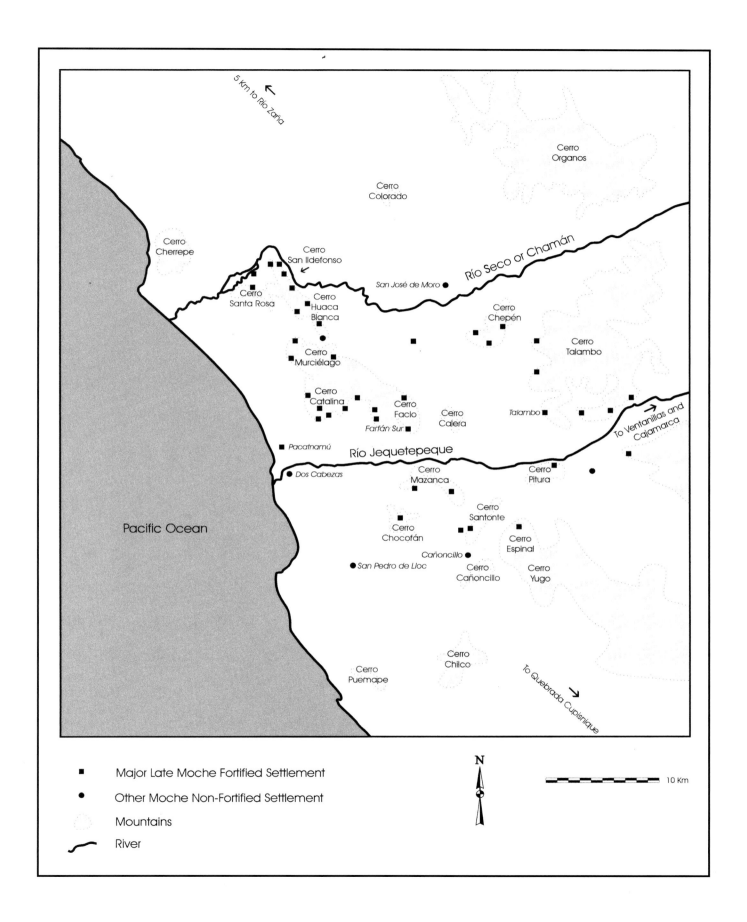

Major Late Moche Fortified Settlement
Other Moche Non-Fortified Settlement
Mountains
River

N

10 Km

and with the nature of changing environmental and settlement conditions in these valleys. I have two specific and interrelated issues to discuss. First, in the lower and middle sectors of these valleys nearly every hilltop adjacent to a Moche V community is associated with a fortress or fortified settlement. This contrasts sharply with the later Chimú period, when such constructions are far less common. This would suggest that there was a great deal of internal conflict in late Moche times and leads me to question the nature of the late Moche political system. Was the north coast truly a highly centralized state in Moche V (or even earlier) times, as some researchers have postulated (Keatinge 1977; Wilson 1988)? Or was it occupied by several powerful inter-valley polities or factions competing for control over peers and occasionally forming a federation that had a shared elite iconography and ideology, as others have contemplated (see Bawden this volume, and 1996; Uceda and Mujica 1994)? If the northern valleys from Lambayeque to Chicama constituted a single Moche state, it was clearly a very different polity from the later powerful Chimú state. The few Chimú fortresses are located at key positions to defend the valley, not specific communities in the countryside.

Second, archaeologists have long realized that major social transformations occurred in the final phases of the Moche culture (c. A.D. 600–750) and have postulated that environmental and economic stress may have been important factors in this process (Donnan 1997; Eling 1987; Moore 1991; Moseley 1978; Moseley, Feldman, and Ortloff 1981; Moseley, Satterlee, and Richardson 1992; Schaedel 1985; Shimada 1978, 1985, 1994b; Shimada et al. 1991). These scholars, for the most part, have interpreted local developments as part of a broader regional process of political conflict, disruption, and reconstitution. In doing so they have made a significant contribution to our understanding of the ideological changes that occurred at the apex of late Moche society. Elites evidently strove to maintain their central power at a time of growing vulnerability caused by social and/or environmental stress. The wider subject population, however, less visible in the archaeological record, was equally affected by periods of widespread change. Indeed, in many cases the responses of these people to stress and the political

agendas they had with and apart from ruling elites may have been deciding factors in directing the course of late Moche history. Although not always explicitly considered by archaeologists, these aspects of late Moche history have important implications for a fuller understanding of social dynamics, political organization, environmental stress and competing ideologies.

Competing Ideologies

Ideological beliefs are complex sets of ideas that influence and guide people's actions. Social theorists in anthropology have traditionally taken a strict functionalist approach to preindustrial complex societies, believing that people's beliefs and actions were largely controlled by ruling elites (for example Bourdieu 1977; Braudel 1973; Hebdige 1979; Rossignol and Wandsnider 1992; Therborn 1980; Thompson 1990). Inherent in Andean settlement pattern and social studies is the idea that small groups of powerful rulers created ideological systems and public rituals that affirmed their hierarchical power over commoners. Recent theorists (for example Bawden, this volume), however, have turned their attention to the ideologies of the commoners —ideologies that often contradicted and competed with those of ruling elites.

Due to this relentless functional interpretation of hierarchical political structures and settlements, most Andeanists have reduced the richness and cultural significance of late Moche ideology exclusively to elite control. Elite material culture shows formal similarities throughout the Moche region. Most specialists assume that this indicates a uniform ideological power among elites, and thus reflects even further a highly centralized state organization (see Bawden 1995, 1996; Donnan 1976). But as I have discussed before (Dillehay 1976, 1979, 1987), this may not always have been the case in the Andes. There were probably times when competing ideologies existed at all levels of Moche society, with some operating among elites and others operating between urban and rural communities. In other words, a centralized state society operating under a single ideology may have been the exception, not the rule, and commoners may have had more independence than previously recognized.

Garth Bawden is one of few Moche scholars to recognize the potential independence of commoners. He states in his book *The Moche* that commoners "...as the substratum to a succession of native dominions...had long nurtured the kin-based structural foundations of Andean social life despite the endeavors of systems like that of the Moche [elite] to subordinate this to a more hierarchical and exclusive political system. Ultimately, the commoners with their primary conception of social order outlasted all of the imposed political systems" (Bawden 1996: 338).

Perhaps Andeanists do not study less powerful ideologies and practices because they focus most of their work on the ceremonial center, a place where the dominant ideology is housed and sustained. Other or competing ideologies are not represented at these centers because the elites controlling them simply did not permit their existence. To detect other ideologies, we must look elsewhere—to secondary or smaller settlements in the countryside. For this reason, the presence of numerous fortified settlements in the Zaña and Jequetepeque valleys intrigues me. If the late Moche were a unified state society, why were so many fortresses necessary within their own boundaries? I do not at present have all of the answers to this question, nor do I understand all of the social and environmental variables involved. Nonetheless, I believe that at certain times and in certain places, major environmental stress triggered or accentuated fissures in either internal or external relations, which in turn produced political turmoil and rapid change. This position does not represent environmental reductionism but admits to the potential influence major natural events may have on the decisions made by societies to respond to stress.

Centralization, City, and Countryside

To date our ideas of urban societies in the precolonial Andean world have focused mainly on the centralization of services and functions within cities (or "ceremonial centers"), which have been conceived primarily as bounded space physically manifested in a concentration of public and private architecture and other urban infrastructures. As a result, we have tended to perceive all hinterland or countryside sites as rural or peasant communities, as if they had one rationality and no ideology, internal economy, and social policy of their own. In other words, each peasant community just waited for another urban ruler to come along and give it orders, the premise being that commoners cannot survive as acephalous units.

Yet, when we look beyond the city to the countryside, we see other interactions not only linked to the city itself but to other sectors of society and to the land in a way the city is not (Anders 1990; Bawden 1983; Conrad 1990; Crumley and Marquardt 1990; Isbell and McEwan 1991; Kolata 1990, 1991, 1993, 1996; Moseley 1982; Rapoport 1982; Schaedel 1966, 1972; Shimada 1994b; Topic 1982, 1990, 1991). For instance, countryside settlements have relations with other non-urban communities and distant lands independent of an urban center. Also, the city is heavily dependent on social and economic forces in the countryside. When viewed from this perspective, the city cannot be disentangled from dynamic social processes within the countryside, such as changing patterns of economic growth or recession, environmental stress affecting economic production, fluctuations in the consumption needs of dispersed human populations, or periodic abandonment and reuse of strategically located rural settlements. In short, the city is permeable and often emulates rural social structures. Some rural communities may operate outside the formal sphere of influence of the city. That is, hinterland communities may have had a life of their own, especially in times of demise of large, centralized political authority when the populace at large continued to survive. During periods of demise (or growth), there may even have been different, but complementary economies associated with elite and hinterland communities. In other ancient societies, scholars have stressed the importance of distinguishing between economic management by elites and management by local communities, suggesting that separation of rural communities from elite economic control can engender a heterarchical rather than a hierarchical social system within developing polities. Oscillations in the power of late Moche provincial lords may reflect this pattern.

This is not to deny the centralizing power nested in urban settings. Urban areas such as

Cerro Corvacho, Songoy, and Oyotún in the Zaña Valley (fig. 1) and Pacatnamú and San José de Moro in the Jequetepeque Valley (fig. 2), undoubtedly altered the relationship of the lower valley population's social and physical environment in fundamental ways (Kosok 1965). The presence of these sites meant that populations were probably differentiated spatially by social status, economic activity, and political and ideological practice. Social interdependency among these differentiated populations would be intensified by the creation or acceleration of interlocal economic, political and ideological linkages. Finally, substantial environmental change would be generated by stimulating rapid increases in collective consumptions of renewable and nonrenewable resources.

The point here is that most studies have failed to take into account the social permeability of city boundaries, the pervasive emulation of rural social structures in the organization of the city, the interaction between both urban and rural communities, and changing physical environments. A more complete picture of Moche history can be formed by conceiving of these cities not merely as centralizers of populations, infrastructures, services and functions, but rather as dynamic and highly differentiated processes of social and environmental relations. In addition, the hinterland communities should be viewed as having potential independence apart from the city center. We also need to recognize that major environmental change, such as excessive drought and flooding (see Barber and Chavez 1983; Bull 1991; Craig and Shimada 1986; Diaz and Markgraf 1992; Moore 1991; Nials et al. 1979; Philander 1989; Sandweiss et al. 1996; Thompson and Moseley-Thompson 1989; Uceda and Canziani 1993), periodically altered the conditions of interdependency between urban and rural populations.

Research in the Zaña and Jequetepeque Valleys

Between 1977 and 1995, the Zaña-Niepos-Udima Project located eighty-two Moche period sites in the lower, middle, and upper Zaña Valley (Dillehay and Netherly 1977, 1979, 1984; Dillehay, Rossen, and Eling 1989). Although the survey was systematic, it was not fully comprehensive in the lower and middle sectors, concentrating on large and intermediate scale habitation, fortress, ceremonial-civic, and cemetery sites dating primarily to the Moche IV and V periods (fig. 1). Among a number of other remains located and mapped during the survey were roads and other features dating to these periods.

The Zaña Valley settlement patterns differ from those in the Jequetepeque Valley to the south (fig. 2) and the Lambayeque Valley to the north in several ways. Unlike the Jequetepeque Valley, a moderate Moche IV and V presence characterizes the late Moche occupation in the Zaña Valley. Large and intermediate settlements are located at La Leonera, Las Huacas, Cojal, Cerro Corvacho, Songoy, Cerro Motete, Cerro Culpón, Campaña, and Nueva Arica. Unlike other north coast valleys, a heavy upper and upper-middle valley Cajamarca presence was recorded, apparently limiting the expansion of Moche populations beyond Oyotún in the middle valley (Calabrese 1993). A few Moche IV and V sherds are found at *huacas* (monumental platform mounds) in these valley sectors, but they are associated with intrusive Moche burials, not with domestic sites. Another difference is that the Moche IV and V occupations in the Zaña Valley are not as large or as extensive as those in the Lambayeque and Jequetepeque valleys. My impression is that the Zaña Valley served as a buffer zone between these two larger and presumably more powerful valleys, and between these valleys and the adjacent Cajamarca highlands.

Prior and ongoing research projects in the lower Jequetepeque Valley (fig. 2) have begun to establish chronological and contextual control for understanding Moche V mortuary practices, dietary regimes, economic relations and social development. Luis Jaime Castillo's and Christopher Donnan's investigations (Castillo, this volume; Castillo and Donnan 1994a) at San José de Moro have revealed elite burials in both residential and ceremonial contexts. At Dos Cabezas, a massive early Moche complex located south of Pacatnamú, Christopher Donnan's research has brought to light a wide variety of archaeological materials that, along with data from San José de Moro and other sites, demonstrates that there was a significant increase in external contact with highland Cajamarca and central coast polities (for example, Nievería) in a

3. Fortified hillside settlement dating to the late Moche and Chimú periods, Cerro Corvacho, lower Zaña Valley. Chimú compound is in the background

local social context of fragmented political structures.

Donnan's previous work at Pacatnamú is significant (Donnan and Cock 1986, 1997; see also Hecker and Hecker 1982, 1985, 1991; Keatinge 1977; Ubbelohde-Doering 1983) because he defined the major internal structures of the site, and identified a number of activity areas through excavation of elite and non-elite buildings (Donnan and Cock 1986; Gumerman 1991, 1994). According to Donnan, Pacatnamú experienced an intensive occupation in the Moche II–III Period, and then again in the Moche V, Lambayeque and Chimú periods, which resulted in construction of the majority of the large, terraced and ramped mounds at the site (Donnan and Cock 1986; 1997; Keatinge 1977). Donnan and others at Pacatnamú have suggested that the site achieved early prominence as a religious center and, by late Moche times, was transformed into an extensive "sacred city" and, possibly a pan-north coastal center of religious pilgrimage (Donnan and Cock 1986; Keatinge 1978; Schaedel 1985).

The surveys of Eling (1978, 1981, 1987), Hecker and Hecker, and the author (Dillehay and Rossen 1989b) in the lower Jequetepeque Valley collectively recorded 192 sites dating to the late Formative through the Inca periods. Although none of these projects attempted a systematic, full-coverage survey in all physiographic zones of the lower valley, they are highly valuable for locating major settlements and recording agricultural features such as irrigation canals, aqueducts, and fields.

Recent archaeological work by the author and Alan Kolata in the Jequetepeque Valley (Dillehay and Kolata 1997; Dillehay et al. 1998; Eling, Dillehay, and Rossen 1990; see also Ravines 1981) concerns long-term human and environment interaction on the north coast by developing an integrated multiphase research strategy. During three recent field seasons in the lower Jequetepeque Valley, we found 322 Moche period sites. The sites date to the Moche II–V periods. Sherds of the Moche IV period are rare, with the majority of the sites pertaining to the Moche V period (fig. 2).

Collectively, we have recorded a total of 412 Moche sites spread over portions of the Zaña and Jequetepeque valleys. Site types include large Moche towns, ranging from fifty to eighty hectares, (for example Pacatnamú,

4. Fortified hilltop settlement (PV-39-125) dating to the late Moche period, lower Jequetepeque Valley

San José de Moro, Cerro Corvacho, and Cerro Songoy), intermediate-scale towns (twenty to forty hectares in size), and small villages and farmsteads. Agricultural fields and canals, fortresses, cemetery plots, and miscellaneous features were also recorded. Most of the habitation sites are small to intermediate in size and provide a highly detailed view of Moche activity in the countryside.

In looking more closely at the regional settlement pattern data, it appears that a number of large to intermediate-size urban centers were occupied only intermittently at various points in Moche history. These include Cerro Corvacho, Songoy, and Oyotún during the Moche IV and V periods in the Zaña Valley, and Pacatnamú, San José de Moro, and possibly San Pedro de Lloc during the Moche V period in the Jequetepeque Valley. The social and economic status of these settlements is known almost exclusively from limited survey and excavations at Pacatnamú and San José de Moro. It is not known whether Pacatnamú was functionally more complex than other late Moche settlements or just larger, or just different. We also do not know the relationship between these larger sites and smaller and intermediate-size settlements.

Numerous large or intermediate-size walled towns also exist. Most major towns seem to have been walled complexes of tightly compacted stone and adobe brick houses. These sites appear to have grown substantially during the Moche V period. The large walled towns may imply some central planning and design, but most of the small to intermediate size settlements do not adhere to rigid plans; rather, they conform to local hillside topography. Sites without monumental architecture show considerable variability. I would suggest that the lack of uniformity in layout at the intermediate and small communities indicates that they were built at different times and/or on local initiative, not under the direction of a central authority.

The survey has also documented massive mountaintop forts, fortified hilltop communities (figs. 3–5), and agricultural fields. Most of these are associated with walled, intermediate-size communities located at strategic points in the valley. These defensive positions are important because they have never been reported in detail for a late Moche north coast population, although Wilson (1988) has reported them in the Santa Valley. The fortified hilltop communities are between

5. Fortified hilltop settlement (PV-39-286) dating to the late Moche period, near Cerro Cañoncillo, lower Jequetepeque Valley

twenty-five and forty hectares in size; the mountaintop forts range between twelve and twenty hectares.

There are many methods of defending a community that are difficult to detect archaeologically. The absence of defensive walls at some sites does not mean that there was no armed conflict. Sites such as Pacatnamú were difficult of access due to the agglomeration of walls and structures, with entry only via limited roads; such layouts can be seen as functionally defensive.

There also are 'huaca communities,' or relatively circumscribed settlements around one or two principal, presumably religious, platform mounds. At the San Pedro de Lloc site and elsewhere there are substantial settlements directly associated with one or two huaca complexes. Although sectors of these communities may have been partly seasonal and associated with maritime and/or agricultural activity, administrators, craftpersons, and others may have resided there permanently.

Turning to small countryside villages and towns, we found many small settlements representing part-time or full-time farmsteads. These sites range in size between 0.25 and 8 hectares with an average size of approximately

2.5 hectares. In most areas these sites are located immediately adjacent to low hills, fortresses, and the valley floor.

Extensive areas of ancient agricultural fields, canals, aqueducts, and furrows were recorded by Eling's survey of the lower Jequetepeque Valley (Eling 1989). Most of these are located around Cerro Faclo, Cerro Catalina, and Cañoncillo. Similar fields exist in several areas of the lower Zaña Valley but they are not as extensive as those in the Jequetepeque Valley. Fragments of fields are also found near the desert margin on either side of both rivers throughout the lower and middle portions of the valleys. Many of these fragments are associated with lateral canals and intermediate and small-scale settlements located at the base of large hills and mountains, especially in the Cerro Corvacho and Songoy areas of the Zaña Valley and in the Cerro Chepén area in the Jequetepeque Valley.

It is difficult to date all sites and to determine their sequence of use and abandonment, as north coast chronology is still poorly understood. The transition between Moche IV and Moche V is not well documented in any valley. In general, we suspect that during

this time the southern territories (the Virú, Chao, and Santa valleys) ceased to participate in the Moche interaction sphere farther north (see Castillo and Donnan 1994a; Donnan and Cock 1986, 1997). In the Moche Valley, this period is marked by the collapse of the capital at the Huaca del Sol and the Huaca de la Luna, and a notable population shift inland. A new capital arose around A.D. 600–650 at Pampa Grande in the Lambayeque Valley. The areas in this study lie between these northern and southern capital valleys.

Our surveys in the Zaña and Jequetepeque valleys show that the degree of urbanization increased over time in the late Moche period, although at individual sites increased urbanization was not a constant. The sites waxed and waned, as evidenced by examination of numerous stratigraphic cuts showing intermittent periods of site use and abandonment. Although we have not carried out extensive survey in the middle sector of the Jequetepeque Valley, our cursory inspection of the area shows most sites being small to intermediate in size, and without large mounds. One exception is Ventanillas, which dates to the early Moche period. Also notable is the scant presence of Cajamarca sherds in the Jequetepeque Valley in comparison to the Zaña Valley.

The situation is more complex in the Zaña Valley, where Early Intermediate and Late Intermediate period Cajamarca settlements are found in the middle valley (Calabrese 1993; Dillehay and Netherly 1984). This presence probably deterred a stronger Moche or Lambayeque expansion upvalley. Also different in the Zaña Valley is the presence of Moche IV and V, particularly in the middle valley where Moche V is ubiquitous. I suspect that this indicates waning of Moche power in late Moche IV times and explains why Moche V is found primarily in the lower valley, especially in the Jequetepeque Valley. To date, evidence for a Moche IV occupation of the Jequetepeque Valley has been scarce, leading some scholars to suggest that it was entirely absent. Our survey rarely found Moche IV materials in lower valley sites, although a few were encountered in the middle valley. Confirmation of a Moche IV presence in the lower valley may be achieved through greater attention to domestic contexts, where utilitarian wares of the Moche IV period may exist. The

two contexts often contain different ceramics and thus different chronologies.

Settlement Distribution and Environmental Stress

There is good archaeological and geological evidence in both the Zaña and Jequetepeque valleys to demonstrate the impact of major environmental events on late Moche society. For instance, the Moche V phase at Pacatnamú was marked by El Niño (ENSO)[1] flooding that may have spurred the site's demise, or at least destabilized its political economy and damaged its status as an important center (see Donnan and Cock 1986, 1997). This same ENSO event is recorded at Moche V sites outside the valley, including the Galindo site in the Moche Valley (Bawden 1996) and the Pampa Grande site in the Lambayeque Valley (Shimada 1994a). A later episode of massive flooding is documented at the sites of Batán Grande and Huaca Chotuna in the Lambayeque Valley to the north.

Our research at several localities in the Zaña and Jequetepeque valleys has confirmed the impact of numerous ENSO events. For instance, runoff from El Niño events triggered heavy flooding, soil erosion or mass wasting of unconsolidated sediments in these locations. Although ENSO-driven rains probably did not persist for long periods in any one area, stratigraphic cuts at the Chimú sites of Huaca A in Farfán Sur and Cañoncillo, and several small to intermediate-scale late Moche residential sites in selected areas of the lower Zaña and Jequetepeque valleys exhibit thick (20–80 cm) wash deposits of colluvial silt and fragments of adobe walls that abruptly and severely interrupted occupational activity. These events also had a negative impact on agricultural production and possibly on the continuity of political leadership in some areas. In addition, sediment release signatures of slack-water flood deposits forming beds 30–85 cm thick were observed in several natural drainage cuts throughout the study area, but particularly at Cañoncillo and the desert plains between Pacatnamú and Cerro Faclo, where dissected, steep topography facilitated rapid discharge. These buried deposits often contain Moche V and Chimú sherds indicative of outwash events that date sometime after A.D. 600.

Although several studies report the presence of ENSO events in major urban settlements, they provide no evidence for its impact on communities in the countryside.

In some localities, outwash events associated with canals, agricultural fields, aqueducts and rural settlements serve as temporal indicators, as well as indices of highly localized and differential land use patterns by communities that were evidently aware of the potential destructive impact of periodic flooding. These communities avoided severe impact by locating some settlements and agricultural infrastructure in areas less susceptible to rapid runoff and destructive outwash. Although the physical damage from ENSO events was widespread throughout the study area (Kolata and Dillehay 1998), impacts were highly localized and varied significantly in terms of effect, depending on local hydrology, slope and topographic characteristics.

Periods of extreme aridity are also documented at several localities, as indicated by extensive deposits of aeolian sand and periodic abandonment and reuse of sites and agricultural features. Archaeological surveys in both valleys have revealed wind-blown deposits in the form of sand sheets and dune formations that choked irrigation canals, buried old agricultural surfaces, and covered residential surfaces. Extraordinary examples of massive dune fields are seen on the desert plain from the Pacific Ocean to Cañoncillo and Quebrada Cupisnique and across the plain from Rio Seco or Chamán to Cerro Colorado and the southern bank of the Zaña River. The evidence also suggests settlement shifts from one localized area to the other through time. What triggered these shifts is not yet understood, nor do we have a chronology sufficiently resolved to determine whether these changes were abrupt or protracted. Long-term social and/or environmental stress on all population sectors and their resources should be our focus, rather than any single climatic event.

Environmental perturbations elicited variable combinations of cultural responses that may have underlain the interactions of the wider populations in parts of both valleys. Environmental stresses were potential sources of economic opportunity and productive activity, as well as potential sources of conflict and alliance building. For instance, communities apparently responded to major ENSO events by relocating some settlements in landscapes less susceptible to flooding; others simply rebuilt damaged structures. Communities opportunistically expanded cultivation in the short-term to take advantage of ENSO-driven rainfall in low, wet areas. Individual farmers and communities may have responded to short-term drought through a variety of strategies, such as reducing the intensity or extent of irrigation, changing the composition of cultigens, or shifting production to heavier reliance on maritime or pastoral resources. Response to protracted environmental stress, on the other hand, may have required coordinated response on a regional scale by higher-level authorities or on a local scale by a network of allied groups. Such responses may have included massive population movement or intergroup conflict. The widespread abandonment of sites may indicate the effects of factional competition over choice land and/or environmental stress.

As repetitive environmental stress occurred over a prolonged period of time, we should observe a learning curve from late Moche through Chimú times as populations moved primary production zones away from vulnerable areas, reengineered irrigation systems and altered production strategies. We have preliminary archaeological evidence for such a curve in the lower Zaña and Jequetepeque valleys, where agricultural fields were systematically relocated away from areas of heavy water runoff to better drained land less subject to flood damage (Kolata and Dillehay 1998). The Chimú learned from their predecessors, as evidenced by comparing the Moche V and Chimú settlement patterns. The Chimú located communities in areas less susceptible to water damage and deposition of aeolian sand. The presence of late Moche settlements in all areas, even those highly susceptible to excessive dunation and/or flooding, may indicate one or more of the following things: (1) the late Moche population was larger than the later Chimú population and thus placed more pressure on the land; (2) the Chimú were much more centralized as a state-level society and could coordinate the placement of people in selected localities across the valley; and (3) Moche society was characterized by factional conflict, and communities adhered strictly to

their homelands regardless of differential and periodic environmental impact (see Conrad 1990; Donnan and Cock 1997; Eling 1987; Keatinge 1982; Keatinge and Conrad 1983; Moseley 1990; Topic 1990, 1991).

Political Configuration and Settlement Pattern

In returning to the question of political order in late Moche society, one important finding relates to population distribution. Richard Schaedel (1951, 1966, 1972, 1985) has long argued that the Moche populations were concentrated primarily in resource-rich large ceremonial centers such as Huaca de la Luna and Huaca del Sol, Galindo, Pacatnamú, and Pampa Grande. Only in recent years have there been enough fine-grain settlement data available to show that there was an uneven occupation of high-productivity zones, especially in the lower valleys. Rather than filling up primary agricultural zones in an optimal way, people in the countryside of both the Zaña and Jequetepeque valleys clumped together in certain areas, forming separate pockets of population, often divided by tracts of unoccupied and apparently rarely used land. Large urban settlements were geographically fixed localities, but were apparently abandoned from time to time, as shown at Pampa Grande, Túcume, and Pacatnamú. Our work in the Zaña and Jequetepeque valleys reveals that people in the countryside also tended to move over time, as indicated by periodic abandonment of all types of sites. This movement, however, may not be related to the ebb and flow of the major urban settlements.

More specifically, our work suggests that the location and layout of villages and household clusters changed markedly during the Moche V and, where evidence is present, Moche IV periods. Our preliminary test excavations at several sites in both valleys and our observation of more than eight hundred exposed stratigraphic profiles from habitation and agricultural sites, also indicate widespread and periodic abandonment and reuse of most sites. The impetus behind these changes is not well understood, although they presumably had something to do with new kinds of interactions taking place among local social groups. These new kinds of interactions may have developed in tandem with the rise and fall of the large urban settlements, and probably as a result of the long-term effects of sequential and at times converging climatic changes. The chronology of these changes is not well understood. Was abandonment gradual, planned with relocation within a short distance, or abrupt, with people relocating at greater distances? The spatial dimensions of these shifts are also unclear. Was there a shift from a pattern of rural occupation with small villages and towns to the growth of a few large urban centers such as Pacatnamú, San José de Moro and Cerro Corvacho? Further research may show that some intermediate-size sites were temporary defensive localities for populations living in the large centers. While this remains a possibility, the size and well planned layouts of the intermediate sites suggest that they were more than temporary solutions. In addition, hilltop fortresses, not well planned settlements, would suffice for temporary refuge from conflict.

Thus, the basic pattern of settlement in the Zaña and Jequetepeque valleys was of enclaves of small and intermediate-scale communities spread out across the irrigable parts of the plain. Each enclave of sites was within five kilometers of one of two major settlements, though we do not know if they were under the control of these settlements. Smaller sites were located at short distances from intermediate-scale settlements and were often found in linear patterns, following the major mountain and stream courses. Some of the enclaves were far enough apart that there would have been unfarmed land between them; others were located side-by-side, in which case occasional disputes over land and water almost certainly occurred, as suggested by the presence of hilltop fortresses and fortified settlements in these areas. Although the settlement pattern in Moche V times was strongly shaped by basic environmental and demographic factors, I suspect that it was also heavily influenced by a preferred way of living—a preference for the village life and highly localized administrative systems.

The same questions about location may be applied in the analysis of large urban sites. Access to irrigation water and to a hillside position on a steep precipice overlooking the valley floor or ocean were primary determinants

of site location and long-term economic success. Several of the larger sites were located along the major courses of the Zaña and Jequetepeque rivers. The rivers offered a relatively constant and manageable supply of water for simple, small-scale irrigation systems. Location adjacent to hill slopes provided immediate protection, as a view for advance warning of an approaching threat, and the height itself gives a tactical advantage in battle. The exception to this is Pacatnamú; here one finds a double defensive wall and a moat for protection.

The determining effects of some political factors are also evident. The large and intermediate-size settlements built in the Moche V period appear on major north to south roads. In fact, the shift of population to the lower Jequetepeque Valley in Moche V times, and the increased growth of the ceremonial complex at Pacatnamú, are probably best understood as a response to political factionalism and to certain environmental processes, not just internal or external relations. In Chimú and Inca times, regional political and economic factors were powerful determinants of settlement location, and the lower valleys were favored, largely due to local environmental and historical factors. The settlement configurations in the Moche V period in the countryside of the Zaña and Jequetepeque valleys are found next to adjacent hills rising above the valley floor, for defensive purposes. Even Cerro Corvacho, Songoy, Pacatnamú, and San José de Moro are at the junctures of environmental diversity, communication, and defense.

Armed Conflict

Armed conflict has often been cited as a powerful stimulus to population aggregation and, in many cases, urbanism in Peru and elsewhere. On the basis of archaeological evidence, however, it is difficult to measure the effects of military threats—real or perceived—on settlement patterns and composition in the two valleys. The immense mountaintop fortresses of Cerro Faclo and Cerro Guitarra, and the vast majority of hilltop fortresses associated with small and intermediate communities, surely reflect military threats. In the absence of written records, it is difficult to determine what hostilities, if any, took place, and whether they were in the form of raids, skirmishes, or organized campaigns. Some forms of combat and raiding, however, were surely a part of Moche V society, as implied by the need to locate hilltop fortresses immediately above settlements. We do not know whether the number of fortified sites in these two valleys is greater in comparison with other valleys, as the latter have not been systematically surveyed. The larger number of fortresses in the Zaña and Jequetepeque valleys may be a function of their location as a frontier zone between conflicting polities in the Lambayeque Valley to the north.

Based on the presence of numerous forts in both valleys, which appear to date primarily to the late Moche period, most likely Moche V, we can suggest that periodic conflict, if not organized warfare, was a crucial element in the culmination, maintenance, and demise of late Moche society. Conflict probably had two important effects: 1) people who were being attacked were forced to consider defensive operations; and 2) the attackers had to organize offensive operations. Large, densely nucleated population aggregates were advantageous for defense, but their concentrations of material wealth probably made them rich sources to plunder.

Community defense is evidenced in the massive stonewall and rock-cut ditches constructed in late Moche times at numerous sites, including Cerro Chepén, Cerro Faclo, and Cerro Guitarra. The concentrated wealth of the settlements they defended and the fear of being raided were probably strong enough stimuli to prompt the largest cooperative architectural effort of that period, the site on Cerro Faclo. The walls and ditches at Pacatnamú also suggest defensive efforts in the face of warfare. It is more difficult to identify with certainty weapons used in armed conflict. The prevalence of large storage vessels, probably for water and food, and sling stones and piles of rocks on defensive walls, however, supports the interpretation that these were defensive settlements and not ritual places. Enclosure walls are also present at other Moche V sites not associated with hilltop forts or fortified slopes. Each community with defensive works was a settlement with a concentration of portable material wealth, as evidenced by the presence of *Spondylus* shells, turquoise, stored food surplus, copper

jewelry, and other items of value. It is unlikely that attacks on these settlements were well organized campaigns, and there is little archaeological evidence to suggest that attackers destroyed any of the aforementioned communities.

The possibility of discontinuous or continuous armed conflict opens the door to a variety of social and ecological questions concerning political tensions and the spatial distribution of communities. Do the fortresses imply internal conflict among distinct communities in the valley, defense against intruders from beyond the valley, or simply fortresses associated with the gradual expansion of late Moche polities into northern frontiers? How do we reconcile the presence of fortresses with the depiction of violent encounters in art, and mortuary evidence of conflict? Does conflict increase in times of environmental stress? Are fortresses associated with external frontiers of the late Moche polity? Or are they associated with individual communities, suggesting factional competition both within and among local Moche communities? Did Moche rulers take advantage of factional competition to favor one side over another, as in succession wars? Did the emergence of elite centers in some places occur at the expense of elite centers in other places? Was the intensity of competition related to exchange, labor services, or to competition over patchy resource zones of high productivity and/or land less susceptible to environmental impact? Were the great monuments and burial rituals of the Moche, with their displays of consumption, designed to promote political careers and form factional solidarity? Do factions reflect informal, structured political situations without a centralized authority?

This latter point may be a bother to some Moche specialists, but perhaps we should consider that factionalism among competing elites or among communities at large is a potential aspect of any competitive process, and that competition and cooperation are potentially interlocking in almost every human activity. Factions may be alliances forged by individual leaders to increase their ability to compete. Such alliances would also have provided local Moche leaders access to resources outside their territory during times of famine or stress.

City and Countryside

I believe that as a result of environmental stress in certain zones, and as a result of periodic autonomy during moments of political collapse, countryside communities in the Zaña and Jequetepeque valleys anchored themselves to particular kinds of landscapes, and periodically to such large urban areas as Pacatnamú and San José de Moro. This attachment to the land probably relates to the rationality and social order of these communities and to competition among communities over high-productivity zones less susceptible to major environmental stress. I say this because I am not convinced that all outlying communities were under the permanent and strict control of elites residing at the large urban settlements. Instead, it may be that individual communities were vying for access to power in multiple ways and that large centers were not central but perhaps peripheral to a different level of interaction, one taking place between countryside communities. To understand this issue more we need to return to relations between rulers and the ruled and between Andean cities and adjacent hinterland populations.

Andeanists have worked under the assumption that large, intermediate and small settlements within a circumscribed valley represent a strictly nested political hierarchy. The hierarchical nature of Moche society throughout its history is taken for granted by most Moche specialists. This hierarchical model is based on three data sets: distribution and type of grave goods in burials; the representation of presumed social stratification in art; and settlement patterns. If mortuary goods truly reflect differences in access to wealth, power, and prestige, then the Moche were a hierarchically arranged society from A.D. 300. Moche specialists have tended to overlook the power relationships between local, less powerful elites and communities of the countryside. These relations are crucial, not only during times of power in the large settlements but during periods of demise and abandonment of those centers, when the population at large continued to survive and reconstitute a new social and economic order. As mentioned earlier, there may even have been separate spheres of social and economic interaction in late Moche times, character-

ized by coexisting elite and non-elite economic networks.

Furthermore, some specialists have argued that the warfare-related evidence is also proof that hierarchies existed. For example, the battles seen in Moche art, whether real or fictive, can be construed as illustrative of hierarchical tensions between different elites or communities. Considering the archaeological evidence for conflict, the difference in size between some large hilltop forts and the small settlements they often defended suggests that a larger administrative power might have been necessary to construct these forts for the security of several settlements. This arrangement may also speak of different polities or factions, however, and not of a centralized state system. Factionalism typifies organizations without clear hierarchical structures (Landé 1977). Periodically groups could have coalesced in the countryside to undertake major public works such as fortresses; yet no strong centralized political authority is necessarily required to oversee such major endeavors. In other words, late Moche populations may have had a heterarchical system whereby they ranked or unranked themselves according to different situations and power shifts. That is, some settlements were dominant in exchange, others in leadership during warfare, others in organizing religious events, and others in craft production. There was hierarchy but it may have been embedded in heterarchy. In this regard, mortuary patterns may reflect hierarchical arrangements within a community or within an allied group of factions or lords organized on a heterarchical level.

Once locally powerful rulers emerged in some places in the Moche V period, neighboring groups may have been displaced and absorbed into expanding complex polities, or they may have strengthened their position through ever increasing alliances. On the other hand, it is possible that local leadership was tenuous and confined to certain sectors of Moche society such as monument building and public ceremony. After all, local communities are quite capable of accomplishing major works without centralized rulers. Local communities are also quite capable of shedding the yoke of centralized powers. For instance, Shimada (1994a) argues that Pampa Grande violently collapsed by A.D. 700–750

due to an internal revolt against the elite. The postulated revolt at this important site may signal the role of outside powers in local affairs or the potential political power residing in local communities. Furthermore, at the Moche V site of Galindo (Bawden, this volume) commoners used the visual arts and architecture to recreate their social identities in the unfamiliar urban setting of the site, and probably to preserve their social cohesion in the face of any new political orders mandated by elites. Social tension between classes may here too have led to the collapse of social order at Galindo, according to Bawden.

Additional examples of the strengths of commoners are drawn from other valleys. In the case of the Moche and Chicama valleys, studied by Charles Ortloff (Ortloff, Feldman, and Moseley 1985), repeated coastal uplift progressively led to channel entrenchment. For proper function, irrigation canals then required water from higher-lying heads, located further back in the foothills. Canals also had to be protected from El Niño floods. Eventually the intervalley canal between the Chicama and Moche valleys was devised as a last resort to draw water from one valley across to the next via a 75 km long canal. Such an undertaking would have required massive labor investments over the course of a century, in addition to great engineering sophistication. The project was never fully completed. Ortloff offers a circumstantial argument that the large-scale planning in anticipation of changing circumstances, as well as the labor mobilization required, reflect a creative and effective bureaucracy that managed water policy across several centuries with a good grasp of complex environmental and engineering problems. Patricia Netherly (1984) sees this situation differently. She believes that with the exception of the intervalley canal, the one possible instance of state intervention, the role of the state may have been limited to providing labor or capital. The canal system could have been built and maintained by small-scale communities, as they were in the early colonial period.

In other early complex societies, it is clear that while a powerful central authority may have existed, it did not necessarily control all aspects of community life. For instance in ancient Egypt, massive labor conscription is

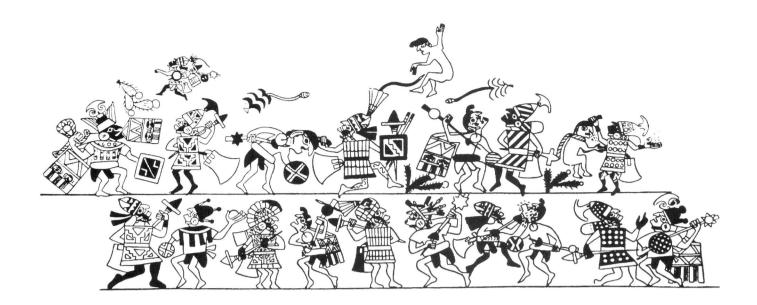

evidenced in the building of royal monuments, and the pharaoh symbolically guaranteed the annual flood cycle. The historical texts, however, extending back almost five thousand years and confirmed by nineteenth-century historical sources, show that there was no managerial bureaucracy controlling water resources (Butzer 1984). Instead, outlying local communities controlled them.

In summary, there is no doubt that there were long periods in Moche history when centralized authorities ruled from the city centers. My hunch is that during some periods of Moche history many commoners lived relatively free of state intervention, retaining some independence even during periods of strong centralized authority. How was this possible and sustainable? It may be as Bawden has noted: commoners found ways to express their social identity and to regulate certain politicoeconomic affairs on their own accord.

Moche History and Political Logic

An appropriate question at this point may be why do commoners cooperate with their own subordination and exploitation in noncoercive circumstances? Why do people revolt? Godelier's (1978) answer is that people only surrender autonomy in exchange for services of leaders recognized as owners of the supernatural means of production. This may be applicable to Moche, where there was a context of intense communal belief in ritually

controlled supernatural forces of awesome power. Secular political power developed much later—in this case probably in Chimú times. It is hard for me to accept interpretations of political authority which ignore the Moche politywide religious cult and its functional advantage. The functional efficiency of cult and religion in unifying people for military and other group efforts, for legitimizing rulers and class stratification, and for facilitating all other operations necessary to the polity seems apparent. What I question is how long the cults lasted, how long were the large *huacas* used, and how much power did they exercise? In other words, what was their social and spatial reach and their temporal *durée*? My hunch is that the monumentality and conspicuousness of the massive, highly decorated and expansive Moche centers were much more short lived than the archaeological record reflects, having been used periodically during many short periods of centralized authority over a long period of time. From an archaeological perspective, the massiveness of these sites and the imprecision of radiocarbon dating tend to overcomplicate these issues and make the *huacas* seem immortal and everlasting in Moche times.

The issue of the political and economic relationships embedded in ancient Moche culture is highly complex. No doubt the creation of monumental architecture and elaborate cults required an enormous flow of exotic items, such as gold, plumage, textiles

6. Roll-out drawing of a fine-line painting on a stirrup-spout bottle in the collections of Museum für Völkerkunde, Berlin
Drawing by Donna McClelland

OPPOSITE PAGE:
7. Modeled vessel with a representation of sacrifice in a mountain setting
Museum für Völkerkunde, Berlin (VA 48095)
Photograph by Steve Bourget

8. Drawing of a detail from the Berlin vase illustrated in figure 7
Drawing by Donna McClelland

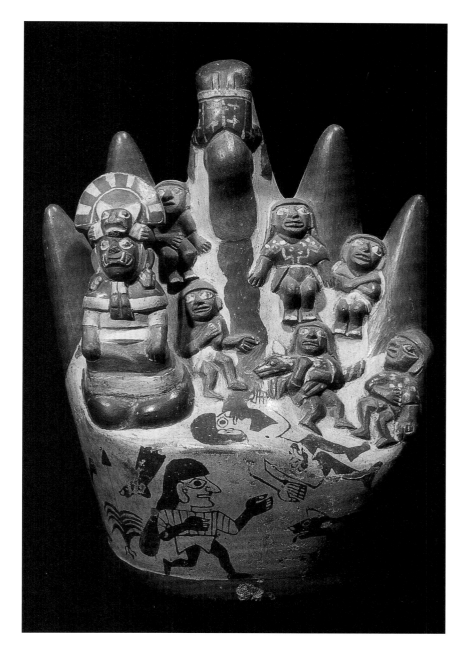

and so forth, on occasion. The labor costs were real and impressive, but the capital value must be regarded as largely symbolic in light of its tremendous value as a potent mechanism of social control. Most likely the majority of the Moche people lived within a complex web of economic relationships that extended across the polity, from corvée labor performed for the ruling elite by the ordinary populace, to small-scale exchange within the community in food and other commodities. Yet, it also is possible that many of the small fishing and agricultural sites scattered throughout the two valleys were most strongly linked to less powerful lords who resided at the intermediate sites and formed alliances among themselves.

While it seems clear to me that Moche society never unified into a state system in late Moche times, there is reason to believe that at least one major earlier attempt at unification occurred: at the Huaca del Sol and Huaca de la Luna in Moche II and III times. As described by Bawden (1996), the community at Huaca del Sol and Huaca de la Luna attempted to make it the political and religious center for the entire Moche culture. The degree of success achieved by this polity in establishing a distinctive, pervasive state religion remains a topic of debate. But it is reasonable to suspect, as Schaedel (1985) does, that the motivations of the Moche in establishing major alliances outside the valley were unification with, and hegemony over, the other Moche populations in the north. Instead of unification, however, these polities collapsed. There are many possible explanations for the collapse, but I suspect that one major reason is competition over choice land. This may have encouraged the development of warfare, both as a means of boundary maintenance and as a means of supplementing local supplies with booty and captives for sacrifice and slavery. Conflict over choice land (less susceptible to environmental impact) may have led to the initial establishment of local elites residing in intermediate-level sites rather than in one of the major power settlements such as San José de Moro or Pacatnamú. Wars could lead to unification, but they could also lead to internal weakening and outside invasion. Conquest may have played a major role in the early development of Moche society, while factional war may

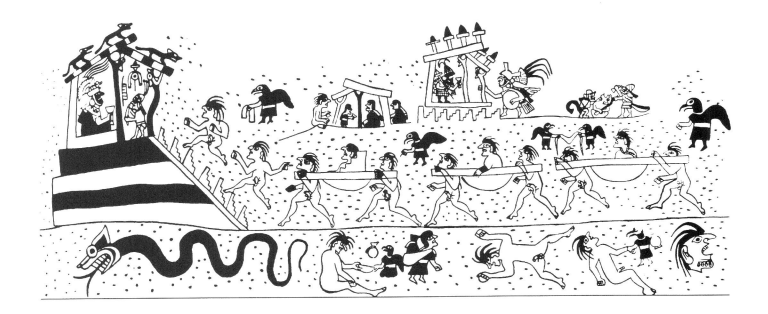

have been a major factor in the collapse of late Moche society.

Until recently, information on Moche conflict came almost solely from the exquisite fine-line paintings on modeled ceramics (figs. 6–9; Bawden 1996; Benson 1972: Berezkin 1978; Donnan 1976, 1995; Donnan and Mackey 1978). Most of the representations of conflict graphically portray individuals being mutilated, decapitated, and dismembered. Both sacrificial and combat scenes shown on these vessels have figured prominently in arguments about the nature of Moche armed conflict (Bonavia 1985; Castillo 1989; Donnan 1976; Moser 1974; Quilter 1990, 1997; Uceda et al.1994; Uceda and Mujica 1994) and thus political structure. Some researchers have even suggested that ritual battles still conducted today in highland Andean communities may serve as an ethnographic analogy for Moche combat (Topic and Topic 1997).

The iconography of late Moche vessels suggests conflict among neighboring rival populations or perhaps exclusively among competing elites within a centralized polity. Several Moche specialists have questioned whether these scenes represent real battles showing organized warfare or just ritualized or fictive combat among elite rulers (see Verano, this volume). Most seem to represent Moche-to-Moche combat, although a few may represent battle between Moche and foreign warriors. In Figure 6, for example, some of the combatants wear unusual headdresses (for example the figure on the extreme right of the lower register), suggesting that perhaps they are from a different cultural group. Other scenes appear to depict the ritual sacrifice of captive warriors taken from non-Moche polities.

Recent research has shown that many of these practices were actually carried out at Moche sites and that these practices must have formed an integral part of late Moche ideology and religion (Bourget, this volume; Verano, this volume). Yet we still do not know about any potential conflict outside of the ceremonial centers, or the broader political ramifications of the ceremonial sacrifices. Did battles occur within a centralized or noncentralized political context? Did they take place within an urban or nonurban setting? Only a few of the depictions show any clues as to the setting of the battles and rituals; Figure 7, for example, shows a ritual in a mountain setting. On the side of this vessel, a cactus plant is shown (fig. 8), suggesting a desert setting for the action. Did conflict consist largely of periodic raiding or skirmishing between factions or was it more of an all-out affair, leaving burned settlements and subjugated populations?

A number of scholars have pointed out that the iconographic evidence for armed conflict in the late Moche period suggests that it was an activity largely confined to competing

9. Roll-out drawing of a fine-line painting on a stirrup-spout bottle in the collections of the American Museum of Natural History, New York
Drawing by Donna McClelland

elites. The early Moche seem to have focused on the role of conflict as an instrument of conquest and statecraft; the late Moche seem to have focused on the capture, humiliation, and sacrifice of high-status individuals. Endemic conflict in late Moche times was evidently not simply over political conquest, but for booty, slaves, and sacrificial victims. The focus in Moche art appears not to be on places taken in battle, or even on subjugated elites, but rather on the treatment of the individual and occasionally their status or identity. Figure 9, for example, shows in great detail the arraignment of stripped prisoners. Thus, it may be that one purpose of conflict was to procure individuals for sacrifice. Furthermore, warfare was probably a highly stratified activity, fully integrated into ritual hierarchy and the cycle of festivals at ceremonial centers. Yet conflict may also have taken place in the countryside, either between competing elites of lesser power or between individual communities.

Whatever the situation may have been, the processes of political unification, hierarchy, or heterarchy must be seen within the context of the interaction of Moche sociopolitical models and shifting geopolitical situations. Local elites probably competed for power and prestige, pursuing personal and group interests, within this context. In doing so, they largely maintained the existing symbols (iconography and architecture, for instance) and models of the Moche, rather than replacing them and developing novel models of organization. These models probably retained much of their force and legitimacy in the transition period and later into the early Chimú period.

Epilogue

I am becoming weary of the Andeanist propensity to mold archaeological interpretations by analogy with centralized state models of cosmology and social organization. We archaeologists tend to treat the record in terms of a utopia of hierarchical relations between elites and non-elites. This certainly simplifies the interpretation of the archaeological record. I think, however, that we must consider a more complex interplay between two types of ideologies in the Andes. One is the preservation of local communities and their kinship-based rituals, which is important for the development of a viable peasant substratum. The second is the aggrandizement and emulation of lords. In late Moche times, communities may not have been just a place or a group of kinspersons living together in close proximity, let alone solidarity. There may have been an underlying cohesion not based just on kinship but a higher level: one related to institutionalized land tenure, which regulated access of individuals to land, especially in times of environmental stress and/or population pressure on resources.

To gain a clearer understanding of Moche history, it seems that we must study political authority and community structure as a language to formulate social obligations, that is as ideology, before taking for granted its effectiveness as a principle of political control and social organization. The aggregation of communities in certain areas of the countryside is important. The signals in archaeological variability and abandonment of both large and small settlements tell us of societies that at their very core are accustomed to high mobility—perhaps within set politico-economic structures and among specific geographic places, including more dispersed settlement in places less susceptible to environmental and social stress. That is, we have a countryside or peasant stratum engaged in a multiplicity of activities in a multiplicity of places, practicing a *culture of mobility*. There may have been a sense of community based on amorphous units fusioning and fissioning and perhaps vying for access to the large urban settlements when they were active.

But what does the late Moche archaeological record tell us? Two scenarios come to mind. First, late Moche society may have been more highly mobile and dispersed, and less urban or centrally placed, than we realized. The late Moche may also have been more defensive and economically minded, moving from locality to locality in an urban and rural "foraging" pattern, leaving behind a thin and redundant archaeological pattern. This pattern would likely have been associated with rapid resource depletion in some areas during periods of physical stress, forcing some groups to move and others to defend their positions. Second, these sites may represent the very end of the late Moche period, when the centers were abandoned, internal

conflict ensued, and people lived in defensive positions. To understand these and other possibilities, we need to study why some sites were briefly occupied, and how the periodically occupied sites relate stratigraphically to the centers. More work correlating sectors within sites and between sites will also help us to comprehend these scenarios. Yet, either model probably reflects a waxing and waning political system characterized by decentralization, collapse, and conflict. We need to explore not only the different ways in which, over a period of a few centuries, those with economic and political power and the necessary symbolic and cultural capital have attempted, physically and aesthetically, to appropriate and control the landscape, but also how these appropriations have been contested by those engaged with land in quite different ways.

NOTES

The author wishes to thank the Instituto Nacional de Cultura in Lima and Trujillo for granting us the opportunity to carry out archaeological research in the Zaña and Jequetepeque valleys. Particular thanks are extended to the following individuals who served as co-directors on different phases and areas of this long-term research project: Walter Alva, Cristóbal Campana, Patricia Netherly and Jack Rossen (Zaña Valley), and Duccio Bonavia and Alan Kolata (Jequetepeque Valley). I am also grateful to César Gálvez Mora and Jesús Briceño Rosario of the Instituto Nacional de Cultura, La Libertad, for sharing their knowledge of north coast archaeology with me and for help administering our work in the study areas. Lastly, I thank the National Science Foundation for supporting most of the work in these two valleys.

1. El Niño–Southern Oscillation (ENSO) events are climatic shifts when warm waters accumulate in the central Pacific Ocean and move east, reversing the normal trade winds and bringing warm, humid air to the west coast of South America. During major El Niño events this results in heavy rains and floods along the normally arid coastal desert.

BIBLIOGRAPHY

Anders, Martha B.
1990 Maymi: Un sitio del Horizonte Medio en el valle de Pisco. *Gaceta Arqueológica Andina* 5 (17): 27–39.

Barber, Richard T., and Francisco P. Chavez
1983 Biological Consequences of El-Niño 1982–83. *Science* 222: 1203–1210.

Bawden, Garth L.
1983 Cultural Reconstitution in the Late Moche Period: A Case Study in Multidimensional Stylistic Analysis. In *Civilization in the Ancient Americas: Essays in Honor of Gordon R. Willey*, ed. Richard M. Leventhal and Alan L. Kolata, 211–235. Albuquerque, N.M., and Cambridge, Mass.

1995 The Structural Paradox: Moche Culture as Political Ideology. *Latin American Antiquity* 6 (3): 255–273.

1996 *The Moche.* Oxford and Cambridge, Mass.

Benson, Elizabeth P.
1972 *The Mochica: A Culture of Peru.* New York and London.

Berezkin, Yuri
1978 The Social Structure of the Mochica Through the Prism of Mythology (Ancient Peru) [written in Russian with English summary]. *Vestnik Drevnei Istorii* 3: 38–59. [Moscow].

Billman, Brian R.
1996 The Evolution of Prehistoric Political Organizations in the Moche Valley, Peru. Ph.D. dissertation, Department of Anthropology, University of California, Santa Barbara.

Bonavia, Duccio
1985 *Mural Painting in Ancient Peru*, trans. Patricia J. Lyon. Bloomington, Ind.

Bourdieu, Pierre
1977 *Outline of a Theory of Practice*, trans. Richard Nice. Cambridge and New York.

Braudel, Fernand
1973 *Capitalism and Material Life, 1400–1800*, trans. Miriam Kochan. New York.

Bull, William B.
1991 *Geomorphic Responses to Climatic Change.* New York.

Butzer, Karl W.
1984 Long-Term Nile Flood Variation and Political Discontinuities in Pharaonic Egypt. In *From Hunters to Farmers: The Causes and Consequences of Food Production in Africa*, ed. J. Desmond Clark and Steven A. Brandt, 102–112. Berkeley, Calif.

Calabrese, John
1993 A Study of Cultural Interaction in
 Northern Peru: 200 B.C. to A.D. 1532.
 Master's thesis, University of Kentucky,
 Lexington.

Castillo, Luis Jaime
1989 *Personajes míticos, escenas y narraciones
 en la iconografía Mochica*. Lima.

Castillo, Luis Jaime, and Christopher B. Donnan
1994a La ocupación Moche de San José de Moro,
 Jequetepeque. In *Moche: Propuestas y
 perspectivas* [Actas del primer coloquio
 sobre la cultura Moche, Trujillo, 12 al 16
 de abril de 1993], ed. Santiago Uceda and
 Elías Mujica, 93–146. Travaux de l'Institut
 Français d'Etudes Andines 79. Trujillo and
 Lima.

1994b Los Mochica del norte y los Mochica del
 sur. In *Vicús*, by Krzysztof Makowski,
 Christopher B. Donnan, Iván Amaro
 Bullón, Luis Jaime Castillo, Magdalena
 Diez Canseco, Otto Eléspuru Revoredo,
 and Juan Antonio Murro Mena, 143–181.
 Colección Arte y Tesoros del Perú. Lima.

Conrad, Geoffrey W.
1990 Farfan, General Pacatnamu, and the
 Dynastic History of Chimor. In *The
 Northern Dynasties: Kingship and
 Statecraft in Chimor* [A Symposium at
 Dumbarton Oaks, 12th and 13th October
 1985], ed. Michael E. Moseley and Alana
 Cordy-Collins, 227–242. Washington.

Craig, Alan K., and Izumi Shimada
1986 El Niño Flood Deposits at Batán Grande,
 Northern Peru. *Geoarchaeology* 1: 29–38.

Crumley, Carole L., and William H. Marquardt
1990 Landscape: A Unifying Concept in
 Regional Analysis. In *Interpreting Space:
 GIS and Archaeology*, ed. Kathleen M. S.
 Allen, Stanton W. Green, and Ezra B. W.
 Zubrow, 73–79. London.

Diaz, Henry F., and Vera Markgraf
1992 (Editors) *El Niño: Historical and
 Paleoclimatic Aspects of the Southern
 Oscillation*. Cambridge and New York.

Dillehay, Tom D.
1976 Competition and Cooperation in a
 Prehispanic Multi-Ethnic System in the
 Central Andes. Ph.D. dissertation,
 University of Texas at Austin.

1979 Pre-Hispanic Resource Sharing in the
 Central Andes. *Science* 204 (4388): 24–31.

1987 Estrategias políticas y económicas de las
 etnias locales del valle del Chillón durante
 el período prehispánico. *Revista Andina* 5
 (2): 407–456.

Dillehay, Tom D., Herbert H. Eling, Jr., and Jack
Rossen
1989 Informe técnico sobre la campaña de 1989
 en el valle de Zaña. Report submitted to
 the Instituto Nacional de Cultura, Lima.

Dillehay, Tom D., and Alan L. Kolata
1997 Informe sobre la investigación arqueo-
 lógica del Proyecto Pacasmayo en el valle
 de Jequetepeque. Report submitted to the
 Instituto Nacional de Cultura, Lima.

Dillehay, Tom D., and Patricia J. Netherly
1977 Informe de investigación arqueológica en
 el valle de Zaña. Report submitted to the
 Instituto Nacional de Cultura, Lima.

1979 Informe de investigación arqueológica en
 el valle de Zaña. Report submitted to the
 Instituto Nacional de Cultura, Lima.

1984 Informe de investigación arqueológica en
 el valle de Zaña. Report submitted to the
 Instituto Nacional de Cultura, Lima.

Dillehay, Tom D., and Jack Rossen
1989a Informe de investigación arqueológica en
 el valle de Zaña. Report submitted to the
 Instituto Nacional de Cultura, Lima.

1989b Informe técnico de la campaña de 1989 en
 el valle de Jequetepeque. Report submitted
 to the Instituto Nacional de Cultura, Lima.

1992 Informe de investigación arqueológica en
 el valle de Zaña. Report submitted to the
 Instituto Nacional de Cultura, Lima.

Dillehay, Tom D., J. Warner, J. Iriarte, and Alan L.
Kolata
1998 Informe sobre la investigación arqueo-
 lógica del Proyecto Pacasmayo en el valle
 de Jequetepeque. Report submitted to the
 Instituto Nacional de Cultura, Lima.

Donnan, Christopher B.
1973 *Moche Occupation of the Santa Valley,
 Peru*. University of California
 Publications in Anthropology 8. Berkeley
 and Los Angeles.

1976 *Moche Art and Iconography*. UCLA Latin
 American Center, Latin American Studies
 33. Los Angeles.

1995 Moche Funerary Practice. In *Tombs for
 the Living: Andean Mortuary Practices* [A
 Symposium at Dumbarton Oaks 12th and
 13th October 1991], ed. Tom D. Dillehay,
 111–159. Washington.

1997 Introduction. In *The Pacatnamu Papers,
 Volume 2*: The Moche Occupation, ed.
 Christopher B. Donnan and Guillermo A.
 Cock, 9–16. Fowler Museum of Cultural
 History, University of California, Los
 Angeles.

Donnan, Christopher B., and Guillermo A. Cock
 1986 (Editors) *The Pacatnamu Papers. Volume
 1.* Museum of Cultural History,
 University of California, Los Angeles.

 1997 (Editors) *The Pacatnamu Papers. Volume
 2: The Moche Occupation.* Fowler
 Museum of Cultural History, University
 of California, Los Angeles.

Donnan, Christopher B., and Carol J. Mackey
 1978 *Ancient Burial Patterns of the Moche
 Valley, Peru.* Austin, Tex.

Eling, Herbert H., Jr.
 1978 Interpretaciones preliminares del sistema
 de riego antigua de Talambo en el valle de
 Jequetepeque, Perú. In *El hombre y la
 cultura Andina* [Actas y Trabajos, III
 Congresso Peruano, 31 de enero–5 de
 febrero 1977], ed. Ramiro Matos Mendieta,
 2: 401–419. Lima.

 1981 Prehispanic Irrigation Patterns: Monad-
 nocks of the Pampa de Mojucape, Jequete-
 peque Valley, Perú. Paper presented at the
 4th Andean Archaeological Colloquium,
 University of California, Los Angeles.

 1987 The Role of Irrigation Networks in
 Emerging Societal Complexity During
 Late Prehispanic Times, Jequetepeque
 Valley, North Coast Peru. Ph.D.
 dissertation, Department of Anthropology,
 University of Texas at Austin.

 1989 Informe técnico de la campaña de 1989 en
 el valle de Jequetepeque. Report submitted
 to the Instituto Nacional de Cultura,
 Lima.

Eling, Herbert H., Jr., Tom D. Dillehay, and Jack
Rossen
 1990 Informe sobre investigaciones arqueo-
 lógicas en el valle bajo de Jequetepeque.
 Report submitted to the Instituto
 Nacional de Cultura, Lima.

Godelier, Maurice
 1978 Infrastructures, Societies, and History.
 Current Anthropology 19 (4): 763–771.

Gumerman, George IV
 1991 Subsistence and Complex Societies: Diet
 Between Diverse Socio-Economic Groups
 at Pacatnamú, Peru. Ph.D. dissertation,
 Department of Anthropology, University
 of California, Los Angeles.

 1994 Feeding Specialists: The Effect of
 Specialization on Subsistence Variation. In
 *Paleonutrition: The Diet and Health of
 Prehistoric Americans*, ed. Kristin D.
 Sobolik, 80–97. Southern Illinois
 University at Carbondale, Center for
 Archaeological Investigations, Occasional
 Paper 22. Carbondale.

Hebdige, Dick
 1979 *Subculture: The Meaning of Style.* London.

Hecker, Giesela, and Wolfgang Hecker
 1982 *Pacatnamu: vorspanische Stadt in
 Nordperu.* Munich.

 1985 *Pacatnamú y sus construcciones: Centro
 religioso prehispánico en la costa norte
 Peruana.* Frankfurt.

 1991 *Die Huaca 16 in Pacatnamú: eine
 Ausgrabung an der nordperuanischen
 Küste.* Berlin.

Isbell, William H., and Gordon F. McEwan
 1991 (Editors) *Huari Administrative Structure:
 Prehistoric Monumental Architecture and
 State Government* [Papers from a round
 table held at Dumbarton Oaks, 15–17,
 1985]. Washington.

Keatinge, Richard W.
 1977 Religious Forms and Secular Functions:
 The Expansion of State Bureaucracies as
 Reflected in Prehistoric Architecture on
 the Peruvian North Coast. *Annals of the
 New York Academy of Sciences* 293:
 229–245.

 1982 The Chimú Empire in a Regional
 Perspective: Cultural Antecedents and
 Continuities. In *Chan Chan: Andean
 Desert City*, ed. Michael E. Moseley and
 Kent C. Day, 197–224. School of American
 Research Advanced Seminar Series.
 Albuquerque, N.M.

Keatinge, Richard W., and Geoffrey W. Conrad
 1983 Imperialist Expansion in Peruvian
 Prehistory: Chimu Administration of a
 Conquered Territory. *Journal of Field
 Archaeology* 10 (3): 255–283.

Kolata, Alan L.
 1990 The Urban Concept of Chan Chan. In *The
 Northern Dynasties: Kingship and
 Statecraft in Chimor* [A Symposium at
 Dumbarton Oaks, 12th and 13th October
 1985], ed. Michael E. Moseley and Alana
 Cordy-Collins, 107–144. Washington.

 1991 The Technology and Organization of
 Agricultural Production in the Tiwanaku
 State. *Latin American Antiquity* 2 (2):
 99–125.

 1993 *The Tiwanaku: Portrait of an Andean
 Civilization.* Oxford and Cambridge, Mass.

 1996 (Editor) *Tiwanaku and Its Hinterland:
 Archaeology and Paleoecology of an
 Andean Civilization. Volume 1:
 Agroecology.* Washington.

Kolata, Alan L., and Tom D. Dillehay
 1998 Human and Environmental Interaction in
 the Lower Jequetepeque Valley. Proposal
 submitted to the National Science
 Foundation, Washington.

Kosok, Paul
1965 *Life, Land and Water in Ancient Peru.*
 New York.

Landé, Carl H.
1977 Introduction: The Dyadic Basis of
 Clientelism. In *Friends, Followers and
 Factions: a Reader in Political
 Clientelism*, xiii–xxxvii. Edited by Steffen
 W. Schmidt, Laura Guasti, Carl H. Landé,
 and James Scott. Berkeley, Calif.

Moore, Jerry D.
1991 Cultural Responses to Environmental Cat-
 astrophes: Post-El Niño Subsistence on
 the Prehistoric North Coast of Peru. *Latin
 American Antiquity* 2 (1): 27–47.

Moseley, Michael E.
1978 An Empirical Approach to Prehistoric
 Agrarian Collapse: The Case of the Moche
 Valley, Peru. In *Social and Technological
 Management in Dry Lands: Past and
 Present, Indigenous and Imposed*, ed.
 Nancie L. Gonzalez, 9–43. American
 Association for Advancement of Science,
 Selected Symposium 10. Boulder, Colo.

1982 Introduction: Human Exploitation and
 Organization on the North Andean Coast.
 In *Chan Chan: Andean Desert City*, ed.
 Michael E. Moseley and Kent C. Day, 1–24.
 School of American Research Advanced
 Seminar Series. Albuquerque, N.M.

1990 Structure and History in the Dynastic
 Lore of Chimor. In *The Northern
 Dynasties: Kingship and Statecraft in
 Chimor* [A Symposium at Dumbarton
 Oaks, 12th and 13th October 1985], ed.
 Michael E. Moseley and Alana Cordy-
 Collins, 1–41. Washington.

Moseley, Michael E., Robert A. Feldman, and Charles
R. Ortloff
1981 Living With Crises: Human Perception of
 Process and Time. In *Biotic Crises in
 Ecological and Evolutionary Time*
 [Proceedings of the 3rd Annual Spring
 Systematics Symposium, 10 May 1980,
 Field Museum of Natural History,
 Chicago], ed. Matthew Nitecki, 231–267.
 New York.

Moseley, Michael E., D. Satterlee, and James B.
Richardson III
1992 Flood Events, El Niño Events, and
 Tectonic Events. In *Paleo-ENSO Records:
 International Symposium: Extended
 Abstracts* [International Symposium on
 Former ENSO Phenomena in Western
 South America—Records of El Niño
 Events, Lima, 4–7 March 1992], ed. Luc
 Ortlieb and José Macharé, 207–212. Lima.

Moser, Christopher, L.
1974 Ritual Decapitation in Moche Art.
 Archaeology 27 (1): 30–37.

Netherly, Patricia J.
1984 The Management of Late Andean
 Irrigation Systems on the North Coast of
 Peru. *American Antiquity* 49 (2): 227–254.

Nials, Fred L., Eric E. Deeds, Michael E. Moseley,
Shelia Pozorski, Thomas Pozorski, and Robert A.
Feldman
1979 El Niño: The Catastrophic Flooding of
 Coastal Peru. *Field Museum of Natural
 History Bulletin* 50 (7): 4–14 (Part I) and 50
 (8): 4–10 (Part II).

Ortloff, Charles R., Robert A. Feldman, and Michael
E. Moseley
1985 Hydraulic Engineering and Historical
 Aspects of the Pre-Columbian Intravalley
 Canal Systems of the Moche Valley, Peru.
 Journal of Field Archaeology 12 (?): 77–98.

Philander, S. George
1989 El Niño and La Niña. *American Scientist*
 77 (5): 451–459.

Quilter, Jeffrey
1990 The Moche Revolt of the Objects. *Latin
 American Antiquity* 1 (1): 42–65.

1997 The Narrative Approach to Moche
 Iconography. *Latin American Antiquity* 8
 (2): 113–133.

Rapoport, Amos
1982 *The Meaning of the Built Environment: A
 Nonverbal Communication Approach.*
 Beverly Hills, Calif.

Ravines, Rogger
1981 *Mapa arqueológico del valle del
 Jequetepeque.* Instituto Nacional de
 Cultura, Proyecto Especial de Irrigación
 Jequetepeque-Zaña, Lima.

Rossignol, Jacqueline, and LuAnn Wandsnider
1992 (Editors) *Space, Time, and Archaeological
 Landscapes.* New York.

Sandweiss, Daniel, H., James B. Richardson III, Eliza-
beth J. Reitz, Harold B. Rollins, and Kirk A. Maasch
1996 Geoarcheological Evidence from Peru for a
 5000 years B.P. onset of El Niño. *Science*
 273: 1531–1533.

Schaedel, Richard P.
1951 Major Ceremonial and Population Centers
 in Northern Peru. In *The Civilizations of
 Ancient America: Selected Papers of the
 29th International Congress of
 Americanists* [New York, 1949], ed. Sol
 Tax, 232–243. Chicago.

1966 Urban Growth and Ekistics on the Peru-
 vian Coast. In *Proceedings of the 36th
 International Congress of Americanists*,
 2: 531–539. Buenos Aires.

1972 The City and the Origin of the State in
 America. In *Actas y Memorias del 39
 Congreso Internacional de Americanistas*,
 2: 15–33. Lima.

1985 Coast-Highland Interrelationships and Ethnic Groups in Northern Peru, (500 B.C.–A.D. 1980). In *Andean Ecology and Civilization: An Interdisciplinary Perspective on Andean Ecological Complementarity*, ed. Shozo Masuda, Izumi Shimada, and Craig Morris, 443–473. Papers from Wenner-Gren Foundation for Anthropological Research Symposium 91. Tokyo.

Shimada, Izumi
1978 Economy of a Prehistoric Urban Context: Commodity and Labor Flow at Moche V Pampa Grande, Peru. *American Antiquity* 43 (4): 569–592.

1985 Perception, Procurement, and Management of Resources: Archaeological Perspective. In *Andean Ecology and Civilization: an Interdisciplinary Perspective on Andean Ecological Complementarity.* ed. Shozo Masuda, Izumi Shimada, and Craig Morris, 357–399. Papers from Wenner-Gren Foundation for Anthropological Research Symposium 91. Tokyo.

1986 Batán Grande and Cosmological Unity in the Prehistoric Central Andes. In *Andean Archaeology: Papers in Memory of Clifford Evans*, ed. Ramiro Matos Mendieta, Solveig A. Turpin, and Herbert H. Eling, Jr, 163–188. University of California, Los Angeles, Institute of Archaeology Monograph 27. Berkeley and Los Angeles.

1990 Cultural Continuities and Discontinuities on the Northern North Coast of Peru, Middle-Late Horizons. In *The Northern Dynasties: Kingship and Statecraft in Chimor* [A Symposium at Dumbarton Oaks, 12th and 13th October 1985], ed. Michael E. Moseley and Alana Cordy-Collins, 297–392. Washington.

1994a *Pampa Grande and the Mochica Culture.* Austin, Tex.

1994b Los modelos de la organización sociopolítica de la cultura Moche: Nuevos datos y perspectiva. In *Moche: Propuestas y perspectivas* [Actas del primer coloquio sobre la cultura Moche, Trujillo, 12 al 16 de abril de 1993], ed. Santiago Uceda and Elías Mujica, 359–387. Travaux de l'Institut Français d'Etudes Andines 79. Trujillo and Lima.

Shimada, Izumi, Crystal B. Schaaf, Lonnie G. Thompson, and Ellen Mosley-Thompson
1991 Cultural Impacts of Severe Droughts in the Prehistoric Andes: Application of a 1,500-Year Ice Core Precipitation Record. *World Archaeology* 22 (3): 247–270.

Tainter, Joseph
1988 *The Collapse of Complex Societies.* Cambridge.

Therborn, Göran
1980 *The Ideology of Power and the Power of Ideology.* London.

Thompson, John B.
1990 *Ideology and Modern Culture: Critical Social Theory in the Era of Mass Communication.* Stanford, Calif.

Thompson, Lonnie G., and Ellen Mosley-Thompson
1989 One-Half Millennia of Tropical Climate Variability as Recorded in the Stratigraphy of the Quelccaya Ice Cap, Peru. In *Aspects of Climate Variability in the Pacific and the Western Americas*, ed. David H. Peterson, 15–31. American Geophysical Union, Geophysical Monograph 55. Washington.

Topic, John R.
1982 Lower-Class Social and Economic Organization at Chan Chan. In *Chan Chan: Andean Desert City*, ed. Michael E. Moseley and Kent C. Day, 145–175. School of American Research Advanced Seminar Series. Albuquerque, N.M.

1990 Craft Production in the Kingdom of Chimor. In *The Northern Dynasties: Kingship and Statecraft in Chimor* [A Symposium at Dumbarton Oaks, 12th and 13th October 1985], ed. Michael E. Moseley and Alana Cordy-Collins, 145–176. Washington.

1991 The Middle Horizon in Northern Peru. In *Huari Administrative Structure: Prehistoric Monumental Architecture and State Government*, ed. William H. Isbell and Gordon F. McEwan, 233–246. Washington.

Topic, John R., and Theresa Lange Topic
1997 La guerra Mochica. *Revista Arqueológica SIAN* 4: 10–12. [Trujillo].

Ubbelohde-Doering, Heinrich
1983 *Vorspanische Gräber von Pacatnamu, Nordperu.* Materialien zur allgemeinen und vergleichenden Archäologie 26. Munich.

Uceda, Santiago, and José Canziani
1993 Evidencias de grandes precipitaciones en diversas etapas constructivas de la Huaca de la Luna, costa norte del Perú. In *Registros del fenómeno El Niño y de eventos Enso en América del Sur*, ed. José Macharé and Luc Ortlieb, 313–343. *Bulletin de l'Institut Français d'Etudes Andines* 22 (1).

Uceda, Santiago, Ricardo Morales, José Canziani, and María Montoya
1994 Investigaciones sobre la arquitectura y relieves polícromos en la Huaca de la Luna, valle de Moche. In *Moche: Propuestas y perspectivas* [Actas del primer coloquio sobre la cultura Moche, Trujillo, 12 al 16 de abril de 1993], ed. Santiago Uceda and Elías Mujica, 251–303. Travaux de l'Institut Français d'Etudes Andines 79. Trujillo and Lima.

Uceda, Santiago, and Elías Mujica, eds.

1994 (Editors) *Moche: Propuestas y perspectivas*
 [Actas del primer coloquio sobre la cultura
 Moche, Trujillo, 12 al 16 de abril de 1993].
 Travaux de l'Institut Français d'Etudes
 Andines 79. Trujillo and Lima.

Wilson, David J.

1988 *Prehispanic Settlement Patterns in the
 Lower Santa Valley, Peru: A Regional
 Perspective on the Origins and Develop-
 ment of Complex North Coast Society.*
 Smithsonian Series in Archaeological
 Inquiry. Washington.

Yoffee, Norman, and George L. Cowgill

1988 (Editors) *The Collapse of Ancient States
 and Civilizations.* Tucson, Ariz.

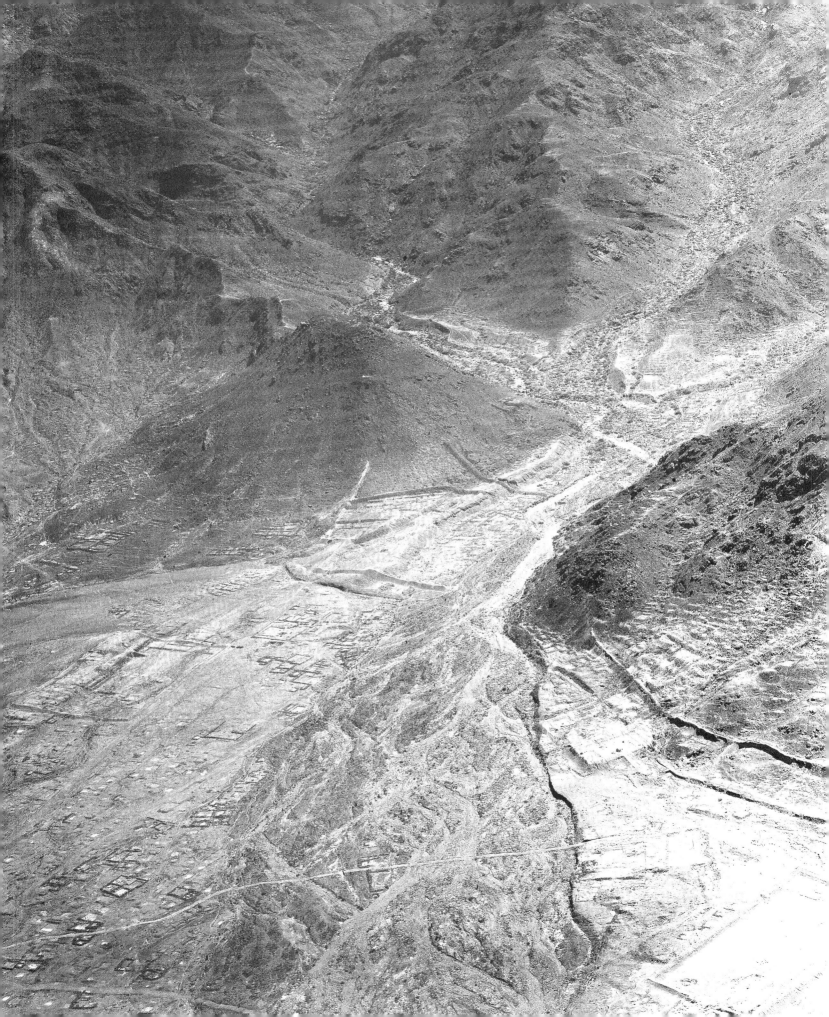

GARTH BAWDEN
University of New Mexico

The Symbols of Late Moche Social Transformation

Scholars have long realized that major change occurred in all areas of Moche society in its latest phase (A.D. 600–750). While the material and environmental aspects of this change have long been intensively studied, its more inaccessible ideological elements have received less attention. This situation is changing, however. Recently, scholars have begun to meet the challenge posed by Christopher Donnan's (1978) splendid iconographic research to explore more intangible aspects of Late Moche history. These studies mostly interpret local developments from the viewpoint of Moche rulers and their political responses to disruption. In so doing they have made important contributions to our understanding of the ideological changes that occurred at the apex of Moche society as leaders strove to maintain their power at a time of growing vulnerability. Such periods of widespread change also affect subject populations who are less visible in the archaeological record. Indeed, their reactions to social stress may well play a crucial role in shaping wider social response. Clearly, then, this issue holds important implications for fuller understanding of local and regional social dynamics in the Late Moche period.

In this paper I examine the general process of change that affected Late Moche society at the end of the sixth century A.D. More specifically I study the role played in this process by changing relations between rulers and ruled at the town of Galindo in the Moche Valley.

This settlement has long been regarded as a material expression of the pan-Andean changes that heralded the Middle Horizon period. Once interpreted as the physical evidence of an invasion by the Wari, an expansionist state based in the southern highlands, its innovative features are now recognized as products of Moche society in its final phases. The location, settlement plan, architecture, funerary practices, and ceramics, all attest to the profound nature of social change at this time and, significantly, permit examination of the disparate quality of this change in the contrasting social arenas inhabited by the rulers and the subject population.

I examine the material inventory of Late Moche culture at Galindo in its full temporal and spatial contexts. I regard this inventory as the residue of a complex network of symbolic communication through which elite and commoner groups constructed and asserted new forms of identity in the context of severe social disruption. The distinctive interests of the two groups and the disparate resources at their command determined that they utilized very different strategies in search of their common goal. Rulers tried to build a new political ideology around which to consolidate their position. Commoners, excluded from this process, faced the more fundamental need to recreate their group identity without recourse to the processes and symbols of political power in a hostile urban setting that alienated them from their traditional social

285

supports. These twin endeavors increasingly separated the Galindo population from the discredited belief system that had for so long integrated Moche society. At the same time they drove a wedge between the two groups and created internal tension that must have contributed to the early demise of Galindo. Together they mark the first steps in the construction of a social identity that, while no longer "Moche" in the traditional sense, was still far from comprising a well-integrated successor.

Social Identity

I develop my study in the context of the social discourse that on the one hand incorporated the political ideology of Moche leaders, on the other the collective identity of commoners. These groups occupied very different arenas, each the center of a network of social interaction that provided the conceptual basis for the construction of power. Here I define power broadly, viewing it as the domain of social practice where human agents mobilize the conceptual and material resources at their command to generate consequences whose precise outcomes they may or may not foresee. In this sense power is inherent in all human interaction whether individual or institutional. However, here I focus on its role in effecting social reproduction and change in the context of the endeavors by different interest groups to establish their social autonomy.

Social identity is the legacy of history. In the broadest sense it is an outcome of the reflexive interaction between a human group and the particular circumstances that it encounters in time and space. This unceasing process leads to the development of a discrete set of structural principles that engender the rules and values whose implicit acceptance promotes social cohesion and the appropriate forms of speech, behavior and material symbolism that manifest them in daily life. Constantly asserted and reconstituted through social interaction, these unique assemblages of conceptual, behavioral, and material constructs generate the recognition of shared membership that becomes the self-ascribed foundation of collective identity.

Societies are not simply accumulations of identical human units. They use their common structural legacy in different ways. Thus, except in times of external threat, people forge their strongest active connections, not with the macrocommunity, but with various smaller groupings within it. Corporate, civic, ethnic, kinship and religious organizations, among others, provide the direct focus for communal activity and both nourish and assert the distinct objectives and philosophies of their members. While the deep structures that cross-cut all population segments create the shared mental language within which social negotiation can occur, the conscious realities constructed by individuals and groups from these shared structures represent different understandings of their experience and are central constituents of lived identity. It is at this conscious level that people mediate their lives. The dogmatic verbal and literary assertions through which individuals and groups strive to establish their agendas, together with their associated practices, symbols and institutions, collectively comprise the discursive arena of active social statement. Together social statement and deeper structure comprise the reality within which individuals construct their identities and contest their social locations (Fish 1989: 34; Harman 1988: 125–126). More specifically, such contestation occurs through the agency of ideology.

Ideology

I regard ideology as that specialized formulation of social statement that promotes the interests of its advocates in the wider community. Ideology is thus the possession of all interest groups in a society. Within this broader ideological context, dominant ideology, which seeks to promote cohesion in the interests of established social order, represents its most prominent expression. Dominant ideology achieves its impact by narrowing and condensing the discourses that represent reality for its adherents and communicating these to the public at large through the established agencies of communication and participatory ceremonies. In its Marxist sense dominant ideology is frequently regarded as a set of ideas used by rulers to hide repressive reality behind a persuasive façade which proclaims the universal benefits of the existing social order and

naturalizes any inequalities that may exist within it. This usage has been justly criticized because of its necessary assumption of the existence of some deeper truth that ideology seeks to mask, rather than being itself an interpretation of perceived reality (Foucault 1984). Moreover, it overly emphasizes the powerlessness of the masses and their passive acceptance of tenets that may well oppose their interests (Abercrombie, Hill, and Turner 1980). In fact history makes clear that this does not usually happen. When ideological discourse and group interest fall into opposition, dominant ideology may be discarded speedily. During those periods when unitary ideology prevails, it is because it successfully reproduces notions of social reality and advantage espoused by society as a whole. In such instances prevailing ideological discourse does not mask deeper truth-shared perception *makes* it social reality for all.

Even within its own epistemological logic, however, dominant ideology encounters challenge. In stable conditions, negotiation and adjustment are contained within the conceptual boundaries set by its dogma. But at times of stress, when large segments of a population become convinced that their social order is causing adversity, the situation intensifies. In extreme circumstances perceived contradiction between ideological substance and individual self-interest can lead to fundamental challenge to the ruling order. It is now that lived reality is discerned as being detached from ideological "truth." Criticism is not long confined within the hegemonic framework of dominant dogma and expands into areas incompatible with its structural logic. In this process the ideological discourses of subordinate groups come more directly into play as in-place locations for social opposition. Here alienated groups use their own social realities to define more clearly their own distinct identities and in so doing create the foundation for wider power. Inimical to the discredited system of domination, these actions serve to neutralize its power over them and to create the dynamic for major modification of the existing order or, in more extreme instances, profound social transformation.

Symbolism as Social Action

Symbols are important agents in the social and ideological negotiation that I discussed in the previous section. While they have been studied in various ways (see, for example, Firth 1973; Leach 1976; Mach 1993; Ricoeur 1974), most scholars would agree that symbols include a wide range of conceptual, behavioral, and material forms, whose meanings are rooted in the cognitive world models of their related cultures. This culture-specific character of symbolism plays a central role in the construction of individual and group identity by organizing people's experience, asserting their particular values, ideologies and stereotypes, and directing their relations with others. These qualities clearly possess the potential for power construction at all levels of the social ladder. It is this issue that principally concerns me here.

In the context of religious and political ideology, symbols are most successful when they confine and focus partisan meaning, thereby lessening the potential for individual interpretation and heightening their value as agents of authority. Here symbols suffuse explicit ideological values and goals with an emotional force that stimulates involvement and mobilizes people to act on behalf of the communicated message (Turner 1967: 30). It is, then, not surprising that they are essential players in arenas of social control where they may be used to assert the prestige of and stimulate support for dominant ideology and its proponents. In complex societies of the central Andes such as the Moche this role is expressed through rich iconography executed in a variety of media.

Ideological discourse is not confined to the dominant political sector; rather it is central to the construction of group identity and power relations at all social levels. Common cognitive origin ensures that symbols carry at some level a certain degree of understandable meaning throughout their community. The potential for flexible interpretation, however, creates the opportunity for individual groups to manipulate this common heritage to further their own interests. Moreover, the readily accessible character of symbolic communication directly identifies it with the essential source of power—the ability to influence people and events. Each subgroup within

society possesses a distinctive set of symbols which potentially serves to assert its values and ideas in the public awareness. These properties are important factors in the competitive interaction between groups engaged in political and social struggle, where they may act to sustain the values of a subordinate group against dominant ideology, to mediate relationships among groups of equal political influence, or to impress the dogma of central authority on an entire community.

Cultures do not develop in isolation. Every society is to some extent influenced by its neighbors and adopts cultural elements from this contact. The question thus arises as to how foreign symbols have meaning in their receptor societies. Often, intercultural familiarity fosters adoption, reinterpretation, and absorption of such forms to the extent that they are no longer distinguishable as foreign. There are, however, fewer instances where symbols are intentionally adopted by a particular group to further its message. This is perhaps most common in the political arena, where it is not unusual for rulers to embrace foreign symbols to enhance their authority. These adoptions may merely carry the added prestige of admired exotic images. They may also carry a specifically religious or political meaning that transcends local beliefs and identifies the elite with a powerful universalist ideology. Such borrowing functions to focus authority on a single group but inhibits incorporation into the broader symbolic structure of society. In this situation, the very quality that accords them influence also raises the possibility that these symbols will be rejected upon the eclipse of their principal adherents.

Places as Ideological Discourse

Communal life has much to do with place. Human groups use buildings and the modified landscape around them to organize their social lives and the daily activities that this entails. Such constructions express the distinctive cultural ideals of their makers; these built environments constitute symbolically charged places that reinforce the individual and collective values of their users. While the architectural signifiers of place vary greatly in form from culture to culture they share two important characteristics. First, they delineate the physical locations of social action. Second, as cultural manifestations they carry symbolic meaning in their own right and through the objects and activities associated with them. These places and the people who use them are part of the complex of physical, behavioral, and conceptual networks that together comprise the community. Whether temple, residence or plaza, they are the active settings where people negotiate their particular experiences of social reality to effect change or maintain stability. Together these settings and the symbols to which they gave meaning reveal the changing relationship between the central ideology at Late Moche Galindo and the diverging values of much of its population.

The urban built environment, the focus of this study, comprises a variety of components. Elite architecture asserts a powerful symbolic force reflecting dominant interests. Great architectural centers of government have throughout history projected the ideology of dominance in various ways. They inspire awe through their size and elaboration. Their inaccessible sancta, set aside for the activities of officials and priests, evoke the mystery and remoteness of elite rule. They act as powerful agents of social cohesion by providing places where rituals are held. They also communicate the content of central ideology through symbolic embellishment affixed to their façades and portable artifacts used in ceremonies. In the town of Galindo the places from which rulers exercised and asserted their authority included architectural forms associated with administrative, economic, and religious institutions, as well as residences and burial places of the rulers.

By contrast the architectural evidence of commoners is almost entirely confined to their homes and tombs. At the broadest level, domestic form and content manifest residential modes constituted in the historical and cultural experience of their society. They thus continually remind household members of the canons that govern appropriate domestic behavior (Bourdieu 1977; Rapoport 1982, 1990: 12ff) and play active roles in constructing boundaries to social action. Within these imposed limits, however, household members, through daily practice, may manipulate ideas embedded in residential structure to

effect change. By adjusting political and religious symbolism, by modifying domestic space and form, and by exploiting household ritual, people manipulate basic residential principles to support collective identity and strengthen social solidarity, thus creating the basis for local power. At times of social tension, the ability of subordinate groups to resist the demands of dominant opposition may be restricted to this private realm of household discourse.

Traditional Foundations of Moche Political Power

I now turn to the later Moche periods, when rulers and commoners alike used ideology, together with its related visual symbolism and places of social interaction, to consolidate their threatened social positions at a time of disruption and transformation. Within this apparently common goal, their diverging aspirations and strategies vividly demonstrate the fluid nature of power as it is differentially constructed in contrasting domains of social life. The resulting social contradictions may also be seen as dynamic mechanisms in the ultimate transformation of wider north coast social identity from Moche times to the ensuing Late Intermediate period.

The structure of traditional Moche political authority is most apparent in the great platform mounds that still dominate the coastal Peruvian river valleys. These edifices, together with portable items and funerary practices, comprise the material component of an ideological discourse that maintained Moche dominance on the north coast of Peru for centuries. Earlier archaeological investigations of the Moche culture indicated that their platform mounds were generally located in rather specialized centers, which possessed only limited residential occupation for the ruling elite and their retainers. This view must be modified to some extent as it applies to the southern part of the region in light of the work of Wilson (1988) in the Santa Valley and Topic (1982) and Chapdelaine (this volume, and 1997) in the Moche Valley. Their work suggests that while the bulk of the population lived in smaller settlements scattered through the valleys (a conclusion also reached by Billman in his 1996 Moche Valley

settlement survey), some major centers incorporated large population concentrations. Chapdelaine's work at the Moche site, however, also indicates that his "urban" population was mostly comprised of people of some status, and thus implies that the settlement was not regarded as the appropriate home by the largest lowest-status segment of the population. This demographic situation is of importance to my discussion, as it contrasts with that of the later town of Galindo in the same valley.

Through their great size, Moche platforms proclaim the ability of leaders to organize the labor of local communities. Furthermore, the segmentary platform construction technique suggests that this labor force was organized into a system of work teams drawn from specific locations in the southern Moche region (Moseley 1975). But platforms also played active continuing roles in affirming the dominant ideology of power. Their great bulk and height conveyed the power of central authority. As symbols they recreated the sacred mountains whose divinities provided the rivers that supported life. It was in their shadow that the general populace participated in ceremonies ensuring social integration. In their role as locations of sacred time and space their summits acted as stages where, in full view (Moore 1996), leaders conducted the rituals that manifested the tenets of north coast religious belief. Here they conducted sacrifice of prisoners taken in ritual combat (Bawden 1996; Bourget, this volume; Topic and Topic 1997; Verano, this volume). Occasionally this identification of rulers with the ritual centers of power transcended corporeal life when, as at Sipán, rulers were actually buried in the structures (Alva, this volume; Alva and Donnan 1993; Uceda, this volume). These tombs of ancestral leaders undoubtedly reinforced the sacred power of the monuments, and served as mortar for the continuity of the social order.

Thus, by identifying themselves with sacred places, Moche rulers stressed a shared conceptual history to enhance their own positions. As mediators with a supernatural past and present in the liminal space of ritual, the elite presented themselves as the powers responsible for cosmological balance.

In addition to the great architectural manifestations of power, Moche leadership was

also proclaimed through portable symbolism. Finely painted stirrup-spout vessels, objects of precious metal, and textiles all carried depictions of the rituals of power. In some instances, as in the case of the Sacrificer or Decapitator motif, the familiar meaning and form of this imagery linked Moche ritual with distant north coast antecedents (Cordy-Collins 1992), endowing its ideological message with the legitimacy of traditional cultural meaning. In other instances such as the Recuay Moon Animal (Menzel 1977: 62–63), powerful motifs were borrowed from neighboring cultures, infused with meaning from the north coast tradition and integrated into the Moche symbolic system. By these means portable symbolism promulgated the dominant ideology and reinforced the prevailing social order. The most elaborate material symbols, such as the striking portrait vessels (Donnan, this volume) whose realistic depiction proclaimed the high degree of power incumbent in individual members and positions of the ruling elite, were reserved for contexts of central authority. Simpler examples of this shared ideological symbolism, however, circulated in all arenas of daily life. Thus, in non-elite houses, stirrup-spout vessels and figurines replicated in abbreviated form the images of dominant myth, while the tombs of commoners usually contained items whose iconography reproduced the images most frequently used in the central locations of power.

Burial practice represents another important context for ideological discourse through symbolic communication, and is of special importance to my study. Burials are especially sensitive to the interests of intracommunity groups. In all societies, preparation of the dead is shaped by the aspirations and relationships of their survivors as much as by the actual qualities of the deceased. The practices that surround death are in a real sense conditioned by the social and political needs of the living. Thus funerary ritual and burial practice are often regarded as potent symbolic activities through which real or desired social situations are illuminated in an attempt to influence the wider community. Commonly, such objectives include endorsement of a specific interest group and its values, sanction of the dominant social order, maintenance of communal traditions and origins, and rein-

forcement of territorial integrity by reference to ancestral lands and the sacred places associated with them.

Prior to Late Moche times the prevailing mortuary style was a rectangular tomb lined with adobe brick or stone capped by wood and cane roofing (for summaries of Moche funerary practices, see Donnan 1995; Donnan and Mackey 1978). People were without exception laid on their backs with arms and legs fully extended. Small pieces of copper were often placed at feet, hands, and mouth; a practice that dates to pre-Moche times (Fogel 1993: 281) and again links Moche ritual to traditional north coastal practice. The dead were almost always accompanied by grave goods that bore distinctive Moche iconography, a specific link to the dominant ideology. The majority of the burials were in cemeteries. The tombs of rulers were incorporated into special burial platforms and contained large amounts of elaborate precious stone and metal objects and fine ceramics.

In addition to formal cemeteries, burial locations included residential zones (Chapdelaine, this volume, and 1997; Donnan and Mackey 1978; Topic 1982). These burials were often placed in plazas outside of the residential spaces, and when located within the house perimeter they were never incorporated into the above-floor domestic architecture. In conformity with prevailing custom, the interred individuals were always placed in an extended supine position. Moreover, in virtually every instance, burial items of characteristic Moche form and iconography accompanied the interments. This occurred in places like Huanchaco (Donnan and Mackey 1978), where the interred represented a small fishing group of low social standing, and at the Moche site (Chapdelaine, this volume; and 1997), whose occupants were probably of significantly higher status. We will see that all of these traditional practices changed dramatically in Late Moche residential burial practice at Galindo.

Critical to any social order is a general acknowledgment by its adherents that it addresses their circumstances and needs. The accessibility of the central tenets of official ideology to the populace—whether ritually performed on great platforms emblazoned with the murals of traditional myth, proclaimed through symbolic household items,

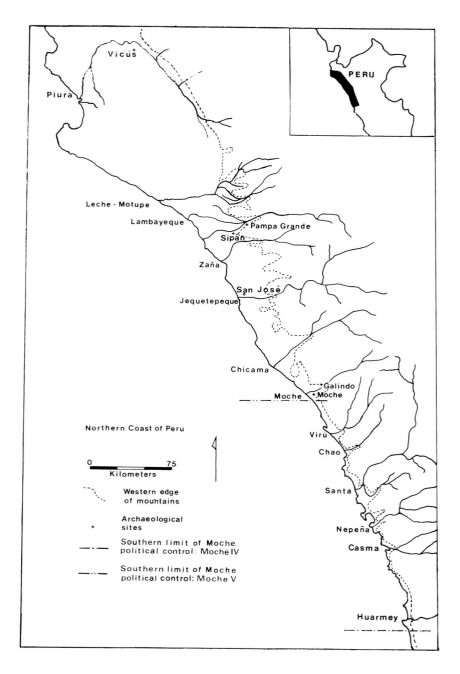

symbolism. In these ways, by affording all people access to the beliefs and practices of social order and deriving these from shared local cultural conception, the earlier Moche ideological system was largely one of social inclusion. Through its symbols, dominant ideology asserted and justified the preeminence of the rulers and, importantly, largely represented the social reality of the entire population during a time of political and economic success.

Crisis on the North Coast

In the last decades of the sixth century A.D. north coast peoples experienced profound disruptions that have variously been ascribed to climatic disaster, external invasion and internal tension (see Bawden 1996 for summary). Geographical and historic factors determined that the most severe impact fell on the polity based in the Moche Valley, which, in the previous period, had controlled a domain extending south to the Huarmey Valley (fig. 1). These extensive southern domains were abandoned and the valley itself was reduced to a small peripheral zone of the shrunken Moche culture area, vulnerable to now-hostile neighbors. Economically, loss of the resources of the south was exacerbated in the Moche Valley by inundation of agricultural land south of the river by wind-blown sand and possibly by the influx of displaced settlers from the southern valleys. In the face of this disruption the focus of settlement and subsistence shifted inland to the neck of the valley, to an area where irrigation agriculture was still possible.

Clearly the challenges to leadership in the wake of such disaster were immense, and generated responses that transformed Moche Valley society. A key element in this reorganization was the introduction of new ideological tenets, an attempt by rulers to reaffirm their shaken authority. The existing Moche system with its regional focus was dramatically modified, and some of its most important components were rejected. This shift was projected into the cultural landscape. At the largest population center, the great Huaca del Sol platform, a manifestation of Moche cosmology and political power, was abandoned, although large areas of the adjoining settlement continued to be occupied. In

1. Map of the north coast of Peru showing the reduction in the area under Moche influence at the end of the Middle Moche (Moche IV) phase

or embodied in shared burial practices—conformed to the pattern appropriate to a belief system that was largely shared by all social groups. To a high degree the success of this ideology appears to have stemmed from its grounding in traditional mythic and ancestral beliefs of a rural society organized by kinship ties. These structural foundations transcended specific political systems and linked people to the historic core of their social beings through the active agency of ritual and

2. Map of Moche Valley with sites mentioned in the text

an abrupt shift the historic pattern of dispersed rural occupation was rejected, and much of the population concentrated in the newly established town of Galindo in a social situation that differed drastically from that of the earlier period (fig. 2; Billman 1996: 292). Here radically new physical symbols of central authority were constructed to replace the rejected platforms. Large areas of the new town contained residential houses, whose small size, poor construction, sparse household content and limited access to food and water were a dramatic contrast to the households of the elite. This suggests the presence of a significant population living at a status level much reduced from their counterparts at the Moche site. Inevitably, these changes threatened the integrity of the low-status groups, drawn to the town from the surrounding countryside, by separating them from their ancestral rural lands and the kin-related community organization. They were congregated in an urban setting in which traditional ways of establishing their group identity were no longer possible. The subject populace confronted this structural crisis by manipulating the new social context, sepa-

rated to an unprecedented degree from that of their rulers.

Two vital requirements for the construction of a dominant ideology are the ability of the ruling powers to persuade the majority of the populace of the benefits of their rule, and, in times of stress, to explain and effectively contain threats posed by historic circumstance. There can be little doubt that the earlier Moche system successfully met these needs, with the economic benefits accruing from domination of the southern valleys as a material advantage. It is equally clear that the disruptions of the late sixth century severely threatened existing political authority throughout the region. Response varied along the coast. In the northern areas the effects of disruption were less severe. In the Moche Valley, however, the magnitude of collapse was so great that the dominant social order, undoubtedly held responsible for the disaster by the general population, was overwhelmingly rejected, together with its ideological base and the rituals and symbols that were the active agents of its authority.

As I have previously noted, the manifestations of crisis included cessation of large-

3. Aerial photograph of Galindo, Moche Valley. Note the elite burial mound palace enclosure at bottom right, the small platform of traditional form directly above it, and the large *cercadura* enclosures at center and left center. Image (no. 334935) reproduced by courtesy of the Department of Library Services, American Museum of Natural History.

4. Plan of Galindo

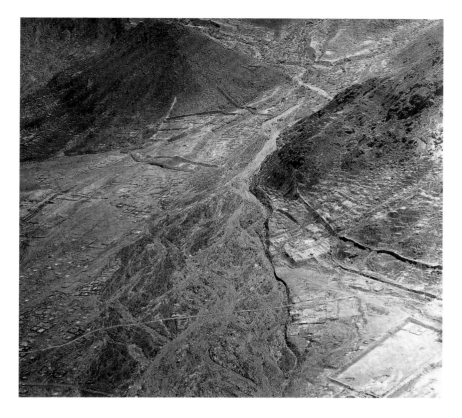

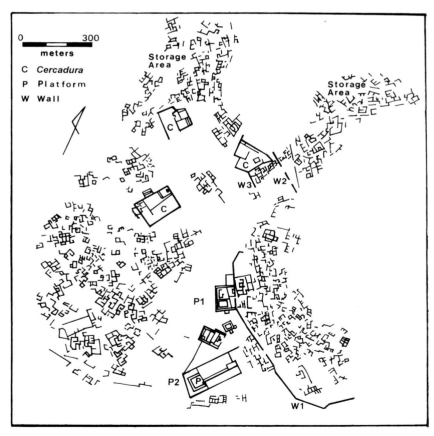

scale public construction in the Moche Valley, abandonment of the great Huaca del Sol, and a dramatic rise in the degree of urbanism at the expense of the rural occupation. Moche monumental architecture possessed much cosmological import. Thus the abandonment of the previous center of Moche society, together with rejection of its very form as a central symbol of social integration, reflects deep structural stress. It follows that with rejection of the cosmology associated with these centers, the authority of leaders who had based their ability to control their society on its ideological potency would be undermined. Power would have to be rebuilt on very different foundations.

With traditional strategies of social integration rejected, rulers and ruled strove to recreate their ideological supports in the unstable Moche Valley setting. They did this in very different ways. Rulers linked their authority to pan-Andean concepts that would free them from identification with the failures of their predecessors. In the very strength of this venture lay its weakness, however. Unless a new ruling order identifies with familiar beliefs rooted in the shared cultural cognition of the population, its acceptance is largely limited to the initiating group and it cannot become the focus of widespread social cohesion (Hobsbawn and Ranger 1983: 283). This was the situation at Galindo, where commoners were divorced from their erstwhile social supports. First, they experienced the failure and rejection of the previous ideological system that had ceased to provide wide social cohesion. Second, they were excluded from the new dominant ideological system that looked to foreign concepts for strength. Finally, they found themselves in the hostile urban setting of Galindo, separated from the familiar kinship foundations of their earlier rural life. The resulting sense of alienation directed them to construct their own bases of social identity. To do this, they drew support from their persisting structural beliefs—the principles that had been the foundations upon which the rejected superstructure of traditional Moche political ideology was built, and which remained the core of their threatened social beings. I suggest that the divergent interests and strategies of rulers and ruled—the former looking to rebuild political authority on an ideational

basis that transcended local traditions, the latter attempting to maintain their traditional social identity in the new urban setting—represented incompatible constructions of power. These differences ultimately exacerbated the social stress that characterized the Late Moche period in the south.

Symbolism of Urban Transformation

The new social structure that emerged in the Late Moche period relied on concentration of the previously dispersed valley population in the new town of Galindo (Billman 1996: 292). Replacement of the rural part of the settlement pattern that had dominated the Moche Valley in earlier times by a new town drastically altered the social environment of its occupants and the relationships that structured their lives. The dynamic political and demographic changes involved in the transition to urbanism usually demand major modification of preexisting community structure (Gailey 1987: 36–38). Differentiation by status, economic power, and ideological practice replaces local kinship relationship as the dominant organizing rule of society. At Galindo, in a situation of crisis, these qualities were present to an extreme degree. Unprecedented levels of social separation, coercive control, and explicit population hierarchy replaced shared beliefs, kinship-based organizational principles, and rituals of public participation as the foundation of political authority. Galindo's founding marks a major discontinuity in Moche social organization and the concurrent rise of internal structural stress, which is most evident in the physical remains of the town.

Just as their predecessors centuries before adopted central components of the powerful Chavín religious complex to confront local weakness (Burger 1992: 183ff), the rulers of Galindo appear to have looked outside their region for the ideological foundations of authority. They found them in the expansive highland Wari polity that had influenced many parts of the Andean region by Late Moche times. In a general sense the urban innovations at Galindo evoke the physical forms introduced in the Wari-influenced areas and may reflect the principles of government associated with them as the new basis for authority.

Galindo may be seen as a symbol of the changed social circumstances (figs. 3, 4). The 6 km^2 settlement, located along the lower slopes of Cerro Galindo, is comprised of an extensive residential area and several monumental architectural structures. Extreme differentiation of population groups and urban functions is apparent in residential, storage, and governmental architecture to an extent not seen in earlier Moche periods, even in comparably large settlements such as that at Moche. Residential occupation was segregated according to size, content, and distance from water sources. A dense zone of low-status houses extends across the steep hillslopes and adjacent plain, much of it separated from the rest of the settlement by a massive wall (fig. 4, W1). This wall was probably built for defensive purposes early in the town's existence, suggesting that unrest afflicted the Moche domain in the late sixth century A.D. (Topic 1991). The small elite residential area, adjacent to the site's most elaborate public architecture, is also shielded by tall stone walls (fig. 4, W2, W3). This emphasis on population segregation suggests that social tension, a consequence of collapse, prevailed at Galindo to such degree that rulers were constrained to rely on coercion to assure their authority.

A large area of storage terraces, whose access was regulated by walls was located on the sides of ravines at the northern periphery of the town (figs. 3, 4). Establishment of this unprecedented public storage facility may reflect the resolve of rulers to control the much-reduced food resources still available to them, and indicates the straightened economic circumstances that demanded such a measure. Indeed, Galindo's very location at the valley neck underscores the pressures on Moche V subsistence economy. Here, relatively protected from outside intrusion, its government could most easily regulate the movement of water to the surviving agricultural lands north of the river. Moreover, accumulation of most of the valley's agricultural workers at the site assured central regulation of production to a degree not previously possible or necessary.

The monumental architecture at the site displays the same qualities of hierarchical separation and control. Three walled complexes, known as *cercaduras* (fig. 4, C), stand

in the center of the town. They contain courts and ramped terraces, upon which secluded daises mark loci of supreme authority. The new *cercadura* forms, although clearly differing in detail from Wari counterparts, do reflect the same emphasis on physical enclosure, functional separation, and ideological exclusivity (Isbell and McEwan 1991). I have noted that these same qualities accompany segregation of the various residential status areas at Galindo. With the elimination of a dominant ideology grounded in the common conceptual history of society as a whole, power inevitably came to be founded on strict control rather than consensus. At Galindo the activities of government were obscured by *cercadura* walls, and the public participation of earlier times was explicitly denied.

The *cercaduras* are in many ways similar and possibly antecedent to the Chimú *ciudadelas* of Chan Chan (Conrad 1974: 226). As with the later *ciudadelas*, *cercaduras* combined administrative, residential and funerary purposes. In one instance (fig. 4, P2) the enclosure was part of a unique architectural complex incorporating elite residential quarters that probably served as the palace of a ruler and a burial platform in which this paramount personage may been interred. Other elite burials were found in clusters of stone-lined rectangular chambers, strictly segregated from lower-status burials and located near the central symbols of authority—the *cercaduras*.

Absent from Galindo are the majestic platform mounds that for centuries had dominated the Moche social scene. In fact most Galindo platforms are little more than modifications of the ground surface, located well away from the central *cercaduras* near the periphery of the site. The traditional platform appears to have played a secondary role in the overall sociopolitical scene at Galindo. I suggest that in the new order it denoted a measure of continuity with the past, but given the overwhelming prominence of new, more central locations, the platforms probably lacked the powerful ideological meaning that this type of architecture once had in earlier times. Their transformed and diminished state relative to the *cercaduras* signifies an interruption in the Moche tradition of social integration.

5. Traditional ceramic *florero* from a high-status residential context
Instituto Nacional de Cultura, La Libertad, Trujillo

6. Traditional ceramic stirrup-spout vessel from a low-status residential context
Instituto Nacional de Cultura, La Libertad, Trujillo

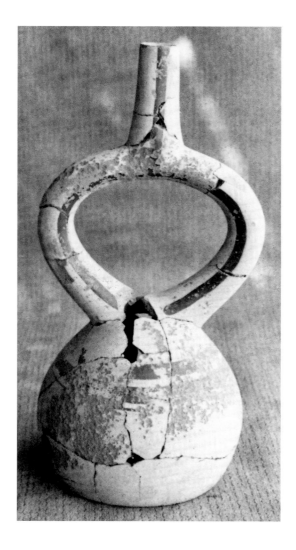

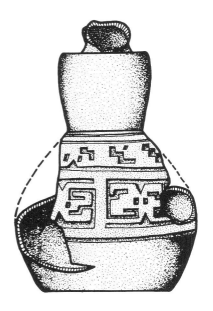
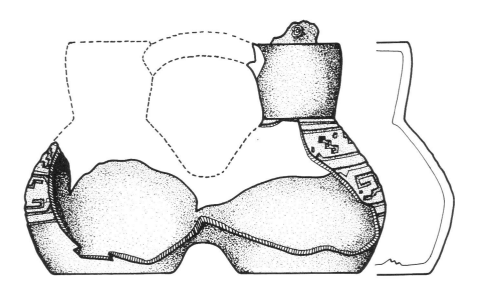

7, 8. Innovative reduced-ware double-chambered from high-status burial (drawings of side and frontal views)
Instituto Nacional de Cultura, La Libertad, Trujillo

Iconography of Ideological Change

The new ideological orientation was also proclaimed through changes in the portable symbols of authority. At Galindo decorated ceramic vessels comprise the majority of examples of portable symbolism and, as with the architecture, ceramic styles changed in the Late Moche period. The changes were twofold. First, while the traditional Moche stirrup-spout bottles and bowls, decorated with red ochre over cream slip, continued to be used at Galindo, the representational iconography that had identified earlier Moche rulers with central political power virtually disappears. This powerful body of visual symbolism had represented the explicit symbolic language through which earlier Moche leaders had infused an ideological message drawn from the north coast cultural experience with the emotional force of myth and history. Most drastic was the total abandonment of the portrait vessel. This form had been one of the most vivid symbols of dominant ideology in earlier Moche times and represented what we presume are the likenesses of specific leaders (Donnan, this volume). These portraits emphasized the leaders' special roles in rituals of social order and asserted their authority. Almost as marked as the disappearance of portraiture is the virtual absence of narrative art at Galindo. Scenes painted on ceramic vessels depicted rituals where leaders played their central roles as arbiters with the supernatural on behalf of their communities, thus reinforcing their position on religious grounds. With the rejection of this rich tradition of narrative symbolism Late Moche elite ceramic decoration at Galindo came to rely largely on abstract geometrical imagery (figs. 5, 6). Such major modification of the traditional iconography of power cannot simply be ascribed to stylistic development. Rather, it reflects rejection and abandonment of a discredited ideology and the elimination of its material symbols of communication.

This reduction in the iconographic inventory was matched by concurrent innovation in other areas of ceramic production. I have described additions to the Late Moche inventory in detail elsewhere (Bawden 1994). The innovations include a number of dark brown and blackware forms, mostly new to the Moche tradition, produced by oxygen-reduced firing. Most are embellished with registers of impressed geometrical design. Of special note are the double-chambered form (figs. 7, 8), the square bowl (fig. 9), and the neck jar with large elliptical body (figs. 10, 11). These forms are all embellished with bands of relief decoration drawn from a restricted group of abstract geometric designs. These include pairs of facing squared spirals, step designs, and stylized fish and bird heads. In addition two undecorated polished blackware bowl forms—the form with sharply

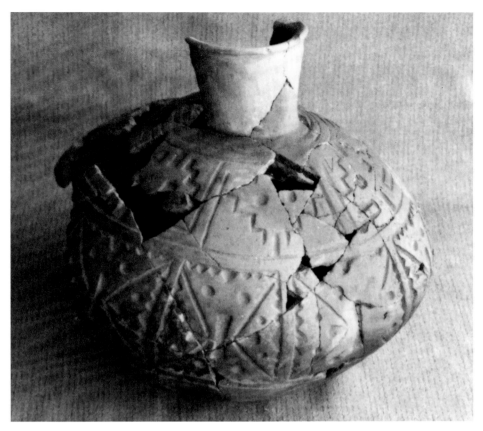

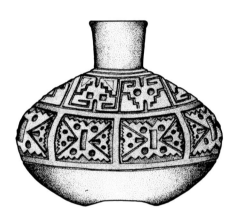

9. Fragment of innovative reduced-ware square bowl from high-status residential context
Instituto Nacional de Cultura, La Libertad, Trujillo

10, 11. Innovative reduced-ware vessel with elliptical-shaped body from a high-status residential context (drawing and photograph)
Instituto Nacional de Cultura, La Libertad, Trujillo

12. Innovative reduced-ware angle-rimmed bowl from a high-status residential context
Instituto Nacional de Cultura, La Libertad, Trujillo

13. Innovative reduced-ware round bowl from a low-status residential context
Instituto Nacional de Cultura, La Libertad, Trujillo

angled rim, and the rounded form (figs. 12, 13)—complete the Galindo innovations.

These innovations show both continuities and disjunctions with earlier Moche practice. The double-chambered vessel has a long history on the north coast, and was especially common in the earlier Gallinazo culture. Earlier examples, however, almost always incorporated a modeled human or animal figure on one of its chambers. The Galindo blackware examples do not have this feature. In general the new blackware forms and relief designs relate to similar styles that appear in the Middle Horizon period, particularly those of the Wari-influenced central coastal (Menzel 1977). At Galindo a regional elite introduced symbolic features inspired by distant but broadly influential Wari ideology. Thus the Galindo rulers, as with their counterparts along the coast, linked their power base to pan-Andean ideas. In so doing, they adopted a broadly shared system that largely ignored and transcended the preexisting local ideologies.

Greater continuity is present in ceramic decoration. The squared spiral with its

associated step design appears occasionally on earlier Moche vessels (see, for example, Bankes 1971: fig. 7; Kroeber 1925: pls. 54h, 55e). The stylized fish head has an even more extensive history in traditional pottery, appearing on Gallinazo vessels (see, for example, Willey 1953: pl. 59) and quite frequently in the Moche inventory (for example Bankes 1971: figs. 8a, 35; Donnan 1978: fig. 189; Kroeber 1925: pl. 58b; Kutscher 1955: pl. 76; Strong and Evans 1952: pl. IX, M). The pendant bird head similarly has clear Moche antecedents (Bankes 1971: fig. 37; Strong and Evans 1952: pl. XVI, E; Willey 1971: fig. 3-64). It is important to realize that continuity goes beyond any mere sharing of motifs to include their stylistic organization. The regular bands of relief decoration of the Galindo forms are anticipated in earlier Moche ceramic painting. Their appearance here as a major decorative theme, however, marks an important stylistic departure.

We can address the significance of these innovations in ceramic vessels by examining the specific nature of the changes and the social contexts of their use. First, it is important to remember that although the new styles and forms clearly depart from the Moche ceramic tradition, they do this in a way that incorporates a degree of continuity. The continuity, however, is limited to designs that played relatively minor roles in earlier ceramics, as borders on the portrait and narrative vessels whose purpose was to proclaim the ideology of power through precise representation. At Late Moche Galindo this narrative visual language was abandoned, and its subsidiary decorative component was expressed in a new stylistic context. Clearly the meaning conveyed by such abstract motifs was very different and more generalized than the varied detailed messages of earlier times. I suggest that the ruling order of Galindo intentionally selected this restricted component of traditional elite symbolism as best suited to their new ideology. By so doing they associated themselves with the esteem of the communal past while eliminating the more specific signifiers of their predecessor's rejected political system. In many ways this parallels their use of the architectural symbolism of the platform mound, albeit with changed meaning, for the same purpose.

The new ceramic forms appear almost exclusively in locations associated with the exercise of authority. They are restricted to the most elaborate residential structures at Galindo. With the single exception of the small round bowl (fig. 13), which seems to have filled a more general utilitarian function, they never appear in the homes of the general population. Elaborate examples of the new forms also appear in the *cercaduras* and the palace complex. Finally, they were interred in elite burials. None have been found in non-elite burials.

In summary, it appears that Moche Valley leadership transformed the nature of symbolic communication by eliminating those central elements that had asserted the specific language of traditional ideology and by ascribing different meaning to others that they retained. This heralded the adoption of an exclusive ideology of power associated with influential pan-Andean concepts. In a general sense this was part of the Middle Horizon phenomenon, which involved the differential spread of tenets drawn from a more universalist ideology. By linking themselves to this broader system, rulers might have attempted to create a supragroup authority base while rejecting the localizing strictures of the past. It is important to note, however, that some traditional features of elite material technology and art did persist as links with the Moche cultural past. Thus, it seems that leaders attempted to combine the broadly legitimizing authority of a modified traditional discourse with the new pan-Andean features, in order to construct an effective ideological system to replace its discredited predecessor. This attempt failed ultimately, probably as a consequence of the extreme social alienation inflicted upon the non-elite population by the dramatic transformation to urban life with its enhanced social stratification and economic deprivation.

Symbolism of Social Reconstitution

To this juncture I have described changes initiated by Moche Valley leaders that adversely affected many of their subjects. Human groups are rarely helpless in the face of social transformation, however. It was left to the commoners to accept the profound transformations of the new order or to use the

potential for power offered by regional structural principles to reconstruct their own social identities. The material record indicates that they chose the latter course. While manifestations of the dominant ideology are obviously more prominent in the archaeological record, signs of the ideological systems of subordinate social groups are less apparent because their proponents were denied access to such highly visible means of communication. It follows that evidence of strategies devised by these groups to confront the Late Moche urban crisis is best revealed in the restricted social arena that remained largely under their control—the household.

At Galindo ideological construction by subordinate groups is most visible in low-status domestic occupation and through its distinctive associated funerary ritual. The basic residential house consisted of three rectangular spaces separated by walls: a food preparation area (fig. 14, *cocina*), general living area (fig. 14, *sala*), and small storage area (fig. 14, *depósito*). The living space was a

rectangular room with stone-faced benches of rubble lining the walls and enclosing a small patio. Bench surfaces offer plentiful evidence of spinning and weaving, food consumption, and use of finer pottery, suggesting that this was the general living and sleeping location of the occupants of the house, with food preparation, cooking and tool construction being conducted in adjacent areas. This space also served another important purpose. Galindo commoners were buried here *within* the benches.

Residential burials were generally modest in form and content. A sample of eleven excavated structures on the level terrain at the foot of Cerro Galindo and a larger number of partially destroyed hillside examples reveals that they were formal interments rather than casual disposals. Burials were either in roughly lined adobe and stone chambers (figs. 15, 17) or simple pits incorporated into the rubble fill of the bench interior (fig. 16). In several instances the body lay at a level above that of the adjacent house floor, suggesting that the bench was reopened following original construction (fig. 16). In every instance, however, the bench was carefully closed and its surface used for general domestic activities, demonstrating that burial occurred during the active life of the house. The deceased rested on their backs, or by contrast with earlier times, on their sides, with adults being placed in mostly extended position while children were usually flexed. The few grave goods that accompanied the dead included simple textile wrappings and small pieces of copper placed at the head and feet.

Although, as I have previously noted, residential burials were quite common in earlier valley sites, the new Galindo practice differs in almost all respects from the traditional pattern. Earlier Moche residential burials appear to have had no specific canons governing their placement and are found in a variety of locations under house floors or outside of the residential space. By contrast, Galindo burials are almost invariably carefully built into the above-floor benches that line the chief domestic space—the *sala*, suggesting a ritual governed by well-defined physical and conceptual rules. Burial content displays the same measure of consistency. Although the Galindo population at all levels had access to nonutilitarian items of metal and pottery

14. Plan of low-status residential structure located at base of Cerro Galindo

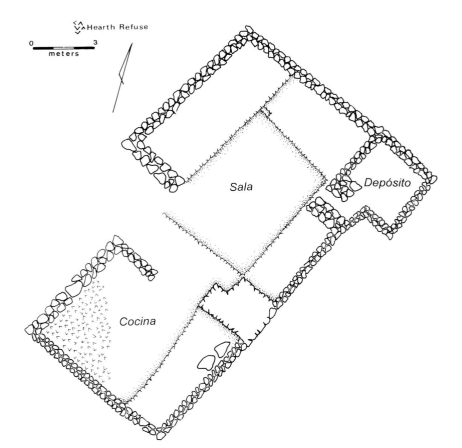

Hearth Refuse

0 ___ 3
meters

Sala

Depósito

Cocina

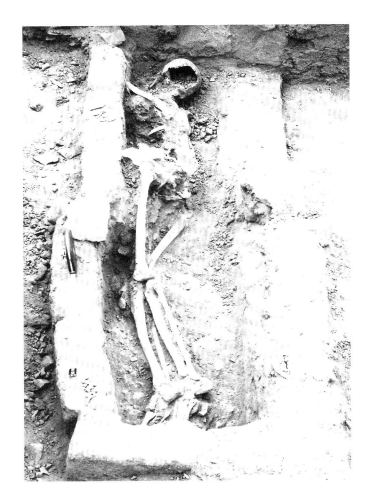

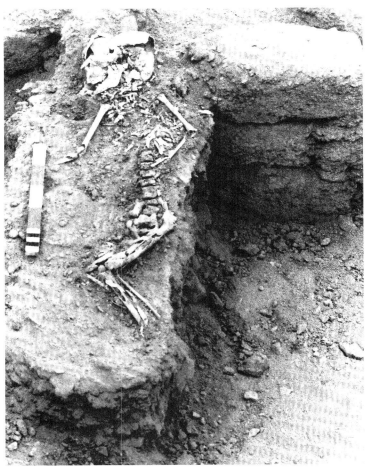

15. Adult male burial within room bench of low-status residential structure

16. Child burial within room bench of low-status residential structure

17. Child burial within room bench of low-status residential structure

(albeit the low-status inhabitants had lower-quality items), grave goods were invariably absent from burials, with the single exception of pieces of copper placed at the head and feet of the deceased. This single feature represents a connecting link to the north coast funerary tradition both during and prior to the Moche period (Fogel 1993: 281). The burial inventory again contrasts with earlier practice, where even the low-status Huanchaco burials included a variety of grave goods (Donnan and Mackey 1978), and strongly suggests that intentional choice governed the restricted selection of such items. Finally, the placement of the dead on their sides in a partially flexed position marks yet another general change from existing Moche practice. Together these features identify a new funerary ritual with its formal set of procedures and rules.

At first glance, the innovative architectural setting and treatment of the dead breaks with existing regional traditions. Conversely, on a purely material level, the rectangular stone-lined tombs of the Moche elite, their burial with abundant fine ceramic accompaniments, and the placement of elite burials in small cemetery clusters, appear to follow cultural convention more closely. Closer scrutiny suggests that the reverse is true. I have already stressed that the rulers of Galindo adopted foreign-derived ideological symbolism in order to break with and transcend the discredited symbols and practices of the past. The incorporation of the material signs of this transformation into the highly charged symbolic setting of burial and the placement of elite burials near the new architectural centers of authority were part of this attempt to transform the Moche social order. By contrast, the household burial customs, while superficially innovative, as I will suggest below, reveal the attempt by a newly urbanized Moche Valley population to reconstruct group cohesion from beliefs embedded in traditional social principles.

The particular potency of funerary practice derives from the great power ascribed to the dead in most societies. Among the many important attributes assigned to them in various societies, ancestors may possess power to ensure fertility, authenticate communal property rights, effect healing, and promote social order. Ultimately they may guarantee the very balance between the spatial and temporal aspects of human experience necessary for social renewal. Universally, proper funerary rituals are necessary to ensure that this potency is properly harnessed and directed on behalf of the living (van Gennep 1960 [1909]; Turner 1967). In this context belief and attendant ritual together constitute powerful social practice that may well affect the very continuance of a community.

Funerary customs, in common with all social constructs, acquire their form and meaning from the historic experience of their related communities. These customs are characterized by two important qualities. First, funerary practice plays as important a role in establishing and directing the relationships between living members of a society as in forging links between them and their dead. Second, funerary customs and the relationships and meanings that they incorporate can be manipulated by the living to provide a powerful vehicle for mediating group interests. It follows that variation through time and space in the material record will reflect these changing relational circumstances (for recent archaeological studies, see Hodder 1990; Kristiansen 1991; Parker Pearson 1993; Thomas 1993; Tilley 1996).

In order to interpret the paradoxical juxtaposition of major material change and conceptual continuity embodied in Galindo residential funerary practices, we must briefly review the implications of the Moche V transformation. Traditional north coast social organization, in accord with broader Andean practice, was based on local kinship-ordered groups attached to their ancestral lands. If we can project later Chimú practice into the past, it is probable that the southern Moche polity was organized according to an extended segmentary system in which local groups retained social autonomy and communal land privileges and were loosely integrated into the wider structure through reciprocal obligations to their own leaders and those of the larger polity (Netherley 1984, 1990).

This order was deeply grounded in principles that identified distinct kin-based groups with their ancestral lands through a combination of mythic association and sacred geography. At the core of this belief was the implicit acceptance that human groups exist at the juncture of their spatial and temporal

experience. In this sense the sacred space of communal lands represented the map on which social life was distributed. Place was embodied in communal being. Life equally gained meaning, however, in the context of its temporality. In a real sense it existed as a projection of the past, continually reinterpreted through myth and manifested in the social arena through beliefs and practices of social cohesion in which ancestral reverence firmly anchored it to its temporal axis. In this worldview time, space, and social reality were inextricably enmeshed, and occupation of ancestral lands was just one unquestioned denominator of human social being.

Undoubtedly ancestral spirits were active players in the daily affairs of the living, regularly manifested through ritual. It may be possible to study the ethnographic present to explore this theme further (Dover, Seibold, and McDowell 1992). Ritual in contemporary traditional north coast society seeks to mobilize supernatural forces on behalf of individuals and community. Traditional healers enter sacred time and space and mediate the assistance of ancestral and natural force in order to maintain the cosmological balance that is the necessary condition for social order (Joralemon and Sharon 1993). Moreover, such ritual inevitably involves places charged with spiritual force that define the geographical experience of the living community and link it with its past and future. In this sense ritual connects community members, their ancestors and descendants, with their wider natural and spiritual world. It is not surprising, then, that in the pre-Christian epoch the physical remains of the dead, whose spiritual force is of such importance in these beliefs and practices, were awarded special treatment and were themselves regarded as sacred beings or *huacas*.

The Late Moche disruptions threatened these basic structural foundations of daily life. On one hand the new urban order of Galindo removed the general populace from the vital physical center of their social lives. On the other hand the narrowly focused political ideology of their rulers, intended as it was to consolidate an exclusive position of authority, could not begin to replace the lost foundations of group cohesion. By merging previously separated communities in a common location and alienating them from the

sacred places that gave physical and spiritual significance to their daily lives, urbanism destroyed their collective boundaries and threatened the very social identities of their members. In response, people compensated for this disruption by reconstructing the familiar substance of their social identity in the new setting. Central to this endeavor was the need to integrate traditional sacred landscape and temporality in a radically different physical context. To accomplish this, people drew on past cultural experience for continuity of meaning, and on the structural basis of their communal being to reconstitute this meaning in their daily lives.

At Galindo the autonomous social space was reduced to the confined setting of the home. While residential space and its architecture always plays an important role in shaping the communal experience of its occupants, in the new setting it became in its own right the reduced counterpart to the wider sacred landscape from which Galindo inhabitants had been displaced. In this confined physical arena they created a system of ritual practice and belief whose material expressions ignored reference to dominant discourses of Moche power, past or present. Absent was the narrative symbolism that had suffused the common structural conception of north coast people with the tenets of earlier Moche dominant ideological discourse. Indeed, the only note of continuity was struck by the persistence of traditional forms intentionally devoid of such iconography. Even here, in the domestic arena new blackware bowls are testament to the hastened replacement of this tenuous symbolic link to the past. Even more conspicuously absent from domestic space and residential burial were innovative Late Moche ceramic forms decorated with the new symbolism of dominant ideology. Indeed, the burials diverged in every way from the traditional custom—in form, location, position of the dead and burial goods. Thus, the ideological focus of lower-status social identity totally rejected both symbolic continuity with the past and the present social order. Instead people turned for support to the fundamental ancestral precepts embedded in their basic communal history. By inserting their dead into the pivotal social space of the household as sacred *huacas* and spiritual presences, they reconstituted the

elemental relationships of their social being. Although not accessible in the archaeological record, we can assume that associated funerary ritual added the social domain within which households reconstituted their identities in practice, drawing together in liminal time the various threads that provided cohesion and continuity to their social lives.

Conclusion

My interpretation of the Galindo archaeological record as the symbolic record of transformation at the end of the Moche period sheds light on some otherwise puzzling contradictions. Paradoxically, the very different forms of material symbolism used by rulers and commoners can be attributed to a common determination to maintain identity through transformation. Deeper examination of this shared motivation shows that it took two very different directions according to the divergent goals of its proponents. In this time of economic and political disruption rulers strove to sustain their identity as dominant arbiters of power by separating themselves from the failure of the past and imposing a new and alien dominant ideology on the Moche Valley. To do this they drew on conceptual and symbolic signifiers that transcended local cultural experience to accord status, social distance, and power to their new order and attempted to legitimize them through association with a secondary level of earlier Moche material symbolism and social practice.

In response, commoners were faced with a very different, though equally urgent, concern. With the traditional kinship foundation of their social cohesion threatened, they were motivated by the need to sustain their identity as a group rather than striving for status or political authority. They did this through recombining the essential tenets of north coast social consciousness in the hostile setting of Galindo. While the rough household tombs can easily be regarded as benign alternatives to the burials of the elite, in fact, their very simplicity embodied separation and resistance. At the heart of this unpretentious household practice lay total rejection of the dominant ideological discourses that had led to the dislocation of their lives. The nature and form of their response led commoners in a very different, conservative, direction from their rulers, one where household ritual became the mobilizing agency for social cohesion.

Inevitably as part of this process traditional Moche symbolic imagery lost its meaning as a major means of maintaining group identity. On one hand, as part of a necessary process of social renewal, commoners eliminated Moche symbolism from the household setting. On the other hand rulers replaced the rejected traditional forms with the symbols of a more effective ideology, introducing new material agents of communication for this purpose. Through these diverse means an entire society took the essential step towards construction of a social identity that is already at Galindo difficult to characterize as "Moche." In the diverse symbolism, which evoked a still vivid past but reached toward an uncertain future, we see the irrevocable beginnings of the ethnic transformation that would ultimately produce Chimú cultural identity.

BIBLIOGRAPHY

Abercrombie, Nicholas, Stephen Hill, and Bryan S. Turner
 1980 *The Dominant Ideology Thesis*. London.

Alva, Walter, and Christopher B. Donnan
 1993 *Royal Tombs of Sipán* [exh. cat., Fowler Museum of Cultural History, University of California]. Los Angeles.

Bankes, George H. A.
 1971 Some Aspects of the Moche Culture. Ph.D dissertation, Institute of Archaeology, London University, London.

Bawden, Garth L.
 1994 Nuevas formas de cerámica Moche V procedentes de Galindo. In *Moche: Propuestas y perspectivas* [Actas del primer coloquio sobre la cultura Moche, Trujillo, 12 al 16 de abril de 1993], ed. Santiago Uceda and Elías Mujica, 207–222. Travaux de l'Institut Français d'Etudes Andines 79. Trujillo and Lima.

 1996 *The Moche*. Oxford and Cambridge, Mass.

Billman, Brian R.
 1996 The Evolution of Prehistoric Political Organizations in the Moche Valley, Peru. Ph.D. dissertation, Department of Anthropology. University of California, Santa Barbara.

Bourdieu, Pierre
 1977 *Outline of a Theory of Practice*, trans. Richard Nice. Cambridge and New York.

Burger, Richard L.
 1992 *Chavín and the Origins of Andean Civilization*. London and New York.

Chapdelaine, Claude
 1997 Le tissu urbain du site Moche, une cité péruvienne précolombienne. In *A l'ombre du Cerro Blanco: Nouvelles découvertes sur la culture Moche, côte nord du Pérou*, ed. Claude Chapdelaine, 11–81. Université de Montréal, Département d'anthropologie, Les Cahiers d'Anthropologie 1. Montréal.

Conrad, Geoffrey W.
 1974 Burial Platforms and Related Structures on the North Coast of Peru: Some Social and Political Implications. Ph.D. dissertation, Department of Anthropology, Harvard University, Cambridge, Mass.

Cordy-Collins, Alana
 1992 Archaism or Tradition?: The Decapitation Theme in Cupisnique and Moche Iconography. *Latin American Antiquity* 3 (3): 206–220.

Donnan, Christopher B.
 1978 *Moche Art of Peru: Pre-Columbian Symbolic Communication* [exh. cat., Museum of Cultural History, University of California]. Los Angeles.

 1995 Moche Funerary Practice. In *Tombs for the Living: Andean Mortuary Practices* [A Symposium at Dumbarton Oaks, 12th and 13th October 1991], ed. Tom D. Dillehay, 111–159. Washington.

Donnan, Christopher B., and Carol J. Mackey.
 1978 *Ancient Burial Patterns of the Moche Valley, Peru*. Austin, Tex.

Dover, Robert V. H., Katharine E. Seibold, and John H. McDowell
 1992 (Editors) *Andean Cosmologies Through Time: Persistence and Emergence*. Bloomington, Ind.

Firth, Raymond
 1973 *Symbols: Public and Private*. London.

Fish, Stanley E.
 1989 *Doing What Comes Naturally: Change, Rhetoric and the Practice of Theory in Literary and Legal Studies*. Durham, N.C.

Fogel, Heidy
 1993 Settlements in Time: A Study of Social and Political Development during the Gallinazo Occupation of the North Coast of Peru. Ph.D. dissertation, Department of Anthropology, Yale University.

Foucault, Michel
 1984 Truth and Power. In *The Foucault Reader*, ed. Paul Rabinow, 51–75. New York.

Gailey, Christine W.
 1987 Culture Wars: Resistance to State Formation. In *Power Relations and State Formation*, ed. Christine W. Gailey and Thomas C. Patterson, 35–56. American Anthropological Association, Washington.

Gennep, Arnold van
 1960 *The Rites of Passage*, trans. Monika B.
 [1909] Vizedom and Gabrielle L. Caffee, with an introduction by Solon T. Kimball. Chicago.

Harman, Willis W.
 1988 The Postmodern Heresy: Consciousness as Casual. In *The Reenchantment of Science: Postmodern Proposals*, ed. David Ray Griffin, 115–128. Albany, N.Y.

Hobsbawm, Eric, and Terence Ranger
 1983 (Editors) *The Invention of Tradition*. Cambridge.

Hodder, Ian
 1990 *The Domestication of Europe: Structure and Contingency in Neolithic Societies*. Oxford and Cambridge, Mass.

Isbell, William H., and Gordon F. McEwan
 1991 (Editors) *Huari Administrative Structure: Prehistoric Monumental Architecture and State Government* [Papers from a round table held at Dumbarton Oaks, 15–17, 1985]. Washington.

Joralemon, Donald, and Douglas Sharon
 1993 *Sorcery and Shamanism: Curanderos and*

Clients in Northern Peru. Salt Lake City, Utah.

Kristiansen, Kristian
1991 Chiefdoms, States, and Systems of Social Evolution. In *Chiefdoms: Power, Economy and Ideology*, 16–43, ed. Timothy K. Earle. School of American Research Advanced Seminar Series. Cambridge.

Kroeber, Alfred L.
1925 *The Uhle Pottery Collections from Moche.* University of California Publications in American Archaeology and Ethnology 21(5): 191–234, plates 50–69. Berkeley.

Kutscher, Gerdt
1955 *Ancient Art of the Peruvian North Coast,* trans. Walter Hermann Bell. Berlin.

Leach, Edmund R.
1976 *Culture and Communication: the Logic by which Symbols are Connected: An Introduction to the Use of Structuralist Analysis in Social Anthropology.* Cambridge and New York.

Mach, Zdzislaw
1993 *Symbols, Conflict and Identity: Essays in Political Anthropology.* Albany, N.Y.

Menzel, Dorothy
1977 *The Archaeology of Ancient Peru and the Work of Max Uhle.* R. H. Lowie Museum of Anthropology, University of California, Berkeley.

Moore, Jerry D.
1996 *Architecture and Power in the Ancient Andes: The Archaeology of Public Buildings.* New Studies in Archaeology. Cambridge and New York.

Moseley, Michael E.
1975 Prehistoric Principles of Labor Organization in the Moche Valley, Peru. *American Antiquity* 40 (2): 191–196.

Netherly, Patricia J.
1984 The Management of Late Andean Irrigation Systems on the North Coast of Peru. *American Antiquity* 49 (2): 227–254.

1990 Out of Many, One: The Organization of Rule in the North Coast Polities. In *The Northern Dynasties: Kingship and Statecraft in Chimor* [A Symposium at Dumbarton Oaks, 12th and 13th October 1985], ed. Michael E. Moseley and Alana Cordy-Collins, 461–487. Washington.

Parker Pearson, Michael
1993 The Powerful Dead: Archaeological Relationships Between the Living and the Dead. *Cambridge Archaeological Journal* 3 (2): 203–229.

Rapoport, Amos
1982 *The Meaning of the Built Environment: A Nonverbal Communication Approach.* Beverley Hills, Calif.

1990 Systems of Activities and Systems of Settings. In *Domestic Architecture and the Use of Space: An Interdisciplinary Cross-Cultural Study,* ed. Susan Kent, 9–20. Cambridge.

Ricoeur, Paul
1974 *The Conflict of Interpretations,* ed. Don Ihde. Evanston, Ill.

Strong, William Duncan, and Clifford Evans
1952 *Cultural Stratigraphy in the Virú Valley, Northern Peru: the Formative and Florescent Epochs.* Columbia Studies in Archeology and Ethnology 4. New York.

Thomas, Julian
1993 The Hermeneutics of Megalithic Space. In *Interpretative Archaeology,* ed. Christopher Tilley, 73–97. Oxford.

Tilley, Christopher
1996 *An Ethnography of the Neolithic: Early Prehistoric Societies in Southern Scandinavia.* Cambridge.

Topic, Theresa Lange
1982 The Early Intermediate Period and Its Legacy. In *Chan Chan: Andean Desert City,* ed. Michael E. Moseley and Kent C. Day, 255–284. School of American Research Advanced Seminar Series. Albuquerque, N.M.

1991 The Middle Horizon in Northern Peru. In *Huari Administrative Structure: Prehistoric Monumental Architecture and State Government* [Papers from a round table held at Dumbarton Oaks, 15–17, 1985], ed. William H. Isbell and Gordon F. McEwan, 233–246. Washington.

Topic, John R., and Theresa Lange Topic
1997 La guerra Mochica. *Revista Arqueológica SIAN* 4: 10–12. [Trujillo].

Turner, Victor
1967 *The Forest of Symbols.* Ithaca, N.Y.

Willey, Gordon R.
1953 Prehistoric Settlement Patterns in the Virú Valley, Perú. Smithsonian Institution, Bureau of American Ethnology Bulletin 155. Washington.

1971 *An Introduction to American Archaeology, Volume 2: South America.* Englewood Cliffs, N.J.

Wilson, David J.
1988 *Prehispanic Settlement Patterns in the Lower Santa Valley, Peru: A Regional Perspective on the Origins and Development of Complex North Coast Society.* Smithsonian Series in Archaeological Inquiry. Washington.

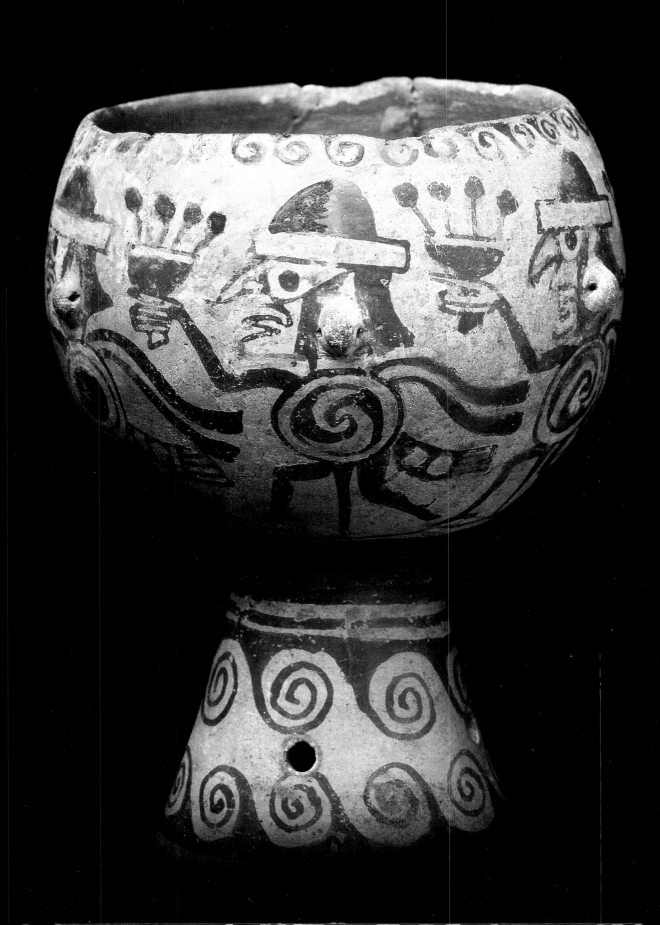

LUIS JAIME CASTILLO

Pontificia Universidad Católica del Perú

The Last of the Mochicas: A View from the Jequetepeque Valley

Moche archaeology has advanced in a surprising way over the past few years, thanks to multidisciplinary research programs and important discoveries. The many diverse aspects of this society have been approached in a comprehensive way, including study of the geopolitical organization, the form and function of ideology, the structure of iconographic communication systems, and the settlement and burial patterns. The majority of these studies, however, have centered on the Moche III and IV chronological phases, and especially complex sites such as Sipán, Huaca de la Luna, the El Brujo complex, and Cerro Mayal. These projects have allowed us to focus on the period of the greatest development of this society, as well as the forms and styles that characterize its artistic expressions (Alva 1994; Alva and Donnan 1993; Franco, Gálvez, and Vásquez 1994; Russell and Leonard 1994; Uceda and Mujica 1994).

The San José de Moro Archaeological Project, in contrast, has focused on late Moche development in the Jequetepeque Valley (fig. 1).[1] This emphasis has resulted in theoretical and empirical approaches that differ from what has prevailed in other studies. For example, the theme of social collapse, or political and ideological management of a society in crisis, is a fundamental issue for us. In this article I intend to approach such issues apparent in Late Moche society. This study will begin in the Middle Moche period, and carry through to the what we have defined as

the Transitional period, which includes the end of Moche (c. A.D. 800) to the Lambayeque conquest of the Jequetepeque Valley (c. A.D. 950). To place this within a broader Andean framework, it concerns the Early Intermediate to Middle Horizon periods.

San José de Moro offers exceptional conditions for the study of the evolution of funerary and ceremonial practices. Our sources of information are doubly rich, as in addition to the burials we have an extraordinary corpus of vessels with fine-line paintings on them found in graves. In the evolving funerary patterns and their related ceremonies and ceramics, we can see a rich history of cultural influences, of strategies for power based on complex ideological manipulations, and the absorption of, or resistance to, the pressures of foreign societies.

Before beginning the analysis of the San José de Moro data, I wish to note two theoretical assumptions inherent in our research regarding Moche geopolitical organization and the chronological and regional ceramic sequences. First, Moche territory was divided into two clearly defined regions. The northern Moche region included the Piura, Lambayeque and Jequetepeque valleys, which coexisted with greater or lesser political independence among them (Castillo and Donnan 1994b; Donnan and Cock 1986). The southern Moche region included the Chicama and Moche valleys as a nuclear zone, while the Virú, Chao, Santa, and Nepeña valleys were

Moche ceremonial cup found in the tomb of the Priestess from San José de Moro (M-U41) (height: 11.5 cm)
Instituto Nacional de Cultura, La Libertad,Trujillo
Photograph by Juan Pablo Murrugarra

1. General view of the San José de Moro excavation
Photograph by Juan Pablo Murrugarra

incorporated through military conquest (Willey 1953). Secondly, the ceramic sequence of the Jequetepeque Valley is different from the southern Moche region, which has been divided into five phases by Larco (1948). The ceramic sequence in Jequetepeque, however, comprises three periods: Early Moche, corresponding to Phases I and II in the south; Middle Moche, contemporaneous with Phase III and part of Phase IV; and Late Moche, coeval with the end of Phase IV and Phase V. In the Jequetepeque Valley, the Late Moche period is followed by the Transitional period and finally the Lambayeque occupation. This sequence, apparently, could also apply to Moche ceramic evolution in Lambayeque and Piura (Castillo and Donnan 1994b).

The Collapse of Moche Society

Only three projects have systematically studied the Late Moche period: the Pampa Grande Project directed by Kent Day and Izumi Shimada (Shimada 1994); Garth Bawden's Galindo study (this volume, and 1977, 1982), and the San José de Moro Archaeological Project. Otherwise, any additional information we have comes from numerous isolated finds, often come across accidentally. These include tombs, mural paintings, and ceramic and metal objects, some of which have entered museum collections throughout the world. Settlement pattern studies not solely centered on the Late Moche period have also contributed to our understanding of the occupational history of various valleys or regions (Proulx 1973; Russell 1990; Willey 1953; Wilson 1988, among others).

Societal collapse marked the fundamental character of the Late Moche period. In the literature, three factors have been suggested for the demise of the Moche: environmental instability at the end of the sixth century A.D.; the influence of Wari, an expansionist polity of the Middle Horizon period based in the southern highlands, and societies related to them; and finally, an internal collapse of Moche society, particularly its political and ideological structures. The authors who have studied this period emphasize one or the other of these factors. Thus, while Shimada (1994; Shimada et. al. 1991) gives priority to environmental factors, Bawden (1996), Castillo and Donnan (1994a) incline more toward the internal weakness of Moche society. Nevertheless, it has become more

evident that the role of Wari cultural diffusion is contingent upon the other two; in other words, Wari had an influence on the north coast only after the Moche governing elite were debilitated, which could only have happened through the combination of the other two factors. Our capacity for understanding the impact of the Wari phenomenon is limited, as we have no clear idea of the mechanisms of cultural interaction between Wari and other regional groups related to it, let alone their interactions with populations of the north coast. Many questions remain unanswered about the character of Wari, particularly its peculiar form of dispersion in the central Andes. The evidence considered here leads us to believe that Wari had an indirect presence on the north coast, a primarily ideological influence that was mediated through other societies. This mediation seems to have had two forms: Wari symbols and ideas were reelaborated by geographically intermediate societies along the central coast and northern highlands and through these areas arrived at the Jequetepeque Valley; and secondly, these societies served as distributing agents of artifacts originally produced in the south.

Various investigators have discussed the internal weakness of Late Moche society. Shimada (1994) assumes that a latent social conflict existed, generated by the politics of an oppressive elite who dominated other ethnic villages, which would finally have resulted in rebellion against the oppressors. In contrast, Bawden (1996) explains the internal weakness as an effect of a structural flaw, which was inevitably produced by the inherent contradictions of Moche political ideology. On the one hand, this ideology tended to favor the elite; on the other, it was confronted by intrinsic Andean tenets of reciprocity and solidarity. Bawden interprets the site plan of Galindo, a typical Phase V site in the Moche Valley, as the physical expression of these conflicts among segments of the society, where the elite isolated themselves from the common people through large walls and portals that simultaneously controlled access between *barrios*, or neighborhoods, and exercised control of stored resources.

Such external and internal pressures could have accelerated a crisis in Late Moche society. Various authors have argued that two important changes occurred in settlement patterns at this time. First, the most important population centers were found at the necks of the valleys, so as to control the canal intakes of the irrigation systems (Moseley 1992).[2] Secondly, moving the capital of the supposed Moche state from the Huaca de la Luna and the Huaca del Sol in the Moche Valley to Pampa Grande in the Lambayeque Valley would have aggravated the crisis. Unfortunately, there are still insufficient data to support this second hypothesis.

As the San José de Moro Archaeological Project has been focusing most recently on ceremonial and funerary aspects of the site, we have not yet had time to study the environmental history of the site, although to date we have encountered little evidence of dramatic environmental upheaval. In spite of the lack of evidence so far, we suspect that climatic instability played a role in the fortunes of Moche society. Climatic instability, however, seems to have had a greater influence on the transition between the Middle and Late Moche periods than in the Moche collapse. Fortunately, this factor is being studied in the Jequetepeque Valley by other researchers (Dillehay, this volume). We have been emphasizing investigation of the two remaining factors: Wari influence and the internal deterioration of Moche society.

San José de Moro

The San José de Moro Archaeological Project differs from other projects that have studied late Moche society because of the site's peculiar nature. While Galindo and Pampa Grande are habitational sites that include monumental ceremonial structures and were occupied for only a short period of time, San José de Moro was essentially a cemetery and ceremonial center continuously occupied for more than a thousand years. San José de Moro's occupational history began in the Middle Moche period and lasted through the Inca conquest, with its most dense occupation occurring in the Late Moche and Transitional periods.

As looters have destroyed many of the structures that existed at the site, we focused on a series of flat areas, perhaps ritual plazas, located in front of mounds. Between 1991 and 1992, we excavated the area in front of Huaca de la Capilla, where we found five large tomb

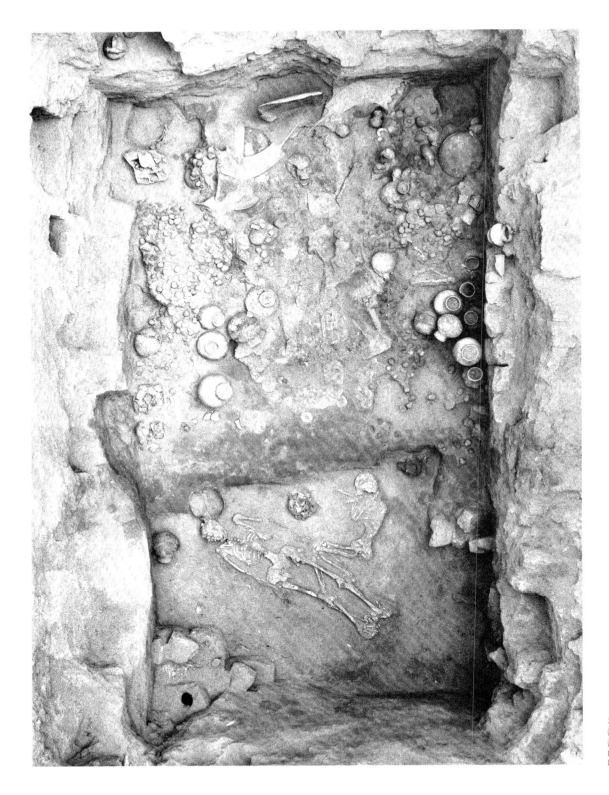

2. Tomb of the Priestess
(M-U41) found in 1991
(shown head to top)
Photograph by Christopher B.
Donnan

chambers, two of which pertained to indi-
viduals now known as the San José de Moro
Priestesses (Castillo 1996; Castillo and Don-
nan 1994a, 1994b; Donnan and Castillo 1994)

(fig. 2). The excavations revealed a significant
number of tombs in clusters and specific
alignments. It is evident now that tombs of
the same period and complexity tend to be

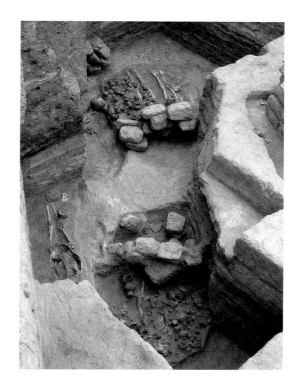

seem to have external markers, allowing us to identify clusters of tombs, usually arranged in lines or circles (figs. 3, 4). In this fashion, we have been able to follow groupings of up to six elite burials. Apparently ritual activities were celebrated on the grounds surrounding the tombs. We have found alignments of adobe bricks that delineate rectangular spaces. The adobe bricks did not form structural walls, as we found one or two lines of bricks without foundations. It would seem that these were used only to delimit ritual space. Within these spaces we found groups of ceramics, including large ceramic storage vessels, or *paicas*, placed in line or in clusters (fig. 5). The *paicas* were probably used for the preparation of *chicha* (maize beer), or some other product.

In addition to the tombs and ceremonial spaces at San José de Moro, we have studied the occupational mounds. They show a very complex stratification, beginning with the Middle Moche period and culminating with the Chimú occupation (Castillo and Donnan 1994a; Rosas 1999). These have already been reported by Disselhoff (1958a, b) and Chodoff (1979), both of whom did early stratigraphic excavations at the site. The ceramic sequence that has been reconstructed through the

3. Cluster of Moche tombs in 1996–1998 excavations units
Photograph by Juan Pablo Murrugarra

grouped together. We have registered concentrations of Middle Moche, Late Moche, and Lambayeque period elite graves as well as graves of lesser status. Many of the graves

4. Boot-shaped tomb seen in cross section. The bottom portion of a *paica* (large ceramic storage vessel) is visible at the upper left, by the entrance to the tomb
Photograph by Juan Pablo Murrugarra

stratigraphic study is obviously rich, even more so now, as it has been refined, corrected, and complemented by forms that appear in the corresponding tombs. One should note that in the stratigraphic profiles, however, "fine" ceramics rarely appear.

The Moche at San José de Moro

While the beginning of the Moche occupation at San José de Moro in the Middle Moche period is relatively easy to define, the precise end of Moche is more difficult to discern, as a clear Moche influence can be detected in contexts that would generally be considered post-Moche chronologically. In the following sections I present evidence on Late Moche society at San José de Moro, and propose some hypotheses to explain the data. I will begin with a discussion of the Middle Moche period in order to identify the antecedents to the Late period. My conclusions with respect to the Transitional period are still preliminary, as data are still being discovered and analyzed.

The Middle Moche Period

According to the Jequetepeque Valley ceramic sequence (Donnan and Castillo 1994), the Middle Moche period is a distinct cultural phenomenon, and not a local variant of the Moche III period as described by Larco (1948). Phase III of the southern Moche region is characterized by higher-quality ceramics, which are finely modeled and painted with pictorial designs. Based on stylistic and chronological criteria, we think that Middle Moche was contemporaneous with Phase III and possibly part of Phase IV in the south, although we have still not been able to establish firm correspondences.

Data for this period in the Jequetepeque Valley come from excavations at San José de Moro and Pacatnamú, the latter carried out by Ubbelohde-Doering in 1938 (1983) and Donnan and Cock more recently (1986, 1997b). At San José de Moro, we have located sixteen tombs belonging to this period, all of which correspond to a type known as a boot-shaped tomb. These consist of a vertical pit of variable depth (from 0.5 m to 2 m) that ends in a lateral funerary chamber, very restricted in height and width. Although organic preservation is very poor, it appears that individuals

5. Cluster of *paicas*
Photograph by Juan Pablo Murrugarra

were wrapped in thick cloth and laid out over reed mats. Some fiber bands were fixed at pelvis height to what seems to have been a semirigid mat. These were perhaps used to hold the body in place. The funerary chambers seem to have been filled with clean sand before they were sealed with walls of adobe bricks. In general, adobe bricks associated with Middle Moche tombs are thin (approximately 12 cm) and show signs of mold manufacture, compared with Late Moche bricks, which are double in thickness. Finally, the entrance of the vertical pit was filled. Recently, we have been able to document a number of *paicas* as tomb markers. These *paicas* appear in the fill at the mouth of the tomb, perhaps jutting out slightly over an occupation floor, and would have been used during funerary rituals to seal the tomb, and for subsequent offerings or celebrations. In some cases, the burnt remains of camelid bones were discovered in the *paicas*.

A unique feature of Middle Moche tombs at San José de Moro is that most contain a single fine ceramic piece, usually a stirrup-spout bottle. Only two burials contained simple artifacts, such as cooking vessels or

jars, and these were in limited numbers, particularly when compared with the quantity of ceramics seen in Late Moche tombs. The ceramics are typically located near the body, beside the head or at the feet, occasionally on top of the body.

More than eighty burials have been located at Pacatnamú in two areas of Moche occupation; the majority can be attributed to the Middle Moche period. In 1938 Ubbelohde-Doering (1983) found a series of Moche tombs in the area around Huaca 31; Donnan and Cock (1997b) later located a Moche cemetery of the same period that they designated H45CM1. These two cemeteries are very different in terms of the type of tombs they contained. The cemetery found by Ubbelohde-Doering would seem to be of elite individuals, given the presence of multiple superficial pit tombs and three enormous boot-shaped tombs excavated in the rubble, with many varied artifactual associations.[3] The tombs of the H45CM1 cemetery pertain to individuals from the lower levels of society, possibly peasants and fishermen; hence they include only very simple offerings such as domestic ceramics, fragments of metal artifacts and worn textiles. The Middle Moche period tombs found at San José de Moro seem to correspond to an intermediate social segment, as they are not as rich and complex as some from the Huaca 31 cemetery, but contain generally finer ceramics than those found at H45CM1.

The similarities between the Middle Moche ceramics found at Pacatnamú and those at San José de Moro are undeniable, to the point that some pieces from both sites could have come from the same mold (fig. 6). In contrast to San José de Moro, however, the Pacatnamú tombs contained large quantities of ceramic vessels of domestic and mid-grade quality.

As we analyzed the Middle Moche ceramics from both sites, it became apparent that ceramics painted with elaborate fine-line pictorial decoration did not exist. A very advanced use of lineal design with narrative iconographic scenes was developing in Phases III and IV in the southern Moche region, yet it seems to be absent in the north. The most complex decorative motifs in Jequetepeque were figures painted with thick lines on the vessel bodies (Donnan and McClelland 1997: figs. 10a, 10b, and 12b). In addition to the cream and ochre slips, and in contrast to

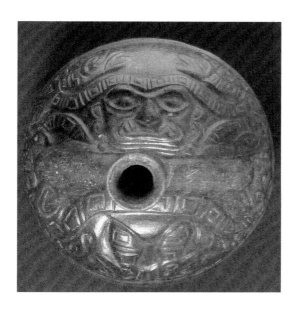

6. Middle Moche stirrup-spout bottle from San José de Moro, viewed from above, with an Aia Pec representation in relief (Tomb M-U318 C1). (Compare with Ubbelohde-Doering 1983: figs. 21.1–2, 28.2, 57.1)
Instituto Nacional de Cultura, La Libertad, Trujillo

other regions, a purple slip was used to decorate the vessel bodies with lines and bands (Donnan and McClelland 1997: figs. 11a, 11c). Another characteristic of Middle Moche ceramics is the presence of vessels with decorative details showing a clear continuity with the earlier Virú or Gallinazo style, particularly eyes rendered with lines and incised dots, "tears," and other facial features characteristic of this style (Donnan and McClelland 1997: 31d, 108, 205).

Influence from the Virú culture in Middle Moche ceramics is congruent with findings by Donnan at Dos Cabezas and Mazanca (Donnan and Cock 1995, 1996, 1997a; Donnan, personal communication, 1999) and suggests that the Moche style could have derived from a Virú culture substratum. This substratum did not disappear as the Moche style was crystallizing, but persisted as a substyle within the varieties of Moche art. This stylistic line persists to the Late period, in addition to others that seem more familiarly Moche.

Not only are there no Middle Moche fine-line ceramics at San José de Moro, there appears to be little or no influence in the ceramics from contemporary external sources. There is no discernable stylistic affinity with Cajamarca ceramics, which is somewhat surprising given the proximity of this highland culture to Jequetepeque. Nor is there evidence of stylistic borrowings or exchange of imagery from cultures of the central coast. Moreover, there seems to be no connection

with the Moche III ceramics of the Chicama and Moche valleys. The Middle Moche ceramics are technologically very simple and less refined than those of the southern region, and show a continuity with simple forms of Early Moche in the northern region (see Castillo and Donnan 1994a: 162–169).

The lack of elaborate pictorial decoration and the overall poorer quality of the wares are characteristic of the Middle period of northern Moche ceramics. This includes the Middle Moche site of Sipán, where the extraordinary quality of the goldwork contrasts with the relatively poor quality of the ceramics.[4] These facts only reaffirm questions surrounding the origins of the elaborate pictorial styles that characterize the fine-line ceramics of the Late Moche period in the northern Moche area.

The Late Moche Period

To date, one of the most difficult processes to understand has been the transition from Middle Moche to Late Moche periods in the Jequetepeque Valley. The sudden appearance of fine-line ceramics, which characterized the Late period, particularly at San José de Moro, was unexplained. As we will see, focusing almost exclusively on the origin and evolution of fine-line ceramics distracted us from understanding the true nature of the transition. The data under consideration now indicate that a fluid transition existed between these periods; however, the Late period appearance of fine-line ceramics may be the result of outside influences.

Our data on Late period Moche occupation in the Jequetepeque Valley come from graves at Pacatnamú (Ubbelohde-Doering 1983) and thirty-nine tombs and other contexts in San José de Moro (Castillo and Donnan 1994a, 1994b; Castillo, Mackey, and Nelson 1996, 1997, 1998). The tombs represent a wide range of social positions and functions, from the extremely elaborate tombs of the Priestesses of Moro (Donnan and Castillo 1994a) to the very simple pit tombs with no artifacts. The most common tombs for this period, however, are still boot-shaped tombs sealed with adobe bricks.

The close relationship between archaeology and iconography has led to considerable advances in understanding funerary customs of Late Moche society. Beginning with the study of the funerary associations, it is possible to recognize two individuals buried at San José de Moro wearing the regalia of a personage known from Moche iconography as the Priestess (Donnan and Castillo 1994). In the iconography, the Priestess appears as a participant in a number of ritual scenes, particularly those of prisoner sacrifice and presentation (Introduction to this volume, fig. 5; Alva and Donnan 1993: fig. 143, chapter V; Donnan 1978: 158–173), the Revolt of the Objects (Lyon 1981; Quilter 1990), and maritime scenes, such as the image of the Priestess riding a reed raft or crescent moon (Cordy-Collins 1977). It is noteworthy that the women buried at San José de Moro had coffins decorated with some of the implements associated with the Priestess, such a headdress with serrated-edge extensions (fig. 2). One coffin contained a pedestal cup, an item closely associated with the Priestess in the Presentation Scene (fig. 7). Based on this evidence, we infer that during their lives these women fulfilled the role of the Priestess, perhaps conducting rituals similar to the ones depicted on the ceramics, or at the very least, they were intimately related to it, to the extent of being buried with the Priestess' attributes. This association between the Moche elite and the most important figures

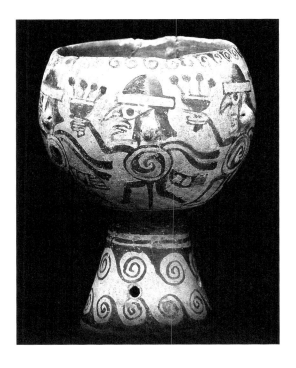

7. Ceremonial cup found in the tomb of the Priestess from San José de Moro (M-U41)
Instituto Nacional de Cultura, La Libertad, Trujillo
Photograph by Juan Pablo Murrugarra

8. Architectural model from
San José de Moro
Instituto Nacional de Cultura,
La Libertad, Trujillo

9. Typical forms of the Late
Moche period, San José de
Moro: a) bottle with fine-line
painting, b) jar, and c) *olla*
with platform rim
Instituto Nacional de Cultura,
La Libertad, Trujillo
Drawings by Percy Fiestas

seen in the iconography is not new, as the tomb of the Lord of Sipán included the same sort of regalia seen in depictions of the principal figure of the Sacrifice Ceremony (Alva, this volume; Alva and Donnan 1993). To date, no other burial found at San José de Moro has been associated with personages known from the iconography, but the possibility remains that others will be discovered in the future. Perhaps more important than the precise identification of religious entities in these tombs is the confirmation that the Moche elite had a clear relationship to ritual specialists and the divine.

By the standards of most sites, the Priestesses' burials were quite complex for their time. The grave goods included not only the artifacts previously mentioned, but also imported ceramics, sacrificed individuals, and a significant number of ceramic vessels, including a type of small vessel known as a *crisol*. Other chamber tombs included architectural models made of unfired clay, originally painted in bright colors (fig. 8). The models represent rectangular, roofed structures with platforms, patios, benches, ramps and corridors (Castillo, Nelson, and Nelson 1997). In spite of this, when we compare these Moche elite burials with their counterparts of the Early and Middle periods (Sipán, La Mina, Loma Negra, Dos Cabezas), there is a surprising absence of gold and silver artifacts. In earlier periods, it is common to find a high concentration of gold crowns, headdresses and adornments, and copper figurines in elite tombs. Not only is there a lack of precious metals, but also a general decrease in metal artifacts.

The majority of the burials located at San José de Moro do not correspond to the highest echelon of Moche society, who were presumably buried in the chamber tombs we found. The second rank of elites were generally buried in boot-shaped tombs. Individuals were buried in an extended, supine position, with the majority placed with their heads oriented to the south. This pattern is maintained not only until the end of the Late

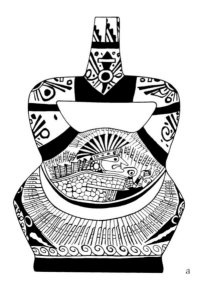

a

b

c

Moche period, but continues as the primary pattern for the Transitional period burials as well.[5] Late Moche period mid-grade ceramics, or ceramics that are neither fine nor domestic, show a clear continuity in form and decoration with artifacts found in the Middle period tombs. Face-neck jars (jars with an effigy modeled on the neck of the vessel), flasks with small lateral handles, open-mouth jars, and slightly fired *crisoles* still predominate. Of course, new forms appear in the Late period, while others disappear (fig. 9). Forms rare in the Middle period, such as small flat-based jars with slightly streamlined bodies and flared neck, become very popular. Some important changes occurred with domestic

ceramics; for example, jars with composite necks typical of Middle Moche are replaced by the highly diagnostic jars with platform rims (fig. 9, c). Some forms have a singular longevity and continue through different periods; such is the case of the face-neck jars with a modeled arm or arms projecting over the face, covering the mouth or an eye (fig. 10). This form is known in earlier Virú or Gallinazo ceramics and appears in late contexts at Pacatnamú, San José de Moro and Pampa Grande.[6] In summary, for mid-grade ceramics, we do not see a rupture between the Middle and Late phases, but rather a clear continuity, with evolving forms, disappearing forms, and emerging modalities based on older forms.

10. Ceramic vessels from various periods: Virú-Early Moche (a, b, c from Mazanca, Instituto Nacional de Cultura, La Libertad, Trujillo); Middle Moche (d, e, from Pacatnamú, Instituto Nacional de Cultura, La Libertad, Trujillo), Late Moche (f, from San José de Moro, Instituto Nacional de Cultura, La Libertad, Trujillo; and g, from Pampa Grande, Instituto Nacional de Cultura, Lambayeque); and Transitional (h, from San José de Moro, Instituto Nacional de Cultura, La Libertad, Trujillo)
Drawings by Percy Fiestas

The Appearance of Fine-Line Style in Northern Moche Sites

An innovation of the Late period is the irruption of what we call, after McClelland (1990), the fine-line iconographic style characteristic of the Late Moche phase in the Jequetepeque Valley and in particular at San José de Moro. This style has received much attention for its formal and technological quality and its elaborate narrative iconography (Donnan and McClelland 1979, 1999; McClelland 1990). Intricate scenes, usually painted in red slip on a cream-colored base, cover the body and often the neck of stirrup-spout vessels. A variant appears in the double-spout-and-bridge vessels (Larco 1966a: figs. 108, 109; Rowe 1942) and in the stirrup-spout ceramics decorated with Moche iconography, albeit in polychrome (Shimada 1994: fig. 9.1).

Examples of vessels with fine-line decoration have been reported occasionally at southern Moche sites, like El Carmelo (Larco 1966a: figs. 106, 107), the El Brujo complex, and Cerro Mayal (personal communication, Régulo Franco and Glenn Russell respectively), as well as at sites farther afield such as Paredones in Lima (Stumer 1958) and in the Piura Valley (Larco 1966a: 107). Additionally, at Pampa Grande some vessels have been reported in ceremonial and production contexts (Shimada 1994: figs. 7.35.C, 8.12.B, and 9.7). Nevertheless, the great majority of the scientifically excavated vessels, and almost all of those without provenance that have ended up in museum and private collections, are believed to originate from San José de Moro.

As was stated at the beginning of this section, the fine-line style does not have antecedents in the Middle Moche period of the Jequetepeque Valley, and therefore does not appear to have developed locally. We do not find ceramics with pictorial decoration that we could call transitional between the Middle and Late periods. We had thought that this missing transition could be attributed to a gap in the sequence—we had simply not found the layers of occupation or tombs reflecting the transition between the Middle and Late periods. However, in investigations conducted by Marco Rosas (1999) at San José de Moro in six stratigraphic cuts of 6 m depth, we did not find a single interruption in the sequence. Instead, there was extensive evidence of occupational continuity, underscoring the stylistic continuum of the midgrade ceramics. Nor do there exist examples in local or national collections that could be attributed to a transitory phase between the Middle and Late Moche ceramics. In other words, the sequence is apparently correct, and fine-line ceramics did not evolve within it, but instead appeared suddenly. If this is the case, there is a need to define the origin of the fine-line style in the Jequetepeque Valley.

Middle Moche period ceramics of the Lambayeque and Piura valleys, as with those of the Jequetepeque Valley, are not elaborately decorated. In his article on the lords of Loma Negra, Makowski presents a series of ceramic vessels, which he attributes to Late Moche A and Late Moche B periods (Makowski 1994: figs. 89–91), contemporaneous with Middle Moche of Jequetepeque. We can see how simple the pictorial designs of this region are, hence it is probably correct to assume that this style would not lead to the elaborate fine-line style of San José de Moro. Neither can we find antecedents for these styles developing in the Cajamarca highlands to the east of Jequetepeque. There, the most elaborate cursive styles do not appear until after the Moche decline, suggesting that the Late Moche influenced Cajamarca.

g

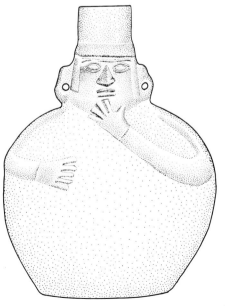

h

If the fine-line style did not evolve from the seat of Moche culture at Jequetepeque or from the north or the east, it is important to examine carefully the possibility of a southern origin. We are confronted with a chronological problem in this line of investigation, as we do not know with certainty when the style began developing, or what was occurring simultaneously in the southern Moche territory. In the current state of investigations, one can only presume that the beginning of the Late Moche period in the northern Moche region is contemporaneous with the end of Moche IV and the beginning of Phase V in the southern Moche region. Tomb MXII excavated at Pacatnamú by Ubbelohde-Doering (1983: 111–122) constitutes the only link between these two traditions, as it contains six apparently imported pieces that correspond to the transitional style between Phases IV and V in Larco's seriation. These vessels appear to be related to intermediate and domestic ceramics of the Late Moche style of the north. As has been stated previously, however, this tomb is particularly complex and contained two occupations, one originally pertaining to the Middle Moche period, and the other intrusive, pertaining to the Late period. If our interpretation is correct, this context could help us to situate the beginning of Late Moche with the beginning of Larco's Moche V phase of the southern Moche.

If we accept that fine-line style influences came from the south, it is important to consider how this may have come about. Was this stylistic transfer merely the effect of an artistic influence, based on the exchange of objects rather than people? Or does the sudden appearance of this refined and mature style indicate the result of a migration of artisans trained in workshops of the south, into Jequetepeque? Was it the result of a conquest of the Jequetepeque Valley by the southern Moche state?

The least intrusive option, that of a movement of objects rather than people, seems highly improbable, as it would have been difficult to improvise the technical and artistic capacities required to fabricate fine-line pieces based solely on imitation or a "quick course" in ceramic iconography. The most intrusive option, a conquest of the Jequetepeque Valley by the southern Moche state, does not seem probable, as the evidence for

southerners in Jequetepeque is limited to a single intrusive burial and there are no other changes in material production. Significantly, Ubbelohde-Doering's Tomb MXII at Pacatnamú is confirmation that the politically independent northern Moche and southern Moche states maintained open routes of communication and exchange.

Given the sudden appearance of a style clearly mature in all its artistic and iconographic aspects, we are inclined to believe some migration was necessary: highly trained southern artisans moved to the Jequetepeque Valley. They would have brought with them all of the iconographic themes and technical skills for the production and decoration of these high-quality ceramics. It is possible that more than a single artist arrived, and a complete workshop produced these ceramics, albeit under the supervision of the lords of Jequetepeque. Nevertheless, things may not have been quite so simple. The artists would have adapted to the peculiarities of Moche society in the Jequetepeque, and in the process, as we will see, a series of important changes occurred in the iconographic repertoire and ceramic style.

In summary, we are inclined to believe that the Jequetepeque elites were not replaced, nor were their territories conquered by societies from the south. If this had been the case, we would see a more definite presence of the southern Moche ceramic and iconographic repertoire in the local styles. In spite of the appearance of fine-line ceramics, however, there is an enormous quantity of mid-grade and domestic ceramics being produced according to local canons. What occurred then is the adoption of a very restricted aspect of the southern tradition—the pictorial style.

Contextual Evidence of the Fine-Line Style at San José de Moro

Fine-line ceramics appear in the San José de Moro burials in singular conditions. They are relatively scarce: the Late Moche tombs, including the most elaborate ones, contain only one or two pieces of this style. This includes the chamber tombs of the Priestesses, which had only two and four pieces of the fine-line style (Tomb M-U41 and M-U103 respectively). The limited number of fine-line

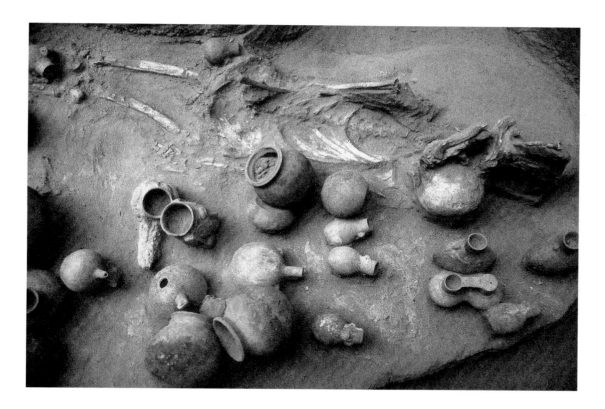

pieces in Late Moche tombs is analogous to what we have described for the Middle period, where we found only one stirrup-spout vessel per tomb. In the Late period tombs, we also found a great quantity of mid-grade and domestic ceramics.[7] Apparently the number of fine-line pieces that an individual could receive as a funerary offering was limited. The presence, and not the number of pieces, implied a certain status. There also seems to be a particular logic to the combination of vessels—it was more important to construct the correct combination of jars, bottles, etc., than to receive many fine-line pieces. It remains for us to decipher the meaning of these combinations (fig. 11).

A peculiarity of fine-line bottles found in the San José de Moro tombs is that a high percentage of the sample is missing their stirrup-spouts. The bottles were apparently mutilated by violently removing the spouts before burial, an action that, because of its recurrence, would seem to be ritual in nature. The missing spouts are not found within the tomb or in the associated fill among discarded artifacts. In Tomb M-U509, for example, we found an extreme case of mutilation. A fine-line stirrup-spout bottle, exquisitely painted,

was missing not only the spout, but also the upper half of the body. The act of breaking the spout also broke the body of the bottle. Neither the spout, nor any missing piece of the body, was found within the funeral chamber or the surroundings. Mutilations of this type have not been reported in the southern Moche area or for the Early or Middle periods of the northern Moche region, although other shared modalities of mutilation exist in these earlier periods, such as the smashing of un-fired effigy vessels at Huaca de la Luna (Bourget, this volume; Uceda et al. 1994: 296). Nonetheless, it is interesting to note that mutilations of fine ceramics are frequent in contexts associated with the Wari tradition (see for example Isbell and McEwan 1991).

If many similarities exist between fine-line ceramics of San José de Moro and their counterparts in the southern Moche region, we also find specific differences due to the adaptation of the southern style by northern artists. Four differences are important in the iconographic sphere: (1) the reduction in number of iconographic themes (Shimada 1994: 227–246); (2) the new emphasis on themes with a maritime character (McClelland 1990); (3) the high frequency of representations of

the Priestess or Supernatural Woman (Hocquenghem and Lyon 1980; Holmquist 1992); and (4) the almost complete disappearance of human beings from the iconographic registry.

Only a small fraction of the wide repertoire of themes that appear in Moche IV iconography of the southern region appear in the Late Moche fine-line style of the northern region. Notable is the absence of scenes of runners, human combat, deer or sea lion hunts, dances, the consumption of coca, or the dance of the dead. Other themes showing shamans or women giving birth, known in modeled ceramics, are also absent. Some themes appear only as partial depictions. Such was the case of the anthropomorphized war club from the Sacrifice scene, represented on the cup of the Priestess from San José de Moro (fig. 7) and on a fragment of a bowl excavated at Pampa Grande (Shimada 1994: fig. 2.10).

Scenes represented in Late Moche fine-line are few and repetitive: the Burial Theme, the combat between supernatural beings, the navigation of the reed rafts, the Priestess on a crescent moon, and the anthropomorphized wave. Beings who combine a human appearance with features of marine creatures (fish or shell) or feline canine teeth are frequently represented. McClelland (1990) has documented a new emphasis on maritime themes in Late Moche. These themes are antecedents to the priorities in Chimú and Lambayeque iconography, where representations of reed rafts, fishermen, marine birds, and anthropomorphic waves are noted (Pillsbury 1993).

The Priestess, also known as the Supernatural Woman (Hocquenghem and Lyon 1980; Holmquist 1992), is the most common personage of Late period iconography. This popularity derives from the high frequency of representations where she appears, principally the burial and the navigation of the reed rafts scenes, as well as a simplified version of the Priestess on a crescent moon scene. It is interesting to note that the increase in the depiction of women coincides with the occurrence of elite tombs for females. It would seem the iconography reflects an increase in the relative importance of women in Moche society (see also Cordy-Collins, this volume). Two other popular personages are the Aia Paec figure (Larco 1945), also called the Wrinkle Face by Donnan (1978) or Anthropomorphic Personage of the Serpents' Belts (Castillo 1989),

and the anthropomorphized iguana. Both are represented in three oft-represented scenes: burial, mythic combat, and the game with sticks and beans that Larco called the Scene of the Decoders (1944).

Finally, perhaps the most peculiar feature of Late Moche iconography is the almost complete disappearance of human beings as principal elements in the representations. This is particularly clear at San José de Moro, where human beings appear only as secondary figures in the Burial Theme. The lack of human beings is even more interesting when we consider the close association between the governing Moche elite and the personages that are represented in Late Moche iconography. If Late Moche society, as we have come to believe, was strongly threatened by external climatic instability and threats from expansionistic societies and internal (the social contradictions generated by the political elite) forces, then art would have fulfilled the function of legitimating the prevailing social system. Translating the iconographic content of southern Moche art to the apparently less diverse northern society produces a thematic selection prioritizing those iconographic programs that favor the governing elite. The iconography turns into a sort of family album, where rulers and their courts are represented in rituals reserved for them. Other segments of society would have been excluded from these representations, and any modification in the iconographic repertoire would have been controlled through attached specialists overseeing the production of artifacts with elaborate iconographic content. In other words, the lower levels of society would have been excluded from appearing on, or possessing, this type of artifact. Thus, the iconographic style of fine-line would have been closely associated with the Moche elite and its exercise of power.

The Beginning of the End

The decline of Moche society at San José de Moro is marked archaeologically by changes in funerary patterns and ceramic styles, particularly the disappearance of fine-line ceramics. These changes are symptomatic of the effects of external pressures and grave internal crisis in the society. We have uncovered more evidence of interaction with Middle

Horizon societies of the central coast at San José de Moro than in almost any other site of the north coast. Nonetheless, it is essential to examine carefully the context in which these artifacts appear. It is also important to identify at what moment the stylistic changes in the occupational sequence, which reflect interaction with other societies, begin to occur. For example, the first evidence of Wari or Wari-derived ceramics appears in the Late Moche period, not after the collapse, and is limited to the most complex burials. Not surprisingly, the local copies of Wari pieces are also produced in the Late Moche period, and not later. This is contrary to earlier assumptions about Wari on the north coast, which held that this interaction came after the fall of Moche. I will first analyze the form these external influences take.

We never found a foreign tomb at San José de Moro, still less a Wari tomb. The external influences, however numerous in the Late and Transitional periods, did not lead to an annexation by an outside state or even demonstrate the presence of individuals representing a foreign political entity at San José de Moro. There is no tomb where the majority of artifacts are of foreign origin. We found imported artifacts, local copies of them, and artifacts locally produced in a hybrid style; but these objects represent a small percentage of the total ceramic assemblage and appear only in very complex tombs, tombs still following the standard Moche funerary pattern. This does not imply, however, that these arti-

facts did not have an important effect on the development of local styles.

If we analyze the evolution of complex ceramic styles at San José de Moro, particularly in ceramics with elaborate iconography, we can distinguish three phases during the Late Moche period:

First Phase: There is no Wari or Wari-derived influence. The most elaborate style was that found on the canonical Late Moche fine-line ceramics. No Wari ceramics have been found from this period at the site of Pampa Grande, either.

Second Phase: The first pieces of imported ceramics appear and new styles derived from external influences flourish. This phase can perhaps be subdivided into two stages: 1) the moment the first imported ceramics arrive and are incorporated into Late Moche elite tombs; and 2) the subsequent production of hybrid styles and local copies of foreign, particularly Wari-related ceramics. The tomb of the Priestess (M-U41), excavated in 1991 (Donnan and Castillo 1994), pertains to the first stage, as we found only imported Nievería and Cajamarca artifacts associated with fine-line Moche ceramics.

Third Phase: Fine-line ceramics disappear, but copies of foreign, Wari-related ceramics continue, reinforcing hybrid styles that combine features of Moche iconography with the forms, colors, and designs of non-Moche types. This phase overlaps with the Transitional period.

Of these three phases, the most complex is the second, as it shows the greatest number of interacting cultural vectors. In this phase, the first versions of Moche polychrome ceramics are produced and the hybrid ceramic style is perfected. In order to understand the evolution of fine-line during this turbulent period of Late Moche, we may evaluate independently three formal aspects, vessel form, colors, and iconographic motifs, and contrast local sources with external influences.

Vessel forms: the two principal shapes employed are typically Moche stirrup-spout bottles and double-spout-and-bridge bottles, a shape of clearly southern origin. Occasionally the fine-line style, bichrome as well as polychrome, is found on simpler forms like jars, cups, or flattened jars.

Color: two color schemes are used to decorate the ceramics. One, red-ochre-over-cream,

12. Wari style ceramics from San José de Moro
Instituto Nacional de Cultura, La Libertad, Trujillo
Photograph by Juan Pablo Murrugarra

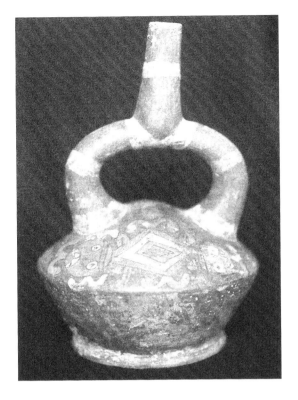

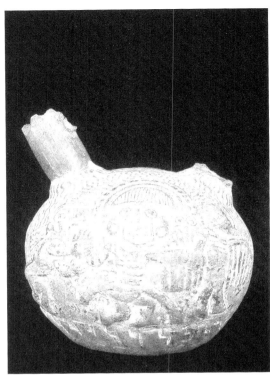

13. Stirrup-spout vessel with Wari polychrome design
Rodriguez Razetto collection
Photograph by Juan Pablo Murrugarra

14. Double-spout-and-bridge bottle (with most of the spout and bridge missing), with an Aia Paec figure being captured by the anthropomorphized iguana and vulture (Tomb M-U314)
Instituto Nacional de Cultura, La Libertad, Trujillo
Photograph by Juan Pablo Murrugarra

is predominantly associated with Moche. The second, a polychrome style, is characteristic of the southern tradition.

Iconographic motifs: these range from canonical Moche narrative scenes, such as the Burial Theme or the Priestess on the raft, to geometric and stylized motifs indicating significant influence from the Wari tradition (fig. 12).

We see two extremes in the fine-line specimens: at one end there are pieces entirely Moche in style, represented by the stirrup-spout form, the bichrome decoration, and the classic motifs of its iconography; at the other extreme, there are pieces with clear Wari influence, represented by polychrome double-spout-and-bridge bottles with geometric designs (see Castillo and Donnan 1994b: 112). Between these two extremes, we find a great quantity of artifacts mixing these three variables. If we exclude ceramics that are exclusively Moche or imported, the combination of variables gives us six theoretical possibilities, of which we find examples of only four: (1) ceramics that combine Moche form and iconography with foreign polychrome (for example, the Museo Amano piece illustrated by Shimada 1994: fig. 9.1); (2)

ceramics that combine foreign form and polychrome with Moche iconography (Larco 1966a: fig. 108–109; Rowe 1942); (3) ceramics that combine Moche form with foreign iconography and polychrome (fig. 13); and (4) ceramics of foreign form with Moche bichrome and iconography. The unique example of this combination is a double-spout-and-bridge vessel found in the Late Moche boot-shaped tomb M-U134 at San José de Moro, with representations of Aia Paec (Wrinkle Face) tied to a bird of prey and an anthropomorphized iguana (fig. 14).[8]

We know of no examples for the two remaining combinations, that is, stirrup-spout or double-spout-and-bridge vessels with bichrome foreign designs. It is possible that the foreign motifs are closely tied to polychromy. Moche iconographic motifs, by contrast, tend to appear in both bichrome and polychrome schemes.

Another important marker distinguishing the collapse of Moche society in the Jequetepeque Valley is the variation in tomb type. During the Late Moche period, the most common type was the boot-shaped tomb, which continued to be used even as influence of foreign ceramic styles becomes more noticeable.

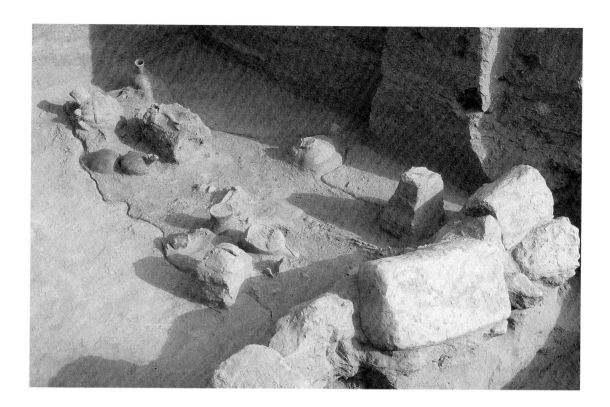

15. View of Late Moche
Tomb M-U623
Photograph by Juan Pablo
Murrugarra

Nonetheless, the boot-shaped tomb falls into disuse at the same time fine-line ceramics disappear. The pit tomb replaces the boot-shape tomb in the Transitional period, although burial position remains the same: the individual is oriented with feet to the north, head to the south, and in an extended dorsal position. The disappearance of boot-shaped tombs at the end of Moche marks the end of a tradition that had existed since the Middle Moche period, and perhaps earlier, and was associated with the middle and upper segments of Moche society. Its replacement by pit tombs in the Transitional period signifies the imposition of a type that was more popular with the lower levels of society. Before disappearing, however, the Late Moche boot-shaped tombs began to show certain variations on the norm, particularly in terms of the orientation of the body (fig. 15).[9] The orientation of the body becomes erratic, with no standard pattern. Many of the tombs contain multiple burials. New types of ceramics, created using new techniques and decoration, also appear in the tombs. *Crisoles*, which were earlier quite simple in form, now have faces modeled on the vessel bodies.

These two concurrent changes, the disappearance of bichrome fine-line ceramics, as well as the polychrome variant on double-spout-and-bridge bottles; and the disappearance of boot-shaped tombs, definitively and permanently mark the end of Moche. During the subsequent period, we have documented some remnants and archaisms, including re-used Late Moche vessels, but generally, the production of this type of ceramics ceases and the technology involved in the manufacture is lost.

This cessation of fine-line ceramics and boot-shaped tombs has important implications for understanding what happened at the end of Moche society. Boot-shaped tombs, as well as fine-line ceramics, had been restricted to the Moche elite: only elite members of Moche society were interred in such elaborate tombs and utilized such fineware. Thus, the end of Moche could be defined by the disappearance of forms that would have marked certain class differences. It is possible that the Moche decline is, in reality, only an elite "collapse," with the elite disappearing or amalgamating with previously socially inferior segments of society. If true, this hypothesis would reinforce the idea that the

Moche collapse is eminently a process of internal crisis and reconstitution of social power (Bawden 1995, 1996; Castillo and Donnan 1994a; DeMarais, Castillo, and Earle 1995).

In order to understand the Wari impact on Moche society, it is useful to analyze what was occurring within both societies. From the Moche perspective, it seems that at the beginning of the Middle Horizon period, Wari or Wari-derived ceramics begin to be imported from Wari-related societies on the coast, such as Nievería, Pachacamac, and Atarco. In this era, Wari culture was most likely conceived as successful, expanding, and the bearer of a refined iconography which symbolized its ideology and religion (Menzel 1964, 1977; Schreiber 1992). The Moche elite would have considered it advantageous to use elements of this new ideology and iconography as part of their own strategies of political control, perhaps to show some degree of communication with the Wari elite. The importation of such exotic ceramics to the Moche region signals an opening up of barriers. The Moche, up until this time, had been relatively impermeable to foreign influence and it was rare to find any imported artifacts before this era. After this opening, however, there is a new status object to mark differential access for the upper level of elites. Thus, only the most complex tombs contain imported ceramics.

Such a diversified and complex Wari presence on the north coast has only been reported for San José de Moro (Castillo and Donnan 1994a, 1994b). To date, the available evidence affirms that this occurs within a Moche cultural matrix, with some elite persons importing and including foreign ceramics in their tombs. There is no evidence of any form of coercion. Previously, the presence of Wari artifacts was evaluated without knowledge of their original contexts or the understanding of their relative scarcity; this, in turn led to speculation that the north coast was under the imperial dominance of Wari society (Menzel 1977; Schreiber 1992). Late Moche style artifacts have been reported in sites from Piura (Larco 1966a) to Lima (Stumer 1958) without anyone suggesting that Moche society had conquered the territory between these two extremes.

What was beneficial about importing artifacts from another culture? And why precisely Wari? Responding to these questions obliges us to make a detailed account of what we presume occurred in the last years of the Moche in the Jequetepeque Valley. Throughout their history, the Moche had developed forms of social control strongly based on ideological content and the management of its manifestations (DeMarais, Castillo, and Earle 1995). This emphasis tended to minimize dissension and increase consensus, which directly affected productivity, social solidarity, and the legitimacy of rulers. The Moche elite would have carried this strategy to its limits, positioning themselves so that they would be conceived of as living deities or their incarnation (Donnan and Castillo 1994). We recall that in this era human beings disappear almost completely from the iconographic registry, and all scenes center on actions of the gods. In other words, the elite no longer would have required mediation in their interactions with the gods; the rulers would have assumed their role directly. This strategy is convenient when all is going well, but in a crisis, it leaves no room to blame an intermediary. The grave climatic fluctuations that characterized the early half of the Late Moche period (Shimada et al. 1991) would have weakened the elite, as they could not impede destruction, yet they still assumed the role of living gods.

Debilitated, rulers would need ways to reproduce their sources of power. Previously, they had employed a combination of political management with ideological legitimacy; this time, however, they tried to reinforce this strategy by introducing elements from another prestigious ideological system. For this reason, they establish the first Wari contacts, perhaps indirectly through intermediary societies, and thus the first imported ceramic style, Nievería, appears in the Jequetepeque Valley, while exported Moche ceramics appear in the Nievería cemetery in the Rímac Valley (Stumer 1958).

Access and communication routes with Middle Horizon societies of the central coast were not located along the coast, but rather connected to the Jequetepeque Valley through Cajamarca in the adjacent highlands, where the Wari presence was stronger (Topic 1991). This can be inferred from the absence of intermediate sites with San José de Moro associations in southern Moche territory.

Furthermore, the appearance of imported Wari style ceramics coincides with the appearance of the first examples of Cajamarca style ceramics.

The Moche elite, and only the upper segment, would have monopolized these imported materials, thus altering one of the basic norms of their social system: the redistribution of sumptuary goods among the middle and lower levels of the same class. More damaging, the governing elite would, for the first time, have been restricted in redistributing these goods, as the prestigious Wari artifacts were not produced by them. Bawden sees this damage to traditional reciprocity models as one of the most important causes of internal crisis in Moche society (Bawden 1995, 1996).

Faced with the impossibility of satisfying obligations owed to their subordinates, and pressured by strong demand, it would have been necessary to fabricate locally pieces that imitated the forms, iconographic motifs, and polychrome of artifacts that earlier had only been imported. To satisfy this demand, a polychrome style was developed. Hence, shortly after importing the first Wari pieces, the Moche elite would have developed new imitations of artifact types and maintained their network of reciprocity with other segments of their class. One would have to surmise that the polychrome pieces, as had occurred before with fine-line and stirrup-spout ceramics in the Middle Moche period, appeared in tombs in very limited quantities.

If the importation and use of Wari artifacts by the upper-level elites reflects an acceptance of certain ideological ideas sponsored by the Wari, an affiliation with this society, and the beginning of a cultural and ideological opening, then the extension of the use of these artifacts to the lower levels of society, via imitation artifacts, implies that Wari ideology and influence on Late Moche society is now widespread.

The ideological implications of these facts are complex. The new ideas and the appearance of polychrome ceramic styles coincide in the archaeological record with an overall stylistic opening of the Late Moche period. New forms appear, and there is a significant reduction in Moche ceramic types. Moche style and culture deteriorate slowly, but constantly.

It should not surprise us that the Moche generated a polychrome style based on the Wari tradition. The archaeological record demonstrates that hybrid styles are common in areas where Wari once interacted with local societies. This happened in the Ica Valley of the south coast with the development of the Atarco style, which combines a Nasca base with Wari influence. It had also occurred in the central coast, where the Lima style gave rise to the Nievería and Pachacamac styles from clear Wari influence. Lamentably, the relationship between Wari and these societies is not clear, nor is its strategy of expansion, influence, and territorial control.

In view of this transformation process, it is critical to define at what moment Moche culture ceases and why. These questions have no easy answers. I indicated earlier two indices that allow us to define the end of the Moche at San José de Moro: the disappearance of fine-line ceramics and boot-shaped tombs. Nevertheless, at the level of ceramic styles, relatively few disappear. Forms and styles typical of mid-grade ceramics during the Middle Moche period are still produced. A few polychrome vessels are still being included in the tombs, and while the quantity of imported ceramics is small, its variety is great. Ceramics of the Viñaque, Pachacamac, and Casma styles are found.

At the end of this process, the only elements that disappear are those most directly associated with the elite. The tombs they utilize disappear, while the most simple tomb form, the pit tomb, predominates. Fine-line iconography disappears, and with it, a complex religious iconography that will never reappear on the north coast. This implies that the elite and their gods, the principal subjects of the representation, disappear from the iconographic repertoire. Geometric motifs, small and generalized anthropomorphic depictions, and simplified animals replace them: these are all motifs that come to populate the art and iconography of the subsequent Lambayeque and Chimú cultures. We can infer, beginning with these transformations, that the predominant authority had changed—that the elite had lost control and were banished, at least from iconographic space. This would signal an internal deterioration that might have had an element of violence, as in this era defensive constructions,

walled cities, and hilltop fortifications multiply—all indications of instability reaching violent levels and requiring action (Dillehay, this volume). Where were the forces of the state in the face of these threats? This all suggests that the principals affected by this crisis were precisely the state and its directors; the elite could not have impeded the spread of violence when they were not capable of defending themselves. Nevertheless, there is also evidence to support the idea that this deterioration was not abrupt; rather, it occurred over a long period of time, perhaps over an entire generation, and culminated with the weakening of the elite, rather than their overthrow.

Epilogue: The Transitional Period

The period after Moche has been given various names in different regions: Larco called it Huari Norteño (1966b); in the Trujillo area, it is designated Early Chimú (Donnan and Mackey 1978); and further north, it is called Early Lambayeque (also Sicán) (Shimada 1994). As with all intermediate periods, this phase is difficult to define. Generally, it has been easier to consider the evidence from societies located on the extremes, which are then defined as a manifestation of the transition. The archaeology of the Jequetepeque Valley has been no exception, and therefore we did not hope to find clear evidence for a period immediately after the Moche.

In the first years of investigation at San José de Moro, we located some pit tombs that contained a mixture of materials related to Moche, but with some Lambayeque elements. Plates with white slip and geometric designs of a style known as Cajamarca Costeña (Disselhoff 1958a) were found associated with these ceramics. For this reason, we assigned these tombs to a period we called Lambayeque-Cajamarca. As the sample for this period increased, we realized that we were not dealing with the Lambayeque period and that relationships with Cajamarca were distant. The assemblage seemed to be a combination of many of the ceramic forms of the mid-grade and domestic types seen in Late Moche with some forms derived from foreign styles. Flasks, face-neck jars and double-chambered vessels are abundant (fig. 16).

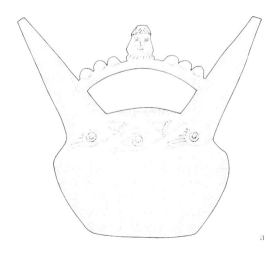

a

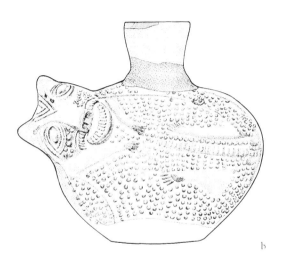

b

c

16. Typical ceramics of the Transitional period (a, double-spout-and-bridge bottle, b) jar and c) face-neck bottle with press-molded design of a pair copulating with radiating profile serpent heads)
Instituto Nacional de Cultura, La Libertad, Trujillo
Drawings by Percy Fiestas

The combination of these ceramic types in various pit tombs, located stratigraphically over the openings of Moche tombs, but under the Lambayeque tombs that were typically intrusive at the site, convinced us that what initially seemed peculiar, was in reality a true occupation period. In the last two years of investigation, the sample of these tombs has increased, and it has been possible to associate them with a series of adobe brick alignments and *paicas*, suggesting that the ritual funerary complexes characteristic of the Middle and Late Moche continued. What we at first expected to be a short-term transition period, became a full occupation period, which, in the absence of radiocarbon dates, we are presuming extended from A.D. 800 to 950. This period marked the end of Moche influences and a synthesis of traits from Middle Horizon societies of the central coast. Given these characteristics, we are calling it in the Transitional period.

Ceramic styles that developed during the Late Moche period persisted into the Transitional period. It would seem that the same artisans who fabricated ceramics with great stylistic freedom in Late Moche continued producing them; only the workshops that made fine-line ceramics disappeared. Some new styles that seem to originate from the Casma region, particularly oxidized ceramics (blackware) with relief designs, were associated with older styles.

The disappearance of the Moche elite does not mean that the Transitional period lacked leadership. In 1998 we identified two superposed chamber tombs, representing at least two phases within the Transitional period associated with elite individuals. The upper chamber contained a great quantity of high-quality Cajamarca Costeña ceramics and Transitional period ceramics. The lower chamber contained more than thirty individuals and over one hundred and fifty vessels, copper masks, metal ornaments, *Spondylus* beads, mother-of-pearl, and camelid bones. The bodies were placed in an extended position, oriented north to south, as they were in the Moche era. This chamber was apparently open during a prolonged period of time, and as more individuals were introduced, the earlier bodies, already disarticulated, were pushed to the sides, as were their offerings. Funerary chambers with so many

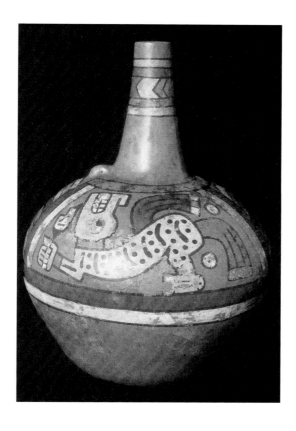

17. Imported ceramic vessel, Transitional period
Rodríguez Razetto collection
Photograph by Juan Pablo Murrugarra

individuals have not been reported for the Late Moche period, although Ubbelohde-Doering excavated a Middle Moche boot-shaped tomb (EI) with more than ten individuals at Pacatnamú (1967, 1983).

The change in governing elite during the Transitional period, however, does not signify a decrease in the proliferation of ceramic styles or the production of imitated styles. On the contrary, we continue to find some imported vessels (fig. 17), including Viñaque, Pachacamac, Cajamarca, and Casma press-molded ware and locally produced copies of these styles. As in the Late Moche period, a small number of imported ceramic vessels appear in elite tombs, and they are surrounded by local variants, indicating a continued restriction of production and distribution of imported artifacts. This combination of styles also suggests that the individuals buried in these tombs were of local origin.

The Transitional period ends abruptly around 950 A.D., when the Jequetepeque Valley was conquered by the expansionist Lambayeque state. At that moment, the plethora of ceramic styles characteristic of the Transitional period disappears, and the

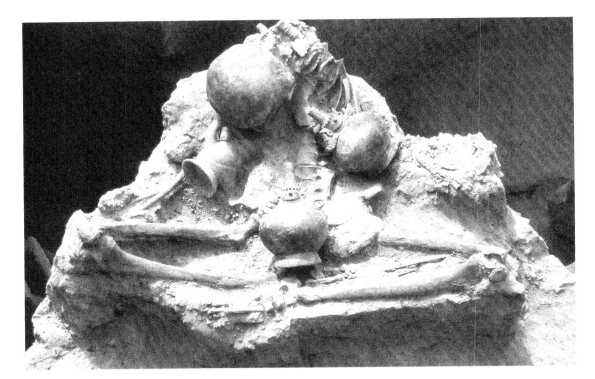

18. Lambayeque ceramics in Tomb M-U501
Now in the Instituto Nacional de Cultura, La Libertad, Trujillo
Photograph by Juan Pablo Murrugarra

Middle Lambayeque style emerged. This style, largely associated with blackware, is represented at San José de Moro by low bowls with annular ring bases, and jars with relief decoration in the upper half of the body (fig. 18). A figure known as the Huaco Rey dominates the iconography. The pit form of tomb construction continues, but individuals are buried in a seated position and frequently associated with large concentrations of chalk. The Lambayeque state eliminated the stylistic liberalism that characterized the Transitional period; the region was once again under centralized control. With the Lambayeque conquest, followed by the subsequent Chimú and Inca conquests, the independence of the Jequetepeque Valley was finished forever, and the region became subject to states centered elsewhere. Converted to a marginal province, Jequetepeque lost its vitality, as reflected in an increasingly diminished cultural production.

NOTES

Work at San José de Moro has been possible thanks to the generous support of the local inhabitants, particularly from Richard and Julio Ibarrola, as well as Dr. Lorenzo Sánchez Cabanillas and Mrs. Miriam Valle de Baltuano, the mayors of Chepén and Pacanga respectively, and the students who diligently participated in the Project over the years.

The investigations were given financial support by many institutions and individuals. In particular, I wish to thank: The Bruno Foundation of Fresno, California; the John B. Heinz Charitable Trust; the University of California, Los Angeles, Academic Senate; the Fowler Museum of Cultural History, University of California, Los Angeles; the Dirección Académica de Investigación, Pontificia Universidad Católica del Perú; the Banco de Crédito del Perú; Luz del Sur; Boyles Bros. Diamantina S.A., among others.

There has been significant editorial collaboration in preparing this text with many of my colleagues and students, whose critiques and suggestions have shaped my ideas on the Moche. I wish to thank especially Christopher Donnan, Carol Mackey, Alana Cordy-Collins, Andrew Nelson, Guillermo Cock, Santiago Uceda, Ulla Holmquist, Krysztof Makowski, Garth Bawden, Julio Rucabado, Flora Ugaz, Gabriela Freyre, Patricia Pérez-Albela, Alexia Brazzini, Cecilia Pardo, and Mónica Nobl. Many of the ideas arose from having taught a course on the Moche. To the students of this course, for their critiques and suggestions, I extend my thanks. Any errors are due to my stubbornness.

1. Investigation at San José de Moro has occurred in three phases. Between 1991 and 1993, the project was directed by Christopher Donnan and Luis Jaime Castillo (Castillo and Donnan 1994a). During this phase, the excavations centered on the Huaca de la Capilla zone and resulted in the discovery of numerous Lambayeque and Late Moche tombs. Among them were five chamber tombs, two of which pertained to the Priestesses of Moro. Between 1995 and 1997, the project was directed by Carol Mackey, Andrew Nelson, and Luis Jaime Castillo (Castillo, Mackey, and Nelson 1996, 1997, 1998). During this phase, the investigations continued, primarily in the soccer field zone and at the Chimú provincial administrative site of Algarrobál de Moro. Since 1997, research directed by the author has concentrated on the excavation of funerary zones and study of the ceremonial areas associated with the burials. In addition, other sites in the region have been examined, particularly those in the Chamán Valley.

2. In the Jequetepeque Valley, the most important Late Moche sites are not found in this zone; however, we can see that tension still existed, given the tendency for walled sites to be constructed near the mountains. Such sites would have served as a defense from an aggressor, both internal and external.

3. The three large boot tombs found by Ubbelohde-Doering at Pacatnamú (EI, MXI, and MXII) have not been properly studied to date. These and two other tombs were only partially published by Ubbelohde-Doering (1967, 1983), and by Giesela and Wolfgang Hecker (1983), based on the reexamination of the original 1938 notes and photographs. There is no agreement yet as to which phase these tombs correspond to. We believe that Tomb EI corresponds to the Middle Moche phase, based on similarities with tombs of San José de Moro from this period. Tomb MXI is incomplete due to looting in antiquity, but would seem to be integrally Late Moche, again based on the similarities with San José de Moro tombs. Finally, Tomb MXII, the most complicated of the three, seems to have had two occupations: (1) one multiple occupation of the Middle Moche period; and (2) a Late Moche period reoccupation in which an individual was inserted into the eastern side of the funerary chamber, with the first occupants and their associated materials pushed to the sides. The individual who reoccupied Tomb MXII seems to have been important, as his grave goods included elaborate earrings and a rattle scepter, as well as metal pieces in the shapes of arms and legs (Donnan and Castillo 1994).

4. Ceramics found in association with the royal tombs of Sipán pertaining to the Middle period were surprising in their formal and decorative simplicity. The tomb of the Old Lord of Sipán included a significant number of face-neck jars, crudely decorated with animal forms and human beings on the vessel bodies (Alva 1994: figs. 160, 199, 333, 334). The Lord of Sipán tomb included an enormous quantity of ceramics in a lateral repository (Alva 1994: figs. 26, 283–296) and in the interior of the same funerary chamber (Alva 1994: figs. 129, 134, 135, 140,

297–308), but again, these ceramics were very simple in style and form.

5. Shimada (1994) suggests that one of the important changes in funerary customs of Late Moche is a shift in the standard burial practice from an extended supine position to either a tightly flexed or an extended, on-the-side, burial position. This affirmation is based on examples reported at the El Brujo complex and a burial excavated by Disselhoff (1941) at Huaca Lucía at Batán Grande. At San José de Moro and Pacatnamú, however, the extended-position burials continued until the Lambayeque conquest. Shimada further suggests that this change in position coincides with other changes, such as the appearance of ceramics with symmetrically placed shoulder lug handles and press-molded decorations. Nevertheless, these forms appear earlier in the Middle Moche ceramics at Pacatnamú and San José de Moro (Ubbelohde-Doering 1983: figs. 17.2, 17.5, 20.7, 21.3).

6. Three pieces (fig. 10, a–c) with this decoration come from the Mazanca excavations, from contexts which date to the transition between the Virú and Moche periods (Donnan, Navarro, and Cordy-Collins 1997: 26, 49). Ubbelohde-Doering (1983: fig. 19.3) published a vessel (fig. 10, d) similar to that found in Tomb EI (fig. 10, e), pertaining to the Middle Moche period at Pacatnamú. For the Late Moche period, we have two examples: one from the tomb of a child at San José de Moro (fig. 10, f; Makowski et al. 1994: 324; fig. 358), and one reported by Shimada at Pampa Grande (fig. 10, g; Shimada and Maguiña 1994: fig. 1.17). Finally, at San José de Moro, we found an example of this peculiar form in a Transitional period burial (fig. 10, h; Rucabado 1999).

7. An important characteristic in Late Moche funerary customs of the Jequetepeque Valley is the significant quantities of mid-grade and domestic ceramics within the tombs. The elite tombs can have between twenty to thirty pieces, among which are jars of various sizes, many stained with soot, simple bowls, and other forms. The inclusion of simple ceramics in late tombs is fortunate for chronological analysis, as it relates the most diagnostic forms, such as stirrup-spout bottles, to less time-sensitive forms such as jars.

8. In same tomb mentioned above with the architectural models, two polychrome jars with rounded-point bases were found (see Donnan 1973: pl. 7, A–D, for similar examples).

9. At San José de Moro, Tomb M-U623 is a good example of what occurs at the end of the Moche period. Burials are oriented east–west, and contain two individuals on their sides, one in front of the other, and associated with polychrome ceramics, albeit fewer in number. Very little within the tomb appears to be Moche, except a face-neck jar, two flasks, and the boot-tomb shape itself.

BIBLIOGRAPHY

Alva, Walter
 1994 *Sipán*. Colección Cultura y Artes del Perú. Lima.

Alva, Walter, and Christopher B. Donnan
 1993 *Royal Tombs of Sipán* [exh. cat., Fowler Museum of Cultural History, University of California]. Los Angeles.

Bawden, Garth L.
 1977 Galindo and the Nature of the Middle Horizon in Northern Coastal Peru. Ph.D. dissertation, Department of Anthropology, Harvard University, Cambridge, Mass.

 1982 Galindo: A Study in Cultural Transition During the Middle Horizon. In *Chan Chan: Andean Desert City*, ed. Michael E. Moseley and Kent C. Day, 285–320. School of American Research Advanced Seminar Series. Albuquerque, N.M.

 1995 The Structural Paradox: Moche Culture as Political Ideology. *Latin American Antiquity* 6 (3): 255–273.

 1996 *The Moche*. Oxford and Cambridge, Mass.

Castillo, Luis Jaime
 1989 *Personajes míticos, escenas y narraciones en la iconografía Mochica*. Lima.

 1996 *La tumba de la Sacerdotisa de San José de Moro* [exh. cat., Centro Cultural de la Pontificia Universidad Católica del Perú]. Lima.

Castillo, Luis Jaime, and Christopher B. Donnan
 1994a La ocupación Moche de San José de Moro, Jequetepeque. In *Moche: Propuestas y perspectivas* [Actas del primer coloquio sobre la cultura Moche, Trujillo, 12 al 16 de abril de 1993], ed. Santiago Uceda and Elías Mujica, 93–146. Travaux de l'Institut Français d'Etudes Andines 79. Trujillo and Lima.

 1994b Los Mochica del norte y los Mochica del sur. In *Vicús*, by Krzysztof Makowski, Christopher B. Donnan, Iván Amaro Bullón, Luis Jaime Castillo, Magdalena Diez Canseco, Otto Eléspuru Revoredo, and Juan Antonio Murro Mena, 143–181. Colección Arte y Tesoros del Perú. Lima.

Castillo, Luis Jaime, Carol J. Mackey, and Andrew Nelson
 1996 Primer informe parcial y solicitud de permiso para excavación arqueológica. Proyecto Complejo de Moro (julio–agosto 1995). Report presented to the Instituto Nacional de Cultura, Lima.

 1997 Segundo informe parcial y solicitud de permiso para excavación arqueológica. Proyecto Complejo de Moro (julio–agosto 1996). Report presented to the Instituto Nacional de Cultura, Lima.

 1998 Tercer informe parcial y solicitud de permiso para excavación arqueológica. Proyecto Complejo de Moro (julio–agosto 1997). Report presented to the Instituto Nacional de Cultura, Lima.

Castillo, Luis Jaime, Andrew Nelson, and Chris Nelson
 1997 Maquetas Mochicas de San José de Moro. *Arkinka* 2 (22): 120–128. [Lima].

Chodoff, David
 1979 Investigaciones arqueológicas en San José de Moro. In *Arqueología Peruana*, ed. Ramiro Matos Mendieta, 37–47. Lima.

Cordy-Collins, Alana
 1977 The Moon is a Boat! A Study in Iconographic Methodology. In *Pre-Columbian Art History: Selected Readings*, ed. Alana Cordy-Collins and Jean Stern, 421–434. Palo Alto, Calif.

DeMarais, Elizabeth, Luis Jaime Castillo, and Timothy K. Earle
 1995 Ideology, Materialization and Power Strategies. *Current Anthropology* 37 (1): 15–31.

Disselhoff, Hans Dietrich
 1941 Acerca del problema de un estilo Chimú Medio, trans. F. Schwab. *Revista del Museo Nacional* 10 (1): 51–62. [Lima].

 1958a Cajamarca Keramik von der Pampa von San José de Moro, Prov. Pacasmayo. *Baessler Archiv* N.F. 6 (1): 181–193. [Berlin].

 1958b Tumbas de San José de Moro (Provincia de Pacasmayo, Perú). In *Proceedings of the 32nd International Congress of Americanists* [1956], 364–367. Copenhagen.

Donnan, Christopher B.
 1973 *Moche Occupation of the Santa Valley, Peru*. University of California Publications in Anthropology 8. Berkeley and Los Angeles.

 1978 *Moche Art of Peru: Pre-Columbian Symbolic Communication* [exh. cat., Museum of Cultural History, University of California]. Los Angeles.

Donnan, Christopher B., and Luis Jaime Castillo
 1994 Excavaciones de tumbas de sacerdotisas Moche en San José de Moro, Jequetepeque. In *Moche: Propuestas y perspectivas* [Actas del primer coloquio sobre la cultura Moche, Trujillo, 12 al 16 de abril de 1993], ed. Santiago Uceda and Elías Mujica, 415–424. Travaux de l'Institut Français d'Etudes Andines 79. Trujillo and Lima.

Donnan, Christopher B., and Guillermo A. Cock
 1986 (Editors) *The Pacatnamu Papers, Volume 1*. Museum of Cultural History, University of California, Los Angeles.

 1995 Excavaciones en Dos Cabezas, valle del Jequetepeque, Perú. Primer informe parcial,

primera temporada de excavaciones (julio–agosto, 1994). Report submitted to the Instituto Nacional de Cultura, Lima.

1996 Excavaciones en Dos Cabezas, valle del Jequetepeque, Perú. Segundo informe parcial, segunda temporada de excavaciones (julio–agosto, 1995). Report submitted to the Instituto Nacional de Cultura, Lima.

1997a Excavaciones en Dos Cabezas, valle del Jequetepeque, Perú. Tercer informe parcial, tercera temporada de excavaciones (julio–agosto, 1996). Report submitted to the Instituto Nacional de Cultura, Lima.

1997b (Editors) *The Pacatnamu Papers, Volume 2*: The Moche Occupation. Fowler Museum of Cultural History, University of California, Los Angeles.

Donnan, Christopher B., and Carol J. Mackey
1978 *Ancient Burial Patterns of the Moche Valley, Peru*. Austin, Tex.

Donnan, Christopher B., and Donna McClelland
1979 *The Burial Theme in Moche Iconography*. Dumbarton Oaks Research Library and Collections, Studies in Pre-Columbian Art and Archaeology 21. Washington.

1997 Moche Burials at Pacatnamu. In *The Pacatnamu Papers, Volume 2*: The Moche Occupation, ed. Christopher B. Donnan and Guillermo A. Cock, 17–187. Fowler Museum of Cultural History, University of California, Los Angeles.

1999 *Moche Fineline Painting: Its Evolution and Its Artists*. Fowler Museum of Cultural History, University of California, Los Angeles.

Donnan, Christopher B., H. Navarro, and Alana Cordy-Collins
1998 Proyecto Mazanca. Report submitted to the Instituto Nacional de Cultura, Lima.

Franco, Régulo, César Gálvez, and Segundo Vásquez
1994 Arquitectura y decoración Mochica en la Huaca Cao Viejo, complejo El Brujo: Resultados preliminares. In *Moche: Propuestas y perspectivas* [Actas del primer coloquio sobre la cultura Moche, Trujillo, 12 al 16 de abril de 1993], ed. Santiago Uceda and Elías Mujica, 147–180. Travaux de l'Institut Français d'Etudes Andines 79. Trujillo and Lima.

Hecker, Giesela, and Wolfgang Hecker
1983 Gräberbeschreibung. In *Vorspanische Gräber von Pacatnamú, Nordperu*, by Heinrich Ubbelohde-Doering, 39–131. Materialen zur allgemeinen und vergleichenden Archäologie 26. Munich.

Hocquenghem, Anne-Marie, and Patricia J. Lyon
1980 A Class of Anthropomorphic Supernatural Females in Moche Iconography. *Ñawpa Pacha* 18: 27–48, plates III, IV.

Holmquist, Ulla
1992 El Personage mítico femenino de la iconografía Mochica. B.A. thesis, Facultad de Letras y Ciencias Humanas, Pontificia Universidad Católica del Perú, Lima.

Isbell, William H., and Gordon F. McEwan
1991 (Editors) *Huari Administrative Structure: Prehistoric Monumental Architecture and State Government* [Papers from a round table held at Dumbarton Oaks, 15–17, 1985]. Washington.

Larco Hoyle, Rafael
1944 La escritura peruana pre-incaica. *El México Antiguo* 6 (7–8): 219–238.

1945 *Los Mochicas (pre-Chimu, de Uhle y early Chimu, de Kroeber)*. Buenos Aires.

1948 *Cronología arqueológica del norte del Perú* [cat., Museo de Arqueología Rafael Larco Herrera]. Buenos Aires.

1966a *Vicús 2: La cerámica de Vicús y sus nexos con las demás culturas*. Lima.

1966b *Perú*. Archaeología Mundi. Barcelona.

Lyon, Patricia J.
1981 Arqueología y mitología: La escena de "los objetos animados" y el tema de "el alzamiento de los objetos." *Scripta Ethnológica* 6: 105–108. [Buenos Aires].

Makowski, Krzysztof
1994 Los señores de Loma Negra. In *Vicús*, by Krzysztof Makowski, Christopher B. Donnan, Iván Amaro Bullón, Luis Jaime Castillo, Magdalena Diez Canseco, Otto Eléspuru Revoredo, and Juan Antonio Murro Mena, 82–141. Colección Arte y Tesoros del Perú. Lima.

Makowski, Krzysztof, Christopher B. Donnan, Iván Amaro Bullón, Luis Jaime Castillo, Magdalena Diez Canseco, Otto Eléspuru Revoredo, and Juan Antonio Murro Mena
1994 *Vicús*. Colección Arte y Tesoros del Perú. Lima.

McClelland, Donna
1990 A Maritime Passage from Moche to Chimu. In *The Northern Dynasties: Kingship and Statecraft in Chimor* [A Symposium at Dumbarton Oaks, 12th and 13th October 1985], ed. Michael E. Moseley and Alana Cordy-Collins, 75–106. Washington.

Menzel, Dorothy
1964 Style and Time in the Middle Horizon. *Ñawpa Pacha* 2: 1–105.

1977 *The Archaeology of Ancient Peru and the Work of Max Uhle*. R. H. Lowie Museum of Anthropology, University of California, Berkeley.

Moseley, Michael E.
1992 *The Incas and Their Ancestors: The Archaeology of Peru*. London and New York.

Pillsbury, Joanne
 1993 Sculpted Friezes of the Empire of Chimor.
 Ph.D. dissertation, Department of Art
 History and Archaeology, Columbia
 University, New York.

Proulx, Donald A.
 1973 *Archaeological Investigations in the
 Nepeña Valley, Peru.* Department of
 Anthropology, Research Report 13.
 University of Massachusetts, Amherst.

Quilter, Jeffrey
 1990 The Moche Revolt of the Objects. *Latin
 American Antiquity* 1 (1): 42–65.

Rosas, Marco
 1999 Caracterización de la secuencia ocupacio-
 nal del sector habitacional de San José de
 Moro. Parte 1: Las ocupaciones Moche y
 Transicional. Manuscript on file, Proyecto
 Arqueológico San José de Moro, Pontificia
 Universidad Católica del Perú, Lima.

Rowe, John Howland
 1942 A New Pottery Style from the Department
 of Piura, Peru. *Notes on Middle American
 Archaeology and Ethnology* 1 (8): 30–34.

Rucabado, Julio
 1999 Informe de la excavación de entierros del
 periódo Transicional en San José de Moro,
 campañas 1997 y 1998. Manuscript on
 file. Proyecto Arqueológico San José de
 Moro, Pontificia Universidad Católica del
 Perú, Lima.

Russell, Glenn S., and Banks L. Leonard
 1990 Preceramic through Moche Settlement
 Pattern Change in the Chicama Valley,
 Peru. Paper presented at the 55th Annual
 Meeting of the Society for American
 Archaeology, Las Vegas.

Russell, Glenn S., Banks L. Leonard, and Jesús
Briceño
 1994 Cerro Mayal: Nuevos datos sobre la pro-
 ducción de cerámica Moche en el valle de
 Chicama. In *Moche: Propuestas y perspec-
 tivas* [Actas del primer coloquio sobre la
 cultura Moche, Trujillo, 12 al 16 de abril
 de 1993], ed. Santiago Uceda and Elías
 Mujica, 181–206. Travaux de l'Institut Fran-
 çais d'Etudes Andines 79. Trujillo and Lima.

Schreiber, Katharina J.
 1992 *Wari Imperialism in Middle Horizon
 Peru.* University of Michigan, Museum of
 Anthropology, Anthropological Papers 87.
 Ann Arbor.

Shimada, Izumi
 1994 *Pampa Grande and the Mochica Culture.*
 Austin, Tex.

Shimada, Izumi, and Adriana Maguiña
 1994 Nueva visión sobre la cultura Gallinazo y
 su relación con la cultura Moche. In
 Moche: Propuestas y perspectivas [Actas

del primer coloquio sobre la cultura
Moche, Trujillo, 12 al 16 de abril de 1993],
ed. Santiago Uceda and Elías Mujica,
31–58. Travaux de l'Institut Français
d'Etudes Andines 79. Trujillo and Lima.

Shimada, Izumi, Crystal B. Schaaf, Lonnie G.
Thompson, and Ellen Mosley-Thompson
 1991 Cultural Impacts of Severe Droughts in
 the Prehispanic Andes: Application of a
 1,500-Year Ice Core Precipitation Record.
 World Archaeology 22 (3): 247–270.

Stumer, Louis M.
 1958 Contactos foráneos en la arquitectura de
 la costa central del Perú. *Revista del
 Museo Nacional* 27: 11–30. [Lima].

Topic, Theresa Lange
 1991 The Middle Horizon in Northern Peru.
 In *Huari Administrative Structure:
 Prehistoric Monumental Architecture and
 State Government* [Papers from a round
 table held at Dumbarton Oaks, 15–17,
 1985], ed. William H. Isbell and Gordon F.
 McEwan, 233–246. Washington.

Ubbelohde-Doering, Heinrich
 1967 *On the Royal Highways of the Inca:
 Archaeological Treasures of Ancient Peru,*
 trans. Margaret Brown. New York.

 1983 *Vorspanische Gräber von Pacatnamú,
 Nordperu.* Materialien zur allgemeinen
 und vergleichenden Archäologie 26.
 Munich.

Uceda, Santiago, Ricardo Morales, José Canziani, and
María Montoya
 1994 Investigaciones sobre la arquitectura y
 relieves policromos en la Huaca de la Luna,
 valle de Moche. In *Moche: Propuestas y
 perspectivas* [Actas del primer coloquio
 sobre la cultura Moche, Trujillo, 12 al 16
 de abril de 1993], ed. Santiago Uceda and
 Elías Mujica, 251–303. Travaux de
 l'Institut Français d'Etudes Andines 79.
 Trujillo and Lima.

Uceda, Santiago, and Elías Mujica
 1994 (Editors) *Moche: Propuestas y perspectivas*
 [Actas del primer coloquio sobre la cultura
 Moche, Trujillo, 12 al 16 de abril de 1993].
 Travaux de l'Institut Français d'Etudes
 Andines 79. Trujillo and Lima.

Willey, Gordon R.
 1953 *Prehistoric Settlement Patterns in the
 Virú Valley, Peru.* Smithsonian Institution,
 Bureau of American Ethnology Bulletin
 155. Washington.

Wilson, David J.
 1988 *Prehispanic Settlement Patterns in the
 Lower Santa Valley, Peru: A Regional
 Perspective on the Origins and Develop-
 ment of Complex North Coast Society.*
 Smithsonian Series in Archaeological
 Inquiry. Washington.

Index

Contributors

WALTER ALVA is director of the Museo Arqueológico Nacional Brüning de Lambayeque. Since 1987 he has directed the Proyecto Arqueológico Sipán, which has concentrated on the excavation of Moche royal tombs at the site of Sipán. His archaeological investigations elsewhere in the Lambayeque Valley include Formative period sites. He is the author and coauthor of numerous publications including several books on Sipán.

GARTH BAWDEN is professor of anthropology, director of the Maxwell Center for Anthropological Research, and director of the Maxwell Museum of Anthropology, at the University of New Mexico. He has conducted research in the Middle East and Andean South America. His recent volumes include *The Moche* (1996) and *Environmental Disaster: The Archaeology of Human Response* (2000). Current research concerns the nature of political structure in ancient societies and the role of ideology and symbolism in constructing human group identity.

STEVE BOURGET is assistant professor of art history at the University of Texas at Austin, and a research associate at the Sainsbury Research Unit for the Arts of Africa, Oceania and the Americas, University of East Anglia. He has conducted fieldwork at several sites on the north coast of Peru, including Huaca de la Luna and Huancaco. He is the author of "Children and Ancestors: Ritual Practices at the Moche Site of Huaca de la Luna, North Coast of Peru," (forthcoming in "Ritual Sacrifice in Ancient Peru: New Discoveries and Interpretations," edited by Elizabeth P. Benson and Anita G. Cook).

JESÚS BRICEÑO ROSARIO is the director of the Department of Monuments of the Instituto Nacional de Cultura, La Libertad, Trujillo. His principal research interests are the Paleo-Indian period, Moche culture, northern Peruvian ethnography, and interregional relations in the Andes. He has published extensively on these topics, and is coauthor (with Claude Chauchat, César Gálvez and Santiago Uceda) of *Sitios Arqueológicos de la Zona de Cupisnique y Margen Derecha del Valle de Chicama* (1998).

LUIS JAIME CASTILLO BUTTERS is associate professor of archaeology at Pontificia Universidad Católica del Perú. His research has focused on Moche funerary archaeology and iconography, particularly concerning the collapse of the Moche and the ideological aspect of political power. He has directed archaeological excavations in San José de Moro since 1991, and is completing a book on the results of his investigations.

CLAUDE CHAPDELAINE is professor of archaeology at the Université de Montréal. From 1995 until 2000 he directed an archaeological research project at the urban sector of the

Moche site. He is currently leading a project on the Moche presence in the lower Santa Valley. He has published on the Moche struggle to cope with natural catastrophes, its urban class, burial patterns, and metallurgy. His book on the Moche state and its capital city is forthcoming.

ALANA CORDY-COLLINS is professor of anthropology and director of the David W. May Indian Artifacts Gallery at the University of San Diego. She has conducted extensive fieldwork on the north coast of Peru. Her publications include works on Cupisnique, Chavín, Moche, and Lambayeque cultures. Now she is engaged in research and preparation for a book about elite Moche "giants" excavated in the Jequetepeque Valley.

TOM D. DILLEHAY is the T. Marshall Hahn, Jr. Professor of Anthropology at the University of Kentucky. His research has focused on a variety of anthropological topics in South America, ranging from the peopling of the Americas to the rise of chiefdoms and the development of the Inca state. He has published numerous books and articles and has taught and carried out research in Peru, Chile, Argentina, Uruguay, Colombia, Ecuador, and Mexico. He is presently engaged in a joint project with Alan Kolata on the long-term interactions between humans and environments on the north coast of Peru.

CHRISTOPHER B. DONNAN is professor of anthropology at the University of California, Los Angeles. His work seeks to understand Moche civilization by combining a systematic study of Moche art with what can be learned from the excavation of Moche sites. His excavation projects include Pacatnamú, San José de Moro, and Dos Cabezas. His most recent book, coauthored with Donna McClelland, is *Moche Fineline Painting: Its Evolution and Its Artists* (1999).

CÉSAR GÁLVEZ MORA is the director of the Department of Conservation of Cultural Patrimony at the Instituto Nacional de Cultura, La Libertad, and since 1991, co-director of the Proyecto Arqueológico Complejo El Brujo. He has published on the Preceramic and Early Intermediate periods of the north coast of Peru and is coauthor (with Claude Chauchat,

Jesús Briceño and Santiago Uceda) of *Sitios Arqueológicos de la Zona de Cupisnique y Margen Derecha del Valle de Chicama* (1998).

MARGARET A. JACKSON is visiting associate professor of art history at the University of Illinois at Urbana-Champaign. Her primary areas of interest are the ancient arts of the Andes and Mesoamerica, specializing in the imagery and iconography of the Moche of Peru. Her current research addresses the production and dissemination of ideology in elite imagery, art as a catalyst for the creation of social identity, and systems of visual notation.

JULIE JONES is the curator of Precolumbian art and curator-in-charge of the Department of the Arts of Africa, Oceania, and the Americas at the Metropolitan Museum of Art, New York. She has long worked with issues of ancient American works of art in metal, with emphasis on Moche metalwork particularly the early Moche group, Loma Negra. Among her publications is *Art of Empire: The Inca of Peru* (1964).

JOANNE PILLSBURY is a lecturer at the Sainsbury Research Unit for the Arts of Africa, Oceania and the Americas, University of East Anglia. Her research interests center on the art and architecture of the ancient Americas, specifically the cultures of the north coast of Peru. In 1990–1991 she directed an archaeological project focusing on the architectural sculpture of Chan Chan, capital of the Chimú culture. She is editor of the forthcoming "Historiographic Guide to Andean Sources."

JEFFREY QUILTER is director of Precolumbian studies and curator of the Precolumbian collection at Dumbarton Oaks, Washington, D.C. In addition to his interest in Moche art, he has conducted archaeological fieldwork in North America, Peru, and Costa Rica, based on issues of nonstate complex societies. A book on his recent investigations of the Rivas Site, Costa Rica, is forthcoming.

GLENN S. RUSSELL is a research associate with the Cotsen Institute of Archaeology at the University of California, Los Angeles, and a senior environmental planner for the County of San Diego, California. He has carried out archaeological fieldwork in the highlands and

on the coast of Peru since 1982. Among his recent publications is a chapter addressing issues of craft specialization at the Cerro Mayal ceramic workshop in *Andean Ceramics: Technology, Organization, and Approaches*, edited by Izumi Shimada (1998).

IZUMI SHIMADA is associate professor of anthropology at Southern Illinois University, Carbondale, and director of the Sicán Archaeological Project. He has conducted archaeological research at the urban and ceremonial centers of Pampa Grande and Batán Grande on the north coast of Peru. His work centers on complex societies, technology, and craft production (ceramic and metallurgy). His recent publications include: *Pampa Grande and the Mochica Culture* (1994), and *Cultura Sicán: Dios, Riqueza y Poder en la Costa Norte del Peru* (1995).

SANTIAGO UCEDA CASTILLO is professor of archaeology and director of the Museo de Arqueología, Antropología e Historia at the Universidad Nacional de Trujillo. His principal research interest is Andean archaeology, particularly the Paleo-Indian period. Since 1991 he has directed (with Ricardo Morales) the Proyecto Arqueológico Huaca de la Luna. He is the coeditor (with Elías Mujica) of *Moche: Propuestas y Perspectivas* (1994).

JOHN W. VERANO is associate professor of anthropology at Tulane University. He has conducted field and museum research in Peru since 1983, investigating disease in skeletal and mummified remains, evidence of warfare and human sacrifice, and mortuary practices in ancient Peru. He is coeditor, with Douglas Ubelaker, of *Disease and Demography in the Americas* (1992).

Studies in the History of Art
Published by the National Gallery of Art, Washington

This series includes: Studies in the History of Art, collected papers on objects in the Gallery's collections and other art-historical studies (formerly Report and Studies in the History of Art); Monograph Series I, a catalogue of stained glass in the United States; Monograph Series II, on conservation topics; and Symposium Papers (formerly Symposium Series), the proceedings of symposia sponsored by the Center for Advanced Study in the Visual Arts.

[1] *Report and Studies in the History of Art,* 1967

[2] *Report and Studies in the History of Art,* 1968

[3] *Report and Studies in the History of Art,* 1969 [In 1970 the National Gallery of Art's annual report became a separate publication.]

[4] *Studies in the History of Art,* 1972

[5] *Studies in the History of Art,* 1973
[The first five volumes are unnumbered.]

6 *Studies in the History of Art,* 1974

7 *Studies in the History of Art,* 1975

8 *Studies in the History of Art,* 1978

9 *Studies in the History of Art,* 1980

10 *Macedonia and Greece in Late Classical and Early Hellenistic Times,* edited by Beryl Barr-Sharrar and Eugene N. Borza. Symposium Series I, 1982

11 *Figures of Thought: El Greco as Interpreter of History, Tradition, and Ideas,* edited by Jonathan Brown, 1982

12 *Studies in the History of Art,* 1982

13 *El Greco: Italy and Spain,* edited by Jonathan Brown and José Manuel Pita Andrade. Symposium Series II, 1984

14 *Claude Lorrain, 1600–1682: A Symposium,* edited by Pamela Askew. Symposium Series III, 1984

15 *Stained Glass before 1700 in American Collections: New England and New York (Corpus Vitrearum Checklist I),* compiled by Madeline H. Caviness et al. Monograph Series I, 1985

16 *Pictorial Narrative in Antiquity and the Middle Ages,* edited by Herbert L. Kessler and Marianna Shreve Simpson. Symposium Series IV, 1985

17 *Raphael before Rome,* edited by James Beck. Symposium Series V, 1986

18 *Studies in the History of Art,* 1985

19 *James McNeill Whistler: A Reexamination,* edited by Ruth E. Fine. Symposium Papers VI, 1987

20 *Retaining the Original: Multiple Originals, Copies, and Reproductions.* Symposium Papers VII, 1989

21 *Italian Medals,* edited by J. Graham Pollard. Symposium Papers VIII, 1987

22 *Italian Plaquettes,* edited by Alison Luchs. Symposium Papers IX, 1989

23 *Stained Glass before 1700 in American Collections: Mid-Atlantic and Southeastern Seaboard States (Corpus Vitrearum Checklist II),* compiled by Madeline H. Caviness et al. Monograph Series I, 1987

24 *Studies in the History of Art,* 1990

25 *The Fashioning and Functioning of the British Country House,* edited by Gervase Jackson-Stops et al. Symposium Papers X, 1989

26 *Winslow Homer,* edited by Nicolai Cikovsky Jr. Symposium Papers XI, 1990

27 *Cultural Differentiation and Cultural Identity in the Visual Arts,* edited by Susan J. Barnes and Walter S. Melion. Symposium Papers XII, 1989

28 *Stained Glass before 1700 in American Collections: Midwestern and Western States (Corpus Vitrearum Checklist III),* compiled by Madeline H. Caviness et al. Monograph Series I, 1989

29 *Nationalism in the Visual Arts,* edited by Richard A. Etlin. Symposium Papers XIII, 1991

30 *The Mall in Washington, 1791–1991,* edited by Richard Longstreth. Symposium Papers XIV, 1991, 2002

31 *Urban Form and Meaning in South Asia: The Shaping of Cities from Prehistoric to Precolonial Times,* edited by Howard Spodek and Doris Meth Srinivasan. Symposium Papers XV, 1993

32 *New Perspectives in Early Greek Art,* edited by Diana Buitron-Oliver. Symposium Papers XVI, 1991

33 *Michelangelo Drawings,* edited by Craig Hugh Smyth. Symposium Papers XVII, 1992

34 *Art and Power in Seventeenth-Century Sweden,* edited by Michael Conforti and Michael Metcalf. Symposium Papers XVIII (withdrawn)

* Forthcoming